CONVERSION MACHINES

Conversions
Series Editors: Paul Yachnin and Bronwen Wilson

Available Titles
Ovidian Transversions: 'Iphis and Ianthe', 1350–1650
Valerie Traub, Patricia Badir and Peggy McCracken

Performing Conversion: Performing Conversion
José R. Jouve Martín and Stephen Wittek

Conversion Machines: Apparatus, Artifice, Body
Bronwen Wilson and Paul Yachnin

Visit our website at: www.edinburghuniversitypress.com/series/CONV

CONVERSION MACHINES

APPARATUS, ARTIFICE, BODY

Edited by Bronwen Wilson and Paul Yachnin

EDINBURGH
University Press

Edinburgh University Press is one of the leading university presses in the UK. We publish academic books and journals in our selected subject areas across the humanities and social sciences, combining cutting-edge scholarship with high editorial and production values to produce academic works of lasting importance. For more information visit our website: edinburghuniversitypress.com

Edinburgh University Press Ltd
The Tun – Holyrood Road, 12(2f) Jackson's Entry, Edinburgh EH8 8PJ

Typeset in 10/12.5 Sabon by
Cheshire Typesetting Ltd, Cuddington, Cheshire, and
printed and bound in Great Britain

A CIP record for this book is available from the British Library

ISBN 978 1 3995 1600 6 (hardback)
ISBN 978 1 3995 1602 0 (webready PDF)
ISBN 978 1 3995 1603 7 (epub)

CONTENTS

LIST OF FIGURES

ACKNOWLEDGEMENTS

This book is the result of many years of collaborative work with our fellow authors, as well as with dozens of colleagues and students who have been a part of Early Modern Conversions. This Partnership initiative, the largest humanities project of its kind at the time, was generously funded by the Social Sciences and Humanities Research Council of Canada for six years. It brought scholars together from a wide range of disciplines for meetings, conferences, workshops, summer seminars, and classes. It included numerous associations, centres, performing groups, and universities in Canada, the United States, Mexico, the United Kingdom, and Australia. It also spawned an extraordinary wealth of scholarship by junior and established scholars. The range of interests, expertise, and approaches attest to the intellectual generosity and openness of the team, as well as to their energetic commitment to public humanities and creative thinking. We are grateful to SSHRC, which has been a model of funding for developing innovative research. It fosters mentoring and learning from younger scholars and from other disciplines, as well as productive debates. McGill University has been a home and an exemplary supporter of the project. Our thanks also to UCLA, and to the Center for Medieval and Renaissance Studies (now CMRS-Center for Early Global Studies), one of the Partners, and to the Department of Art History.

Our book series, Early Modern Conversions, is intended to showcase innovative research from established and the ablest early career scholars. The series takes up questions about how the proliferation of new forms of conversion

transformed Europe and its worlds from around 1400 to around 1700 and opened pathways toward the political, ideological, and religious cultures of modernity. Each book speaks to questions about culture, religion, and how conversion in its multiple forms, including as a way of thinking about historical change, brought about the transformations that made the world modern. We warmly thank Edinburgh University Press, and the staff, including Michelle Houston, Susannah Butler, Fiona Conn and Adela Rauchova. Two readers provided more assistance than they might have imagined, for which we thank them sincerely.

Conversion Machines: Apparatus, Artifice, Body attests to the intellectual rewards of learning from and working with graduate students, as well as scholars whose research has been ground-breaking for early modern studies. All of them have been important interlocutors in how the book has evolved. The ideas for this volume emerged from classes, seminars on the theme, and from innumerable discussions with colleagues. These include, but are certainly not limited to Patricia Badir, Marie-Claude Felton, Iain Fenlon, Simon Goldhill, Torrance Kirby, Kathleen Perry Long, José-Juan Lopez-Portillo, Peter Marshall, Steven Mullaney, Marjorie Rubright, Benjamin Schmidt, Helen Smith, John Sutton, Angela Vanhaelen, Val Traub, and Stephen Wittek. Dylan Reid's assistance and insights about the texts have been illuminating. Finally, we are especially grateful to Cynthia Fang for extraordinary assistance.

SERIES EDITORS' PREFACE

Conversion is a strange thing. It is something confected from natural, material and corporeal kinds of transformations that in turn transforms the multiform becomings of all kinds of matter and living creatures. Stone becomes sand by the movement of water, and sand becomes glass in the heat of fire. And animal and human bodies metamorphose in a host of ways. Early modern Europeans seem to have believed that bear cubs, shapeless at birth, were literally licked into shape by their mothers.

But conversion is also a particular case of transformation: it is both a force and a response to a force; it describes being pulled or directed toward a new kind of being. Bodies and matter change in themselves; conversion reaches out from the phenomenon of transformation to radiate change across the temporal and spatial character of the world itself.

Neither the route nor the momentum of conversion follows a straight path. For conversion is enabled, hindered, orchestrated and resisted by elemental, environmental, material, institutional, social and bodily demands and desires, which render the process open and subject to reversals and reorientations. Its itineraries cannot easily be traced, nor its effects measured. Its temporal and spatial dimensions are inevitably intertwined – its pasts, presents and futures arrested and accelerated. To confront conversion in its historical and phenomenal permutations therefore entails exploring how these experiences, sensations and transmutations are materialised in cultural forms and in human bodies – through imagination,

narration, performance, violence, experimentation, social structures and institutional apparatuses.

Augustine's account of his conversion is a critical instance of narrative's potential to convey the temporal and spatial dynamics of conversion, together with its anticipatory and ineluctable character. He tells the story of his life differently because of the revelatory experience in the garden. All his wanderings, fallings, sufferings become necessary parts of a narrative leading up to the time-shaping child's cry of 'tolle lege [pick it up and read]' and his reading of the passage from Romans. 'For instantly,' Augustine reports, 'as the sentence ended, there was infused in my heart something like the light of full certainty and all the gloom of doubt vanished away.' The moment of conversion changes him by transforming his past into wanderings away from and then back to his true home. It also fashions his future life into an evangelical mission oriented around a polestar dialogic relationship with God – a relationship where speaking with God and being seen by God guarantees Augustine's substantial meaning and value. His retelling shows how conversion is able to organise time into a meaningful dwelling place in relation to the moment of turning, which for the convert, is toward a higher order of being.

The Conversions series sets out to explore the efflorescence of various forms of conversion and their social, corporeal and material integuments as they played out across early modernity. As recent work on the distributed nature of human thinking and feeling confirms, humans are never alone on the pathways of conversion (or alone with the divine). Movement toward, or away from, modes and expressions of self-realisation, salvation or ensoulment unfold in ecologies that include politics, law, religious practice, the arts and the material, corporeal and natural realms.

From 1492, which saw the last battle of the Reconquista and the start of conversional war against the First Peoples of the Americas, up to 1656, when Baruch Spinoza, one of foundational thinkers of secular modernity, was cast out of the Jewish community of Amsterdam, Europe and the new worlds that the Europeans were coming to know emerged as a vast theatre of conversion. The process of conversion in early modernity was manifested in institutional, bodily and artistic practices, and it permeated a multiplicity of cultural forms and technologies. These material and subjective transformations were of a piece with geopolitical reorientations that issued from oceanic journeys and from evolving relations with Islamic dominions and other civilisations. Encounters with ancient, indigenous and unfamiliar worlds gave impetus to the rethinking and translation of forms of knowledge and languages; to the conversion, sometimes violent, of built and natural environments; to gender and sexual metamorphoses; to ethnic, religious and social performances; and to the reimagining of God.

The history of the Reconquista, the conquest and conversion of the Americas, the back-and-forth changes of the national church in England, and the French Wars of Religion show us that conversion was not only an often winding pathway toward the realisation of self and soul. It also became in this period a sublime weapon of war and instrument of domination. The First Peoples of the Americas, the Jews of Spain and the Catholics of England, among many others, were compelled to convert by violence and threats of violence. They seldom found themselves free to find their own way toward fulfilment or salvation. But conversion also became in the period a surprisingly potent instrument of resistance to the power of the State or the Church, a way for subjects such as Bartolomé de las Casas, Anne Askew or Martin Luther to stand out against the powerful and even to begin to create new conversional publics.

Individually, the volumes in the Conversions series will address important matters in original ways – matters such as how the politics of conversion developed inside Europe and across an increasingly globalised world, how Ovidian 'transversions' – conversions in the realm of gender and sexuality – were themselves transformed by a host of writers and artists in England and France, how the crisis of conversion created Shakespeare's theatre, how Europeans invented scores of new, purpose-built 'conversion machines' and how the performance of conversion reimagined the space and the social character of cities in Europe and the Americas. Each volume in the series will bring forward cutting-edge work in particular disciplines or interdisciplinary fields, and all the volumes will also set out to be of interest and value to readers outside those particular disciplines or sets of disciplines. Together, the volumes in the series will undertake to tell a new story about early modernity and will explore how conversion in its multiple forms, including as a way of thinking about historical change, brought about the transformations that made the world modern.

Bronwen Wilson and Paul Yachnin

CONTRIBUTORS

Juan Luis Burke was trained as an architect with a specialisation in the preservation of the built heritage in his native Mexico. He received his doctorate from McGill University in 2017. His scholarly interests revolve around the history and theory of architecture and urbanism of the early modern, to the modern periods in Mexico and Latin America, and its connections to Europe, in particular to Spain and Italy. He is the author of *Architecture and Urbanism in Viceregal Mexico: Puebla de los Ángeles, 16th –18th Centuries* (Routledge, 2021) and he has published several articles, papers, and edited chapters in Spanish and English, on architectural and urban theory in viceregal Mexico, and other architectural and urban subjects. He is assistant professor of architecture and architectural history and theory at the University of Maryland, College Park.

Eric R. Dursteler joined the History Department of Brigham Young University in 1998, where he is currently professor and former chair. He earned his PhD from Brown University in 2000. His research focuses on the entangled history of the early modern Mediterranean, and in particular questions of gender, language, religious identity, and food. He has received numerous fellowships, including from the Fulbright Commission, the National Endowment for the Humanities, and the Harvard Center for Italian Renaissance Studies. His most recent book, *The Medieval and Early Modern Mediterranean World*, co-authored with Monique O'Connell, was published by Johns Hopkins

University Press in 2016 (Turkish translation 2019). His other publications include *Venetians in Constantinople: Nation, Identity and Coexistence in the Early Modern Mediterranean* (2006, Turkish translation 2012), *Renegade Women: Gender, Identity and Boundaries in the Early Modern Mediterranean* (2011, Turkish translation 2013), and as editor, *A Companion to Venetian History, 1400–1797* (2013). He is currently working on a book on food and foodways in the early modern Mediterranean. He is the editor of the *News on the Rialto*.

Anna Lewton-Brain is a faculty member in the English Department of Dawson College in Montreal. Her recently completed dissertation, 'Metaphysical Music' (2022), is a study of the musical qualities and contexts of the poetry of John Donne, George Herbert, and Richard Crashaw. Anna has maintained a singing career in tandem with her academic pursuits, performing with the King's College Chapel Choir, Symphony Nova Scotia Chorus, Montreal Symphony Orchestra Chorus, McGill Chamber Orchestra, The Theater of Early Music, in the Montreal Bach Festival, and for Musique Royale with Aureas Voces. She has led workshops on music and poetry at the Montreal Baroque Festival, the Stratford Shakespeare Festival, CRASSH (the Centre for Research in the Arts, Social Sciences and Humanities) at the University of Cambridge, and at the Guildhall School of Music in London. She is also a founding member and past president of the Montreal-based early music ensemble One Equall Musick.

Kathleen Long is Professor of French in the Department of Romance Studies at Cornell University. She is the author of two books, *Another Reality: Metamorphosis and the Imagination in the Poetry of Ovid, Petrarch, and Ronsard* and *Hermaphrodites in Renaissance Europe*, and editor of three volumes: *High Anxiety: Masculinity in Crisis in Early Modern France*; *Religious Differences in France*; and *Gender and Scientific Discourse in Early Modern Europe*. She has written numerous articles on the work of Théodore Agrippa d'Aubigné, on gender, and on monsters. She is preparing a translation into English of *L'Isle des hermaphrodites* (The Island of Hermaphrodites), and a book on early modern discourses of monstrosity and modern discourses of disability. She is the co-editor for a series on *Monsters and Marvels: Alterity in the Medieval and Early Modern Worlds* (Amsterdam University Press).

Peter Marshall is Professor of History at the University of Warwick, UK. He has published widely on the political and cultural impact of the British and European Reformations, and his books include *Beliefs and the Dead in Reformation England* (2002), *Mother Leakey and the Bishop: A Ghost*

Story (2007), *The Reformation: A Very Short Introduction* (2009), and *Heretics and Believers: A History of the English Reformation* (2017).

Walter S. Melion is Asa Griggs Candler Professor of Art History at Emory University in Atlanta, where he has taught since 2004 and currently directs the Fox Center for Humanistic Inquiry. He was previously Professor and Chair of Art History at The Johns Hopkins University. He has published extensively on Dutch and Flemish art and art theory of the 16th and 17th centuries, on Jesuit image-theory, on the relation between theology and aesthetics in the early modern period, and on the artist Hendrick Goltzius. In addition to monographs on Jerónimo Nadal's *Adnotationes et meditationes in Evangelia* (2003–2007), and exhibition catalogues on scriptural illustration and on religious allegory in Dutch and Flemish prints of the 16th and 17th centuries (2009 and 2019), his books include *Shaping the Netherlandish Canon: Karel van Mander's 'Schilder-Boeck'* (1991), *The Meditative Art: Studies in the Northern Devotional Print, 1550–1625* (2009) and *Karel van Mander and his 'Foundation of the Noble, Free Art of Painting'* (2022).. He is a recipient of awards such as 2016 Distinguished Scholar Award of the American Catholic Historical Association, and the 2019 Baker Award of the Michael C. Carlos Museum. Melion has been President of the Sixteenth Century Society, and is currently President of Historians of Netherlandish Art.

Anthony Meyer is a PhD Candidate in the Department of Art History at the University of California, Los Angeles where he studies the Indigenous arts of the Americas and the Early Modern period, with a focus on Nahua art and architecture. His dissertation examines the objects and spaces crafted, shaped, and transformed by Nahua religious leaders (*tlamacazqueh*) during Mexica rule (1325–1521 CE), as well as the critical impacts these figures and their objects had in sixteenth-century New Spain and Europe. He has received numerous fellowships, including from the Social Science Research Council, the Fulbright Association, and the Center for Advanced Study in the Visual Arts.

Yelda Nasifoglu is a historian of early modern mathematics and architecture, and an associate member of the Faculty of History, University of Oxford. She was trained as an architect in New York, studied history of science, medicine, and technology at Oxford, and received her doctorate from McGill University with her dissertation 'Robert Hooke's *Praxes*: Reading, Drawing, Building' (2018). She has been a researcher with the AHRC-funded project 'Reading Euclid's *Elements of Geometry* in Early Modern Britain and Ireland' based at Oxford, and she is one of the editors of the 'Robert Hooke's Books' database.

Justin E. H. Smith is professor of history and philosophy of science at the University of Paris 7 – Denis Diderot. In 2019–2020 he was the John and Constance Birkelund Fellow at the Cullman Center for Scholars and Writers of the New York Public Library. Among his many publications are the following books (all from Princeton University Press): *Irrationality: A History of the Dark Side of Reason* (2019), *The Philosopher: A History in Six Types* (2016), *Nature, Human Nature, and Human Difference: Race in Early Modern Philosophy* (2015), *Divine Machines: Leibniz and the Sciences of Life* (2011). He is a regular contributor to the *New York Times, Harper's Magazine, n+1, Slate,* and *Art in America.*

Ivana Vranic received her doctorate in Art History from the University of British Columbia in 2019. Supported by the Social Sciences and Humanities Research Council of Canada, her research explored a sculptural phenomenon in terracotta from Northern Italy: life-size groups representing the Lamentation over the Dead Christ. The thesis establishes a critical history for these life-size works and provides a technical explanation of how they were created. Her work shows that the technology of making terracotta sculpture was a highly specialised practice in the Renaissance. She currently teaches at Columbia College in Vancouver.

Bronwen Wilson teaches at UCLA, where she is the Edward W. Carter Chair in European Art and the Director of the Center for 17th- and 18th-Century Studies and William Andrews Clark Memorial Library. Her research and teaching explore the artistic and urban cultures of early modern Europe (1300–1700), with a focus on space, print, portraiture, landscape, and transcultural, material, and environmental interactions. Her most recent edited volume, with Angela Vanhaelen, is *Making Worlds: Global Invention in the Early Modern Period.* Their new five-year research project, Making Green Worlds: Early Modern Art and Ecologies of Globalization (making-greenworlds.net), is supported by the Social Science and Humanities Research Council of Canada. Wilson's current book project, 'Otherworldly Natures: the subterranean imminence of stone', probes the artistic turn to quarries, riverbeds, and lithic formations in early modern painting.

Paul Yachnin is Tomlinson Professor of Shakespeare Studies at McGill University. From 2013–2019, he directed the Early Modern Conversions Project (http://earlymodernconversions.com). His ideas about the social life of art were featured on the CBC Radio series, 'The Origins of the Modern Public'. Among his publications are the books, *Stage-Wrights* and *The Culture of Playgoing in Early Modern England* (with Anthony Dawson), co-editions of *Richard II* and *The Tempest,* and edited books such as *Making Publics in*

Early Modern Europe (with Bronwen Wilson) and *Forms of Association*. He leads the TRaCE McGill Project (http://tracemcgill.com), tracking the career pathways of 5,000+ PhD graduates and telling the stories of 150+ of them. He publishes regularly on graduate education policy and academic culture and on how Shakespeare can speak to the challenges of the 21st century.

INTRODUCTION: CONVERSION MACHINES: APPARATUS, ARTIFICE, BODY

Bronwen Wilson and Paul Yachnin

A half-length male nude, carved in the early sixteenth century from wood and painted to resemble flesh marked with blood, is an arresting presence in the Castello Sforzesco in Milan (Fig. 1.1). The arms of the figure are bound behind its back and drips of red paint on the shoulders evoke the crown of thorns. That crown is absent, however, because the head of Christ has been replaced by a demonic one. Its monstrous fleshy visage, harrowing expression, and gaping orifices are accentuated with calligraphic lines. Its ears are part human, part creature, its eyes are simultaneously penetrating and vacant, and its serrated teeth flash from a gaping jaw. Hinged like a human mandible, the mouth opens to eject a flame-red tongue. Animated by a metal crank at its base, the devil spews smoke, even flames, emitting a yowling cry as its glass eyes roll wildly.

The automaton manifests transformative effects ascribed by early moderns to a fallen, or evil, soul. Startling viewers, it conjures bodily reactions from onlookers similar to those performed by the sculpture – externalising expressions of interior movements of the mind and the passions. These effects are emphasised in the description, in Chapter 7 of the guidebook to the museum, that was published in 1666: 'De i moti quasi perpetui' (On the motions, as if perpetual):

> Pedestal, where in the top part, one can observe the head of a horrible monster locked up; with the simple touch of a trigger, a door opens up immediately releasing the monstrous Head, with a terrible rumbling voice

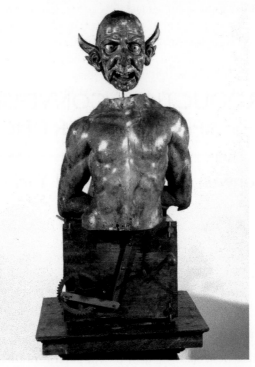

Fig. 1.1 Lombard Workshop, *Automaton*, cherry wood, polychrome, cork, iron, life-size, sixteenth-seventeenth century © Comune di Milano – Raccolte Artistiche, Castello Sforzesco, Milan.

that it transmits on its own, and which fills those who hear it with fright; from two small cannons, that hang down from both ears, worked by a cord, two vipers shoot out furiously, instigating a thousand twisted wriggles and no less terror among those watching; realizing that the causes of their fear may be unfounded, they [those watching] with joyful laughter revived their previously perturbed soul, when the sudden opening of a little window over the said head will send them into turmoil once again causing the Head to be more monstrous, unwinding a tongue that comes out from the lips, and twisting its flaming eyes between its frightful eyelashes, and moving its ears, like those of an Ass, they are invited anew to the terror of appearances, or to laughter from the playful deception.[1]

The demonstration would have accrued a quasi-scientific function in the museum of the Milanese physician, Ludovico Settala (1552–1633), and his son Manfredo (1600–1680), a naturalist and a canon in the city's cathedral.[2] Visitors could marvel at the repurposing of the sculpture of Christ, and the

corresponding bodily and aural dimensions of its reanimation.[3] The redesign evidently converted an iconic figure into a devilish toy – something that frightens and delights by enlisting spectators to become parts of the devil machine, as agents of devilish expressiveness. Rotating the crank that spools the cord, the operator and those who watch become parts of the machine, verifying its transformation. Its ingenuity would have generated calls for the spectacle to be repeated, as those gathered around experienced its effects, and witnessed each other's reactions anew. In the meanings of its components, in its manufacture, and in its potential to reveal spontaneous responses, the automaton performs conversion, exacts it from others, and produces evidence of its effects.[4]

The Christ-Devil is an exemplary 'conversion' machine, a term used in this book to bring into view an efflorescence, beginning in the fourteenth century, of cultural forms and practices designed to solicit, to persuade, to coerce, and to move individuals toward some purpose. These machines could be devised by institutions, collaborators, or individuals, using diverse spaces and media that were cleverly crafted to create effects on bodies. Their ends were often abstract ideals and beliefs, understandings, or dispositions – even human mindfulness itself. They were spiritual and political, as well as sexual, corporeal, spatial, epistemological, and elemental. As the case studies in the chapters to come demonstrate, these ends were often intertwined.

Alchemy is an illustrative example of how a process of conversion could be directed toward multiple ends that were often intangible.[5] It entailed combining substances to improve them, thereby turning them into an ideal. Alchemy referred to the creation of precious stones and metals from divine forces and from materials that embodied principles of change (salt, quicksilver, sulphur), as well as to the reassembly of cut stones into luxury furnishings, explored in Chapter 6, and to their effects as gifts, which could enhance social relations between rulers.[6] Alchemy also explained conversions of bodies of rulers themselves. The hermaphrodite, for instance, was understood as the alchemical conjoining of male and female bodies into one. It could be an ideal body, a symbol of royal legitimacy in official contexts, as it was for the English and French monarchs, Elizabeth I and Francis I, both of whom were portrayed as a melding of both sexes.[7] This positive gendering of politics could be inverted, however. During the Wars of Religion (1562–1628), critics of the policies of the French King, Henry III, fastened onto his coterie of 'Mignons'. On the frontispiece of the anonymous satirical tale analysed in Chapter 8, *L'Isle des hermaphrodites* (The Island of Hermaphrodites, ca.1605), Henry was depicted declaring 'I am neither male, nor female' (Fig. 1.2).[8] The narrator's descriptions of the island's disorienting architectural spaces, which force bodies to bend, to fall, and to fold, also evoke the state-sanctioned violence that accompanied religious conversion.

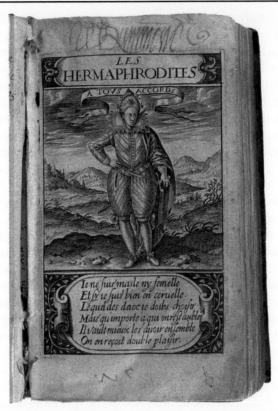

Fig. 1.2 Frontispiece, *L'Isle des hermaphrodites* (1605). Folger Shakespeare Library Shelfmark: PR1711.A68 H4 1605 Cage. Used by permission of the Folger Shakespeare Library.

The hermaphrodite was also used as a substitute for enslaved and colonised peoples, particularly Africans and native Americans and first peoples. In French burlesques and courtly ballets, including one in 1626 in which Louis XIII was a star performer, dancers wore costumes designed as female and male bodies conjoined. These androgyns, perhaps echoing the inhabitants of the imaginary island of hermaphrodites, lived in distant places associated with luxury goods. They became signs of racialised differences, embodying, as they danced at court, the conversion of natural resources into commodities in Europe.[9]

Demonstrations of material and bodily conversions in spaces such as city streets and squares, churches, patios, convents, and books studied in this volume, enabled processes of transformation to unfold before viewers while also managing how these conversions were to be understood. In the Settala Museum, for instance, the artifice and the effects of the Christ-Devil automaton in action would have been compared to other natural, mechanical, creative,

and scientific inventions: cabinets filled with rarities, animals preserved through taxidermy, and clocks and diverse kinds of instruments (Fig. 1.3). Its meanings were also shaped by the family's professional, natural historical, theological, and geopolitical investments. Taking into account Ludovico's medical expertise and knowledge of anatomy, the automaton would surely have stimulated discussions on the animation of the human body.

Andreas Vesalius's influential *De humani corporis fabrica* (On the device [or machine] of the human body), published in 1543, describes the body as a machine. Its text and large woodcut illustrations elucidate natural processes that were ascribed to humoral theories and to the mechanical operations of joints and muscles. The format of the treatise is itself machine-like in its methodical sequence of revelatory images.[10] Vesalius's *Fabrica* is distinctive for its artifice – its large scale, its manufacture, and its inventive references to and treatment of anatomical imagery. Importantly, it is distinctive, but neither singular nor anomalous. Not unlike the automaton in the museum, and the museum itself, the impact of the *Fabrica*, and its operations, depends upon a network of connections. The scenes and descriptions on its pages recall and direct viewers to other anatomy treatises, to tables in anatomy theatres, to civic spaces, to prints and to paintings, and to the bodies of criminals and outsiders that were bound, paraded, suspended, manipulated, posed, and opened up to reveal their working parts. These human bodies, as sites for performances of conversion, were avowedly redeemed as forms of civic (Christian) knowledge.[11]

Why 'conversion machines' to account for these demonstrations and procedures? Conversion and metamorphosis were both terms with which early

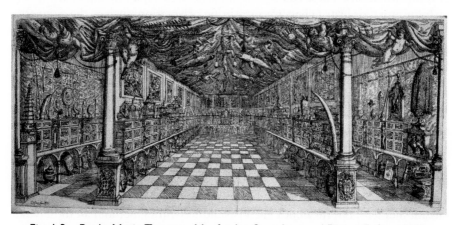

Fig. 1.3 Paolo Maria Terzago, Manfredus Septalius, and Pietro F. Scarabelli, *Museo, ò Galeria, adunata dal sapere e dallo studio del sig. canonico Manfredo Settala nobile milanese* (Tortona, 1666). n.p. (409). Accession number 85-B25073. Digital image courtesy of the Getty's Open Content Program.

moderns could understand change, and yet there are important differences. Metamorphosis is defined in the *OED* as 'a change of the form or nature of a thing or person into a completely different one, by natural or supernatural means.' Humans, animals, and other natural phenomena pass through stages, such as the caterpillar that becomes a butterfly. In the realm of the supernatural, Daphne, who flees Apollo, becomes a laurel tree. The divine forces that cause Daphne's bodily transformation are invisible, but their efforts are audible and visible – she calls out to her father and her body is turned into leaves and bark. The results of metamorphoses are normally verifiable through our senses, even if these changes are imaginary.

Conversion is similar in referring to 'the process of changing or causing something to change from one form to another'(*OED*), but whether a change has occurred, and what the extent of it might be, is not something that could be substantiated by hearing it said, touching it, or seeing it. Conversion also described, particularly for early moderns, the turnings of individuals, materials, and forms toward an end, a goal, or a horizon.[12] Those ends were often ideals, truths, and beliefs, which made it difficult for authorities and for individuals to ascertain if they had been reached. The causes of what directs a thing or a person to an end might be identified, such as group pressure, torture, or desire, but evidence of conversion required witnesses, such as those in the Settala Museum, who would have seen and heard each other's responses to the automaton in action.

Efforts to confirm the changed inward states of humans, or of material things, generated procedures for acquiring and analysing causes and effects of transformations. These could be legal, such as the questioning of witnesses by Inquisitors, or instruments for measuring orientation, such as the compass. To assess transformations that were not readily quantifiable required ongoing monitoring, revising, and correcting. Recall the story of Mary Magdalene, who, having heard the voice of her master calling her name, turns toward Christ. As she reaches out to touch him, he says 'do not hold onto me' (Noli mi tangere; John 20:17 [Vulg.]), as he withdraws and disappears.[13] Countless visual representations promoted, and served as evidence of, the belief that Jesus appeared to Mary Magdalene after his death. Turning toward the image of Christ in altarpieces, beholders became witnesses to the apparition and to her conversion. The stories of Paul struck down by God on the road to Damascus or of Augustine called to pick up and read the Scriptures in the garden in Milan can make it seem that conversion could be accomplished in one single terrifying, radiant moment; but they both knew, as did Martin Luther and all those who devised the rituals of Confession, Holy Communion, and the other repeatable practices of religious worship, that conversion, as Luther said in the first of the 95 Theses, must be a life-long practice of turning to God – 'that the whole life of believers should be repentance'.[14] Participation, witnessing, and repetition,

as the chapters in this volume demonstrate, were critical for conversion to be meaningful, including for those who may have been resisting it.

Conversion machines are apparatuses, artfully-fashioned preparations, arrangements, and things that demonstrate processes of change. Consider another example from the Settala Museum, the *sordellina*, that converts air into sounds. Fabricated from an inflatable bag, pipes, keys, and bellows, the sordellina allows a musician to play and to sing at the same time (Fig. 1.4).[15] The performer manipulates the keys with his fingers, and his foot works the bellows, which inflates the bag. Making music while he breathes to sing, he becomes a part of the equipment. The instrument's glistening metal, polished wood, and multiple moveable parts would have enhanced the spectacle of the conversion of air into sounds. In a portrait, now missing, of Manfredo Settala with some of the objects from the Museum, he directs us toward the sordellina, which is suspended above the table to showcase its working parts (Fig. 1.5).[16] Its repetitive mechanical character is emphasised by displaying the instrument alongside a goblet crafted from ivory on a lathe and an armillary sphere whose parts could be rotated to observe the movement of the earth in relation to the celestial sphere. Galileo Galilei was among those astronomers who used the word *conversione* frequently in his writings to describe the orbit of the earth, as well as geometrical manipulations, considered in Chapter 10.[17]

Fig. 1.4 Illustration of a sordellina, in Marin Mersenne, *Harmonie universelle, contenant la théorie et la pratique de la musique* (Paris: S. Cramoisy, 1636). Bibliothèque nationale de France, département Arsenal, FOL-S-1449.

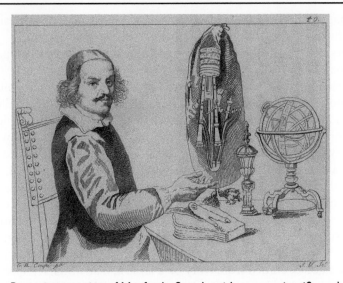

Fig. 1.5 Portrait engraving of Manfredo Settala with some scientific and musical instruments [1640], in *Select Engravings from a Collection of Pictures: by the most Eminent Italian, Flemish, and Dutch masters exhibiting at the Saloon of Arts, Old Bond Street* (London: J. Moyes, 1818), p. 31. Yale Center for British Art, Paul Mellon Collection.

Another item exhibited in the Museum was a feather cloak, which introduces the complex transatlantic dynamics of conversion that are discussed in Chapters 4 and 5. The artifact was displayed alongside the armillary sphere and Christ-Devil automaton. The arrangement can be seen on the far right of the large etching that unfolds from the back of the detailed guide to the museum (Fig. 1.6).[18] Purposefully curated to highlight their manufacture, the sphere is positioned above the automaton and in front of the garment whose overlapping feathers are carefully executed by the illustrator. The garment is likely the Tupinambá cloak, fabricated from vibrant red feathers, that Manfredo received from Federico Landi, an Italian prince with connections to the King of Spain and Duke of Milan.[19] Examining a similar cloak in Augsburg, Albrecht Dürer commented on its 'subtle ingenuity'.[20] Fascination summoned by the garment's artifice is an important aspect of the uptake of apparatuses, which also sheds light on networks of institutions, spaces, and procedures for scientific inquiry, acquisition, colonisation, and exhibition. The etching of the Museum also alerts us to ways in which such considerations were entangled with European knowledge systems, such as theological and elemental theories. Note, for our purposes, the vertical arrangement of artifacts (Fig. 1.6). The animal skull and demonic automaton conjure the fiery subterranean spaces of hell; the base and the armillary sphere suggest the ascent through purgatory

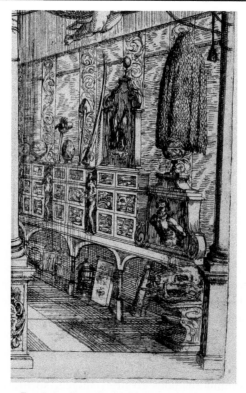

Fig. 1.6 Detail of 1.3, *Museo, ò Galeria.*

and earth, with paradise and air evoked in the resemblance of the feather cloak to the red wings of seraphim in European altarpieces. Note also that the automaton is constrained by chains, which must have recalled enslaved bodies, especially when seen below the armillary sphere, an instrument associated with navigation, and a Brazilian cloak. In light of Manfredo Settala's religious and political connections, the arrangement also signals efforts to convert Indigenous bodies into Christian ones.

The sordellina, automaton, armillary sphere, and feather cloak are distinctive kinds of things, arrangements of parts that were designed to move bodies and minds – those of their performers and their viewers. They converted air into music, a controlled body into a terrifying one, the earth into a part of a dynamic system, and the wearer of the cloak into a human bird, or warrior, according to European assumptions.[21] Each of these examples demonstrated what was difficult to perceive, or to quantify. They showed, or at least endeavored to show, the motions of bodies, elements, minds, and souls, by converting them into something that could be apprehended, sometimes viscerally, and verified through the ear, the eye, and the hand.

Conversion, especially religious conversion, has attracted significant scholarly attention over the past two decades.[22] Research of missionary activities and oceanic trade have underscored the global impact of religious conversion.[23] Area studies have been furthering understandings of institutional dynamics of surveillance and judicial processes in various jurisdictions.[24] Gender, sexuality, and racialised identities have been at the forefront of this research, together with transcultural, decolonial, and intersectional approaches.[25] Many studies show that religious conversion could be undertaken for pragmatic reasons, and reversed, sometimes with apparent ease. It could also be forced, as it was for enslaved peoples, and it could be revoked.[26] Material dimensions of conversion have also been a focus of recent scholarship. Anthropologists, art historians, musicologists, literary scholars, and historians have explored the role of the voice, ink, print, bones, relics, clothing, pearls, and water, as well as the conversion of materials themselves.[27]

Of course, conversion is not exclusively an early modern phenomenon, but diverse factors contribute to its importance from the fourteenth century into the seventeenth. Recurring plagues reduced the strength of long-standing east-west trade routes through the Mediterranean to Asia, which led to the growing economic and political influence of European centres and increasing north-south coastal trade.[28] Knowledge of Ptolemy's system of geographical coordinates, celestial navigation, and the compass, whose magnetic attraction to the north was described as a conversion, spurred oceanic travel. As concomitant political, economic, and religious rivalries surged, so too did demands for staging, elucidating, policing, and representing conversion.

Examples include an uptick in reports of heresy in the fifteenth century, which provided the grounds for religious orders to mechanise interrogations. The Inquisition could be tailored, as it was in the case of witchcraft, for female bodies.[29] Preoccupations with blood purity (pureza [limpieza] de sangre), legislated in Spain in 1449, targeted Jews and Muslims.[30] With the Alhambra Decree in 1492, these religious groups were forced to convert or be expelled from Spain, an edict that was extended to the entire Iberian Peninsula during the first two decades of the seventeenth century. Censorship and persecutions generated a spectrum of reactions, including dissimulation, which erupts again in the wake of the Reformation and the Catholic response, and with the globalising of Christian conversion through missionary activities and colonialism.[31] Authorities scrutinised individuals and surveyed communities; they oversaw populations, geographical borders, and forms of cultural production; and they sought to regulate even the most profound human experiences.

Dissimulation was a particular conundrum for authorities, since coercive tactics led peoples to conceal their religious and political beliefs. Affiliations, faiths, and ethnicities were expressed through words and gestures, which could be expressed in private. Attire could be changed, as it was for self-protection,

notably for those on the move.[32] Verifying a person's faith or identity, there-fore, sometimes led to procuring physical evidence. Inquisition cases from Malta, studied in Chapter 11, shed light on methods used to examine intimate characteristics of the bodies of individuals, as well as testimonies about their histories. Ensuring conformity required equipment and procedures designed to verify doubts and claims made about the status and faith of individuals in such cases, including what could not be ascertained through outward appearances.

Concerns with bodily and material transformations intensified with argu-ments about the very substance of matter during the Reformation and Counter Reformation, as theologians and philosophers interrogated tran-substantiation, saints, relics, and the functions and uses of images. Consider the example of lay women in Germany in the later fifteenth century, whose gatherings for devotional purposes threatened religious authorities. The Dominicans responded in 1486 with the well-known *Malleus maleficarum* (Hammer of Witches).[33] With its inventory of signs (from weather-making to medical practices), procedures for interrogation, and multiple editions, it became a machine for suppressing, controlling, and obliterating different groups of people. Misogyny also provoked serial forms of inventive imagery devoted to witchcraft in which putrefaction evokes bodily fluids, serpentine clouds mimic intestinal forms, elemental debris is projected from steaming cauldrons by unknown magical forces, and goats take flight (Fig. 1.7). Lines gouged from wood and copper by printmakers with sharp implements evoke the torment inflicted by inquisitors on the bodies of those who threatened boundaries – enacted in graphic imagery discussed in Chapter 10. Pigments ground for ink, fumes from heating viscous substances, and acid that cor-rodes metal, conjure magic attributed to demonic forces and the conversion of materials into art. Such transformations – earth into terracotta, stone into paper, words into sensations – are central to our accounts of apparatuses and their effects on bodies.

Conversion machines, then, are purposefully assembled systems and struc-tures for turning, bending, and directing bodies, souls, and materials toward ends. They involve apparatuses, which referred in the early modern period, as it does today, to the work of preparing, arranging, and maintaining systems.[34] Apparatuses are oaths and protocols, spaces and equipment, media and formats.[35] Their artifice attracted attention, transforming oaths, sculpture, architecture, books, poetry, geometry, procedures, and plays in ways that provoked on-going engagement. Cannily crafted and self-aware in their forms of manufacture, conversion machines incited participation from operators, performers, and audience members – sometimes willingly, and sometimes not. They produced bodily sensations in listeners, readers, and viewers, and did it repeatedly.

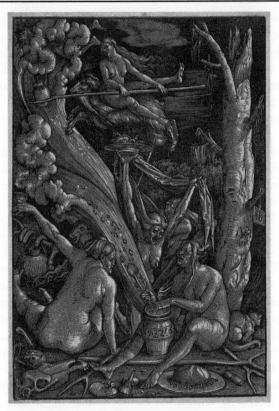

Fig. 1.7 Hans Baldung Grien, *The Witches' Sabbath*, chiaroscuro woodcut in two blocks, printed in grey and black, 1510. Accession number 41.1.201. Digital image courtesy of the Metropolitan Museum of Art's Open Content Program.

In the first chapter, Peter Marshall elucidates how swearing an oath, a conventional gesture in the legal system of early modern England, was transformed into a conversion machine by the Succession Act of 1534. The Succession Oath, with its implicit rejection of papal authority, was intended as a mechanism through which English citizens would be swiftly bound to the Protestant succession of Henry VIII. In city spaces, university colleges, Parliament, and various religious houses, the King's subjects professed their allegiance, uttering words, raising their hands, and even kissing books. These collective displays proved to be no guarantee of fealty, since individuals could declare their conformity on the outside while renouncing their words on the inside. Counter to its intent, the Act had the effect of gathering dissenters as members of a newly christened Roman Catholic opposition, through their shared recognition of their resistance to conversion. Instead of producing a sudden conversion to Protestantism, then, as Marshall demonstrates, the oath campaign laid the

ground for what was a gradual and incomplete process of turning the King's subjects toward English authority over the Church, a process that combined two forms of conversion, the official Constantinian kind that is imposed, and the personal Augustinian form that emerges from within.

Displays of gestures that were repeated in multiple spaces over decades are also the focus of Ivana Vranic's analysis of Sepulchre groups in Chapter 3. These arrangements of sculptures lamenting the death of Jesus populated hundreds of chapels across Europe from the middle of the fifteenth century to the middle of the sixteenth. As scholars have noted, these groups of figures are certainly different from each other in their commissioning and their use of materials – wood, stone, terracotta. As a result, however, striking similarities between these groups of mourners – their poses and gestures, their gendered expressions of grief, their verisimilitude, their artistic self-awareness, and how these traits petition beholders' responses – have been overlooked. Highlighting these interconnections, and their orientation to the dead body of Christ, Vranic argues for their shared function as a re-creation of his funeral. Each group of sculptures is one instance of devotional expressions within a broader geographical network of shared devotional practices and obligations for its patrons. They recreated the move from death to life, transformed real people into sacred characters, and connected diverse geographical places. These Sepulchre groups purposefully generated artistic, religious, and cultural conversions.

Intriguing similarities come to light in New Spain, the geographical focus of Chapters 4 and 5, where European religious and architectural beliefs were imposed, translated, and reinvented through Indigenous practices, and then reimposed through colonial practices. Anthony Meyer elucidates the multiplication of stone crosses, each a distinctive variation on the theme, that were erected on the patios of convents throughout the Valley of Mexico. Instead of biblical protagonists surrounding the dead Christ, it is the location and the shape of the cross that acts as a compass for those gathered in the patio. In contrast with the European tradition of Christ nailed to the cross, his body is invoked by details – wounds that bleed, scourges, obsidian mirrors – that are sculpted in relief on the surface of the stone by Nahua artists. These *arma Christi* and autochthonous motifs, Meyer argues, would have motivated Indigenous viewers to move around the cross, to touch the stone, and to make connections with their own bodies and beliefs. Extricated from both imported and local traditions, the sensual appeal of these motifs would have invited speculation about their meanings as well as inventive, potentially idolatrous, forms of devotion. If heterodoxy were a concern for Christian friars, Meyer's account suggests the mixing of sacred iconographies and the relocation of crosses to patios would have contributed to the success of these patios as conversion machines. Every time new converts entered these transitional spaces between the city and the church, the crosses would rekindle associations with

sacrifice and the interpretative process of transformation, an operation Meyer connects to *tlaquimilōlli* – Nahua sacred bundles. Crosses, relegated to patios of religious institutions and inventively remade in stone, exemplify how a European form was fabricated into a machine for the conversion of bodies to Christianity, but also how that machine failed to fully transform them.

If bundling motifs of physical torment in sculptural reliefs proved useful in the early history of converting peoples into colonial subjects, such bricolage in the built environment was countered by a reimposition of architectural ortho-doxy, as Juan Luis Burke shows in Chapter 5. Architectural treatises were sent to New Spain early in the conquest to establish and to impose European cul-tural traditions. Their illustrations provided models of the classical orders for new religious and political buildings, and for additions to existing structures, thereby converting and incorporating Indigenous architecture and motifs to support colonial objectives. However, the persistence of local forms and inventive recombinations evidently raised doubts about the completeness of the political transformation. Partial evidence of the need to reassert European models resides in an edition of Vitruvius' *De architectura libri decem* (Ten Books on Architecture) that was found in a library in Mexico. Annotations and sketches in its margins attest to its use by an architect to correct earlier errors of translation. It is unsurprising that architectural treatises contributed to the visibility of European institutions in Viceregal Mexico, but the anno-tated Vitruvius is a critical example of an apparatus; not unlike an Inquisitor following judicial procedures, perhaps, the architect used Vitruvius to inter-rogate the language of the built environment.

Each of the next three chapters focuses on a highly unusual printed book, whose form and content are ingeniously devised to sway readers and viewers. In the *Descrizione del Sacro Monte della Vernia* (Description of the Sacred Mountain of La Verna, 1612), virtual pilgrims navigate between rocky terrain that provokes uncertainty and defies the book format, and perspective views that swiftly reorient their bodies toward the sacred. A collaborative enterprise, this lavish folio-sized volume was intended to reignite interest in the cult of St Francis and his montane retreat. The engravings and etchings, designed by Jacopo Ligozzi, together with Lino Moroni's legends, manage experiences of viewers. Paper overslips, itineraries, and devotional performances, petition viewers to become active participants and witnesses. As Bronwen Wilson shows, viewers are continually guided between material and spiritual worlds, which gradually become enfolded through canny designs. She brings to light the focus on quarrying and assembling stone in the images, and how the format of the book itself becomes a part of what Moroni describes as a 'gran fabbrica', a vast working structure. Stone is also a protagonist in Ligozzi's *pietra dura* designs in Florence, where cutting stones revealed unseen elemen-tal forces. This lithic imagination, as Wilson argues, operates in tandem with

bespoke printing and perspective in the *Descrizione,* in which the mountain becomes a vision-generating machine.

The Franciscan *Descrizione* unmoors beholders by obscuring their sight in order to disclose miracles and revelatory visions, whereas images for the Jesuits, in Jan David, SJ's *Veridicus Christianus* (The True Christian, 1601) are used to unmask Calvinist deceptions. In Chapter 7, Walter Melion examines this dynamic of converting heretics to orthodoxy in the Low Countries. With one hundred engravings, the tome is an image-making weapon devised to battle against Calvinist distortions of religious truths. Disputes and deceptions are played out in the images and described in pithy captions in Latin, Dutch, and French. Letters in the emblems are keyed to captions, a common device also seen in the Franciscan *Descrizione,* but used with particular urgency in the *Veridicus Christianus.* They compel the reader-viewer to identify heretical deceptions. Seemingly benign scenes are swiftly unveiled as dangerous: a man listens intently to a creature, who is seated casually on a nest of serpents, and a pastor ventriloquises words of hovering demons to gullible listeners. By repeatedly turning the pages back and forth, the volume purposefully converts – emblem by emblem – reader-viewers back to the Catholic commonwealth.

From Jesuits battling Calvinist untruths, we turn to religious conflicts and the brutality that accompanied them in France, imagined through the disorienting effects of architectural perspectives encountered by readers of *The Island of Hermaphrodites* (1605). In Chapter 8, Kathleen Long describes the destabilising architectural scenographies in this satirical novel. Since references to the Wars of Religion were prohibited by the King, critics of the violence turned to indirect references within literary genres and artistic mediums. The toppling of the bodies of Protestants, witnessed in urban spaces in France, is invoked through the anonymous traveller's journey through nonsensical perspectives and chimerical furnishings. Architectural settings that confound visitors on the imaginary island resemble contemporary manipulations of perspective by Hans Vredeman de Vries. In contrast to its reassuring character in the Franciscan *Descrizione* discussed in Chapter 6, perspective is subversive in the designs of Vredeman de Vries and in *The Island of Hermaphrodites.* Disorienting viewers and readers with spaces that turn and unfold in manifold directions, these visual and textual examples call into question any single point of view, particularly the assertion that peace can be enforced by eliminating political and religious differences.

The body comes into sharper focus in the next three chapters, beginning with Anna Lewton-Brain's analysis of the sways between grief and joy in George Herbert's poetry. Reverberations of sounds in the body were desired by Herbert, whose crafting of words in his collection of poems, *The Temple,* is the focus of Chapter 9. Herbert's own religious conversion resounds in his poetic language, which accentuates its dynamic sensory effects, and the always

incomplete nature of the process. Instead of appealing to readers' minds by exhorting them through words, he provokes sentient responses designed to invoke the wavering of the soul. The temporal fluctuations and emotional intensities of Herbert's personal struggle are converted into sonorous lyrics that can be felt by others as they hear them. Musical verse thereby imbues language with the force to move listeners.

Returning to the Jesuits in Chapter 10, it was the body's ability to withstand torments that were used to instruct seminarians in their colleges. Focusing on this didactic context in Rome, Yelda Nasifoglu draws attention to the geometry of instruments of torture, by way of a satirical comedy. She begins with the famous fresco cycle, painted in 1583 by Niccolò Circignani at San Stefano Rotondo in Rome, that circulated in printed images. Jesuit seminarians would have encountered these images of Christian martyrs undergoing violent mutilations, and also instructed on the success of their forerunners in procuring converts. Witnessing the defiance of martyrs in the face of torture, supposedly resulted in mass conversions to the Catholic Church. The images illustrate diverse apparatuses and tools, such as racks, gallows, flames, ropes, and weights, that were parts of the cruel machinery of conversion. The geometry of these devices is recalled a few decades later in an academic comedy, *Blame Not Our Author,* that was penned in the Venerable English College in Rome, then under Jesuit administration. In it, efforts to make a circle from a square fail, even with the use of torture and mathematical instruments. Forced conversions, even mathematical ones, the comedy suggests, reveal doubts about the evidence they yield.

Bodies 'provided a form of corporeal testament', as Eric Dursteler says in Chapter 11, describing the evidence obtained by inquisitors from inspecting the flesh of potential renegades on the island of Malta. A geographical crossroads and a centre for piracy, Malta was home to a lucrative trade in Muslim slaves. Attempts to avoid this fate resulted in numerous claims of unlawful enslavement. The tribunal tasked with distinguishing real Catholics from pretenders drew upon Inquisition protocols for assessing heresy. These included questioning witnesses about attire, language, and what and when they ate. But these protocols were less useful in the frontier environment of Malta, where people changed their attire readily and spoke several languages. Corporeal evidence was thus especially important, as the two cases studied by Dursteler demonstrate. Circumcision, and its perhaps surprising complexities, is the forensic focus of the first case of a man who asserts he was forcibly enslaved and converted to Islam. In the second trial of a woman who maintains her Muslim faith and identity, authorities endeavour to quantify the corporeal evidence by entreating witnesses to report on her size, the colour of her eyes, the sound of her voice, and especially a scar on her foot.

In introducing this book, we have been making what at first seems like a peculiar claim, that conversions may be akin to the operations of machines. It is peculiar since we tend to understand conversion as something to which humans gravitate, or even wilfully choose. However, the chapters show how the mechanical and plural natures of spaces, devices and ingenious things are designed to make us think we choose. The final two chapters offer new thinking about machines, perception, and selfhood.

Taking G.W. Leibniz's ideas about bodies and souls in new directions, in Chapter 12 Justin Smith challenges the idea that artificial intelligence can replicate thinking. According to Leibniz, 'the human body is, manifestly, a machine disposed to the perpetuation of contemplation'. He furthers the mechanical parallels by describing the body and the soul as automata, because for the seventeenth-century philosopher, perceptions and contemplation are already enfolded in bodies that cannot be divided. If beings are machines, however, why do they perceive other bodies? Smith develops a case, building on Leibniz, for the distinctive character of animate beings: that it is their perceptions of outside worlds that distinguishes them from inanimate things. Spiders are web-weaving machines, for example, but they also perceive other animate things. Living beings – spiders and humans among them – represent the world through their multiple perspectives of it. Perceptions are akin to those produced by a camera obscura: they are virtual images, unmediated, and qualitative. We represent the Christ-Devil and its movements through the multiple images we perceive of it, but the automaton does not perceive us. If our brains are like camera obscuras for Leibniz, their multiple slices of the world are akin to conversion machines, apparatuses that bundle and assemble images into shared perspectives of the world.

In thinking that grows out of Smith's chapter, Paul Yachnin considers how conversion can bring forward a novel way of understanding human consciousness and selfhood. If our brains are machines, according to Smith, then they are far more like cameras than like computers. They do not process data so much as they take in and represent the world as it is. In this way, argues Yachnin in Chapter 13, human beings are conversion machines par excellence. By the act of turning and seeing the world wholly, and wholly differently, humans are able to wake into consciousness from the deep drowsiness of mere biomechanical embodiment. Conversion in this account is radically emancipatory, but what Yachnin calls 'super-converts' often go on to make conversion machines that have the capacity to programme how humans see, think, and feel. They have the power, ironically enough, to undo the monadic character of human perception and contemplation and to re-mechanise human bodies and brains.

To understand early modern conversions is, we think, to begin to grasp where we are now and to imagine futures. Whether it is an awakening to

a new faith, an induction into a religious cult or a radical political move-
ment, a sexual transformation, or the re-engineering of human beings as
bio-mechanical cyborgs, the study of conversion offers ways of understand-
ing the relation between the early modern and modernity.[36] Not unlike our
current predicament, early modern religious and political understandings were
upended by debates about the status of the ear or the eye as the source of
truth, and concomitant debates about the status of hearsay and uses of media.
Rivalries between political and religious institutions, and for global resources,
fuelled inventive visual and material forms to promote their own versions of
facts. The framework of conversion machines outlined above may be especially
pertinent today because of their appeal to desires and feelings of disenfran-
chisement. Unlike weapons deployed to destroy worlds, they make something
into something else. They reveal inventive mechanisms for enlisting participa-
tion as well as persuasive rhetorical effects directed toward the bodies and
minds of individuals; they even emulate, in their shared purposes and systems
of surveillance, how those minds reflect on the world. Conversion machines
are paradoxical things – at once intent on verifying what was invisible, uncer-
tain, and even unknowable, while also acting as sowers of dissimulation. In all
this, as bundles of virtual images, they resemble thinking. Perhaps, if we look
closely at these procedures for enlisting early modern minds and bodies, we
will better understand the shaky foundations of our own institutional appara-
tuses, their assertions of truths and their illusions, and identify points of failure
with which to disarm their operations.

The case studies underscore the purposeful setting out of repetitive procedures
for changing allegiances, faiths, materials, and forms, and concomitant spaces
for managing, surveying, observing, and recording. If materials, practices,
and bodies are changeable, however, they are also recalcitrant, resourceful,
and wilful. Conversions could be resisted and fail to be realised, and accord-
ingly conversion machines could foster defiance and self-awareness. They are
certainly powerful, but their power seems able to escape the will of those who
operate or administer them.

NOTES

1. Bronwen Wilson's translation, with thanks to Elisa Antonietta Daniele. 'Piedestallo,
nella cui parte superiore rinchiuso si mita un capo d'horribil Mostro; col semplice
tocco di un grilletto, ecco immantinente aprirsi una porta della quale uscendo sì
mostruoso Capo con terribil rimbombo di voce, che da se stesso tramanda, riempie
chi l'ode di spavento; Da due cannoncini, che da entrambi gli orecchi gli pendono,
trattone un filo, escono furiosamente due vipere, che frà mille ritorte divincol-
andosi non poco terrore a'riguardanti arrecano; e questi mentre del lor timore
esser vana la cagione contemplando, con giocondo riso ripigliano dell'animo la
già conturbata quiete, quando dal subito disserarsi di una picciola finestra, che
sopra al detto capo si osserva, in nuovo sconvolgimento si abbattono, faccen-
dosi all'improvviso vedere un più mostruoso Capo, che snodando dalla sboccatura

de'labri una lingua, e contravolgendo frà le spaventose sue ciglia l'occhio fiammeggiante, e movendo gli orecchi, che d'Asino porta, sono di nuovo invitati ò allo spavento dall'apparenze, ò al riso dal giocoso inganno,' Terzago et al., *Mvseo,* pp. 38–9.

2. Manfredo Settala discusses his collection of moving machines in relation to mechanical and philosophical questions (Ibid., pp. 34–9). On Settala, see Montbel, Eric, 'Le portrait'; on his intellectual circles, philosophical outlook, and on collecting, see Findlen, *Possessing Nature,* esp. pp. 335–6.

3. The repurposed wooden torso resembles that of Christ in Donato Bramante's painting *Christ Tied to the Column* in the Pinacoteca di Brera, in Milan (ca. 1490). https://artsandculture.google.com/asset/automata-anonymous-italian-lombard-workshop/ggG_1opfb9hu-A?hl=en (last accessed 12 November 2022).

4. On automata, see Bredekamp, *Lure of Antiquity*; Galluzzi, 'Art and Artifice in the Depiction of Renaissance Machines'; Smith, *Divine Machines*; Riskin, *Restless Clock*; Riskin, 'Machines in the Garden'; Vanhaelen, *Reanimating the Moving Statue*; Hanafi, *Monster in the Machine*.

5. On alchemy, see Dym, 'Alchemy and Mining'; Moran, 'Art and Artisanship'; Rampling, *Experimental Fire;* Newman and Grafton, *Secrets of Nature.*

6. Horacek, 'Alchemy of the Gift'.

7. The French King was depicted as a composite of mythological gods in a manuscript painting wearing Minerva's helmet, Mars's armour, Mercury's winged sandals and his staff, Diana's hunting horn, and Cupid's bow and quiver. On the painting, see Meyer, 'Marguerite de Navarre'.

8. /Ie ne suis masle, ni femelle/ [Artus], *L'Isle des hermaphrodites*, 1605. See the text in Fig. 1.2. Editors' translation.

9. Louis XIII performed in René Bordier's *Grand Ball of the Dowager of Billebahaut*, which was staged in 1626 with designs by Daniel Rabel. On court entertainments and colonialism see Daniele, 'Drawing Worlds'; Welch, *Theater of Diplomacy*; Pisani, 'Imagining Native America in Music'.

10. On the circulation of the *Fabrica* and annotations, see Margócsy, Somos, et al., *The Fabrica.*

11. See Gobin, *Picturing Punishment.*

12. https://www.oed.com/view/Entry/40773?redirectedFrom=conversion#eid.

13. See Nancy, *Noli me tangere*. On the theme and conversion, see Wilson, 'Federico Barocci's Christ and Mary Magdalene'.

14. Luther, *Ninety-Five Theses*. Note that the Latin word 'penitentiam', here translated as 'repentance', means both penance and metanoia, that is, an inward change of heart or mind.

15. Terzago, *Museo*, p. 364. See Giovanni Lorenzo Baldano's sordellina manuscript of 1600: *Libro per scriver.*

16. Montbel, 'Le portrait'.

17. See numerous uses of 'conversione' by Galileo Galilei, in *10 opere italiane; IntraText – Concordanze*: http://www.intratext.com/ixt/ita0188/OT.HTM.

18. Terzago, *Museo.*

19. Ibid., 'Capo di Gazza brasiliana'vccello, che gl'Indiani addimandano *Taucan*, il cui rostro è assai più grosso di tutto il suo corpo', p. 177. On the Tupinambá cloak in the Ambrosiana, see: https://www.ambrosiana.it/en/news/il-mantello-cerimoniale-tupinamba-museosegreto-2019/.

20. 'hab mich verwundert der subtilen Ingenia der Menschen in fremden Landen'; cited in Rublack, *Dressing Up,* p. 184. On featherwork see Russo et al. *Images take Flight,* especially Buono, 'Their Treasures Are the Feathers', pp. 179–89; Herrera, 'Conversion and Conservation', pp. 205–39.

21. On the feather cloak, see Aldrovandi, *Ornithologiae*, pp. 657v and 658r. Both the male and female figure were used again in his *Monstrorum historia*, 1642. For the painting see Tavole vol. 001–2 Animali – Fondo Ulisse Aldrovandi – Università di Bologna. 74r. http://aldrovandi.dfc.unibo.it/pinakesweb/main.asp. Associations with rulers circulated in the *Relación de Texcoco,* one of the indigenous manuscripts from the *Relaciones geográficas* that were produced from 1577–1582 for the administration of the Spanish colonies.

22. Foundational studies of conversion include Hadot, 'Conversion'; van der Veer, ed., *Conversion to Modernities*; see esp. Asad, 'Comments on Conversion', pp. 263–73; Kendall, *Conversion to Christianity;* Stelling et al., *Turn of the Soul.*

23. Schmidt, 'From Hot Reverence to Cold Sweat'; Thomas, *Entangled Objects*; Keane, *Christian Moderns*; Veer, (ed.), *Conversion to Modernities*; Boer, (eds), *Space and Conversion*; Terpstra (ed.), *Global Reformations Sourcebook.*

24. On the Inquisition see Pullan, *The Jews of Europe*; Bethencourt, *The Inquisition: A Global History*; Kamen, *The Spanish Inquisition.*

25. On conversion and gender see 'Religious Conversion, Gender Relations'; Dursteler, *Renegade Women*; Smith and Ditchfield, *Conversions, Gender and Religious* Change; Traub, et al., *Ovidian Transversions.* On conversion and the Mediterranean, see García-Arenal, (ed.) *Conversions islamiques*; Marzouki and Roy, *Religious Conversions in the Mediterranean World*; Amelang, *Parallel Histories*; Norton, *Conversion and Islam*; Rogozen-Soltar, *Spain Unmoored*; Stow, *Jewish Life in Early Modern Rome*; Clines, 'The Converting Sea', https://doi.org/10.1111/hic3.12512. On conversion and the Iberian Peninsula, see Cardaillac, *Moriscos y cristianos*; García-Arenal, *Inquisición y moriscos*; Assis and Kaplan, *Jews and Conversos*; Bethencourt, *The Inquisition*; García-Arenal and Wiegers, *The Expulsion.* For a useful synopsis, see Hsia and Palomo, 'Religious identities in the Iberian worlds', and Amelang and García-Arenal, 'Religious Conversion and Identities', pp. 245–60. On conversion and the Atlantic, see also Ireton, '"They Are Blacks of the Caste of Black Christians"'; Gerbner, *Christian Slavery.*

 Useful introductions to the Reformation include Bamji, et al. *Ashgate Research Companion to the Counter-Reformation*; Marshall (ed.), *The Oxford Illustrated History of the Reformation*; Marshall, *Heretics and Believers*; Marshall, *The Reformation*; Shoulson, *Fictions of Conversion*; Duffy, *Reformation Divided.*

26. For an example, see Clines, *A Jewish Jesuit.*

27. Edgerton, et al., *Theaters of Conversion*; Dean and Leibsohn, 'Hybridity and Its Discontents'; Keane, 'The evidence of the senses'; Fromont, *Art of Conversion*; San Juan, 'Transformation of the Río De La Plata'; San Juan, *Vertiginous Mirrors*; Stelling, et al., (eds), *Turn of the Soul*; Bauer and Norton, 'Introduction: Entangled Trajectories'; Göttler and Mochizuki, (eds), *Nomadic Object*; Warsh, *American Baroque.*

28. Farago, 'The 'Global Turn' in Art History', p. 300; Abu-Lughod, *Before European Hegemony.*

29. Clark, (ed.), *Languages of Witchcraft*; Clark, *Thinking with Demons*; Roper, *Oedipus and the Devil*; Martin, *Witchcraft and the Inquisition.*

30. Sicroff, *Los estatutos de limpieza de sangre.*

31. On dissimulation, see Zagorin, *Ways of Lying*; Snyder, *Dissimulation.*

32. See, for instance, the Trachtenbuch of Matthäus Schwarz. On the costume book and dissimulation, see Groebner, 'Inside Out'.

33. Kramer, *Malleus maleficarum*; Rothkrug, 'Religious Practices', pp. 206–09.

34. https://www.oed.com/view/Entry/9508?redirectedFrom=apparatus#eid.

35. Agamben, *What is an Apparatus*; Althusser, 'Ideology and Ideological State Apparatuses'.
36. See Wittek, 'Coda: Performing Conversion in an Early Modern Future'. Haraway, 'The Cyborg Manifesto'; Sawday, '"Forms Such as Never Were in Nature"'.

WORKS CITED

Abulafia, David, *Mediterranean Encounters, Economic, Religious, Political, 1100–1550* (Aldershot: Ashgate, 2000).

Abu-Lughod, Janet L., *Before European Hegemony: The World System A.D. 1250–1350* (New York: Oxford University Press, 1989).

Agamben, Giorgio, *What is an Apparatus and other Essays* (Stanford: Stanford University Press, 2009).

Aldrovandi, Ulisse, *Monstrorum historia* (Bologna: Nicolai Tebaldini, 1642).

———, *Ornithologiae* (Bologna: Franciscum de Franciscis Senensem, 1599).

Althusser, Louis, 'Ideology and ideological state apparatuses (Notes towards and investigation)', in Slavoj Zizek (ed.), *Mapping Ideology* (London and New York: Routledge, 1994).

Amelang, James S., *Parallel Histories: Muslims and Jews in Inquisitorial Spain* (Baton Rouge: Louisiana State University Press, 2013).

Amelang, James S. and Mercedes García-Arenal, 'Religious Conversion and Identities in the Iberian Peninsula', in *The Iberian World, 1450–1820*, pp. 245–60. https://www.routledgehandbooks.com/doi/10.4324/9780429283697-5/.

[Artus, Thomas], *L'Isle des hermaphrodites* ([Paris], ca. 1605).

Asad, Talal, 'Comments on Conversion,' in Peter van der Veer (ed.), *Conversion to Modernities: The Globalization of Christianity [1968]* (New York: Routledge, 1996), pp. 263–73.

Assis, Yom Tov, and Yosef Kaplan (eds), *Jews and Conversos at the Time of the Expulsion* (Jerusalem: Shazar, 1999).

Baldano, Giovanni Lorenzo, *Libro per scriver l'intavolatura per sonare sopra le sordelline* (Savona, 1600).

Bamji, Alexandra, Geert H. Janssen, and Mary Laven (eds), *The Ashgate Research Companion to the Counter-Reformation* (Farnham, Surrey, England: Ashgate, 2013).

Bauer, Ralph and Marcy Norton, 'Introduction: Entangled Trajectories: Indigenous and European Histories', *Colonial Latin American Review* 26, no. 1 (2017), pp. 1–17.

Bethencourt, Francisco, *The Inquisition: A Global History, 1478–1834*, trans. Jean Birrell (Cambridge: Cambridge University Press, 2009).

Boer, Wietse de, Aliocha Maldavsky, Giuseppe Marcocci, and Ilaria Pavan (eds), *Space and Conversion in Global Perspective* (Leiden: Brill, 2015).

Bredekamp, Horst, *The Lure of Antiquity and the Cult of the Machine: The Kunstkammer and the Evolution of Nature, Art, and Technology* (Princeton: M. Wiener Publishers, 1995).

Buono, Amy, 'Their Treasures Are the Feathers of Birds: Tupinambá Featherwork and the Image of America', in Alessandra Russo, Gerhard Wolf, and Diana Fane (eds), *Images take Flight: Feather Art in Mexico and Europe (1400–1700)* (Munich: Hirmer, 2015), pp. 179–89.

Cardaillac, Louis, *Moriscos y cristianos: un enfrentamiento polémico (1492–1640)*, trans. Mercedes García-Arenal (Madrid, 1979).

Clark, Stuart (ed.), *Languages of Witchcraft: Narrative, Ideology, and Meaning in Early Modern Culture* (New York: St Martin's Press, 2001).

———, *Thinking with Demons: The Idea of Witchcraft in Early Modern Europe* (Oxford: Clarendon Press, 1997).

Clines, Robert John, *A Jewish Jesuit in the Eastern Mediterranean: Early Modern Conversion, Mission, and the Construction of Identity* (Cambridge: Cambridge University Press, 2019).

_____, 'The Converting Sea: Religious Change and Cross-cultural Interaction in the Early Modern Mediterranean', *History Compass* 17, no. 1 (2019), https://doi.org/10.1111/hic3.12512.

Daniele, Elisa Antonietta, 'Drawing Worlds: Bodies and Smoke in the Courtly Ballet *Il Tabacco* (1650)', in Angela Vanhaelen and Bronwen Wilson (eds), *Making Worlds: Global Invention in the Early Modern Period* (Toronto: University of Toronto Press, 2022), pp. 85–109.

David, Jan, SJ, *Veridicus Christianus* (Antwerp, 1601).

Dean, Carolyn and Dana Leibsohn, 'Hybridity and Its Discontents: Considering Visual Culture in Colonial Spanish America', *Colonial Latin American Review* 12, no. 1 (2003), pp. 5–35.

Deleuze, Gilles and Claire Parnet, 'The Actual and the Virtual', in *Dialogues II*, trans. Hugh Tomlinson and Barbara Habberjam (New York City: Columbia University Press, 1977).

Duffy, Eamon, *Reformation Divided: Catholics, Protestants and the Conversion of England* (London: Bloomsbury Publishing, 2017).

Dursteler, Eric, *Renegade Women: Gender, Identity, and Boundaries in the Early Modern Mediterranean* (Baltimore: Johns Hopkins University Press, 2011).

_____, *Venetians in Constantinople: Nation, Identity, and Coexistence in the Early Modern Mediterranean* (Baltimore: Johns Hopkins University Press, 2006).

Dym, Warren Alexander, 'Alchemy and Mining: Metallogenesis and Prospecting in Early Mining Books', *Ambix* 55, no. 3 (November 2008), pp. 232–54.

Edgerton, Samuel Y., *Theaters of Conversion: Religious Architecture and Indian Artisans in Colonial Mexico* (Albuquerque: University of New Mexico Press, 2001).

Farago, Claire, 'The "Global Turn" in Art History: Why, Where, and How Does It Matter', in Daniel Savoy (ed.), *The Globalization of Renaissance Art: A Critical Review* (Leiden: Brill, 2017).

Findlen, Paula, *Possessing Nature: Museums, Collecting, and Scientific Culture in Early Modern Italy* (Berkeley: University of California Press, 1994).

Fromont, Cécile, *The Art of Conversion: Christian Visual Culture in the Kingdom of Kongo* (Chapel Hill: University of North Carolina Press, 2014).

Galilei, Galileo, *Siderius Nuncius* (Venice: Baglioni, 1610).

Galluzzi, Paolo, 'Art and Artifice in the Depiction of Renaissance Machines', in Wolfgang Lefevre, Jürgen Renn, and Urs Schoepflin (eds), *The Power of Images in Early Modern Science* (Berlin: Springer, 2003).

García-Arenal, Mercedes, *Inquisición y moriscos: Los procesos del Tribunal de Cuenca* (Madrid, 1978).

_____, (ed.), *Conversions islamiques: identités religieuses en islam méditerranéen = Islamic Conversions: Religious Identities in Mediterranean Islam* (Paris: Maisonneuve et Larose, 2001).

García-Arenal, Mercedes and Gerard Wiegers (eds), *The Expulsion of the Moriscos from Spain: A Mediterranean Diaspora*, trans. Consuelo López-Morillas and Martin Beagles (Leiden: Brill, 2014).

García-Arenal, Mercedes and Yonatan Glazer-Eytan (eds), *Forced Conversion in Christianity, Judaism and Islam: Coercion and Faith in Premodern Iberia and Beyond* (Leiden: Brill, 2019).

Gelder, Maartje van and Tijana Krstić, 'Introduction: Cross-Confessional Diplomacy and Diplomatic Intermediaries in the Early Modern Mediterranean', *Journal of Early Modern History* 19, no. 2–3 (2015), pp. 93–105.

Gerbner, Katharine, *Christian Slavery: Conversion and Race in the Protestant Atlantic World* (Philadelphia: University of Pennsylvania Press, 2018).

Gobin, Anuradha, *Picturing Punishment: The Spectacle and Material Afterlife of the Criminal Body in the Dutch Republic* (Toronto: University of Toronto Press, 2021).

Göttler, Christine, and Mia Mochizuki (eds), *The Nomadic Object: The Challenge of World for Early Modern Religious Art* (Leiden: Brill, 2017).

Groebner, Valentin, 'Inside Out: Clothes, Dissimulation, and the Arts of Accounting in the Autobiography of Matthäus Schwarz, 1496–1574', *Representations*, no. 66 (Spring, 1999), pp. 100–121.

Hadot, Pierre, 'Conversion', *Encyclopaedia Universalis* 4 (1968).

Hanafi, Zakiya, *The Monster in the Machine: Magic, Medicine, and the Marvelous in the Time of the Scientific Revolution* (Durham: Duke University Press, 2000).

Haraway, Donna, 'The Cyborg Manifesto', in Amelia Jones (ed.), *The Feminism and Visual Culture Reader* (New York: Routledge, 2010), pp. 587–608.

Herrera, Juliana Ramírez, 'Conversion and Conservation: Mexica Featherwork, the Miraculous, and Early Modern European Practices of Collecting', *Estudios de Cultura Náhuatl* 53 (2017), pp. 205–39.

Horacek, Ivana, 'Alchemy of the Gift: Things, Material Transformations, and Geopolitics at the Court of Rudolf II', PhD diss., University of British Columbia, 2015.

Hsia, Ronnie Po-chia, and Federico Palomo, 'Religious identities in the Iberian worlds (1500–1700), in Bouza, F., Cardim, P., and Feros, A. (eds), *The Iberian World: 1450–1820* (Routledge, 2019), pp. 77–105, https://doi.org/10.4324/9780429283697

Ireton, Chloe, '"They Are Blacks of the Caste of Black Christians": Old Christian Black Blood in the Sixteenth- and Early Seventeenth-Century Iberian Atlantic', *The Hispanic American Historical Review* 97, no. 4 (2017), pp. 579–612.

Kamen, Henry, *The Spanish Inquisition: A Historical Revision* (New Haven: Yale University Press, 2014).

Keane, Webb, *Christian Moderns: Freedom and Fetish in the Mission Encounter* (Berkeley: University of California Press, 2007).

_____, 'The Evidence of the Senses and the Materiality of Religion', *The Journal of the Royal Anthropological Institute* 14 (2008), pp. 110–27.

Kendall, Calvin B., *Conversion to Christianity: From Late Antiquity to the Modern Age: Considering the Process in Europe, Asia, and the Americas* (Minneapolis, MN: CEMH Center for Early Modern History, University of Minnesota, 2009).

Koeppe, Wolfram and Metropolitan Museum of Art, *Making Marvels: Science and Splendor at the Courts of Europe* (New York, NY: Metropolitan Museum of Art, 2019).

Kramer, Heinrich, *Malleus maleficarum* (Speyer, 1486).

Luther, Martin, *The Ninety-Five Theses of Martin Luther* (1517), http://www.crivoice.org/creed95theses.html.

Margócsy, Dániel, Mark Somos and Stephen N. Joffe, *The Fabrica of Andreas Vesalius: A Worldwide Descriptive Census, Ownership, and Annotations of the 1543 and 1555 Editions* (Leiden: Brill, 2018).

Marshall, Peter, *Heretics and Believers: A History of the English Reformation* (New Haven: Yale University Press, 2017).

_____, (ed.), *The Oxford Illustrated History of the Reformation* (Oxford: Oxford University Press, 2015).

_____, *The Reformation: A Very Short Introduction* (Oxford: Oxford University Press, 2009).

Martin, Ruth, *Witchcraft and the Inquisition in Venice, 1550–1650* (Oxford, UK; New York: Blackwell, 1989).

Marzouki, Nadia and Olivier Roy, *Religious Conversions in the Mediterranean World: Islam and Nationalism* (London: Palgrave Macmillan, 2013).

Meyer, Barbara Hochstetler, 'Marguerite de Navarre and the Androgynous Portrait of Francois Ier', *Renaissance Quarterly* 48, no. 2 (1995), pp. 287–325.

Montbel, Eric, 'Le portrait de Manfredo Settala attribué à Carlo Francesco Nuvolone: un hommage au collectionneur et facteur de sourdelines', in Florence Gétreau (ed.), *Portraits, ballets, traités: Musique-Images-Instruments* (Paris: CNRS Éditions, 2015), pp. 11–36.

Moran, Bruce T. 'Art and Artisanship in Early Modern Alchemy', *Getty Research Journal 5*, no. 5 (2013), pp. 1–14.

Nancy, Jean-Luc, *Noli me tangere: On the Raising of the Body,* trans. Sarah Clift (New York: Fordham University Press, 2008).

Newman, William R. and Anthony Grafton (eds), *Secrets of Nature: Astrology and Alchemy in Early Modern Europe* (Boston: MIT Press, 2001).

Norton, Claire, *Conversion and Islam in the Early Modern Mediterranean: The Lure of the Other* (Florence: Routledge, 2017).

Ortega, Stephen, 'Across Religious and Ethnic Boundaries: Ottoman Networks and Spaces in Early Modern Venice', *Mediterranean Studies* 18, no. 1 (2008), pp. 66–89.

_____, *Negotiating Transcultural Relations in the Early Modern Mediterranean: Ottoman-Venetian encounters* (Aldershot: Ashgate, 2014).

_____, 'Religious Conversion, Gender Relations and Cross-Cultural Logic in the Early Modern Mediterranean', *Gender & History* 20, no. 2 (2008), pp. 332–48.

Rogozen-Soltar, Mikaela H., *Spain Unmoored: Migration, Conversion, and the Politics of Islam* (Bloomington: Indiana University Press, 2017).

Pisani, Michael V., 'Noble Savagery in European Court Entertainments, 1550–1760', in *Imagining Native America in Music* (New Haven: Yale University Press, 2008), pp. 17–43.

Pullan, Brian, *The Jews of Europe and the Inquisition of Venice, 1550–1670* (Oxford: Basil Blackwell, 1983).

Rampling, Jennifer M., *The Experimental Fire: Inventing English Alchemy, 1300–1700* (Chicago: University of Chicago Press, 2020).

Riskin, Jessica, *The Restless Clock: A History of the Centuries-long Argument over What Makes Living Things Tick* (Chicago: The University of Chicago Press: 2016).

_____, 'Machines in the Garden', *Republic of Letters* 1, no. 2 (2014) https://arcade.stanford.edu/rofl/machines-garden.

Roper, Lyndal, *Oedipus and the Devil: Witchcraft, Sexuality and Religion in Early Modern Europe* (New York: Routledge, 1994).

Rothkrug, Lionel, 'Religious Practices and Collective Perceptions: Hidden Homologies in the Renaissance and Reformation', *Historical Reflections* 7 no.1 (1980), pp. i–266.

Rothman, Natalie E., *Brokering Empire: Trans-Imperial Subjects between Venice and Istanbul* (Ithaca: Cornell University Press, 2012).

Rublack, Ulinka, *Dressing Up: Cultural Identity in Renaissance Europe* (Oxford: Oxford University Press, 2010).

Russo, Alessandra, Gerhard Wolf, and Diana Fane, *Images take Flight: Feather Art in Mexico and Europe (1400–1700)* (Munich: Hirmer, 2015).

San Juan, Rose Marie, 'The Transformation of the Río De La Plata and Bernini's Fountain of the Four Rivers in Rome', *Representations* 118, no. 1 (2012) pp. 72–102.

_____, *Vertiginous Mirrors: The Animation of the Visual Image and Early Modern Travel* (Marchester: Manchester University Press, 2011).

Sawday, Jonathan, '"Forms Such as Never Were in Nature": The Renaissance Cyborg', in Erica Fudge, Ruth Gilbert, and Susan Wiseman (eds), *At the Borders of the Human: Beasts, Bodies, and Natural Philosophy in the Early Modern Period* (New York: St Martin's Press, 1999), pp. 171–95.

Schmidt, Benjamin, 'From Hot Reverence to Cold Sweat: Christian Art and Ambivalence in Early Modern Japan', in Angela Vanhaelen and Bronwen Wilson (eds), *Making Worlds: Global Invention in the Early Modern Period* (Toronto: University of Toronto Press, 2022), pp. 110–39.

Shoulson, Jeffrey S., *Fictions of Conversion: Jews, Christians, and Cultures of Change in Early Modern England* (Philadelphia: University of Pennsylvania Press, 2013).

Sicroff, Albert A. *Los estatutos de Limpieza de Sangre: controversias entre los siglos XV y XVII* (Madrid: Taurus, 1985).

Smith, Helen and Simon Ditchfield, *Conversions: Gender and Religious Change in Early Modern Europe* (Baltimore: Johns Hopkins Univeristy Press, 2017).

Smith, Justin E. H., *Divine Machines: Leibniz and the Sciences of Life* (Princeton: Princeton University Press, 2011).

Snyder, Jon R., *Dissimulation and the Culture of Secrecy in Early Modern Europe* (Berkeley: University of California Press, 2012).

Stelling, Lieke, Harald Hendrix, and Todd Richardson, *The Turn of the Soul: Representations of Religious Conversion in Early Modern Art and Literature*, vol. 23, Intersections (Leiden: Brill, 2012).

Stow, Kenneth, *Jewish Life in Early Modern Rome: Challenge, Conversion, and Private Life* (Routledge: New York, 2018).

Terpstra, Nicholas (ed.), *Global Reformations Sourcebook: Convergence, Conversion, and Conflict in Early Modern Religious Encounters* (Abingdon: Routledge, Taylor & Francis Group, 2021).

Terzago, Paolo Maria, *Mvseo, ò galeria, adunata dal sapere e dallo studio del sig. canonico Manfredo Settala nobile milanese*, trans. Pietro Francesco Scarabelli (Tortona, 1666).

Thomas, Nicholas, *Entangled Objects: Exchange, Material Culture, and Colonialism in the Pacific* (Cambridge: Harvard University Press, 1991).

Traub, Valerie, Patricia Badir, and Peggy McCracken, *Ovidian Transversions: 'Iphis and Ianthe', 1300–1650* (Edinburgh: Edinburgh University Press, 2019).

Vanhaelen, Angela, *Reanimating the Moving Statue: Labyrinths, Automata, Fountains, and Waxworks in 17th-Century Amsterdam* (University Park: Pennsylvania State University Press, 2022).

Veer, Peter van der (ed.), *Conversion to Modernities: The Globalization of Christianity* (New York: Routledge, 1996).

Warsh, Molly A., *American Baroque Pearls and the Nature of Empire, 1492–1700* (Chapel Hill: University of North Carolina Press, 2018).

Welch, Ellen R., *A Theater of Diplomacy: International Relations and the Performing Arts in Early Modern France* (Philadelphia: University of Pennsylvania Press, 2017).

Wilson, Bronwen, 'The Itinerant Artist and the Islamic Urban Prospect: Guillaume-Joseph Grélot's Self-portraits in Ambrosio Bembo's "Travel Journal"', *Artibus et historiae* 38, no. 76 (2017), pp. 157–80.

_____, 'Spiritual and Material Conversions: Federico Barocci's Christ and Mary Magdalene', in Walter S. Melion, Elizabeth Carson Pastan, and Lee Palmer Wandel (eds), *Quid est sacramentum? Visual Representation of Sacred Mysteries in Early Modern Europe, 1500–1700,* (Leiden: Brill, 2019), pp. 398–424.

Wittek, Stephen, 'Coda: Performing Conversion in an Early Modern Future', in Stephen Wittek and José R. Jouve Martín (eds), *Performing Conversion: Cities, Theatre and Early Modern Transformations* (Edinburgh: Edinburgh University Press, 2021), pp. 172–93.

Zagorin, Perez, *Ways of Lying. Dissimulation, Persecution, and Conformity in Early Modern Europe* (Cambridge: Harvard University Press, 1990).

2

THE CONVERSIONAL POLITICS OF COMPLIANCE: OATHS AND AUTONOMY IN HENRICIAN ENGLAND

Peter Marshall

Conversion, as a recognised phenomenon in the history of religion, is generally considered to manifest itself in two fairly distinct, albeit interrelated, ways. One is personal, and the outcome of individual agency (or, arguably, divine grace); the other social and political, and produced or facilitated by the (often coercive) exercise of earthly power. Thus, we speak about the conversion of St Augustine or Luther's conversion, and also about the conversion to Christianity of Anglo-Saxon England or Scandinavia's conversion to Protestantism in the course of the sixteenth century. The former mode of conversion is an intense, usually private, spiritual experience of transformation and renewal – of turning or reorientation. Historically, it is one which we can recognise as a conversion only when it is performed, or narrativised in some way.[1] The latter form of conversion might well involve such dramatic affirmations in particular cases, but it need not do so, and it should certainly not be considered as the sum or aggregate of individual conversions in a Pauline or Augustinian sense. The processes involved here have often been referred to as the 'Constantinian' model of conversion, rather than the Augustinian.[2] There is in fact debate among scholars as to whether 'conversion' is at all the appropriate designator when societies as a whole transfer allegiance from one belief system to another, nearly always as a result of an exertion of political might. Some historians, whether of late antique Europe, or of the early modern Americas, choose to speak of Christianisation rather than conversion.[3] Others prefer the apparently oxymoronic term 'forced conversion', though the degree

of force required varied considerably across different historical settings. Many historians studying the effects of these societal, political conversions now emphasise patterns of social and cultural negotiation, of gradual adaptation of new norms, which are changed in the process of being received. In a recent overview, commenting on work about the first centuries of Islamisation in Iran, Felipe Fernandez-Armesto states that 'adaptation occurs independently of conversion, and ... over time the religious profile of a society can change without much impact on the individuals who compose it'.[4]

The era of the Reformation witnessed an intensification of both forms of conversion, within Europe and also beyond it. The patterns, and the divergences between them, can seem particularly vivid in the case of England, a polity which over the course of the sixteenth century experienced serial changes of official religion: from papalist Catholicism to anti-papalist reformism under Henry VIII (ca. 1532 onwards); from the latter to full-blooded Reformed Protestantism in the reign of Edward VI (1547–1553); back to Roman Catholicism under Edward's sister, Mary (1553–1558); to a moderated (and contested) version of Edwardian Protestantism after the accession of Elizabeth I (the 'Settlement' of 1559). Here too, of course, there were many conversions of the classical Pauline or Augustinian kind, within religious groups, and across the emergent confessional boundaries: from Catholicism to Protestantism, and sometimes from Protestantism to Catholicism.[5] But during several decades following Henry VIII's decision to break with the Pope England seemingly became a Protestant country, as Christopher Haigh once wittily put it, without becoming a nation of Protestants.[6] The scholarship on the English Reformation as a process of cultural change, now firmly in a post-revisionist phase, very often lays emphasis on gradual accommodation and ways of coming to terms with the new order.[7] Society was slowly and incompletely reshaped by the willingness of the vast majority to adopt a variety of conformist behaviours – principally the conformism of continuing to attend the local parish church, even as its liturgy and furnishings were reformed and reshaped.

Yet, in England, right at the start of this process, we encounter a remarkable and unique episode, which conflates in interesting ways the two, supposedly distinct, or at least distinguishable, models of conversion referred to above. The subject of this chapter is the attempt, in 1534, of King Henry VIII to bind the entire nation in individual conscience to his momentous religio-political reorientation, away from the Pope and towards the monarchy as the locus of spiritual authority.[8] It was an outcome to be achieved by the imposition of an oath, a phrase which in itself sounds paradoxical, if not contradictory, given that an oath, then as now, was widely understood to be a solemn, voluntary affirmation – of belief, allegiance, or promised undertaking.

The Henrician oath campaign of 1534 was not merely a typical 'Constantinian' exercise in compelled if nominal conversion. It went beyond the era's usual

parameters of compliance and obedience to demand an authentic inner assent, outwardly expressed. It was without doubt an ambitious and powerful conversional instrument, a radical extension of the psychological reach of sovereign authority; indeed, it might seem to anticipate in some ways the tactics of modern authoritarian regimes, obsessively concerned with demonstrating the enthusiastic consent and support of coerced and controlled subjects. Yet, as I will seek to show, this 'conversion machine', brought into operation in support of Henry's annexation of the English branch of the Western Church, was transformative of attitudes in a variety of ways the regime had neither wanted nor foreseen. It was in some respects a resounding success; in others, a flawed and failed experiment, never to be repeated in quite the same way again. The mass oath-swearing, I will argue, was an unexpectedly productive catalyst of popular politics, as well as a pointer towards the limitations, as much as to the potential, of royal authority. Examining it invites the paradoxical conclusion that, in the early modern era (as perhaps also in our own), forms of repression and coercion can serve as much to delineate and produce dissidence as to identify and suppress it.

The background to the decision to implement the oath represents fairly familiar territory. Henry VIII's doubts about the validity of his marriage to Catherine of Aragon, caused from around 1526 by some combination of the absence of a legitimate male heir and the all-too-present allures of Anne Boleyn, had by the early 1530s caused the king to undergo what can with some justification be described as a conversion experience.[9] Henry did not then or ever become a Protestant, but he did become a 'Henrician', someone who believed fervently and truly in himself. More particularly, he had discovered a religious fact which the papacy and its minions had over centuries sought to suppress: the anointed monarch was, by divine law, supreme head of the Church in his territories, in both temporal and spiritual matters. This convenient truth offered an obvious way out of the labyrinth of the King's first marriage, the ongoing case for annulment of which had become thoroughly stalled by the end of the 1520s. If Henry and his theological advisors were right, there was no need to secure a ruling from Rome, whose bishop had no valid authority in England. The marriage was duly annulled, and in 1533 a pregnant Anne Boleyn was crowned as queen of England.

None of this was as straightforward or painless as the brisk summary here makes it sound. There was very considerable unease and unhappiness, at all levels of society, both with the increasingly vehement attacks on the pope and with the decidedly shabby treatment of Queen Catherine, reduced to the status of 'dowager' to the deceased Prince Arthur, and separated from contact with her daughter, Mary. Modern scholarship is inclined to emphasise rather than minimise the scale and seriousness of the opposition Henry and his ministers faced.[10]

The centrepiece of security for the political revolution Henry was unleashing was an Act of Succession, passed by Parliament in the spring of 1534. The act confirmed the validity of the King's marriage to his 'lawful wife Queen Anne', and laid down draconian penalties for anyone slandering it, in print or in person. Succession to the throne was vested in Anne's children by Henry, 'lawfully begotten'. But the final stipulation of the act was the most remarkable. It declared that

> all the nobles of your realm spiritual and temporal, as all your other subjects now living ... shall make a corporal oath in the presence of your highness or your heirs, or before such others as your majesty or your heirs will depute for the same, that they shall truly, firmly and constantly, without fraud or guile, observe, fulfil, maintain, defend, and keep, to their cunning, wit, and uttermost of their powers, the whole effects and contents of this present Act.

Anyone commanded to take this oath and refusing to do so was 'to be taken and accepted for offender in misprision of high treason' (i.e. a deliberate concealer of treason), and to be subject to consequent forfeitures and imprisonment.[11]

There was nothing unusual or unfamiliar in early Tudor England about the swearing of oaths, or of the solemn form of the 'corporal oath', recited with a hand on a book of the Gospels or other sacred object. Oaths, indeed, were the legal and cultural lubrication of much of the machinery of society. Sacred undertakings, invoking God and the saints as witnesses, were sworn in courts of law, on the taking up of office, on admission to guilds and trades, or indeed, at the contracting of marriages.[12] At his coronation, Henry, like his predecessors, had sworn an oath to uphold the liberties of the English Church, though at some stage, either before or after the break with Rome, he changed the wording of the text to clarify that it referred only to those ecclesiastical rights and liberties 'not prejudicial to his jurisdiction and dignity royal'. Bishops had long sworn oaths of obedience to the crown, as well as of fealty to the pope – a dual loyalty that, prior to the crisis of the early 1530s, had been satisfactorily assuaged by some nifty legal footwork. In doing homage to the king for the estates ('temporalities') of their sees, new bishops habitually renounced any clauses in the papal bull of provision appointing them to their diocese that could be considered prejudicial to the rights of the crown. Yet by 1532, with the bishops dragging their heels with respect to royal policy on the divorce, and in response to the King's increasingly assertive claims to supreme jurisdiction, Henry had decided that the customary declaration of obedience to the pope was 'clean contrary to the oath that they make to us'; evidence that bishops and other clergy were 'but half our subjects; yea, and scarce our subjects'.[13] Oaths, and their capacity to identify

who was with us and who was against us, were very much on the king's mind as the severance with Rome reached its critical phase.

The policy of 1534 was something quite new, however. Never before had the entire nation been required to swear a collective oath, and an oath that was not just an affirmation of conventional pieties or of broad obedience to the crown, but of assent to a specific, deeply controversial new direction in royal policy. The oath was offered to members of both Houses of Parliament on 30 March 1534, and through the spring and summer groups of commissioners toured England and Wales administering it to clergy and laymen in towns and villages across the realm. Letters were sent in advance to parish constables and civic officials ordering them to assemble the community to take the oath at a specified time and place. On arrival, the commissioners made certification of the names of every man swearing.[14] One potential ambiguity was not settled until several weeks into the process. On 5 May, Bishop Stephen Gardiner wrote to the king's chief minister Thomas Cromwell to check whether he and his fellow commissioners had acted correctly to 'take men oonly for men a[nd] not women; wherin I praye youe wryte sumwh[at] again of the Kinges pleasour, that we erre not'.[15] It appears that men did indeed mean men, a disparity whose possible implications have not been much noticed nor explored by historians. Not for the last time, the restricted legal and social standing of women paradoxically functioned to afford them greater latitude for the exercise of the conscience.[16]

There is some uncertainty about the exact wording of the oath proffered to Henry's subjects in 1534. Rather carelessly, the Act of Succession itself did not specify a text, probably because such an exercise had never been attempted before, and the government was improvising the procedure. It seems very likely, however, that the standard form was the same as that which was required from parliamentarians, and recorded in the Journal of the House of Lords:

> Ye shall swear to bear your Faith, Truth, and Obedience, alonely to the King's Majesty, and to the Heirs of his Body, according to the Limitation and Rehearsal within this Statute of Succession above specified, and not to any other within this Realm, nor foreign Authority, Prince, or Potentate; and in case any Oath be made, or hath been made, by you, to any other Person or Persons, that then you to repute the same as vain and annihilate; and that, to your Cunning, Wit, and uttermost of your Power, without Guile, Fraud, or other undue Means, ye shall observe, keep, maintain, and defend, this Act above specified, and all the whole Contents and Effects thereof, and all other Acts and Statutes made since the Beginning of this present Parliament, in Confirmation or for due Execution of the same, or of anything therein contained; and thus ye

shall do against all Manner of Persons, of what Estate, Dignity, Degree, or Condition soever they be, and in no wise do or attempt, nor to your Power suffer to be done or attempted, directly or indirectly, any Thing or Things, privily or apertly, to the Let, Hindrance, Damage, or Derogation thereof, or of any Part of the same, by any Manner of Means, or for any Manner of Pretence or Cause.

So help you God and all Saints.[17]

In this formulation, the oath carefully avoided naming the pope, or making any precise assertions about the scope of royal supremacy, though the requirement to swear to uphold 'all other Acts and Statutes made since the Beginning of this present Parliament' came close to being an explicit renunciation of papal authority. It was perhaps in an effort to make the process more acceptable to waverers that a revised version of the Act of Succession, passed in November, did specify the form of the oath, but reduced its scope by only requiring consent to the act itself, 'and all other Acts and statutes made in confirmation, or for execution of the same'.[18]

Nonetheless, the oath was not, and could not be, solely about dynastic security and the line of succession. Any recognition of the Boleyn marriage involved at least implicit rejection of papal obedience, and there could be little doubt in anyone's mind about the identity of the 'foreign authority or potentate', who was now declared to have no claim whatsoever on the fealty of swearers.

The broad mass of the laity was one matter. The affirmations demanded from the Pope's most likely adherents, the clergy, were more unequivocal. In addition to swearing the Oath of Succession, secular priests were obliged to subscribe to the proposition that 'the Roman bishop has no greater jurisdiction conferred to him by God in this kingdom of England than any other foreign bishop'. An actual (second) oath, explicitly repudiating the Pope, and affirming the royal supremacy, was demanded from newly consecrated bishops in 1534, and in all probability from existing ones as well. The friars – identified as a potential hub of opposition – were targeted for a similarly explicit statement, and by the early summer all members of religious houses, cathedral chapters, and university colleges were being required to do the same.[19]

Henry and his counsellors got the result they wanted. Overt resistance to swearing was on an extremely limited scale. It may have helped that Londoners were summoned to take the oath on the very same day that the rebellious prophetess Elizabeth Barton, 'the Nun of Kent', faced execution – her head was placed on Tower Bridge, while those of various clerical supporters were placed on the gates of the city.[20] Sir Thomas More was one of only a tiny handful of laymen to decline to take the oath, and John Fisher of Rochester was the solitary bishop. Among the wider clergy, instances of open refusal were more or less limited to the most austere examples of the religious orders:

the Franciscan Observants and Carthusians.[21] Reports sent in by the royal commissioners often emphasised the alacrity and devotion with which people seemed willing to swear: 'very obediently' was the assessment of Stephen Gardiner about the demeanour of oath-takers in the diocese of Winchester. The royal commissioner in the city of Norwich even noted that one or two hundred people, particularly youths, in taking the oath 'of free force' had stooped to kiss the book.[22] It seemed that the government had secured precisely what was intended: an overwhelming symbolic demonstration of the consent of the nation to its newly independent course in political and religious matters. The imperial ambassador, Eustace Chapuys, was called before the royal council in May 1534 to be told that the King's marriage and succession had been endorsed not only by Parliament but 'universally by the frank consent and voluntary oaths of all his subjects'.[23]

It was, without doubt, a seminal moment in the Reformation politics of conversion, an unprecedented display of the reach of state power. Yet the campaign was not the unalloyed triumph the raw numbers of known swearers and non-swearers might suggest. It is possible to argue that the oath campaign of 1534, and the events flowing from it, not only exposed the limits of state power, but in significant ways served to challenge and subvert it. The conversional politics of 1534–1535 were particularly fluid and unpredictable.

When Ambassador Chapuys was summoned to be lectured about the universal support of the nation for the King's stance, he declared himself signally unimpressed. Jurists, he retorted, believed a coerced oath to be illegitimate, and he had no doubt that many who had sworn 'comforted themselves by the consideration that an oath given by force and against good morals is not binding'. Moreover, he added, takers of the oath might well think themselves able to violate it quite as honourably as the Archbishop of Canterbury, 'who, the day after he had sworn fidelity and obedience to the Pope, decreed the citation against the Queen'.[24] This was a shrewd and barbed observation; to facilitate a smooth appointment to office in 1532, Thomas Cranmer had been willing to be consecrated in the usual papal form. Like all his predecessors, Cranmer swore an oath of loyalty to the pope. He immediately followed it with a second oath: loyalty to the king would nullify anything of substance promised in the first.[25]

Cranmer's flexible attitude towards the prior avowed commitment contrasts with that of some of the household servants of Catherine of Aragon. In late 1533, they reportedly refused to take a new oath to her as 'Princess Dowager' on the grounds they were formerly pledged to her as Queen, and believed that 'no man sworn to serve her as Queen might change that oath without committing perjury'.[26] The Oath of Succession itself, in directing swearers to repudiate foreign authorities, required that 'in case any oath be made, or hath been made, by you, to any [such] person or persons, that then you to repute the

same as vain and annihilate'.[27] But this raised an immediate and uncomfortable question, which both the framers and takers of the oath could hardly avoid contemplating. Could a solemn spiritual vow simply supplant and replace an earlier, contradictory one, without thereby implicitly advertising its own conditionality and contingency?

In the aftermath of the huge logistical operation of 1534, evidence started to accumulate that some people thought not. 'An othe loslie made may loslie be brokyn'. That was the guidance that George Rowland, a Crossed or Crutched Friar of London, gave in confession in early 1536: the penitent turned out to be an evangelical, looking to entrap him. Rowland's advice was justified by analogy with the kind of social dilemma anyone might find themselves confronted with: if a friend were to press him, with 'importynate suete', to go for a drink with an enemy, and under pressure he promised on his faith to do so, 'trowe you that I wyll forgyve hym with mi harte?' Likewise, 'uppon this othe concernyng the abiuracyon of the pope I wyll not abiure hym in my harte'.[28]

Others spoke in a less homely manner, but clearly regarded the oath's coercive nature as nullifying its binding power over the conscience. A servant of Bishop Fisher was reported to have counselled him to take the oath, as 'me thinketh that it is no great matter, for your lordship may still thinke as you list'. His fellow refusenik, Thomas More, was clearly hearing similar advice. Writing to his daughter Margaret, he observed how 'some may be peradventure of that minde, that if they say one thing and thinke the while the contrary, God more regardeth their harte than their tonge'.[29] That seems to have been the conclusion reached by George Croftes, chancellor of Chichester diocese, who took the oath in 1534, but four years later was reported to have said that 'he is in his stomach the same man in all opinions that he was xx yeares past'.[30] John Forrest, an Observant Friar of Greenwich, likewise swore obediently in 1534, but subsequently explained to a penitent during confession that 'he had denyed the busshope of Rome by an oth given by his outwarde man but not in thinward man'.[31] The reasoning here became notorious, one evangelical writing a few years later that conservative clergymen habitually argued they could 'keepe their inward man free' when required outwardly to conform.[32]

There is no reason to suppose that large numbers of Catholic conservatives swore the oath lightly or flippantly, their fingers, as it were, crossed behind their backs. An oath was a solemn undertaking, and performing one which seemed unjust, illicit, or perjurious might involve the swearer in real agonies, or gymnastics, of the conscience. Laurence Bloneham, Cistercian monk of Woburn in Bedfordshire, justified to himself and others that he had never actually sworn to forsake the pope because, in the apparent confusion of the oath-taking ceremony, 'I dyd not ley my hande apon the booke & kyse yt but whas ouer passyde by resone of mouche company'.[33]

Mental and psychological forms of evasion were more common than physical ones. There were ways of making the oath seem licit – more or less – in the mind of the swearer, subverting its intentions without resorting to what theologians might formally have considered lying. This involved employing the nascent techniques of casuistry, equivocation, or 'mental reservation', adding qualifications, openly or secretly, that altered the meaning of the oath being taken.[34] An accusation against the abbot of Reading, Hugh Cooke, executed for treason in 1539, was that when he was sworn to the King's supremacy, he silently added, 'of the temporal Church, but not of the spiritual'.[35]

A distinct irony here is that there was a recent precedent for such equivocation, which Henry VIII himself had sanctioned. In 1531, while the break with Rome was still pending, and in return for a royal pardon for the alleged offence of praemunire, the Convocation of Canterbury agreed to recognise royal headship over the Church, 'as far as the law of Christ allows'. In the following year, when the King demanded a complete and categorical surrender of the clergy's independent right to make canon law, some bishops in Convocation still subscribed conditionally and equivocally. John Longland of Lincoln and Henry Standish of St Asaph added qualifying clauses to stipulate that good constitutions should remain unaffected; John Stokesley of London agreed to sign only on the understanding 'it were not contrary to divine law, or general councils'.[36]

Some religious communities approached the Succession and Supremacy Oaths with the same lawyerly precision. In August 1534, the master and fellows of Balliol College, Oxford, subscribed to the supremacy with the added proviso that in doing so they did not 'intend anything against divine law, nor against the rule of orthodox faith, nor against the doctrine of our mother, the holy Catholic Church'.[37] Three months earlier, Prior John Houghton and the London Carthusians were with great reluctance prevailed upon to take the Oath of Succession, agreeing to do so only when they were allowed to add the reservation 'as far as it was lawful' – a temporary concession which was not repeated when the community was called upon to swear to the supremacy in the following year. In 1537, after the gruesome execution of Houghton and several of his Carthusian brethren, a shattered remnant of the community did swear to recognise the royal supremacy. According to the community's chronicler, Maurice Chauncy, when they did so they employed a secret mental reservation, 'but in this', he added ruefully, 'we are not justified'.[38]

Just how many other clergy or laity swore the oath with profound reservations, or with a secret reservation in the more technical, casuistical sense, is simply impossible for us to know. Cromwell's agent John Hilsey, who in 1535 would replace John Fisher as bishop of Rochester, wrote to his master in June 1534 that he had not yet encountered any monks or friars downright refusing to take the oath. But some had sworn with undoubted ill-will and 'slenderly hathe takyn an othe to be obedyent'.[39]

In 1534, the English government used compulsion, alongside the full bureaucratic and cultural resources of a profoundly conformist and hierarchical society, to produce an apparently free affirmation of near-universal assent. The regime had ostensibly laid open the hearts and minds of its subjects, but in consequence it found itself for years afterwards worrying about dissimulation, disloyalty, and secret dissent. For the rest of the reign, bishops and ecclesiastical and secular office-holders of various kinds were required solemnly to renounce the pope and profess the royal supremacy. But the universal, collective exercise witnessed in 1534 was never repeated.

Nonetheless, the episode arguably had profound, unintended, and long-term consequences. Chief among these was its role in helping to release into the body politic a germ of the notion that outward obedience and inner assent need not always go together; that there were spaces for free exercise of the conscience where the tentacles of the state could not reach. The formal, public, symbolic nature of the oath-swearing also had the likely if inadvertent effect of focusing attention and reflection on the very issues which the regime wished people to regard as settled and incontestable. It could in itself be a precipitant of conversional action. A scrivener, James Holywell, left England for Rome in 1534–1535, telling people when he got there that 'when every man was sworne to the King, he was not, nor would be'.[40] A more significant case was that of the English royal ambassador, Richard Pate, who at Christmas 1540 fled from the emperor's court in the Netherlands to Rome and declared himself for the pope. Pate had probably never fully reconciled himself to the break with Rome, and his unease about the direction of government policy had been growing over the course of the 1530s. But a recent study of the case concludes that, due to his overseas postings, Pate had probably never taken the oath, and a fear that it would be proffered to him on his next return to England was what tipped him into open rebellion.[41]

The oath, I wish to argue, was an important catalytic factor in the emergence of a new religious phenomenon in England: Roman Catholicism. This paradoxical-sounding claim does not for a moment seek to deny the obvious fact that, prior to the 1530s, England was a largely orthodox Catholic nation, under the jurisdictional authority of the papacy. Papal authority was certainly recognised and respected, for example in the considerable number of English people applying to Rome for dispensations from the prescriptions of canon law, in marital and other cases. But precisely because, for a century and more, papal spiritual authority had not been much questioned or challenged, it is unclear how significant it actually was as a component of people's core identities as Christians.[42] In 1534, Henry VIII demanded performative recognition of a new religio-political orthodoxy: it was not now possible to be a good Catholic Christian while recognising the authority of the pope. It is no accident that at precisely the same moment the derogatory word 'papist'

(borrowed from Lutheran nomenclature) began to enter official parlance, in direct juxtaposition with 'Catholic'.[43] But in making this demand, Henry was helping to propel some of his subjects to precisely the opposite conclusion: that it was impossible to be a true Catholic without recognising the authority of the pope. By virtue of the very ferocity of the attack on it, communion with Rome was assuming a political and spiritual importance it had not previously enjoyed.

To see this dynamic in action, we can turn to the most famous case of refusal of Henry VIII's oath, that of the former lord chancellor, and renowned humanist scholar, Thomas More. Before the break with Rome, More, so most modern scholars have thought, was a very unenthusiastic papalist, or even a conciliarist who doubted the divine origins of the papacy and considered a general council to be the supreme legislative authority for the Church.[44] Eamon Duffy has drawn attention to an incident reported in Cardinal Reginald Pole's St Andrew's Day sermon in Mary's reign, which apparently originated in the recollections of More's friend, the Italian merchant Antonio Buonvisi. In the early 1530s, just before the rupture with Rome was completed, the two men discussed the growing threat of sacramental heresy. Buonvisi asked More what he thought of the papal primacy itself, and More answered that 'it was not a matter of so great moment and importance, but rather ... inventyd of men for a political order, and for the more quyetnes of the ecclesiastical bodye, than the verye ordinaunce of Chryste'. But having said so, More immediately felt conscience-stricken by his own answer, and asked Buonvisi to meet with him again after he had had time to read and reflect on the matter properly. Ten days later, in a fit of self-reproach, More retracted his earlier unconsidered opinion. He had come to see that the primacy of the Pope was that which 'holdyth up all'.[45]

The coincidence of this conclusion, first recorded in 1557, with the ideological agenda of the Marian regime is certainly fortuitous. But there is more direct and contemporary evidence for a change in the texture of More's beliefs regarding the papacy. In a letter to Cromwell of 5 March 1534, More confessed that 'I was myself sometime not of the mind that the primacy of that see should be begun by the institution of God'. What had changed his mind? Nothing other than reading 'those things that the king's highness had written in his most famous book against the heresies of Martin Luther'. This was both a mischievous and a tactically adept claim. There is, in fact, corroborating evidence that in 1521, commenting on a text of the King's *Assertio Septem Sacramentorum* (Defence of the Seven Sacraments), More had advised Henry that the power of the papacy might be 'more slenderly touched', in case political or diplomatic quarrels arose to cause the king embarrassment in the future. In the published version of the *Assertio*, in fact, the basis of the papal primacy was not a subject Henry felt moved to develop at any length, content merely to

declare that 'I will not wrong the Bishop of Rome so much, as troublesomely, or carefully to dispute his right, as if it were a matter doubtful'.[46]

More famously kept silent as to precisely why he would not swear the Oath of Succession, but at his trial, after conviction as a traitor on the probably perjured evidence of Richard Rich, he broke his silence in offering a 'motion in arrest of judgement'. The indictment was invalid, he claimed, because it was

> grounded upon an act of parliament directly repugnant to the law of God and his Holy Church, the supreme government of which … may no temporal prince presume by any law to take upon him, as rightfully belonging to the See of Rome, a spiritual pre-eminence by the mouth of Our Saviour himself, personally present upon the earth, only to Saint Peter and his successors, bishops of the same see, by special prerogative granted … this realm, being but one member and small part of the Church, might not make a particular law disagreeable to the general law of Christ's universal Catholic Church, no more than the City of London, being but one poor member in respect of the whole realm, might make a law against an act of parliament to bind the whole realm.[47]

That was the account given by William Roper, not present in the court that day, and writing More's biography twenty years later. Perhaps we should heed John Guy's advice to be cautious about what looks suspiciously like a Marian Catholic version of what More ought to have said.[48] But it seems very unlikely that Roper's account, drawing on the testimony of eyewitnesses, is entirely fanciful. There is little doubt that More's thinking about the nature of the Church, and about the role of the papacy within it, was deeply affected by the rising tide of heresy and the emergent reality of schism. Thomas More, it can reasonably be argued, was a late medieval English Catholic humanist who at some point in the late 1520s or early 1530s became one of the first Reformation-era English Roman Catholics. The King's unswerving and all-consuming demand that he swear an oath contrary to his conscience seems to have confirmed More in what we might well want to regard as a religious conversion, albeit a conversion within a faith tradition, rather than between separate ones.

There was another unintended effect of the oath campaign. More's refusal to swear lead directly to his death, as it did for Bishop Fisher and for several Carthusian priors and other assorted clergy. For medieval and early modern people, martyrdom was a critical instrument of cultural self-understanding, and it swiftly and productively nurtured the embryonic dissident identity of English Roman Catholicism. Within England, Henry's victims, the non-jurors of the oath, were almost immediately being hailed, albeit covertly, as saints and martyrs of the true faith. On the feast of St John the Baptist, two days after the beheading of Fisher in 1535, John Darlay of the London Charterhouse was visited in his cell by the ghost of a deceased brother. The apparition urged him

to follow the example of Prior Houghton, whom he knew to be a 'martyr in heaven next unto angels'. On a subsequent visit, the spirit reported 'my lord of Rochester' to be there too. Reports were soon spreading, within England and abroad, that Fisher's head, displayed on London Bridge, was miraculously preserved from corruption. Alarmed, the authorities threw it into the Thames. But over the course of 1535–1536 this did little to prevent the arrival of a stream of reports about disaffected subjects, praising Fisher, More, and the Carthusians for being, as the abbot of Colchester Thomas Marshall put it, 'martyrs and saints ... for holding with our holy father the pope'.[49] Others prepared mentally to follow their example. In a sermon of June 1535, Christopher Michell, curate of Winstead in Holderness in the East Riding of Yorkshire, asked his parishioners to pray for him, 'for I am bound to such a journey that I trawe never to see you again, for it is said that there is no pope, but I say there is a pope'.[50]

Abroad, the reaction was one of horror and disbelief at Henry's actions. In Italy, Reginald Pole started to compose an excoriating attack on Henry's policies, and a demand that he should repentantly surrender himself to the judgement of the Church. Pole was the King's protégé, as well as his kinsman, and as recently as 1530 he had been an active participant in the campaign to bring about the divorce. But the treatment of More and Fisher affected him deeply, and pressure from Henry to state his true opinions on the marriage and the supremacy crystallised a change in his thinking of an order which merits the label of conversion. Like More, Pole started from the assumption that the papacy was a venerable instrument of good ecclesiastical order, but not an institution of divine origin central to the Church's very being. But he changed his mind on this, largely because of the effect of the executions of 1534–1535, which spoke to him as a message from God and reconfigured in his thinking the institution for which More and Fisher died as an instrument of divine providence.[51]

Coming at a crucial juncture of Henry VIII's break with Rome, the oath-swearing of 1534 turns out to have been a 'conversion machine' of very considerable potency, and of decidedly wayward performance. More broadly, as I hope this brief survey has managed to suggest, the conversional politics in evidence at the outset of the English Reformation are distinctly multifaceted, creative, and transactional in character. They complicate the notion that the governing dynamic of these events was straightforwardly an 'act of state'. And they equally invite us to interrogate the assumption that what is usually termed 'Catholic resistance' was simply a reactive upholding of the status quo ante by a stubborn remnant or residue of the old order. What a study of this episode teaches us seems to me an intriguing yet little recognised paradox of the Reformation era, and perhaps of other eras too: that political demands for conversional forms of conformity do not merely reveal or expose non-conformity; they can positively create it, and activate it for oppositional purposes.

NOTES

1. A point which has emerged with particular force from the work of the project based at the University of York, 'Conversion Narratives in Early Modern Europe'. See Ditchfield and Smith, 'Introduction', pp. 1–13; Mazur and Shinn, 'Conversion Narratives'.
2. Kendall, 'Introduction', pp. 5–6.
3. For example, Traboulay, *Columbus and Las Casas*; Armstrong and Wood, *Christianizing Peoples and Converting Individuals*.
4. Fernandez-Armesto, 'Conceptualizing Conversion', pp. 20–1.
5. Marshall, 'Evangelical Conversion'; Questier, *Conversion, Politics and Religion*.
6. Christopher Haigh, *English Reformations*, p. 280.
7. For a survey of these trends, see Marshall, '(Re)defining the English Reformation'.
8. The most detailed survey of the topic is now Gray, *Oaths and the English Reformation*, an impressive study with rather different points of emphasis from those pursued here.
9. Rex, 'Religion of Henry VIII', is the most convincing account of this.
10. See, for example, Shagan, *Popular Politics*, chapters 1–2; Bernard, *King's Reformation*, chapter 2; Marshall, *Heretics and Believers*, chapter 7.
11. Gee and Hardy, *Documents*, pp. 232–43.
12. Brigden, 'Religion and Social Obligation', pp. 86–92.
13. Marshall, *Heretics and Believers*, p. 96, pp. 77–8, p. 197.
14. Elton, *Policy and Police*, p. 120, pp. 224–5.
15. Gardiner, *Letters*, p. 57.
16. For discussion of the theme in relation to later Catholic recusants, see Walsham, *Church Papists*, pp. 77–81.
17. *Lords' Journal*, p. 82.
18. Gee and Hardy, *Documents*, pp. 245–6.
19. Gray, *Oaths and the English Reformation*, pp. 61–8.
20. Rex, 'Execution of the Holy Maid of Kent', 216–20.
21. Marshall, *Heretics and Believers*, pp. 210–1.
22. Gray, *Oaths and the English Reformation*, pp. 127–8.
23. *Letters and Papers*, VII, p. 690.
24. *Letters and Papers*, VII, p. 690.
25. MacCulloch, *Cranmer*, pp. 88–9.
26. *Letters and Papers*, VI, p. 1541.
27. Gee and Hardy, *Documents*, p. 245.
28. The National Archives, SP 1/102, fol. 73v (*Letters and Papers*, X, p. 346).
29. Gray, *Oaths and the English Reformation*, pp. 131–2.
30. *Letters and Papers*, XIII (2), p. 829.
31. The National Archives, SP 1/132, fol. 155 (*Letters and Papers*, XIII (1), p. 1043 (1)). See Marshall, 'Papist as Heretic'.
32. Ryrie, *Gospel and Henry VIII*, p. 79n.
33. Gray, *Oaths and the English Reformation*, p. 133.
34. The 'science' of casuistry became more developed later in the sixteenth century: see Holmes, *Elizabethan Casuistry*; Somerville, 'New Art of Lying'; Zagorin, *Ways of Lying*.
35. *Letters and Papers*, XIII (2), p. 613.
36. Marshall, *Heretics and Believers*, p. 184, 198.
37. Rymer, *Foedera*, XIV, 498 (my translation).
38. Knowles, *Religious Orders*, pp. 229–31; Whatmore, *Carthusians*, p. 27, 180.
39. The National Archives, SP 1/84, fol. 239 (*Letters and Papers*, VII, p. 869).

40. *Letters and Papers*, VIII, p. 763.
41. Sowerby, 'Richard Pate', pp. 265–85.
42. For discussion of the role of the papacy in pre-Reformation England, see Marshall, *Heretics and Believers*, pp. 66–81.
43. Marshall, 'Is the Pope Catholic?', pp. 34–5.
44. Guy, *More*, p. 201; Oakley, *Conciliarist Tradition*, pp. 135–6.
45. Duffy, *Saints, Sacrilege and Sedition*, pp. 206–8.
46. More, *Selected Letters*, pp. 212–13; Roper, 'Life of Sir Thomas More', p. 235; Henry VIII, *Assertio*, pp. 202–4.
47. Roper, 'Life of Sir Thomas More', p. 248.
48. Guy, *More*, pp. 203–4.
49. Wright, *Letters*, pp. 34–5; *Letters and Papers*, IX, p. 46, 873; XI, p. 486; Elton, *Policy and Police*, p. 24, 157, pp. 355–56.
50. Hoyle, *Pilgrimage of Grace*, p. 58.
51. Duffy, *Saints, Sacrilege and Sedition*, pp. 183–84.

WORKS CITED

Armstrong, Guyda and Ian N. Wood (eds), *Christianizing Peoples and Converting Individuals* (Turnhourt: Brepols, 2000).

Bernard, George, *The King's Reformation: Henry VIII and the Remaking of the English Church* (New Haven and London: Yale University Press, 2017).

Brigden, Susan, 'Religion and Social Obligation in Early Sixteenth-century London', *Past and Present*, 103 (1984), pp. 67–112.

Ditchfield, Simon and Helen Smith, 'Introduction', in Ditchfield and Smith (eds), *Conversions: Gender and Religious Change in Early Modern Europe* (Manchester: Manchester University Press, 2017), pp. 1–17.

Duffy, Eamon, *Saints, Sacrilege and Sedition: Religion and Conflict in the Tudor Reformations* (London: Bloomsbury, 2012).

Elton, Geoffrey R., *Policy and Police: the Enforcement of the Reformation in the Age of Thomas Cromwell* (Cambridge: Cambridge University Press, 1972).

Fernandez-Armesto, Felipe, 'Conceptualizing Conversion in Global Perspective: From late Antique to Early Modern', in Calvin B. Kendall, Oliver Nicholson, William D. Philipps, Jr., and Marguerite Ragnow (eds), *Conversion to Christianity from Late Antiquity to the Modern Age: Considering the process in Europe, Asia, and the Americas* (Minneapolis: Center for Early Modern History, 2009), pp. 13–44.

Gardiner, Stephen, *The Letters of Stephen Gardiner*, ed. James A. Muller (Cambridge: Cambridge University Press, 1933).

Gee, Henry and William J. Hardy (eds.), *Documents Illustrative of English Church History* (London: MacMillan, 1896).

Gray, Jonathan M., *Oaths and the English Reformation* (Cambridge: Cambridge University Press, 2013).

Guy, John, *Thomas More* (London: Arnold, 2000).

Haigh, Christopher, *English Reformations: Religion, Politics, and Society under the Tudors* (Oxford: Oxford University Press, 1993).

Henry VIII, *Assertio Septem Sacramentorum*, ed. and trans. Louis O'Donovan (New York: Benziger Brothers, 1908).

Holmes, Peter J., (ed.), *Elizabethan Casuistry* (London: Catholic Record Society Publications, 67, 1981).

Hoyle, Richard, *The Pilgrimage of Grace and the Politics of the 1530s* (Oxford: Oxford University Press, 2001).

Journals of the House of Lords, Volume 1: 1509–1577 (London: HMSO, 1836).

Kendall, Calvin B., 'Introduction', in Calvin B. Kendall, Oliver Nicholson, William D. Philipps, Jr., and Marguerite Ragnow (eds), *Conversion to Christianity from Late Antiquity to the Modern Age: Considering the process in Europe, Asia, and the Americas* (Minneapolis: Center for Early Modern History, 2009).

Knowles, David, *The Religious Orders in England: Vol. III The Tudor Age* (Cambridge: Cambridge University Press, 1959).

Letters and Papers, Foreign and Domestic, of the Reign of Henry VIII, ed. J. S. Brewer, J. Gairdner and R. H. Brodie, (21 vols in 33 parts), (London: Public Record Office, 1862–1910).

MacCulloch, Diarmaid, *Thomas Cranmer: A Life* (New Haven and London: Yale University Press, 1996).

Marshall, Peter, 'Evangelical Conversion in the Reign of Henry VIII', in Peter Marshall and Alec Ryrie (eds), *The Beginnings of English Protestantism* (Cambridge: Cambridge University Press, 2002), pp. 14–37.

_____, *Heretics and Believers: A History of the English Reformation* (New Haven and London: Yale University Press, 2017).

_____, 'Is the Pope Catholic? Henry VIII and the Semantics of Schism', in Ethan Shagan (ed.), *Catholics and the 'Protestant Nation': Religious Politics and Identity in Early Modern England* (Manchester: Manchester University Press, 2005), pp. 22–48.

_____, 'Papist as Heretic: The Burning of John Forest, 1538', *Historical Journal*, 41 (1998), pp. 351–374.

_____, '(Re)defining the English Reformation', *Journal of British Studies*, 48 (2009), pp. 564–86.

Mazur, Peter and Abigail Shinn, 'Conversion Narratives in the Early Modern World', special issue of *Journal of Early Modern History*, 17 (2013).

More, Thomas, *Selected Letters*, ed. Elizabeth F. Rogers (New Haven and London: Yale University Press, 1961).

Oakley, Francis, *The Conciliarist Tradition: Constitutionalism in the Catholic Church 1300–1870* (Oxford: Oxford University Press, 2003).

Questier, Michael, *Conversion, Politics and Religion in England, 1580–1625* (Cambridge: Cambridge University Press, 1996).

Rex, Richard, 'The Execution of the Holy Maid of Kent', *Historical Research*, 64 (1991), pp. 216–20.

Rex, Richard, 'The Religion of Henry VIII', *Historical Journal*, 57 (2014), pp. 1–32.

Roper, William, 'The Life of Sir Thomas More', in Richard S. Sylvester and Davis P. Harding (eds), *Two Early Tudor Lives* (New Haven and London: Yale University Press, 1962).

Rymer, Thomas, ed., *Foedera* (20 vols., London, 1704–35).

Ryrie, Alec, *The Gospel and Henry VIII: Evangelicals in the Early English Reformation* (Cambridge: Cambridge University Press, 2003).

Shagan, Ethan, *Popular Politics and the English Reformation* (Cambridge: Cambridge University Press, 2003).

Sommerville, Johann P., 'The "New Art of Lying": Equivocation, Mental Reservation, and Casuistry', in Edmund Leites (ed.), *Conscience and Casuistry in Early Modern England* (Cambridge: Cambridge University Press, 2002), pp. 159–84.

Sowerby, Tracey, 'Richard Pate, the Royal Supremacy, and Reformation Diplomacy', *Historical Journal*, 54 (2001), pp. 265–85.

Traboulay, David, *Columbus and Las Casas: The Conquest and Christianization of America, 1492–1566* (Lanham: University Press of America, 1994).

Walsham, Alexandra, *Church Papists: Catholicism, Conformity and Confessional Polemic in Early Modern England* (Woodbridge: Boydell Press, 1993).

Whatmore, Leonard Elliott, *The Carthusians under King Henry VIII* (Salzburg: Institut für Anglistik und Amerikanistik, 1983).

Wright, Thomas, (ed.), *Three Chapters of Letters Relating to the Suppression of the Monasteries* (London: Camden Society, 26, 1843).

Zagorin, Perez, *Ways of Lying: Dissimulation, Persecution, and Conformity in Early Modern Europe* (Cambridge: Harvard University Press, 1990).

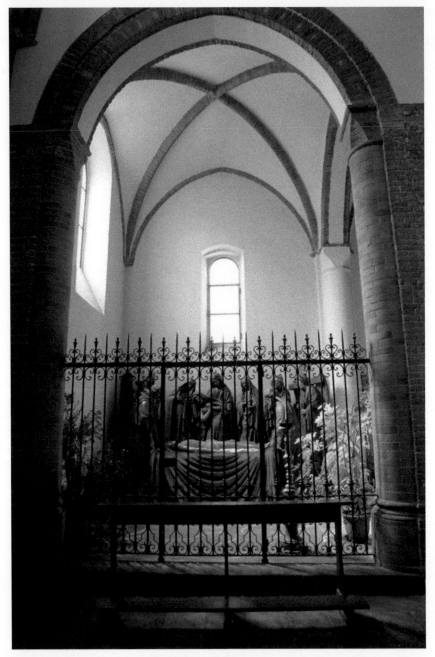

Fig 3.1 Anonymous artist, *Compianto sul Cristo morto*, ca. 1424–1553. Polychrome
sandstone, over life size. Church of Santa Maria della Scala, Moncalieri.
Photo by author.

3

THE SEPULCHRE GROUP: A SITE OF ARTISTIC, RELIGIOUS, AND CULTURAL CONVERSION

Ivana Vranic

Supposing that the disciples, the future apostles, the women who had followed Him and now stood at the Cross, all of whom believed in and worshipped Him – supposing that they saw this tortured body and face so mangled and bleeding and bruised as here represented (and they must have so seen it) – how could they have gazed upon the dreadful sight and yet have believed that He would rise again?

Fyodor M. Dostoevsky, *The Idiot*[1]

SCULPTURAL CONVERSION

Positioned in a semi-circle around a tomb-like altar on which rests the supine Christ, twelve biblical figures participate in one of the seven corporeal works of mercy – the burial of their dead (Fig. 3.1). Lifelike in their bodily and emotive expressions, these heavily draped, winged, and armoured figures – portraying the Virgin Mary, John the Evangelist, Nicodemus, Joseph of Arimathea, the Three Maries, the Angels of the Resurrection, and the three sleeping soldiers – solicit the viewer to witness the dead body of Christ in tangible time and space. Together, the life-size polychrome statues form a sculptural group, *Compianto sul Cristo morto* (Lamentation over the Dead Christ). The monumental composition is kept in a brick-vaulted chapel inside the church of Santa Maria della Scala in Moncalieri, a town just outside Turin. The sculptures are framed against a pastel-coloured wall and an ornamental iron gate, which is not how they were exhibited initially, namely without any barriers. Between the early

fifteenth and mid-sixteenth centuries, hundreds of such large-scale works made of various materials were displayed in parish, monastic, hospital, and cemetery churches across Europe. In this chapter, I examine several of these groups – they come from sites in France, Germany, Switzerland, Italy, and Spain – and I propose that their formal, iconographic, and contextual characteristics reveal how local artists and patrons adopted different artistic traditions and devotional practices for their making. In contrast to previous scholarship that has, for the most part, categorised the Sepulchre groups into distinct regional works, I argue that they belonged to the same artistic phenomenon that made Christ's burial a site of multifold processes of conversion, the first of which is sculptural.

Two bearded attendants stand atop a rugged base on either side of Christ's tomb in Moncalieri (Fig. 3.2). The attendants are slightly hunched forward because they hold onto the edges of the shroud with which they transported Christ from the Cross. He is dressed only in a loincloth and a woven wreath of thorns. Holes imitating the Five Holy Wounds of the Crucifixion are visible on his hands, feet, and chest. Every strand of his curly hair and forked beard is well-defined, not unlike the designs inscribed on the leather and tasselled moneybag carried by Joseph of Arimathea, situated next to Christ's head, or the richly embossed armour worn by the guards sleeping at the foot of the tomb. One guard is propped up on a shield emblazoned with letters – SPQR – that

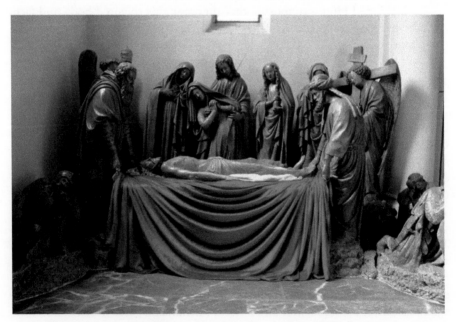

Fig. 3.2 Detail of Fig. 3.1, *Compianto*, Moncalieri. Photo by author.

signal his allegiance to the Roman emperor and historically set him apart from his viewers. The second attendant stands next to the indisposed soldier. His identity is rolled into the blue and yellow pattern of his red turban. This head-dress identifies the figure as Nicodemus; it also situates the funeral scene in the location of the biblical past, the Orient.

In contrast to the linen-like material of the white shroud and the stark lifelessness of Christ's body, the mourners that surround the tomb are made animate by heavy folds that undulate across their multicoloured robes, mantles, and veils. Even though they pause in grief, the mourners react to the sight of the body presented in front. Three hooded women stand in the middle, among them the Virgin, who clasps her hands together and swoons towards the head of her son, only to be held up from behind by a standing male. This figure is John the Evangelist, recognisable by his shoulder-length hair, green tunic, and red cloak. The redness of his mantle calls up the blood that must have congealed in Christ's wounds, and yet no blood is visible on the deceased. That this body was only recently cleaned and anointed with scented oil is implied by an ointment jar held by one of the female followers. Her long, exposed hair distinguishes her as the Magdalene, while the mustard colour of her dress matches the paleness of the recumbent figure. Despite its stiffness, Christ's body glistens when sunlight floods the small chapel, along with the wings of two angels perched in the back and on top of the platform that simulates the rugged ground of Golgotha. The angels carry the Holy Cross, inscribed with INRI, and the Pillar of the Flagellation, among other arma Christi. Together, these objects and mourners narrate Christ's burial.

Variously dated, from as early as 1424 to as late as 1553, the Compianto from Moncalieri is nearly identical to two other groupings located some distance away. The first work, inscribed with the year 1433, is kept in the Chapel of the Holy Sepulchre in the Swiss Cathedral of Saint Nicolas in Fribourg (Fig. 3.3), and the second is in the church of Saint Martin in Pont-à-Mousson in north-eastern France (Fig. 3.4).[2] The three works share many similarities, including the thirteen-figure configuration and the central motif of the swooning Virgin, who is held up by John the Evangelist, along with minor details, such as the bending curve of the angelic wings and the satchels hanging from the belts of the male attendants. Previous studies have focused on finding parallels between the thirty-nine statues: recognising comparable poses, gesticulations, and fashions, and locating stylistic equivalents. As a result, the work from Lorraine is often described as featuring Germanic and Flemish influences, while Franco-Flemish sources are sought in the Swiss configuration, which is thought to be directly quoted in Piedmont. Curiously, and regardless of these parallels, scholars insist on classifying the French, the Italian, and the Swiss groups into regional types that have significant iconographic, cultural, and functional differences. By contrast, I posit that these geographically distant

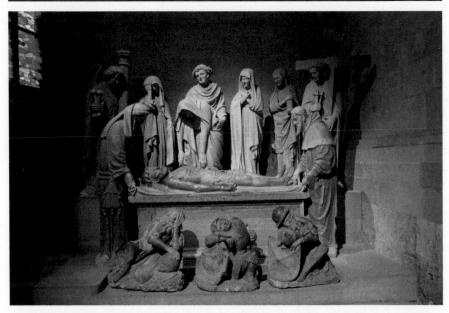

Fig. 3.3 Master of the Family Mossu, *Grablegung Christi*, 1433. Polychrome sandstone, life size. Cathedral of Saint Nicolas, Fribourg. Photo by author.

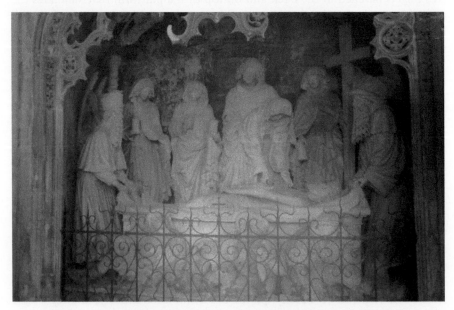

Fig. 3.4 Anonymous artist, *Mise au tombeau du Christ*, ca.1415–1430. Polychrome limestone, close to life size. Church of Saint Martin, Pont-à-Mousson. Photo by author.

works are only three instances, albeit more obvious ones, of a single sculptural type – what I will call the Sepulchre group.

Despite being an international phenomenon, the sculptural type is known by different names. Over four hundred Sepulchre groups are preserved in France, more than sixty in Italy, at least two dozen in Spain, twenty-eight in Belgium, and over twenty in Germany.[3] This is only a small fraction of the works that were made in the fifteenth and sixteenth centuries. When they appear in France, they are called *Mise au tombeau du Christ*; in German-speaking regions they are identified as *Grablegung Christi* or *Heilige Grab*; *Compianto sul Cristo morto* is the imperative label given in the Italian studies; while *Santo Entierro de Cristo* is the preferred title in the Spanish context.[4] These labels are often applied in the international scholarship as a confirmation of what are perceived to be historically and culturally distinct artworks. While these designations can be practical, for example when considering the iconographic subject of individual arrangements, they draw attention away from the many fruitful connections that warrant closer study.

The Sepulchre groups are distinguished from other kinds of contemporary representations that feature an effigy of Christ by their shared formal, contextual, functional, and iconographic elements. Compositionally, the Sepulchres can have between six and twelve biblical characters distinctively arranged – kneeling or standing, and often holding cleansing objects and the arma Christi. These characters are positioned around a figure of the dead Christ – shown carried in a shroud, recumbent on a stone slab, or interred in a sarcophagus, and displaying his wounds.[5] These figures and objects use what the eye can see to tell us the story of how Christ was prepared for burial. The story is told through disparate moments that combine elements from the scenes of the Passion – the Deposition, the Pietà, the Lamentation, the Entombment, and the Resurrection – with appropriate funerary rites, including anointing, enshrouding, and mourning.[6] Emphasising one iconographic moment over another was part of how the compositions were adapted to suit local contexts and the demands of a variety of patrons – ranging from clerics and royal patrons to monastic and lay orders. Moreover, these devotional works served many functions, as a figural model of the Holy Sepulchre, an Easter Sepulchre, a family memorial, a votive offering, a pilgrimage site, and a devotional image. They were mounted in donor chantries, cathedral crypts, confraternal oratories, parish chapels, and funerary monuments. Within these sacred spaces, Christ's funeral became a site of multiform piety.

Since the early nineteenth century, scholars following Emile Mâle have been interested in classifying the extant Sepulchre groups into regional types.[7] Recent studies have recognised that the interconnected nature of the diverse examples is more than just a formal coincidence, albeit they still emphasise their functional and cultural differences. According to early studies, the life-size

polychrome groupings developed in France from the Flemish altarpieces of the Passion and spread with the Franciscan orders. William H. Forsyth and Michel Martin, in particular, claim that the French monuments are unique to France because they narrate the Entombment, which was a scene that, according to Mâle, the sculptors 'translated into stone' from the mystery plays.[8] In contrast, Elsa Karsallah reasons that the French Entombments correspond formally to the fourteenth-century German tradition of the Holy Graves but also display many adaptations.[9] In addition, Donna L. Sadler concludes that these Germanic graves were formally updated when they reached Burgundy and Champagne by being modelled on religious dramas and local practices in funerary and religious sculpture.[10] These practices included statues made by the renowned Dijon workshop of Dutch sculptors, particularly Claus Sluter, along with altarpieces and *gisants* – the recumbent figures of the deceased placed on top of Gothic tombs.[11] Following this and other recent scholarship, I contend that we need to understand the whole range of Sepulchral groupings that came to vivid life across Europe in light of three kinds of conversion.

First, they embody a scene of conversion from life to death, a transformation that conditions all human existence. This conversion is materialised by the lifelike statues that translate an ordinary subject – death and a funeral – using extraordinary characters, the biblical figures, and the Son of God. Second, by representing Christ's funeral, these statues served as instruments for contemplating faith, mortality, and salvation. They were staged to incite religious conversion and devotion by merging real life with sacred history. Third, the figural arrangements were highly mobile and changeful. It is this mobility and the adaptive modes of artifice that I set out to explore in this chapter, such as for example differences in materials and techniques used, along with the kinds of experiences that these devotional works offered to their patrons and viewers. In particular, I investigate how the movement of this sculptural type throughout the continent took on numerous forms, meanings, and functions. I feature nine Sepulchre groups, including the one from Moncalieri, as case studies around which to unfold the intricate relationships and analogies that exist between different works and contexts.

LOCAL CONVERSION

The monumental Sepulchres were formally and functionally adapted as they were created across the modern-day borders of the Netherlands, Germany, France, Switzerland, Spain, and Italy. They circulated widely throughout Europe thanks to travelling artists, patrons, and pilgrims who modified the figural arrangements and their characteristics to conform to regional customs, devotional practices, and artistic conventions. Before I discuss individual groups in more detail, a brief overview of the many modes of conversion, including those noted above, is useful for identifying some of the ways these

sculptural works were altered in local contexts. Consider, for instance, how several Flemish groups present Christ being lowered into an open sarcophagus using a shroud. The sculptors drew this motif from contemporary paintings of the Deposition in which Christ is taken down from the Cross by his followers, who use his shroud as a pulley. The French Mises au tombeau, by contrast, rarely show Christ being actively lowered in the tomb. Instead, they display the deceased lying on top of or inside a sarcophagus. As I observed earlier, these French works highlight the iconography of the Entombment rather than the Deposition. This iconographic adaptation is related to the fact that the French examples often functioned as funerary monuments. On the other side of the Pyrenees, the figural Sepulchres rarely served as funerary art. In Spain and Italy, the artistic form converged with para-liturgical practices and existing sculptural traditions, above all the large-scale wooden Depositions.[12] Similarly, in Germany, the Sepulchres functioned as props in Easter triduum ceremonies, when they helped the parishioners and members of the monastic communities perform scenes of the Passion.[13] These German groups integrate the sleeping soldiers and the Angels of the Resurrection with the usual seven biblical characters. Interestingly, in Italy the statues of the mourners were made to exhibit highly theatricalised poses and expressions that reflected the religious practices of the lay confraternities and the noble patrons. The pathos of these figures is why the Italian Compianti are thought to represent the Lamentation, a scene borrowed from Byzantine art and frequently re-enacted in vernacular songs and religious theatre.[14]

Among the countless formal and cultural adaptations that were made to the Sepulchre groups in local contexts, the first were the choice of material and the number of figures. With some exceptions, they were sculpted from materials procured in nearby quarries and woodlands. Many of the French, Flemish, and German compositions were fashioned from native sandstone, while the Spanish and Italian arrangements were generally carved in wood or modelled from clay. The choice of material depended on distinct factors, from the skill of the available sculptor to the proximity and cost of local resources. For example, the previously mentioned Mise au tombeau from Pont-à-Mousson is made of yellow limestone, named *pierre de Jaumont* and native to Lorraine, while sandstone quarried from the Swiss Molasse basin was used to make the Grablegung in Fribourg. Located on the other side of the Alps, the Moncalieri Compianto was carved from *pietra da Cantoni*, a type of sandstone excavated less than a hundred kilometres away in the area of Montferrat (Fig. 3.1). Except for its material, the Compianto in Moncalieri has many formal details in common with Sepulchres found elsewhere in Europe, including the fact that it was initially polychrome and was repainted in later centuries. Significantly, the Italian Sepulchre incorporates the soldiers and the angels native to the German Holy Graves, in addition to the seven mourners typically seen in the

Italian Compianti. The Moncalieri Sepulchre also displays Christ on a shroud and atop a tomb-like altar – two elements that were derived from the Flemish and the French examples.

The largest number of Sepulchres were created between the Valois courts in Brussels, Paris, Bourges, Dijon, and Angers, most especially in the Duchy of Lorraine, which is home to the Mise au tombeau in Pont-à-Mousson (Fig. 3.4).[15] Remaining under the political control of the Holy Roman Empire until the late seventeenth century, along with the contested region of Alsace, Lorraine was fertile ground for artistic exchanges between the Burgundian Netherlands and the Black Forest in the Rhine Valley. Stimulated by the sculptures produced in Sluter's Dijon workshop, cited above, these artistic dialogues combined to form the Sepulchre in Pont-à-Mousson, a city that served as a margraviate seat to the Duchy of Bar, and in 1430 became part of the Duchy of Lorraine. That same year, as Christoph Brachmann explains, the Sepulchre was documented in a donation of a chantry and an altar, placed in front of the traceried chapel where the biblical figures were installed to commemorate the death of ducal family members, and the Holy Sepulchre in Jerusalem.[16] Intriguingly, the figures in this grouping also incorporate formal characteristics standard in German Gothic sculpture, particular to the dramatic expressionism associated with statues of the Pietà and the Holy Graves.[17]

The Holy Graves are encountered predominantly in Alsace and the Black Forest regions, bordering France, Switzerland, and Germany, from at least the early fourteenth century. Conceived as an Easter Sepulchre, the Holy Grave came in different forms, from a single polychrome effigy kept in a portable wooden chest to an elaborate stone shrine complete with life-size sculpted figures of the Three Maries, the angels, and a supine Christ, displayed on a sarcophagus on which the guards are often carved in relief.[18] Evoking the Anointing, the Visitation, and the Resurrection, these Biblical characters were of considerable importance during Easter, when para-liturgies were performed in front of the Holy Graves. In contrast to the temporary Easter Sepulchres and the wall recesses that were prominent in England, and unlike the German Sacrament Houses constructed to preserve the Host, the Holy Graves functioned as year-long *Andachtsbilder*, devotional images, that were donated customarily as funerary monuments in exchange for chantry obligations.[19] In the fifteenth century, the Rhinish Holy Graves were transformed – with the inclusion of Joseph of Arimathea and Nicodemus, responsible for carrying, enshrouding, and entombing Christ – into the Grablegung.[20]

In the Germanic territories of the Holy Roman Empire, the French duchies, the Low Countries, and the recently reunited Kingdom of Spain, the Sepulchre groups served as funerary monuments, and as indulgenced devotional images that benefited many worshippers and not just the sponsoring patrons. Interchangeably a devotional image, an Easter altar table, a receptacle for the

Host, and a family cenotaph, the Sepulchre served to commemorate the death of its donors as much as it recalled Christ's redemptive sacrifice. The donation of a Sepulchre was often supplemented with Requiem Masses and a granting of indulgences that benefited everyone involved in its making, upkeep, and use. The indulgences, which are documented in a small number of cases, grant forty days and sometimes more out of Purgatory to those confessed and penitent viewers who visit, donate to, and pray in front of the Sepulchre.[21] Notably, the indulgences encourage the faithful to visit these figural monuments at Easter, Christmas, Pentecost, any observed feasts, and in some cases every Friday.

Sepulchres functioned as pilgrimage sites that locals and foreigners alike were invited to visit throughout the year, and especially on Easter Sunday, when they stood in for the Holy Sepulchre.[22] The groups are typically denoted by the terms *sepulchrum Domini*, or simply, *sepulchrum*, in the available ecclesiastical documents. These terms communicate how the artworks were understood, namely as representations of the holy site in Jerusalem.[23] During Easter, when pilgrimage was keenly promoted by the indulgences, these sculptures functioned as replicas of Christ's tomb. Some custodians even relocated the Biblical figures to chapels and underground spaces that simulated the Holy Sepulchre. Such relocations took place decades or even centuries after the figures were mounted for the first time. In 1878, for example, the thirteen-figure Grablegung from Fribourg was reinstalled into a newly designed chapel meant to imitate the sacred tomb.[24] And, in Pont-à-Mousson, the vaulted niche of the chapel where the statues are kept was punctured with three holes on each wall in imitation of the windows described by contemporary pilgrims to Jerusalem, which have since been walled up.[25]

While an inscription, situated just below Christ's right hand, dates the Grablegung in Fribourg to 1433, it was probably installed decades later when it came to serve as a memorial and a timely reminder of the political and spiritual loss of Jerusalem (Fig. 3.3).[26] The Swiss group is attributed to a little-known sculptor identified as the Master of Family Mossu. It served as a private monument for a wealthy patron and rector of the factory of Saint Nicolas, Jean Mossu, and his family.[27] The statues were only placed in the family chapel decades after the rector commissioned the Sepulchre because it took longer for the chapel to be financed and completed. Its delayed installation coincided with the conquest of Constantinople in 1453, when the devotional work gained a new significance by becoming a cenotaph to Christ's tomb – a tomb few pilgrims could access after that conquest.

The Fribourg Grablegung offered visitors a virtual pilgrimage to Jerusalem, as did the other Sepulchre groups, particularly when the holy city was inaccessible for religious travel in the late fifteenth and early sixteenth centuries. Such pilgrimages were expounded widely in the meditative and travel literature of *devotio moderna*, which inspired worshippers to imagine themselves visiting

sacred sites at home or in their parish.[28] It is no coincidence that the Sepulchres became widespread when taking a pilgrimage to Jerusalem was made difficult by the increasing hostilities between the European powers in the West and the Ottoman Empire in the East. A similar context spurred the making of the Holy Sepulchre models in the medieval period which brought the tomb of Christ closer to the devout pilgrims in Europe.

The architectural and topological models of the Holy Sepulchre are formally distinct from the artworks discussed in this chapter. Crucially, the broader tradition of the models predates the making of the sculptural groups by over a thousand years.[29] Many distinctions can be drawn between these models and the groups, the most critical being that the former were conceived as empty spaces, and therefore without figures. The sculptural Sepulchres, by contrast, establish a narrative space that visitors were welcomed to enter to experience Christ's death. In return, the pious would be transported back in time and to the Holy Land.[30] Accordingly, the groups offered an immersive experience that was fully embodied given that the lifelike sculptures materialise the body of Christ.

The Sepulchre groups make the figure of Christ present – in life-size, form, and colour – to the viewer, since the sculptors carefully carved and modelled his body to evoke the violent bruises left by the arma Christi and to show that he is indeed dead. The wounds on the body were created when sculptors probed and punctured the surface of the figure using the tools of the sculptor's trade – tools that came to stand in for the instruments of the Passion. The application of colour certainly intensified the affective potential of these perforated surfaces. Unfortunately, none of the groups fully preserve their original polychromy because they were restored, cleaned, and repainted many times over the last five centuries. We can, thus, only imagine the colour of Christ's hands in the Mise au tombeau from Pont-à-Mousson. The colour was added to his limbs using painterly techniques and transformed the sculpted holes into congealed wounds that simultaneously brought to mind Christ's flesh and blood, and the Eucharistic wafer and wine. The sculptors and painters accorded great care to rendering the figure of Christ accurately in order to bring the sacred body to life. This is important considering that the recumbent statue functioned as a relic, according to Sadler.[31] In contrast to the relic-like figure of Christ, his followers were highly mutable, which is in part what made the groups suitable to serve various functions as they were customised in local contexts.

CHARACTER CONVERSION

The mourners in the Sepulchre groups are distinguished by their gender, age, dress, and gesticulation; nonetheless, their identity is not always representative of biblical characters. The figures often wear clothing and have hairstyles that were part of contemporary fashions. Their physiognomy is quite remarkable, too. The sculpted faces are veristic and they frequently resemble those

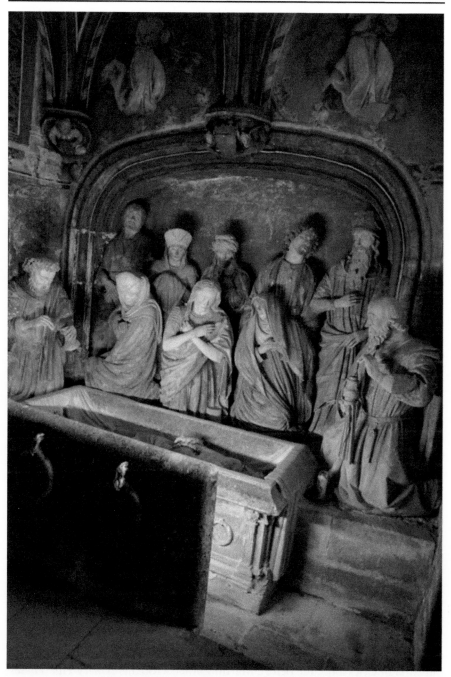

Fig. 3.5 Anonymous artist, *Mise au tombeau du Christ*, ca. 1475–1490. Polychrome limestone, life size. Church of Saint Jean Baptiste, Chaumont. Photo by author.

who commissioned them. More often than not, Christ's mourners mimic their patrons. A superb example of these mourning patrons is the Mise au tombeau in the Basilica of Saint Jean Baptiste in Chaumont, not far from Pont-à-Mousson (Fig. 3.5). Carved by an unknown sculptor, the work was commissioned in 1471 by a wealthy patroness, Marguerite de Baudricourt, and finished some decades later. She was a widow of Geoffroy de Saint-Belin, the bailiff of Chaumont and chamberlain to King Louis XI. Baudricourt intended the Sepulchre to serve as a memorial to her late husband; however, it was completed by her daughter and son-in-law, who transformed it into a family cenotaph.[32]

The Sepulchre groups were ideally suited to serve as funerary monuments because they included donor portraits, as is evidenced in the Mise au tombeau in Chaumont. This grouping shows ten mourners gathered around an open sarcophagus, in front of which rests a large stone slab with hooped handles. A linen-like shroud spills from the inside of the tomb, revealing a pale and thinly framed figure of Christ. His body was prepared for burial using the ointment kept in the jars held by two male attendants flanking the tomb. While holding their hands at their chests and tilting their heads in grief, eight more figures kneel behind the grave. Significantly, these mourners reproduce portraits of the patroness's family. As a result of the portraits this Sepulchre group mimics life rather than biblical history. Quite intriguingly, the donors look like they are attending Mass. They kneel in prayer, while dressed in their Sunday best. In this way, the Sepulchre converted real people into sacred characters, and vice versa. Their potential to conflate temporal, biblical, liturgical, and eternal time is what made the Sepulchre groups befitting to serve as funerary art. These extratemporal tombs offered eschatological benefits to their donors because, like the saints and martyrs, they would be first to rise at the sounding of the seventh trumpet during the Second Coming of Christ.

The Sepulchre groups represent funerary rites and a burial, which is why they are also found in cemeteries. Even though the Chaumont group includes portraits of the patrons, it was used as a direct model for another Mise au tombeau that was commissioned by a sixteenth-century nobleman, Matthieu Chanoine, and exhibited in the nearby church of Saint Michel.[33] This later copy was moved to a local cemetery in the eighteenth century, as was the case with many other groups, which were relocated or dismantled following the French Revolution and the Napoleonic suppression of sacred spaces. Others were transported even earlier due to changes in burial practices. For instance, burials within city walls were banned in France during the eighteenth century, due to a lack of space in the crowded parish yards as well as hygiene reasons. In Germany, by contrast, city councillors began relocating cemeteries to the outskirts of cities a decade before Martin Luther wrote his *Ninety-Five Theses* in Wittenberg.[34] This history is relevant to the commissioning of a Grablegung in Nuremberg from a local sculptor, Adam Kraft (Fig. 3.6).

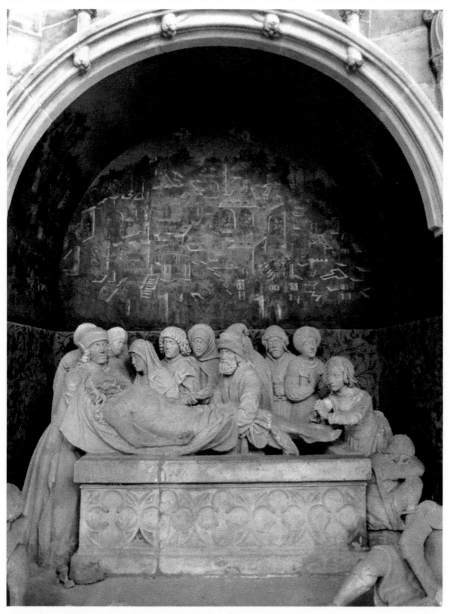

Fig. 3.6 Adam Kraft, *Grablegung Christi*, 1508. Polychrome sandstone, close to life size. Holzschuherkapele, Johannisfriedhof cemetery, Nuremberg. Photo by Paolo de Riestra.

Corresponding to changing funerary and religious observances, Kraft's Grablegung was placed in 1508 at the Johannisfriedhof cemetery, instead of a parish or monastery, which is where most other groups are preserved. Carved out of hard white sandstone quarried in Vach near Nuremberg, the Grablegung was installed into the newly rebuilt Chapel of the Holy Sepulchre, which was paid for by patrician families in Nuremberg and designed by the civic architect Hans Beheim the Elder.[35] This Sepulchre group is not far from the last stop along the Seven Stations of the Cross, carved in relief on pillars and dispersed in the streets of Nuremberg, and a large-scale Calvary group – all sculptures that Kraft produced for a Bamberg knight, Heinrich Marschalk von Rauheneck. Commissioned perhaps as early as 1493, when the sculptor was completing his Sacrament House in the Lorenzkirche that includes at its base a now infamous self-portrait, Kraft's tripartite sculptural programme transformed the streets and the main cemetery of Nuremberg into the Via Dolorosa and Golgotha.[36] Situated in front of a mural depicting the densely populated landscape of Jerusalem, Kraft's group is composed of fifteen tightly crowded statues that mimic fashionable city-dwellers. In fact, Kraft's mourners resemble both sixteenth-century citizens of Nuremberg who have gathered to participate in the burial of a parishioner after having come to the end of the funeral procession, and Christ's contemporaries at the last stop on their way to the Cross.

Kraft's Sepulchre figures were influenced by art in Nuremberg. The figures are comparable in form and composition to the black-and-white characters lining the engravings of the Passion designed by a local and contemporary artist, Albrecht Dürer, who is recognised for his extraordinary skill in print-making. Certainly, Dürer's prints were circulating in Nuremberg at the time when Kraft was working on his sculptural project at the cemetery. That the two artists influenced each other suggests another layer of conversion for Kraft's Sepulchre – the conversion between distinct visual forms. Indeed, the image of Christ's burial was continuously translated between painted, printed, and sculpted media, which helps explain why the large-scale groups resemble works made in other media.

The Sepulchre groups also have aesthetic qualities that tie them not only to local artistic discourses but also to Italian Renaissance art theory. Kraft's Grablegung pays homage to the German Holy Graves as it includes a sarcophagus decorated with five large quatrefoils and guarded on either side by three soldiers. In its careful presentation of the deceased, the Sepulchre also exhibits Kraft's awareness of contemporary Italian art. By slanting Christ's body on the shroud and in between the male attendants, the composition simultaneously calls up Flemish altarpieces of the Deposition and converses with late fifteenth-century discourses on art instigated by the Florentine artist, Leon Battista Alberti. In his seminal treatise, *On Painting* (1435), Alberti praised the

skilfully rendered lifelessness of the Greek mythical hero Meleager, frequently carved in relief on ancient sarcophagi.[37] Scenes of Meleager's funeral prompted a competitive interest among Italian artists, such as Donatello, Mantegna, Raphael, and Michelangelo, who quoted from its narrative in order to transform the Christian image of death *all'antica*, 'in the manner of the ancients'.[38] By adopting diverse artistic discourses, Kraft created a work that is equally local and foreign, ancient and contemporary. Similar modes of artistic, religious, and cultural conversion can be found in other Sepulchre groups, perhaps nowhere more clearly than in the Italian Compianti.

Another element from the classical sarcophagi of Meleager was incorporated in the making of Italian Sepulchres: the pseudo-Bacchic poses and dramatic gestures of the female mourners. The emotive responses seen on this ancient funerary motif became an iconographic device that was well-suited to the making of Sepulchre groups in Italy. The ancient figures express their grief in ways similar to how the Holy Women are imaged in Byzantine icons of the *Threnos*, the Lamentation.[39] More precisely, the Maries have sorrowful faces, dishevelled hair, and swaying hands that animate their bodies.

The Italian Compianti are notably more theatrical in their depiction of mourning because they were made in response to changing devotional practices and in dialogue with local sculptural traditions. The Compianti were commonly carved in wood or modelled in clay, depending on the availability of materials along the Po River Valley and in the Apennine Mountains. The materials were adapted according to other local traditions in sculpture, including life-size Crucifixes, Depositions, Calvaries, and the multimedia installations of the northern Italian pilgrimage mountains, called the Sacri Monti.[40] These sculptural traditions were closely linked to devotional practices promoted by the Franciscan orders and the lay confraternities which organised performances of the Passion. By the fifteenth century communal processions, flagellation rituals, devotional hymns, and para-liturgical plays engaged the entire civic body in what Claudio Bernardi and others refer to as a 'theatre of pity'.[41] The Sepulchre groups were an extension of this theatre, which was activated during Holy Week when public and sacred spaces became stages for re-enacting religious stories. Within this context, life-size statues served as mute actors in scenes of Christ's Crucifixion, Deposition, Burial, and Resurrection, and shared the stage with live performers – noblemen, dukes, kings, monks, and confraternity members. These performers engaged the audience to participate by walking, singing, and even crying in sorrow at the sight of Christ's torture and death. The participants who organised, performed, and watched the religious plays also commissioned the sculptural arrangements that were then mounted inside local parishes. In summary, the figures that composed the Sepulchres had many roles; they represented biblical characters, contemporary mourners, donors, and actors, as can be seen in the groups from

Chaumont and Nuremberg, and those discussed in the following sections. The character conversion of the figures motivated viewers to contemplate life, death, and salvation.

STAGING CONVERSION

The Sepulchre groups made the ephemeral and temporal Passion plays permanent when they were placed in confraternal oratories, parishes, and hospital churches, as is the case with the most well-known and often-cited example modelled from clay by Niccolò dell'Arca (Fig. 3.7).[42] A civic brotherhood of flagellants, shortly after they had reformed, commissioned Niccolò to make the Compianto, as Randi P. Klebanoff discovered, for the hospital church of Santa Maria della Vita in Bologna.[43] Only a year after it was delivered on Good Friday, 8 April 1463, the work was cited in a granting of indulgences as a '*Commemoratio Sepulchri dominici*', which indicates that the sculptural arrangement was thought to commemorate the Holy Sepulchre.[44] This Compianto set a precedent for a century-long tradition of making terracotta groups in northern Italy, and especially in the Emilia Romagna region.[45] To create the work, Niccolò remade the format of wooden Depositions,

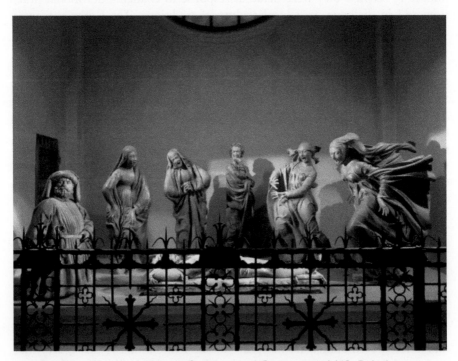

Fig. 3.7 Niccolò dell'Arca, *Compianto sul Cristo morto*, 1463. Polychrome terracotta, life size. Church of Santa Maria della Vita, Bologna. Photo by author.

commonplace in his Puglian birthplace, along with the live performers who activated them on Easter Sunday, into a seven-figure composition of baked clay from the Po Valley. The subject matter of the Bolognese group was influenced by Byzantine art and devotional literature.[46] Christ's supine form and placement on the bier was derived from Byzantine images of the Threnos and the *imago pietatis*, the Man of Sorrows. Following the dramatisation of Paschal liturgy in the tenth century, these motifs were painted on frescoes and icons, and embroidered on the *Epitaphioi*, the ceremonial cloths used to cover the altar on Easter Friday.[47] Niccolò borrowed and improvised on Byzantine art when he positioned the recumbent figure of Christ on a pillow and a flat platform, meant to recall the Stone of Unction. On this pillow, the sculptor lay a clay banderole and while it was still damp and malleable, he carved his signature in Latin.[48] The banderole states: 'OPVS NICOLAI DE APVLIA'. These letters announce that the holy face resting on the pillow is a work of art crafted by Niccolò, and not an *acheiropoieton* – a miraculous image, like the Veil of Saint Veronica.

That Niccolò married the Eastern artistic tradition with the ancient one is most evident in his figures of the Magdalene and Mary Cleofa, who beseech viewers to mourn with them. The Maries appear to rush into the funeral in ways that are emblematic of Aby Warburg's concept of the *Pathosformel*, the 'pathos formula'.[49] The highly theatrical gestures of Niccolò's Maries were in opposition to the municipal regulations imposed against exhibiting gestures of excessive mourning during obsequies, as Klebanoff has shown, which makes their expressions particularly curious in the context of the confraternal commission.[50] The female mourners respond with such extreme emotive force because they were modelled on, and conceived as, actors in mystery plays. Niccolò's Maries in terracotta engender the kinds of responses that would have been familiar from Easter performances, most notably *Planctus Mariae*, the laments of the Virgin sung when Christ was placed in the Virgin's lap, following the scene of the 'unnailing' from the Cross, which is termed the *schiovazione*.[51] During the re-enactments, Christ's death was lamented by actors, representing the biblical witnesses, and the attending public, which gathered in the street and was invited to participate in a communal act of mourning. Niccolò's female followers thus reproduce the bodily and audible responses of this civic body. Arguably, every Sepulchre group memorialised such performances by soliciting contemporary devotees to become one of the grieving witnesses – distinguished only by their breathing from the breathless mourners fashioned out of wood, stone, or clay.

The extreme lifelikeness of Niccolò's figures, along with their dramatic expressions of pathos, demonstrates why the large-scale groups are different from other types of devotional images. The sculptural groupings are akin to icons, albeit not in their form. I propose that the Sepulchral groups, in

Italy and elsewhere, are best understood as three-dimensional icons. Pious viewers were invited to enter these life-size multi-figural compositions and to take part in the religious scenes that they narrated. By becoming one of the mourners, the living partook in biblical history. They, too, witnessed Christ's life and death. When the sculptors first installed the statues, they were accessible to visitors, who stood, knelt, and prayed next to the sacred characters. Conversely, the faithful kissed their faces and presented them with votive offerings. Such proximity between the figures and their visitors is what makes the Sepulchres analogous to icons. In contrast to the two-dimensional and smaller-scale representations of Christian stories, the life-size Sepulchres had the potential to blur the line between subject and object, icon and idol, nature and artifice, which is why railings were mounted in front of many groups beginning already in the sixteenth century.[52] Barriers became necessary when the Counter-Reformation discourses prescribed appropriate forms of piety and barred physical access to religious images. The gates ensured that the statues would not be treated like living, breathing humans, even though they were made in their imitation.

Niccolò's mourners, considered overly dramatic in their corporeal and psychological expression of pathos, are often compared to those found in five other late fifteenth-century Compianti, which were made by Guido Mazzoni for civic, religious, and princely patrons in Busseto, Ferrara, Modena, Venice, and Naples. Mazzoni incorporated diverse techniques, such as casting from life, to model his terracotta statues after the likeness of his patrons, whose faces and bodies served as models for the biblical characters.[53] It is for this reason that Mazzoni's groups functioned as monumental votive offerings, which is especially true of the Compianti in Ferrara and Naples (Figs 3.8 and 3.9).[54] These works are also related to the history of religious theatre at the Renaissance courts.

The Ferrarese Duke, Ercole I d'Este, and the Duchess, Eleonora d'Aragona, commissioned Mazzoni to make a Compianto not long after Good Friday in 1481, when the royal couple participated in a Passion play (Fig. 3.8).[55] Specifically, they partook in the re-enactment of the Descent into Limbo – a scene that followed those of Christ's Crucifixion and Burial. Completing the work by 1485, Mazzoni incorporated the portraits of the duchess and the duke in his terracotta figures of Mary Cleofa and Joseph of Arimathea. These statues resemble the patrons in their physiognomy and clothing. In 1489, only years after he lent his portrait to the mourning figure, Ercole I was chronicled in a performance of the Passion, where he played the character of the Jewish patriarch who ceded his final resting place to Christ and ensured that Christ's burial followed Hebrew customs. Hence, the Duke's role in the religious plays shifted from spectator to actor, while the Sepulchre group he commissioned from Mazzoni combined theatre and the visual arts.

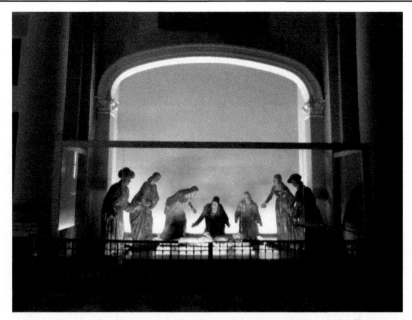

Fig. 3.8 Guido Mazzoni, *Compianto sul Cristo morto*, 1482–1485. Polychrome terracotta, life size. Church of Gesù, Ferrara. Photo by author.

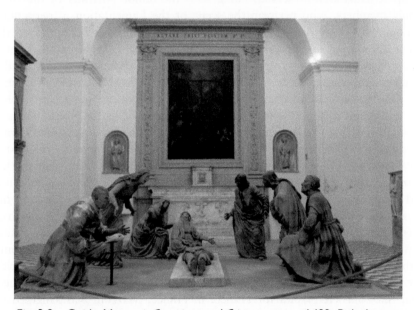

Fig. 3.9 Guido Mazzoni, *Compianto sul Cristo morto*, c. 1492. Polychrome terracotta, life size. Church of Sant'Anna dei Lombardi di Monteoliveto, Naples. Photo by Leah Clark.

Mazzoni's Compianti in Ferrara and Naples are works of Renaissance courtly art, which confirms that the Sepulchre groups are not only a type of popular art related to religious practices and theatre, as many previous scholars have assumed, starting with Mâle. In 1490, Ercole I's brother-in-law, the Duke of Calabria and future king of Naples, Alfonso II, invited Mazzoni to his court to create a Compianto for the Olivetan church of Sant'Anna dei Lombardi (Fig. 3.9).[56] When he modelled this group, Mazzoni imparted the features of Alfonso II's face and body to the Sanderin councillor, just as he had done previously in Ferrara with the portrait of Ercole I. Another correlation between the two groups can be found in correspondence that associates the Neapolitan Compianto with the practices observed in local theatre. In the letter, dated 24 March 1524, and addressed to fellow humanist Marcantonio Michiel in Venice, Pietro Summonte identifies notable artworks in Naples, citing Mazzoni's Compianto as a 'work of plastic' that represents 'the unnailing of Christ from the Cross, with figures of King Ferrante I and King Alfonso II'.[57] Consequently, Summonte understands the subject of the work to be a schiovazione, a term used to describe the 'unnailing' of Christ in religious dramas, as noted above. Alfonso I is cited as performing in an Easter drama on 13 April 1437, almost fifty years before his grandson, Alfonso II, commissioned the Compianto.[58] Unlike the transitory performances, Mazzoni's group remains well-preserved, along with the donor portraits of the royal family members, who perform the scene of the Lamentation in perpetuity. Undoubtedly, Mazzoni's noble clients in Naples and Ferrara intended the sculptural monuments to serve as permanent reminders of their family's devotion to God and, just as importantly, of their political power.[59] A similar argument can be raised about other patrons, such as the lay confraternities and monastic communities across Europe, who used the Sepulchres as a meditative tool and as a means of strengthening their civic status. Quite tellingly, the success of Mazzoni's Compianto in Naples can be gathered from Giorgio Vasari's *Lives of the Artists* (1550 and 1568), where the biographer praises the kneeling statue of Alfonso II, which, as he writes, appears to be truly alive.[60] Mazzoni's ability to instil his Biblical figures with extraordinary verisimilitude, and imbue them with the likenesses of his patrons, is what made him a highly sought out court artist in Italy and influenced King Charles VIII's decision to offer him employment at the French court.

When Mazzoni travelled to France, he took the tradition of the Compianti with him and adapted it to complement his new cultural, artistic, and courtly environment. In 1495, following Alfonso II's brief kingship and abdication, Mazzoni left Naples for France. In France, Mazzoni was knighted by Charles VIII for his work as a court artist and, more crucially, he laid the foundations for the first Italian art workshop, which later employed prominent Florentine artists: Leonardo da Vinci, Benvenuto Cellini, and Rosso Fiorentino.

Mazzoni's most prestigious commission in France was the King's tomb at the Royal Abbey of Saint Denis, in which he merged the Italian and the French sculptural traditions. Unfortunately, the royal monument was destroyed in the political iconoclasm of the French Revolution, but we know what it looked like from a seventeenth-century drawing by François Roger de Gaignières, preserved at the Bibliothèque Nationale de France. It was a large stone sarcophagus, on top of which Mazzoni placed an effigy of Charles VIII. In the drawing, the ruler kneels in front of a prie-dieu, a prayer desk.[61] To make the effigy, the Italian sculptor replaced the gisant figure with a supplicant donor, familiar from the Emilian Sepulchres. The polychrome statue of Charles VIII appeared very similar to the kneeling figure of Alfonso II from the Neapolitan Compianto. The portrait of the French King, likely cast from life, amended French royal customs.[62] Royal burials in France traditionally incorporated an effigy of the deceased monarch that was made of ephemeral materials, which was destroyed soon after the funeral. The royal effigy was part of the burial ceremony because it served as a visual marker of the power that was transferred from the dead to the living king.[63] In contrast to this earlier tradition, Mazzoni ensured that Charles VIII's effigy became a permanent part of the memorial. In doing so, the Italian terracotta sculptor set a precedent for the design of French royal tombs and introduced the supplicant figure from the Compianti.

In France, the traditions of the royal funerary monuments and the Compianti were synthesised into a single sculptural format not long after Mazzoni created Charles VIII's tomb. Remarkably, the Mise au tombeau from Chaumont confirms this transformation as it shows the entire family kneeling in prayer next to Christ's tomb (Fig. 3.5). The Chaumont figures were modelled on the kneeling figure of the French king, which was in turn based on the Italian mourners. The formal similarity between the French examples is supported by the patronage of the Chaumont group, because its noble patrons likely emulated the royal monument in their family cenotaph to display their own social status. In sum, the Mise au tombeau from Chaumont, like other French Sepulchre groups, is the result of a process of conversion that involved foreign artistic conventions, patrons, and artists.

An even more poignant conflation of the French and the Italian artistic traditions can be observed in the Spanish groups, including a Santo Entierro in Valladolid, the making of which was made possible by the breakdown of artistic and political boundaries of Europe in the sixteenth century. Correspondingly, Mazzoni's northern sojourn was an indirect consequence of the decision made by the Milanese Duke, Ludovico Maria Sforza, to invite Charles VIII to invade Italy in 1494. Duke Sforza's invitation resulted in the First Italian War and the complete redrawing of the political map of the continent, along with the Kingdom of Naples, which was divided between the French and the Spanish monarchies. This redrawing sparked an interest in

Italian art that lasted for decades following the Reconquista. When the Holy Roman Emperor Charles V inherited Burgundian, Habsburgian, and recently unified Aragonese and Castilian lands, a dynamic exploration and adaptation of art *all'antica* was fostered across the imperial territories. Furthermore, it created new employment opportunities for European artists trained in Italy and the classical style. Evidence of artistic and cross-cultural conversations exists in several early sixteenth-century Sepulchres from Spain, among them a funerary monument that was originally located in the monastery of San Francisco in Valladolid. This Santo Entierro was commissioned by Antonio de Guevara, who was the Bishop of Mondoñedo, a prominent Franciscan preacher, and Charles V's historiographer and confessor (Fig. 3.10). Guevara's choice to order Christ's Sepulchre is significant because he was well-versed in theological and classical texts, and because he would have seen similar groups while travelling on diplomatic journeys throughout the empire. His choice of artist is relevant as well. Guevara employed a French-born sculptor who was familiar with the sculptural type and who had recently established a local workshop in Valladolid, following his apprenticeship and artistic training in Italy. This sculptor was Jean de Joigny, better-known as Juan de Juni.[64]

Juni's Santo Entierro in Valladolid is formally similar to the Italian Compianti and is unique among other Sepulchres found south of the Pyrenees that closely

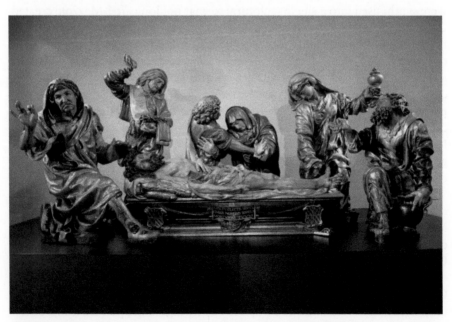

Fig. 3.10 Juan de Juni, *Santo Entierro de Cristo*, 1541–1544. Polychrome wood and gilding, over life size. Museo Nacional de Escultura, Valladolid. Photo by author.

resemble their Flemish and Burgundian counterparts.[65] These earlier examples include Sepulchres carved by two Italian emigrants active in Spain before Juni's arrival. By comparison, Pedro Millán made a Santo Entierro (ca. 1485–1503) out of a large block of terracotta and in high relief for a canon, Antonio Imperial, in the Seville Cathedral. Michelangelo Buonarroti's assistant Jacopo Torni, renamed Jacobo Florentino el Indaco in Spain, carved a wooden Santo Entierro in the monastery of San Jerónimo in Granada, between 1524 and 1526, as part of a burial chapel for the 'Great Captain', Gonzalo Fernández de Córdoba. Torni carved his figures only three-quarters of the way and left them hollow in the back.[66] The groups created by Millán and Torni are similar to another Sepulchre Juni produced around 1571 for the Cathedral of Segovia. Though composed of figures that are formed differently, either left partially unfinished or carved in the round, as is the case with the Santo Entierro from Valladolid, all of the Spanish Sepulchres were put inside large altar frames, *retablos*, prevalent in the Iberian Peninsula. The Valladolid group was initially kept in an elaborate retablo and flanked with two standing soldiers, familiar from the German Holy Graves. To stage the conversion of his Sepulchre group, Juni incorporated artistic traditions that were native to the region, as Mazzoni did for the royal tomb in France.

MATERIAL CONVERSION

To make his Santo Entierro in Valladolid (1541–1544), Juni adapted the eight-figure composition of the Italian Compianti in terracotta using the technical skill particular to the precarious processes involved in carving, painting, and gilding statues in wood.[67] The many steps entailed in the making of Spanish religious sculpture were carefully prescribed and regulated; however, this did not stop Juni from importing foreign elements into his work, perhaps on the advice of his well-travelled patron, Bishop Guevara. The sculptor carved the biblical mourners as freestanding figures, much like those of Niccolò and Mazzoni, whose groups he could have seen in Italy. He then rested the figure of Christ on two tasselled pillows and a green bier, instead of the sarcophagus typical in the Sepulchres that come from Burgundy, where Juni was born. What distinguishes Juni's Sepulchre in Valladolid from the Italian compositions are the many finishes that enliven his biblical characters that, when they were first exhibited, appeared as if they were going to walk out of the retable. When the artist displayed his biblical figures and the related objects of the Passion, he must have allowed specific details to escape the architectural frame, such as, for instance, the nail that Joseph of Arimathea grips between his thumb and index finger, which serves to draw viewers into the sacred scene. As Joseph turns away from Christ and towards viewers, he holds the nail up to direct their attention to it because this pointed detail speaks so eloquently to the technical workmanship of the artist. In its vivacity, Juni's statue of Joseph recalls those that Mazzoni

modelled for his Compianti, while the kneeling pose quotes Niccolò's inter-locutor from Bologna, usually identified as Nicodemus. The Spanish figures are equally as animated and realistically rendered as the mourners in the Italian Sepulchres. Nevertheless, their finishes separate them from these earlier works. The characters that Juni carved are encased in a shimmer of gilded, gessoed, and brocaded surfaces that were fashioned by a local painter. The techni-cal and professional separation of carving from *estofado*, a process of painting and glazing considered to enliven religious sculptures, was regulated by the Spanish art guilds.[68] Still, Juni's muscular and grandiose figures, which are simultaneously Raphaelesque and Michelangelesque in their physique, feature stylistic forms found in the sixteenth-century Compianti made by Alfonso Lombardi and Antonio Begarelli for religious communities in the Emilia region. These Italian terracotta sculptors, like Juni and Kraft, designed monu-mental works that responded to, and participated in, contemporary practices and discourses on art.[69]

As with all the other examples, Juni's Santo Entierro is a work of multiple conversions, and thus able to speak to the international and erudite stature of his patron, who is acknowledged by two coats of arms flanking the bier. Above the supine Christ, Saint John embraces the Virgin, in a manner that evokes the lyrics from a familiar hymn, *Mater Dolorosa*. Below Christ, a small cherub arduously holds up a cartouche between its wings. Unlike Niccolò's banderole, the cartouche does not hold the artist's signature. Inscribed in gold, it addresses the visitors to the Sepulchre with a shortened verse from Genesis that reminded the pious of the cardinal duty to bury their loved ones: 'NOS IN ELECTIS SEPVL CHRIS NOSTRIS SEPELI MORTVVM TVVM'. The extended verse reads as follows in English: 'Hear us, my lord: thou art a mighty prince among us: in the choice of our sepulchres bury thy dead; none of us shall withhold from thee his sepulchre, but that thou mayest bury thy dead' (Gen. 23:6 (KJV)). Significantly, then, the inscription provides us with a vital insight into why the Sepulchre groups were produced on a large scale, and specifi-cally to serve as funerary monuments in the fifteenth and sixteenth centuries. More precisely, it implies that when commissioning their tombs, the faithful elected to cede their final resting place to Christ, just like Joseph of Arimathea. The Sepulchres served as memorials to Christ's death, and as reminders of the Christian promise: to be buried with Christ is to have eternal life. The verse on Juni's bier then points to the fact that the conversion from life to death, and death to the afterlife, is intricately tied to the artistic as much as the Eucharistic body of Christ.[70]

A colourful sheen, more subdued than the glazed finishes seen on Juni's statues, reverberates across the mantles, wings, and objects in the Compianto from Moncalieri with which I began this chapter (Fig. 3.1). Despite a few schol-arly hypotheses and archival documents that date this work to the sixteenth

century, its original location and patronage remain shrouded in mystery. The artwork cannot be easily contextualized as its formal characteristics are similar to those found in the fifteenth-century Grablegung in Fribourg and the Mise au tombeau from Pont-à-Mousson. Their common characteristics have led some scholars to infer that these Sepulchres were contemporary with each other, and that they were made by a group of travelling artists.[71] The provenance of the Moncalieri work is conveyed by a seventeenth-century document which records that the Compianto was donated by the French governor of Moncalieri, Blaise de Lasseran-Massencôme, in 1549 on behalf of King Henry II of France. The royal intercessor, more widely known as Blaise de Montluc, was a marshal of France and a knight in the Order of Saint Michael. He served five Valois kings and participated militarily in the political formation of sixteenth-century Europe. Further indication that the governor donated the group is provided by the life-size polychrome bearded and armoured figure, preserved in the same church, that closely resembles accepted portraits of Montluc. The governor may have ordered this portrait when he commissioned the monumental tomb on the bequest of Henry II. The Compianto would have made a thought-ful present to the city of Moncalieri since its foreign occupiers were familiar with the sculptural type that had a long-standing tradition in France. Another hypothesis can be formed about the commission, based on the formal similarities with the Swiss group. Namely, the Italian work could have been a diplomatic gift from the citizens of Fribourg to the Dukes of Savoy, who had a court in Moncalieri. It may have been gifted sometime after June 10, 1452, when the councilmen met at the Cathedral of Saint Nicolas in Fribourg – where the Grablegung from 1433 is located – to abolish the Austrian suzerainty and to pledge their allegiance to Duke of Savoy, Louis I.[72] This context would clarify why the two Sepulchres in Moncalieri and Fribourg are exceptionally similar. However, the likelihood that the two were completed a century apart is far more probable, and interesting, especially when considered in light of the many instances of conversion traced above.

To conclude, I want to offer a clue as to why the Compianto from Moncalieri gives us ample evidence of the conversional nature of the Sepulchre groups. From the archival documents, we understand that the work was commissioned by a foreign patron and carved by local artists, named as Gaspare Boccardo and Michele Blando in a late nineteenth-century manuscript.[73] The clue as to the malleability of the sculptural type is given in the material in which the Moncalieri work was carved: the sandstone of Montferrat. While this type of sandstone is composed of volcanic tuff native to the area, it is unlikely that a resident requested this material, rather than wood or clay, which were more readily used for the making of the Compianti in northern Italy. Foreign training, if not authorship, on the part of the carvers, would better clarify why the composition formally resembles a Grablegung and a Mise au tombeau, and

not a Compianto. It is possible that the artists travelled outside Moncalieri to find inspiration for their group and to please their French patron. For all their similarities, then, the Sepulchres from Moncalieri, Pont-à-Mousson, and Fribourg may be connected less by proximity in time or style and more by what they share with the history of making these multi-figural works across Europe. Importantly, this history can be written variously by following the many examples of adaptation, translation, innovation, and change amalgamated into every case study. Ultimately, the Sepulchre group functioned like a machine – a machine designed to generate artistic, religious, and cultural conversion. Each assembly of sculptures was capable of engendering the question posed by Dostoevsky's dying student, Ippolit Terentyev: 'How could they have gazed upon the dreadful sight and yet have believed that He would rise again?'

The research presented here was generously supported by travel grants from the University of British Columbia and the SSHRC Early Modern Conversions Project. I am immensely grateful to the editors of this volume and project leaders Bronwen Wilson and Paul Yachnin for their support, mentorship, and academic vigour, including the critical insights they offered on the present chapter. I am also thankful to other project collaborators and colleagues, especially Tomasz Grusiecki, who have helped shape this work.

NOTES

1. Dostoevsky, *The Idiot*, p. 281.
2. Forsyth, *Entombment of Christ*, pp. 46–7; Cottino, 'Le arte figurative a Moncalieri', pp. 98–102; Repaci Courtois, 'Problemi di scultura quattrocentesca', pp. 40–9; Reiners, 'Il Santo Sepolcro di Moncalieri', pp. 78–81; Reiners 'Der Meister des Heiligen Grabes', p. 28; Brachmann, 'The Crusade of Nicopolis, Burgundy', pp. 155–90.
3. Karsallah, 'Les mises au tombeau', p. 263; Martin, *La statuaire de la mise au tombeau*, p. 11; Forsyth, *Entombment of Christ*, pp. 171–90.
4. Kroesen, *Sepulchrum Domini*, pp. 109–116.
5. Martin, *La statuaire de la mise au tombeau*, pp. 64–80; Sadler, *Stone, Flesh, Spirit*, pp. 9–24.
6. Forsyth, *Entombment of Christ*, pp. 5–21; Karsallah, 'Les mises au tombeau', pp. 22–31.
7. Mâle, *L'art religieux de la fin du Moyen Age*, p. 130–2.
8. Quoted and translated from, Mâle, *L'art religieux de la fin du Moyen Age*, p. 130. See also, Martin, *La statuaire de la mise au tombeau*, p. 49; Forsyth, *The Entombment of Christ*, p. 19.
9. Karsallah, 'Les mises au tombeau', pp. 9–21.
10. Sadler, *Stone, Flesh, Spirit*, pp. 25–71.
11. Ibid., p. 186.
12. Martin, *La statuaire de la mise au tombeau*, pp. 328–57.
13. Kroesen, *Sepulchrum Domini*, p. 110.
14. Forsyth, *Entombment of Christ*, p. 138.
15. Martin, *La statuaire de la mise au tombeau*, p. 37.

16. Brachmann, 'Crusade of Nicopolis', pp. 183–5.
17. Ibid., pp. 160–5.
18. Schwarzweber, *Das Heilige Grab*, p. 68; Kroesen, *Sepulchrum Domini*, pp. 53–116.
19. Karsallah, 'Les mises au tombeau', pp. 105–7.
20. Schwarzweber, *Das Heilige Grab*, p. 68.
21. Sadler, *Stone, Flesh, Spirit*, p. 5, pp. 83–6.
22. Kroesen, *Sepulchrum Domini*, pp. 109–16.
23. Gentile, 'Testi devoti e iconografia', pp. 167–78.
24. Karsallah, 'Les mises au tombeau', pp. 228–30.
25. Brachmann, 'Crusade of Nicopolis', p. 161.
26. Karsallah, 'Les mises au tombeau', p. 60.
27. Reiners, 'Der Meister des Heiligen Grabes', p. 25.
28. Sadler, *Stone, Flesh, Spirit*, pp. 89–90.
29. Kroesen, *Sepulchrum Domini*, pp. 3–108.
30. Sadler, *Stone, Flesh, Spirit*, pp. 4–5.
31. Ibid., p. 109.
32. Karsallah, 'Les mises au tombeau', pp. 190–1; Maître, et al., *Le Sépulcre de Chaumont*, pp. 7–8; Sadler, pp. 83–6.
33. Karsallah, 'Les mises au tombeau', pp. 156–9.
34. Koslofsky, *The Reformation of the Dead*, pp. 41–57.
35. Chipps Smith, *Nuremberg*, p. 25.
36. Schleif, 'Nicodemus and Sculptors', pp. 599–603; see also, Zittlau, *Heiliggrabkapelle und Kreuzweg*.
37. Alberti, *On Painting*, p. 75.
38. Nagel, *Michelangelo and the Reform of Art*, pp. 25–48.
39. Emiliani, 'Dal realismo quattrocentesco', pp. 221–31.
40. Weil-Garris, '"Were this Clay but Marble"', p. 65.
41. Bernardi, 'Theatrum Pietatis', pp. 7–22; see also essays in, Flores D'Arcais, *Il teatro delle statue.*
42. Klebanoff, 'Bolognese sculpture of Niccolò dell'Arca', p. 49.
43. Ibid., pp. 36–42.
44. Fanti, 'Nuove ricerche sulla collocazione del "Compianto"', pp. 59–83.
45. Weil-Garris, '"Were this Clay but Marble"', p. 62; Bennett Purvis, 'Palpable Politics and Embodied Passions', pp. 54–66.
46. Gentile, 'Testi devoti e iconografia', pp. 175–86.
47. Weitzmann, 'The Origins of the Threnos', pp. 476–90.
48. Boffa, 'The Touch of Sanctity', pp. 293–301; Ciammitti, 'Opus Nicolai De Apulia', pp. 271–88.
49. Cieri Via, 'Niccolò dell'Arca e le immagini', pp. 121–38.
50. Klebanoff, 'Passion, Compassion, and the Sorrows', pp. 146–172.
51. Graham, 'Compassionate Suffering', pp. 82–115; Verdon, 'Si tu non piangi', pp. 151–66.
52. Vranic, 'Making and Remaking Renaissance Sculpture', pp. 232–40.
53. Verdon, 'Art of Guido Mazzoni', pp. 14–15.
54. Pane, 'Guido Mazzoni e la Pietà di Monteoliveto', p. 55.
55. Seragnoli, 'Compianto sul Cristo morto', pp. 13–15.
56. Verdon, *The Art of Guido Mazzoni*, pp. 79–90; Hersey, *Alfonso II and the Artistic Renewal*, pp. 118–24.
57. Cicogna, 'Intorno la vita e le opere di M. Michiel', pp. 359–60.
58. Paoletti, 'Wooden Sculpture in Italy', p. 92; Corbin, *La Déposition liturgique*, p. 257.

59. Graham, 'Affecting Bodies', p. 4.
60. Vasari, *Le vite*, vol. 1 (1550), pp. 356–7; and *Le vite*, vol. 1 (1568), p. 352.
61. Panofsky, *Tomb Sculpture,* p. 78; Verdon, 'Guido Mazzoni in Francia', pp. 139–64.
62. Verdon, 'Guido Mazzoni in Francia', p. 141.
63. Verdon, *Art of Guido Mazzoni*, pp. 126–8.
64. Griseri, *Juan de Juni*, p. 5.
65. Martin, *La statuaire de la mise au tombeau*, p. 328; Colón Mendoza, *Cristos Yacentes*, pp. 14–15.
66. Pérez-Embid, *Pedro Millán*, pp. 53–7; Martin, *La statuaire de la mise au tombeau*, p. 408.
67. Colón Mendoza, *Cristos Yacentes*, pp. 43–4; see also, Bray, 'The Sacred Made Real', pp. 15–43.
68. Colón Mendoza, *Cristos Yacentes*, p. 46.
69. Weil-Garris, '"Were this Clay but Marble"', pp. 67–71; for monographic studies, see, Bonsanti, *Antonio Begarelli*, and Sinigalliesi, *Alfonso Lombardi*.
70. Colón Mendoza, *Cristos Yacentes*, p. 47.
71. Cottino, 'Le arte figurative a Moncalieri', pp. 100–2.
72. Gallenga, *History of Piedmont*, 2, p. 269.
73. Cottino, 'Le arte figurative a Moncalieri', p. 101.

Works Cited

Agostini, Grazia and Luisa Ciammitti (eds), *Niccolò dell'Arca: Seminario di studi, atti del convegno, 26–27 maggio 1987* (Bologna: Nuova Alfa, 1989).
Alberti, Leon Battista, *On Painting and On Sculpture: The Latin Texts of De pictura and De statua*, trans. Cecil Grayson (London: Phaidon, 1972).
Bennett Purvis, Betsy, 'Palpable Politics and Embodied Passions: Terracotta Tableau Sculpture in Italy, 1450–1530', PhD diss., University of Toronto, 2012.
Bernardi, Claudio, 'Theatrum Pietatis: Images, Devotion, and Lay Drama', *Mediaevalia* 27, no. 1 (2006), pp. 7–22.
Boffa, David, 'The Touch of Sanctity: Niccolò dell'Arca's Signature on the *Lamentation*', *Source: Notes in the History of Art* 35, no. 4 (Summer, 2016), pp. 293–301.
Bonsanti, Giorgio, *Antonio Begarelli* (Modena: F.C. Panini, 1992).
Brachmann, Christoph, 'The Crusade of Nicopolis, Burgundy, and the Entombment of Christ at Pont-à-Mousson', *Journal of the Warburg and Courtauld Institutes* 74 (2011), pp. 155–90.
Bray, Xavier, 'The Sacred Made Real: Spanish Painting and Sculpture, 1600–1700', in Xavier Bray (ed.), *The Sacred Made Real: Spanish Painting and Sculpture, 1600–1700* (London: National Gallery, 2009), pp. 15–43.
Chipps Smith, Jeffrey, *Nuremberg: A Renaissance City, 1500–1618* (Austin: University of Texas Press, 1983).
Ciammitti, Luisa, 'Opus Nicolai de Apulia', in Grazia Agostini and Luisa Ciammitti (eds), *Niccolò dell'Arca: Il Compianto di Santa Maria della Vita* (Bologna: Nuova Alfa Editoriale, 1985), pp. 271–88.
Cicogna, Emmanuele A., 'Intorno la vita e le opere di M. Michiel, patrizio veneto della prima metà del secolo XVI', *Memorie dell'I. R. Istituto veneto di scienze lettere ed arti*, IX (Venice, 1861), pp. 359–60.
Cieri Via, Claudia, 'Niccolò dell'Arca e le immagini della passione tra pathos ed ethos', in Francesca Cappelletti (ed.), *Le due muse: Scritti d'arte, collezionismo e letteratura in onore di Ranieri Varese* (Ancona: Il lavoro editoriale, 2012), pp. 121–38.

Colón Mendoza, Ilenia, *The Cristos Yacentes of Gregorio Fernández: Polychrome Sculptures of the Supine Christ in Seventeenth-Century Spain* (Burlington, VT: Ashgate, 2015).

Corbin, Solagne, *La Déposition liturgique du Christ au Vendredi Saint; sa place dans l'histoire des rites et du théâtre religieux (analyse de documents portugais)* (Paris: Société d'éditions 'Les Belles Lettres', 1960).

Cottino, Alberto, 'Le arte figurative a Moncalieri', in Micaela Viglino Davico and Gian Giorgio Massera (eds), *Moncalieri: territorio e arte dal medioevo al XX secolo* (Moncalieri: Famija Moncalerèisa, 2000), pp. 97–123.

Dostoevsky, Fyodor M., *The Idiot*, trans. Frederick Whishaw (London: Vizetelly, 1887).

Emiliani, Andrea, 'Dal realismo quattrocentesco allo stile patetico e "all'antica"', in Grazia Agostini and Luisa Ciammitti (eds), *Niccolò dell'Arca: Seminario di studi* (Bologna: Nuova Alfa, 1989), pp. 221–31.

Fanti, Mario, 'Nuove ricerche sulla collocazione del "Compianto" in Santa Maria della Vita', in Grazia Agostini and Luisa Ciammitti (eds), *Niccolò dell'Arca: Seminario di studi, atti del convegno, 26–27 maggio 1987* (Bologna: Nuova Alfa, 1989), pp. 59–83.

Flores D'Arcais, Francesca (ed.), *Il teatro delle statue: gruppi lignei di Deposizione e Annunciazione tra XII e XIII secolo, atti del convegno 'Attorno ai gruppi lignei della Deposizione': Milano, 15–16 maggio 2003, Museo diocesano Fondazione S. Ambrogio, Università cattolica del Sacro Cuore* (Milan: Vita e Pensiero, 2005).

Forsyth, William H., *The Entombment of Christ: French Sculptures of the Fifteenth and Sixteenth Centuries* (Cambridge: Harvard University Press, 1970).

Gallenga, Antonio, *History of Piedmont,* vol. 2 (London, 1855).

Gentile, Guido, 'Testi devoti e iconografia del *Compianto*', in Grazia Agostini and Luisa Ciammitti (eds), *Niccolò dell'Arca: Seminario di studi, atti del convegno, 26–27 maggio 1987* (Bologna: Nuova Alfa, 1989), pp. 167–211.

Graham, Heather, 'Affecting Bodies: Guido Mazzoni's *Lamentations* in Context', PhD diss., University of California, Los Angeles, 2010.

_____, 'Compassionate Suffering: Somatic Selfhood and Gendered Affect in Italian Lamentation Imagery', in Heather Graham and Lauren Kilroy-Ewbank (eds), *Visualizing Sensuous Suffering and Affective Pain in Early Modern Europe and the Spanish Americas* (Boston: Brill, 2018), pp. 82–115.

Griseri, Andreina, *Juan de Juni, Maestri della scultura,* vol. 72 (Milan: Fratelli Fabbri, 1966).

Hersey, George L., *Alfonso II and the Artistic Renewal of Naples, 1485–1495* (New Haven, CT: Yale University Press, 1969).

Karsallah, Elsa, 'Les mises au tombeau monumentales du Christ en France (XVe–XVIe siècles): Enjeux iconographiques, funéraires et dévotionnels', PhD diss., Paris, L'Universite Paris-Sorbonne, 2009.

Klebanoff, Randi P., 'The Bolognese sculpture of Niccolò dell'Arca and Michelangelo: Studies in Context', PhD diss., Harvard University, 1994.

_____, 'Passion, Compassion, and the Sorrows of Women: Niccolò dell'Arca's *Lamentation over the Dead Christ* for the Bolognese Confraternity of Santa Maria Della Vita', in Barbara Wisch and Diane Cole Ahl (eds), *Confraternities and the Visual Arts in Renaissance Italy: Ritual, Spectacle, Image* (New York: Cambridge University Press, 2000), pp. 146–172.

Koslofsky, Craig M., *The Reformation of the Dead: Dead and Ritual in Early Modern Germany, 1450–1700* (Basingstoke: Macmillan, 2000).

Kroesen, Justin, *The Sepulchrum Domini Through the Ages: Its Form and Function* (Sterling, VA: Peeters, 2000).

Lugli, Adalgisa, *Guido Mazzoni e la rinascita della terracotta nel Quattrocento* (Turin: Uberto Allemandi, 1990).

Maître, Christelle, Marie-Agnès Sonrier and Pascal Michaut, *Le Sépulcre de Chaumont* (Chaumont: Le Pythagore Editions, 1997).

Mâle, Emile, *L'art religieux de la fin du Moyen Age en France: Étude sur l'iconographie du Moyen Age et sur ses sources d'inspiration* (Paris, 1908).

Martin, Michel, *La statuaire de la mise au tombeau du Christ des XV et XVI siècles en Europe occidentale* (Paris: Picard, 1997).

Nagel, Alexander, *Michelangelo and the Reform of Art* (New York: Cambridge University Press, 2000).

Panofsky, Erwin, *Tomb Sculpture: Four Lectures on its Changing Aspects from Ancient Egypt to Bernini*, ed. H. W. Janson (New York: H.N. Abrams, 1992).

Paoletti, John T., 'Wooden Sculpture in Italy as Sacral Presence', *Artibus et historiae* 13, no. 26 (1992), pp. 85–100.

Pane, Roberto, 'Guido Mazzoni e la Pietà di Monteoliveto', *Napoli nobilissima* 11 (1972), pp. 49–69.

Pérez-Embid, Florentino, *Pedro Millán y los orígenes de la escultura en Sevilla* (Madrid: Real Academia de Belles Artes de San Fernando, 1972).

Reiners, Heribert, 'Der Meister des Heiligen Grabes in Freiburg (Schweiz)', *Oberrheinische Kunst* 4 (1929–30), pp. 25–35.

_____, 'Il Santo Sepolcro di Moncalieri', *Il Bollettino del centro di studi archeologici ed artistici del Piemonte* 1 (1941), pp. 72–82.

Repaci Courtois, Gabriella, 'Problemi di scultura quattrocentesca nel Piemonte occidentale', *Critica d'arte* XII, no. 74 (October, 1965), pp. 40–9.

Romano, Giovanni, in 'Da Giacomo Pitterio ad Antoine de Lonhy', in Giovanni Romano and Simone Baiocco (eds), *Primitivi piemontesi nei musei di Torino* (Turin: Fondazione CRT, 1996), pp. 111–209.

Sadler, Donna, *Stone, Flesh, Spirit: The Entombment of Christ in Late Medieval Burgundy and Champagne* (Boston: Brill, 2015).

Schleif, Corine, 'Nicodemus and Sculptors: Self-Reflexivity in Works by Adam Kraft and Tilman Riemenschneider', *The Art Bulletin* 75, no. 4 (1993), pp. 599–626.

Schwarzweber, Annemarie, *Das Heilige Grab in der deutschen Bildnerei des Mittelalters* (Freiburg im Breisgau: Albert, 1940).

Seragnoli, Daniele, '"Compianto sul Cristo morto" e la sacra rappresentazione ferrarese', in Anna M. Visser Travagli (ed.), *Guido Mazzoni: II Compianto sul Cristo morto nella chiesa del Gesù a Ferrara, l'opera e li restauro* (Florence: Centro Di, 2003), pp. 23–48.

Sheingorn, Pamela, *The Easter Sepulchre in England* (Kalamazoo: Western Michigan University, 1987).

Sinigalliesi, Daniela and Graziano Campanini, *Alfonso Lombardi: lo scultore a Bologna* (Bologna: Compositori, 2008).

Timmermann, Achim, *Real Presence: Sacrament Houses and the Body of Christ, c. 1270–1600* (Turnhout: Brepols, 2009).

Vasari, Giorgio, *Le vite de' più eccellenti pittori, scultori, e architettori* (Florence: Lorenzo Torrentino, 1550).

_____, *Le vite de' più eccellenti pittori, scultori, e architettori* (Florence: Giunti, 1568).

Verdon, Timothy C., *The Art of Guido Mazzoni* (New York: Garland Pub., 1978).

_____, 'Guido Mazzoni in Francia: Nuovi contributi', *Mitteilungen des Kunsthistorischen Institutes in Florenz* 34, no. 1–2 (1990), pp. 139–64.

_____, '"Si tu non piangi quando questo vedi ...": Penitenza e spiritualità laica nel Quattrocento', in Grazia Agostini and Luisa Ciammitti (eds), *Niccolò dell'Arca: Seminario di studi* (Bologna: Nuova Alfa, 1989), pp. 151–66.

Vranic, Ivana, 'Making and Remaking Renaissance Sculpture: The Terracotta Groups (1460–1560)', PhD diss., University of British Columbia, Vancouver, 2019.

Weil-Garris, Kathleen, '"Were this Clay but Marble": A Reassessment of Emilian Terra Cotta Group Sculpture', in Andrea Emiliani (ed.), *Le arti a Bologna e in Emilia dal XVI al XVII secolo,* Vol. 4, *Atti del XXIV congresso internazionale di storia dell'arte, Bologna, 1979* (Bologna: CLUEB, 1982), pp. 61–79.

Weitzmann, Kurt, 'The Origins of the Threnos', in Millard Meiss (ed.), *De artibus opuscula XL: Essays in Honor of Erwin Panofsky* (New York: New York University Press, 1960), pp. 476–90.

Zittlau, Reiner, *Heiliggrabkapelle und Kreuzweg: Eine Bauaufgabe in Nürnberg um 1500* (Nuremberg: Stadtarchiv, 1992).

4

STONY BUNDLES AND PRECIOUS WRAPPINGS: THE MAKING OF PATIO CROSSES IN SIXTEENTH-CENTURY NEW SPAIN

Anthony Meyer

Having once marked the centre of the courtyard or patio at the Exconvento de San Francisco, the stone cross at Tepeapulco, northeast of Mexico City in present-day Hidalgo, now sits plastered to the modern church's façade (Fig. 4.1). Even in its new, peripheral home, the former patio cross still stands out against the Exconvento's architectural fabric. At roughly 1.2 metres in height, the cross amasses various symbols carved in low and high relief, pigments that ooze from drilled, vacant holes, and sculpted textures that prompt viewers to explore and touch its body. Upon closer inspection, the cross's symbols reveal themes related to Christ's death: a crown of thorns marks the centre, a red-tipped spear extends across the diagonal, a skull near the base foretells his bodily end at Golgotha, and the slanting letters *INRI* at the top identify the Messiah from Nazareth. Patio crosses produced in New Spain, such as this example from Tepeapulco, display the *arma Christi* to recount Christ's Passion. These crosses, made by and for Nahua converts in central New Spain, were key components of conversion spaces built throughout the Valley of Mexico in the sixteenth century.

Following their arrival in New Spain in 1524, mendicant friars needed to construct religious spaces that could serve large groups of Indigenous converts. In a copper engraving by Franciscan friar Diego Valadés, we see their architectural response (Fig. 4.2).[1] As his idealised print reveals, outdoor patios and evenly spaced chapels functioned as spaces to teach Christian doctrine, administer sacraments, study language, and convert Indigenous souls.[2]

Each patio's design in New Spain was unique, but most had four walls and a central cross. At the centre of Valadés's print, the twelve Franciscan friars who first arrived in the Valley of Mexico hold up the Church to usher in a new era of Christianity. At the centre of actual patios, however, the carved patio crosses stood tall, sometimes on a rising pedestal. During Christian feast days and special masses, friars led converts counterclockwise around the patio's perimeter and recited Christian teachings or reviewed the stations of the cross. The patio cross anchored these spatial narratives in the patio landscape, and its symbols further unveiled Christ's final days on Earth. Given their central role in the visual and didactic programmes of the patio, crosses and their arma were useful devices in a spatial pedagogy that centred around the life and death of Christ.

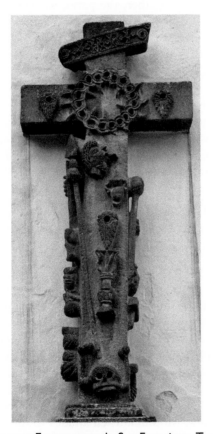

Fig. 4.1 Patio Cross at Exconvento de San Francisco, Tepeapulco, Hidalgo, Mexico. 1.2 m (h). Volcanic rock and polychrome plaster. Photograph by the author. Reproduction authorised by the Instituto Nacional de Antropología e Historia.

As a space of conversion, the sixteenth-century patio guided converts toward an embodied understanding of Christianity. These outdoor monastic spaces were part of a larger, ideological apparatus that served to indoctrinate Indigenous groups into Christianity and the Church.[3] Other key elements of this apparatus were the sculpted cross, the many attendees of outdoor celebrations, and the Christian doctrine and scripture spoken by friars and heard by Nahua converts. In the first decades of Iberian occupation, mass baptisms revealed the mechanical nature of the patio and its components. Because the patio was an open space that could hold numerous people, it provided a venue where Nahuas could witness each other's induction into the Church and their conversion to Christianity. The patio cross and its symbols reminded spectators and converts of Christ's sacrificial gift to his followers and guided them through their conversion. Together, the patio, its central cross, and congregated witnesses structured how individuals experienced the space, its objects, and Euro-Christian knowledge. Acting like cogs in a machine, the patio space and its cross worked to drive conversion and orient Indigenous bodies to a colonial Christian world.

To ensure the patio's efficacy in their conversion project, friars established these spaces across the Valley of Mexico and beyond. Over the course of the sixteenth century, patios became integral parts of mission complexes and featured the sculpted cross and its arma in prominent, open-air views. Sixteenth-century Franciscan friar Toribio de Benavente Motolinía writes about the widespread placement and success of the cross in his 1541 memoir:

> Everywhere in this land the emblem of the Cross is so extolled that it is said in no part of the Christian world is it esteemed so highly nor are such high crosses found so often. Those in the patios of the churches are especially stately, and every Sunday and feast day [the Indians] adorn them with many roses, flowers, reeds, and garlands.[4]

The original intent of patios, as Cristina Cruz González has pointed out, was to transform rather than destroy Indigenous traditions.[5] And Motolinía's observation would have us credit the seeming victory of the early colonial apparatus to its patio and cross. But, as Cruz González adds, outdoor conversion and sacraments became uncontrollable because of the patio space and its visual components. Church officials in the mid-century, for instance, worried that baptisms in the patio were ineffective at converting Nahuas and reducing idolatry.[6] They began to fear that their tools of conversion worked against their goal. In his remark, Motolinía even alludes to the perplexing and later worrisome attention that converts paid toward patio crosses through their adornment and engagement. Such Nahua devotions toward patio crosses caused great anxiety for friars in the sixteenth century and reveal moments where the conversion project of New Spain broke down.

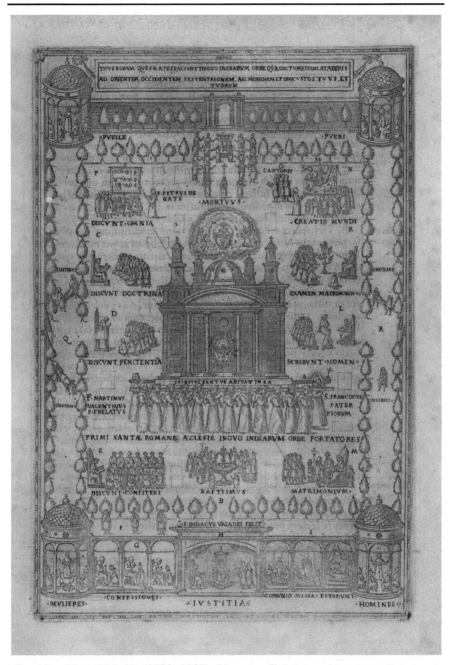

Fig. 4.2 Diego Valadés (1533–1582), *Rhetorica Christiana ad concionandi et orandi unsum accommodate* [...] (Perugia, Italy: Petrus Jacobus Petrutius, 1579), plate after 106. Engraving, 18.8 × 12.7 cm. Courtesy of the John Carter Brown Library.

To approximate Nahua experiences in the patio, scholars have emphasised the cross and patio as representative of Indigenous space. These authors contend that the four *posas*, or corner chapels, and central cross are a diagram of the Nahua *quincunx*, or five-pointed cosmos. Art and architectural historians alike have argued that the patio cross situates Christ at the centre of the Nahua cosmos as a sacred tree that threads through its upper and lower layers.[7] These insights have expanded our understanding of the early colonial patio, but by focusing on spatial design, scholars have downplayed the visuals of patio crosses and the crucial ways Nahuas contributed to and experienced patios through the making and use of these sculptures. A primary argument has been that friars conceived of the crosses' visual programmes.[8] I invert that argument by looking at how Nahua artists greatly influenced the symbols and styles of these crosses, and how Nahua converts dictated their use.

In addition to spatial design, terms used to describe patio crosses' unique, entangled styles have clouded an understanding of their making and reception. Scholars of sixteenth-century art and architecture in the Americas have offered enduring ideas – such as syncretism and hybridity – to explain cultural and visual encounters. But, as art historians Carolyn Dean and Dana Liebsohn have shown, these optics are comfortably seated in colonial paradigms that privilege the Eurocentric and neglect the Indigenous experiences of early colonial works. In effect, they flatten the complex and uneven entanglements that result in colonial objects made by and for Indigenous communities.[9] Patio crosses, as I argue, offer a remarkable case study for unpacking the complex, varied exchanges between Nahua converts and European friars in New Spain. They also shed light on how religious understandings between these groups converged to produce sculpture that was part of a larger conversion project but tailored by Nahua makers and users for their local use.

To better understand this diversity and understand patio crosses as Indigenous objects, I turn to bundles. Among Indigenous communities in the Americas, bundles are useful tools for unfolding social dynamics, since many groups have sacred bundles and understand them as part of the world's relational and interwoven sacred forces.[10] These objects contain the individual possessions and attributes – such as garments, textiles, bones, feathers, stones, and so on – of a sacred figure that guides the community. When its materials are present and in use, a bundle can manifest the sacred figure's powers housed inside. Each community's bundles are unique and contain materials that refer to their local histories, beliefs, patrons, and traditions. Thus, as a theoretical and decolonial lens, bundles also account for the past and present relationships among the Indigenous peoples, objects, and ideas that surround them.

Taking into account thirty-seven examples of patio crosses across the Valley of Mexico, I argue that patio crosses acted as bundles for Nahua communities in the early colonial period. Nahuas, while under Mexica rule, referred

to sacred bundles as *tlaquimilōlli*, meaning 'something that is wrapped or bundled'.[11] This essay looks to patio crosses as akin to tlaquimilōlli; in other words, as bundles of Nahua metaphors – such as carved feathers, blood, maize stalks, cactus spikes, fire sacrifice, and paper banners – that reinterpreted Christian knowledge. Bundled together, these symbols presented Christ's sacred power for the Nahua converts who carved them and then wrapped them with animating materials and devotions.[12] Communities engaged with crosses like they were sacred bundles by inserting precious stones into drilled holes, laying out offerings at their base, and wrapping them with paper, garlands, and precious feathers. Each community's patio cross was unique in its assemblage and patronage. Because bundles are particular to their community, they help us to make sense of this variability between patio cross symbols, styles, and devotions in the Valley of Mexico. Nahuas' engagements with patio crosses as bundles to understand Christianity also reveal how these sculptures both facilitated and challenged the conversion project in New Spain.

In what follows, I examine how the first wooden patio crosses, which appeared with the arrival of friars in the Valley of Mexico in the early sixteenth century, were replaced with stone versions as their Nahua users converted to Christianity. Because of its robust use in the Mexica Empire, stone sculpture caused anxiety among friars, who feared it would spark a return to Mexica traditions. However, stone was more resistant to natural damage, and the friars' inexperience with stone sculpture afforded Nahua artists creative liberties. In their new stone form, patio crosses exhibited symbols of Christ's Passion with Nahua veneers. I explore these symbols and disentangle how this discursive residue emerged between Nahua carvers and European friars. As I reveal, carvers interpreted Christian ideas through a Nahua worldview to bundle and present themes of the Passion on Nahua terms. After this material and visual analysis, I turn to spatial dynamics and reinscribe the cross into its context: the monastic patio. I examine the cross's relationships with the missionary complex and describe how patios and crosses came to serve the local interests of Nahua communities in a world that sought to control them. I conclude this chapter by exploring how crosses provided moments of resistance to conversion and colonial rule in their role as bundles. Though patio crosses were designed to drive the conversion of Nahuas, their use as bundles allowed converts to weld their traditions to Christianity and frustrate friars' intentions.

Material Shifts: Early Crosses and Sculptural Slippage

The Mexica, more popularly known as the Aztec, ruled over a vast number of other Nahua and ethnically distinct groups indigenous to the Valley of Mexico. By placing monuments and conducting ceremonies within its sacred landscapes, the Mexica dominated both the physical and ideological space of the Valley. Even after Iberian conquerors had dismantled the Mexica capital,

Tenochtitlan, Nahua stone sculpture continued to mark the wider landscape with its skilled carving and twisted, monumental forms. These artworks terrified European conquerors and friars alike and contributed to their early disapproval of stone sculpture in monastic spaces. In this section, I explore the first wooden crosses that arrived in the Valley of Mexico with conquistador Hernan Cortés, their intake into Nahua religious activities, and the pressing reasons and slippage that led to their production in stone. As Nahuas were converted into Christian congregations, wooden crosses likewise experienced a shift to stone. This shift provided a vector of artistic liberty for Nahua carvers, as well as a future source of concern for the European friars who commissioned them.

As Cortés campaigned toward the ceremonial capital of Tenochtitlan in 1519, he left wooden crosses and Marian images in the communities he visited. One of his first documented visits was at Cempoala, a Totonac centre that was located near the new Iberian port of Villa Rica. Chronicler and companion on the journey, Bernal Díaz del Castillo, writes that Cortés ordered Totonac religious leaders to 'fumigate the holy image of Our Lady and the sacred wooden cross with the incense of the country ... and to always keep candles burning on the altar'.[13] At Cempoala, Cortés encouraged Indigenous devotions in the form of ever-burning fires and routine blessings with local incense. In doing so, he set a precedent for the future use of Christian crosses in Nahua religious activities and their role in Christian conversion. In a drawing from the 1552 *Lienzo de Tlaxcala*, a European priest from Cortés's retinue baptises Nahua lords from the city-state of Tlaxcala (Fig. 4.3). Affixed to the wall behind

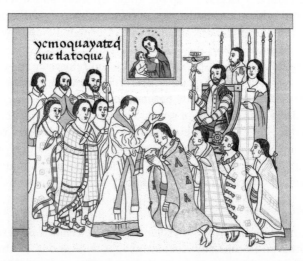

Fig. 4.3 Baptism of Tlaxcala lords, "ycmoquayateq que tlatoque."
Digital reconstruction of cell no. 8 of the now lost *Lienzo de Tlaxcala*, 1552.
Image courtesy of www.mesolore.org.

them, a painted wooden image of the Virgin Mary and Christ child operates as a backdrop for their conversion. To the Virgin's left sits Cortés, who lifts a wooden cross and overlooks the conversion scene. Though produced by Tlaxcalans decades after the Invasion, the *Lienzo* drawing conveys early conversion scenes during Cortés's march inland, as well as visualises the wooden crosses that anchored them.

Once inside the Mexica capital's walls, Cortés attempted to enact similar protocols to emplace the image of the cross in the ceremonial centre, but the ruler Moteuczoma at first denied Cortés's pleas. After five months of Cortés's urging, Moteuczoma granted him an altar where he could install the wooden images of the cross and the Virgin Mary. Cortés charged Nahua religious leaders to 'keep it swept and to burn incense and keep wax candles burning there by day and night, and to decorate it with branches and flowers'. With these orders, Cortés continued the devotions he had prescribed in earlier communities.[14] Historian Richard C. Trexler has commented on the unique cultural practices that overlapped in these encounters, arguing that Christian imagery in Tenochtitlan did not replace Mexica sacred objects but instead joined them.[15] Hence, well before the newcomers had usurped the Mexica capital, Iberian and Nahua religious practices were in dialogue, with wooden crosses serving as the material focus.

Even after Iberians had demolished the Mexica's central temple and disbanded their religious staff, wooden crosses continued to occupy focal points in newly minted Christian spaces. Shortly after the fall of Tenochtitlan in 1521, mendicant orders charged into the Valley of Mexico. Witnessing the large, gruesome forms of Nahua stone sculpture first-hand, they were impressed yet terrified by its morbid imagery. First to arrive, the Franciscans secured access to Nahua lands in the central Valley and pushed west toward Tarascan lands. The Dominicans, arriving two years later in 1526, directed their efforts to the south and east among the Zapotec and Mixtec. Last to arrive, the Augustinians plunged northward to convert the Chichimeca and Otomí. Despite their geographic monopolies, all three orders built monastic complexes in and around the former Tenochtitlan, which now formed the foundations of Mexico City. Each order took different approaches in their conversions of Indigenous groups: the Franciscans were the most stringent in their oversight, while the Augustinians – perhaps because they arrived a decade late – built their complexes with haste. Such rapid building practices begat lesser control and greater flourish in artistic and architectural styles than among the Franciscans and Dominicans.[16] As shown in Valadés's ideal patio, crosses became anchoring points for larger processions and outdoor activities that fuelled the conversion project of these orders in the Valley (Fig. 4.2).[17]

Mildred Monteverde was perhaps the first to explore the use of wooden crosses in early sixteenth-century Christian shrines and spaces in New Spain.

Her dissertation on the Christian iconography of patio crosses looked at four wooden examples in small chapels located on Tepeyac Hill, the place where the Virgin of Guadalupe appeared to a Nahua man, Juan Diego, in 1531. Built before 1539, perhaps even as early as 1531 when the Marian cult began, the crosses dated roughly to the orders' arrival in the Valley of Mexico. Monteverde observes that these crosses shared coloured plaster and certain symbols with later stone crosses; in particular, she catalogues the use of Christ's head as a reference to the sudarium of Veronica's veil.[18] Wooden crosses such as these were common in medieval Iberia and used in processions both around and within ecclesiastical spaces. For Iberian friars who hailed from these cultural traditions, wooden crosses were thus an obvious choice for the pomp that accompanied their conversion project in the Americas.

As far as we know, early patio crosses followed the model of those at Tepeyac Hill. Though no longer extant, one of the earliest was a monumental wooden cross installed at the Franciscan school San José de los Naturales, designed by Fray Pedro de Gante in 1526. Early schools such as San José cultivated and encouraged the artistic ventures of young Nahua pupils, many of whom likely carved patio crosses and painted monastic interiors.[19] For the San José cross, friars ordered students to hew a 200-foot-tall sacred *āhuēhuētl*, or cypress tree, in nearby Chapultepec. In the school's four-cornered courtyard, which doubled as an open-air liturgical space, the sacred tree was converted into a Christian cross and raised in its centre.[20] Crosses like the one at San José were raised in many other outdoor patios because of their resonance with Nahua communities, who linked them to their sacred tree sources. For example, Nahua converts in Tlaxcala referred to their patio cross as the *tonacacuahuitl*, or 'tree of sustenance', a label that marked the tree as a provider of life.[21] Elsewhere, wooden patio crosses were just as monumental in size. One sixteenth-century source describes how Nahuas in Huexotzinco set up a colossal wooden cross that was eventually weakened by winds and replaced with a stone version. A monastery in Querétaro to the north also replaced their 35-foot wooden cross with its current stone form in 1555, just two decades after the monastery was founded.[22]

As these last examples illustrate, wooden patio crosses were vulnerable to the elements and needed replacement soon after their construction. For instance, lightning struck the wooden cross at the Santuario in Cholula twice, which caused friars to demand a more resistant stone form. Eventually, friars even considered the cross in the San José courtyard too tall and dismantled the cross after it began to lean over the enclosing walls. Its breakage caused a flurry among Nahua converts, who salvaged the scraps of the former āhuēhuētl tree. This inability of wooden crosses to withstand the capricious weather of the central Valley resulted in a 1539 mandate from the diocese of Mexico City, which decreed 'in the future, crosses should be made of

stone because thunder and lightning damage the wooden crosses ... many of them rot, collapse, even cause fatalities'.[23] From that point forward, carvers rendered crosses in harder, more durable media, and they drew inspiration from a robust tradition of Nahua carving. Friars, who had scorned Nahua sculpture on account of its idolatrous nature, likely agreed to this new facture reluctantly.

As friars converted Nahua souls to the Christian faith, patio crosses likewise underwent a conversion, but in their materials. The need for this more durable medium ran alongside a desire to generate imagery that was legible to new converts. These stone crosses and their European referents have long puzzled scholars, and some have put forth the Iberian *cruz de humilladero*, which marked the entrances of medieval cities and villages from Fuenterrabia to Santiago de Compostela, as a prototype.[24] For patio crosses that stand high on large platform structures, the parallel is striking. Patio crosses on high platforms in colonial paintings often resemble humilladero crosses, which indicates they at least held visual parallels for Iberian colonisers. However, they were often outside church grounds, a location that differed from patio crosses' central locale in courtyards. Humilladero crosses also differ in their classical, dwarfed forms, which worked to increase their visibility in expansive urban landscapes. Other Iberian wooden crosses featured in processions, meaning their use differed from the stationary patio crosses. Another possible European referent is the Celtic high cross used in the conversion projects of Northern Europe as early as the ninth century.[25] This link is especially relevant because Motolinía calls the patio cross a 'high cross' in his 1541 memoir. Northern Europe had a tradition of marking open-air markets and squares with these crosses, and some scholars have argued they acted as anchors for relic processions.[26] Celtic high crosses, however, exhibit local styles of knots, low relief, and anthropomorphic scenes that differ from those of crosses in New Spain. Though they were both part of conversion projects, these last observations show how humilladero, Celtic, and patio crosses ultimately differ in their location and style, and how they were used in festivals.

Regardless of their European influences, stone patio crosses became Indigenous objects in a colonial Mexican context. For Nahua artists before the Iberian Invasion, stone carving animated religious themes on sculpture, buildings, and ceremonial objects.[27] The switch from wood to stone would not have been technically difficult for Nahua artists, who were comfortable working in the medium. Many crosses from the sixteenth century are made from basalt and *tezontli* (a spongy, pumice-like rock), which are available in volcanic areas close to Tepeapulco and across the southern Valley. Bernardino de Sahagún describes tezontli as 'black, chili-red, rough, it has holes ... it is crumbled, pulverized'; in other words, it can be manipulated and carved.[28] The edges of the patio cross at the Excovento de San Miguel Arcángel in Huejotzingo exhibit the rough,

pumice-like quality that de Sahagún says is characteristic of tezontli. Crosses are also made from volcanic andesite such as lamprobolite, and these choices between volcanic media were likely due to local availability.[29] Working in tezontli is difficult because of its porosity and fragility. Its volcanic tuff contains many impurities that artists must consider during carving, which reveals the rich knowledge carvers drew on when selecting and manipulating stone. Based on a comment by Motolinía in his memoir, George Kubler conjectures that patio cross carvers were itinerant stonemasons who travelled between pueblos in the Valley of Mexico. However, the fluctuation in style and execution between crosses instead suggests they were worked by different hands.[30] This continuity in stone use and knowledge between the Mexica and early colonial periods would have resonated for Nahua artists and converts. Many in the first generation after the Iberian Invasion would have likely understood tezontli, andesite, and lamprobolite as part of a new religious and imperial style.[31]

Given the anxieties of friars over Nahua stone sculpture, the crosses' creativity and number of Nahua symbols is surprising. Yet, if we turn to Spanish ideals at the time of the carving of these symbols, reasons for their presence become clearer. During the sixteenth and seventeenth centuries in New Spain, painting was preferred over stone sculpture, because it was considered more prestigious and European. This value discrepancy surfaces in de Sahagún's portrayals of Nahua artistic trades in his encyclopaedic *Historia general*, a work written in both Nahuatl and Spanish that the friar crafted with Nahua scholars to capture aspects of Nahua culture and history. De Sahagún praises techniques of painting, feather working, and metallurgy, and he translates each of these passages from Nahuatl into Spanish. However, on the topic of stone carving, de Sahagún leaves the Nahuatl text untranslated, with an aside that characterises stone carving as self-explanatory, rudimentary, and unworthy of further commentary.[32] De Sahagún's casual skip over stone carving is reflective of Spanish ideals toward sculpture in the sixteenth century. Polychrome wood formed the basis of the Spanish sculptural tradition, because Spain's lack of Carrara marble quarries and bronze training had made them dependent on the medium.[33] Since Iberian friars had a deeper understanding of and respect for painting and wood sculpture, stone sculpture likely had less oversight in New Spain. Thanks to this neglect, stone enabled a certain degree of artistic agency for Nahua carvers, who excelled in the medium.

By 1557, colonial officials in Mexico City had begun to control ways of making religious images. Ordinances on painting and artists' guilds articulated the channels through which art was examined before its sale and display, as well as forced painters to adhere to European traditions and techniques.[34] These ordinances also regulated entrance into and subsequent work within guilds, or *gremios*, and membership was largely restricted by ethnicity. For example, in 1568 the sculptors' gremio prohibited artists of African descent

from joining, but not Indigenous ones.[35] By 1686, however, another set of policies was more restrictive toward Indigenous carvers who had not received proper artistic training.[36] What this brief history of guilds in New Spain illustrates is how sculpture slipped through the cracks as painting became a source of concern for colonial institutions. When the first guild ordinances in 1557 were released, stone crosses had undergone almost two decades of production without any stringent oversight. A date of 1555 on the Cuauhtitlan patio cross at the former Convento de San Buenaventura comes as no surprise, since it was made just two years before Nahua carving fell prey to closer scrutiny. Guild ordinances also evince the higher status of painting over stone as an art form. This greater attention toward painting helps explain why patio crosses boasted Nahua symbols well into the seventeenth century.[37]

The transition from wood to stone, then, afforded Nahua carvers some artistic liberty in their rendering of patio crosses. Volcanic stone, such as tezontli and andesite, was a well-suited medium with Mexica roots that permitted carvers to execute symbols in Nahua ways. The relational value of stone to painting, as well as its fewer bureaucratic constraints, made patio crosses less subject to colonial authority. As stone sculpture escaped colonial control, this slippage allowed Nahua carvers to understand and render the arma Christi on their own terms. Even when officials tightened protocols halfway through the sixteenth century, carvers continued to veil symbols in creative ways, as the various styles of patio crosses in the following section illustrate. Despite the conversion of their makers and users into colonial Christian subjects, patio crosses continued to operate within Nahua frameworks. This flexibility of Nahua religious and artistic traditions in the wake of evangelisation, though it at first facilitated Nahua conversion, would also come to work against it.[38]

DISCURSIVE RESIDUE: CARVING AND BUNDLING METAPHORS

Though their general forms are similar, patio crosses vary in their assemblage of symbols and the ways converts could engage with them. Taking this diversity into account, I argue patio crosses are material bundles of both Nahua and European metaphors that seek to understand Christian doctrine – more specifically, moments from Christ's Passion – in Nahua terms and in local contexts. The tangling of such cultural viewpoints reveals how conversion in central New Spain was a process and shift toward a new Christian status but also a back-and-forth dance that afforded Nahua converts a return to their core traditions and beliefs. Whereas terms like hybridity privilege the European side of the process and flatten dynamic exchanges, thinking of crosses as bundles brings greater attention to how Nahua makers and users interpreted these objects. Bundles, because they are specific to local communities, also allow us to make sense of the variability between cross styles and assemblages, as well as spotlight the context-specific forms of Christianity in New Spain.

With a lack of first-hand accounts from makers and users, scholars have relied on European sources to wrestle with how Nahuas made and experienced these crosses. Using the material record, however, we can examine colonial sources critically and approach a deeper understanding of how Nahua converts shaped and reacted to patio crosses. Although Louise Burkhart focuses on Nahua and European rhetoric on morality and sacraments in the sixteenth century, she also provides a constructive framework for investigating materials that resulted from European and Nahua discourse. Burkhart prompts readers to view cultural contact as a meeting of metaphors, which she paints as an exchange between nature-oriented Nahuas and body-centric Christians.[39] Objects and discourse that resulted from this tangling of metaphors, Burkhart adds, are the physical 'residue of a dynamic interaction between Europeans and Nahuas' that took place within a colonial power structure.[40] In this vein, mixed metaphors thus appear on the surfaces of crosses because Nahua carvers attempt to comprehend and sift Christian discourse through their own worldview.

Common ground between Nahuas and Europeans must have first arisen through dialogue that framed the making of crosses. Such discourse would have included linguistic trial and error in Spanish and Nahuatl to arrive at a finished product: the patio cross. A famous example of a 1524 encounter between Franciscans and the former religious leaders of Tenochtitlan illustrates the dialogues that might have occurred. Later recorded in the 1560s by de Sahagún as part of his *Coloquios*, this verbal exchange portrays several Nahua leaders who defend their sacred figures against the Christian god and question whether or not they should disavow their traditional beliefs.[41] As Jongsoo Lee has recently argued, this sequence of events was likely invented by de Sahagún to transform Nahua religious leaders into European-like philosophers and strip them of their religious authority.[42] Its fictional nature aside, similar struggles of moving toward and pushing against Christian beliefs would have occurred, even within the power structures of New Spain.

A common early practice among Nahua artists seeking to comprehend Christian doctrine was to translate Christian images and texts from European prints into Nahua art forms. Friars ferried these prints across the Atlantic and circulated them throughout religious institutions in New Spain. One of the most published examples of these translated graphics is the *Mass of St. Gregory* featherwork of 1539, which drew inspiration from itinerant European prints such as those by Israhel van Meckenem.[43] Prints of Christ's Passion and its instruments were among those that circulated in the sixteenth century, and the arma Christi had a particular 'representational flexibility' that allowed them to proliferate and reanimate across media in Europe.[44] For newly converted Nahuas, the arma articulated the tools necessary to achieve salvation and showcased the magnanimity of Christ's sacrifice. They served as mementos of

Christ's bodily suffering and materialised this narrative for Nahua learners.[45] As Nahua carvers and European friars partnered to render the arma legible to new converts, it was the materiality of the arma that resonated with Nahua artists.[46] On patio crosses, carvers gravitated toward and wrestled with both the materiality of the arma and the corporeality of Christ through their translation of these symbols from print to stone.

For example, carvers attempted to show Christ and his bodily cross as precious. The Nahua idea of 'preciousness' is connected to specific materials found in nature such as jade, greenstone, obsidian, and feathers. This joining was sometimes explicit, as in the case of a small cross sent to Spain in 1524. Although now lost, an early modern inventory describes it as 'twisted ... with three *chālchihuitl* [turquoise stones] on the back of the cross and forty-eight beads like small bells'.[47] Made of precious Nahua materials, this cross is an embodied example of Christ interpreted as something precious and sacred. During Holy Week, Motolinía also writes how Nahuas carted around ex-voto crosses covered in feathers and turquoise stones.[48] Converts also decorated the containers for small crucifixes with feathers to encase the cross in a precious shroud.[49] Much like these smaller, portable examples, patio crosses display similar subtle and creative links to Nahua ideas of preciousness.

On several patio crosses, such as the Tepeapulco one that launched this chapter (Fig. 4.1), Christ's stigmata are represented in Mexica style. From these small hollows, carved blood oozes, coloured with red pigment. Much like the chest cavities of Mexica statues, patio crosses would have held precious stone offerings inside these stigmata. For the Mexica, adding precious stones like greenstone or obsidian activated the sculpture and imbued it with sacred energy. Precious stones, in early colonial Nahua thought, symbolised hearts that energised the recipient with an animate and fertile power.[50] On patio crosses, Nahua carvers thus link the two materials – blood and stone – in their design. At the Exconvento de San José in Ciudad Hidalgo, another patio cross holds a circular obsidian plate at its centre. Here, the obsidian replaces what is often a crown of thorns or Christ's head on other patio crosses. Eleanor Wake aligns this plate with the sacred Tezcatlipoca, a trickster figure among the Mexica known for his divination skills, which he conducts with the aid of an obsidian mirror.[51] I would argue that obsidian more likely evokes Christ's precious qualities than any specific sacred figure. For instance, this expansive take appears in Nahuatl translations of early modern texts like Thomas à Kempis's *Imitatio Christi*. In these passages, Christ and his words are compared to precious stone necklaces and polished mirrors.[52]

Apart from preciousness, other specific symbols resonated with Nahua beliefs and may have resulted from carvers' discursive exchanges with friars. At their core, patio crosses are reminiscent of Mexica sculpture. They are rendered in volcanic stone, are monumental, boast polychromy, and exhibit both

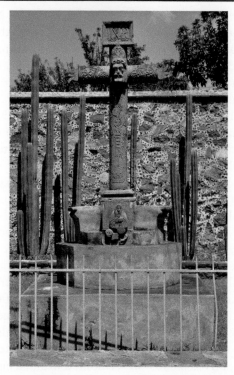

Fig. 4.4 Patio cross at Exconvento de San Agustín, Acolman, Mexico.
Volcanic rock., 1.2 m (h). Photograph by the author. Reproduction authorised
by the Instituto Nacional de Antropología e Historia.

high- and low-relief carvings. Artists in the Mexica empire often carved on the undersides of sculptures to communicate the invisible presence of sacred forces. A similar tactic of carving underneath is evident in the Passion symbols on the arms of many patio crosses. Another Mexica practice was to carve the image of Tlalteuctli, a sacred figure of the earth and underworld, on the reverse of a sculpture's base. Given the opportunity, it would be intriguing to uproot patio crosses in situ and inspect what lies underneath. On the patio cross at the Exconvento de San Agustín in Acolman, the carver included the Virgin in the guise of a skeletal earth-mother figure at the bottom of the cross (Fig. 4.4). Its location at the base may represent an attempt by the Nahua carver to adapt or at least nod to that Tlalteuctli tradition.

Vegetal metaphors also surface on patio crosses. Some crosses have a maize stalk in lieu of the reed sceptre that Christ carried during the Passion. In these instances, maize could function as a double entendre for both Christ and corn as a provider of life and sustenance. Maize dough was also a popular medium for sculpting sacred figures in the Mexica world. After their manufacture,

these figures were then sacrificed as divine offerings, a theme that mirrors Christ's role in relation to humanity in the Passion.[53] Floral imagery such as the *cempōhualxōchitl*, a marigold that symbolised death, on the arms of the Acolman cross and others may allude to Christ's corporeal end. Occasionally, carvers also redesigned the body of the cross as a cactus. Examples at the Exconvento de San Miguel Arcángel in Huejotzingo and the Parroquia de Todos los Santos in Zempoala exhibit these forms, perhaps to mirror the crown of thorns and evoke the idea of the water-providing cactus. Spiky bodies would thus unveil Christ as a provider or giving tree, since the nopal cactus was valued for its succulent fruit and water. The nopal also held a special place in Mexica history and identity, as evidenced in the toponym of their capital Tenochtitlan, the 'place of the cactus of the stone'.[54]

The arms of crosses also take on three-dimensional forms similar to those of the Mexica year bundles known, symbolically, as *xiuhmolpilli* or 'bound years'. The carvings of xiuhmolpilli sculpture are made in low relief and often cover all sides of the tubular body (Fig. 4.5). These sculptures resemble wooden fire bundles, known as *tlepilli*, which were part of a Mexica festival called *toxiuhmolpiliā* or 'the binding of our years'. Honoured every fifty-two years when the calendar reset, the ceremony was an auspicious time. The Mexica believed that if a new fire was not lit during the event, the sun's life would end. Under the cloak of night, a skilled religious leader drilled into a stone with a stick atop Huixachtlan to create fire and then fed a sacrificial victim to the flames. This blood-fuelled spark then engulfed several tlepilli, which were made of fifty-two pieces of wood tied together. Carrying the tlepilli or 'children of the fire' throughout the Valley, religious leaders renewed flames in sacred precincts, religious buildings, and domestic hearths.[55] The entire ritual centred on individual sacrifice and communal renewal, which made it a perfect metaphor for interpreting the sacrifice Christ gave to his followers.[56] Nahua cross carvers visualised the stony xiuhmolpilli in several ways; for example, arms are often held together by a carved rope or fabric that encircles them, and the ends sometimes delineate individual rods. Some arms are even aflame, for example on the Acolman cross. It is also striking that the last known ceremony was in 1507, with the next set to occur in 1559 around the time Nahua carvers sculpted many of these patio crosses.[57]

A final metaphoric fusion that escaped mendicants' watchful eyes are the ruffles that trail the circumference of many crosses' arms. Scholars have interpreted these ruffles as petals, but a tall, cylindrical pillar from the Museo Nacional de Antropología in Mexico City invites us to reinterpret (Fig. 4.6). Representing the plumed serpent, a common sacred being throughout the central Americas, this Toltec pillar carries undulating lines at its top to mark the figure. In one way, Nahua carvers replicated these folded forms on patio crosses to index preciousness, since they helped to evoke the brilliance and

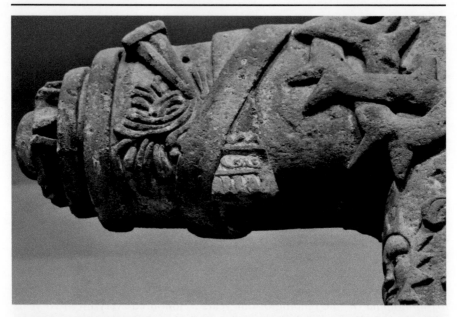

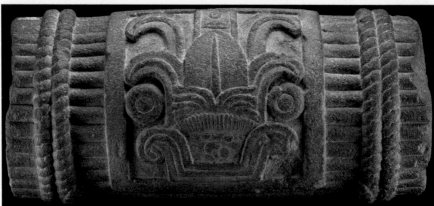

Fig. 4.5 (a) Left arm of the patio cross at Museo de Basilica de Guadalupe, Tepeyac, Mexico. Volcanic tuff, 1.3 m (h). Photograph by author. Authorised by Bienes Propiedad de la Nación Mexicana, Secretaría de Cultura, Dirección General de Sitios y Monumentos del Patrimonio, Museo de la Basílica de Guadalupe. (b) *Xiuhmopilli* bundle, 15th to 16th century, Mexica. Volcanic rock, 0.61 m (l). Photograph from the Archivo Digital de las Colecciones del Museo Nacional de Antropología. INAH-CANON. Reproduction authorised by the Instituto Nacional de Antropología e Historia.

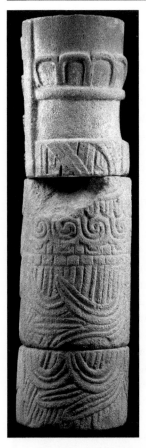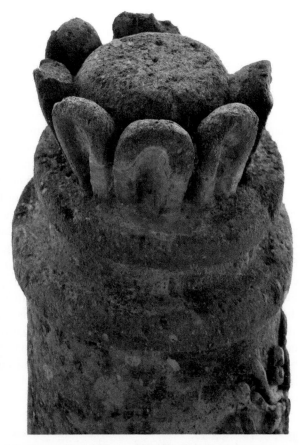

Fig. 4.6 (a) Feathered Serpent pillar, 850 to 1250 CE, Toltec. Volcanic rock., 1.87 m (h). Photograph from the Archivo Digital de las Colecciones del Museo Nacional de Antropología. INAH-CANON. Reproduction authorised by the Instituto Nacional de Antropología e Historia.
(b) Left arm of the patio cross at Exconvento de San Mateo Apóstol, Huichapan, Hidalgo, Mexico. Volcanic tuff, 1.3 m (h). Photograph by the author. Reproduction authorised by the Instituto Nacional de Antropología e Historia.

splendour of Christ. Alessandra Russo has argued that the use of feathers and related forms in early colonial art also alluded to sacrifice and the Holy Spirit.[58] Yet, these folded forms could also be an attempt to understand Christ as another Quetzalcoatl, or plumed serpent, who occupied a special place in Nahua religion as a man-god and religious leader. Another, more striking reference is to Toltec sculpture itself. The Toltecs rose to power centuries before the Mexica, and their capital lay at Tula in the nearby modern state

of Hidalgo. During the Mexica period, Nahua carvers were celebrated for executing objects in Toltec style, and the most outstanding artists were called *tōltēcah*.[59] On colonial patio crosses, Nahua carvers executed this Toltec style to place themselves within a prestigious tradition of Indigenous artistry.

Artists re-interpreted and carved the arma Christi to render them legible to Nahua audiences by bundling them together. For Nahuas in the Valley of Mexico, the bundles known as tlaquimilōlli were once a core part of their religious ideology. These bundles contained the relics and possessions of a sacred figure, which in turn manifested the sacred force, or *teōtl*, of that figure when present or in use.[60] Nahuas thus believed that each sacred figure, such as the Mexica patron figure Huitzilopochli, had a bundle made of elements that re-presented their sacred *teōtl* essence.[61] A drawing from the 1539 inquisitorial trial of Miguel Pochtecatl Tlaylotla illustrates the wrappings and material possessions of the Huitzilopochtli bundle, as well as the guardians charged with protecting it following the Iberian Invasion (Fig. 4.7). Tlaquimilōlli were formed after the deaths of sacred figures in Nahua myth, and communities collected and carried these remains across time and space. In the process, each bundle became part of a mythic past and sacred landscape as it passed through different hands that added and removed materials. Each of these associations and materials combined to manifest the sacred figure's power, which continued to alter with the bundle's assemblage.[62] Nahua communities revered these bundles through their ritual devotion and, as objects, bundles presented the larger historical and cultural meshwork in which they were forged. Nahuas conceived of sacred objects and forces as bundles, and, as illustrated above,

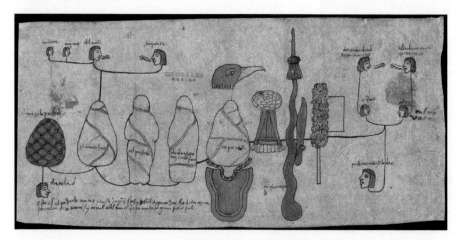

Fig. 4.7 Huitzilopochtli bundles from the 1539 Inquisitorial trial of Miguel Pochtecatl Tlaylotla. Archivo General de la Nación, manuscrito tradicional indígena, expediente 4848.

patio crosses also represented sacred bundles of key metaphors and attributes that served converts and reflected their colonial milieu.

Perhaps crosses, for Nahuas, operated in an analogous way to tlaquimilōlli.[63] Each patio cross, with its unique metaphors and devotional practices, would have worked as a whole to present and supplicate the living energies of a deceased Christ. Carvers amassed tailored symbols and metaphors for audiences in specific places, meaning that the assemblage of each stony bundle differed. Bundles are also, by their nature, permeable. Patio crosses shared that permeability, since converts could insert or remove precious stones and feathers from the sculpture. As we will see, converts could also wrap and unwrap crosses with paper, garlands, precious feathers, dancing, and their fluctuating views of the cross as they moved. Such acts allowed converts to make and unmake patio crosses through bodily engagements. Though friars oversaw the production of these crosses – and colonial officials did so more stringently after the ordinances of 1557 – Nahua carvers managed to bundle stylised elements and features for converts who had familiarity with a Mexica canon. Further use of and devotion toward the cross among Nahua converts who experienced, worshipped, and wrapped these sculptures brought its identity as a tlaquimilōlli to the fore. The next section of this chapter will reveal how converts performed Christianity toward crosses in ways that challenged the conversion project of New Spain.

Performing Christianity: Space, Devotion, and Wrapping

Nahua converts not only viewed patio crosses but also physically engaged and interacted with them. Because crosses occupied the open, outdoor patio, converts could practice a range of devotions, from festooning crosses with paper to dancing around them to the beat of a drum. This section characterises the devotions that surrounded patio crosses, which became emblems for the converted Nahuas who attended to them. Certain devotions, such as offering, sweeping, and dancing, reveal how Nahua converts cared for patio crosses and treated them as sacred energies bound within a tlaquimilōlli. Community relationships with these objects of conversion became anchored in Nahua traditions, and visual programmes on later crosses reflected Nahua views toward the horrors within these spaces of conversion. With such engagements, Nahua converts complicated friars' conversion programmes and negotiated forms of Christianity in New Spain.

Previous scholars have emphasised the cross and patio as representative of the five-pointed cosmos. Though this insight is accurate for its represented space, the patio was much more than a European schematic of an Indigenous microcosm. By accounting for spatial dynamics beyond design, I will instead shed light on the patio as a lived space.[64] The patio, in unison with the interior spaces of the monastic complex, worked to create a distinction between friars

and Nahua converts. Interior monastic spaces catered to European interests and needs, whereas exterior spaces like the patio became Nahua places through their separation and their use by Nahua converts. Certain Nahua converts, such as cantors and mural painters, did have access to interior spaces in the monastic complex, but most did not.[65] In theory, however, the exterior was accessible to all converts. It is here that Nahua devotions continued, and through such activities the patio became a unique, Indigenous place.[66] Objects such as patio crosses and their imagery reinforced and facilitated Nahua place-making practices through religious devotions that both supported and challenged conversion.

In light of this spatial division, we should push beyond the crosses' instructional use and investigate how crosses came to serve as community emblems in these Indigenous places. An earlier pictorial practice among Nahua communities in the Valley of Mexico was to identify city-states, termed āltepētl or 'water-mountain', by personalised, drawn glyphs.[67] On a map of Tlamacazcatepec from the 1579 Relación de Suchitepec, a cross in patio style tops a sloped hill-like building. The artist rendered this monastic building in the style of an āltepētl toponym to serve as an identity marker for its congregation. With its large size, the cross dominates the town's mapped landscape.[68] Elsewhere in the drawn landscape, four plain crosses rise above multi-tiered platforms to delineate a five-pointed cosmos that places the monastic complex and its cross at centre. Massive platform structures for patio crosses, such as the one at Cuauhtitlan, echo the sloping lines and monumentality of the cross-topped architecture on the Tlamacazcatepec map. Other patio crosses, such as at Acolman, sit atop tiered platforms. These visual references, both on maps and in patio spaces, announce Nahua ideas of place and the crosses' ties to local communities.[69] Patio crosses, through their use and imagery, thus became rooted in Nahua experiences during the colonial period, so strongly so that groups described and visualised them as integral parts of their lands and communities.[70]

Devotional activities around patio crosses facilitated the transformation of the patio into an Indigenous place. To define devotions, historian David Tavárez's work on idolatry from the sixteenth to eighteenth centuries in Oaxaca and central Mexico offers an ideological scaffold. He proposes the term 'devotion' instead of 'idolatry' as an alternative way to identify a broader range of ritual practices. Whereas idolatry isolates non-Christian practices, devotion allows for a greater inclusion of both Nahua and European religious practices. Moreover, it reduces the problem of juxtaposing Indigenous ritual and Christian religion, two categories that operated together in early colonial contexts.[71] Devotion also expands how we understand conversion in these patio spaces. While idolatry points to the failures of conversion programmes, devotion instead captures the conversion project's triumphs and shortcomings. Devotions in the patio space toward Christian images on crosses show that

Nahua converts engaged with their new Christian statuses in meaningful and varied ways. However, these engagements were conducted in self-determined, Nahua ways that pushed back on the friars' goals in New Spain: to transform idolatrous Nahuas into fully fledged colonial and Christian subjects.

For instance, Nahua viewers could insert precious stones into Christ's stigmata or, as in the case of a patio cross at the Catedral in Cuernavaca, they could leave offerings at its foot. The artists of the Cuernavaca example staged the cross behind a Mexica offering box known as a *cuāuhxīcalli* or 'eagle gourd vessel'. During the Mexica period, these vessels typically held the hearts of sacrificial victims, but they could also hold sundry, everyday offerings such as foodstuffs for feasting events.[72] While this *cuāuhxīcalli* would have held devotees' small offerings and ex-votos in the colonial period, its placement at the base of the cross echoed Christ's sacrifice to mankind, for the cross itself was an offering placed inside the vessel. Motolinía writes of this devotion in the 1540s, recalling how Nahuas would hide sacred items at the bases of crosses or below the stones that held up these colonial sculptures.[73] For its Nahua users, acts of offering underscored the permeable and sacred nature of the cross as a bundle, whose ritual materials were inserted and removed.

Many colonial sources also describe the constant sweeping of patio crosses, which was a purifying practice among Nahuas. Burkhart remarks on the role of sweeping among Nahua women as a daily defence against 'invading dirt and disorder', with the broom helping its user to purify domestic spaces.[74] Sweeping is even listed and pictured among Nahua religious activities in de Sahagún's early drafts of the *Historia general,* called the *Códices matritenses.* Nahua scribes wrote that sweeping purifies temple spaces of their ritual residue.[75] As a devotional practice, sweeping continued well into the colonial period, and its ritual significance was at first undetected by European friars. Franciscans accepted the sweeping of churchyards and patios as acts of good Christian faith, but their attitudes soon changed. For instance, the Indigenous converts of Jilotepec constantly swept a broad path to their patio cross, but friars proscribed this practice after they exposed a cache of sacred statues underneath the earthen path.[76] Franciscan friar Diego Durán suspected that domestic sweeping continued to hold idolatrous meaning in the late 1570s. His observation attests to the ideological hold sweeping had among Nahuas but also the central roles women played in devotions within patios and toward crosses.[77]

As with sweeping, friars also at first allowed converts to decorate crosses with crafted fig bark, garlands, and feathers. Draping fig bark sheets was a common Nahua practice that mirrored Mexica rituals of creating sacred spaces and bundles. Molly Bassett, in her monograph on sacred corporeality, describes *quimiloā* – the act of wrapping – and how fig bark functioned as a bandage and wrapping for ceremonial bundles.[78] Outer layers such as cloth, fig bark,

and animal skins helped to contain and assemble the materials and energies of the sacred bundle. In the Mexica festivals of Ochpaniztli and Tititl, officiants would decorate structures with fig bark and figural accoutrements to present the sacred forces of Teteo Innan and Ilama Teuctli, respectively. In these spatialised bundles, fig bark acted as the binding agent to hold and amass each sacred piece. Within Mexica spaces, brightly coloured fig bark also allowed religious leaders to wrap both themselves and spaces to create spiritual and protected environments.[79] I would argue that Nahua converts, by festooning patios and crosses with fig bark and flowery garlands, framed these sculptures in similar ways. Fig bark and garlands wrapped patios with sacred protection and acknowledged the cross as a tlaquimilōlli that required wrapping. Indeed, many of the crosses' arms exhibit ropes and cloth-like banners carved onto their surfaces, and patio crosses are still draped with cut fig bark in festivals today.

Movement and musical ceremonies were also integral parts of the patio landscape. Processions held in the patio often erupted into dance after they concluded, and friars allowed converts to play wooden drums such as *teponāztli* and *huēhuētl* to keep rhythm. For example, when Nahuas at Huejotzingo set up a towering wooden cross, they danced around it in unique cruciform patterns.[80] In Tlaxcala, similar practices occurred when Nahua churchgoers tore away feathers that decorated the crucifix, dancing with them around the cross. These dances occurred so frequently that the local Cabildo in Tlaxcala issued a decree to limit these bodily movements.[81] Dances resonated with typical Mexica festivals and worked to elevate the sacredness of the patio and celebrate the cross at its centre. Durán captured another instance among the Nahuas of Tlalhuica, who carried a stone statue to the centre of an open-air courtyard and asked the sculpture for permission to dance around it. Durán describes how the converts placed floral arrangements in its fists, attached feathers to its head and neck, and wrapped a cloak around its body.[82] Though the Tlalhuica sculpture is not a cross, its central placement in a courtyard and subsequent wrapping with materials and movements reveal how other stone sculptures experienced bundle-like treatment in similar landscapes.

It is also important to consider the potential movement of Nahua converts toward and around the patio cross. Located in the centre, often at the crossroads of manmade paths in an otherwise empty patio, the cross exudes a centrifugal pull over visitors. As one circles the cross, certain arma on its surface disappear and reappear as the sacred bundle unwraps and rewraps before the convert's eyes. The religious knowledge associated with these images is thus slowly revealed with bodily movements, and converts could witness each other's experiences of the cross. Many crosses bear the head of Christ at centre, and as one moves around the cross, the head vanishes and then resurfaces. In Nahua paintings of tlaquimilōlli, particularly those of Huitzilopochtli, the head performs a similar illusion, sometimes illustrated and other times not.[83]

Perhaps the use of the head on the front of the cross – and other times not at all – mimics that Mexica convention, both in the sense that it existed on some crosses but not others, and that where it existed, it appeared and disappeared as converts navigated the area around these sculptures.

Patio crosses and the devotions that surrounded them eventually caused great anxiety among idolatry-ridding friars. For instance, the friars at the Exconvento de San Andrés Apóstol in Epazoyucan designed their living quarters with critical vantage points on outdoor patios, crosses, and their Nahua users. Around the time of the guild restrictions, colonial officials released synods in 1555 and 1565 that prohibited Indigenous converts from organising processions and celebrating without the presence of a local priest. Forms of Indigenous music were also removed from church interiors and consigned to outdoor spaces.[84] This tightening of devotions likely did not sit well with converts and probably factored into later rebellions against friars at places like Acolman in 1557. Aged fractures and old repairs that now dissect cross bodies, such as the one at Acolman, might be the faint echoes and ghostly reminders of these harrowing pasts and their resulting insurgences. The unease and physical clashing between friars and Nahuas illustrate how the conversion project began to break down in New Spain. The patio cross, which had earlier been a critical tool in converting Nahuas, became a site where Nahua converts engaged with Christianity on their own terms. Crosses and their uses gave way to friars' fears that they had failed to transform Nahuas fully.

Once sixteenth-century synods and later guild restrictions had tried to stamp out Nahua ways of expressing their religious conversion in public settings, many of the patio crosses likely fell out of habitual use. A few crosses were relocated beyond patio borders, such as those of Cuauhtitlan and Acolman. As a result, their direct use in conversion programmes changed. Photographs from 1925 in the Archivo General de la Nación boast of the 'discovery' of the Acolman cross, which had become overrun with twisting tendrils and thorny cactuses.[85] Other early twentieth-century photographs show Indigenous peoples staged around well-kept crosses.[86] These captured moments suggest that some crosses still cleaved to local communities even after the legal end of colonial rule, at least in the mind of Mexican photographers. Though not all experienced such nurtured afterlives, many crosses attest to the sacred power these crosses continued to hold for local communities. Their afterlives also reveal the continued devotion they received, and the ways in which conversion to new religious forms and ideas succeeded despite mendicants' concerns. To friars, however, these conversions were incomplete and reflected the ways idolatry had crept in and taken root.

Having explored the media, metaphors, and devotions of patio crosses, we can return to the patio cross at Tepeapluco to witness it anew. What once

displayed visual tools of the Passion now tells a unique history of Nahua artistry, use, and conversion. Its intricate, high-relief carving fits within an advanced Mexica repertoire, likely carved by Nahua *tōltēcah*. Several stigmata disclose holes where converts placed precious stones and animated the sacred essence of Christ. A skull at its base peers outward, confronting converts and relating Christ's corporeal end. Twists and coils in the rope on its side parrot Mexica forms and echo the ephemeral ways in which converts wrapped crosses. Traces of red pigment and plaster layer the cross as if to keep the stony bundle and its history together, while breaks across the vertical body may catalogue moments of conflict or disagreement that bubbled between friars and converts at Tepeapulco.

By re-analysing the Nahua imagery and activities that animated patio crosses, we uncover how these objects served their communities and how they factored into conversion programmes. Though friars oversaw the crosses' production, carvers and parishioners imbued them with meaning through their array of styles and symbols, as well as their upkeep and devotion. In the sixteenth century, this arma Christi assemblage became a sacred bundle of legible metaphors for Nahua converts. Crosses thus took on many of the same traits once ascribed to tlaquimilōlli in the Mexica world: the caching and revelation of religious knowledge, the union of materials to present a sacred figure, the use as a community emblem, and the activation through wrapping, offering, and bodily movement. Crosses became focal points in patio spaces as Nahuas witnessed each other's conversions and devotions. As bundles, patio crosses in turn materialised the sacred power of Christ for Nahua converts to help them understand and formulate their own forms of Christianity. Indeed, the patio cross drove outdoor conversion programmes in New Spain, but it also allowed Nahuas to determine the dynamics of their conversion.

Throughout this chapter, we have seen how Nahua artists and converts made crosses their own. Positioned a few metres away from the Tepeapulco patio cross, another sculpted cross shows how these objects served as sites where artists could reflect on the conversion programme in New Spain. This small stone sculpture sits in the *portería*, a space that borders the patio and once doubled as an open-air chapel for Nahua converts in the sixteenth century. On its surface, Christ is flanked by two men who are dressed as Iberian conquistadors with flagellates in hand. The carver has replaced Roman soldiers from the Passion with colonisers, to understand Christ's torture in dialogue with the physical trauma brought by the Iberian Invasion.[87] As the portería cross demonstrates, crosses could exhibit creative readings of Christian doctrine and adopt defiant perspectives on the gruesome and violent truths that befell Nahua converts.

By carving, bundling, and wrapping, Nahua makers and users worked through and toward their conversion to local forms of Christianity that

clashed with friars' expectations. As Nahua-made and -used objects, patio crosses must be understood through a Nahua worldview in order to grasp their creation and reception more fully. Looking at patio crosses as sacred bundles, or tlaquimilōlli, allows us to address how patio crosses related to Nahua converts, and how such objects reflect specific moments where Christian conversion triumphed in New Spain and where it broke down. As a framework, bundling also helps us to move beyond Eurocentric theories and categories – such as syncretism or hybridity – that have constrained analyses of early colonial objects and silenced Nahua histories and experiences. It grants us a sharper view of how Nahua communities made, revered, and shaped such sacred, central objects as their own.

NOTES

I would like to thank Bronwen Wilson and Paul Yachnin for inviting me to contribute to the volume and for their instrumental feedback. I would also like to thank several individuals who either read drafts or discussed key ideas, including Rafael Barrientos Martínez, Erin Benay, Tania Bride, Louise Deglin, Lothar von Falkenhausen, Stella Nair, JoAnna Reyes Walton, Miranda Saylor, Tori Schmitt, and Kevin Terraciano. I am also indebted to the Center for 17th- and 18th-Century Studies at UCLA who generously funded this research. All faults in this chapter are my own.

1. Valadés composed an image that captured his ideal form of the patio. Its design was likely modelled after Nahua courtyards and discussed while he trained under Pedro de Gante at San José de los Naturales in Mexico City. As mentioned later in this chapter, San José had a large patio, chapels, and a monumental wooden cross.
2. Scholars have called these complexes *atria*, a term borrowed from Roman architecture. The term used more consistently by sixteenth-century writers in New Spain, however, was 'patio'. Fray Toribio de Benavente Motolinía provides an early example of its use in 1541. I invoke the term 'patio' to reflect the singularity of this space to colonial Mexican history. Edgerton, *Theaters of Conversion*, p. 52.
3. Althusser, 'Ideology and Ideological State Apparatuses', pp. 127–86.
4. De Benavente Motolinía, *Historia de los Indios*, p. 188 (my translation).
5. Cruz González, 'From Conversion to Reconversion', p. 128.
6. Franciscans and Dominicans were divided on how and when baptisms could be performed. Debates both in Europe and New Spain prompted meetings and lectures that reconsidered sacramental efforts in the Americas. In the early 1540s, for example, Bartolomé de las Casas and Francisco de Vitoria advocated for greater instruction prior to baptism to ensure that new converts participated in Christianity fully. Their opinions worked to address increasing anxieties about the extent and success of conversion in New Spain. Pardo, *The Origins of Mexican Catholicism*, pp. 43–4.
7. For example, see: Callaway, 'Pre-Columbian and Colonial Mexican', pp. 199–231; Edgerton, *Theaters of Conversion*; Kubler, *Mexican Architecture*; Lara, *City, Temple, Stage*; McAndrew, *The Open-Air Churches*; Monteverde, 'Mexico Atrio Crosses'; Wake, *Framing the Sacred*.
8. Monteverde, 'Mexico Atrio Crosses', p. 3.
9. Traditionally, scholars invoked terms like hybridity and syncretism to parse visual differences and styles. These studies aimed to separate the multicultural styles of

'mixed' or 'hybrid' objects. However, to categorise early colonial objects according to whether they are more European or Indigenous in style is to colonise material culture with Eurocentric values. Interpreting these same objects within Indigenous frameworks and looking beyond their visual appearance to aspects of making, materiality, and use help to decolonise our understanding of these objects. Dean and Liebsohn, 'Hybridity and Its Discontents', pp. 5–35.

10. These key sources provide a genealogy of bundle theory: Deleuze and Guattari, *A Thousand Plateaus*; Ingold, *Lines*; Nieves Zedeño, 'Bundled Worlds'; Pauketat and Alt, 'Water and Shells', p. 92.

11. 'cosa liada assi'. De Molina, *Vocabvlario en lengua castellana y mexicana,* part II, fol. 134r.

12. Byron Hamann has shown the value of bundles for interpreting Nahua manuscripts. Hamann, 'Object, Image, Cleverness'. See also: Guernsey and Reilly, 'Introduction', v–xvi.

13. Díaz del Castillo, *The True History,* vol. 2, p. 109.

14. Ibid., vol. 2, p. 148.

15. Trexler, 'Aztec Priests for Christian Altars', pp. 489–90.

16. Augustinians defended such luxury and relaxed control as a necessary method for stimulating new converts. McAndrew, *The Open Air-Churches*, p. 181.

17. Fray Gerónimo de Mendieta says that patios developed from early friar lodgings built around open-air spaces. De Mendieta, *Historia eclesiástica Indiana,* p. 240.

18. I attempted to locate these crosses without success. In the 1960s, they were already in poor condition and may not have survived. Monteverde, 'Mexico Atrio Crosses', pp. 76–82.

19. Mendieta notes 'there were among them great sculptors in stone' (Había entre ellos grandes escultores de cantería ...). De Mendieta, *Historia eclesiástica*, p. 111.

20. McAndrew, *The Open-Air Churches*, pp. 247–8.

21. Callaway, 'Pre-Columbian and Colonial Mexican', p. 206; Weissmann, *Mexico in Sculpture,* pp. 7–13, pp. 189–91.

22. *Códice franciscano (1569–1571)* (México, D.F.: Chávez Hayhoe, 1941), p. 207, p. 215.

23. With this timestamped decree, we can infer that stone crosses existed more officially after 1539. English translation by Monteverde. Monteverde, 'Mexico Atrio Crosses', p. 67; Garcia Icazbalceta, *Don Fray Juan*, pp. 134–5.

24. Monteverde is an ardent proponent of the *humilladero* as a prototype, but she disregards their differences in function, form, and iconography. Monteverde, 'Mexico Atrio Crosses', p. 58.

25. Interestingly, the arma Christi were also popular in Ireland after the fifteenth century. They appeared on crosses, tomb sculptures, vestments, and church walls, though not to the isolated degree we find in New Spain. Ryan, 'The *Arma Christi*', p. 268.

26. High crosses were also located within monastic complexes and sometimes delineated boundaries or nearby crossroads. Timmerman, *Memory and Redemption*, pp. 1–2.

27. For a detailed study on the links between stone sculpture and Mexica imperial religion, see: Townsend, 'State and Cosmos', 1–78.

28. 'Teçontli: tliltic, chichiltic, chachaquachtic, côcoioctic, papaiaxtic, cuechtic'. De Sahagún, *Florentine Codex,* book XI, p. 264 (my translation).

29. For instance, lamprobolite sources are found in the Chiquihuite and Sierra de Guadalupe mountains of the northern Valley. López Luján, Torres, and Montúfar, 'Los materiales constructivos', pp. 142–6.

30. It is equally plausible that knowledge of making crosses travelled between areas of production. Kubler, *Mexican Architecture,* p. 361, p. 416; Motolinía, *Historia de los Indios,* p. 237.

31. In some instances, this relationship was direct. Callaway archives a cross in Topiltepec, Teposcolulua, Oaxaca fashioned out of a Mexica or Mixtec religious monument. Callaway, 'Pre-Columbian and Colonial Mexican', p. 214.

32. 'En este letra se pone la manera que tenian los lapidaries de labrar las piedras: no se pone en romance, porque como es cosa muy usada, y siempre se usa, en los pueblos principales della nueva españa, quien quisiere entender los vacblos, y esta manera de hablar podralo tomar de los mesmos officiales.' Dibble, 'Sahagún's Historia', Introduction and Indices, p. 20; Ibid., book IX, chapter 17.

33. McKim-Smith, 'Spanish Polychrome Sculpture', p. 21.

34. Toussaint, *Pintura colonial en México,* p. 221.

35. Donahue-Wallace, *Art and Architecture,* p. 140.

36. Toussaint, *Pintura colonial,* p. 221.

37. For more on the dominant role of painting over stone sculpture in *gremios,* see: Del Barrio Lorenzot, *El trabajo en México;* Carrera Stampa, *Los gremios mexicanos;* Santiago Cruz, *Las Artes.*

38. Some scholars suggest we should instead refer to a 'Nahuatised Christianity' in colonial Mexico given the adaptability of Nahua religiosity. Klor de Alva, 'Aztec Spirituality', p. 182.

39. Metaphor works well since European and Nahua groups were from separate semantic domains. Analogies enabled efficient communication between them. Burkhart, *The Slippery Earth,* p. 13.

40. Ibid., p. 184.

41. In these imagined dialogues, Nahua religious leaders do not attack Christianity; rather, they aim to preserve their beliefs alongside Christian ones. Lockhart, *The Nahuas after the Conquest,* 205.

42. Lee, 'The Europeanization of Prehispanic tradition'.

43. For readings on this particular work, see: Fitzpatrick Sifford, 'Hybridizing Iconography', pp. 133–42; Russo, 'Recomposing the Image', pp. 465–81.

44. Indulgence arma prints numbered in the thousands by the late fifteenth and early sixteenth centuries. Gayk, 'Early Modern Afterlives', p. 281.

45. Scholars of early modern Europe have also characterised the arma as assemblages or bundles with their own visual and memorial agency. Cooper and Denny-Brown, 'Introduction. *Arma Christi*', p. 3.

46. This reaction is unsurprising, since Mexica state religion was rooted in materialism. Berdan, 'Material Dimensions', p. 249, p. 261.

47. 'un crucifijo grande con una cruz torcida con tres chalchuies en las espaldas de la cruz y cuarenta e ocho cuentas a manera de campanillas'. Joyas que Hernán Cortés, Cit. (note 16), vol. 1, doc. 62, pp. 412–15; cited in Russo, 'Cortés's objects', p. 243, footnote 91.

48. Motolinía, *Historia de los Indios,* pp. 147–9.

49. Restall, Sousa, and Terraciano, *Mesoamerican Voices,* p. 186.

50. McKeever Furst, *The Natural History,* p. 55, p. 75; López Austin, *The Human Body and Ideology,* pp. 326–7.

51. Wake, *Framing the Sacred,* pp. 201–3.

52. Tavárez, 'Nahua Intellectuals', pp. 223–4.

53. Dough figures were often inlaid with maize kernels to create eyes and teeth and to activate them. Durán, *Book of the Gods and Rites,* p. 86; Morán, 'Food in Aztec Public Ritual', p. 44.

54. Barbara Mundy has shown how the nopal cactus also acts as a cosmic tree in Nahua art. Mundy, 'Mapping Babel'.
55. De Sahagún, *Florentine Codex*, book VII, pp. 27–30.
56. Fire occupied a central role in mediating sacrifice because it transformed offerings into smoke that could reach the sacred realm. Limón Olvera, *El fuego sagrado*, p. 17, p. 328.
57. In 1539, New Spanish bishops also forbid the burning of devotional fires at patio cross bases, which shows Indigenous worshippers related these sculptures to fire. Lara, *City, Temple, Stage*, p. 173. For the 1557 date, see: DiCesare, *Sweeping the Way*, pp. 161–5; Nicholson, 'Representing the Veintena Ceremonies in the Primeros Memoriales', p. 66.
58. Russo, 'Plumes of Sacrifice', pp. 226–50.
59. Nahua songs recorded in the early colonial period characterise a *tōltēcah* as an individual who 'converses with his heart, finds things with his mind … invents things, works skilfully, creates.' Clendinnen, *Aztecs*, pp. 214–5; De Sahagún, *Códice Matritense* 8, fol. 115v, p. 174.
60. Bassett, *The Fate of Earthly Things,* p. 166.
61. *Teōtl* is a powerful sacred energy-in-motion, eternally self-generating and self-regenerating. Maffie, *Aztec Philosophy*, p. 62, p. 121. See also: Bassett, *The Fate of Earthly Things*, pp. 89–129; Hvidtfeldt, *Teotl and Ixiptlatli*, pp. 140–2.
62. Nicholson, 'Religion in pre-Hispanic Central Mexico', p. 410.
63. One could argue that the patio cross acts as a *teīxīptla* (a figure's sacred effigy or image) rather than a tlaquimilōlli. However, Molly Bassett shows that, even though both present sacred figures, the tlaquimilōlli is an object that deals more with wrappings, worshipper experience, and assemblage. What defines patio crosses and tlaquimilōlli are the ways in which devotees engaged with these objects and how devotees safeguarded them. Bassett, *The Fate of Earthly Things*, pp. 190–1.
64. To better encapsulate spatial dynamics, Henri Lefebvre developed a model of three spaces always in tension: spatial practice, representations of space, and representational space. While the design of the patio is a representation of space, its everyday and ritual use falls under spatial practice. Nahua approaches to conversion and the diverse use of patio crosses occupy the representational space, a sort of counter-hegemonic space of resistance. All three, together, help us to understand the patio's role more precisely. Lefebvre, *The Production of Space*.
65. For more information on Indigenous painters' access and their visual negotiations inside the complex, see: Peterson, *The Paradise Garden Murals*; Peterson, 'Synthesis and Survival', pp. 14–35.
66. I borrow my understanding of space from cultural geography as something through which one moves and place as a space in which one pauses: Tuan, *Space and Place,* p. 6–7.
67. Nahuas continued to understand communities as āltepēuh (pl.) in the early colonial period. Lockhart, *The Nahuas after the Conquest*, pp. 14–5.
68. Eleanor Wake identifies this image as the mountain-church of Tlamacazcatepec which she interprets as a *teōcalli* or temple. Here, the cross tops the church as a mountain to indicate a sacred place, much like the platforms that support patio crosses. Wake, *Framing the Sacred*, pp. 116–7. For more on how Nahuas conceived of sacred mountains, see: López Austin and López Luján, *Monte sagrado-Templo Mayor*.
69. For recent studies on how place-names cite Nahua ties to land and sacred histories, see: Diel, *The Tira de Tepechpan*; Diel, *The Codex Mexicanus*; Mundy, 'Place-Names'; Mundy, *The Death of Aztec Tenochtitlan*, p. 49.
70. William Taylor has made a similar conclusion for wooden crosses in Mexico, from the colonial period to the present day. Taylor, 'Placing the Cross', p. 178.

71. Tavárez, *The Invisible War*, p. 12.
72. Taube, 'The Womb of the World', p. 89.
73. Motolinía, *Historia de los Indios*, p. 31.
74. Burkhart, 'Mexica Women on the Home Front', p. 35.
75. See folio 271v of the manuscript. De Sahagún, *Primeros Memoriales*, p. 126.
76. McAndrew, *The Open-Air Churches*, p. 253.
77. Durán, *Historia de las Indias*, p. 65, p. 149.
78. Bassett, *The Fate of Earthly Things*, pp. 167–8.
79. Sahagún, *Florentine Codex*, book II, p. 87.
80. McAndrew, *The Open-Air Churches*, p. 248; De Torquemada, *Monarquía Indiana*, III, p. 202.
81. Restall et al., *Mesoamerican Voices*, p. 186.
82. Durán, *Book of the Gods and Rites*, pp. 290–1.
83. Bassett notes that tlaquimilōlli are often designed to conceal the sacred entity. Bassett, *The Fate of Earthly Things*, p. 191.
84. Ricard, *The Spiritual Conquest of Mexico*, p. 178, p. 182.
85. Archivo General de la Nación, Archivos Fotográficos, Colección Ignacio Avilés (283), Caja 25, Expedientes IA-3975 and 3976.
86. For example, see: Archivo General de la Nación, Archivos Fotográficos, Colección Fotográfica Propiedad Arística y Literaria (287), Caja 14, Expendiente PAL 1965; Caja 24, Expediente PAL 3568.
87. A sixteenth-century painted version of the cross resides inside the complex at Tepeapulco. Jennifer Scheper Hughes has also argued that Mexican crucifixes portray Christ's suffering as equal to the colonial experiences of Indigenous converts. Scheper Hughes, *Biography of a Mexican Crucifix*, p. 14.'

WORKS CITED

Althusser, Louis, 'Ideology and Ideological State Apparatuses (Notes Towards an Investigation)', in Slavoj Zizek (ed.), *Mapping Ideology* (London: Routledge, 1994), pp. 127–86.

Barrio Lorenzot, Francisco del, *El trabajo en México durante la época colonial: Ordenanzas de gremios de la Nueva España* (México, D.F.: Talleres Gráficos, 1921).

Bassett, Molly H., *The Fate of Earthly Things: Aztec Gods and God-Bodies* (Austin: University of Texas Press, 2015).

Berdan, Frances F., 'Material Dimensions of Aztec Religion and Ritual', in E. Christian Wells and Karla L. Davis-Salazar (eds), *Mesoamerican Ritual Economy: Archaeological and Ethnological Perspectives* (Boulder: University Press of Colorado, 2007), pp. 245–66.

Burkhart, Louise, *The Slippery Earth: Nahua-Christian Moral Dialogue in Sixteenth-Century Mexico* (Tucson: University of Arizona Press, 1989).

_____, 'Mexica Women on the Home Front: Housework and Religion in Aztec Mexico', in Susan Schroeder, Stephanie Wood, and Robert Haskett (eds), *Indian Women of Early Mexico* (Norman: University of Oklahoma, Press, 1997), pp. 25–54.

Callaway, Carol, 'Pre-Columbian and Colonial Mexican Images of the Cross: Christ's Sacrifice and the Fertile Earth', *Journal of Latin American Lore* 16, no. 2 (1990), pp. 199–231.

Carrera Stampa, Manuel, *Los gremios mexicanos. La organización gremial en Nueva España, 1521–1861* (México, D.F.: Edición y distribución Ibero Americana de Publicaciones, S.A., 1954).

Clendinnen, Inga, *Aztecs: An Interpretation* (Cambridge: Cambridge University Press, 1991).

Códice franciscano (1569–1571) (México, D.F.: Chávez Hayhoe, 1941).

Cooper, Lisa H., and Andrea Denny-Brown, 'Introduction. *Arma Christi*: The Material Culture of the Passion', in Lisa H. Cooper and Andrea Denny-Brown (eds), *The Arma Christi in Medieval and Early Modern Material Culture* (Burlington, VT: Ashgate Publishing, 2014), pp. 1–20.

Cruz González, Cristina, 'From Conversion to Reconversion: Assessing Franciscan Missionary Practices and Visual Culture in Colonial Mexico', in Xavier Seubert and Oleg Bychov (eds), *Beyond the Text: Franciscan Art and the Construction of Religion* (Saint Bonaventure, NY: Franciscan Institute Publications, 2013), pp. 125–46.

Dean, Carolyn, and Dana Liebsohn, 'Hybridity and Its Discontents: Considering Visual Culture in Colonial Spanish America', *Colonial Latin American Review* 12, no. 1 (2003), pp. 5–35.

Deleuze, Gilles, and Félix Guattari, *A Thousand Plateaus: Capitalism and Schizophrenia*, trans. Brian Massumi (Minneapolis: University of Minnesota Press, 1987).

Díaz del Castillo, Bernal, *The True History of the Conquest of New Spain*, trans. Alfred Maudslay, 5 vols (Nendeln: Kraus Reprint, 1967).

DiCesare, Catherine R., *Sweeping the Way: Divine Transformation in the Aztec Festival of Ochpaniztli* (Boulder: University Press of Colorado, 2009).

Diel, Lori Boornazian, *The Codex Mexicanus: A Guide to Life in Late Sixteenth-Century New Spain* (Austin: University of Texas Press, 2018).

———, *The Tira de Tepechpan: Negotiating Place under Aztec and Spanish Rule* (Austin: University of Texas Press, 2008).

Donahue-Wallace, Kelly, *Art and Architecture of Viceregal Latin America, 1521–1821* (Albuquerque: University of New Mexico Press, 2008).

Durán, Diego, *Book of the Gods and Rites and The Ancient Calendar,* ed. and trans. Fernando Horcasitas and Doris Heyden (Norman: University of Oklahoma Press, 1971).

———, *Historia de las Indias de Nueva-España e islas de Tierra Firme* (México, D.F.: Impr. de J. M. Andrade y F. Escalante, 1867).

Edgerton, Samuel Y., Jorge Pèrez de Lara, and Mark Van Stone, *Theaters of Conversion: Religious Architecture and Indian Artisans in Colonial Mexico* (Albuquerque: University of New Mexico Press, 2001).

Fitzpatrick Sifford, Elena, 'Hybridizing Iconography: The *Miraculous Mass of St. Gregory* Featherwork from the Colegio de San José de los Naturales in Mexico City', in James Romaine and Linda Stratford (eds), *ReVisioning: Critical Methods of Seeing Christianity in the History of Art* (Eugene, OR: Cascade Books, 2013), pp. 133–42.

Garcia Icazbalceta, J., *Don Fray Juan de Zumarraga, primer obispo y arzobispo de México* (México, D.F.: Andrade y Morales, 1886).

Gayk, Shannon, 'Early Modern Afterlives of the *Arma Christi*', in Lisa H. Cooper and Andrea Denny-Brown (eds), *The Arma Christi in Medieval and Early Modern Material Culture* (Burlington, VT: Ashgate Publishing, 2014), pp. 273–307.

Guernsey, Julia, and F. Kent Reilly, 'Introduction', in Julia Guernsey and F. Kent Reilly (eds), *Sacred Bundles: Ritual Acts of Wrapping and Binding in Mesoamerica* (Barnardsville, NC: Boundary End Archaeology Research Center, 2006), x–xvi.

Hamann, Byron, 'Object, Image, Cleverness: The *Lienzo de Tlaxcala*', *Art History* 36, no. 3 (2013), pp. 518–45.

Hvidtfeldt, Arild, *Teotl and Ixiptlatli: Some Central Conceptions in Ancient Mexican Religion* (Copenhagen: Munksgaard, 1958).

Ingold, Tim, *Lines: A Brief History* (London: Routledge, 2007).

Klor de Alva, J. Jorge, 'Aztec Spirituality and Nahuatized Christianity', in Gary H. Gossen in collaboration with Miguel León Portilla (eds), *South and Meso-American Native Spirituality: From the Cult of the Feathered Serpent to the Theology of Liberation* (New York: Crossroad, 1997), pp. 173–97.

Kubler, George, *Mexican Architecture in the Sixteenth Century*, 2 vols (Westport, CT.: Greenwood Press, 1972).

Lara, Jaime, *City, Temple, Stage: Eschatological Architecture and Liturgical Theatrics in New Spain* (Notre Dame: University of Notre Dame Press, 2004).

Lee, Jongsoo, 'The Europeanization of Prehispanic tradition: Bernardino de Sahagún's transformation of priests (*tlamacazque*) into classical wise men (*tlamatinime*)', *Colonial Latin American Review* 26, no. 3 (2017), pp. 291–312.

Lefebvre, Henri, *The Production of Space*, trans. Donald Nicholson-Smith (Oxford: Wiley Blackwell, 1991 [French orig. 1974]).

León Portilla, Miguel, *Pre-Columbian Literatures of Mexico*, trans. Grace Lobanov (Norman: University of Oklahoma Press, 1969).

Limón Olvera, Silvia, *El fuego sagrado: simbolismo y ritualidad entre los nahuas* (Mexico, D. F.: Universidad Nacional Autónoma de México, Centro de Investigaciones sobre América, Latina y el Caribe, 2012).

Lockhart, James, *The Nahuas after the Conquest: A Social and Cultural History of the Indians of Central Mexico, Sixteenth through Eighteenth Centuries* (Stanford, CA: Stanford University Press, 1992).

López Austin, Alfredo, *The Human Body and Ideology: Concepts of the Ancient Nahuas*, 2 volumes, trans. Thelma Ortiz de Montellano and Bernard Ortiz de Montellano (Salt Lake City: University of Utah Press, 1998).

López Austin, Alfredo, and Leonardo López Luján, *Monte sagrado-Templo Mayor. El cerro y la pirámide en la tradición religiosa mesoamericana* (México, D.F.: Instituto Nacional de Antropología e Historia, Universidad Nacional Autónoma de México, 2009).

López Luján, Leonardo, Jaimes Torres, and Aurora Montúfar, 'Los materiales constructivos del Templo Mayor de Tenochtitlan', *Estudios de cultura náhuatl* 34 (2003), pp. 137–66.

Luis Martínez, José (ed.), 'Joyas que Hernán Cortés envió a España desde México inventariadas por Cristóbal de Oñate.' in *Documentos cortesianos*, vol. 1, doc. 62, pp. 412–15 (México, D.F.: Fondo de Cultura Económica, Universidad Nacional Autónoma de México, 1990).

Maffie, James, *Aztec Philosophy: Understanding a World in Motion* (Boulder: University of Colorado Press, 2014).

McAndrew, John, *The Open-Air Churches of Sixteenth-Century Mexico: Atrios, Posas, Open Chapels, and other studies* (Cambridge: Harvard University Press, 1965).

McKeever Furst, Jill, *The Natural History of the Soul in Ancient Mexico* (New Haven, CT: Yale University Press, 1995).

McKim-Smith, Gridley, 'Spanish Polychrome Sculpture and its Critical Misfortunes', in Suzanne L. Stratton (ed.), *Spanish Polychrome Sculpture 1500–1800 in United States Collections* (Dallas, TX: The Meadows Museum, 1993), pp. 13–31.

Mendieta, Gerónimo de, *Historia eclesiástica Indiana, obra escrita á fines del siglo XVI* (México, D.F.: Antigua librería, 1870).

Molina, Alonso de, *Vocabvlario en lengua castellana y mexicana* (Mexico City, New Spain: Casa Antonio de Spinosa, 1571).

Monteverde, Mildred A., 'Mexico Atrio Crosses: A Study in Iconography', PhD diss., University of California Los Angeles, 1969.

Morán, Elizabeth, 'Food in Aztec Public Ritual', in *Sacred Consumption: Food and Ritual in Aztec Art and Culture* (Austin: University of Texas Press, 2016), pp. 37–61.

Motolinía, Toribio de Benavente, *Historia de los Indios de la Nueva España* (Madrid: Dastin, S. L., 2001).

Mundy, Barbara, *The Death of Aztec Tenochtitlan, the Life of Mexico City* (Austin: University of Texas Press, 2015).

_____, 'Mapping Babel: A 16th-Century Indigenous Map from Mexico', *The Appendix: A New Journal of Narrative and Experimental History* 1, no. 4 (2013).

_____, 'Place-Names in Mexico-Tenochtitlan', *Ethnohistory* 61, no. 2 (2014), pp. 329–55.

Nicholson, H. B., 'Religion in pre-Hispanic Central Mexico', in Robert Wauchope, Ignacio Bernal, and Gordon F. Ekholm (eds), *Handbook of Middle American Indians*, vol. 10 (Austin: University of Texas Press, 1971), pp. 395–446.

_____, 'Representing the Veintena Ceremonies in the Primeros Memoriales', in Eloise Quiñones Keber, *Representing Aztec Ritual: Performance, Text, and Image in the Work of Sahagún* (Boulder: University of Colorado Press, 2002), pp. 63–106.

Nieves Zedeño, María, 'Bundled Worlds: The Roles and Interactions of Complex Objects from the North American Plains', *Journal of Archaeological Method and Theory* 15 (December 2008), pp. 326–78.

Pardo, Osvaldo F., *The Origins of Mexican Catholicism: Nahua Rituals and Christian Sacraments in Sixteenth-Century Mexico* (Ann Arbor: University of Michigan press, 2006).

Pauketat, Timothy R., and Susan M. Alt., 'Water and Shells in Bodies and Pots: Mississippian Rhizome, Cahokian Poiesis', in Eleanor Harrison-Buck and Julia A. Hendon (eds), *Relational Identities and Other-than-Human Agency in Archaeology* (Louisville: University Press of Colorado, 2018), pp. 72–99.

Peterson, Jeannette, *The Paradise Garden Murals of Malinalco: Utopia and Empire in Sixteenth-Century Mexico* (Austin: University of Texas Press, 1992).

_____, 'Synthesis and Survival: The Native Presence in Sixteenth-Century Augustinian Murals of Mexico', in Emily Umberger and Tom Cummins (eds), *Native Artists and Patrons in Colonial Latin America, Phoebus* (Arizona State University) 7 (1995), pp. 14–35.

Restall, Matthew, Lisa Sousa, and Kevin Terraciano, eds, *Mesoamerican Voices: Native-Language Writings from Colonial Mexico, Oaxaca, Yucatan, and Guatemala* (Cambridge: Cambridge University Press, 2005).

Ricard, Robert, *The Spiritual Conquest of Mexico: An Essay on the Apostolate and Evangelizing Methods of the Mendicant Orders in New Spain, 1572*, trans. Lesley Byrd Simpson (Berkeley: University of California Press, [1933] 1966).

Russo, Alessandra, 'Cortés's objects and the Idea of new Spain: Inventories as Spatial Narratives', *Journal of the History of Collections* 23, no. 2 (November 2011), pp. 229–52.

_____, 'Plumes of Sacrifice: Transformations in Sixteenth-Century Mexica Feather Art', *RES: Anthropology & Aesthetics* 42 (Autumn 2002), pp. 226–50.

_____, 'Recomposing the Image. Presents and Absents in the *Mass of St. Gregory*, Mexico, 1539', in Manuela De Giorgi, Annette Hoffman, Nicole Suthor (eds), *Synergies in Visual Culture / Bildkulturen im Dialog* (Florence: Kunsthistorisches Institut-Max Planck, 2013), pp. 465–81.

Ryan, Salvador, 'The *Arma Christi* in Medieval and Early Modern Ireland', in Lisa H. Cooper and Andrea Denny-Brown (eds), *The Arma Christi in Medieval and Early Modern Material Culture* (Burlington, VT: Ashgate Publishing, 2014), pp. 243–72.

Sahagún, Bernardino de, *Florentine Codex: General History of the Things of New Spain*, 12 vols., trans. Arthur Anderson and Charles Dibble (Salt Lake City: University of Utah Press, 2012).

_____, *Primeros Memoriales*, trans. Thelma D. Sullivan (Norman: University of Oklahoma Press, 1997).

Santiago Cruz, Francisco, *Las Artes y los Gremios en la Nueva España* (México, D.F.: Editorial Jus., 1960).

Scheper Hughes, Jennifer, *Biography of a Mexican Crucifix: Lived Religion and Local Faith from the Conquest to the Present* (Oxford: Oxford University Press, 2009).

Taube, Karl, 'The Womb of the World: The *Cuauhxicalli* and Other Offering Bowls in Ancient and Contemporary Mesoamerica', *Maya Archaeology* 1 (2009), pp. 86–112.

Tavárez, David, *The Invisible War: Indigenous Devotions, Discipline, and Dissent in Colonial Mexico* (Stanford, CA: Stanford University Press, 2011).

_____, 'Nahua Intellectuals, Franciscan Scholars, and the *Devotio Moderna* in Colonial Mexico', *The Americas* 70, no. 2 (October 2013), pp. 203–35.

Taylor, William B., 'Placing the Cross in Colonial Mexico', *The Americas* 69, no. 2 (October 2012), pp. 145–78.

Timmerman, Aachim, *Memory and Redemption: Public Monuments and the Making of Late Medieval Landscape* (Turnhout: Brepols Publishers, 2017).

Torquemada, Juan de, *Monarquía Indiana (ca.1612/1615)*, 3 vols (México, D.F.: Chávez Hayhoe, 1943).

Toussaint, Manuel, *Pintura colonial en México*, Xavier Moyssén (ed.), 3rd edition (México, D.F.: UNAM, 1990).

Townsend, Richard, 'State and Cosmos in the Art of Tenochtitlan', in *Studies in Pre-Columbian Art and Archaeology no. 20* (Washington, D.C.: Dumbarton Oaks Research Library and Collection, 1979), pp. 1–78.

Trexler, Richard C., 'Aztec Priests for Christian Altars: The Theory and Practice of Reverence in New Spain', in *Church and Community 1200–1600: Studies in the History of Florence and New Spain* (Rome: Edizioni di Storia e Letteratura, 1987), pp. 469–92.

Tuan, Yi Fuan, *Space and Place: The Perspective of Experience* (Minneapolis: University of Minnesota Press, 2001).

Wake, Eleanor, *Framing the Sacred: The Indian Churches of Early Colonial Mexico* (Norman: University of Oklahoma Press, 2010).

Weissmann, Elizabeth, *Mexico in Sculpture, 1521–1821* (Cambridge: Harvard University Press, 1950).

5

THE CONVERSION OF THE BUILT ENVIRONMENT: CLASSICAL ARCHITECTURE AND URBANISM AS A FORM OF COLONISATION IN VICEREGAL MEXICO

Juan Luis Burke

INTRODUCTION

It is difficult to determine when the first architectural treatises arrived in vice-regal Mexico. However, we know that Antonio de Mendoza (1494–1552), the first viceroy of New Spain, owned a copy of the *De re aedificatoria*, the architectural treatise by the Italian architect and humanist Leon Battista Alberti. Specifically, Mendoza possessed a 1512 edition printed in Paris that he brought with him to Mexico and annotated around the year 1539,[1] making Alberti's one of the first Renaissance architectural treatises to reach the New World in the sixteenth century. Viceroy Mendoza was not only an educated man but was particularly committed to the patronage of civic institutions. He promoted the foundation of the Royal and Pontifical University of Mexico, established in 1553, introduced the printing press in New Spain, and supported the founding of the city of Valladolid, today Morelia, around the year 1543.[2]

Given that Mendoza expressed a marked interest in architecture and urban planning, the advice he left to his successor, Luis de Velasco, acquires particular importance. In effect, around the year 1550, when the end of his tenure was near, Mendoza wrote a letter to Velasco. In the letter, among other issues – such as the state of infrastructure in the viceroyalty, or the state of relations and negotiations with Indigenous communities – Mendoza informed Velasco that concerning 'the construction of monasteries and public works, there had been many mistakes in their designs, and other matters were not carried out

properly', because nobody, according to Mendoza, supervised the works.[3] The errors that viceroy Mendoza mentioned, as well as the issue of the arrival of architectural treatises in the New World, both point to the same topic: the introduction and establishment of the classical architectural tradition in the nascent viceroyalty. Indeed, in the letter addressed to Velasco, Mendoza also advised him to attract architects from the Iberian Peninsula to New Spain, in order to elevate the construction quality of civic and religious buildings. Velasco heeded Mendoza's advice, and his mandate saw the arrival of the first professional European architect[4] in the viceroyalty, the Spaniard Claudio de Arciniega (1520–1593). Arciniega, known for his refined classicism, would go on to consolidate a successful architectural practice in New Spain.[5]

The arrival of the classical architectural tradition in the viceroyalty is not mere historiographical trivia. Instead, as will be argued in this short essay, the reception and deployment of the classical tradition played a fundamental role in the social, cultural, and material conversion of the built environment during the viceregal period. Architectural classicism was, in effect, part of a more extended colonial apparatus.

The conversion of the built environment, in turn, was intimately linked to a central principle of Iberian culture in the early modern period: the idea that the city was the rightful, and the only, place where Spanish civilisation could flourish. In other words, the city, understood here as a concept rather than as a literal site, was where all the colonial institutions were exhibited, and whence the legitimacy of colonial power emanated. Architecture has always acted as a disseminator of the political and social power of religious and civic institutions, and this is undoubtedly the case – perhaps even more so – in a colonial context. Ultimately, this essay argues that the classical or Renaissance tradition of architecture played a central role as a colonial performer or coadjutant in viceregal New Spain, given that the Spanish colonisers granted the classical language of architecture the ability to become the bearer of civic, religious and political decorum.

ARCHITECTURAL TREATISES IN NEW SPAIN

The architectural treatise is a unique technical, scientific, and literary genre. It has existed in the Western tradition since at least Greek antiquity, as Vitruvius reveals in the introduction to Book VII of his treatise *De architectura libri decem* (The ten books of architecture), where he informs us that his work employed the knowledge collected by characters such as Silenus, who published a treatise on buildings of the Doric order, or Ictinus and Carpion, who wrote a treatise on the Golden Temple of Minerva at the Acropolis in Athens, among others.[6] Relatedly, the Vitruvian treatise was, contrary to popular belief, relatively well-known during the medieval period in Europe, since builders such as Alcuin of York, Hugh of St Victor, Petrus Diaconus, the mystic

Hildegarde von Bingen, and others knew and discussed the work of the Roman engineer-architect.

However, the modern architectural treatise was undeniably born with the Italian Renaissance in the mid-fifteenth century, alongside the development of the printing press in Italy. Indeed, Leon Battista Alberti's *De re aedificatoria*, which was the most influential treatise after Vitruvius during the Renaissance, was written around 1450 and was initially intended to be circulated in manuscript form, in small humanist circles. However, it became widely popular with the appearance of printed versions of the treatise in 1485, which made it a European phenomenon and later a transatlantic one. Other treatises followed a similar path. For this reason, the Renaissance architectural treatise, which is typically considered an exclusively European phenomenon, should be understood and studied as a transatlantic and even a global one.[7]

The fact that the Renaissance architectural treatise, the art of xylography, and the printing press developed along similar timelines is of utmost importance to architecture. As Mario Carpo has suggested, 'the mechanical reproduction of images was to have important and long-lasting consequences for the transmission of scientific knowledge, and even more for technical subjects and the visual arts. Architecture was no exception'.[8] Once the printed word and the woodcut merged, books became the primary artifacts through which architectural images were disseminated. Carpo's general argument is that Renaissance architectural design, through the gradual popularisation of the architectural treatise, became a more imitative activity, as opposed to the medieval tradition of transmitting construction knowledge orally, and to a lesser extent visually, and exclusively in closed circles – primarily in guilds. As Carpo succinctly explains: 'It was only in the Quattrocento that architectural imitation became what it has never ceased to be—a visual act'.[9]

The possibilities that architectural treatises – understood here as disseminators of rhetorical and visual messages – acquired once in New Spain could not have been anticipated in a European context. In other words, the weight that these treatises gained in the colonised territories of the Americas is due to the fact that the colonisation process hinged, to a large extent, on constructing a built environment that resembled that of the metropolis, and architectural treatises represented and contained the ideal formulas for creating those built environments. In a colonial context, Spaniards had to shape a built environment that integrated the messages they wanted to convey, namely: the pre-eminence and global power of the Spanish Empire (reflected in its civic institutions and its use of public space); the power and pre-eminence of the Catholic Church (presented in the endless number of religious buildings); and Hispanic domesticity (that is, the Iberian way of inhabiting and exploiting the land and its resources). Therefore, the built environment was undoubtedly a central element in the construction of the Spanish Empire in the Americas, and

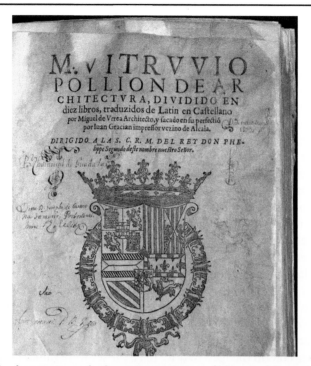

Fig. 5.1 The frontispiece of a Spanish translation of Vitruvius' *De architectura libri decem* (Ten Books on Architecture) from 1582, published in Alcalá de Henares, Spain, and translated by Miguel de Urrea. The volume contains marginalia. Today this volume is housed in the Lafragua Rare Book Library of the State University of Puebla (BUAP), Mexico. Image courtesy of the Lafragua Library, Benémerita Universidad Autónoma de Puebla, Mexico.

architectural treatises were one of the many vehicles that enabled the transmission and eventual institutionalisation of that European architectural tradition.

Viceroy Mendoza's copy of Alberti was not, evidently, the only architectural treatise to cross the Atlantic. There is ample evidence that a considerable number of architectural treatises arrived in the New World, starting in the mid- to late sixteenth century and continuing throughout the rest of the viceregal period.[10]

Furthermore, the research carried out on the arrival and use of architectural treatises – particularly those by Vitruvius, Alberti and Sebastiano Serlio – in the Hispanic world of the early modern period shows that they had a substantial impact on the configuration of the colonial architecture of Spanish America.[11] For this reason, their role as colonialist artifacts, that is, the precise roles they played as part of a more sophisticated colonial machinery, should be duly recognised.

A central question regarding the potential of architectural treatises lies in their visual dimension. In this sense, the development of printing technologies, the art of xylography, and the popularisation of books allowed architectural treatises to become repositories of visual resources for architects. Thanks to the treatises, the professional builder and, in effect, anyone interested in the subject could study and reflect on the text and its visual aspects, immersing themselves in a hermeneutic dialogue through which readers learned about the classical architectural tradition.

Although it would be impossible to explain such a sophisticated tradition in a few sentences, suffice it to say that classical architecture consisted of several categories that an architect had to balance and understand, such as *imitatio*, a term understood as attachment to tradition, *licentia*, or creative license (as the rules of architectural composition were never thoroughly and universally laid down), as well as *decorum*, the proper use of the architectural orders based on the architectural programme and symbolic intention. At the same time, the practitioner had to have command of the rules that governed the proportions of the orders down to the constituent elements of the orders – base, shaft, capital, frieze, and others – and the extensive possibilities for combining them, among many other aspects.[12]

In the context of the viceregal period in New Spain and the rest of the Spanish possessions in the New World, the treatises were valuable tools for the master builders or architects who arrived from the metropolis.[13] These books not only allowed architects in the New World to apprehend or reinforce the knowledge necessary to articulate a classical piece of architecture, but also to legitimise that knowledge through the treatises' authority, as they were considered the most important sources of knowledge on the subject. Furthermore, owning an architectural treatise, like owning any book at this time, was a sign of scholarship and social standing that, in the case of architecture, showed that the practitioner in question was knowledgeable and, therefore, could be trusted to design and build an architectural work with the proper decorum. Finally, becoming familiar with the classical canon was eventually a requirement for those wanting to join the builders' guilds that controlled the profession in the cities inhabited by the most significant Spanish and *criollo*, or Creole, communities, such as Mexico City and Puebla de los Ángeles. These guilds were controlled by Spaniards and Creoles, while Indigenous and Mestizo practitioners were relegated to either labourers or supervisors, but prohibited from entering the guilds of master masons.[14]

ARCHITECTURAL CLASSICISM AS A COLONIALIST TOOL

One of the most critical theories about the deployment of the Renaissance tradition in the New World and its negative consequences comes from the Argentine academic Walter Mignolo, who considers colonialism the

Renaissance's 'darkest' legacy. One of the central concepts of his theory is the 'fissure', which operates in Western civilisation as soon as it begins to colonise the so-called New World. The fissure represents the transition of European civilisation into a modern conception of space and time.[15] Indeed, the concept of time was closely related to cosmology and religion in pre-modern European societies. Meanwhile, the conception of space was linked to a micro-macro model that originated with the body as a universal measure, with the ability to project this concept onto larger-scale elements, such as a city or a sacred building – a cathedral, for instance. However, modernity transformed the idea of time into a mechanism to carry out commercial operations and the administration of goods, services, and people, accompanied by related notions of geometric projection and arithmetic calculation.

Taking Mignolo's theory further, we could argue that the classical architectural tradition also operated under a 'fissure', meaning that some of its most salient traits, such as rigidity and its strict attention to a system of proportions – also related to notions of precision, rigidity, and mathematical systems – could be considered the measure of a civilising ideal.[16] Classical architecture was a system of formal devices related to the rhetorical arts and poetry, but also to notions of mathematical proportions and correspondences. As Mignolo affirms, 'Territoriality, within a context of ethnic rationalization of space, is a complex calculus of time, space, memory and semiotic codes.'[17] The classical architectural tradition is, therefore, an inherent part of what we commonly identify as the legacy of the Renaissance; hence Mignolo identifies this heritage as the 'darkest' aspect of the period, as it served to underline 'the rebirth of the classical tradition as a justification of colonial expansion'.[18]

Another theorist of decolonial studies, the philosopher Enrique Dussel, frames this problem differently. He argues that the invasion and colonisation of Mexico by the Spaniards was, first of all, the fulfilment of a 'Christian ideal' that was not feudal or medieval but belonged to the Renaissance period. Dussel calls it 'the first moment of modernity'.[19] In this colonial campaign, this apparatus was set up by the three de facto powers of viceregal Mexico (the Spanish Crown, the Catholic Church and the ruling class of Spaniards and Creoles), which carried out a colonisation and conversion process that 'permeated all facets of public life and the everyday'.[20]

This process included the colonisation and conversion of Indigenous languages, history, pictorial and artistic representations, and space – the latter through urban planning, architecture, and cartography, among others things. Framed within this complex scenario, the classical tradition of architecture played a critical role, since architectural and urban theory provided colonisers with a tradition of thought and action that allowed them to (re)produce an architectural culture, shaped by civic decorum and the concept of *policía*

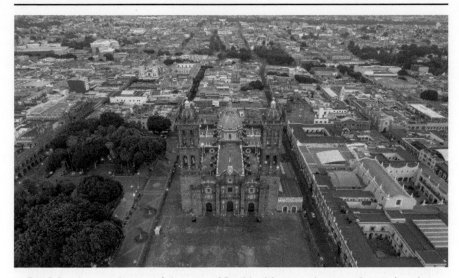

Fig. 5.2 An aerial view of the city of Puebla, Mexico, showing the city's urban layout, following the principles of urban design contained in treatises such as Vitruvius' *De architectura libri decem* (Ten Books on Architecture), or Leon Battista Alberti's *De re aedificatoria* (On Architecture). Photo courtesy of Rubén Olvera (IG: @ruda.taller).

humana,[21] that evoked the ideas and institutions that were familiar to them from the Iberian Peninsula.

In this context, the architectural treatise, that is, the book as a means of communication and a repository of practical and theoretical knowledge, was essential for the transmission of architectural and urban knowledge – a product of the European Renaissance that helped the colonisers to deploy their construction and urban planning efforts in New Spain.

The architectural treatise, which experienced a period of popularity from the sixteenth to the eighteenth centuries in Europe thanks to the printing press, played its role in New Spain as a transmitter of knowledge and a repository of the urban and architectural ideals of Hispanic culture of the early modern age. For this reason, architectural treatises were at once both symbols of idealised knowledge and artifacts for practical action. At this point, however, a pertinent question is, why was classical architecture the style chosen to express civic decorum in the American viceroyalties? Perhaps the answer lies in the Spanish Empire's expansion during Charles V's reign, and as an image of imperial power was fabricated. As with any imperial image of power, architecture played a critical role in this endeavour. In the case of Charles V's construction of his palace at the Alhambra, by Pedro Machuca, the building of his pavilion at the Alcázar of Seville, and the erection of the cathedral of Córdoba by Diego

de Siloé, all point to what scholar Cammy Brothers suggests represented 'his mastery over Spain's Moorish past' in which 'rational geometry and classical rhetoric' served to represent a form of subjugation.[22] Ultimately, classicism came to define the Habsburg architectural taste under Philip II's tenure, and the finishing of El Escorial, the famed monastery and mausoleum, in 1584 became its consecrating event.

Indeed, the palace of Charles V in Granada, completed by his son, Philip II, represents a bold decision by the Spanish monarchy to express its ideological-political programme architecturally. Philip II would make the classic architectural language conclusively representative of the Spanish Crown.[23] In this context, when trying to evoke a sense of policía humana in the newly colonised territories and the newly founded towns and cities, the classical architectural tradition was a practical solution for the Spanish colonisers. Classicism, to put it bluntly, evoked the noble and monarchical character of the Spanish Empire. It was, in effect, the architectural language that would come to represent the institutions of the Crown.[24]

Spanish Viceregal Cities and Policía Humana

The construction of the most outstanding civic and religious buildings in an urban centre, those that represented the institutions of the Empire, collectively symbolised the civic decorum of that community. In the case of early modern Hispanic culture, this concept was intimately linked to the notion of policía humana. To understand this term, it is essential to begin by explaining how, according to Richard Kagan, the idea of the urban in the Renaissance period revolved around the dual notion of *urbs* and *civitas*. On the one hand, the idea of urbs stood for, in general terms, the material fabric of the city: its buildings, urban form, and streets, among other things. In contrast, civitas referred to the city's institutions, as well as its religious and spiritual beliefs, its ordinances and bylaws, its municipal council, and, most importantly, its citizens. Kagan argues that the genealogy of the terms urbs and civitas dates from classical antiquity. Authors from Thucydides, Plato, and Aristotle to Isidore of Seville, St Augustine, St Thomas Aquinas, and Leon Battista Alberti all touched upon the subject in slightly different terms.[25]

Although the concept of the urban in European culture was prominent all over the continent, the Spanish notion of the city was, during the early modern period, what distinguished Hispanic culture from the rest of Europe. According to Kagan, the Spanish were characterised by the 'emphasis given to the Aristotelian concept of the city as the site of civilized life'.[26] Furthermore, the term *policía* – widely used in the early modern period by the Spanish to refer to urban life – derives at its root from the Greek *politeia* (πολιτεια), a word used by both Plato and Aristotle to refer to the polis, but that also incorporated connotations gleaned from Roman culture. In effect, for Spaniards of the

early modern period, policía was also synonymous with refinement, urbanism, and, therefore, with 'civilized' life.[27] In fact, for Kagan and other scholars, like Fraser, Spain is perhaps the European nation that placed the most importance on the notion of the urban in the sixteenth century. The founding of cities was, in effect, the central strategy of their programme of conquest and colonisation in the Americas. As Kagan succinctly puts it,

> For Spaniards, therefore, policía signified life in a community whose citizens were organized into a republic. More specifically, again following Aristotle, this implied the subordination of individual wishes and interests to those of a community, a subordination guaranteed by ordinances and laws.[28]

This idea, in turn, was closely related to the notion that the city was an 'antidote' to 'what the Spanish perceived as a strange environment inhabited by hostile peoples'.[29] This 'antidote' was undoubtedly used in the reconquest of the Iberian Peninsula by the Catholic monarchs and again in the conquest of the New World. It is a well-known fact, for example, that one of the first acts that Hernán Cortés carried out when disembarking on the coast of Veracruz, before he and his men set out to explore and conquer the centre of present-day Mexico, was to gather his crew and establish a council, a cabildo in Spanish. Setting up a cabildo was a legal strategy by Cortés to defend himself against the possibility of being accused of insurrection for sailing from Cuba against the orders of the island's governor, Diego Velázquez.[30]

To reinforce the notion that the urban environment is the place of 'civilized life' in the Hispanic world of early modernity, we must also turn to Spain, where the sixteenth century witnessed a 'golden age of the Spanish city'. Indeed, many of the principal cities of the Iberian Peninsula enjoyed a period of prosperity, urban renewal, and redefinition. A combination of economic and political circumstances, including commercial activity with the New World, sparked the flourishing of cities such as Segovia, Barcelona, Seville, and especially Madrid, which in 1561 became the de facto capital of the Spanish Empire. These cities began to experience profound changes in their urban fabrics, such as new gates, widened avenues, urban growth past the defensive walls, improvements to or construction of public buildings, and so on.[31]

The flourishing of the mannerist and baroque city on both sides of the Atlantic was accompanied by an outpouring of festivities in the main public spaces. These festivities reminded the public of the image of the king and his 'symbolic body'. In effect, the objective was to amplify and legitimise his figure amongst the populace. In the American possessions, the role of the king was delegated to the viceroy and, at the local, urban level, to the body of the cabildo or council, which, in the final instance, represented the Spanish Crown.[32]

THE MESOAMERICAN CITY

Although it would be impossible to summarise the pre-Hispanic urban tradition in a few sentences, it is worth discussing, even if briefly, the concept of urbanity in a representative Indigenous culture of Mexico, the Nahua. Doing so allows us to gain an understanding of how much it contrasted with European notions of the urban, and what was at stake when the Spaniards pursued their colonial operations to convert the built environment and the Indigenous peoples of central Mexico. The Nahuas, at the time of contact with the European colonisers, had a sense of landscape and territoriality that differed significantly from that of the Spaniards.

To begin with, the territorial unit that defined an urban centre was called an *altepetl*, the guiding concept of Nahua territoriality, which was defined based on its forms of community organisation. The altepetl needed a series of essential elements to exist. First, a territorial or urban demarcation; second, a series of institutions that sustained the existence of this unit; and finally, a ruler of lineage, known as *tlatoani*. But in addition, it also required an architectural dimension of necessary infrastructure. The essential architectural and institutional elements were the temple or *teocalli*, the palace or *tecpan*, and the market or *tianquiztli*. The altepetl as a communal settlement was, in turn, divided into neighbourhoods, also called *calpolli*, which were reflections or 'microcosms' of the altepetl itself and provided it with tribute and labour.[33]

The main differences between the notion of the urban in sixteenth-century European terms, and those of the Nahuas at the time of contact with the Spaniards, can be boiled down into two concepts. The first was the porous and fluid character of the geographical limits of an altepetl, since although it contained an urban centre made up of the teocalli, the tecpan, and the tianquiztli, the urbanity of the calpollis, the residential areas, was more difficult to grasp from a Western perspective of what constituted the urban. The calpolli could be defined in modern terms as a low-density, sprawled-out residential area, since the residential units were surrounded by ample farmland and lacked any strict patterns of dense organisation. In contrast, the Spaniards employed very defined and dense urban forms in the establishment of their towns, in which residential units were grouped densely on clearly defined plots of land within a rigid layout.

The second element that distinguished Nahua urbanism was the intimate relationship that the *altepeme* (plural form of 'altepetl') established with the landscape in which they settled and that surrounded them, mainly hills, mountains, trees, and streams, rivers, and other bodies of water. The role of the landscape of the altepetl and its resources was not only to provide raw materials and food – it did not exist solely for exploitation. Rather, its topographical and geographical elements also constituted the mythical-religious foundation that

informed the urban-architectural configuration of an altepetl and its constituent urban elements, such as plazas, temples, and marketplaces. In addition, the symbolism provided by the landscape endowed the cosmological vision of the inhabitants of the altepetl with sources of meaning and continuity.[34]

Moreover, the altepetl, as García Zambrano and Fernández Christlieb affirm, had its conceptual equivalent in other pre-Hispanic cultures. Although not exactly the same, very similar cases can be seen with the Totonaca, Zapotec, Mayan, Huasteca, Mixe-Zoque, and other cultures. The Nahua culture and others had a common point in the veneration of the landscape and its topographic elements, and in a cosmogony that divided the universe, both physical and mythological, into simple geometric elements, such as the four directions of the world and the centre as a geometric position (which made reference to the central axis of the universe, often envisioned and represented as a sacred mountain or a hill). Likewise, they identified mythological-geometric elements such as the columns of the universe. These traits nourished the Nahua and other Mesoamerican cultural cosmogonies while informing their urban and architectural decisions.[35]

However, the introduction of European and Hispanic construction and domestic cultures, as well as their methods for administering and exploiting the territories of New Spain, inevitably caused a dramatic transformation of Indigenous urban and architectural traditions. In this way, their understandings of space and territoriality, as well as the intimate relationships they established with the landscape, were sometimes wholly dissolved or dramatically altered. In this sense, it is important to highlight the role of the introduction of early modern European ideas related to space and time to New Spain in the dramatic conversion of the cosmological vision of Indigenous cultures at the time of contact with Europeans.

Conclusion: Colonisation, Conversion, and the Phenomenology of the Built Environment

It is the notion of conversion – the conversion of religious beliefs, ideologies, environments, and traditions – that lies at the heart of the colonisation of the Americas. In effect, as established earlier and as affirmed by Dussel and Mignolo, the colonisation of the Americas by Europeans attempted to transform the sense of space and time of the colonised. Therefore, at the heart of the processes of colonisation lies the concept of conversion, without which colonisation would not have been possible in Spanish America. Indeed, the idea of colonising and the way it is typically defined, as the act of establishing colonies of settlers on behalf of a colonial power or state that establishes political control over a territory, might apply to colonial endeavours by the British or the Dutch, but only partially defines the colonisation of New Spain and other territories in the Spanish Americas during the early modern period.

Indeed, in New Spain and other territories colonised by the Spanish, the need to maintain and subjugate the Indigenous peoples in order to exploit their labour and to gain their souls on behalf of Christianity made the act of colonisation a process that hinged on the initiation and success of the conversion operation. Only if conversion was successful would the act of colonising the people and their territories ever be completed. In this regard, the act of conversion of the Indigenous populations of New Spain, together with the psychophysiological and sociological aspects associated with the concept of conversion, were essential in attempting to fulfil the colonisation of New Spain and the New World.[36]

According to Pierre Hadot, the notion of conversion stands for a reversal, a 'change of direction' that designates, succinctly, any turn in the terms of a proposition. Hadot's definition of conversion can be applied to the colonisation enterprise that upended the lives of the Indigenous peoples of Mexico, given that, as Hadot also argues, conversion aspires to universality and 'lay[s] claim to the totality of the person'.[37] In effect, every religious and political doctrine that demanded a total conversion was missionary in essence. In addition, if force from a military or political apparatus were employed to achieve conversion, its outcome could very well end up being violent. Indeed, the need to 'conquer' souls might be the fundamental aspect of Western Christianity, as Hadot argues, and we find that the colonisation of the Spanish American territories, understood as a process of conversion, fulfils all the aspects enunciated by Hadot: aspiration to universality, the employment of violence in missionary endeavours, and the conquering of as many souls as possible for Christendom.

Furthermore, as has been argued here, in the context of the cultural and spiritual conversion of New Spain the built environment played a fundamental role in inciting, suggesting, mandating, and norming the attitudes and expectations of Indigenous peoples in their conversion processes. In phenomenological studies, the role played by the material context has been proved to be crucial in determining attitudes toward the lived experience.[38] The built environment, in this way, was central to the religious and cultural conversion of the Indigenous peoples of New Spain. Seeing the religious significance of a material environment, as in a church building, determines, at least in part, the significance of the religious experience. Indeed, the religious experience is grounded in the experience of the material context, an idea that can be extended to both specific buildings and landscapes or environments. A similar notion can be applied to civic and social life, wherein the built environment will be conducive to orienting and thereby determining the behaviours and social norms of the colonised.

In this context, and as argued in this essay, architectural treatises and the tradition of classical architecture in the context of viceregal Mexico should be understood for what they are: part of a more extensive colonial apparatus that

was deployed with an apparent agenda in mind, that of the conversion of the subjugated peoples of New Spain and the public declaration of power on behalf of the colonisers. This statement acquires particular importance in the context of architectural history, given that the scholarship on Renaissance architecture has traditionally focused on Italian architecture of the fifteenth and sixteenth centuries. The problem with this practice resides in what gets excluded from that narrative, namely, how Renaissance architecture reached all corners of Europe and beyond, and what occurred in the process. Questions of how other cultures appropriated that tradition for themselves and to what ends, and how classical vocabularies became entangled with other traditions, Indigenous ones in the case of New Spain, remain understudied. These issues point to notions of how identities were shaped and by whom, and which groups of people experienced a condition of alterity. In other words, the classical tradition in colonial contexts often embodied messages of authority, subjugation, conversion, or consensus as the world became modern.

While the global expansion of classicism remains underexplored by scholarship, the limited existing research reveals the extent to which classical architecture developed in and became incorporated into different contexts amidst an array of social, cultural, and political agendas.[39] Indeed, the classical tradition beyond Italy tells countless and fascinating stories associated with the movement of people, treatises, and spolia, as well as various forms of political and religious conversion in colonial contexts. These histories, directly or indirectly, disclose the subaltern quality of certain groups in relation to others, just as architecture and urbanism reveal their own central roles in those processes of conversion.

NOTES

For an earlier version of this essay, please see: Juan Luis Burke, 'La teoría arquitectónica clásica en la Nueva España y los tratados arquitectónicos como artefactos colonialistas', *Bitácora Arquitectura* 43 (July–November 2019): pp. 70–9, http://dx.doi.org/10.22201/fa.14058901p.2020.43.72951

1. Regarding Viceroy Mendoza's volume of Alberti, see: Tovar de Teresa, 'La utopía del virrey de Mendoza'. Regarding the arrival and dissemination of architectural treatises to New Spain, see Pérez Galdeano, 'Algunas consideraciones', pp. 107–18.
2. Basalenque, *Historia de la provincia*, pp. 198–200, http://cdigital.dgb.uanl.mx/la/1080027706/1080027706.html.
3. Portilla, *Instrucciones*, p. 46.
4. The term architect was uncommon in the Spanish language in the sixteenth century, and alternative terms such as master builder (*maestro mayor*), master stonemason (*maestro de albañilería*), and the like, were employed instead. The term *alarife*, derived from the Arabic, deserves special attention, given that its use conveyed mastery of a series of abilities and skills, such as construction technology, surveying, and engineering. For a discussion of the nature and definition of

the word alarife in the context of the sixteenth and seventeenth centuries in Spain and New Spain, see, for example: Fernández, 'El albañil', pp. 49–68; Morales, *Constructores*; Kagan, *Spanish Cities*, p. 404.

5. Cuesta Hernández, *Arquitectura del Renacimiento*, pp. 83–8.
6. Vitruvius Pollio, *On Architecture*, p. 194.
7. Evers and Thoenes, *Teoría de La Arquitectura*, p. 25.
8. Carpo, *Architecture in the Age of Printing*, p. 6.
9. Ibid., p. 45.
10. Another study on this topic is Cuesta Hernández, 'La teoría de la arquitectura', pp. 442–59.
11. The scholarship on architectural treatises in New Spain is vast. Some titles are: Cuesta Hernández, 'Sobre el estilo arquitectónico', pp. 61–88; Terán Bonilla, 'Serlio en Nueva España', pp. 13–23; Fernández, *Cristóbal de Medina*; Toussaint, 'Vitruvio interpretado', pp. 85–92.
12. Alina Payne's work discusses categories such as *imitatio, licentia, decorum*, and ornament, while the work of Liane Lefaivre and Alexander Tzonis helps untangle the notions of decorum, ornamentation, and taxis, among others. See Payne, *The Architectural Treatise*; Lefaivre and Tzonis, *Classical Architecture*.
13. It is important to recognize that before the arrival of Arciniega there was already a construction industry in New Spain, but there was no professionalization of the discipline, nor was there a definite style present in the viceroyalty's civic and religious buildings, a situation that changed in the late sixteenth century. See: Kubler, *Arquitectura Mexicana*; Fernández, *Cristóbal de Medina*; Fernández, 'El nacimiento', pp. 17–28; Toussaint, 'Vitruvio interpretado', pp. 85–92; McAndrew and Toussaint, 'Tecali, Zacatlan, and the Renacimiento Purista', pp. 311–25.
14. In Puebla, in fact, Indigenous builders were allowed to enter the guild, at least from sometime in the seventeenth century, as qualified labour was scarce. However, their spheres of practice were limited to less sought-after commissions or to building in peripheral, Indigenous, or mixed-race neighbourhoods. In Mexico City, the guild ordinances for builders specifically prohibited Indigenous men from joining their ranks. Castro, *Constructores de la Puebla*; Fernández, 'El albañil'; Olvera Calvo, 'Los sistemas constructivos', pp. 7–43.
15. Mignolo, *The Darker Side*. See particularly 'Part 3. The Colonization of Space'.
16. Lefaivre and Tzonis, *Classical Architecture*, pp. 1–6.
17. Mignolo, *The Darker Side*, p. 242.
18. Ibid., p. vii.
19. Dussel, 'Las motivaciones reales', p. 406.
20. Ibid.
21. This was a common term in the Hispanic world of the early modern era, which referred to the notion of governance and civility. See below for a further discussion of this concept.
22. Brothers, 'The Renaissance Reception', p. 98.
23. Checa and Nieto, 'Una imagen definida y precisa'.
24. Fraser, *The Architecture of Conquest*. See, particularly, pp. 154–67.
25. Kagan, *Urban Images*.
26. Ibid., p. 26.
27. Ibid., p. 27.
28. Ibid.
29. Ibid.
30. Cortés and Pagden, *Hernán Cortés*, p. 26; Díaz del Castillo and Carrasco, *The History of the Conquest*, p. 71.
31. Kagan, *Spanish Cities*, p. 26.

32. For festivals and public performances in the European Renaissance, see Strong, *Art and Power*; for a great study on Mexican viceregal public spectacles and rituals, specifically in the city of Puebla, see Ramos, *Identity, Ritual, and Power*; and for an exhaustive work that explores the figure and role of the Spanish king during the early modern period and his symbolic presence in the New World, see the great work by Cañeque, *The King's Living Image*.
33. Bernal García, and García Zambrano, 'El altépetl colonial'.
34. Ibid., see in particular the introduction and chapter 1.
35. López Austin, 'Las columnas del cosmos', pp. 13–37; García Zambrano and Fernández Christlieb, 'Introducción', pp. 14–15.
36. The psychophysiological aspects that Hadot alludes to include aspects of consciousness, physiological conditioning, and brainwashing. Sociological aspects include being uprooted from a social milieu and adhesion to a new community and a new religion. See: Hadot, 'Conversion', pp. 979–81. https://aioz.wordpress.com/2010/05/17/pierre-hadot-conversion-translated-by-andrew-irvine/.
37. Hadot, 'Conversion'.
38. Wynn, 'Phenomenology of Religion'. https://plato.stanford.edu/archives/win2016/entries/phenomenology-religion/.
39. Temple, Piotrowski and Heredia, 'Introduction', pp. 1–14.

Works Cited

Bernal García, María Elena, and Ángel Julián García Zambrano, 'El altépetl colonial y sus antecedentes prehispánicos: contexto teórico-historiográfico', in *Territorialidad y paisaje en el altépetl del siglo XVI*, 1st edition (Mexico City: Fondo de Cultura Económica, 2016), pp. 31–113.

Brothers, Cammy, 'The Renaissance Reception of the Alhambra: The Letters of Andrea Navagero and the Palace of Charles V', *Muqarnas* 11 (1994), pp. 79–102.

Cañeque, Alejandro, *The King's Living Image: The Culture and Politics of Viceregal Power in Colonial Mexico*, 1st edition (New York: Routledge, 2004).

Carpo, Mario, *Architecture in the Age of Printing: Orality, Writing, Typography, and Printed Images in the History of Architectural Theory* (Cambridge: The MIT Press, 2001).

Checa, Fernando, Alfredo Morales J., and Víctor Nieto, *Arquitectura del Renacimiento en España. 1488–1599* (Manuales de Arte) (Madrid: Cátedra, 2009).

Cortés, Hernán, and Anthony Pagden, *Hernán Cortés: Letters from Mexico*, revised 2nd edition (New Haven: Yale Nota Bene, 1986).

Cuesta Hernández, and Luis Javier, *Arquitectura del Renacimiento en Nueva España: 'Claudio de Arciniega, Maestro Maior de la Obra de la Yglesia Catedral de Esta Ciudad de México'* (Universidad Iberoamericana, 2009).

_____, 'La teoría de la arquitectura en la Nueva España. La Architectura Mecánica Conforme a la Práctica de esta Ciudad de México, en su contexto', *Revista Destiempos* I (14) (abril, 2008), pp. 442–59.

_____, 'Sobre el estilo arquitectónico en Claudio de Arciniega', *Anales del Instituto de Investigaciones Estéticas* 76 (2000), pp. 61–88.

Díaz del Castillo, Bernal, and David Carrasco, *The History of the Conquest of New Spain by Bernal Díaz Del Castillo* (Albuquerque, NM: University of New Mexico Press, 2008).

Dussel, Enrique, 'Las motivaciones reales de la Conquista', *Concilium. Revista internacional de teología*, no. 232 (November 1990), pp. 403–15.

Evers, Bernd, and Christof Thoenes, *Teoría de La Arquitectura. Del Renacimiento a la actualidad*, vol. 1 (Cologne: Taschen, 2015).

Fernández, Martha, *Cristóbal de Medina Vargas y la arquitectura salomónica en la Nueva España del siglo XVII* (UNAM, 2003).

_____, 'El albañil, el arquitecto y el alarife en la Nueva España', *Anales del Instituto de Investigaciones Estéticas* XIV, no. 55 (1986), pp. 49–68.

_____, 'El nacimiento de la arquitectura barroca novohispana: una interpretación', *Anales del Instituto de Investigaciones Estéticas* 14, no. 56 (8 June 1986), pp. 17–28.

Fraser, Valerie, *The Architecture of Conquest: Building in the Viceroyalty of Peru, 1535–1635* (Cambridge: Cambridge University Press, 1990).

García Zambrano, Angel Julián, and Federico Fernández Christlieb, 'Introducción', in *Territorialidad y paisaje en el altépetl del siglo XVI* (Mexico City: Fondo de Cultura Económica, 2007), pp. 13–25.

Hadot, Pierre, 'Conversion', in *Encyclopaedia Universalis*, trans. Andrew Irvine, 4 (Paris: Encyclopaedia Universalis, 1968), pp. 979–81. https://aioz.wordpress.com/2010/05/17/pierre-hadot-conversion-translated-by-andrew-irvine/.

Kagan, Richard (ed.), *Spanish Cities of the Golden Age: The Views of Anton van Den Wyngaerde* (Berkeley, Los Angeles, London: University of California Press, 1989).

_____, *Urban Images of the Hispanic World, 1493–1793* (New Haven: Yale University Press, 2000).

Kubler, George, *Arquitectura Mexicana del Siglo XVI* (Fondo de Cultura Económica, 1983).

Lefaivre, Liane, and Alexander Tzonis, *Classical Architecture: The Poetics of Order*, 2nd edition (Cambridge: MIT Press, 1987).

López Austin, Alfredo, 'Las Columnas del Cosmos', *Arqueología Mexicana, Cosmogonía y geometría cósmica*, no. 83 (December 2018), pp. 13–37.

McAndrew, John, and Manuel Toussaint, 'Tecali, Zacatlan, and the Renacimiento Purista in Mexico', *The Art Bulletin* 24, no. 4 (1942), pp. 311–25.

Mignolo, Walter D., *The Darker Side of the Renaissance: Literacy, Territoriality, & Colonization* (Ann Arbor: University of Michigan Press, 1998).

Morales, Efraín Castro, *Constructores de la Puebla de Los Ángeles: Arquitectos, alarifes, albañiles, canteros y carpinteros novohispanos* (Puebla, Mexico: Museo Mexicano, 2004).

Olvera Calvo, María del Carmen, 'Los sistemas constructivos en las "Ordenanzas de albañiles de la ciudad de México de 1599." Un acercamiento', *Boletín de Monumentos Históricos – Tercera época*, no. 22 (August 2011), pp. 7–43.

Payne, Alina A., *The Architectural Treatise in the Italian Renaissance: Architectural Invention, Ornament and Literary Culture* (Cambridge: Cambridge University Press, 2011).

Pérez Galdeano, Ana María, 'Algunas consideraciones sobre la difusión de los tratados de arquitectura en Hispanoamérica (siglos XVI–XVII)', *Cuadernos de arte de la Universidad de Granada* 40 (2009), pp. 107–18.

Portilla, Anselmo de la, *Instrucciones que los virreyes de la Nueva España dejaron a sus sucesores*, vol. 1 (Mexico City: Imprenta de Ignacio Escalante, 1873).

Ramos, Frances L., *Identity, Ritual, and Power in Colonial Puebla*, 1st edition (Tucson: University of Arizona Press, 2012).

Strong, Roy, *Art and Power: Renaissance Festivals, 1450–1650* (Woodbridge, Suffolk: Boydell Press, 1984).

Temple, Nicholas, Andrzej Piotrowski, and Juan Manuel Heredia, 'Introduction: A "world" Reception of Classical Architecture', in *The Routledge Handbook of the Reception of Classical Architecture* (New York: Routledge, 2020), pp. 1–14.

Terán Bonilla, José Antonio, 'Serlio en Nueva España. Estudio preliminar', in *Tercero y quarto libro de architectura de Sebastián Serlio Boloñés. Edición facsimilar* (Puebla: Secretaría de Cultura, Gobierno del Estado de Puebla, 1996), pp. 13–23.

Toussaint, Manuel, 'Vitruvio interpretado por un arquitecto novohispano', *Anales del Instituto de Investigaciones Estéticas 5*, no. 18 (1950), pp. 85–92.

Tovar de Teresa, Guillermo, 'La utopía del virrey de Mendoza', in *La utopía mexicana del siglo XVI: Lo bello, lo verdadero y lo bueno*, 1st edition (Mexico City: Editorial Azabache, 1992).

Vitruvius Pollio, Marcus, *On Architecture*, trans. Richard Schofield (London: Penguin, 2009).

Wynn, Mark, 'Phenomenology of Religion', in *The Stanford Encyclopedia of Philosophy* (Stanford, CA: Stanford University, 2016). https://plato.stanford.edu/archives/win2016/entries/phenomenology-religion/.

6

MATERIAL AND SPIRITUAL CONVERSIONS: JACOPO LIGOZZI AND THE *DESCRIZIONE DEL SACRO MONTE DELLA VERNIA* (1612)

Bronwen Wilson

Lithic forms, their uneven surfaces accentuated by dense cross-hatching, surge upward as they vie for attention on a page of a tall printed book (Fig. 6.1). A dark outcrop on the left is obstructed by a luminous slab that tilts back, as if from the force of tussling with the large tree whose roots probe its crevices. Resembling fossilised limbs, the extremities of the slab reverberate in the animated branches and trunks of trees, as slow geological forces quicken into arboreal foliage. At the bottom of the sheet, serrated rocks impede access to the mountain, rendering viewers uncertain about their location. Honed edges of stone in the foreground gesture toward the left where the corner of a small building appears, its human artifice easily overlooked in this isolated setting. And yet, the masonry wall contrasts purposefully with surrounding rocks, some of which have been cut out from paper and can be manipulated. Pulling down a boulder near the building exposes a pilgrim and his guide navigating a path (Fig. 6.2). Turning another large overslip to the right reveals the stone bed of St Francis of Assisi (Fig. 6.3). The challenging landscape slows the journey through the saint's retreat at La Verna, amplifying its difficulties, and accordingly also its rewards.

The location of the stone bed and Francis' oratory is 'very remote and obscured', according to Lino Moroni's title for the image in his *Descrizione del Sacro Monte della Vernia* (Description of the Sacred Mountain of La Verna, 1612). The engraving is the eighteenth of twenty-three images in this ambitious volume, 45 cm in height, in which bespoke printing, the mountain,

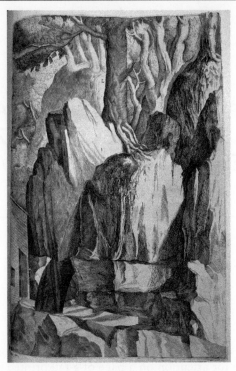

Fig. 6.1 Jacopo Ligozzi (designer) and Domenico Falcini (engraver), Plate R, 'Description that is characteristic of the place known as the Bed of Father St Francis, with his very remote and obscured Oratory', in Lino Moroni, *Descrizione del Sacro Monte della Vernia* (1612). Princeton University Library, Special Collections – Graphic Arts Collection, E-000010.

and miracles ascribed to the saint are intertwined.[1] La Verna, in the valley of Casentino in the province of Arezzo, had been donated to Francis to use as a retreat in 1213.[2] He was believed to have received the stigmata there, which led to a swift canonisation in 1228, only two years after his death. Remaking the monastic complex in the format of a book nearly 400 years later was intended to reignite interest in the Franciscan cult and the site, which had fallen into a state of disrepair from damage caused by a fire and the appropriation of its buildings to house troops.[3] In his brief dedication to Cardinal Arcangelo da Messina, Archbishop of Monreale and general of the Franciscan Observant order, Moroni explains having been inspired to undertake the work by the Cardinal's desire to promote veneration of the site. Moroni was a friar at San Salvatore di Ognissanti in Florence, where he met Jacopo Ligozzi, whom he commends to the Cardinal for his designs of the volume, noting also his work for the Medici Dukes, '*in servizio di quest'Altezze Serenissime*'.[4]

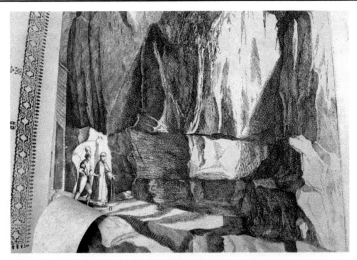

Fig. 6.2 Detail of 6.1, Jacopo Ligozzi (designer) and Domenico Falcini (engraver), Plate R. Princeton University Library, Special Collections – Graphic Arts Collection, E-000010.

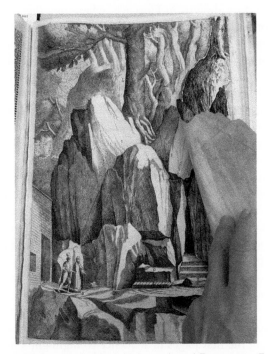

Fig. 6.3 Detail of 6.1, Jacopo Ligozzi (designer) and Domenico Falcini (engraver), Plate R. Photo by author. Getty Research Institute, Los Angeles, (84-B16400).

The artist had been employed by the Observants to paint a fresco cycle in their cloister during the 1590s, and he designed a *pietra dura* (hard stone) altar front for their apse at Ognissanti, dated to 1593–1605 (Fig. 6.22). He travelled with Moroni, Friar Lino, to La Verna in 1607, where they recorded dimensions of the mountain's vertiginous bluffs, buildings, and hidden places where miracles and visions were believed to have occurred. Etchings and engravings of Ligozzi's drawings were executed by Raffaello Schiaminossi and Domenico Falcini.[5] The printed images were published in 1612, probably in Florence, with Friar Lino's legends on the facing pages.

Extant copies of the *Descrizione* are few, but it is well-known to scholars of Ligozzi's works.[6] Lucilla Conigliello, for example, in her comprehensive and foundational study of the drawings, the prints, and the iconography, highlights connections the book asserts between La Verna and Calvary.[7] Noting the unusual combination of both accurate measurements and Friar Lino's ebullient descriptions of miracles that accompany the printed images, Conigliello refers to the volume as a *guazzabuglio* – a jumble of scientific intentions and religious zeal.[8] Building on this intriguing contradiction, this chapter fastens onto the dynamics of print making, of cutting and making things from stone, and of earth's creative potential. Stone is a protagonist in both the *Descrizione* and in Ligozzi's pietra dura designs in Florence, where its otherworldly character manifests transformations of matter and of time. This lithic imagination operates in tandem, as I will argue, with inventive uses of print and perspective to solicit on-going interaction with the site. An exemplary conversion machine, the *Descrizione* repeatedly unmoors beholders and then reorients them toward the mysteries of the mountain and the order's founder.

The work of the printed image is introduced in a brief address to 'the reader and spectator'. Friar Lino reports 'wanting to publish the description of the Sacred Mountain of VERNA, first with prints cut in copper, and then with the inscription of words, so that each part would be better understood, and so that all the faithful would be delighted by the Angelic Father Saint FRANCIS and this Sacred Mountain, inhabited by him, by some of his companions, and by other Blessed in succession over time all the way to the present day'.[9] That Friar Lino uses the term *spettatore*, which refers to an audience member at an event, warrants note. For the printed images and large format are constructed as a sequence of performances, even moving images.

The complex designs of the *Descrizione* attest to ways in which conversions of souls, bodies, and materials were understood as on-going, incomplete processes. Every encounter with the volume illuminates something previously unobserved. Accordingly, my account of the volume is necessarily partial. I begin by describing the first pages in sequence to highlight some of the inventive and recurring strategies as they unfold. I then consider the Florentine context, where Ligozzi made designs for pietra dura for the Medici Dukes and

for the Observants. Exploring the translation of cutting stone into print in the *Descrizione,* I conclude with comments on the volume's ornamentation and printing in Florence.

On the first plate, extra-terranean cliffs shoot upward (Fig. 6.4). They tower over the valley that can be glimpsed in the lower left corner. Unfolding the etching to the right, the mountain expands across three sheets of paper that have been pasted together to measure 77cm. Cross-hatching converges in inky crevices of rocky escarpments that undulate horizontally across the etching (Fig. 6.5). Cliffs fracture into perilous shards as they ascend, accentuating precipitous settings where miracles and visions were believed to have occurred in the past, and foreseeing those on the pages of the book to come. Consider, for instance, the small detail of a falling body that provokes inspection (Fig. 6.6). The arc of the body, arrested mid-flight, is doubled by the swoop of the shadow cast by a Franciscan habit against the face of the cliff. The letter V, inscribed between the two curving forms, is keyed to the legend on the facing page, where the text explains how a friar, who lost his footing, was saved from death. The legend, in turn, may prompt notice of a miniscule chapel, perched at the top of the cliff on the far left, near the letter A. Returning to the falling friar, vertiginous bluffs begin to metamorphose, their surfaces swelling and softening as their height diminishes toward the right where a large rock topped with a cross marks the entrance. The path, designated by a parapet wall, makes a turn to the left where three pilgrims can be seen beginning their ascent. The caption for the letter T reads: 'A road, that was cut into the stones to climb up to the convent'.[10] Stones, and signs of their being cut, are ubiquitous.

Friar Lino anticipates viewers' experiences of the printed images in his brief address, by describing his own disorientation, astonishment, and eventual comprehension of La Verna as it comes into focus *'come gran fabbrica'* – like a great working structure. The terrain changes constantly, he explains, with impressions of it varying as one approaches: 'this Sacred Mountain displays itself (fà mostra di sè) from different sides, and from various distances'. From Romagna, from Umbria, from the cities of Arezzo and Florence, on the road from Casentino, and from the 'Mountain called Consuma, above the Valley of Ombrosa,' it can be difficult to see (oscuro, oscurissimo). But then gradually one recognises buildings (fabbriche), habitations, and structures (fabbriche), and moving closer, one recognises it rather better to be a structure (fabbrica), and habitation, and even grander, and finally, encountering its 'nude rocks ... of a height so vast, it appears to be 'come gran fabbrica'.[11] To make sense of the site for Friar Lino entails moving closer, stepping back, and comprehending the disposition of its parts gradually – discovering something in the darkness and moving toward understanding.

The *Descrizione* was envisioned in part as a memory device – as a guide to La Verna's working parts that would provoke devotion. In his dedication,

Fig. 6.4 Detail of 6.5, Jacopo Ligozzi (designer) and Raffaello Schiaminossi (etcher), Plate A. Photo by author. Getty Research Institute, Los Angeles (84-B16400).

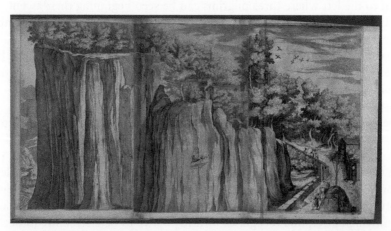

Fig. 6.5 Jacopo Ligozzi (designer) and Raffaello Schiaminossi (etcher), Plate A, 'The following prospect shows how the Mountain of La Verna appears close to a quarter mile while journeying from Casentino, noting the most important Places by the letters of the Alphabet, according to the promised order, which will be observed in this Work, as in other parts of it', in Lino Moroni, *Descrizione del Sacro Monte della Vernia* (1612). Image: 58318751. Courtesy The New York Public Library, Digital Collections.

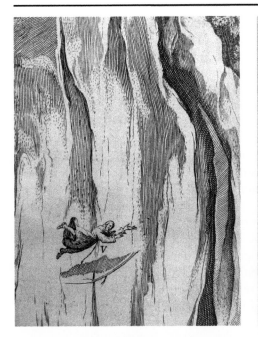

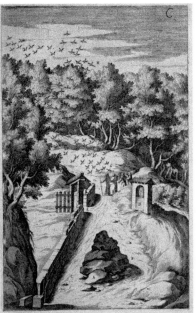

Fig. 6.6 Detail of 6.5, Jacopo Ligozzi (designer) and Raffaello Schiaminossi (etcher), Plate A. Photo by author. Getty Research Institute, Los Angeles (84-B16400).

Fig. 6.7 Jacopo Ligozzi (designer) and Raffaello Schiaminossi (etcher), Plate C, 'Imprint that represents the place where many Birds came to meet Father St Francis when he first came to this Holy Mountain, with the distinguishing things that were found at that site', in Lino Moroni, *Descrizione del Sacro Monte della Vernia* (1612). Getty Research Institute, Getty Research Institute, Los Angeles (84-B16400).

Friar Lino recalls the Cardinal's desire 'to increase devotion among people to this place through some particular memory of it, and especially for those who are absent from these parts'.[12] He cites extensive research of earlier written sources, while emphasising the contribution of the volume's visual images to knowledge about the mountain.[13] A closing remark at the end of the volume reiterates the 'clear intelligence' afforded by the description 'of all the working parts (fabbrica) of this site'.[14] However, the *Descrizione* offers neither a precise itinerary, nor a straightforward narrative. Particulars sometimes strike viewers in a flash, but most come to the surface gradually through repeated

engagement with the book. Drawn toward details, distracted by detours, and reoriented toward the sacred by creative strategies, viewers are petitioned to become active participants and witnesses to what they have seen.

In using the term fabbrica repeatedly, Friar Lino evokes its meanings as both the assembling of buildings into a larger structure, and the institutions overseeing this process, as well as its figurative potential. The word has long referred to 'the activity, the work of building … construction and maintenance'.[15] In canon law, the term identified both a 'church or other sacred edifice in its material structure', as well as the institution and those responsible for its conservation and maintenance – such as the 'fabbrica di San Pietro'.[16] It was used by Andreas Vesalius for his *De humani corporis fabrica* (1543), where it refers both to the human body as a system of parts, and to the format of the anatomical treatise as a graphic compilation of those working parts. *Una fabbrica dei sogni*, to draw on modern figurative usage, refers to a dream factory and to dream builders.[17] Friar Lino's description of the mountain resembling a 'gran fabbrica' is thus of a piece with its buildings and artworks, friars and visitors, artistic and technical expertise, and religious practices and meanings compiled in the volume. It also calls to mind the wider network of sites, institutions, and spectators it connects. Through bespoke printing, the Sacred Mountain becomes a mechanical producer of visions.

A principal strategy for this enterprise was to juxtapose the mutability of the mountain with human manufacture. On plate A, for instance, viewers contend with the vertiginous cliffs until the raking diagonal of a parapet wall directs their focus (Fig. 6.5). The wall, constructed from ashlar masonry, draws attention to the form of the large rock. With its cross and arma Christi, it associates La Verna with Calvary. The dimensions of the rock's faceted surfaces, however, mirror those of the blocks of the parapet wall, calling to mind the quarrying of stone and the work of building. Two pages later, on plate C, the entrance to the mountain appears again, but with notable differences (Fig. 6.7). A less robust parapet wall can be seen on the left, and the rock in the centre is neither quarried nor marked by symbols of the Passion. Most of the structures assembled on the right of plate A are also missing from plate C, but the number of birds has multiplied tenfold. The image propels viewers back to the thirteenth century to see the birds as they turn down from the sky, flocking toward Francis as his brothers circle around. In an easily overlooked detail, one of the friars casts a glance toward the picture plane, to confirm that spectators also witness the scene.

On plate D, an assemblage of buildings unfolds across two pages (Fig. 6.8). A tall masonry wall runs along the lower edge of the left side, its vertical surface flush with the picture plane until the fold line. The wall turns at an angle, as if another page of the book, to illustrate the vaulted gateway. Two large boulders flank the entrance, their sides cut to allow access. Above the

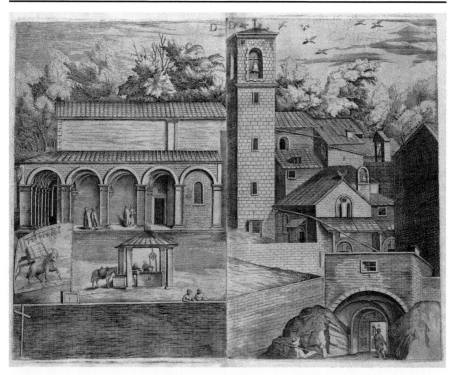

Fig. 6.8 Jacopo Ligozzi (designer) and Domenico Falcini (engraver), Plate D,
'Perspective of the entrance of the first door, with the Piazza, Church, and Loggias
of the Monastery of the Mountain of La Verna, as it appears this year, M.D.C. XII',
in Lino Moroni, *Descrizione del Sacro Monte della Vernia* (1612). Getty Research
Institute, Los Angeles (84-B16400).

gate, buildings proliferate, their angled walls resembling the structure of a
concertina. Buildings on the left side, on the other hand, adhere to the planar
order of the page: the piazza and the nave and the arcade of the church run
parallel with the masonry wall in the foreground. Horizontal lines of ashlar
blocks enhance awareness of human-made forms, while also calling attention
to the flat pages of the book and gesturing to the replicative nature of print.

Connections between architecture and book design are furthered on the next
page, with the façade of the Minor Church and the Door to the Convent depicted
close to the picture plane (Fig. 6.9). Financial support, a theme throughout the
volume, is prominent here. The legend on the facing page is keyed to signs in
the image. The letter O reads: 'Door of the Convent, and \ with the Doorman,
who dispenses alms to the poor', as if the gesture of the disabled man with
outstretched hand requires underscoring. Two men of means pose in the portal,
their elegant costumes contrasting with the rags of the poor and ill, who bend

their bodies deferentially and lie supine in the foreground. The well-dressed pair flank the letter B, which refers readers to Count Orlando, who built the church. The letter D identifies his coat of arms, and his donation of the site. The letter N notes the arms of supporters, including the fifteenth-century pope, Eugene IV; the city of Florence; and the wool guild. Architectural elements, escutcheons, the painting of Francis, sun dial, bell, and human figures are disposed in concert with the combination of horizontal captions and floriated marks on the legend. The visual resemblances between the legend and the image, encourage reading the façade with its ornamentation as if a text.

Increasingly, leaves of paper and walls of buildings resemble each other. As if the façade of the Minor Church were the cover of a book, viewers see inside the building when they turn the page (Fig. 6.10). Constructed as a perspective box, the walls and floor of the church extend from the edges of the printed image toward the apse. The space is divided into three sections by an iron trellis and the *tramezzo* (partition), which displays a crucifix. The tramezzo was used to separate the laity from the monastic community during the mass.[18] The Council of Trent (1545–1563) had otherwise called for the removal of tramezzi in churches to allow visual access to the mass, while also advocating for the use of screens of the kind seen closer to the entrance of the Minor Church. To highlight the function of the metal grille, the partition has been devised as a moveable paper flap.

This screen, which resembles those installed in front of chapels on some Sacri Monti after Trent, prompts consideration of these other sites, especially since the title of the *Descrizione* refers to La Verna as a Sacro Monte. Varallo, near Milan, is a well-studied example of these locales on which chapels were constructed to recreate pilgrimages to the Holy Land.[19] The first Sacro Monte in Northern Italy, it was begun in 1486 by Friar Bernardo Caimi, an Observant Franciscan.[20] Decorated with life-size sculptural and painted figures, its chapels present vivid, sometimes violent, scenes beginning with Adam and Eve and culminating with the Crucifixion. Three-dimensional sculptures and architectural forms merge with illusionistic figures and settings rendered in fresco painting.

Adding metal grilles and glazing (*vetriate*) to the chapels at Varallo made it more challenging to see clearly. They marked a threshold between profane and sacred worlds, while construing the scenes at Sacri Monti as images of other places, as visions of sacred *loci* in the Holy Land.[21] Often requiring visitors to bend their bodies or to kneel, screens enhanced the embodied experience, as pilgrims followed the route prescribed on printed maps, in pamphlets, and in small books with information on appropriate devotional practices. Margaret Bell's study of the vetriate that were designed for Varallo by Galeazzo Alessi between 1565 and 1569, furthers arguments about how these screens were intended to function. Like glass and crystal enclosures of reliquaries, they amplified sacred mysteries and disciplined the faithful, according to Gabriele

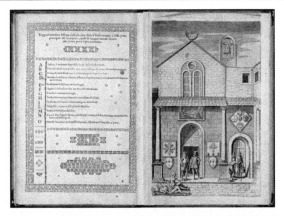

Fig. 6.9 Jacopo Ligozzi (designer) and Domenico Falcini (engraver), Plate E, 'Clear representation of the façade of the Minor Church, and of the main door of the Convent, which are seen entering from the first door mentioned above', in Lino Moroni, *Descrizione del Sacro Monte della Vernia* (1612). Getty Research Institute, Los Angeles (84-B16400).

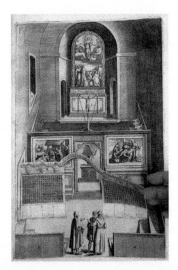

Fig. 6.10 Jacopo Ligozzi (designer) and Domenico Falcini (engraver), Plate F, 'Design of the interior of the first Church, known as the minor Church, on which the Virgin MARY, St John the Evangelist, and St John the Baptist are drawn, built by Count' Orlando Catani, who donated the Mountain to Friar St Francis, & at his request on the same model, and design, was built with the adornments of various ecclesiastical things later made in succession', in Lino Moroni, *Descrizione del Sacro Monte della Vernia* (1612). Photo by author. Getty Research Institute, Los Angeles (84-B16400).

Paleotti's analogy. Writing in 1582, the Archbishop of Bologna explains: 'in the same way that a thin cloth or a transparent crystal is put in front of the sacred relics, the great secrets of things eternal are to be protected in their majesty, and also, by this means, the people more efficiently kept in due reverence'.[22] Paleotti's attentiveness to institutional control of religious mysteries, in this chapter of his treatise, is a veiled challenge to Protestant ideas about direct access to God (a challenge taken up more explicitly by the Jesuits, as Walter Melion shows in Chapter 7 of this book).

This architectural concept and reliquary analogy, which reverberate in ingenious ways in the *Descrizione*, are introduced with the paper trellis partition in the Minor Church – the first overslip encountered in the volume (Fig. 6.10). The visitor standing in the foreground is turned toward the entrance, listening to his Franciscan guides, while the perspective view allows virtual pilgrims to see the sanctuary that is normally reserved for the friars. Raising and lowering the paper screen demonstrates how it alters visual perceptions of sacred images. Manipulating the overslip also provokes notice of the lace-like ornamental decorations on the facing page, whose horizontal bands echo the divisions of space on the page.

On the following sheet, foreboding obstacles challenge sure footing and easy understanding. Dark boulders, that have tumbled down the mountain from the right, mask the precarious cliff-side path that winds toward Francis' first cell (Fig. 6.11). The pile of boulders evokes dangers of landslides, drawing attention to the steep incline to the left, where a tree clings to an outcrop with roots searching for stable ground.

After contending with uneven terrain, and the distractions of elemental forces, the effects of geometry in the image of the Chapel of Mary Magdalene are reassuring (Fig. 6.12). Beholders are reoriented by the familiar architectural surroundings of an interior space and the perspectival ordering of details on the page. The vanishing point propels viewers' eyes to the heart of the penitential saint, who kneels under a rocky canopy.

Turning the page, virtual pilgrims are swiftly thrown off balance again (Fig. 6.13). The direction of the journey is thwarted by uneven lithic formations of unknown dimensions that purposefully defy the book format. Their irregular surfaces provoke reaching out to make sense of their scale by tracing their contours. The Marvelous Boulder (also known as the *Sasso Spicco*) is the first instance in which boulders that block the journey can be manipulated. Turning the overslip exposes the distinctive shape of the projecting rock and the cross (Fig. 6.14). On the left, a Franciscan guides visitors to the location where the saint reported a vision, one in which he saw the fissures of La Verna come into formation in the wake of the earthquake at Christ's death.

Vision, including spiritual visions, as well as touch, are sensory themes that recur throughout the *Descrizione*. Francis' companions tilt their heads to see

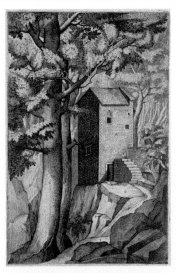

Fig. 6.11 Jacopo Ligozzi (designer) and Domenico Falcini (engraver), Plate G, 'Vista made from the perspective of the Chapel called the Cardinal, together with that of St Mary Magdalene, that are where the first cell inhabited by Father St Francis was', in Lino Moroni, *Descrizione del Sacro Monte della Vernia* (1612). Getty Research Institute, Los Angeles (84-B16400).

Fig. 6.12 Jacopo Ligozzi (designer) and Domenico Falcini (engraver), Plate H, 'One describes separately the site of the Chapel of Mary Magdalene, which is where the first Cell of Father St Francis was, & the mystery of the Stone called the Table of Father St Francis', in Lino Moroni, *Descrizione del Sacro Monte della Vernia* (1612). Getty Research Institute, Los Angeles (84-B16400).

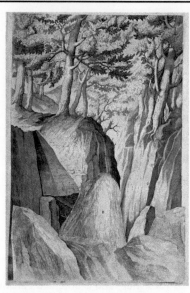

Fig. 6.13 Jacopo Ligozzi (designer) and Domenico Falcini (engraver), Plate I, 'Marvelous Boulder, which is found on the Mountain of La Verna, under which the Father St Francis said The Seven Psalms, & where he had the revelation, that all this mountain, and stones were fractured at the death of JESUS CHRIST', in Lino Moroni, *Descrizione del Sacro Monte della Vernia* (1612). Getty Research Institute, Los Angeles (84-B16400).

Fig. 6.14 Detail of 6.13, Jacopo Ligozzi (designer) and Domenico Falcini (engraver). Photo by author, Getty Research Institute, Los Angeles (84-B16400).

the birds (Fig. 6.7). A visitor and his guide standing in the piazza look down from the parapet wall on the left (Fig. 6.8). A friar gestures to the works of art in the Minor Church (Fig. 6.10). Pilgrims fold their bodies to see the sacred stone in the Magdalene Chapel (Fig. 6.12). The Marvelous Boulder appeals to the sense of touch (Figs 6.13, 6.14). Unable to see the pathway, viewers are compelled to reach out to the overslip as if blind; pulling it back, the mountain discloses its mysteries. Turning the page, another perspective directs virtual pilgrims to the altarpiece in the Chapel of the Cross. The focus is furthered by those in the engraving who sit on benches, stand in doorways, observe from a distance, and genuflect at the altar (Fig. 6.15).[23]

Turning the pages of the *Descrizione* continually reactivates the effects of linear perspective, which resonates with Antonio Manetti's account of Filippo Brunelleschi's apparatus. Manetti describes the device in 1475, in his biography of the architect. Now lost, it was created in about 1420 to demonstrate Leon Battista Alberti's theory of perspective. According to Manetti, the apparatus consisted of a mirror that reflected a small panel with a painting of the Florentine Baptistery, which was dedicated to the city's patron saint John the Baptist.[24] 'Creating the picture', he writes,

> required the painter to postulate beforehand a single point from which his painting must be viewed, taking into account the length and width of

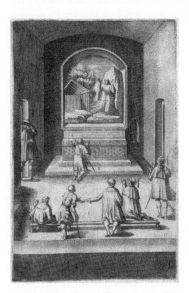

Fig. 6.15 Jacopo Ligozzi (designer) and Domenico Falcini (engraver), Plate L, 'One notes separately the Chapel of the Cross, as it is known today, which is where the second cell of St Francis was, and where he did the Lent of the Angels'. Getty Research Institute, Los Angeles (84-B16400).

the sides as well as the distance such that no errors resulted from looking at it, as any divergence from this spot would alter what the eye perceived; [Brunelleschi] had made a hole in the painted panel, located in that part of the painting [showing] the temple of San Giovanni (St John).[25]

Looking through the hole from the back of the panel, the viewer would see 'a flat mirror directly opposite in such a way that the painting was reflected in it'.[26] Brunelleschi must have been standing in the entrance to the Cathedral when he created the picture, and the hole must have corresponded to his vantage point to ensure that the viewer's eye and the vanishing point of the painting were aligned. As a result, when viewers looked into the device, regardless of where they were standing in Florence, they would have found themselves facing the east doors of the Baptistery – the view from the Cathedral entrance. Alberti called this imaginary line between the viewer's eye and the vanishing point the *raggio centrico* (centric ray), referring to it as the 'prince of the rays'.[27] In the context of the perspective device, this ray corresponds to the east-west axis of the nave of the Cathedral, which was the processional route from the high altar to the Baptistery.

That the latter was where Florentines became Christians must have contributed to the astonishing, even epiphanic, effects of the apparatus, as Manetti describes it. Geometry had been advanced as a means for artists to direct viewers to God since the thirteenth century, but Manetti's account conveys how perspective was seen as proof of geometry's divine nature. 'To look at it', he professes, 'it seemed that one was seeing truth itself.'[28] His description attests to the revelatory and repeatable character of looking into the apparatus: it was a vision of the 'truth itself', he writes, 'and I held it in my hands and saw it several times in my own day'.[29] Alberti's theory (*costruzione legitima*) is itself a conversion machine, one that was demonstrated repeatedly in pictures and in the ingeniously crafted apparatus. The demonstration had an operator, Brunelleschi or others who would have assisted participants, and witnesses would have gathered round.

Manetti's emphasis on the iterative assurance of optical geometry reverberates in the *Descrizione*, where perspective is used strategically, and in two different ways. Both operate in tandem with the large vertical format of the book. On one level, Ligozzi's perspective chapels retain Alberti's alignment between viewer and vanishing point (Figs 6.10, 6.12, 6.15). The mirroring effect of the shuttle between them, along the centric ray, sets the process in motion perpetually, propelling the eye swiftly toward the centre of the altarpieces. Turning the pages, the perspectives reorient viewers to the sacred mysteries, a process that resonates with Manetti's flash of recognition when looking through the hole in the apparatus again and again. In contrast to Alberti's theory, however, in which the eye-height of the viewer is commensurate with those of the human figures depicted in the picture, in Ligozzi's perspectives the virtual pilgrim

looks down on the space. Surveying the religious activities, the design recalls the window in the Vasari Corridor, where the Medici family could listen to the mass at S. Felicità, elevated above and unobserved by the people below. The arrangement of details – benches, partitions, relics, lecterns, altars, sacred sites – combined with the vertical axis of the page, create a set of stopping points that arrests viewers as they move back and forth between the foreground and the sacred image in the altarpiece.

This prospective view enhances the processional character of the religious drama by guiding spectators from the material world in the foreground to the immaterial world of spiritual visions. In plate H, with the Magdalene Chapel, the strapwork cartouche prompts spectators to pause at the picture plane (Fig. 6.12). It encourages them to read the inscription commemorating the 'translation' of the sacred stone to the chapel. The stone was considered a relic, on account of Francis' visions of conversing there with Christ. Just beyond the cartouche, where the stone was installed, two men kneel on the ground. The younger man lowers his torso to inspect the stone through the iron grille that encases it; he leans down with his hands on the ground, conveying the physical effort to understand. Not unlike the screen in the Minor Church, the enclosure distances the relic from his desire to touch it, setting his world apart from the divine one. On the left, the older pilgrim kneels further back. Clasping his hands in prayer, his eyes are fixed on the stone with its trellis frame. Closer to the altar, the stone appears again with Francis and Christ seated on it, which prompts returning to consider the metal trellis again. It becomes clear that the two men who genuflect cannot see the holy figures that Ligozzi has conjured for virtual pilgrims.

In emphasising differences between the gestures of the two pilgrims, the image suggests different levels of understanding that circulated in earlier textual sources, studied by Friar Lino, as he notes in the dedication. Augustino di Miglio's guide to La Verna, for example, which was dedicated to the Medici dukes and published in 1568, has four interlocutors: one is 'determined to reason', another is 'diligent' and 'desires to know'; another is sceptical; and the fourth is 'very devoted to Francis'.[30] The dialogue format enabled authors to give voice to different levels of belief, and to convey stages of belief. Echoing di Miglio's dialogue, Ligozzi's younger man diligently inspects the stone, conveying his 'desire[s] to know', whereas the older man is evidently 'determined to reason'.[31] The latter looks toward the metal grille with conviction, as if summoning Francis' vision to his mind. These devotional activities are performed for spectators who, in contrast to the men in the print, see the vision clearly.

The engraving of the Magdalene Chapel is emblematic of the *Descrizione's* Tridentine aspirations – that visual images should be didactic and also amplify religious mysteries. As Paleotti maintained in his treatise, naturalistic images impressed themselves in the unwary minds of viewers, and more directly than

texts.[32] Paleotti's convictions may be echoed in Friar Lino's aspirations for copper-plate printing, noted above, that the images take precedence over the texts, and that they manifest the mysteries of La Verna. Like the design cut into the matrix, the vision of Christ and Francis on the stone should impress itself in the minds of viewers of the book.

Consider also the role of the altarpiece in Ligozzi's design, and how progress toward the altar overlaps with the immediacy of the single-point perspective, which compels viewers to reflect on the image of Mary Magdalene simultaneously (Fig. 6.12). With the trellis surrounding the sacred stone and the vision of Francis conversing with Christ, Mary kneeling before a rock serves as both an antecedent and a double for Francis. Viewers familiar with her story from the Gospel of St John would recall that Christ also appeared to her after his death, and like Francis, also spoke to her. In the Biblical story, Mary is tending the garden at the tomb when she hears a voice calling her name. Hearing her master's voice, she turns toward him, extending her fingers to touch the apparition. She reaches out to 'hold on to' Christ as he disappears (John 20:17 [NIV]). The trellis is ubiquitous in visual imagery of the Noli mi tangere theme – as a reference to the garden, and also as a marker of the threshold between worlds, between the material world of Mary Magdalene and Christ's divine world.[33] In the engraving of the chapel, the trellis marks this threshold between body and spirit – between tactile desires and sacred visions – and encourages conjoining Francis' visions of conversing with Christ to those of Mary Magdalene.

The lithic outcrop where Mary kneels in the altarpiece fosters connections between the remote sites of her penitence, Christ's tomb, Calvary, and La Verna. This network of places comes into focus on the following page, the Marvelous Boulder, where Francis reported his vision of La Verna's conversion into a second Calvary. Notice how the overhanging stone behind Mary Magdalene with her cross anticipates and also mirrors the boulder and cross disclosed by turning the overslip (compare Figs 6.12, 6.14). In this instance, manipulating paper rocks cut from scissors resonates with stone relics hewn from the lithic surface depicted in the print. Pilgrims to the site reportedly chipped at the stone, taking pieces away as relics of both the body of Francis and the sacred mountain. At Sacri Monti, such as Varallo noted above, the mountains themselves were not sacred. Instead, as representations of the Holy Land and Calvary, it was the performances of piety that became recognised as a source of sacred power and attracted pilgrims.[34] La Verna, in contrast, for Observants and pilgrims, was believed to be sacred. The mountain is not a representation of Calvary, but rather, like the body of St Francis, its re-formation.

With its prospects of the mountain and revelatory overslips, the *Descrizione* recalls the progressive opening up of bodies in anatomy treatises, such as

Vesalius' *De fabrica*, noted earlier, and on fugitive sheets.[35] An example of the latter is Jacob Frölich's *Anathomia oder abconterfettung eines Weibs leib* (Anatomy, or a Faithful Reproduction of the Body of a Female; Fig. 6.16). The woodcut, printed in 1564, presents a female figure sitting on a high bench, her legs parted. A large vessel-shaped flap lifts upwards to display her internal organs. Surrounding the body are details of its parts, including a womb carrying a tiny infant, to the right of the woman's rounded belly. The comparison is worth underscoring, for rocky formations, underground spaces, and quarrying were intimately connected both to remote sites and to the womb of the Virgin Mary.

Consider in this light Andrea Mantegna's *Madonna of the Rocks (Madonna delle Cave)*, painted in tempera in 1488–1490, that was in Francesco de'Medici's collection in Florence when Ligozzi was the family's court artist (Fig. 6.17).[36] The panel presents the Virgin and Child enthroned on

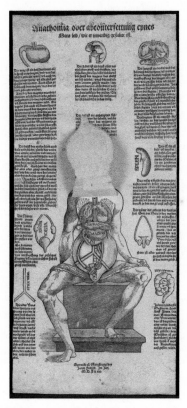

Fig. 6.16 Jacob Frölich (after Heinrich Vogtherr), Anathomia oder abconterfettung eines Weibs leib (Anatomy, or a Faithful Reproduction of the Body of a Female) 1564. Woodcut, 52 × 23.9 cm. The Wellcome Library, London.

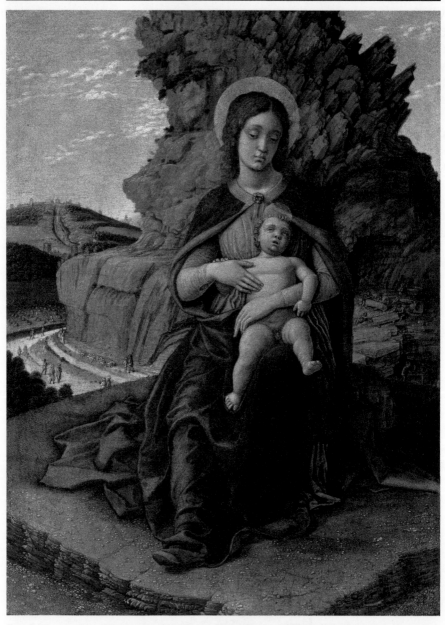

Fig. 6.17 Andrea Mantegna, *Madonna of the Caves*, 1488–1490. Tempera on panel, 32 × 29.6 cm. Florence, Galleria degli Uffizi. Photo: Scala/Ministero per i Beni e le Attività culturali / Art Resource, NY.

a crystalline rock. Above the infant, outcrops sprout from the fantastic lithic throne surrounding them. The pleated limestone to the left is echoed in Mary's robes, and on the right, the cave alludes to her womb. As Jacob Wamberg proposes, the scene evokes a legend that was described by a ninth-century abbot in which the Virgin was identified with a mountain. Christ was miraculously cut from it, according to the story, becoming the rock that was 'born without conjugal labour'.[37] In the cave, however, cutters are at work quarrying and working stone. Wamberg links this legend, through the mythological structure of Pliny the Elder's *Natural History*, with the fall of the iron age and robbing mother earth of minerals and metals. The detail on the right of Mantegna's painting suggests internal forces, the coming into being of art through mining and quarrying.[38] The cavern, with its men cutting stone, resembles caves in the mountains around Florence from which *pietra serena* (serene stone) was excavated for the city's characteristic architectural designs, such as those created by Brunelleschi for the Medici.[39] Mantegna's painting must have appealed to the Dukes whose family began to control access to local quarries as early as the fifteenth century.

The Medici dukes imported stones, studied them, and managed their fabrication in the Opificio della Pietra Dura (Manufactory of hard stone), where Ligozzi's designs for luxury furnishings exemplify his deft expertise with depicting natural phenomena.[40] The artist arrived in Florence in 1577, having been recommended to Francesco de'Medici by Ulisse Aldrovandi. The famous natural historian in Bologna visited Florence the same year, remarking in a letter to the duke that the flora and fauna in Ligozzi's paintings seemed 'to be made from nature as if born in their natural habitat'.[41] Such paintings were the focus of Ligozzi's work in the 1570s and 1580s, which attest to his systematic engagement with the diversity of the natural world. As court artist to the Medici dukes, he instructed members of the family in drawing and painting and he produced designs for an array of luxury objects, from embroidery to festival decorations to paintings of wildlife for the Tribune.[42] He served as *capomaestro* (chief head) of the Florentine Academia del Disegno, but a falling-out with the academy resulted in his dismissal as court artist. The Medici continued to employ him, however, for pietra dura designs, especially after the family consolidated many workshops into the Galleria dei Lavori in 1588.

Ligozzi's design for a tabletop that represents the port of Livorno, attests to the inventive possibilities of these *commesso* works (Fig. 6.18). In commesso production, which refers to materials that are sawn and joined, hard stones are cut into shapes and polished to create images that employ veins, colouration, and natural formations found in the material. Many commesso furnishings were intended for export, often as luxury gifts, but the Livorno example, which is resolutely Medicean in its celebration of both a naval battle against the Ottoman Turks and the Duchy's maritime port, was retained in Florence.

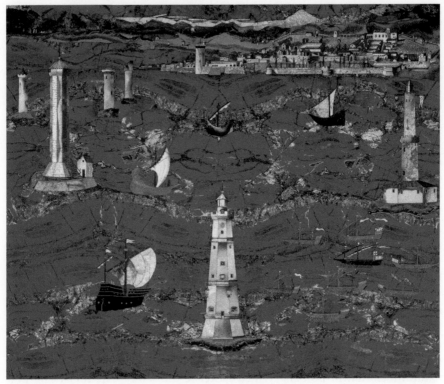

Fig. 6.18 Cristofano Gaffuri from a design by Jacopo Ligozzi, *Port of Livorno*, 1604.
Pietra dura table top, 107 × 94 cm. Florence, Galleria degli Uffizi.
Photo: akg-images / Rabatti & Domingie.

Livorno was where stones arrived by sea for their state-run workshops, which
is also showcased in Ligozzi's tabletop, executed with Cristofano Gaffuri in
1604, when the Ognissanti altar front was likely underway (Figs 6.21, 6.22).
Rocks extracted from mountains and imported by sea have been transformed
into a seascape. Exploiting the effects of colours and veins, semi-precious
stones have been cut into forms for mountains seen on the horizon. They
have been made into architecture and into transitory images: crests of waves,
reflections of buildings on the surface of water, and canvas sails filled with air.
The pulsating viscosity of the lithic frame (not illustrated), with its variegated
colouration and blurred edges, reveals invisible elemental forces.[43]

In the letter commending Ligozzi to Francesco, Aldrovandi also comments
on the beauty and variety of stones. Enclosing samples for the duke to admire,
he provides information about the specific location 'on or beneath the surface
of the earth' where each stone was 'born' or 'generated'.[44] Aldrovandi's under-
standings of stones were drawn from their visual similarities with other natural

Fig. 6.19 'Alabaster', in Ulisse Aldrovandi, *Musaeum metallicum in libros IIII distributum Bartholomaeus Ambrosinus … labore, et studio composuit cum indice copiosissimo* (Bologna, 1648), p. 749. Photo: archive.org.

phenomena. Describing a section of Alabaster, for example, he compares the veins running through it to a flowing river (Fig. 6.19).[45]

Throughout the *Musaeum metallicum* (Museum of Metals), he refers to images from nature, such as trees, that appeared when cutting into specimens. Sensual understanding was also important. In his *Discorso naturale*, he comments on dangers to his life resulting from the study of minerology that entailed entering mines 'to make their true anatomy'.[46] 'Personal expenses and bodily exertion', he explains, were needed 'in order to write the truth of these things and to verify many doubts', and also for 'verifying so many beautiful speculations I had recorded'.[47] Harnessing vision to the exploratory hand of the anatomist, he declares 'not writing anything that I have not seen with my own eyes and touched with my own hands, and opened up by anatomy of the exterior and interior parts'.[48] Probing the mines in the dark, Aldrovandi recalls feeling the surfaces of the stone with his hands.

In Florence, cutting open stones provided vivid evidence of images that were attributed to divine and natural forces. Particularly spectacular are the landscapes and cityscapes or ruins, and impressions of cloud formations that appeared to be painted by nature on the faces of *pietra paesina* (stone of a place, landscape stone). Horizontal strata of the limestone and fissures were permeated by hydroxides of iron and manganese. Not unlike *acheiropoieta*, icons made without human hands, these images appeared to be formed by divine and natural forces, which were revealed by slicing them open.[49]

Cutting stones exposed natural formations that resembled other phenomena, which engendered inventive reconfigurations, such as another of Ligozzi's designs for commesso, painted in oil on paper about 1610 (Fig. 6.20).[50]

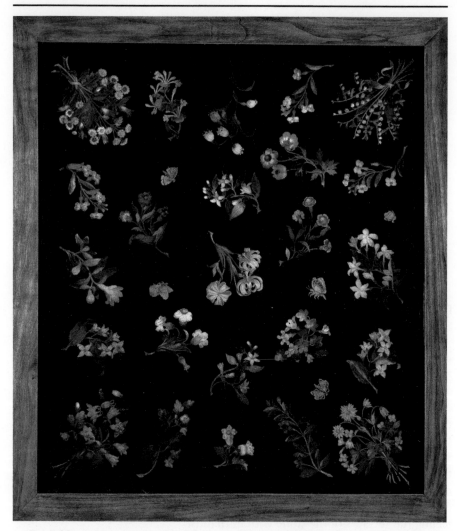

Fig. 6.20 Jacopo Ligozzi, Model for a table top with flowers, ca. 1610–1621. Oil on paper, 78 × 88 cm. Florence, Museo dell'Opificio delle Pietre Dure, inv. 2703. Photo by concession of the Ministero della cultura–Museo dell'Opificio delle Pietre Dure di Firenze.

The painting demonstrates how he translated skilful observation of flora and fauna into a canny essay on the elements. Diverse flowers, sometimes gathered into bundles, and occasionally rendered on their own, populate the black ground as if suspended in some indeterminate space – the sky at night, perhaps, or a subterranean cavern. Contributing to the ornamental, even abstract, character of the composition are butterflies that look, from a distance, like single

blossoms. Wings, petals, and foliage resemble each other, creating uncertainty for viewers about what they are seeing, especially when we consider these transient forms will be cut from hard stones and assembled into a tabletop. Pietra paesina and pietra dura attested to earth's creative forces, which reverberate in the Franciscan altar front at Ognissanti (Fig. 6.21), as well as in the *Descrizione*.

Three of Ligozzi's designs for the altar front were also adapted for the *Descrizione*, including one with the small chapel marking the site of a miraculous Beech tree. The tree's powers were attributed to a source of water in its cavity, in which Francis had bathed his wounds. In the pietra dura panel, the orderly structure of the chapel contrasts with the fractured montane landscape, which was assembled from more than fifteen pieces of pietra paesina (Fig. 6.22). On the far left, a burly section of dark brown has been cut along its irregular contours to simulate the stump of a tree. Just to the right and above, two pieces of the stone have been matchbooked to create the trunk of another tree, but one that is verdant instead, its green granite foliage set against lapis blue to resemble the sky. References to Christ's death and resurrection through the stump, cut down and bereft of foliage, and the branch that flourishes above are familiar, but the material conversion of stone into tree multiplies religious meanings. Such transformations would have called to mind biblical references to Christ as the living stone.[51] And the outstretched limbs of the Beech tree, seen through the arch of the chapel, echo Francis' arms, as if tree and man are about to embrace. Such an interpretation is encouraged by the central panel of the altar front, where the gestures of the Seraph and Francis are repeated (Fig. 6.21). The design for the left panel thereby conjoins the saint's receipt of Christ's wounds, with the location where he washed them.

For the engraving for plate Q (Fig. 6.23), the title explains: 'Little chapel made on the very site where there was a Beech tree named dell'Aqua which cured many illnesses, but in particular of the eyes'.[52] At first glance, the tree appears to be in concert with the arboreal surroundings. However, when Ligozzi drew the chapel, the tree was no longer present at the site; nor was Francis, who reaches inside it to wash his wounds. It has been suggested that the engraving represents a painting that was on the wall of the chapel.[53] However, it is surely telling that none of the three men in the foreground, who have been added to the printed image, look at Francis and the tree. One of the two pilgrims listens to the story recounted by their Franciscan guide and the second has turned to inspect the tabernacle. The letters A and B are keyed to the chapel's dimensions in the adjacent legend, inviting virtual pilgrims to look again, and to look closely. Only then does the engraving reveal discrepancies between the larger scale of the surrounding foliage, and the vision, framed by the arch, of the miraculous Beech tree. In the legend, Friar Lino refers readers to the tree (E) and to Francis bathing his stigmata (F). Significantly, he uses the

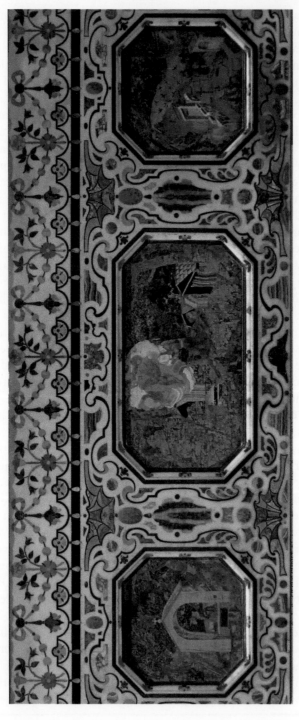

Fig. 6.21 Jacopo Ligozzi (designer), Main Altar, Church of Ognissanti, pietra dura, 1593–1605. Florence. Photo by Sailko, Creative Commons.

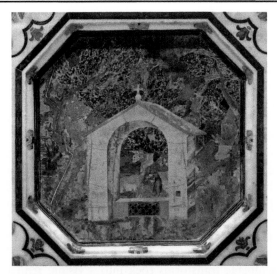

Fig. 6.22 Jacopo Ligozzi (designer), Detail of left panel of Main Altar, Church of Ognissanti, pietra dura, 1593–1605. Florence. Photo by Sailko, Creative Commons.

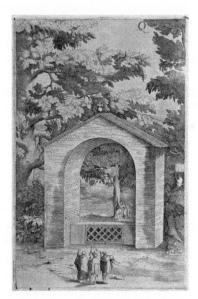

Fig. 6.23 Jacopo Ligozzi (designer) and Raffaello Schiaminossi (etcher), Plate Q, 'Little chapel made on the very site where there was a Beech tree named dell'Aqua which cured many illnesses, but in particular of the eyes', in Lino Moroni, *Descrizione del Sacro Monte della Vernia* (1612). Getty Research Institute, Los Angeles (84-B16400).

term *ritratto* (portrait) – the same term he used for the vision of Francis and Christ seated on the stone in the Magdalene Chapel. Rather than a representation painted on the surface of the chapel, the term ritratto, from *ritrarre*, refers in these instances to a copy – to the tracing of something that is no longer present.[54] The trellis design on the base of the tabernacle, with its reference to the threshold between material and spiritual worlds, would have reminded those who genuflect at the altar, as well as those looking at the engraving, that what they are seeing is a vision.

These material and spiritual resonances further the special relation between Christ and Francis created in the other two panels on the altar front, which are also printed in the *Descrizione* (Figs 6.21, 6.7, 6.24). In the right panel for the church, the saint appears with birds, whose numbers seem to multiply through the variety of stones used to create them. In the central panel, Francis receives the stigmata from the Seraph, its startling otherworldly appearance a result of an efflorescence of luminous white marble and vibrating onyx.[55] This dynamic and floating assemblage transforms rock into a vision, rendered miraculous through the combination of art and nature. In doing so, the deep geological time of stone and the biblical time of Christ's death metamorphose into the tree on the left panel, and on the right, into the vertical movement of birds who take flight into the air. Christ reappears, through the vision of the Seraph, seen in the centre, when Francis receives the stigmata. For the faithful, this spiritual vision is beyond time, an idea suggested by the pulsating luminescence surrounding the Seraph, but also from images concealed in stone, such as those found in pietra paesina, discussed above.

For the printed image of the stigmatisation, the 'misteriosa Figura' (mysterious Image; plate Y; Fig. 6.24), the Seraph floats near the top of a perilous escarpment, whose height can be verified by the dimensions in the legend.[56] Friar Leo, depicted witnessing the scene, shields his eyes from the light, as Francis mirrors the Christ-like Seraph, whose wings echo the surrounding natural forms. The radiance created by vibrating waves of onyx in the pietra dura version of the mandorla, is translated into faintly adumbrated cracks that explode into pulsating rays around the luminous white paper ground. The irregular and rougher marks of the rays, which resemble fissures incised in stone, are the result of acid removing the copper from the plate where Schiaminossi would have inscribed the waxy ground. The work of the printed image culminates here, with Francis' conversion into a second Christ.

From the frontispiece, with a portrait of the saint displaying his wounds, to the final etching presenting the stigmatisation, the *Descrizione* stages the dynamics of making things. On the frontispiece, Francis is surrounded by a profusion of ecclesiastical and temporal regalia alongside metal armour and instruments of the Passion (Fig. 6.25). The saint's wounds, reiterated on two flanking escutcheons, underscore Franciscan claims to their founder having

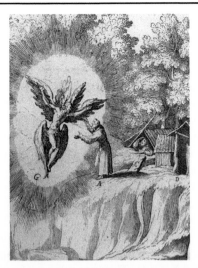

Fig. 6.24 Jacopo Ligozzi (designer) and Raffaello Schiaminossi (etcher), Plate Y, 'Hereby, in front of this mysterious Image, is reduced to memory the place, the person & the fact of the mystery of the reception of the sacred Stigmata of Father St Francesco, given to him by JESUS CHRIST on the Mountain of La Verna', in Lino Moroni, *Descrizione del Sacro Monte della Vernia* (1612). Getty Research Institute, Los Angeles (84-B16400).

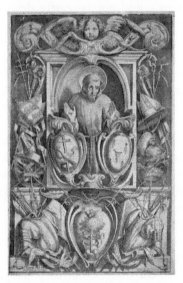

Fig. 6.25 Jacopo Ligozzi (designer) and Domenico Falcini (engraver), Frontispiece, in Lino Moroni, *Descrizione del Sacro Monte della Vernia* (1612). Getty Research Institute, Los Angeles (84-B16400).

become a second Christ. Weapons, sharp implements, and incised metal surfaces also gesture to the cutting of the copper plates used to manifest the saint's visions and material transformations to come. With the title for the final etching (Fig. 6.24), Friar Lino conflates being in front of the 'mysterious Image' (*misteriosa Figura*) of the Seraph with the printed impression (Figura) that 'reduces to memory the place, the person, & the fact of the mystery of the reception of the sacred Stigmata'. The 'mystery of the reception' of Christ's wounds on Francis' body, as the title and etching insinuate, is akin to the mirror image of a figure incised into the matrix that is revealed when the paper is pulled back from the copper plate.[57]

Throughout the *Descrizione*, we have seen how inventive printing practices express diverse temporal dimensions and convergences – geological, historical, and theological time; divine, natural, and human forms of making; the substantiality of stone and the immateriality of apparitions. Viewers journey back to the thirteenth century, which provokes contemplation of the time of the Crucifixion (Figs 6.13, 6.14). They see pilgrims from their own time, but also a vision of Francis washing his wounds in the thirteenth century, and a miraculous tree that fell to the ground in the sixteenth century (Fig. 6.23). They return to the day on September in 1224 that Francis reported receiving the stigmata, and see a vision, outside of time, of his conversations with Christ on the sacred stone (Figs 6.24, 6.12).

The book's complex designs attest to experimentation with generating temporal experiences that could not be easily described in either texts or in images, which brings me to Friar Lino's legends and the volume's letterpress ornamentation. Consider once again the example of the Chapel of Mary Magdalene (Fig. 6.12). The details begin at the bottom of the image (A), which refers to the Archbishop of Messina, and the date of the stone's return from Spain to La Verna. Progressing into the chapel, and vertically on the page, the sequence continues with the grille (B), the stone encased inside (C); the two pilgrims inspecting it (D); the saint's vision of conversing on the stone (E); the altar (F); the altarpiece with Mary Magdalene (G); and the architectural vault above (H). The last two letters identify the door on the left (I), and the window facing the altar (L), that is, the picture plane. Letters identifying details in the images, which take precedence over the legends, according to Friar Lino, generally correspond to the viewer's experience of moving through the image. The legend provides an itinerary for returning to the image with more information, rather than prescribing the initial encounter with the scene. The large capital letters in the legends are functional, in that they are keyed to those in the images, but they are also separated from the captions by an ornamental border. Standing apart from the text, the letters prompt moving down the left side of the legend first, which becomes a palette of ornamental dies.

This column of letters and floriations provoke recognition of the less explicit, and intriguing, role of the ornamentation on the page. Although the legends are similar to each other, each arrangement of decorative marks is distinctive and operates in tandem with the adjacent design. Borders, zones, and ornamental patterns mirror the forms and activities that are represented on the recto sheets. In the Magdalene Chapel, for instance, the irregular frame of the shell cartouche in the foreground is echoed in the constellation of marks on the bottom register of the facing page. The scallops of the shell, with its horizontal inscription, are mimicked in the undulating floriations that coalesce on the left. Note also how the swooping wings of the cherubim and the curving strapwork at the top of the cartouche on the right are reflected in the concave forms of the ornamental configuration and parallel lines of spiralling floriations. Moving up the legend, the diamond like pattern of marks corresponds to the trellis that frames the sacred stone. The floriations above have been assembled into a rectangle, whose shape echoes the sacred stone, and the pattern above the captions marks the altar. Throughout the *Descrizione*, inchoate decorative forms constellate into patterns that reiterate screens, thresholds, relics, altars, paintings and even their accompanying devotional practices. Floriated marks coalesce into decorative formations and sometimes disaggregate into smaller parts.

Ornamental typesetting contributes to the visual ordering of the printed page, evoking the repetition of prayers as well as associations with the rosary. The rhythmic sequence of artful letterpress designs circling each page recalls roses strung together. Francis was the first saint to be associated with the miracle of the roses. According to the legend, to resist the temptation of more sleep, which meant fewer prayers, he threw himself on a rosebush. As a result, his bloody body resembled the marks on Christ's flesh from the Passion, while the bush was miraculously freed of its thorns. The Dominicans adopted the legend of the crown of roses, and instrumentalised the rosary as a conversional apparatus to stimulate repeated prayers to the Virgin Mary. In the sixteenth century, the Franciscans reactivated their political rivalry with the Dominican order by challenging the appropriation of the legend.[58] Perhaps the repeated floriated marks in the *Descrizione* contribute to Franciscan claims to the miracle of the roses. At least, for members of the order, who carried rosaries, the floriations on the facing pages surely encouraged incantations of prayers.

These associations shed light on how the ornamental patterns operate in between text and image in the *Descrizione*. They do not express meanings like words, but they convey – as images cast into dies and arranged into a matrix – how letters are assembled by compositors into sentences and paragraphs. Columns of letters and ornaments, horizontal borders, and single marks punctuate the space of the page. Many printers used similar floriated dies during these decades, with the bespoke character of the *Descrizione*

making a Florentine printer likely. Floriations are ubiquitous in volumes published by Cosimo Giunti, for example, and Raffaello Gualtarotti's *L'universo, overo, Il Polemidoro*, which was printed in 1600, is particularly illuminating (Fig. 6.26). Inventive and singular constellations of ornamental dies appear at the end of each canto.[59] Gualtarotti's *Polemidoro* is especially noteworthy, however, for its engraved frontispiece. Its design, as Massimiliano Rossi has observed, is more interesting than the author's epic poem. At first, the printed image appears to be unfinished, as if a proof for the final plate. However, the figures and ornamental strapwork are purposely incomplete; draperies, faces, and volutes are partial, and either cursorily outlined, or only suggested by hatching. Rossi elucidates the metaphorical concept of the design: 'the youth of the poem's protagonist is ... compared to the incomplete creation of the World'.[60] The impression in and from the copper plate – of a world becoming visible – may have provided inspiration for the *Descrizione*. The turning of the strapwork, with its allusions to metal, and the incomplete architecture and allegorical figures, reverberate in the revelatory character of the overslips, in the quarrying and cutting of stone at La Verna, and in the potential for print to convey visions – such as the Seraph coming into relief from the ethereal white ground (Fig. 6.24).

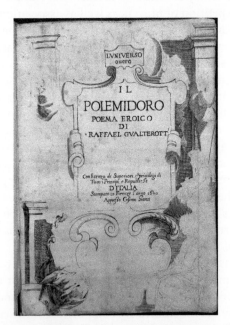

Fig. 6.26 Frontispiece, Raffaello Gualterotti, *L'vniverso ouero il Polemidoro: poema eroico* (Florence: Cosimo Giunti, 1600). Engraving, 22.4 × 15.4 cm. Photo by author. Newberry Library.

I have been arguing that the *Descrizione* is a material and spiritual conversion machine, a Franciscan universe-making project in its combinations of measuring and drawing, of etching and engraving, of letterpress text and ornamental patterns, of quarrying stones and assembling them, of historical research and Franciscan proselytism. Unusually self-aware in its manufacture and its ornamentation, the volume directs viewers from darkness to light, from black ink to white paper, from formless matter to visions of other worlds. The mountain thwarts clear understanding, but it becomes 'clear, perfect, and intelligible', as Friar Lino promises readers at the outset. With its complex ornamentation and compiling of La Verna's parts into a 'great working structure', it may be useful to recall etymological associations.[61] Ornament, the common meaning of cosmos, identifies a position within a hierarchy. Cosmos, which derives from the ancient Greek κόσμος, means to put in order, as well as 'ornament, world or universe'. From the fourteenth to the seventeenth centuries, ornament referred to the 'accessories or furnishings of a church or temple'. Ornament also derives from the Latin term for equipment – with the assembling of constituent parts into a machine.[62]

I have been emphasising the making of the *Descrizione* and how it manages experiences of virtual pilgrims, without touching upon whom Moroni and his collaborators were addressing. The volume is neither a portable guide, nor a souvenir of the visit, which were printed for Sacri Monti. The large size of the volume requires a table or an easel for support, and producing the detailed illustrations, sheets that unfold, and overslips, would have been a costly enterprise. Clearly there were hopes that readers and spectators, including the Medici Dukes, would be moved to provide financial support to the Observants. My assumption is also that the universe-making aspirations of the volume were directed toward furthering a network of religious communities. Its scale allows groups of people to share the experience.

Some evidence for this idea can be found in the copy at the Newberry Library that was once in a Franciscan convent in Minnesota (Fig. 6.27). At some point, the book was left open to the Chapel of St Francis, and for some time – evidenced by the corpses of five flies. In the engraving, four fervent pilgrims kneel in the foreground, their different poses creating a moving image of conversion as they turn their bodies toward the rock where the Seraph was reported to have appeared to Francis. Two friars point toward the location, which is also adorned by a trellis, and flanked by two orderly rows of hooded Franciscans. Standing at their benches on either side, they witness and contemplate the pilgrims' devotion. For the American brothers, and visitors to their convent who may have seen the book, the *Descrizione* may have fulfilled the goal, noted by Friar Lino, of providing knowledge of the mountain to those unable to journey to La Verna. Through the mechanical character of the apparatus, they become bodies in the machine. Turning the pages, manipulating

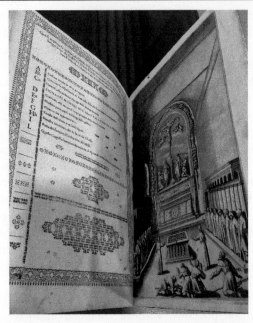

Fig. 6.27 Jacopo Ligozzi (designer) and Domenico Falcini (engraver), Plate M, 'Here is produced the mysterious Church of the sacred Stigmata, being as it is the very place where from JESUS CHRIST was Stigmatised the Seraphic Father St Francis in the year one thousand two hundred twenty-five,' in Lino Moroni, *Descrizione del Sacro Monte della Vernia* (1612). Photo by author. Newberry Library.

the flaps, inspecting details, standing back, and chanting prayers, they experience its effects together with others gathered round, witnessing each other's reactions over and over again.

Notes

This chapter has benefited from insightful comments and suggestions from numerous colleagues and students, including David Bardeen, Tracy Cooper, Cynthia Fang, Lia Markey, Walter Melion, Anthony J. Meyer, Annie Rana, Suzanne Karr Schmidt, Rose Marie San Juan, Rachel Weiss, Ashley West, and Paul Yachnin.

Translations are my own, unless noted otherwise. For details of the printed images, and the original text for the titles, please see the copy of Moroni's *Descrizione* at the Getty Research Institute (GRI): https://archive.org/details/gri_33125008411585/mode/2up. I have translated the long titles literally, with minor exceptions for clarity. The order of Lino Moroni's phrasing, if awkward in English, is often instructive.

1. Moroni, *Descrizione*.
2. Savelli da Stia, *Breue dialogo*; di Miglio, *Nuovo dialogo*. On the variety of imagery on La Verna and its images, see Baldini, *Altro Monte*; Prosperi et al., *L'immagine di San Francesco*; Sarnecka, 'Experiencing La Verna at Home'.
3. Ligozzi and Conigliello, *Ligozzi*; Conigliello, 'Jacopo Ligozzi'.

4. On Ligozzi see: Ligozzi et al., *Jacopo Ligozzi: pittore universalissimo*; Ligozzi and Conigliello, *Jacopo Ligozzi: le vedute*; Ligozzi, et al., *Jacopo Ligozzi: altro Apelle*; Adam, 'Jacopo Ligozzi'.

5. In 1594, Schiaminossi was enrolled in the artists guild in Florence. Falcini, also from Siena, was in Florence in 1604. Biferali and Firpo, 'Vincenzo Berdini', p. 194.

6. WorldCat identifies fourteen libraries with the 1612 edition, however at least one of those is the scan of the volume in the GRI. None that I have seen has all the original overslips. The Princeton Library volume, in Figures 1 and 2, for instance, is missing the overslip on the right side of Plate N, whereas the volumes in the GRI and the Newberry Library are missing the flap seen in the Princeton copy. Overslips have also been replaced in several versions.

7. Ligozzi and Conigliello, *Jacopo Ligozzi: le vedute*; Conigliello, 'Jacopo Ligozzi pittore e La Verna'; Ligozzi et al., *Jacopo Ligozzi: altro Apelle*, pp. 45–7. On the mechanical character of the book, see Schmidt, *Interactive and Sculptural Printmaking*.

8. Ligozzi and Conigliello, *Jacopo Ligozzi: le vedute*, p. x.

9. 'VOLENDO dare in luce la descrizione del Sacro Monte della VERNIA, con Stampe intagliate in Rame prima, e poi con iscrizione di parole, acciò meglio sia inteso, e goduto, sì il tutto, come ciascheduna parte da i devoti del Serafico Padre San FRANCESCO, e di questo Sacro Monte habitato da lui, da alcuni suoi compagni, e da altri Beati, per la successione de tempi sino à questi presenti giorni', Moroni, *Descrizione*, 'Al lettore'.

10. 'Una strada, che fù tagliata nè massi per salire al Convento', Ibid., Plate A, T. https://archive.org/details/gri_33125008411585/page/n11/mode/2up?view=theater.

11. Moroni, *Descrizione*, 'Al lettore', https://archive.org/details/gri_33125008411585/page/n11/mode/2up.

12. 'haveva desiderio, che per augumento di devozione ne i popoli à tal luogo, di quello ci fussi qualche memoria particolare, e massime per li assenti da queste nostre parti', ibid., Dedication. On the *Descrizione* and memory, see de Luca, 'Il libro'.

13. See the guide to La Verna, published in the form of a dialogue and dedicated to Duke Cosimo and his sons: di Miglio, *Nuovo dialogo*.

14. 'Hoggi in tutto questo Masso vi è la Chiesa delle Sacrate Stimate con altri appartamenti descritti per intelligenzia chiara nella pianta di tutta la fabbrica di questo sito', plate Y, Moroni, *Descrizione*.

15. https://www.treccani.it/vocabolario/fabbrica/.

16. Ibid.

17. For one of several current compelling uses of *La fabbrica dei sogni*, see its translation for the 2020 Danish animated film, *DreamBuilders*, https://www.youtube.com/watch?v=Y5vKb9g-XPg.

18. On the *tramezzo*, see Hall, 'Another Look at the Rood Screen'.

19. For the extensive bibliography on Sacri Monti, see the UNESCO site: https://www.sacrimonti.org/en/bibliografia; Symcox, *Jerusalem in the Alps*. Some recent examples include: Afferni and Ferrario, 'Religious Tourism'; Afferni et al. 'A Place of Emotions'; Benzan, 'Coming to Life'; Campbell, *Endless Periphery*; de Klerck, 'Jerusalem in Renaissance Italy'; Göttler, 'Temptation of the Senses'; Leatherbarrow, 'The Image and Its Setting'; van Eck, *The Holy Land*.

20. On Caimi's scheme, see Symcox, *Jerusalem in the Alps*.

21. On Sacri Monti as other places, see Campbell, *Endless Periphery*, esp. pp. 104–15.

22. See Bell, 'Image as Relic'; she cites Paleotti on p. 317, trans. Klein and Zerner, *Italian Art*. Paleotti, *Imagini sacre e profane*, p. 408. On his defense of 'religione nostra' (our religion), see chapter 33, 'Delle pitture oscure e difficili da intendersi'.

23. For Ligozzi's attentiveness to Alberti's theory, see his drawing for this plate: https://collections.louvre.fr/en/ark:/53355/cl020111606.
24. Manetti, et al., *Vita di Filippo Brunelleschi*, pp. 58–9; Damisch, *Origin of Perspective*, pp. 115–16.
25. Ibid.
26. Ibid.
27. Alberti, *La pittura*, esp. pp. 8–9.
28. Manetti, et al., *Vita di Filippo Brunelleschi*, p. 59; Damisch, *Origin of Perspective*, p. 116.
29. Ibid.
30. Procederemo per modo di dialogo con quattro interlocutori, e quali saranno questi AUGUSTINO come persona che determina e'l ragionare. FRANCESCO Principe che con ogni diligenza desidera sapere. VINCENTIO che come ingenioso, muove molti dubbi. ALESSANDRO molto devoto di Francesco. Di Miglio, *Nuovo dialogo,* Proemio, p. i, verso.
31. Ibid.
32. Paleotti, *Imagini sacre e profane*. 'Essendo donque la imaginativa nostra così atta a ricevere tali impressioni, non è dubbio non ci essere istrumento più forte o più efficace a ciò delle imagini fatte al vivo, che quasi violentano i sensi incauti,' p. 230. Earlier, in reference to St Gregory, Paleotti notes 'Onde, se tanta efficacia hanno le parole, che si odono o leggono, di tramutare i sensi nostri, con molta maggiore violenza penetreranno dentro di noi quelle figure, dalle quali si vedrà spirare pietà, modestia, santità e divozione,' p. 228.
33. See Wilson, 'Federico Barocci's Christ and Mary Magdalene'.
34. Campbell, *Endless Periphery*, pp. 104–15.
35. On moveable prints, see Schmidt, *Altered and Adorned*; Dackerman, *Prints and the Pursuit of Knowledge*.
36. On the painting, Giorgio Vasari reports that Duke Francesco held it 'fra le sue cose carissime', Vasari, *Vite*, p. 491.
37. Wamberg, 'A Stone and Yet Not a Stone', p. 46.
38. Ibid., p. 67.
39. For some decades the family had restricted access to local quarries in order to control extraction of resources. See Bastogi, et al., 'Stones: Ornament of Florence'.
40. On Francesco and collecting stones, see Conticelli, *Guardaroba*. On Ligozzi's work as court artist, see: Fumagalli, 'Jacopo Ligozzi al servizio dei Medici'; Groom, 'Early Modern Natural Science'; Gallori and Wolf, 'Tre serpi'.
41. 'che paiano propriamente nate nel suo sito naturale', Badaar, 'Livorno, Lapis Lazuli, Geology', p. 152.
42. Ligozzi and Conigliello, *Ligozzi*, p. 23.
43. The frame can be seen here: https://wsimag.com/museo-degli-argenti/it/artworks/67161 (last accessed 20 November 2022).
44. Cited in Badaar, 'Livorno, Lapis Lazuli, Geology', p. 152.
45. Aldrovandi, *Musaeum metallicum,* p. 749; see also 'Monachi effigies in Marmore', p. 758. On Aldrovandi and mineralogy, see Vai and Cavazza, 'Ulisse Aldrovandi'; Sarti, 'The Geology Collections'; Lohff, 'Antonio Tempesta's Paintings on Stone'.
46. Aldrovandi, *Discorso naturale*, n.p.
47. Ibid.
48. Ibid.
49. 'In Arno assai frombole, et sassi, che hoggi di' s'usano segare cosi' poi lustrare, che in essi si veggono varie fantasie, et scherzi, che fa la Madre natura', Riccio and Barocchi, *Istoria delle pietre,* chapter 88; for images, see https://www.pietrapaesina.com/homeslider.html.

50. Ligozzi et al. *Jacopo Ligozzi: pittore universalissimo,* p. 148–49.
51. Among numerous references, see Peter 2:4; Deut. 32:4.; see also Gerbron, 'Christ Is a Stone'.
52. The history of this tree is not at all straightforward. None of the sources that I have seen refer to any painting in the chapel until Savelli da Stia's *Breue dialogo* whose text is published in 1616. One of his interlocutors, looking perhaps too hastily at Plate Q in the *Descrizione,* asks: 'Che vuol dire questa Capellina qui fuori, dove è dipinto quel Faggio, e che il P.S. Francesco mette la mano in una buca di detto Faggio?' *Breue dialogo,* p. 51. In contrast, see di Miglio's account, published in 1568, *Nuovo dialogo,* pp. 133–36.
53. Conigliello refers to a painting in the chapel on the basis of Savelli da Stia, whose account was published in 1616. Ligozzi and Conigliello, *Ligozzi.*
54. See ritrarre in Rossi, *Vocabolario degli accademici della Crusca,* p. 721. See also Cranston, *Poetics of Portraiture,* p. 81.
55. To see the panel clearly: https://commons.wikimedia.org/wiki/File:Ognissanti,_alta re_maggiore_su_disegno_di_jacopo_ligozzi,_1593-1605,_06_stimmate_di_san_fr ancesco.jpg.
56. To see the full page: https://archive.org/details/gri_33125008411585/page/n97/mo de/2up.
57. 'Con la presente di rincontro misteriosa Figura, si reduce à memoria il luogo, la persona, & il fatto occorso nel misterio della recezione delle sacrate Stimate del P.S. Francesco, dateli da GIESV CHRISTO nel Monte della Vernia.' Moroni, *Descrizione,* Plate Y. On Ligozzi's manuscript inscriptions in the cloister at Ognissanti, and the idea of *visibile parlare,* the divine word converted into pictorial form, see Rossi, 'Pietosi affetti', esp. p. 176.
58. McGrath, 'Dominicans, Franciscans', esp. p. 203.
59. Cosimo Giunti published Gualterotti, *Universo, overo il Polemidoro,* frontispiece and p. 31, verso. Other potential printing houses for the *Descrizione* include Gio. Antonio Caneo e Raffaello Grossi, who published Fra Silvestro da Poppi's, *Sette canzoni* and Fra Aurelio Savelli da Stia's, *Breue dialogo.* See Rossi, 'Pietosi affetti,' on Ligozzi and Giovambattista Strozzi il Giovane, whose *Versi* were collected and edited by da Poppi in his *Rime spirituali,* and published by Volcmar Timan. Schiaminossi produced etchings for Bartolommeo Sermartelli in Florence, and for Salvestro Marchetti e Camillo Turi in Siena, such as *Gran simulacro,* the latter with similar letterpress decorations.
60. 'La giovanezza del protagonista del poema è dunque paragonata alla creazione incompiuta del Mondo', Rossi, 'Princeps artifex', p. 36.
61. Wilson, 'Afterword: Ornament', esp. 378–9.
62. 'equipment, trappings, furniture, attire'. https://www.oed.com/view/Entry/132624? rskey=iYRPhi&result=1&isAdvanced=false#eid.

WORKS CITED

Adam, Edina, 'Jacopo Ligozzi and Notions of Foreignness in Florence', PhD diss., New York University, 2019.

Afferni, Raffaella and Carla Ferrario, 'Religious Tourism and Italian Sacred Mounts: experiences of networking and co-operation at a UNESCO site', *International Journal of Religious Tourism and Pilgrimage* 4, no. 1, Article (2016).

Afferni, Raffaella, Carla Ferrario and Stefania Mangano, 'A Place of Emotions: The Sacred Mount of Varallo', *Turizam: Međunarodni Znanstveno-Stručni Časopis* 59, no. 3 (3 November 2011), pp. 369–86.

Alberti, Leon Battista, *La pittura di Leon Battista Alberti,* trans. Lodovico Domenichi (Venice: Giolito de Ferrari, 1547).

Aldrovandi, Ulisse, *Discorso naturale*, (1572–1573), Biblioteca Universitaria di Bologna
http://aldrovandi.dfc.unibo.it/pinakesweb/UlisseAldrovandi_discorsonaturale.asp
_____, *Musaeum metallicum in libros IIII distributum Bartholomaeus Ambrosinus ...
labore, et studio composuit cum indice copiosissimo* (Bologna: 1648).

Badaar, Hannah, 'Livorno, Lapis Lazuli, Geology and the Treasures of the Sea in 1604',
Espacio, tiempo y forma 5, Serie VII, Historia del Arte (2017), pp. 141–67.

Baldini, Nicoletta, *Altro monte non ha più santo il mondo: storia, architettura ed
arte alla Verna dalle origini al primo Quattrocento; atti del convegno di studi,
Convento della Verna (Arezzo), Biblioteca Antica, 4–6 agosto 2011* (Florence:
Studi francescani, 2012).

Bastogi, Marco, Anna Maria Giusti, and Maurizio Mariottini, (eds) 'Stones: Ornament
of Florence', *Memorie descrittive della carta geologica d'Italia 66* (Rome:
SystemCart, 2004).

Bell, Margaret F., 'Image as Relic: Bodily Vision and the Reconstitution of Viewer/
Image Relationships at the Sacro Monte di Varallo', *California Italian Studies 5*,
1 (2014), pp. 303–31.

Benzan, Carla, 'Coming to Life at the Sacro Monte of Varallo: The Sacred Image *al
vivo* in Post-Tridentine Italy', in Thomas Balfe, Joanna Woodall, and Claus Zittel
(eds), *Ad Vivum?: Visual Materials and the Vocabulary of Life-Likeness in Europe
Before 1800* (Leiden: Brill, 2019), pp. 224–46.

Biferali, Fabrizio, and Massimo Firpo, 'Vincenzo Berdini, Jacopo Ligozzi e una
stampa del 1606. Teologia politica e pedagogia cattolica', *Mitteilungen des
Kunsthistorischen Institutes in Florenz 57*, no. 2 (2015), pp. 190–211.

Bredekamp, Horst, *The Lure of Antiquity and the Cult of the Machine: The
Kunstkammer and the Evolution of Nature, Art, and Technology,* trans. Allison
Brown, intro. Anthony Grafton (Princeton: M. Wiener Publishers, 1995).

Campbell, Stephen J., *The Endless Periphery: Toward a Geopolitics of Art in Lorenzo
Lotto's Italy* (Chicago: The University of Chicago Press, 2019).

Conigliello, Lucilla, 'Jacopo Ligozzi pittore e La Verna', in Nicoletta Baldini (ed.),
*Altro monte non ha più santo il mondo: storia, architettura ed arte alla Verna
dalle origini al primo Quattrocento* (Florence: Studi Francescani 2018), pp. 195–
203.

Conticelli, Valentina, *Guardaroba di cose rare et preziose: lo studiolo di Francesco I de'
Medici: arte, storia e significati* (Lugano: Agora, 2007).

Cranston, Jodi. *The Poetics of Portraiture in the Italian Renaissance* (Cambridge:
Cambridge University Press, 2000).

Dackerman, Susan (ed.), *Prints and the Pursuit of Knowledge in Early Modern Europe*
(Cambridge, MA: Harvard Art Museums, 2011).

Damisch, Hubert, *The Origin of Perspective* (Cambridge Mass: MIT Press 1994).

de Klerck, Bram, 'Jerusalem in Renaissance Italy: The Holy Sepulchre on the Sacro
Monte of Varallo', in Jeroen Goudeau, Mariëtte Verhoeven, and Wouter Weijers
(eds), *The Imagined and Real Jerusalem in Art and Architecture* (Leiden: Brill,
2014) pp. 215–36.

de Luca, Maria Elena, 'Il libro del Sacro Monte della Verna: una 'memoria particolare',
in Omar Calabrese (ed.), *Fra parola e immagine* (Milan: Luca Acquarelli, 2008),
pp. 50–71.

di Miglio, Agostino, *Nuovo dialogo delle devozioni del Sacro Monte Della Verna (etc.)*
(Florence: Stampa ducale, 1568).

Faietti, Marzia, Alessandro Nova, and Gerhard Wolf (eds), 'Jacopo Ligozzi',
Mitteilungen des Kunsthistorischen Institutes in Florenz 57, no. 2 (Florence:
Kunsthistorisches Institut, 2015).

Fumagalli, Elena, 'Jacopo Ligozzi al servizio dei Medici le trasformazioni del ruolo di

pittore di corte', *Mitteilungen des Kunsthistorischen Institutes in Florenz* 57, no. 2 (2015), pp. 158–75.

Gallori, Corinna Tania, and Gerhard Wolf, 'Tre serpi, tre vedove e alcune piante i disegni 'inimitabili' di Jacopo Ligozzi e le loro copie o traduzioni tra i progetti di Ulisse Aldrovandi e le pietre dure', *Mitteilungen des Kunsthistorischen Institutes in Florenz* 57, no. 2 (2015), pp. 212–51.

Galluzzi, Paolo, 'Art and Artifice in the Depiction of Renaissance Machines', in Wolfgang Lefèvre, Jürgen Renn, and Urs Schoepflin (eds), *The Power of Images in Early Modern Science* (Berlin: Springer, 2003), pp. 47–68.

Gerbron, Cyril. 'Christ Is a Stone: On Filippo Lippi's Adoration of the Child in Spoleto', *I Tatti Studies in the Italian Renaissance* 19 no. 2 (2016), pp. 257–83.

Göttler, Christine, 'The Temptation of the Senses at the Sacro Monte di Varallo', in Wietse de Boer and Christine Göttler (eds), *Religion and the Senses in Early Modern Europe* (Leiden: Brill, 2012), pp. 393–451.

Groom, Angelica, 'Early Modern Natural Science as an Agent for Change in Naturalist Painting: Jacopo Lipozzi's Zoological Illustrations as a Case Study', in David Beck (ed.), *Knowing Nature in Early Modern Europe* (New York: Routledge, 2016), pp. 139–64.

Gualterotti, Raffaello, *'L'universo, ouero il Polemidoro, poema eroico* (Florence: Cosimo Giunti, 1600).

Hall, Marcia B., 'Another Look at the Rood Screen in the Italian Renaissance,' *Sacred Architecture* 27 (2015), pp. 11–19.

Klein, Robert, and Henri Zerner, *Italian Art 1500–1600: Sources and Documents* (Evanston: Northwestern University Press, 1989).

Leatherbarrow, David, 'The Image and Its Setting: A Study of the Sacro Monte at Varallo', *RES: Anthropology and Aesthetics*, no. 14 (1987), pp. 107–22.

Ligozzi, Jacopo, Alessandro Cecchi, Lucilla Conigliello, and Marzia Faietti (eds), *Jacopo Ligozzi: pittore universalissimo* (Livorno: Sillabe, 2014).

Ligozzi, Jacopo, and Lucilla Conigliello, *Jacopo Ligozzi: le vedute del Sacro Monte della Verna, i dipinti di Poppi e Bibbiena* (Comune di Poppi: Biblioteca comunale Rilliana, 1992).

Ligozzi, Jacopo and Lucilla Conigliello, *Ligozzi* (Milan; Paris: 5 continents, Musée du Louvre, 2005).

Ligozzi, Jacopo, Maria Elena de Luca, and Marzia Faietti, *Jacopo Ligozzi: altro Apelle* (Florence: Giunti, 2014).

Lohff, Johanna Beate, 'Antonio Tempesta's Paintings on Stone and the Development of a Genre in 17th-Century Italy', in Piers Baker-Bates and Elena Calvillo (eds), *Almost Eternal: Painting on Stone and Material Innovaion in Early Modern Europe* (Leiden: Brill, 2018), pp. 180–219.

Manetti, Antonio, and Domenico De Robertis, *Vita di Filippo Brunelleschi: preceduta da la novella del grasso*, intro. and notes Giuliano Tanturli (Milan: Il Polifilo, 1976).

McGrath, Thomas, 'Dominicans, Franciscans, and the Art of Political Rivalry: Two Drawings and a Fresco by Giovanni Battista della Rovere', *Renaissance Studies* 25 (April 2011), pp. 185–207.

Moroni, Lino, *Descrizione del Sacro Monte della Vernia* ([Florence?]: 1612).

Paleotti, Gabriele, *Discorso intorno alle imagini sacre et profane* (Bologna: [1582?]). https://www.memofonte.it/home/files/pdf/scritti_paleotti.pdf.

Poppi, Silvestro da (ed.), *Rime spirituali di diversi autori ... a consolazione spirituale de' devoti di detto santo* (Florence: Volcmar Timan, 1606).

_____, (ed.), *Sette canzoni di sette famosi avtori in lode del Serafico P. S. Francesco, e del Sacro Monte della Verna* (Florence: Gio. Antonio Caneo e Raffaello Grossi, 1606).

Prosperi Valenti Rodinò, Simonetta, and Claudio M. Strinati. *L'immagine di San Francesco nella Controriforma* (Rome: Quasar, 1982).

Riccio, Agostino del, and Paola Barocchi (ed.), *Istoria delle pietre* (Florence: Studio per Edizioni Scelte, [1597] 1979).

Ritsema van Eck, Marianne P., *The Holy Land in Observant Franciscan Texts (c. 1480–1650): Theology, Travel, and Territoriality* (Ledien: Brill, 2019).

Rossi, Bastiano de, *Vocabolario degli accademici della Crusca* (Venice: Sarzina, 1623).

Rossi, Massimiliano, 'Pietosi affetti e arte grafica nei madrigali dipinti per le storie francescane di Ognissanti', *Mitteilungen des Kunsthistorischen Institutes in Florenz* 57, no. 2 (2015), pp. 176–89.

———, 'Princeps artifex: poetica tassiana, teoria dell'arte e sovranità tra Cinque e Seicento', in Massimiliano Rossi and Fiorella Gioffredi Superbi (eds), *L'arme e gli amori: Ariosto, Tasso and Guarini in Late Renaissance Florence: Acts of an International Conference: Florence, Villa I Tatti, June 27–29, 2001* (Florence: L.S. Olschki, 2004), pp. 27–37.

Sarnecka, Zuzanna, 'Experiencing La Verna at Home: Italian Sixteenth-Century Maiolica Sanctuaries and Chapels', *Religions* 11, no. 6 (2019), pp. 1–21.

Sarti, Carlo, 'The Geology Collections in Aldrovandi's Museum', in Gian Battista Vai and William Cavazza (eds), *Four Centuries of the Word Geology. Ulisse Aldrovandi 1603 in Bologna* (Bologna: Minerva, 2003), pp. 153–67.

Savelli da Stia and F. Aurelio, *Breue dialogo nel quale si discorre, come quel Santo Monte della Verna … . Molte Sante Apparitioni* (Florence: Gio. Antonio Caneo, 1616).

Schmidt, Suzanne Karr, *Interactive and Sculptural Printmaking in the Renaissance* (Leiden: Brill, 2018).

Smith, Justin E. H, *Divine Machines: Leibniz and the Sciences of Life* (Princeton, NJ: Princeton University Press, 2011).

Symcox, Geoffrey, *Jerusalem in the Alps: The Sacro Monte of Varallo and the Sanctuaries of North-Western Italy* Cusor Mundi, Vol. 37 (Turnhout, Belgium: Brepols Publishers, 2019).

Vai, Gian Battista, and William Cavazza, 'Ulisse Aldrovandi and the Origin of Geology and Science', in Gian Battista Vai and Glen E. Caldwell (eds), *The Origins of Geology in Italy* (Boulder: The Geological Society of America, 2006), pp. 43–80.

Vasari, Giorgio, *Le vite de' più eccellenti pittori, scultori, e architettori* (Florence: Giunti, 1568).

Wamberg, Jacob, 'A Stone and yet Not a Stone: Alchemical Themes in North Italian Quattrocento Landscape Imagery', in Jacob Wamberg (ed.), *Art and Alchemy* (Copenhagen: Museum Tusculanum Press, 2006), pp. 41–81.

Wilson, Bronwen, 'Afterword: Ornament and the Fabrication of Early Modern Worlds', in Louisa Arizzoli and Maryanne Horowitz (eds), *Bodies and Maps: Early Modern Personifications of the Continents* (Leiden: Brill, 2020), pp. 376–401.

———, 'Spiritual and Material Conversions: Federico Barocci's Christ and Mary Magdalene,' in Walter S. Melion, Elizabeth Carson Pastan, and Lee Palmer Wandel (eds), *Quid est sacramentum?: Visual Representation of Sacred Mysteries in Early Modern Europe, 1500–1700* (Leiden: Brill, 2019), pp. 398–424.

7

'HAERETICI TYPUS, ET DESCRIPTIO': HERETICAL AND ANTI-HERETICAL IMAGE-MAKING IN JAN DAVID, SJ'S *VERIDICUS CHRISTIANUS*

Walter S. Melion

Jan David launches his catechetical emblem book *Veridicus Christianus* (True Christian; Antwerp: Jan Moretus, 1601) with five chapters on the nature of human sin, chief amongst which is the sin of idolatry (Fig. 7.1).[1] Following chapter 5, he appends a complementary series of ten chapters on heresy, the most heinous form of idolatry, and on the chief means of combatting its pernicious effects – namely, anti-heretical image-making. Heresy must needs be challenged by recourse to images, argues David, and to shore up this point he traces the lineage of anti-heretical image-makers back to Moses, who was taught by God to construe leprosy as a *typus haereseos* (image of heresy), and then to Christ, who renewed the Mosaic image by substituting for it the more vivid parabolic image of a ravening wolf in sheep's clothing. My chapter examines David's bipartite notion of the heretical image, its body and soul, as a prelude to exploring the fundamental opposition he adduces between heretical and anti-heretical image-making. I begin by perusing David's conviction that heresy itself operates or, better, propagates through images. His account of the heretical image can be seen to arise from the parallel he draws between heresy and idolatry. Thereafter, the paper shifts focus to the topic of orthodox image-making. What sorts of defensive image must the good Christian devise to make incontrovertibly evident the heretic's modus operandi, which involves razing the edifice of faith and then building a counter-edifice from these spolia? And how do such images, more particularly David's emblems on heresy, purport to contravene heresy's pernicious effects?

The *Veridicus Christianus* consists of one hundred emblems, each subsuming four components: a *titulus* (title or motto), inscribed above the *pictura* (pictorial image); the pictura proper, overlaid with Roman capitals that correspond to *loci textuales* in the adjacent prose commentary; epigrammatic couplets written in Latin, Dutch, and French scripts, the first line in the form of an *interrogatio* (question), the second, of a *responsio* (response); and the prose commentary that embeds the pictura and constitutes the bulk of the chapter. The chapters centre on the *picturae*, closely responding to them, as well as amplifying and explicating their imagery. Designed and engraved by Theodoor Galle, with the assistance of his brother Cornelis, the plates vary in kind: some appear performatively to illustrate a moral precept or point of doctrine conveyed by the narrative mottos and epigrams; others operate by analogy, comprising one or more comparanda, often a biblical event set against an allegorical scene featuring multiple personifications, or more simply, the figure of Christ standing back-to-back with an epitome of anti-Christian behaviour; a third type of pictura gives special prominence to a single large figure whom the motto describes as an embodied state of being, more precisely, as the image of such an embodiment, either pointedly good or bad. The allusion to the representational status of what is shown, functions as a prompt to the reader-viewers, urging them to consider whether in actual fact it represents them, and conversely, whether in body or spirit, for good or ill, they have fashioned themselves into living images of this paradigmatic image. These latter picturae are designed to be compared or contrasted with similarly posed embodiments elsewhere in the book: emblem 9, for example, 'Diabolici spiritus delineatio' (Drawing of the devilish spirit), clearly correlates to emblem 15, 'Hominis vere Christiani descriptio' ('Description of a truly Christian man'), as also to emblem 45, 'Mundus delirans, non sapit, quae Dei sunt' ('The delirious world knows not what belongs to God') (Figs 7.7, 7.11, and 7.12). Emblems 12, 'Nimium creduli ab haereticis seducuntur' ('The credulous are too often led astray by heretics'), and 13, 'Haereticorum parens et magister diabolus' ('The parent and teacher of heretics is the devil'), exhibit the first type of pictura (Figs. 7.8 and 7.9). In the former, a heretic preacher (A), blunderbuss at the ready, seduces a fickle-hearted congregation (B) whose credulity exemplifies Ecclesiasticus 19:4 ('He that is hasty to give credit, is light of heart'), whereas the sceptical crowd dispersing at right (C) exemplifies Matthew 24:23 ('Do not believe him'). In the latter, another heretic preacher (A), likewise armed to the hilt, delivers a sermon dictated by the devil (B), to student-congregants (C); having themselves become sectarians, they inevitably turn on each other, ranting like rabid dogs (D).

Emblem 14 exhibits the second type of pictura: possessed by a malevolent spirit, the demoniac who attempted to ingratiate Christ in Luke 4:34–35 (D), is ultimately rebuffed by him (E); in the foreground, a devilish heretic (A)

disingenuously puts forward the personification of naked truth (B), thus hiding his insidious motives ('sub simplici eius velamine') (Fig. 7.10).[2] Personified by a shrouded figure with the wings of an insect (C), *Mendacium* ('Mendacity') skulks behind the false image of Truth, whom David's commentary specifically identifies as Biblical Truth: the heretic, he avers, often quotes from Scripture to camouflage his deceptive intentions ('Biblia ipsa sacra, sed depravata, producunt').[3] The audience at right (F) 'open wide their mouths and ears to [the semblance of] truth' meretriciously proffered by the cunning, mendacious heretic.[4] Emblem 14 juxtaposes A, B, C, and F to D and E, contrasting Christ, who refuses to be flattered and exorcises the demon, with the man who doffs his hat and with open arms foolishly welcomes the decoy of Truth (Fig. 7.10). That he and Christ are so similarly posed, heightens telling differences of gesture and facial expression. Moreover, the foreground scene mirrors, in the sense of inverting, the background scene: whereas Christ lunges forward, and the demoniac recoils, Mendacity and the heretic lean into Truth, pushing her toward their victims, the foremost of whom invitingly beckons her to join him and his companions.

Chapters 12 to 14, as will have begun to be apparent, concern the heretic's reliance on images as instruments of seduction and moral corruption. The commentaries for all three chapters assert that heresy is the process that marshals falsely alluring images to entrap the eyes. The only corrective to such enticements involves looking through or beyond images of this sort, piercing their duplicitous superficies, as Proverbs 1:17 counsels: 'It ought truly to be a cause for wonder that men permit themselves to be deceived in droves by heretics, when this is the most injurious deception of all, the most fit to be loathed. "But a net is spread in vain", says Wisdom, "before the eyes of them that have wings"'.[5] Visual deception is the heretic's stratagem of choice, for he prefers to trade in the counterfeit currency of spurious likenesses. Indeed, his speech is captivating in the manner of an enthralling image: 'And indeed, the cunning speech of these selfsame heretics, adorned with the likeness of truth, sent into the ears with painted show, infects the spirits of those who listen, no less than a mouthful of hemlock or some other poison kills the body'.[6] On this account, heresy enters the ears as if it were entering the eyes, like a 'feigned or spurious image of truth', and the heretical convert may thus be compared to King Cambyses, deceived by the mage Smerdes, as recounted by Raphael Fulgosius in the *Consilia postuma* (lib. 9, cap. 16):

> They who wish to be left undeceived by heretics and their feigned and spurious image of truth, let them recall how Cambyses was tricked by the mage Smerdes: who portrayed [Cambyses's] brother after the life ('ad vivum exprimebat'), [impersonating him] in name and outward appearance; and by that deceit, king Cambyses having been deposed, he invested

himself with the king's power, and would have straightway possessed it, had his deception not been exposed by the daughter of Othanis.[7]

The phrase 'ad vivum exprimebat' can refer to an exceptionally convincing act of impersonation, but also to a compelling pictorial likeness or, more expressly, to a portrait painted after the life. This usage strongly implies that the heretical preacher depicted in pictura 12 is impersonating a good Christian, and further, that he is purveying false images in the guise of true doctrine (Fig. 7.8). The motto's warning against seduction ('seducuntur') applies not merely to his words qua speech, but also to his 'simulata veri adumbrataque similitudines' – the falsely semblant images of truth he broadcasts. The only defence against these assaultive images, states David, are counter-images that reveal what it means to fall prey to heresy, and how forcibly one must resist the temptation to succumb. By way of admonishment, David urges us to visualise susceptible Christians as hollow reeden stalks, empty of life, or as mindless windborn chaff, worthy only to be discarded, or again, as a smoking taper that suddenly combusts, burning to nothing, an image connotative of the suicidal character of heresy, and simultaneously, of divine vengeance and hellfire. David then supplies a more positive image, taken from the *Historia ecclesiastica* of Socrates of Constantinople (lib. 2, cap. 38). Let his reader-viewer keep in view the citizens of Constantinople whose faith the unspeakable torments imposed by the arch-heretic Macedonius could not break.

Emblem 13 elaborates upon the notion that the heretic is an image-maker; his art consists in the manufacture of oracular images stolen from the biblical prophets, as the epigram avows (Fig. 7.9): 'Who perpetrates deception even while uttering true oracles? Their Stygian teacher and father, whose common art this is'.[8] David develops this theme by claiming that heresy is a mimetic art, in that the heretic strives to imitate his master and father, the devil, and to simulate the devil's wiles. Pictura 13 conforms the preacher (A) to the serpentine devil (B), thereby to illustrate this imitative relation ('ut omnium oculis subiiciatur'); accordingly, David's commentary argues that just as Christ is the image of God, Son of Truth, begotten of the Father through the mystery of the Incarnation, so heretics, who are images of the devil, may justly be called 'diaboli incarnati' (devils incarnate), whose nature, mores, and speech make manifest their progenitor.[9] Distinguishing heresy from truth is thus a matter of discerning which is the true image of the Lord, which the false. David cites an episode from the story of Saint Martin to bolster this claim: as part of his ongoing campaign to suborn Martin, the devil appeared to him in the image of Christ the King, crowned with a golden diadem, dressed in imperial purple, come to judge humankind. The saint responded by generating a defensive counter-image, picturing to himself Christ the Man of Sorrows: 'But truly acquainted with [the devil's] diabolical arrogance, and mindful of the Lord's

clemency, he says: Christ did not promise to come in this guise; but instead he shall appear with every sign of the Passion borne on our behalf, [wearing] the crown of thorns, scarred and wounded, and [bearing] that victory trophy, the cross, and then shall I believe that he has arrived'.[10] By contrast, the devil projects a self-image that has no evidentiary force: he approaches in brightness and splendour ('luculentus accesserat'), but then, as a matter of course, shows his true colours, and finally, feculent and bedaubed with mire, ignominiously departs ('lutulentus faeculentusque abiit'). The heretic's radiance, like the devil's, is a mere image of apparency, imagined not actually witnessed, and in this sense, wholly inauthentic ('ut nullam illi lucem, nisi apparentem atque imaginariam credas').[11] For this reason, the heretic is impelled by the devil to commit acts of vandalism against truly sacred images sanctioned by the Church. David cites as an example the heretic Leutardus, whose story is told by Rodulfus Glaber in the *Historiarum libri quinque* (lib. 2, cap. 11 and 12):

> In the year 933, as Glaber testifies, a heretic named Leutardus, of Gaul, having lived for some time on his own in the countryside dreamt that a swarm of bees, by some mystery of nature, first entered his belly, then burst clamorously from his mouth, and tormented him repeatedly with its stings. And having long and vexatiously stung him, they seemed to speak, commanding him to perform deeds impossible to men. Wearied he finally came home [...] and entering a church, as if instructed by the Gospel to preach, he seized the crucifix and trampled upon the Lord's image. [...] He drew the people to him, even though he seemed to be raving.[12]

This tale leads David to formulate a closing 'Prayer against Cunning Imitation', wherein he entreats Christ to defend him against the metamorphic sleights of deceitful spirits ('contra versipelles fictorum spirituum defende praestigias'), who disguised as angels of light, put forth a delusive image of truth and righteousness ('angeli lucis obtentu [...] nos veri rectique deludant imagine').[13]

The triad of chapters on heresy as image-making concludes with an epigram that pivots on a pun, using the term *os* (mouth, but also, face) to signify the heretic's dual media of deception. He perpetrates his deceits both aurally *and* visually, through processes of word and image calculated to mislead: 'Who then has the power to deceive by desecrating true things? He indeed whose mind lays traps by means of the mouth / face'.[14]

In point of fact, much of chapter 14 dwells on the theme of artisanship: the heretic is portrayed as a skilled craftsman whose efforts to inspire apostasy demonstrate his cunning artfulness – *vafrities* ('haec est plane eadem haereticorum vafrities'). Whether accosting his victims in private or *en masse*, he behaves like a guileful vendor who sells dearly the mere semblance

of useful things, disguising bad things as good ('merces viliores melioribus obtegunt'), trading in false images ('quisquilias, sub rerum utilium umbra, care venditant').[15] David's choice of phrase for 'guileful vendor' – 'instar propolarum dolosorum' – characterises the heretic as a salesman who purveys untrue images of himself. The many allusions to image-making peak midway through the chapter, in a paraphrase of 3 Kings 22:21–22: 'And there came forth a spirit, and stood before the Lord, and said: "I will deceive him." And the Lord said to him: "By what means?" And he said: "I will go forth, and be a lying spirit in the mouth of all his prophets"'. David amends this passage by reference to the term *os*. He first asks if everything thus far shown has had a salutary effect, causing us to beware the heretic's oracles, and to see them for what they truly are, versions of the pseudo-prophecies adduced in 3 Kings 22. If so, we shall surely realise that the spirit of mendacity resides in such a man's mouth/face ('in horum enim omnium ore residet spiritus mendax'), in the words/images he engenders, which one must resist with both ears and eyes. He adds that the heretic, seen in this way, can be said to substitute an empty *symbolum* (symbolic image) for religious truth: like a secretly poisoned draught (*poculum*), this duplicitous image signifies death and animosity, even while seeming to represent life and friendship.[16] Later in chapter 14, in a closing excursus on seductive women, the heretic's fellow deceivers and bosom companions, he designates this type of image a *schema* (visual figure).[17] Like a beguiling woman, the heretical image aims to entice and enthral, and achieves this end by displacing the verities of faith, with fictions.

David persistently likens heretics to image-makers because he considers heresy an extreme form of idolatry. Comparison of emblem 3, 'Qui, spreto Deo, diabolo servit, desipit' ('He who serves the devil, having scorned God, is void of understanding'), and emblem 8, 'Haeretici typus, et descriptio' ('Image of the heretic, and description [of him]'), drives home this point (Figs 7.2 and 7.6). Pictura 3 contrasts Jesus, arms crossed, eyes raised heavenward, with an idolater who disdainfully spurns the Lord. Richly dressed, but draped with foolscap, the apostate reverences a chimeric idol set on a high pedestal, tenders a lit taper, and with his other hand, dismisses Christ. The epigram character-ises him as a fool's fool: 'Who snatches folly's palm from these selfsame fools? He who prefers to exalt demons above God the thunderer'.[18] In the com-mentary, David's attention turns to the idolater's vices, which he compares to the sins of Solomon (3 Kings 11:4–10), Nabal (1 Kings 25:2–13), and Judas (Luke 22:3–6):

> One may behold, as in a mirror, an exemplum of such folly – King Solomon: who through wifely infatuation fell from great dignity of state before God, into vileness and blindness, giving himself over to the cult of demons, and publicly offering them sacrifice [...]. In this manner, fools

do rave; however many they be, all live impiously, and by sinning arrive at the most iniquitous of follies. Of that ilk was Nabal, and [Judas], that least apostolic of apostles: and likewise whosoever soldiers on under the sign of these men ('sub istorum signis militant'): drunkards, gluttons, the irascible, the prideful, those whose avarice and sexual desire are insatiable, and men of most wicked life.[19]

Solomon appears between Christ and the apostate in pictura 3, accompanied by his wives whom he joins in kneeling before an idol (B) (Fig. 7.2). David asserts that the vices he and all idolaters abhor, result from a refusal attentively to dwell on the image of God – more exactly, the image of the Holy Face – deeply impressed in every human heart. Instead of looking steadily at this image, all the while contemplating God's majesty, and conversely, his own baseness, the idolater obfuscates the *vultum Dei*, puts it out of sight, covers it over with the detritus of sin, and subordinates it to his unruly passions ('sed affectui soli indulgens, Dei vultum in anima sua, peccati faecibus obruit').[20] This is to say that idolatry, like heresy, as discussed above, indulgently layers a self-image – heedless, sinful, passion-led – over the true image of God discernible within. It operates under the sign, in the sense of 'under the image', of fools such as Solomon, a circumstance pictured in episode A, by the idolater's turning away from the Lord's face.

The commentary to emblem 8 describes the heretic in terms closely similar to those applied in emblem 3 (Figs 7.2 and 7.6). Most importantly, he is any renegade Christian who averse to Christ his namesake, turns his back on him:

And so, these things being so, no one is properly called a heretic who was not previously a true Christian: such a one who has turned his back on the Catholic faith, forsaking it, having been made an apostate, banished by the Church and by God. He who crushes Christianity under foot (B), drives away the Holy Spirit (C), and lets in the spirit of wickedness (D).[21]

In pictura 8, the heretic tramples the cross, re-enacting the idolater's aversion to the sign of the cross made by Christ in pictura 3 (Fig. 7.6). Here his action of turning upon the Lord resonates with his earlier action of turning away from him; though different in degree, both are apostatic in kind. The further comparison of a heretic to palled wine ('ut vappa corruptum vinum') – vinegary and putrefying – emphasises that at heart he is a lapsed Catholic, corrupted by evil impulses ('ex malis corruptisque Christianis haereticos fieri').[22] His fallen condition recalls the internal attributes of the idolater, whose sinful passions efface the inborn image of Christ, obscure and 'pall' it, one might say, until its lineaments have been befouled and begrimed, defiled and diluted.

Emblem 6, 'Haeresis, peste perniciosior' ('Heresy, more baleful than the plague'), asseverates that God himself, in the Old Testament and the New,

discloses how heresy may best be combatted – namely, by means of epideictic images founded on simile and metonymy (Fig. 7.4). If heresy imposes itself through images, images yet offer the most effective means of opposing it. Pictura 6 provides an additional potent image, modelled on these scriptural antecedents, for defending against, even repelling the occasion of heresy and heresy's insidious effects. The epigram promulgates this newly fashioned image, which David analogises to the imagery of leprosy in Leviticus 13:45, and the ravenous wolf in Matthew 7:15 and Acts 20:28–29. Heresy is seen to repel and repulse no less forcefully than the plague: 'What deadly poison worse than the plague ought I to flee? Heresy, which the nest of Stygian Hydra incubates'. The commentary supplies the reason why: since the soul is more precious than the body, heresy is more fatal than the plague, for it inflicts spiritual death ('tanto magis illius quam huius pestis et mors').[23] This is why the pesthouse (A) in pictura 6 is smaller and more distant than the imposing personification *Haeresis* (B), who erupts from the jaws of hell (D), causing terrified men, women, and children to take flight. Heresy combines the attributes of Envy and a Fury: her face contorted with rage, snaky hair writhing, she clutches a cornucopia of lethal weaponry. The pestilential vapour exhaled from her mouth indicates that she is noxious like the plague; in this and other respects, as David points out, she embodies allusions to Deuteronomy 32:33 ('Their wine is the gall of dragons, and the venom of asps, which is incurable') and Psalm 13:3 ('Their throat is an open sepulcher: with their tongues they acted deceitfully; the poison of asps is under their lips'). That her profile repeats in small the gaping silhouette of hell signifies the virulence of Heresy's tongue/speech ('ipsorum virulentis linguis'); her emergence from Erebus reveals, in David's words, that that 'infernal serpent, and diabolical hydra', the devil himself, is the 'inventor, inciter, and originator of all heresies'.[24] Similarly, the weapons she furnishes are signs of the 'carnage' wrought by heresy ('internecionis auctores'), and of the 'sectarian conspiracies' that heretics foment ('per conspirationes a vovis conflatas').[25]

David presents these allegorical motifs as licensed by God who ensured the detestation of heresy when he first prefigured it in the guise of leprosy (Leviticus 13:45):

> God of old forewarned and solicitously fortified us with a marvelous example, to make this contagion more execrable and ensure that it be fled: when by law he decreed and admonished whomsoever leprosy had tainted to dress in loose garments, with head bare and face covered; and to cry out that they were defiled and unclean; and to live alone, outside the encampment, so that to the fullest extent possible, having been seen and made known, they might more safely be shunned, and infect no one with their fetid breath or too great proximity.[26]

This image of heresy, Christ and, in imitation of him, Paul rendered even more vivid when they renewed the Mosaic type, layering onto it the parabolic image of a ravening wolf in sheep's clothing, which deceives in order to devour its prey:

> In the present situation of danger, Christ himself renewed this warning in a manner fit to inspire terror, laying bare the latent virus, by saying (Matt. 7:15): 'Beware of false prophets, who come to you in the clothing of sheep, but inwardly they are ravening wolves'. The apostle reminded the Ephesians to be alert and take flight, with almost the same words (Acts 20:28–29): 'Take heed to yourselves, and to the whole flock. [...] I know that, after my departure, ravening wolves will enter in among you, not sparing the flock'. What could be applied more efficaciously toward the diligent, scrupulous flight from heresy, than to expose to view the rapacity and ferocity of the wolf? Who should wish to traffic with wolves? Nay rather, having descried this, who would not presently take thought of himself and flee?[27]

These allegorical images of heresy – plague, leprosy, wolves – are complexly composite: by turns scriptural or pseudo-scriptural, they function both as similes and metonyms, and are vouchsafed to inspire fear and repugnance, as antidotes to the contagion they symbolically picture. Whereas the parable of the wolf and the flock originates with Christ, the typological image of leprotic heresy derives from exegetical tradition, and the specific analogy of plague to heresy, portrayed in pictura 6, is an exegetical image newly coined from Deuteronomy 32:33, Psalms 13:3, Ecclesiasticus 13:1, 1 Timothy 4:1–2, Titus 3:10, and James 3:15, as David explains in his commentary (Fig. 7.4).[28] All three images are exempla, all share the same rhetorical function: they elicit the sort of negative emotions that it is the province of epideictic oratory to activate, for the purpose of adjuring the reader-viewer to detect and repudiate heresy.

Detection is key: as David argues in emblem 5, 'Three things that lead to the ruin of the soul [: bad counsel, bad example, and bad company]', heretics are never more effective than when they manipulate exemplary images to put false doctrine before unwitting eyes, thereby abetting the impulse to sin, ingrained ever since the fall of Adam and Eve (A) (Fig. 7.3). Such examples, he notes, are rightly called 'stumbling blocks' in 1 Peter 2:8: 'And a stone of stumbling, and a rock of scandal, to them who stumble at the word, neither do believe whereunto also they are set'. At issue is our susceptibility to visual examples of all kinds, as the epigram makes plain: 'What precipitates us headlong into the greedy [jaws of] hell? Evil exhortation, evil exempla, and evil teachers and associates'.[29] In pictura 5, the serpent's false counsel illustrates the first inducement to evil (A); the ambivalent example set by Saul when he committed suicide, thus inducing his shield-bearer to do the same, illustrates the second

(B); the men setting stumbling blocks (C), and the boys playing foolish games, as if 'shar[ing] a single purse' (Prov. 1:14), illustrate the third. Visual images, when seized upon by wily corrupters, are uncommonly dangerous, avows David:

> Worse than evil counsel is that other thing, evil example. For whoever commits an evil deed, setting a bad example, shows his fellow man the way to hell [...]. The poet speaks truly (Horace, *Ars poëtica*, 180–181): 'What we learn merely through the ear impresses our minds less than what is presented to the trustworthy eye'. Man, after the fashion of an ape, is prone to imitate; and for this reason, however good and effective it is to lead the way to virtue, so conversely, to set a bad example for others, is pernicious and pestilential.[30]

Heretics make a bad situation worse by feigning to set a good example that serves only to camouflage their evil intentions. They put forward a seemingly true image to conceal the ineluctably false one they secretly harbour. This is the subject of emblem 7, 'The three diabolical nests of heresy [: hell, the human heart, and coverts and conventicles]'.[31] The epigram advises us to beware, lest we find ourselves curating one of these nests, and cultivating, advertently or inadvertently, heretical thoughts and deeds: 'Which nest do you ascribe to me? A question worth asking. Tartarus, black-hearted men who shun the light, woodlands'.[32] Pictura A depicts the three incubators of heresy: the devil hatching heretics, while below, the serpent of sin slithers from its den (A); a heretic reading the Bible, below whom the fox exiting its lair stands for the hatching of heresies (B); and a group of Calvinists gathered in a woodland, where they puzzle over Scripture, hatching various schemes. The devil stares at the heretic to insinuate, as David opines, that he wishes to implant sin in the man's wayward heart, where the seeds of heresy will surely prosper and one day burst forth into the light of day. This man is one thing in body, another in soul – from without, he resembles any good Christian, but within the shadowy recesses of his heart, there lurks the veritable image of the monster Behemoth:

> The aforesaid correlates with the words spoken by the Lord to Job, when he said: 'He sleepeth under the shadow, in the covert of the reed, and in moist places'. In those who live wickedly under the semblance of a Christian man; and in the hearts of idle men, like unto the [hollow] reed and the cane; and in humid men whom luxury, excessive drink, and this kind of carnal concupiscence dissolve, the devil, father of all evil, reposes, finds rest, builds a nest, and stirs up every damnable germ of wickedness.[33]

The doubleness of the true, yet ghastly image concealed within the fictive outer image of a pious man, epitomises the dilemma posed by the heretic,

whose heart, modelled on hell itself, is a workshop wherein the *machinae* (engines, artifices, contrivances, stratagems) of deception are fashioned: 'Here are forged all the instruments and machinery whereby in this life the good are vexed, tempted, and assaulted'.[34] If the devil and his heretical followers deal in meretricious images, none does so more intensively than the Calvinists, who put on the image of a beautiful face, beneath which skulks another image, truer, uglier – resembling the true image of nesting heresy disclosed or, better, unmasked in pictura 7 (Fig. 7.5):

> In such nests of wicked hearts, that fierce, cruel sorceress, that wily serpent finds its fixed abode: who, as saints Gregory and Jerome attest, represents the face of a beautiful woman, whereby she sweetly approaches, all the more surely and savagely to strike the unguarded [heart]; with so much cruelty, that she spares not even her offspring. This rightly represents the nature of Calvinists, who with their sweet speech at first caress the ears of men, but if anything goes against their will, display cruelty, savageness, and vengeful ferocity, that they alone may now take all but full possession of this [heart's] nest of infernal monsters, of heretical vipers, the which they apparently wish at the very least to subdue. Listen to the prophet's fitting words, as follows: 'And [the lamia] has found rest for herself' (Isaiah 34:14). For not before they have rendered the [heart's] every nook and cranny their own, do they cease in their thousandfold exertions, their artful cunning, their evident malice; but in proportion as those they have seduced conform to their depravity, and appear to have been subjugated, then they find their rest; otherwise, let no one hope to discover peace in them, nor concord.[35]

This image of heretical avarice, malice, and truculence coordinates with the explosive image of envious Heresy furiously accosting the Christian community in pictura 6. Like the serpent and fox emerging from their lairs in pictura 7, though far more violently, Heresy propels herself from out of hell, identified in emblem 7 as the originating source of all heretics (Figs. 7.4 and 7.5). It is as if the hidden image in an image described in this emblem were bursting into open view, revealing the true face of heresy, admonishing the viewer ever to keep vigilant; or put in terms of the *nidus haereseos* (nest of heresy), as if Heresy were hatching from its egg, and showing allegorically, by means of an image formerly submerged and now unveiled, what she truly is. This is to say that in its functional relation to pictura 7, pictura 6 operates like a mnemonic exposé, a recrudescent image to be recalled when visualising emblem 7's scabrous description of Calvinists. Thus utilised, pictura 6 reveals the final purpose of David's *imagines haeresis* (images of heresy), which is to defend against heresy's false images by overlaying them with images of the unvarnished truth.

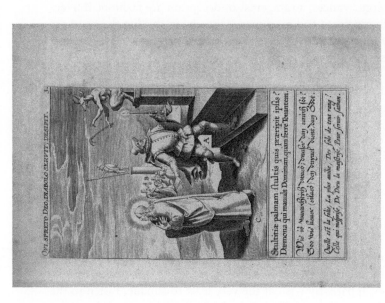

Fig. 7.1 Theodoor and Cornelis Galle, *Veridicus Christianus*, engraving, ca. 1601, in Jan David, S.J., *Veridicus Christianus* (Antwerp: Ex officina Plantiniana, 1606), quarto. Stuart A. Rose Archive, Manuscripts, and Rare Book Library, Emory University.

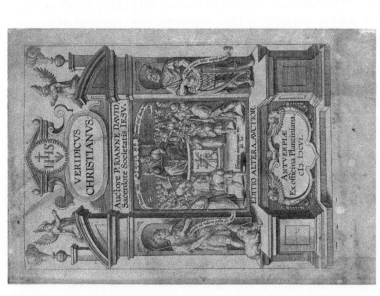

Fig. 7.2 Theodoor and Cornelis Galle, Emblem 3: 'Qui, spreto Deo, diabolo servit, desipit' ('He who serves the devil, having scorned God, is void of understanding'), engraving, ca. 1601, in Jan David, S.J., *Veridicus Christianus* (Antwerp: Ex officina Plantiniana, 1606), quarto. Stuart A. Rose Archive, Manuscripts, and Rare Book Library, Emory University.

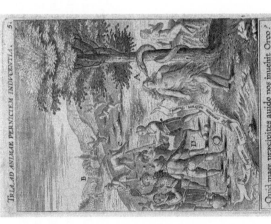

Fig. 7.3 Theodoor and Cornelis Galle, Emblem 5: 'Tria, ad animae perniciem inducentia' ('Three things that lead to the ruin of the soul [: bad counsel, bad example, and bad company]'), engraving, ca. 1601, in Jan David, S.J., *Veridicus Christianus* (Antwerp: Ex officina Plantiniana, 1606), quarto. Stuart A. Rose Archive, Manuscripts, and Rare Book Library, Emory University.

Fig. 7.4 Theodoor and Cornelis Galle, Emblem 6: 'Haeresis, peste perniciosior' ('Heresy, more baleful than the plague'), engraving, ca. 1601, in Jan David, S.J., *Veridicus Christianus* (Antwerp: Ex officina Plantiniana, 1606), quarto. Stuart A. Rose Archive, Manuscripts, and Rare Book Library, Emory University.

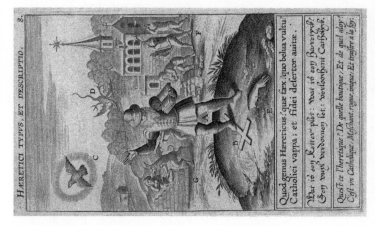

Fig. 7.6 Theodoor and Cornelis Galle, Emblem 8: 'Haeretici typus, et descriptio' ('Image of the heretic, and description [of him]'), engraving, ca. 1601. In Jan David, S.J., *Veridicus Christianus* (Antwerp: Ex officina Plantiniana, 1606), quarto. Stuart A. Rose Archive, Manuscripts, and Rare Book Library, Emory University.

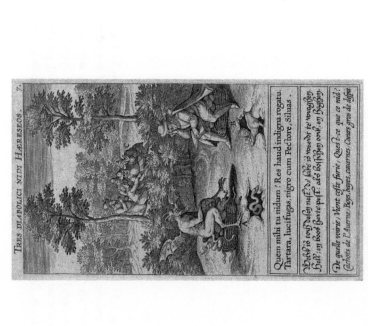

Fig. 7.5 Theodoor and Cornelis Galle, Emblem 7: 'Tres diabolici nidi haereseos' ('The three diabolical nests of heresy [: hell, the human heart, and coverts and conventicles]'), engraving, ca. 1601, in Jan David, S.J., *Veridicus Christianus* (Antwerp: Ex officina Plantiniana, 1606), quarto. Stuart A. Rose Archive, Manuscripts, and Rare Book Library, Emory University.

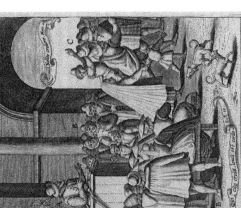

DIABOLICI SPIRITVS DELINEATIO. 9.

Quid dæmon?Erebi quid inadipectabile monstrum.
Angelus; altioli corruptus labe tumoris.

Was Düuuel, meer noch min; Was id een bosse Beest?
Een aertz verdorven sijn; verdoorsent engelsch gheest.

Quest-ce que le diable. Qui tant effroyable Toufiours nous combat?
C'estoit vn bon Ange. Qui par pauure eschange Deuint Apostat.

Fig. 7.7 Theodoor and Cornelis Galle, Emblem 9: 'Diabolici
spiritus delineatio' ('Drawing of the devilish spirit'), engraving,
ca. 1601, in Jan David, S.J., *Veridicus Christianus* (Antwerp:
Ex officina Plantiniana, 1606), quarto. Stuart A. Rose Archive,
Manuscripts, and Rare Book Library, Emory University.

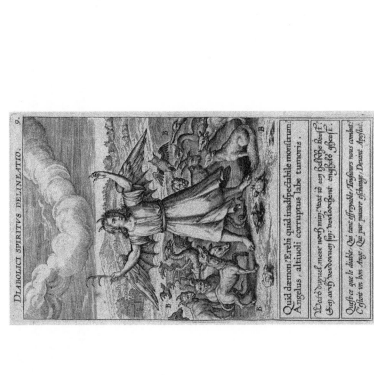

NIMIVM CREDVLI AB HÆRETICIS SEDVCVNTVR. 12.

Quis sese in laqueos facile induit haereticorum?
Immemor hoc semper dare verba; et vendere fumos.

Die laet sterm op s/er punten van Ketters klisp vertragen;
Sulcks die weet en dunckt; dat Ketters altijt liegen.

A qui plus damnable. Sont les sottes fables. De ces Huguenots.
A ceux qui n'adiustent. Qui tant ce qu'ils disent Mensonge et credos.

Fig. 7.8 Theodoor and Cornelis Galle, Emblem 12: 'Nimium
creduli ab haereticis seducuntur' ('The credulous are too
often led astray by heretics'), engraving, ca. 1601, in Jan David,
S.J., *Veridicus Christianus* (Antwerp: Ex officina Plantiniana,
1606), quarto. Stuart A. Rose Archive, Manuscripts, and Rare
Book Library, Emory University.

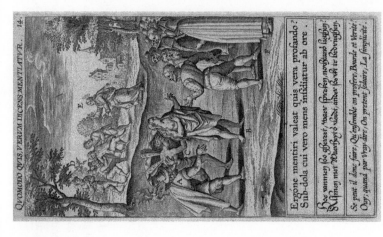

Fig. 7.9 Theodoor and Cornelis Galle, Emblem 13: 'Haereticorum parens et magister diabolus' ('The parent and teacher of heretics is the devil'), engraving, ca. 1601, in Jan David, S.J., *Veridicus Christianus* (Antwerp: Ex officina Plantiniana, 1606), quarto. Stuart A. Rose Archive, Manuscripts, and Rare Book Library, Emory University.

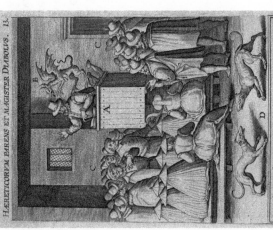

Fig. 7.10 Theodoor and Cornelis Galle, Emblem 14: 'Quomodo quis, verum dicens, mentiatur' ('How someone, in speaking truth, lies'), engraving, ca. 1601, in Jan David, S.J., *Veridicus Christianus* (Antwerp: Ex officina Plantiniana, 1606), quarto. Stuart A. Rose Archive, Manuscripts, and Rare Book Library, Emory University.

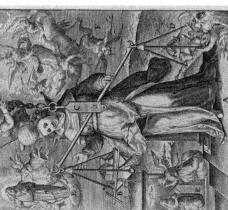

Fig. 7.11 Theodoor and Cornelis Galle, Emblem 15: 'Hominis vere Christiani descriptio' ('Description of a truly Christian man'), engraving, ca. 1601, in Jan David, S.J., *Veridicus Christianus* (Antwerp: Ex officina Plantiniana, 1606), quarto. Stuart A. Rose Archive, Manuscripts, and Rare Book Library, Emory University.

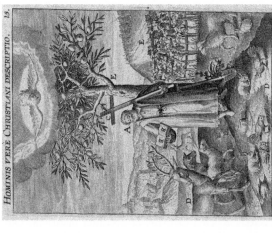

Fig. 7.12 Theodoor and Cornelis Galle, Emblem 45: 'Mundus delirans, non sapit, quae Dei sunt' ('The foolish world knows not the things of God'), engraving, ca. 1601, in Jan David, S.J., *Veridicus Christianus* (Antwerp: Ex officina Plantiniana, 1606), quarto. Stuart A. Rose Archive, Manuscripts, and Rare Book Library, Emory University.

NOTES

1. On the *Veridicus Christianus*, see Imhof, *Jan Moretus*, I: pp. 229–34; and Sors, *Allegorische Andachtsbücher*, pp. 58–83, 139–44.
2. Jan David, *Veridicus Christianus*, p. 40.
3. Ibid., p. 41.
4. Ibid.
5. Ibid., p. 36. All biblical citations come from The Holy Bible, translated from the Latin *Vulgate* [...] with notes by Bishop Challoner (New York: 1941; reprint ed., Fitzwilliam, NH: 2002).
6. Ibid., pp. 36–37.
7. Ibid., p. 37: 'Qui simulata veri adumbrataque similitudine ab haereticis falli nolunt, meminerint, quomodo Cambyses per Smerdem magum deceptus fuit: qui & fratris nomen, & vultum ad vivum exprimebat; eoque fuco, Cambyse regno exuto, se ille eo vestiverat, iamque quietus possedisset, nisi fraus per Othanis filiam detecta fuisset [...]'.
8. Ibid., p. 38 and pictura 13: 'Qui fucum faciunt, mera quamquam oracula fundant? / Qua solet arte, horum Stygius doctorque paterque'.
9. Ibid., p. 38.
10. Ibid., p. 39.
11. Ibid.
12. Ibid.: 'Anno 933. ut Glaber testatur, erat in Galliis haereticus, cui nomen Leutardus; qui primum in agro solus aliquamdiu vixit, somniavitque examen apum sibi per secreta naturae in ventrem intrare, & magno strepitu per os erumpere, quae illum tunc crebris punctionibus agitabant. Ac, diu multumque stimulis agitato, loqui ei videbantur, & multa hominibus impossibilia praecipere, ut faceret. Tandem fatigatus venit domum, [...] Ecclesiam intrans, quasi oraturus, arripuit crucem, & Salvatoris imaginem contrivit. [...] Populum ad se allexit, tametsi insanire videretur'.
13. Ibid.
14. Ibid., p. 40 and pictura 14: 'Ergone mentiri valeat quis, vera profando? / Subdola cui vero mens insidiatur ab ore'.
15. Ibid., p. 41.
16. Ibid., p. 42.
17. Ibid., p. 43.
18. Ibid., p. 10 and pictura 3.
19. Ibid., p. 12: 'Stultitiae huius exemplum in Rege Salomone velut in speculo, licet contueri: qui ex tantae dignitatis gradu apud Deum, in tantam, per mulierum infatuationem, vilitatem, caecitatemque delapsus est; ut se daemoniorum cultui dediderit, ijsque publice litarit; templis etiam & aris idolorum coetui erectis. Hunc in modum insaniunt, quotquot impie vivunt, & ad nequissimam illam stultitiam peccando deveniunt. Talis stultus fuit & Nabal; talis & ille Evangelicus, minime Evangelicus: & quicunque sub istorum signis militant: bibones, epulones, iracundi, fastuosi, insatiatae libidinis & avaritiae, & ide genus homines vitae nequioris'.
20. Ibid.
21. Ibid., p. 27: 'Nullus itaque, his positis, proprie dicitur haereticus, qui non fuerit aliquando verus Christianus: estque eiusmodi, qui fidem Catholicam reliquerit, & ab illa deficiens, ab Ecclesia & Deo extorris, & apostata factus sit. Qui Christianismum suum quasi pedibus calcat, sanctoque spiritu a se abacto, spiritum nequam in se intromisit'.
22. Ibid.
23. Ibid., p. 18.

24. Ibid., p. 19.
25. Ibid., p. 21.
26. Ibid., p. 18: 'In maiorem huius contagij detestationem securioremque fugam, Deus nos mirabili olim praemonuit, & solicite praemunivit exemplo: quando lege lata cavit praecepitque; ut quicumque maculatus esset lepra, haberet vestimenta dissuta, caput nudum, os veste contectum; ac contaminatum se ac sordidum ipse clamaret; solusque extra castra habitaret: quae omnia ad hoc faciebant, ut noti & ad cutem usque perspecti, tutius vitarentur, neque quemquam foetido suo halitu, nimiave vicinitate inficerent'.
27. Ibid.: 'Hanc in tam praesenti periculo cautelam, propius vivaciorique adhuc terrendi modo Christus ipse renovavit, latensque virus aperte detexit, dicens: *Attendite a falsis prophetis, qui veniunt ad vos in vestimentis ovium; intrinsecus autem sunt lupi rapaces.* Cuius attentionis & fugae etiam Apostolus Ephesios commonefecit ijsdem fere verbis: *Attendite vobis, & universo gregi: Scio quod intrabunt lupi rapaces in vos, non parcentes gregi.* Quid posset ad diligentem accuratamque haereticorum fugam efficacius adhiberi; quam lupi rapacitatem ac ferociam obijcere? Quis cum lupo commercij aliquid habere velit? Immo quisnam eo conspecto non illico sibi fuga consulat?'
28. On heresy as disease, see Moore, 'Heresy as Disease', pp. 1–11; and Marshall, *John Locke,* pp. 212–18.
29. David, *Veridicus Christianus* 16 and pictura 5.
30. Ibid., p. 16: 'Alterum est, malum Exemplum, eo deterius priori, quo efficacius. Qui namque facto Exemplum mali praebet, alteri quasi viam ad infernum ostendit; & quot vicibus, vel etiam vitiis, id facit; tot ei quasi passibus ad ignem aeternum praeit. [...] Recte Poëta: *Segnius irritant animos immissa per aurem, / Quam quae sunt oculis subiecta fidelibus.*

 Homo instar simiae ad imitandum pronus est; atque ideo quam bonum atque efficax est, alicui ad virtutem praeire; tam perniciosum est, ac pestilens, aliis in malum exemplo esse'.
31. Coverts and conventicles are the secret meeting places where heretics hatch their plans.
32. David, *Veridicus Christianus* 22 and pictura 7.
33. Ibid., p. 23: 'Praedictis consonant verba Domini ad Job, dum ait; in Behemoth diabolum exprimens: *Sub umbra dormit, in secreto calami, & in locis humentibus.* In illis qui sub umbra Christiani hominis nequiter vivunt; & in cordibus vanorum hominum, qui calamo & arundini similes sunt; & in humentibus, hoc est luxu, crapula, & huiusmodi carnali concupiscentia diffluentibus hominibus, dormit, requiem invenit, nidificat, & damnabile germen suscitat omnis mali pater diabolus'.
34. Ibid.
35. Ibid., p. 24: 'In talibus nequam cordium nidis, etiam immanis illa fera, serpensque versutissimus sedem figet. Qui, teste D. Gregorio, & Hieronymo, formosam foeminae referens faciem, quo blandius aggreditur, hoc certius saeviusque incautum ferit; tantae crudelitatis, ut nec proprio parcat foetui. Calvinistarum recte indolem referens, qui blando primum sermone hominum demulcent aures; sed quando non satis ex voto succedunt omnia, tantam adhibent saevitiam, truculentiam, & vindictae immanitatem, ut nunc nidum hunc infernalium monstrorum, haereticarum inquam viperarum, soli fere possideant; illi saltem praedominari velle videantur. Audi, quomodo & sequentia Prophetae verba, factiosae huic Calvinistarum sectae conveniant: *Et invenit sibi requiem.* Non enim antea cessant a mille moliminibus, nunc astu utentes, nunc aperta malitia, donec omnia ubique locorum suam ad normam redegerint: ut vel seducti ipsorum pravitati consentiant, vel pareant

subiugati: tunc inveniunt sibi requiem; alioqui non est quod quisquam cum eis pacem speret, ullamve concordiam'.

WORKS CITED

David, Jan, SJ, *Veridicus Christianus* (Antwerp: Ex Officina Plantiniana [Balthasar Moretus], 1601).

Imhof, Dirk, *Jan Moretus and the Continuation of the Plantin Press*, Bibliotheca Bibliographica Neerlandica, Series Major III, 2 vols. (Leiden: Brill, 2014).

Marshall, John, *John Locke, Toleration, and Early Enlightenment Culture*, Cambridge Studies in Early Modern British History (Cambridge and New York: Cambridge University Press, 2006).

Moore, Robert I., 'Heresy as Disease', in William Lourdaux and Daniël Verhelst (eds), *The Concept of Heresy in the Middle Ages* (Leuven: Leuven University Press, 1983).

Sors, Anne-Katrin, *Allegorische Andachtsbücher in Antwerpen: Jan Davids Texte und Theodoor Galles Illustrationen in den jesuitischen Buchprojecten der Plantiniana* (Göttingen: Universitätsverlag Göttingen, 2015).

8

DISORIENTATION AS A CONVERSION MACHINE IN *THE ISLAND OF HERMAPHRODITES* (1605)

Kathleen Long

INTRODUCTION

Conversion was a complicated matter during and after the Wars of Religion in France. It was never a certain matter, as it was impossible to verify the sincerity of this act. The proliferation of conversions in the wake of the massacres of Saint Bartholomew's day, occurring in the autumn of 1572, encapsulated this complexity. One example was the conversion of the Protestant pastor Hugues Sureau Du Rosier, whose lengthy confession of Catholic faith, extracted in prison and under the threat of death, was triumphantly published by his Catholic captors in 1573.[1] The same year, Sureau Du Rosier published a retraction in Heidelberg, using the account of his brief conversion as a means to prevent similar conversions on the part of other Calvinists.[2] His case is particularly well-known because his status as an outspoken defender of the Protestant faith led his captors to use him in the attempt to convert other Protestants to Catholicism. But his turn back to Protestantism made him suspect in the eyes of adherents of both religions.[3] As Michael Wolfe explains, for Catholics 'Conversion could thus mean a miraculous transformation of physical property, a commitment to moral probity in everyday life, a spiritual flight from base illusion to a higher truth, and a vigilant observance by the individual of sacred duties that afforded membership in the community of the elect'.[4] Both the Protestant and Catholic versions of Sureau Du Rosier's conversions deploy these last two concepts, the appeal to a higher truth and the invocation of a community of the elect,

to justify their version of events. Of course, Henri de Navarre, later Henri IV, himself converted, or at least promised to, several times. In order to survive the massacres of Saint Bartholomew's Day, he had to promise to become a Catholic, but he fled before he had to make good on that promise. He converted to Catholicism in 1593 in order to be crowned King of France; his track record as a Protestant military leader and his previous feigned conversions made this transformation suspect to many.[5] The unstable nature of these conversions was a source of concern in late sixteenth- and early seventeenth-century France.

While the inhabitants of *The Island of Hermaphrodites* do not force conversions – quite the contrary, they refuse the violence that was so common in France in this period – their lifestyle seems to have a seductive pull on the narrator of the novel, an attraction that seems almost to bring him over to the ways of the hermaphrodites. The palace is the only space the narrator explores on the island, and its architecture seems to play a large role in this seduction. It draws the narrator in, disorienting him and revealing ways of living that he tries but fails to condemn. Even when he has returned to France, the memory of this island stays with him. In this way, it could be argued that the narrative reveals the complexities of conversion, its potential for failure, and the possibility that, even in that failure, some aspects of the conversion remain.

Thus, architecture in *The Island of Hermaphrodites* is used not only to create a setting for the action of the novel, but also to drive its action. All of that action consists of the narrator moving through an elaborate palace, observing the lifestyle and behaviour of its inhabitants. While he seems to be moving forward, he returns several times to the bedchamber through which he entered the palace, suggesting a circular or recursive structure. The anomalous placement of the bedchamber also suggests a blurring of the lines between public and private space, something that had become an issue at the French court. Each time the narrator encounters this bedchamber, it looks like a different space, even though he asserts that it is the same one. Spaces seem to expand as he moves through them (this is particularly evident in the gallery where he finds the laws of the hermaphrodites). And people and objects within these spaces are confused with each other, as the narrator takes statues for living people, and living people for statues. All of these elements in the narration of the space create a surreal atmosphere in the novel, disorienting the reader as well as the narrator himself, and forcing us to re-evaluate our place in this imaginary space as we encounter new challenges to our perceptions. While this disorientation may, thus, create the possibility of conversion, it remains unclear whether conversion actually takes place in this novel, or whether it is being represented as a constant, recursive process that is never quite complete.

Architecture and ornament move the narrator through a series of scenes that transform how he understands the world. The uncertain configurations of spaces in *The Island* recall the vertiginous proliferation of doorways, stairwells,

and perspectives of Hans Vredeman de Vries's (1526–1609)[6] architectural designs. These engravings were collected together in the *Scenographiae*, which was printed in Antwerp by Hieronymus Cock in 1560, reprinted in 1563, 1601, and yet again in 1604 by Theodoor Galle, and finally printed once more sometime after 1636 by Johannes Galle.[7] Copies in collections all over western Europe, but particularly Germany, France, the Netherlands, Italy, Denmark, and Austria, suggest that it was disseminated throughout Europe. Christopher Heuer observes that 'Hieronymus Cock (ca. 1510–1570) had established himself as the most innovative printmaker in north Europe'.[8] With Cock as his mentor, Vredeman de Vries produced another small album of architectural scenes that was eventually augmented with oval intarsia engravings and reprinted in 1601 by Theodoor Galle as the *Variae Architecturae Formae*. This second album focused heavily on ruined buildings; nonetheless, some of the scenes were reminiscent of those in the *Scenographiae*.[9] Other architectural albums, such as the *Artis Perspectivae* (1568)[10] and a treatise in images under the title *Perspective* (1604–05),[11] circulated his images in various forms. Along with albums of designs for tableware,[12] furniture,[13] tombs,[14] wells,[15] gardens,[16] and sculpture,[17] these works established Vredeman de Vries's style and made it accessible to a broad audience of artists and authors. Widely imitated, his designs served as models for theatrical productions and city planning for centuries after his death. It is, therefore, likely that the author of *The Island* was familiar with this tradition.

There are also intriguing points of overlap. Architecture in both works disorients the reader/viewer by playing with perspective and ornament or by means of recursive or endless movement in a scene that forces the viewer, or the narrator and his readers, to reconsider spaces and scenes previously observed and judged. In scenes that seem to convey order and tranquillity, the engravings in the *Scenographiae* subtly reveal the violence that subtends them through the sculptures that serve as ornaments for the architectural spaces. In contrast, in *The Island of Hermaphrodites*, the settings move the narrator from an aesthetics of violence to one of self-care, care, and toleration that might mitigate that violence.

This novel was published in the wake of a revival of Vredeman de Vries's work, featuring the republication and augmentation of many of his albums of engravings, in the early seventeenth century. While the work of Vredeman de Vries generally represents idealised buildings and landscapes, details in the novel signal connections with the French court, both of Henri III (1574–1589) and of Henri IV (1589–1610). Thus, the novel represents more directly, if satirically, historical personages and events, while the engravings tend to allegorise both violence and courtly aesthetics. But the two bodies of work also have some similarities. In both the engravings and the narrative setting, architecture offers a spectre of violence, but also the chance to see the world from various perspectives and to be aware of the coercive nature of a perspective based on a

single point of view. The biography of Vredeman de Vries, a Protestant, possibly a member of the 'much-persecuted Familists',[18] who was forced to leave Spanish-occupied Antwerp and travel throughout Europe on several occasions, also resonates with the self-exiled narrator of *The Island*.[19] These resonances suggest that a reading based on similarities in the aesthetics of the novel and the engravings might prove useful.

STOP MAKING SENSE: THE SHIPWRECK OF RECEIVED KNOWLEDGE

The structure of *L'Isle des hermaphrodites* is, at first glance, fairly clear. A frame narrator, who only later is revealed to be a member of an audience who is being told the story in the novel, introduces the main narrator or storyteller as a man who once fled the Wars of Religion in France. In this narrative, the storyteller lands on an unknown island and works his way through a palace on that island, the only space that is described in his narration. The narrative moves from descriptions of the architecture, to dressing scenes with elaborate descriptions of clothing, to a list of the laws of this strange place, then to a banquet scene, a transcription of some anti-hermaphrodite documents, and finally the return home to tell his story over and over again to his fellow Frenchmen. Thus, the novel consists almost entirely of descriptions within which limited actions are inscribed, creating a strange pseudo-ethnography focused on objects rather than the people who use them. Nonetheless, these objects, generally ornamental like the many tapestries that hang on the walls of the palace, evoke actions and tell stories of their own. Ornamentation thus creates disorienting or distracting intertexts within the narrative that seem to serve as meta-commentaries on the customs of the hermaphrodites.

The book begins with the storyteller setting out on a journey from the New World, where he took refuge, back to France after he hears that an 'invincible and very august monarch'[20] has restored peace to the country. On his way home, he finds himself shipwrecked with a few other men on a floating island: 'we saw the earth on which we walked was entirely floating, and that it wandered vagabond-like on this great Ocean, with no stability'.[21] The island wanders somewhere between the 'terres nouvelles' (new lands), from which the storyteller is returning, and Europe. He thus remains stuck between his place of exile and France until the end of the novel, although the frame narrative presents him as telling his tale to his countrymen after his return, thus blurring boundaries between the 'there' of exile and the 'here' of France (an appropriate confusion for a dystopian satire of the French court). The strangeness of the island also blurs the line between fact and fiction.[22] The shipwrecked men (only two have escaped along with the pilot of the ship) approach a building:

> we set about contemplating a building that was fairly close to us, the beauty of which so enraptured our spirits that we were more of the

opinion that it was an illusion rather than a real thing. Marble, Jasper, Porphyry, gold, and the diversity of enamels was the least of it, for the architecture, the sculpture, and the order that one saw encompassed in all parts, drew the spirit so much into admiration that the eye, which can see so many things in an instant, was not sufficient to comprehend the contents of this beautiful palace. And since beauty is a thing which ordinarily draws to itself, it seems, that which is most distant, forgetting our exhaustion and the travails which we had so long suffered, we were tempted or rather forced by curiosity to look more carefully at this rare masterpiece of nature.[23]

According to the narrator, this work of art is overwhelmingly and forcefully beautiful. He repeats the word *beauté* accompanied by terms that suggest violence and/or seduction; the words *ravis/tentez/forcez*, or ravished/tempted/ forced, create a troubling cluster of concepts. Unable to take it all in, the men are 'ravis', a term that combines pleasure and pain, meaning both 'en extase', 'in ecstasy', and 'emportés par force', 'carried off by force' – a euphemism for rape, according to the 1694 *Dictionnaire de l'Académie française*.[24] This combination of pleasure and pain, of temptation and coercion, evokes the problematic nature of seduction and, by extension, of conversion. This 'masterpiece of nature' is comprised entirely of artifice, made of marble, jasper, porphyry, gold, and enamel. This phrase (*chef-d'oeuvre*)[25] calls into question the boundaries between the natural and the artificial, preparing the reader for the manipulations of bodies that transform them into works of art. While this beautiful space is presented as a relief from suffering, a distraction from a more violent world, it also seems to force itself upon the men. Yet, even as they are overcome by this experience, they cannot take it in, and so the conversion to this new culture and its seductive qualities remains incomplete. The novel seems continually stuck at the first steps of the process, the moment of disorientation rather than reorientation, the turn away from something (France, war, religious zeal) and towards something else (the island, pleasure, religious scepticism) without any resolution in sight. The narrator returns to the same space again and again, always wanting to see more of the inhabitants of the island but never able to adapt to their ways of living or thinking, and he returns home at the end of the novel only to remain stuck in a perpetual narration of his adventures on the island. The narration operates as if he is constantly turning in circles, and never quite arriving anywhere.

Drawn to this strange and alluring place, the shipwrecked men leave the pilot, and move closer to the palace:

and we two (went) towards this rich palace, where we arrived in a little while, and found first of all a long Peristyle or row of Caryatids, that had as their capitol a woman's head. From there, we entered a large

courtyard with pavement so lustrous and slippery that we could barely keep on our feet. Nonetheless, the desire to go further directed us, staggering as we went, towards the great staircase, in front of which there was a large landing surrounded by twelve columns, along with a grand doorway so superbly adorned, that it was impossible to look at it carefully without being dazzled: above the architrave of this doorway was seen an alabaster statue, with the body half coming out of the sea, which was fairly well depicted by means of diverse sorts of marbles and porphyries. This statue was as well-proportioned as possible, and it held in one of its hands a scroll on which was written the word *Planiandrion* (a woman's diadem worn by a man). We barely dared to leave this place, as we were in awe to see such a great solitude, having not yet encountered a single person since we had entered there.[26]

The architectural plenitude, filled with simulacra of body parts, is counterbalanced by the complete lack of inhabitants in this place. Where have

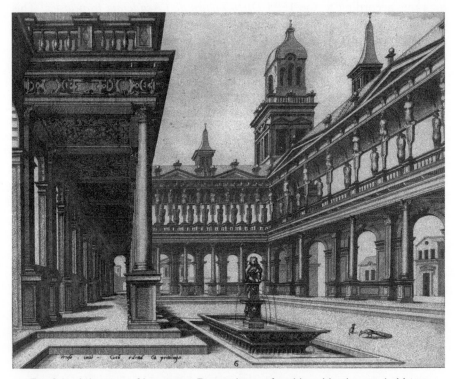

Fig. 8.1 Johannes of Lucas van Doetechum, after Hans Vredeman de Vries, *Scenographiae*, plate 6. Engraving, 1563. 20.6 × 25.9 cm. Photo: Courtesy of the Rijksmuseum, Amsterdam.

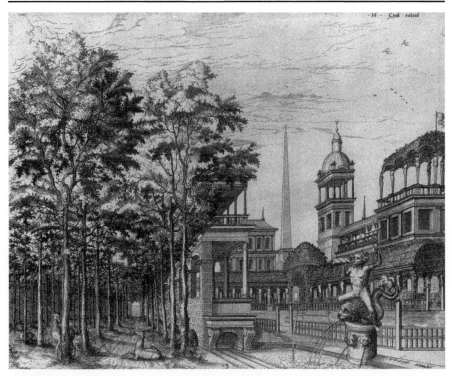

Fig. 8.2 Johannes of Lucas van Doetechum, after Hans Vredeman de Vries,
Scenographiae, plate 13. Engraving, 1563. 20.7 × 25.8 cm. Courtesy of the
Rijksmuseum, Amsterdam.

they gone? This absence of living beings, combined with the proliferation of
pieces of bodies all around the shipwrecked men, stages an ominous scene.
But when they move past this façade, they see a crowd of people,[27] so their
momentary concern seems unfounded. This dynamic of concern and reassur-
ance will play out repeatedly in every space the storyteller encounters in the
palace.

This movement reverses the kind of effect found in Vredeman de Vries's
Scenographiae, particularly in plates 6, 13, and 16 (Figs 8.1, 8.2, 8.3), where
calm scenes of orderly columns, colonnades, archways, and galleries contain
numerous truncated, seemingly mutilated statues, many of which are only
noticeable upon closer scrutiny. The effect is one of a proliferation of dis-
turbing bodies that people the scene in a manner that calls into question
not only the boundaries between animate and inanimate, but also between
the living and the dead. As in the novel, the ornamentation in these works
seems to serve as a complicating commentary on the idealised scenes they
inhabit.

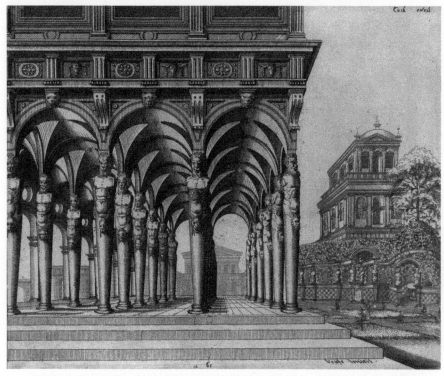

Fig. 8.3 Johannes of Lucas van Doetechum, after Hans Vredeman de Vries, *Scenographiae*, plate 16. Engraving, 1563. 20.9 × 25.6 cm. Courtesy of the Rijksmuseum, Amsterdam.

CONVERTING VIOLENCE INTO PLEASURE: REORIENTATION

The frame of the narration in the *The Island of Hermaphrodites* places it squarely in the realm of the religious wars. The narrator flees France, not wishing to cover his hands in the blood of his fellow men:

> The new world has produced for us in this new age so many new things, that most of the old world, disdaining its antiquity, has preferred to seek, at the peril of a thousand lives, some new fortune, rather than content themselves with the old one and live in rest and tranquillity. But, beyond their natural inclination, the continual upheavals that have taken place in Europe for so many years have persuaded many of them to leave their ancestral homes for some time, out of fear of serving as actors or spectators of the bloody tragedies that have played out on this great stage. So, among them, one of our French men, who had no less valour than wisdom, but from whom a natural kindness had removed the capacity

and the will to soak his hands in the blood of his own kind, chose to risk any other danger than to force his nature in this regard.[28]

This narrative frame shifts perspective abruptly, from the accusation of pleasure-seeking directed at those who leave Europe, to the recognition that this desire might arise from the spectacle of violence that has swept across Europe. The notion of these wars as tragic dramas evoked in this introductory passage was a common one in the period, one later underscored sarcastically by Théodore Agrippa d'Aubigné in his epic, *Les Tragiques* (1616): 'you are not spectators, you are characters in the play'.[29]

One could say that the first conversion in this narrative, then, is away from violence. The problem is that this conversion remains incomplete, as there is nothing to convert to when our storyteller sets out on his trip. In fact, his self-exile could represent a refusal of conversion into the forms of religious fanaticism that had swept France into a frenzy of civil war. He only encounters an alternative religion and culture when he lands on the Island of Hermaphrodites. But even then, he is reluctant to complete his conversion, as this society seems completely alien to him. He spends the rest of the novel travelling through the palace of the hermaphrodites, witnessing their dressing ceremonies, reading their laws, and attending a banquet, before he decides to return home to France. He is clearly drawn to their culture, as he constantly seeks to learn more about them, but he never fully adapts to their ways, which he frequently finds shocking.

The constant movement towards this culture and then away from it drives the novel and undermines any straightforward narration of conversion. For example, the aversion to violence underlying the novelty-seeking nature of the traveller appears throughout the novel in unexpected ways. Within spectacles of pleasure and gender-play, violence erupts momentarily, only to be redirected towards pleasure once more; this is apparent when he recoils in horror at the smoking curling-irons being applied to the hair of the hermaphrodites. Yet the menace seems to resurface continually, or to be implied in many of the scenes of hyper-aestheticised and even sublimated bodies; for example, he recoils once more towards the end of the novel when he sees what he believes to be severed heads – only to be told that these are only wigs. What the spectacles of *The Island of Hermaphrodites* suggest is that the work of forgetting the religious wars is not yet, and perhaps never will be, complete. One can redirect the gaze to pleasurable sights, but the mind, occupied with visions of a horrific past, will continue to see them everywhere.

The element of desire is also inextricably linked to the spatial uncertainties and disorientations that drive the narrative, as the storyteller tries to orient himself both geographically and in the space of the palace within which most of the action takes place. Since the island is a floating one, with no fixed

location, the narrator never knows where he is geographically. Even in the palace, he never quite knows where he is, and must constantly move forward in the attempt to understand his situation. Ironically, on several occasions he finds himself back in the same room through which he entered the palace, and so his movement may not in fact be granting him any better orientation or understanding.

In *The Island of Hermaphrodites*, this constant reorientation is tightly linked to gender orientation, as men transform themselves into hermaphrodites who are at once masculine and feminine. In her work on queer phenomenology, Sara Ahmed proposes 'a new way of thinking about the spatiality of sexuality, gender, and race' by means of a queer approach to phenomenology and to the concept of orientation.[30] She explores the importance of disorientation and the unfamiliar for understanding how we orient ourselves in the world: 'The question of orientation becomes, then, a question not only about how we "find our way" but how we come to "feel at home"'.[31] She discusses the effect of inhabiting what was once an unfamiliar space: 'bodies do not dwell in spaces that are exterior but rather are shaped by their dwelling and take shape by dwelling'.[32] What she calls 'migrant orientation'[33] is that sense of being out of place or unsettled in a place.

The question *The Island of Hermaphrodites* raises is whether people can reorient themselves in a space that has become unfamiliar and unwelcoming, a space that was once home but in which they now feel like migrants. Should they shape themselves to fit that space, or can they shape the space to suit their needs? Long before the mass migrations we study today, many people chose to leave homelands that no longer felt like home to them, and the question of assimilation versus accommodation (conversion versus religious toleration) was already critical. Can this movement through space, an adaptation to another way of life, be seen as a form of conversion? Or is this ability to adapt the opposite of conversion, which should be seen as a movement towards a fixed goal or a stable identity?

Such movement, such adaptation can also be the result of a refusal of religious conversion. The juridical solution to the continual battles and massacres of the Wars of Religion was to create *places de sûreté*, fortified cities and towns where the Protestants could maintain a garrison to protect themselves. This solution was first established in the Peace of Saint-Germain in 1570, and expanded in subsequent treaties through the Edict of Nantes.[34] The importance of these towns became clear in the aftermath of the massacres of Saint Bartholomew's Day, when the Protestant population, H. H. Leonard points out, 'was diminished, in many places dramatically. In addition to the dead, many more, as contemporaries immediately recognised, fled abroad, particularly to England and Switzerland'.[35] Others converted to Catholicism, some permanently. Thus, French Protestants became at first migrants within their

own country, moving to safe towns, or they became exiles from their country. In either case, their refusal to convert to Catholicism resulted in the need to adapt to new environments.

The narrator shares this experience with them, as he exiles himself in order to avoid participating in the violence of the wars. His displacement leaves him without orientation, as he is shipwrecked on an island without a fixed location. The floating quality of the island becomes an allegory for the persistent inconstancy and resulting unfamiliarity of the hermaphrodites themselves. At first, his response to the strangeness of the place is one that encompasses both awe and aversion; he is clearly overwhelmed by the novelty of the place, and disoriented.

This disorientation can cause openness to difference as well, as individuals seek to orient themselves by understanding their surroundings. With this possibility in mind, Ahmed also contemplates the implications of queer phenomenology for the concept of the normative, which she describes as the 'effect of the repetition of bodily actions over time, which produces what we can call the bodily horizon, a space for action, *which puts some objects and not others in reach*'.[36] She sees disorientation as a vital means of experiencing the grounds upon which we orient ourselves, of viewing the normative from other angles.

Ahmed's understanding of disorientation and its relationship to the normative might help us to access more complex messages in *The Island of Hermaphrodites*, which is a profoundly disorienting text, calling upon the reader to make meaning or sense of it but constantly confounding that meaning. It refuses to situate itself, both in geographic and ideological terms. This narrative can and has been read as a satire of the Valois court focused on its excesses and on the perceived effeminacy of Henri III and his *mignons* (favourites),[37] presenting a spectacle of non-normative gender as amusing or entertaining. But the repeated appearance of allusions to the violence of the religious conflicts disrupts this tone of easy mockery.

As the narrator moves through the palace, the effort to orient himself seems to create a desire to understand and to move on to see new things, ostensibly in the service of that understanding. This effort creates an investment in the culture of the island, which counters his (already not very strong) assertions of shock or even disgust at what he observes. He transforms his engagement with this culture into his own narrative of his adventures at the end of the novel, thus extending his at least partial conversion to the ways of that culture to his fellow-Frenchmen. Movement through the space of the island, and experience of its spectacles and rich ornaments, has converted him to the role of a cultural hermaphrodite, crossing boundaries between the French and their others, remaining in spirit on the island he left behind in order to return to France. Perhaps what we are seeing in his development is the process of conversion, which gets stuck at a sort of midpoint, where he neither remains the same nor is

entirely converted to the new culture. This suspension between two possibilities could be seen as the space of toleration, a mindset that embraces both possibilities rather than demanding a completed conversion. This ability to accept two opposing views without uniting them into one is an appropriate mode for the hermaphrodites, and echoes the stance of the *politiques*, the French moderates who sought the peaceful coexistence of two violently opposed religious groups. In fact, the politiques were accused of being doctrinal hermaphrodites.[38]

The engravings in Vredeman de Vries's *Scenographiae* also embed violent elements in court settings, with galleries and vast rooms inhabited by grotesque ornamentation that seems innocuous at first glance, but far more menacing upon closer scrutiny. For example, the seventh plate features a large hall with a coffered ceiling. The extreme perspective draws the eye into a room at the other end of the hall, with an elaborate monumental fireplace. But on the right side of the hall, a deformed putto is drawing a bow, aiming at the two *terms* (the word Hollstein uses for the legless, armless statues that frequently appear in Vredeman de Vries's work)[39] across the hall, in front of the fireplace there. The two *terms* look like they have stumps of arms that are flesh that has been butchered, rather than being the smooth torsos without arms or with more neatly truncated arms of the classical herm or term. At the far end of the hall, two men with swords confront each other, one on either side of the door. Still more scrutiny of the image reveals bodies all over the margins of the open space: two thin men over the fireplace, with a grotesque form above them, animated friezes representing some sort of violence on the other side of the room. The room is in fact crawling with violent life.

The careful use of architectural orders and the extremely ornamental aesthetics and exaggerated perspectives of these scenes at first hide the disturbing elements within them: few human inhabitants, but many statues, mostly terms with truncated or simply missing limbs and distorted features. The disjunction between the idealised architecture and the ornamental elements might give a viewer pause, eliciting some consideration of the distance between form and content, or style and subject matter. Perhaps these works might tell us something concerning the role of architectural orders and ornament in an era of ugly violence.

Both works repeatedly draw the reader or viewer further into the spaces they represent, pulling us into the scenes or narrations and inciting our curiosity, whether further into the interior of the palace as the narrator of the novel goes from a bedchamber through a hidden door to a gallery containing the laws of the hermaphrodites, or deeper into the architecture towards vanishing points on the horizon in most of the plates of the *Scenographiae*. Both also present an almost symbiotic relationship between violence and pleasure by means of these scenes, as pleasure both conceals and depends upon the violence it seems to oppose. While the pleasurable effect of representing violence on the stage in a

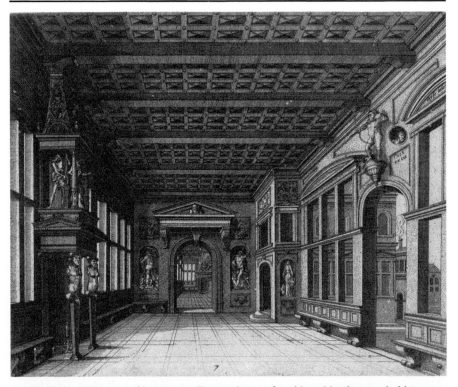

Fig. 8.4 Johannes of Lucas van Doetechum, after Hans Vredeman de Vries, *Scenographiae*, plate 7. Engraving, 1563. 21.1 × 25.8 cm. Courtesy of the Rijksmuseum, Amsterdam.

controlled manner was used in other works of the time as a means of converting civil strife into communal healing, as Andrea Frisch has demonstrated,[40] its dependence on the effacement of lives lost always puts this conversion at risk.

Both *The Island of Hermaphrodites* and the engravings of the *Scenographiae* seem to underscore the incomplete nature of this conversion by presenting us with bodies that call into question the boundaries between the living and the dead, and the natural and the artificial, and by suggesting that these two dichotomies are related. In *The Island of Hermaphrodites*, statues are described as natural and lifelike, and humans are described as artificial, not fully alive. In the *Scenographiae*, church and court interiors are filled with statues or terms that look broken, even injured, perhaps by acts of iconoclasm that evoke destruction of human bodies. For example, in the sixth plate of the series (Fig. 8.1), the columns of the upper storey consist entirely of terms with truncated arms. These terms alternate between male and female, and are all clearly distinct from each other. Some faces are distorted, some seem mutilated

or monstrous, some arm stumps are depicted in a way that makes them look like living flesh that has been cut. All of these details evoke a potential for life (and by extension, death) and movement. This suspension between two states of being raises the spectre of a perpetual connection between them, rather than a clear or definitive movement from one to the other.

Arguably, the impossible but highly aesthetically charged nature of these scenes, with their elaborate and often grotesque ornamentation and plays on classical architectural forms, engage the viewer's attention more fully, as they elicit efforts to find meaning in the scenes, and to orient oneself in relation to them. They create a desire both to see and to understand, and through that desire operate as conversion machines. This effect is similar to that of the desire to see and understand expressed by the storyteller in *The Island of Hermaphrodites*, a desire that marks him as prepared for conversion to the new culture he is observing. But the inability to represent utopia evoked by these engravings and in the novel raises the question of what desire might convert one to, suggesting that the works are at least in part staging the hermeneutic challenges presented by that which is unseen, unseeable, and unknowable.

This staging is perhaps most evident in the long, seemingly interminable, hallways in many of the engravings of the *Scenographiae*, which do not really seem to lead anywhere. In short, these scenes frequently stage uncertainty or ambiguity, with the viewer always on the verge of understanding, but never quite arriving at a conclusion. This effect is mimicked in the eighteenth plate of the *Scenographiae*, with its seemingly endless hall that, on almost impossibly closer scrutiny, ends in another structure that one can see into and through. The ornamentation in this image also plays on the boundaries between life and its imitation, with statues that wriggle and squirm and twist, all seeming to be in movement in a space that contains no representation of a living human.

In Vredeman de Vries's engravings, exaggerated perspective both pulls the viewer in towards the vanishing point and creates a profound sense of disorientation because of the impossibility of the scene, as well as the off-centre positioning of the scene and its viewer. The scenes often stretch into a barely visible or even fully invisible distance, and the off-centre perspective facilitates this sort of game of soliciting the gaze and frustrating it at the same time.

The subtly threatening ornamentation discussed above accentuates this uncertainty. The mutilated body parts that peek out of many locations (and the more you look, the more of them you see), sometimes looking at you looking at them, speak of a violence that is immanent in the ostentatious luxury of the scene. The effect of the engravings in the *Scenographiae* is, thus, both engaging and terrifying, somehow attractive and repulsive, as the viewers' curiosity about the odd scenes draws them in, only to be followed by an aversive reaction to the troubling details.

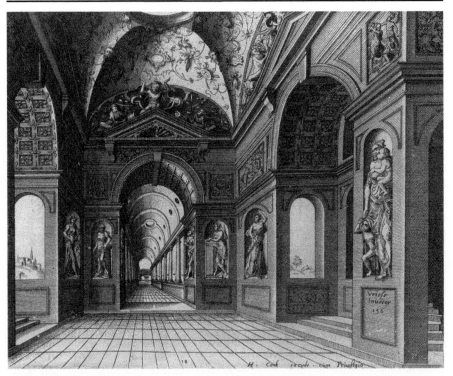

Fig. 8.5 Johannes of Lucas van Doetechum, after Hans Vredeman de Vries, Scenographiae, plate 18. Engraving, 1563. 21.1 x 26 cm. Courtesy of the Rijksmuseum, Amsterdam.

What remains elusive, both in *The Island of Hermaphrodites* and in the work of Vredeman de Vries, is what this violence might mean. In an era of violent political and religious upheaval, one in which the usual tragic figures (kings, princes, and generals) have no moral standing as they have become a threat to their own people, the usual architectural orders and narrative structures may not serve a straightforward exemplary purpose. Formerly didactic images and stories take on multiple, contradictory roles, both presenting social and architectural norms and subverting them. This subversion integrates desire, as elicited by vision, as a motivating force with a violent subtext that resuscitates the historical events that were supposed to have been long buried. It should come as no surprise that Vredeman de Vries designed an engraving of the massacres of the Roman Triumvirate, a favourite subject for artists told not to represent the Wars of Religion.[41] I would argue that this violence, embedded in seemingly calm and orderly architectural images (see plates 7 and 18, Figs 8.4, 8.5, mentioned above, in particular) by means of the dead bodies and severed heads transformed into architectural grotesques and caryatids, equally

subtends the doubt felt by the narrator of the novel. Desire for a pleasing image thus leads us to observe violence, which is shown to be present even in scenes of order and which elicits the response of doubt concerning the reality, or the orderliness, of that order. Perhaps the suggestion is that order based on violence is not in fact order.

MAKING NEW SENSE IN *THE ISLAND OF HERMAPHRODITES*

The relationship between human bodies and architectural ornamentation, playing on similarities between animate and inanimate forms, between the living and the dead, is omnipresent in this novel. Just as the narration is driven largely by the space in which it takes place and the movement of the narrator through that space, along with the 'ornamental' details that he encounters along the way, so the subversion of gender and genre norms, of social hierarchies and sovereign power, is fuelled by the strange representations of these spaces and the things found in them. This subversion becomes evident as the storyteller encounters more and more works of art, and more and more humans who resemble these works, in the oddly recursive space of the palace.

This ambiguity between living being and ornamental embellishment, between the animate and the inanimate, is clear from the first 'action' of the novel, when the narrator enters the palace, walking immediately into a private room, a bedchamber in fact. Here, there are people present: courtiers attending upon hermaphroditic royalty. The royal inhabitant of this room is still in bed, their body invisible to view: 'I had not yet seen what was in this bed, because one could not yet see the hands nor the face'.[42] The choice of the pronoun 'ce que' (what) rather than simply 'qui' (who) signals the storyteller's inability to distinguish the living inhabitants of the palace from the stone ornamentation and other artwork that surrounds them. The men (at this point in the narrative they are called men) remove a sort of linen veil from the face of this thing (the storyteller has only described it as a thing up to this point), and then a mask. Yet still the narrator does not offer us a description of the face. The hermaphrodite (one might guess) goes back to sleep, and the curtain is pulled across their bed. Here we are presented with a scene that stages confusion between the animate and the inanimate very early on in the narration, one that frames the subsequent encounters.

The potential for violence, or the resurgence of violent memories, also becomes very clear early in the novel. The narrator moves on to the next room, and is horrified to see what he imagines are men being tortured:

> I had barely entered into the room, when I saw three men who were held by the hair with little pliers taken from little brazier, so that one could see their hair smoking. At first this terrified me, and it took all the effort in the world to stop myself from screaming, thinking that some outrage was

being committed against them; but when I looked more closely, I realised that no one was doing them any harm.[43]

In fact, these men are having their hair curled. But the word *tenailles* (pliers) evokes an instrument of torture used to rip flesh off the bodies of condemned men about to be executed, or off accused criminals being tortured in the hopes of extracting a confession.[44] Confronted with this spectacle, the narrator first sees what his traumatic memories guide him to see, only later to realise that this is a more pleasurable scene than he had thought (the men are reading, joking, and chatting). The narrator passes through a series of rooms where the hermaphrodites' hair and makeup are being done. One could see this as another form of torture, for example when the hermaphrodites undergo a sort of chemical peel to make their skin more youthful. Pleasure and pain remain inextricably linked, and not only in the mind of the storyteller.

Their hair and makeup done, the hermaphrodites are then dressed, with large feet jammed into tiny shoes, and elaborate clothing layered onto their bodies. The ceremony of making the foot fit into a tiny shoe suggests that bodies are sometimes violently constrained to conform to aesthetic ideals, as the foot is hit repeatedly to shove it in.[45] In this scene, pleasure (or at least beauty) and violence are tightly conjoined, whereas elsewhere in the novel, pleasure and novelty are presented as correctives to violence. The act of dressing the hermaphrodite is compared to torture:

> Once this shirt was put on, the collar was immediately turned up, in such a way that you might have said that the head was waiting in ambush. They brought him a waistcoat, on which there was a sort of little body armour to make the shoulders even, because he had one higher than the other, and right away the one who had given him the waistcoat turned down the large collar made of cutwork, as I described above, and I would have almost thought that it was made of some very white parchment, it made so much noise when it was handled. It was necessary to turn it down in such a precise length, that they had to raise and lower the poor hermaphrodite until it was just right; you would have said that they were torturing him. When this was finally in the form that they desired, it was called the gift of the rotunda.[46]

The body is 'corrected' by the clothing, but it is also forced to fit into that clothing, rather than the clothing being fitted around the body. The military imagery of ambush and armour, the cutwork (*point couppé*) that he has described elsewhere as *taillade* (meaning 'hacking' or 'slashing' and used quite frequently in descriptions of combat to describe the violence men inflict on each other), as well as the reference to torture, set a substrate of violence under a scene that might otherwise simply be read as comical. This description of the

dressing-scene thus suggests the violence of normative ideals that require that the body fit the clothing, and the individual assimilate into the society in which he lives.

Next, everyone proceeds to the room the narrator first came to when he entered the palace, which now looks very different to him. Is he noticing things he had not before, or has the room changed? The floor is covered with flowers, and the bed richly ornamented. In the bed resides the pendant piece to the statue encountered in the courtyard of the palace, the hermaphrodite who elicited his confused reaction when he first entered the palace:

> in the middle of the bed there was visible a statue of a man, half out of the bed, that had a bonnet somewhat in the form of those that little children wear when they are first dressed ... The face was so white, so lustrous, and of such a striking red, that one could readily see that there was more of artifice than of nature in it, which made me think readily that it was only a painting.[47]

While our storyteller has presented the palace, made of marble, jasper, and porphyry, as 'a masterpiece of nature', here he presents one of the inhabitants as unnatural – a work of art. Given the level of body manipulation that he has just observed, this response is understandable, but it does intensify the confusion between the highly ornamented space and the highly ornamented people in it. Once this hermaphrodite has awakened, and actually spoken, the group heads for a room whose door is hidden behind a tapestry. The narrator seeks to follow them, but is told that only those most 'familiar' of the courtiers (that is, those closest to the royal hermaphrodite; with sexual innuendo implied by the French term *familier*)[48] are allowed in this space, which is called something like a wardrobe. It seems that there are limits on the seemingly absolute freedom of this island.

These limits are echoed in the descriptions of a series of tapestries that follows upon the narrator's exclusion from the wardrobe. He stays outside, and contemplates the tapestries, which represent the story of the Roman Emperor Heliogabalus's attempt to become a woman:

> On another panel, I saw this same man stretched out all naked on a table, and several around him who had different kinds of tools, and did everything they could to make him into a woman; but from what I could judge from the continuation of the story, he remained neuter.[49]

This scene evokes an autopsy as much as it does some form of premodern gender reassignment surgery. While the surface interventions of makeup, dress, and behaviour have been used to play with gender distinctions, thereby creating the hermaphrodites, surgical interventions are presented as being problematic here. Whether this is because gender is not a stable or biological state in

the culture of the hermaphrodites, and exists only on the level of appearance, or because of a more normative take on gender difference as a biological given that cannot be altered, is not entirely clear.

FOLDING CHAIRS AND EXPANDING SPACES

Seeking to understand these pictures, the narrator asks a 'domestic' (his word) who understands Latin to explain all this. This man offers to take him on a tour of the palace, and lifts another tapestry to reveal yet another hidden door into a gallery: 'Thus moving further along, we entered into a gallery that was fairly wide, and of medium length'.[50] This space seems to expand as he moves along, always extending further into the distance, and containing an infinite number of curiosities:

> And so, continuing on my way, I saw an infinite number of rare things, which I would take too long to recount here in any detail, for the place was large and completely filled with things that were more intriguing than useful; also, they were collected and arranged for the sole purpose of pleasing the eyes. In that room were a number of folding chairs that could become longer, wider, lower, or higher by means of gears, however one might want them. This was a *Hermaphroditic* invention.[51]

In this ever-expanding space, the narrator encounters folding chairs that adjust to the body of the person sitting in them. These chairs are the opposite of the Procrustean bed, known as the bed of Sodom in Talmudic lore. As Eliezer Segal points out in his detailed survey of the history of this bed: 'The rabbis' criticism of the Sodomites focuses principally on the residents' lack of hospitality and their brutal abuse of visitors to their city and of residents who extended hospitality or kindness to strangers'.[52] The sin of Sodom was represented quite differently in early medieval theology, and not only in Talmudic texts.[53] The classical model for this behaviour, the robber Procrustes, invited his guests to lie in his bed, then cut them or stretched them to fit that bed; for these crimes, among others, he was killed by Theseus.[54] Procrustes and the Sodomites were the images of the horrible host, but the bed has taken on greater meaning, as the image of achieving conformity by violent means, and of knowledge (or scientific inquiry) that alters data to fit preconceptions. Again in Talmudic lore, the bed of Sodom is part of a series of tales that show the Sodomites as maintaining 'a system of laws that was not only unjust, but utterly absurd'.[55] These laws focus on extermination of foreigners by means of arbitrary and restrictive laws, rather than accommodating them as guests. The hermaphrodites' chairs, on the other hand, adjust to the needs of the individual using them, in order to increase their comfort. Like the more hospitable folding chairs in this gallery, the space of the palace accommodates the desires of the narrator, stretching out farther and farther to both whet and satisfy his curiosity, folding back when

he chooses to return. Similarly, Vredeman de Vries's more elaborate scenes, devoid of live human beings but full of statues and grotesque ornamentation, stretch out into the distance. This seemingly infinite prospect of possibilities (the infinity of things the storyteller sees in the gallery) is also the spectre of past and perhaps still present threats: a proliferation of things without people to use them, of things that replace the missing people and signal their absence, a spectacle that gestures towards the violence that generated it.

As our storyteller moves through the ever-expanding gallery, he sees twelve alabaster statues on one side of the room, richly decorated, ambiguously dressed (with both male and female clothing), and bearing the signs of being objects of adoration.[56] They are the deities of the hermaphrodites, classical and mythological examples of gender ambiguity. Next to the statue of Heliogabalus he finds the book of laws of the land, but as it is too long for him to read before dinner, his host gives him a pamphlet summarising the most important ones. The contents of this pamphlet form the middle portion of the book.[57]

SPECTACLE AND CONVERSION

Much of the literary and artistic production in France during and after the Wars of Religion seems at first to stage a negation of violence, representing the violence of those wars in distant or ancient settings, and even moving such violence offstage. By this means, royal power might convert civil strife into peaceful reconciliation, and transform the violence it continues to perpetrate against its own people into at least the illusion of kingly beneficence, as dead bodies disappear from view. There was thus already a mechanism in place for converting violence into pleasure, one elaborated by royal decree. Even as the French Wars of Religion ravaged the country between 1562 and 1598, and lingered on through to the Siege of La Rochelle in 1627–1628, a series of peace edicts was promulgated as part of a royal policy of *oubliance*, or deliberate forgetting of these wars.[58] These edicts forbade speaking of or writing about past differences or even violence, on pain of death, in hopes of easing tensions by erasing the memory of these conflicts.

The response of some, particularly militant Protestants like François Hotman, was to write openly and vehemently about these conflicts. Moderate Catholics did not wish to anger their King, but nonetheless felt compelled to evoke this traumatic violence, so they used various forms of indirection to represent the wars. Baroque and early Classical theatre focused on mythological or ancient historical violence. The popular tragic tales of the period (*histoires tragiques*), written by François de Belleforest among others, often used foreign cultures or the distant past as settings for representations of civil conflict. *The Island of Hermaphrodites* embeds the suggestion of violence in tranquil or even comic scenes. Visual representations can be direct, as in the works of Jean Perrissin and Jacques Tortorel, and of Frans Hogenberg, or incorporate

violence into seemingly ahistorical scenes, as Vredeman de Vries does in his architectural engravings. By playing with highly codified rhetorical or aesthetic norms that dictate the level of discourse appropriate for the various genres of work, from the noble epic to the lowly satire, or the use of particular architectural orders to signal social status, these works often seem to call into question a society dependent upon violence to maintain order.

As Christian Biet has demonstrated, quite a few works written during and after the period of the religious wars defied government censorship against open representations of violence.[59] But some works also performed a critique of the royal policy of oubliance by means of pleasing spectacles, both presenting performances that evoke pleasure and suggesting their relationship to the underlying violence that both informs them and threatens to shatter the illusion of peace that they create.

Both *The Island of Hermaphrodites* and the engravings of Hans Vredeman de Vries feature architecture and architectural ornament as both the setting and the machine that drives conversion, directing the gaze and disorienting it, provoking strong reactions of pleasure and fear, and eliciting the thought required to reorient oneself in the face of the unfamiliar. Both works seem to gesture overtly to their own performative or staged nature, whether through language or in the details of setting. For example, in *The Island of Hermaphrodites* the narrator observes elaborate dressing ceremonies, and comments 'you would have said that this was some sort of masquerade, and, in truth, they [the hermaphrodites] were already fairly disguised, but they did not do any other steps [*figures*] than to go to the bedside in unison'.[60] Meanwhile, with its distinct absence of people, and a strange unused and unusable quality to the settings suggested by the lack of furniture in most scenes and the interminably long perspectives, the *Scenographiae* evokes stage sets. Perhaps at first this emphasis on performance allows the narrator or viewer to establish a distance from the works, becoming an audience or observer rather than a participant. But the spaces described or depicted eventually lead the narrator or viewer into engagement with them, as they turn to go through another door or focus to understand the space that is being depicted and the ornaments that proliferate in it.

RECONVERSION: RETURN FROM THE LAND OF THE HERMAPHRODITES

After spending the entire narration of the novel travelling through the palace, the storyteller goes through another series of bedchambers, down a small hidden staircase, and attends a strange and sumptuous banquet, where most of the dishes are unrecognisable ('the meats of the first course were so finely minced, cut up, and disguised, that they were unrecognisable').[61] The banquet over, he follows his guide, who has to pick something up from the previously forbidden wardrobe. He sees the usual clothing and accessories, but, as is

noted above, is shocked to see 'some sort of half heads',[62] perhaps scalps, and is appalled by such marks of cruelty. His guide reassures him and shows him that these are just wigs used to cover balding heads.[63] Once more, a horrifying spectacle of violence is in reality simply another adornment. Yet this adornment also covers other horrors: this baldness is caused by syphilis. In this way, images of violence are both evoked and neutralised in a constantly recurring loop, perhaps as a way of working through the trauma of religious wars that recede into the distance at some points, but return unexpectedly as the narrator travels through the palace of memory and revives the scenes he sought to avoid. If conversion is like the bed of Sodom, and brings with it the trauma of being constrained to fit into a limited space or role, then one could see the ever-changing hermaphrodites as engaged in resistance to this forcible conversion based on the demands of a brutal society. But like the rock of Sisyphus, the narration of the novel always rolls back to the origin of the story itself: the Wars of Religion, from which the storyteller tried to escape, but from which he did not succeed in extricating his mind.

In fact, he must return to this point of origin, as he is reminded once more of its existence by some 'heretical' works written against the hermaphrodites, which he is given by his guide and which he decides to read in the garden, finally arriving outside the microcosm of the palace. At this point in the novel, he tries to end his narration, but his audience wants more:

> 'But, from what I see, says he, you are not at all tired of listening to me'. 'Not at all, we replied, even if you continued for days on end, for who could ever be bored listening to so many new things?'[64]

This spectacle by proxy has seduced its audience, and it is clear that the narrator himself has told this story repeatedly, unable to shake its hold on his mind and his emotions. He stretches out this tale by means of this retelling. Thus, this narration seems to be continually suspended at the moment of conversion, as the storyteller is drawn to the world of the hermaphrodites but can never quite forget the world he came from or the trauma he previously experienced. The pleasure of the various scenes he witnesses is not quite sufficient, not quite complete enough, to make him forget, and for this reason they seem constantly to re-enact past horror as much as present delight. But neither can he relinquish the pleasure of the hermaphrodites, as he continually returns to his narration of his adventures.[65]

This ambivalence links the storyteller conceptually to the hermaphrodites: he is neither here nor there (and thus literally 'utopian' himself in his affective peregrinations), neither fully French anymore, nor integrated (nor even assimilable) into this new culture. He is alienated from both possibilities, from one due to his rejection of the violence of his culture of origin, from the other because of the lingering normative attitudes that fostered such violence

but that he cannot shake off. While this ambivalence may seem to make our storyteller and his tale examples of imperfect conversion, it also suggests the impossibility of a perfect conversion, a turning away from one choice to another. For it is precisely the demand that one choose one or the other path, with no ambivalence or ambiguity, no lingering remainder of a prior life or prior affective bonds, that fuelled the violence of the religious wars in France. For this reason, the storyteller's lingering between two worlds becomes itself a powerful (non-)conversion, claiming the suspension of judgment, religious tolerance, and the right not to choose – in the name of what was lost and what might still be found – as if the acceptance of differences were not a utopian dream.

NOTES

1. *Confession de Foy Faicte par H. S. Du Rosier*, fol. 31.
2. *Confession et recognoissance de Hugues Sureau, dit Du Rosier, touchant sa cheute en la Papauté.*
3. Beuzart, 'H. Sureau Du Rosier', pp. 249–68.
4. Wolfe, 'The Search for God', *The Conversion of Henri IV*, p. 7.
5. Wolfe, 'The Search for God', 'The Catholic King and Pacification', *Conversion*, pp. 159–63.
6. Heuer, *The City Rehearsed*, p. 1.
7. Hollstein, *Vredeman de Vries*, Part I, pp. 52–3.
8. Heuer, *The City Rehearsed*, p. 31.
9. Hollstein, *Vredeman de Vries*, Part I, p. 88.
10. Ibid., Part I, p. 238.
11. Ibid., Part II, p. 165.
12. Ibid., Part I, p. 151.
13. Ibid., Part II, p. 137. *Differents Pourtraicts de Menuiserie*, Philippe Galle, ca. 1583.
14. Hollstein, *Vredeman de Vries*, Part I, p. 129, *Coenotaphiorum*, Hieronymous Cock, 1563.
15. Ibid., Part II, p. 39; a series of small wells with no title page, apparently produced around 1574.
16. Ibid., Part II, p. 122, *Hortorum*, produced in Antwerp by Philippe Galle in 1583.
17. Hollstein, *Vredeman de Vries*, Part I, p. 203, *Caryatidum*, published by Gerard de Jode in 1565.
18. Heuer, *The City Rehearsed*, p. 7.
19. Ibid., pp. 6–7.
20. *L'Isle des hermaphrodites*, p. 54: 'invincible et tres auguste Monarque'.
21. Ibid., p. 56: 'nous veismes que la terre sur laquelle nous marchions estoit toute flotante, et qu'elle erroit vagabonde sur ce grand Ocean sans aucune stabilité'.
22. Ibid., p. 57: 'nous croyons la fable des champs Elisées estre une pure verité', 'we believe the fable of the Elysian fields to be pure truth'.
23. Ibid., p. 57: 'nous nous mismes à contempler un edifice assez proche de nous, la beauté duquel ravit tellement nos esprits, que nous avions plustost opinion que ce fust une illusion qu'une chose veritable. Le marbre, le Jaspe, le Porphire, l'or, et la diversité des émaux estoit ce qu'il y avait du moindre; car l'architecture, la sculpture, et l'ordre que l'on y voyait compassé en toutes ses parties, attiroit tellement l'esprit en admiration, que l'oeil, qui peut voir tant de choses en un instant, n'estoit pas assez suffisant pour comprendre le contenu de ce beau palais.

Et comme la beauté est une chose qui attire ordinairement à soy ce qui en est, ce semble, le plus esloigné, oubliant nos lassitudes et les travaux que nous avions si longuement soufferts, nous fusmes tentez ou plustost forcez par la curiosité, de voir plus particulierement ce rare chef-d'oeuvre de la nature'.

24. *Dictionnaire de l'Académie Française*, vol. 2. https://artflsrv03.uchicago.edu/philo logic4/publicdicos/query?report=bibliography&head=ravir.

25. The phrase *chef d'oeuvre* is used to designate an exceptional work of art, one used to demonstrate an artisan's skill: https://artflsrv03.uchicago.edu/philologic4/public dicos/query?report=bibliography&head=chef%20d%27oeuvre.

26. *L'Isle des hermaphrodites*, p. 58: 'nous deux vers ce riche palais où nous arrivasmes en peu de temps, et trouvasmes de premier abord un long Peristyle ou rang de colonnes Caryatides, lesquelles avoient pour chapiteau la teste d'une femme; de là nous entrasmes dans une grande court de laquelle le pavement estoit si luisant et si glissant qu'à peine s'y pouvoit on tenir. Toutesfois l'envie de passer plus outre nous feit aller tous chancelans au grand escalier, au devant duquel estoit un perron entouré de douze colomnes, accompagné d'un portail si superbement enrichy qu'il estoit impossible de le considerer sans s'esblouyr: au dessus de l'architrave duquel se voyoit une statue d'albastre, sortant le corps à demy hors d'une mer, qui estoit assez bien représentée par diverses sortes de marbres et de porphires. Ceste statuë estoit autant bien proportionnee qu'il se pouvoit, laquelle tenoit en l'une de ses mains un rouleau où estoit escrit ce mot *Planiandrion*. A peine osions nous sortir de ce lieu, tant nous estions pleins de merveille d'y voir une si grande solitude, que nous n'avions encore rencontré personne depuis que nos estions entrez'.

27. Ibid., p. 59: 'une merveilleusement grande multitude de gens qui alloient et venoient de tous costez'.

28. Ibid., p. 53–4: 'Le nouveau monde nous a produit en ce nouveau siècle tant de choses nouvelles, que la pluspart du monde ancien ... a mieux aymé chercher, au peril de mille vies, quelque nouvelle fortune, que se contenter de l'ancienne et vivre en repos et tranquillité ... mais, outre leur naturelle inclination, les continuels remuements advenus en l'Europe depuis tant d'années en ont encore persuadé plusieurs à quitter pour un temps leurs anciennes demeures, de peur de servir de personnages ou de spectateurs des sanglantes tragedies qui se sont jouëes sur ce grand theatre. Or entre ceux-cy, un de nos François qui n'avoit pas moins de valeur que de prudence, mais à qui une bonté naturelle avoit osté la puissance et la volonté de tremper ses mains dans le sang des siens, fit eslection de courir plustost tout autre danger que de forcer en cela sa nature ...'

29. Aubigné, *Les Tragiques*, 'Misères', line 170, p. 272: 'Vous n'estes spectateurs, vous estes personages'.

30. Ahmed, *Queer Phenomenology*, p. 2.

31. Ibid., p. 7.

32. Ibid., p. 9.

33. Ibid., p. 10.

34. Knecht, *The French Civil Wars*, pp. 155–56: 'The Peace of Saint-Germain which was signed in August marked for the Huguenots a definite advance on earlier settlements, for they were granted four security towns – La Rochelle, Montauban, La Charité and Cognac – for two years'. For a more thorough discussion of the significance of these towns, see Souriac, 'Une solution armée'.

35. Leonard, 'The Hugenots and the St Bartholomew's Massacre', p. 58.

36. Ahmed, *Queer Phenomenology*, p. 66.

37. For the question of Henri III's sexual reputation, see Crawford, 'Love, Sodomy, and Scandal', pp. 513–42. See also Crawford, 'Politics, Promiscuity, and Potency',

pp. 215–40. For a different view of this novel, see Patera, 'Un homme à demy', pp. 430–41.

38. Holt, *The French Wars of Religion*, p. 110; see also Long, *Hermaphrodites in Renaissance Europe*, p. 220.

39. 'Term' is the word Hollstein uses in his catalogue of the work of Vredeman de Vries for the statues that resemble herms, but are load-bearing, as caryatids would be. F.W.H. Hollstein, *Hollstein's Dutch & Flemish Etchings, Engravings, and Woodcuts, 1450–1700*. Volumes XLVII and XLVIII: *Vredeman de Vries* (Rotterdam: 1997). Vredeman de Vries himself uses the word 'caryatid', as in his series of engravings, *Caryatidum [...] sive Athlantidum multiformium ad quemlibet Architecture ordinem accommodatarum centuria prima* (Antwerp: Gerard de Jode, [1565?]).

40. For this, see Frisch, *Forgetting Differences*, on the royal policy of *oubliance* (forgetting) and its relationship to the rise of classical theatre in the seventeenth century.

41. Antoine Caron's version, *Massacres under the Triumvirate* (*Les massacres du Triumvirat*, 1566, at the Louvre), is well-known and was often cited by other French artists in their works.

42. *L'Isle des hermaphrodites*, p. 60: 'Je n'avois encore veu ce que c'estoit qui estoit dans ce lict, car on ne voyoit point encore les mains ny le visage'.

43. Ibid., p. 61: '... à peine fus-je entré dans la chambre, que je vy trois hommes que l'on tenoit aux cheveux avec de petites tenailles que l'on tiroit de certaines petites chaufferettes, de sorte que l'on voyoit leurs cheveux tous fumeux. Cela m'effroya du commencement, et eu toutes les peines du monde à m'empescher de crier, pensant qu'on leur feist quelque outrage; mais quand je les euz considerez de plus prés, je recongneu qu'on ne leur faisoit point de mal'.

44. Gessler, 'Tortures et supplices "modérés"', pp. 165–80.

45. *L'Isle des hermaphrodites*, p. 63: 'puis on luy baille de grands coups contre le bout du pied'.

46. Ibid., pp. 64–65: 'Ceste chemise baillee de laquelle on rehaussa aussi tost le collet, de sorte que vous eussiez dit que la teste estoit en ambuscade, on luy apporta un pourpoint; dans lequel il y avoit comme une forme de cuirassine pour rendre les espaules esgales, car il en avoit une plus haute que l'autre, et aussi tost celuy qui luy avoit baillé son pourpoint luy vint reverser ce grand collier de point couppé que je disois cy dessus et que j'eusse presque creu estre de quelque parchemin fort blanc, tant il faisoit de bruit quand on le manioit; il falloit le renverser d'une mesure si certaine, qu'avant qu'il fust à son poinct on haussoit et baissoit ce pauvre *Hermaphrodite*, que vous eussiez dit qu'on luy donnoit la gesne; quand cela estoit mis en la forme qu'ils desiroient, cela s'appelloit le don de la rotonde.'

47. Ibid., p. 71: 'au milieu du lict on voyoit une statuë d'un homme à demy hors du lict, qui avoit un bonnet à peu pres fait de la forme de ceux des petits enfans nouveaux vestus ... Le visage estoit si blanc, si luysant, et d'un rouge si esclatant, qu'on voyoit bien qu'il y avoit plus d'artifice que de nature; ce qui me faisoit aisément croire que ce n'estoit que peinture'.

48. Ibid., p. 73: 'I wanted to follow them, because it seemed to me that everything was permitted, and that entry to any place should not at all be forbidden me, seeing the ease which I had found in this until then; but someone said to me that they held their most secret councils there, and dealt there with their most private affairs, such that no one had access to this place, except the most familiar ones' ('je les vouloy suivre, car il me sembloit que tout estoit permis, et que l'entrée ne me devoit point estre deffendue de pas un lieu, veu la facilité que j'y avois trouvé jusques icy; mais on me dict qu'ils tenoient icy leurs conseils plus secrets, et traictoient là de leurs privez affaires. De sorte que personne n'y avoit d'accez, que les plus familiers').

49. Ibid., p. 73: 'En une autre pièce, je voyois ce mesme homme estendu tout nud sus une table, et plusieurs à l'entour de luy qui avoient diverses sortes de fer-remens, et faisoient tout ce qui leur estoit possible pour le faire devenir femme; mais à ce que j'en pouvois juger par la suitte de l'histoire il demeuroit du genre neutre'.

50. Ibid., p. 75: 'Ainsi passant plus outre nous entrames en une galerie assez large, et de moyenne longueur'.

51. Ibid., p. 77: 'Ainsi continuant mon chemin je vis une infinité de choses rares, que je serois trop long à déduire icy particulierement, car le lieu estoit grand et tout remply de choses plus curieuses que necessaires; aussi n'y estoient-elles amassées et arrangées que pour contenter l'oeil. Il y avoit là dedans plusieurs chaires brisées qui s'allongeoient, s'eslargissoient, se baissoient, et se haussoient par ressorts, ainsi qu'on vouloit. C'estoit une invention *Hermaphrodique* nouvellement trouvée en ce pays-là ...'

52. For a detailed history of the transmission of the story of the Procrustean bed from Greek mythology through Talmudic lore, see Segal, 'A Funny Thing Happened', pp. 103–29; citation found on p. 113.

53. Eoghan Ahern, 'The Sin of Sodom in Late Antiquity', pp. 209–33.

54. Segal, 'A Funny Thing Happened', pp. 120–21.

55. Ibid., pp. 116–17.

56. *L'Isle des hermaphrodites*, p. 77.

57. Ibid., pp. 81–137.

58. Frisch, *Forgetting Differences*, 'Learning to Forget', pp. 1–25.

59. Biet, *Théatre de la cruauté*.

60. *L'Isle des hermaphrodites*, p. 70: 'vous eussiez dit que c'estoit quelque mascarade, et à la vérité ils estoient dés-ja assez desguisez; mais ils ne firent point d'autres figures, que de s'en aller du mesme geste à la ruelle du lict'.

61. Ibid., p. 144: 'les viandes de ce premier service estoit si fort hachées, descoupées et desguisées, qu'elles en estoient incogneuës'.

62. Ibid., p. 152: 'une certaine sorte de demies testes'.

63. Ibid., p. 152: 'ce n'estoit rien que des cheveux qui estoient ainsi couppez et tressez ensemble'.

64. Ibid., p. 187: 'Mais, à ce que je voy, dict-il, vous ne vous lassez point de m'escouter', – 'Non pas, luy dismes nous, quand vous continüeriez plusieurs journées, car qui se pourroit ennuyer d'oüir tant de nouveautez?'

65. For an analysis of similar affect in the work of Jean de Léry, see Carla Freccero, 'Queer Spectrality', *Queer/Early/Modern*, pp. 69–104.

WORKS CITED

Ahern, Eoghan, 'The Sin of Sodom in Late Antiquity', *Journal of the History of Sexuality*, 27.2, 2018, pp. 209–33.

Ahmed, Sara, *Queer Phenomenology: Orientations, Objects, Others* (Chapel Hill, NC: Duke University Press, 2006).

Aubigné, Théodore Agrippa d', *Les Tragiques*, Raymond Fanlo (ed.) (Paris: Champion, 2006).

Beuzart, P., 'H. Sureau Du Rosier', *Bulletin de la Société de l'Histoire du Protestantisme Français (1903–2015)*, 88, 1939, pp. 249–68.

Biet, Christian (ed.), *Théâtre de la cruauté et récits sanglants en France (XVIe–XVIIe siècle)* (Paris: Laffont, 2006).

Crawford, Katherine, 'Love, Sodomy, and Scandal: Controlling the Sexual Reputation of Henry III', *Journal of the History of Sexuality*, 12:4 (2003), pp. 513–42.

_____, 'Politics, Promiscuity, and Potency: Managing the King's Sexual Reputation', *The Sexual Culture of the French Renaissance* (Cambridge: Cambridge University Press, 2010), pp. 215–40.

Confession de Foy Faicte par H. S. Du Rosier avec abjuration & detestation de la profession Huguenotique: faicte tant par devant Prelats de l'Eglise Catholique et Romaine, que Princes du sang Royal de France & autres, ensemble la refutation de plusieurs points, mis en avant par Calvin & Beze, contre la Foy & Eglise Apostolique (Paris: Sebastien Nivelle, 1573).

Dictionnaire de l'Académie Française (Paris, 1694), t. 2. https://artfl-project.uchicago.edu/content/dictionnaires-dautrefois

Du Rosier, Hugues Sureau, *Confession et recognoissance de Hugues Sureau, dit Du Rosier, touchant sa cheute en la Papauté, et les horribles scandales par lui commis, servant d'exemple à tout le monde, de la fragilité et perversité de l'homme abandonné a soi, et de l'infinie misericorde, et ferme verité de Dieu envers ses esleuz* (Heidelberg: Jan Mayer, 1573).

Ferguson, Gary, *Queer (Re)Readings in the French Renaissance* (Burlington, Vermont Ashgate, 2008).

Freccero, Carla. *Queer/Early/Modern* (Durham, NC: Duke, 2006).

Frisch, Andrea, *Forgetting Differences: Tragedy, Historiography, and the French Wars of Religion* (Edinburgh: Edinburgh University Press, 2015).

Gessler, Jean, 'Tortures et supplices "modérés" (?) sous l'Ancien Régime', *Revue belge de philologie et d'histoire*, 28.1, 1950, pp. 165–80.

Heuer, Christopher P., *The City Rehearsed: Object, Architecture, and Print in the Worlds of Hans Vredeman de Vries* (London and New York: Routledge, 2009).

Holt, Mack, *The French Wars of Religion, 1562–1629* (Cambridge: Cambridge University Press, 1995).

Knecht, Robert J., *The French Civil Wars* (Edinburgh: Pearson, 2000).

Leibacher-Ouvrard, Lise, 'Decadent Dandies and Dystopian Gender-Bending: Artus Thomas's *L'Isle des hermaphrodites (1605)*', *Utopian Studies*, 11, 2000, pp. 124–31.

Leonard, H. H., 'The Hugenots and the St. Bartholomew's Massacre', in *The Huguenots: History and Memory in Transnational Context*, David J. B. Trim (ed.) (Leiden: Brill, 2011), pp. 43–68.

L'Estoile, Pierre de, *Mémoires-Journaux, 1574–1611*, vol. 8. (Paris: Tallandier, 1982).

L'Isle des hermaphrodites, Claude-Gilbert Dubois (ed.) (Geneva: Droz, 1996).

Long, Kathleen, *Hermaphrodites in Renaissance Europe* (Aldershot: Ashgate, 2006; reprint, New York: Routledge, 2016).

Patera, Teodoro, 'Un homme à demy': gender, esthétisme et reconnaissance dans 'L'Isle des Hermaphrodites', *Studi francesi*, 189, 2019, pp. 430–41.

Reeser, Todd W., *Moderating Masculinity in Early Modern Culture* (Chapel Hill: North Carolina Studies in the Romance Languages and Literatures, 2006).

Segal, Eliezer, 'A Funny Thing Happened on my Way to Sodom', *Journal for the Study of Judaism*, 45, 2015, pp. 103–29.

Sextus Empiricus, *Outlines of Pyrrhonism*, trans. R.G. Bury (Cambridge: Harvard University Press, Loeb Classical Library, 1933).

Souriac, Pierre-Jean, 'Une solution armée de coexistence: Les places de sûreté protestantes comme élément de pacification des guerres de Religion', in *La coexistence confessionnelle à l'épreuve*, Didier Boisson and Yves Krumenacker (eds), *Chrétiens et Sociétés*, col. 'Documents et Mémoires', 9, 2009, pp. 51–72.

Stone, Donald, 'The Sexual Outlaw in France, 1605', *The Journal of the History of Sexuality*, 2.4, 1992, pp. 597–608.

Uppenkamp, Barbara, 'The Influence of Hans Vredeman de Vries on the Cityscape Constructed like a Picture', *Hans Vredeman de Vries and the* Artes Mechanicae *Revisited*, Piet Lombaerde (ed.) (Turnhout: Brepols, 2005), pp. 117–128.

Vredeman de Vries, Hans, *Caryatidum [...] sive Athlantidum multiformium ad quemlibet Architecture ordinem accommodatarum centuria prima* (Antwerp: Gerard de Jode, [1565?]).

Vredeman de Vries, Hans, *Scenographiae, sive perspectivae fut aedificia, hoc modo as opticam excitata* (Antwerp: Hieronymus Cock, 1560; 2nd edition, 1563).

Wolfe, Michael, *The Conversion of Henri IV: Politics, Power, and Religious Belief in Early Modern France* (Cambridge: Harvard University Press, 1993).

DYNAMIC CONVERSIONS: GRIEF AND JOY IN GEORGE HERBERT'S MUSICAL VERSE

Anna Lewton-Brain

The Temple, the collection of George Herbert's poetry published shortly after his death in 1633, offers a literary depiction of the lived experience of an individual's relationship with God through life's vicissitudes. Readers of *The Temple* find in it not the orderly exhortations of praise from a decided convert, but rather, verses that dramatise the fraught and unresolved processes of conversion.[1] Herbert himself described *The Temple* in a letter written to his friend Nicholas Ferrar, as '*a picture of the many spiritual Conflicts that have past betwixt God and my Soul, before I could subject mine to the will of* Jesus my Master'.[2] Later in this same letter, Herbert advises Ferrar to publish his manuscript only if 'it may turn to the advantage of any dejected poor soul'. If not, Herbert writes, 'let him burn it'.[3] Thus, Herbert hoped that his artful depiction of an individual's spiritual conflict and struggle with conversion might enable positive spiritual transformation in his readers. Indeed, Herbert's verse was intended to have use, purpose, and power. Without a conversional effect, this poetry, in Herbert's estimation, was worthy only to be kindling for the fire.

According to Herbert, the process of spiritual conversion, of turning the soul towards God, is a long, arduous, and imperfect one. Although Herbert does use the term 'conversion' in the Pauline sense of a singular moment of spiritual clarity, an epiphany of sorts when an individual recognises a true and better way and turns towards it,[4] there is in Herbert's poems always the possibility of falling away from such an assured spiritual state of grace.[5] Even when Herbert offers moments of sublime conversion in *The Temple*, such

conversions are never final or absolute. As Helen Wilcox notes in her commentary on 'The Glance', 'the convert's "sweet originall joy", as Herbert calls it (1. 18), is hardly ever permanently or consistently felt [Instead,] the soul suffers "many a bitter storm" even after the first delightful contact with God'.[6] Thus, Herbert's paraphrase of Psalm 23 describes the continual interventions by God, the good shepherd, to turn and return his sheep to the flock:

> Or if I stray, he [(i.e., God)] doth convert
> > And bring my minde in frame:
> And all this not for my desert,
> > But for his holy name. (lines 9–12)[7]

Richard Strier has pointed out that 'One of the major corollaries of covenant theology was the doctrine of "preparation for grace" ... when regeneration was conceived of as a gradual rather than a sudden process'.[8] Thus the term 'conversion' for Herbert can be applied to a specific moment of contact with the Divine, but it can also, and perhaps more fruitfully in the case of Herbert's poetry, be used to describe the dynamic and life-long processes of both turning and returning to God. Indeed, the Latin verbal form of the word, *convertere*, carries this double meaning of both 'turn' and 'return';[9] 'conversion' can be understood to encompass the processual human experience of being in a continual relationship with the Divine, both before and after any one particular graceful moment.[10] Moreover, 'conversion' can describe the double work that Herbert's poetry might do for both the reader who is not yet 'converted' to God but is undergoing a process of 'preparation for grace' and for the decided convert who reads Herbert's *The Temple* as a means of maintaining a right relationship with the Divine through the spiritual exercises of engaging with his or her emotions, so that, even when he or she does 'stray', he or she may be returned to the flock.[11]

Of course, it is humanity's fallen state, according to Christian doctrine, that requires that we be in this continual process of conversion towards God. In this fallen state, Herbert writes in 'Affliction (V)', 'There is but joy and grief; / If either will convert us, we are thine', that is, God's (lines 13–14). Experiencing grief and joy, according to Herbert, thus offers a way to effect spiritual conversion. For both catechumen and converted readers of Herbert, the process of turning or returning is the same: it first requires God's intervention, and that involves a massaging of the heart through the experiences of grief and joy that He bestows; reciprocally, it requires the convert to be a repentant and worshipful participant in his or her own salvation through his or her emotional, intellectual, and sensual engagement with the griefs and joys of his or her life.[12]

Metrical and musical poetry, for Herbert, offered practical means of engaging the whole person in the processes of grief and the delights of joy that constitute Herbert's conversion ecology. The word 'ecology' seems particularly apt for use in a discussion of Herbert and conversion since Herbert himself

imagines the human heart as a house or *oikos* (οἶκος is the Greek root of the word 'ecology') where God might dwell, and also because conversion was not imagined as occurring individually and alone, but within a system and community of belief and practice. Poetry, as musical language, was thus not merely a pleasing way to pass the time, or to entertain oneself; rather, this temporal and aural art, Herbert believed, could move an auditor, softening his or her heart and making him or her more receptive to God's converting grace.

Poetry's affective and thus conversional powers were linked to its musical and rhythmical properties by Herbert and his contemporaries. While Herbert, the 'sweet singer of the Temple', as he is referred to by his first biographer, Barnabas Oley,[13] is arguably one of the most musical poets of his age, all poetry in the period was understood to be fundamentally related to music. George Puttenham, for example, writes that 'poetical proportion ... holdeth of the musical' and that 'poesy is a skill to speak and write harmonically: and verses or rhyme be a kind of musical utterance'.[14] The musicality of Herbert's poetry has conversional implications because, for Herbert and his contemporaries, the penetration of the body by orderly sounds, especially musical sounds, was a means by which the human soul could be affected. Consider, for example, Plato's statement, definitive for early modern Pythagorean-Platonic thinking about musical sounds:

> speech [and] music, in so far as it uses audible sound, was bestowed for the sake of harmony. And harmony, which was motions akin to the revolutions of the Soul within us, was given ... as an auxiliary to the inner revolution of the Soul.[15]

Similarly, Richard Hooker comments in his *Laws of Ecclesiastical Polity*:

> the very harmony of sounds being framed in due sort and carried from the ear to the spiritual faculties of our souls, is by a native puissance and efficacy greatly available to bring to a perfect temper whatsoever is there troubled.[16]

Or, as Herbert expresses it in *The Country Parson*, speaking of the 'sweet[17] and pleasing words' of Holy Scripture,[18] harmonious sounds have the capacity to penetrate the human soul and tune it, by a 'swift word, passing from the ear to the heart'.[19] We moderns think of music and poetry as not necessarily close kin as art forms, but Herbert and his contemporaries did think of them that way because they thought of their art as having strong effects on people, as capable of initiating or supporting deep change within readers and hearers, because poetry could be a conversion machine.

To illustrate these concepts, this essay examines how grief and joy work as mechanisms of a continual and dynamic conversion process in a selection of Herbert's lyrics, with a focus on Herbert's conversional poem 'The Familie'.

What follows explores some of the musical and poetic techniques Herbert deployed to enable conversion. Attending to the music in Herbert's poetry reminds us of how it was designed to work on the thinking and feeling of its auditors. Herbert develops musical forms and conversional content that enable his poetry to *do* something, even to perform conversional work on the souls of his readers.

Herbert's self-reflexive verses in *The Temple* both describe and enact processes of conversion. They do this primarily by motivically playing on the griefs and joys of lived experience that punctuate humanity's interrupted relationship with the divine. In his poem 'The Familie', for instance, Herbert's speaker, in a prayer to God, portrays how grief and joy play a part in making the heart a ready host for God. The poem describes the speaker's 'inner [psychological] household of thoughts and feelings'[20] while appealing to the auditor's own such 'household'. Through shifts in tone, musical metaphors, and metrical ingenuity, Herbert's poem describes the kind of dynamic harmony of positive and negative emotions that his poems work to evoke, and that are necessary for conversion.

Paradoxically, the inconstant state of the human heart, experiencing both griefs and joys, helps to make the fickle heart ready for God's 'constant' stay in 'The Familie' (lines 23–24). The poem, through its quick shifts in tone between each stanza, helps to evoke in its reader a dynamic oscillation between moods, much like the one it proposes is needed for the heart that will be made ready to house God. The speaker begins with anger and frustration in the rhetorical questions of stanza one:

> What doth this noise of thoughts within my heart
> As if they had a part?
> What do these loud complaints and pulling fears,
> As if there were no rules or ears? (lines 1–4)

But in the second stanza, the tone turns to humorous, teasing self-critique in the admission that some of the speaker's parts are 'wranglers' who 'repine' (lines 6–7):

> But, Lord, the house and familie are thine,
> Though some of them repine.
> Turn out these wranglers, which defile thy seat:
> For where thou dwellest all is neat. (lines 5–8)

By stanza three, the speaker's tone is much quieter and more reasonable:

> First Peace and Silence all disputes controll,
> Then Order plaies the soul;
> And giving all things their set forms and houres,
> Makes of wilde woods sweet walks and bowres. (lines 9–12)

In stanza four, the poem turns sweet and delightful with the image of the personified family pet, 'Obedience' (line 13), who eagerly watches the family consort:

> Humble Obedience neare the doore doth stand,
> Expecting a command:
> Then whom in waiting nothing seems more slow,
> Nothing more quick when she doth go. (lines 13–16)

This sweetness turns sour in the fifth stanza with the painfully sad image of silent weeping at line 20:

> Joyes oft are there, and griefs as oft as joyes;
> But griefs without a noise:
> Yet speak they louder, then distemper'd fears.
> What is so shrill as silent tears? (lines 17–20)

The final stanza balances an antithetical assurance and insecurity between the assertion of the first couplet, 'This is thy house' (line 21) and the conditional mode of the final couplet's uncertain 'Perhaps' (line 23):

> This is thy house, with these it does abound:
> And where these are not found,
> Perhaps thou com'st sometimes, and for a day;
> But not to make a constant stay. (lines 21–24)

Thus, the poem imitates, through its changes in tone, the abundance of contrasting feeling it claims is necessary for the heart to be converted into a 'household' capable of hosting God consistently. The reader or auditor is brought along on that emotional journey of the speaker, and thus she or he, through the poem, begins to experience the griefs and joys that create the oscillating motion that paradoxically moves the heart towards the constant love of God.

This is a surprisingly positive perspective on the vagaries of the human experience, especially on the role of grief in conversion. It is one thing to ask God for joy, and quite another to thank Him for grief.[21] Yet, this is precisely what Herbert does in the sonnet 'Joseph's Coat', when he writes:

> Sorrow hath chang'd its note: such is his will,
> Who changeth all things, as him pleaseth best.
> ...
> I live to shew his power, who once did bring
> My *joyes* to *weep*, and now my *griefs* to *sing*. (lines 3–4, 13–14)

The chiasmus in the final line of the sonnet rhetorically binds together the two contrasting emotional states and actions: weeping and singing and joy and grief. Moreover, the musical images in this poem ('griefs that sing'), and in

'The Familie' (discussed further below) are particularly effective vehicles for conveying the apparent paradox of an inconstant or changeable heart being a constant host to the Holy Spirit, since the nature of music itself is *discordia concors*: harmony, like the human heart, is made sweet by the combination of dissonance and consonance, or, in other words, the converted heart is 'tuned' by both the griefs and the joys that Herbert's God bestows upon him. Moreover, by using musical language and musical imagery to describe the process of conversion, Herbert's poetry engages the conversional powers of music in relation to the emotions, and suggests that poetry and music offer a particularly potent means of working on and in the heart to make it ready for spiritual conversion.

The discord within concord of the human heart, however, was not meant to be cacophony. In the opening of 'The Familie', a scene of domestic music-making gone wrong portrays the discordant inner dynamics of the speaker's psyche.[22] Instead of patiently listening to music, Herbert's speaker's thoughts and fears are behaving 'as if they had a part' (line 2) to sing.[23] They are like those guests at a musical gathering who sing along extempore, harmonising to ill effect, instead of reading their composed part from a part book. The Elizabethan composer Thomas Campion complains of just such 'wranglers' (line 7) in his address 'To The Reader' of his *Two Books of Ayres*: '[they] will be offring at an inward *part* out of their own nature; and true or false, out it must, though to the perverting of the whole harmonie'.[24] In Bodleian MS Tanner 307 (i.e., the Bodleian manuscript of Herbert's poems), the second 'l' of 'pulling' at line 3 has been scratched out with a pen knife.[25] Those 'pulling' or 'puling' fears (both readings were evidently available to contemporary audiences) are especially discordant, for they both pull or tug at the mind of the speaker and whine out of tune. The pun on 'pulling' and 'puling' also suggests how the poem itself exerts a pulling on the reader, drawing him or her to think about his or her own noisy thoughts and also at the same time criticising those noisy thoughts for their infantile and unmusical character.

Herbert was himself a musician and composer, so it is not surprising to find music at the 'heart' of both his domestic and his inner psychological world. Preaching at George Herbert's mother's funeral in 1627, John Donne recounted how the Herbert family ended each Sabbath 'with a generall, with a cheerfull singing of Psalmes',[26] and Izaak Walton reports that George Herbert's 'chiefest recreation was Musick, in which heavenly Art he was a most excellent Master, and did himself compose many *divine Hymns and Anthems*, which he set and sung to his *Lute* or *Viol*'.[27] The sort of domestic music-making pictured in 'The Familie' would have been very much part of Herbert's own everyday lived experience. Moreover, Herbert conceives not only of his heart and inner psychology in musical terms, but he understands his poetry to be a form of musical expression. Thus in 'Praise (II)', for instance, his speaker exclaims,

Wherefore with my utmost art
 I will sing thee,
And the cream of all my heart
 I will bring thee. (lines 9–12)

Music, for Herbert and his early audience, was not merely incidental. Indeed, it is at the very heart of Herbert's verse, so much so that when Herbert wishes to reflect on his own art, his poetry, it is to musical metaphors that he turns. Revealingly, the term 'write' (and its various forms) occurs only 22 times in *The Temple*, whereas 'sing' (and its various verbal forms) occurs 31 times.[28] Thus, in stanza three of 'The Familie', Herbert imagines the soul as a musical instrument that 'Order' plays upon:

Then Order plaies the soul;
And giving all things their set forms and houres,
Makes of wilde woods sweet walks and bowres. (lines 10–12)

Since conversional texts don't merely describe conversion, but in fact enact it, one can trace a subtle progression of the aural images and the sounds of the poetry itself in 'The Familie', as Michelle Dowd has noticed, from disorderly chaotic 'noise' (at line 1) and 'loud complaints' (at line 3) to 'Silence' (at line 9).[29] This progression from noisy thoughts to orderly harmony is observable even at the level of the individual line. In the metre of line 12, for example, there is a movement from the metrical tension of the trochaic and spondaic substitutions of the opening feet to iambic regularity as the 'wild woods' are transformed to 'sweet walks and bowres':

/ ˘ / / ˘ / ˘ / (˘)
Makes of | wilde woods | sweet walks | and bowres.[30]

These orderly and musical sounds of the poetry were indeed understood to be capable of affecting the inner order of the soul.

However, despite the movement in the first half of 'The Familie' towards order and concord, in the second half of the poem, harmony remains under threat. Knowing and even feeling that 'Order' can play on 'the soul' (line 10) and tame natural wildness to harmonious artful expression is not sufficient to protect against the sinful nature that causes a convert to 'stray' from the flock. 'Obedience', here figured as the family's faithful pet, can too readily escape the speaker (line 16), and those 'fears' of the opening cacophony of the poem (line 3) ironically re-appear in the speaker's insecurity about his own ability to remain constant in his 'Obedience' (line 13) to God, and more significantly, in his fear that his heart will not 'abound' with the 'griefs' and 'joyes' that invite God's Grace. Thus, the poem both depicts the cacophonic dangers of untamed or unprocessed emotions (especially the 'puling/pulling fears' that keep inserting themselves into the speaker's mind, though they have no part), and at the

same time asserts that it is the constant changing (or harmonising) of fully felt emotions that makes one capable of God's constant love.

The fear of not being able to feel grief and joy fully, and therefore not having a heart that is capable of conversion towards God, reappears in a number of Herbert's poems. In 'Ephes. 4.30. Grieve not the Holy Spirit',[31] for instance, Herbert's speaker attempts to convince himself to weep, saying,

> Then weep mine eyes, the God of love doth grieve:
> > Weep foolish heart,
> > And weeping live: (lines 7–9)

The speaker longs to experience the physical sensations of grief as a way to catalyse a deeper spiritual transformation in his heart. In this poem, God's grief becomes a model of compassion that the speaker tries to emulate.[32]

The poem begins *in medias res* with the coordinating conjunction 'And'[33] in a clear echo of the scriptural passage from Paul's letter to the Ephesians from which the poem gets its title:

> And grieve not the holy Spirit of God, whereby ye are sealed unto the day of redemption. Let all bitterness, and wrath, and anger, and clamour, and evil speaking, be put away from you, with all malice: And be ye kind one to another, tenderhearted, forgiving one another, even as God for Christ's sake hath forgiven you.[34]

Paul's letter commands Christians to act virtuously and thereby not to cause grief to the God of Love, but Herbert's poem presumes that sinful man has already caused God to grieve, and it is God's grief that is the virtue that should be emulated. The poem, in contrast to Paul's letter, does not teach subjugation of 'anger' or 'clamour', but rather works to evoke sensual emotional response, demanding that the Christian 'cry out' (line 9) and 'wail' (line 31).

Initially, the speaker tries to persuade his heart to weep through sympathy with God; since the God of love grieves, we should too:

> And art thou grieved, sweet and sacred Dove,
> > When I am sowre,
> > And crosse thy love?
> Grieved for me? the God of strength and power
> > Griev'd for a worm, which when I tread,
> > I passe away and leave it dead? (lines 1–6)

When this first attempt at feeling grief fails, Herbert prompts self-reflection in the auditor who feels and thinks of the insignificance of a worm,[35] only to realise he himself is as a worm in comparison of God, and thus he is confronted with his own hard heart even as it looks down on a worm. Richard Strier has suggested that the description of the squishing of the worm forces the auditor to

feel 'the instinctive contempt' and apathy that is in direct contrast to the divine reaction to the suffering of the weak.[36] While feeling this contempt, or perhaps admitting to having in the past felt such contempt for insignificant creatures, the auditor in sympathy with the speaker is simultaneously invited to reflect on his own contempt as a shortcoming in relation to God's love and compassion. Thus, the poem opens with a mortification effected in the auditor through the speaker. Eventually, the speaker uses the threat of mortality to try to convince himself (and by extension, the auditor) to feel with God: 'death is drie as dust' (line 10):

> Then weep mine eyes, the God of love doth grieve:
>> Weep foolish heart,
>> And weeping live:
> For death is drie as dust. Yet if ye part,
>> End as the night, whose sable hue
>> Your sinnes expresse;[37] melt into dew. (lines 7–12)

The implication is that he ought to repent, grieve, feel now, while he is still here on this ground.

While this is a poem aimed primarily at evoking the sensations of grief in the auditor, the poem also contains the dynamic oscillations between negative and positive emotions that are part of the conversion process. For example, stanza two ends with an image of a *diminuendo* (decrease in volume or softening) towards death as a quiet and slow 'melt[ing] into dew' (line 12) (a *rallentando* (slowing down of tempo) is also effected in line 12 through the medial caesura), and stanza three follows with a contrasting clamorous image of 'sawcie mirth' (line 13):[38]

> When sawcie mirth shall knock or call at doore,
>> Cry out, Get hence,
>> Or cry no more.
> Almightie God doth grieve, he puts on sense:
>> I sinne not to my grief alone,
>> But to my Gods too; he doth grone. (lines 13–18)

As in 'The Familie', Herbert turns to images of music-making to dramatise and evoke the proper emotional response to God. At stanza four, the speaker tells himself,

> Oh take thy lute, and tune it to a strain,
>> Which may with thee
>> All day complain.
> There can no discord but in ceasing be.
>> Marbles can weep; and surely strings
>> More bowels have, then such hard things. (lines 19–24)

223

The musical pun on the world 'bowels', which refers to the gut strings made out of the small intestines of animals such as sheep and goats used on lutes and other stringed instruments in the period, assumes a level of musical literacy in a reader/auditor, and also contains in that single moment the combined levity and heaviness that Herbert's poetry works to evoke as it massages the heart of the auditor. The final lines of the stanza are both a most serious condemnation of the speaker's own hard heart that might be harder than marble, which was thought to 'weep' because of the way water condenses on the cold stone, and are at the same time almost bathetic in the grotesque musical pun.

Despite the sympathetic groans of the lute strings, the speaker continues to fear, in the final two stanzas of the poem, that he will not be able to express his grief sufficiently, though he judges himself to be worthy only of continual grief and repentant tears:

> Lord, I adjudge my self to tears and grief,
>> Ev'n endlesse tears
>> Without relief.
> If a cleare spring for me no time forbears,
>> But runnes, although I be not drie;
>> I am no Crystall, what shall I?
>
> Yet if I wail not still, since still to wail
>> Nature denies;
>> And flesh would fail,
> If my deserts were masters of mine eyes:
>> Lord, pardon, for thy Sonne makes good
>> My want of tears with store of bloud. (lines 25–36)

In another pun, the speaker worries that his 'deserts' (line 34), that is, his barren dryness will not produce tears enough to atone for his sinfulness or his just 'deserts'. The consoling final couplet is a grotesque image, linking 'tears' and 'blood', that reminds readers that God not only grieves for us, but bleeds for us.

In the lyric 'Grief', Herbert's speaker likewise desires to express his grief through tears, and laments that his eyes are 'too drie' (line 6). In the opening situation of this poem, the speaker has wept and wept and yet continues to grieve, although he has wept all of the tears his body can produce. In this sonnet-like lyric,[39] Herbert's muscular and performative use of enjambment, and the eventual over-flow and collapse of poetic metre at the end of the poem, suggest, in performance, an aural image of the embodied human experience of the welling up and overflowing physical sensations of grief.

The first twelve lines of the poem elaborate, in metaphysical conceits and hyperbole, on the speaker's desert barrenness and his need for tears:

O who will give me tears? Come all ye springs,
Dwell in my head & eyes: come clouds, & rain:
My grief hath need of all the watry things,
That nature hath produc'd. Let ev'ry vein
Suck up a river to supply mine eyes,
My weary weeping eyes, too drie for me,
Unlesse they get new conduits, new supplies
To bear them out, and with my state agree.
What are two shallow foords, two little spouts
Of a lesse world? The greater is but small,
A narrow cupboard for my griefs and doubts,
Which want provision in the midst of all. (lines 1–12)

Herbert begins the poem by establishing a regular iambic pentameter measure: with the exception of the reversed first foot of line 2, the first four lines of the poem are perfectly regular. Yet, the enjambment introduced at lines 4 to 5 works together with the irregular line five to begin to draw out of the listener those tears, which are the signs of grief, by emotively interrupting his auditory expectations: 'Let ev'ry vein / Suck up a river to supply mine eyes' (lines 4–5). The syntax of lines four to five is muscular; that is, it moves simultaneously in two directions as 'vein' (line 4) pulls the aural imagination backwards to its rhyme word 'rain' (line 2) even as the enjambment of the line moves the ear forwards to the wet-sounding aspirated voiceless velar stop, 'kh' of 'suck'. As line four overflows into line 5, it does not, however, introduce more of the now expected regular iambic pentameter, but rather issues into what is in effect a four-beat line, which scans syllabically like the expected pentameter but accentually like the dactyllic rolling 'river' it describes:

/ ˘ ˘ / ˘ ˘ ˘ / ˘ /
Suck up a | river to | supply | mine eyes, (line 5)[40]

The alliteration of 'weary weeping' at line 6 slows the tempo of the verse down again and returns it to regularity for the rest of the quatrain. At line 9, however, the energetic and performative enjambment on the word 'spouts' mimetically shoots across the line break, and propels the verse into a series of what are measurable as regular pentameter lines, but in effect sound as four-beat lines because of a series of very weak medial iambs that in performance might be closer to pyrrhics, when the expected accent falls on less-important monosyllabic words: 'Of' (line 10), 'is' (line 10), 'for' (line 11), and 'in' (line 12). This creates the auditory effect of rolling anapests at (or near) line end:

/ ˘ ˘ / ˘ / ˘ / ˘ /
What are | two shal | low foords, | two lit | tle spouts →

˘ ˘ / / ˘ / ˘ ˘ ˘ /
Of a | lesse world? | | The grea | ter *is* | but small,

˘ / ˘ / ˘ ˘ ˘ / ˘ /
A nar | row cup | board *for* | my griefs | and doubts,

˘ / ˘ / ˘ ˘ ˘ / ˘ /
Which want | provi | sion *in* | the midst | of all. (lines 9–12)

Emptied of tears, but in need of relief, Herbert's speaker turns to poetry to provide consolation, but this auditory art that should comfort him is rejected as too soft for his 'rough sorrows' (line 14):

> Verses, ye are too fine a thing, too wise
> For my rough sorrows: cease, be dumbe and mute,
> Give up your feet and running to mine eyes,
> And keep your measures for some lovers lute,
> Whose grief allows him musick and a ryme:
> For mine excludes both measure, tune, and time.
> <div align="right">Alas, my God! (lines 13–18)</div>

Yet, even as the poem's speaker denies the capacities of 'measure, tune, and time' (line 18), to contain his 'rough' (line 14) grief, the poem paradoxically relies on these very orderly forms of aural patterning to evoke in the auditor his own 'rough sorrows' (line 14). This conversional text enacts the conversions that it describes.

Thus, the rhythms of Herbert's poem ironically undermine his speaker's rejection of poetry's 'running' feet as being insufficient to express grief since the poem is itself a musical and evocative expression of grief. When the rolling liquid motion of the rhythms and images of the poem have done their work on the speaker (and by extension, the auditor), the end result is a sob, a tear, the non-metrical overflowing emotional ejaculation – 'Alas, my God!' – that, at the opening of the poem, the speaker is in want of. Musical language thus works on and in the speaker as sensual stimulus awakening the physical sensations of grief that his body had previously hardened against.

The musical manipulation of the sounds of language is deployed by Herbert not only to evoke the sensations of grief but also of joy in his poetry, since it is the harmony of contrasting emotions that Herbert sees as necessary for the conversion process. Moreover, in his most joyful poetic expressions he consistently relies on musical images to describe and evoke the physical sensations of joy. If the proper and full physiological response to grief is to weep, the most perfect physical sign of joy is to sing. Thus, in his joyful 'Antiphon (I)' the chorus repeatedly exclaims, 'Let all the world in ev'ry corner sing, / *My God and King*' (lines 1–2, 7–8, and 13–14). The hortative refrain, with its strong

masculine rhyme, invites auditors to feel a sense of joyful communion and a desire to respond and sing along.[41]

Similarly, in 'Praise (II)' (discussed briefly above) the speaker declares that God has 'spared him' (line 8) from damnation because He has noticed the speaker's 'working breast' (line 7), that is, that his heart, the seat of his emotions, has been worked on and in through life's trials and he himself has reciprocally worked to engage with those experiences feelingly. The speaker's response to God's salvation is:

> Wherefore with my utmost art
> I will sing thee,
> And the cream of all my heart
> I will bring thee. (lines 9–12)

Here Hebert uses a perfectly regular falling trochaic metre to create the simple hymnic sound of his lyric. Trochaic metres have a recognisable incantational quality (this is the metre of the witches' songs in *Macbeth* and the spell-casting of the faeries in *A Midsummer Night's Dream*). They are inherently closer to music because they are heavier and tend to be more regular than iambic metres. Thus, the poem itself, when read aloud, is already moving the reader to speak in a heightened musical way that approaches the singing joy that the speaker feels. Through creating the physical sensation of song or song-like sounds in the body of the reader, the poem is thus moving the reader towards experiencing the state of joy that the poem describes.

For Herbert, the ultimate true joy is to be found in the loving reunion of humanity and God. Thus in 'Man's Medley' (yet another of Herbert's poems that relies fundamentally on musical images and metaphors for its meaning), when the speaker hears the joyful earthly music of birdsong he immediately considers the heavenly music of God's song:

> Heark, how the birds do sing,
> And woods do ring.
> All creatures have their joy: and man hath his.
> Yet if we rightly measure,
> Mans joy and pleasure
> Rather hereafter, then in present, is.
> …
> Not, that he may not here
> Taste of the cheer;
> But as birds drink, and straight lift up their head,
> So must he sip and think
> Of better drink
> He may attain to, after he is dead. (lines 1–6 and 13–18)

For Herbert, earthly sounded music is a pleasure and a joy, but not an end in itself. It, like poetry, is useful when it moves an auditor towards God. The shift in the use of images in this poem subtly suggests an important aspect of Herbert's soteriology. First the speaker hears birds singing, and by stanza three, the speaker himself, through simile, and then direct metaphor, becomes a bird. Music and poetry have transformative powers; they can reshape an auditor into a form more fit for heavenly ascent: into a creature that both sings and soars.[42]

Music, for Herbert, is a mediator between earthly and heavenly experience. In Herbert's early Latin lyric, 'De Musicâ Sacrâ', for instance, he describes the power of music to inflame and free the soul to fly up to the stars, to speak with them, and to join the cosmic music of the spheres:

> Tu Diua miro pollice spiritum
> Caeno profani corporis exuens
> Ter millies coelo reponis:
> Astra rogant, Nouus hic quis hospes?

> [You, Goddess, with an amazing thumb releasing
> The spirit from the filth of an unholy body,
> Return it to the sky three thousandfold:
> 'Who is this new guest?' the stars inquire.] (lines 24–28)[43]

For Herbert, the imagery of stars and music are intertwined because music has a special capacity to raise the human from the contemplation of earthly things to the transcendental.

In 'The Starre', the stanza form itself becomes a conversion mechanism. In this poem, the speaker, witnessing a shooting star, addresses the 'bright spark' and imagines himself being carried back to the heavens by the fallen star to join in a joyful circular dance of adoration. The lines in each stanza progress from longer tetrameter lines to a trimeter and then to a dimeter line, making this poem imitate in form the spiralling movement it is evoking through its images. Addressing the star, Herbert's speaker asks it to,

> Get me a standing there, and place
> Among the beams, which crown the face
> Of him, who dy'd to part
> Sinne and my heart:

> That so among the rest I may
> Glitter, and curle, and winde as they:
> That winding is their fashion
> Of adoration.

> Sure thou wilt joy, by gaining me
> To flie home like a laden bee

> Unto that hive of beams
> And garland-streams. (lines 21–32)

Through the delights of the ear, Herbert's verse might evoke the joyful sensations of winding, glittering, and curling in a dance of stars and souls 'which crown [God's] face' (line 22).

Here, however, even in such a joyful vision, there is the serpentine figure of the sin of pride, 'winding' and 'curling' its way in an echo of 'Jordan (II)', a poem in which the speaker chastises himself for writing in too florid a style, 'Curling with metaphors a plain intention, / Decking the sense, as if it were to sell' (lines 5–6). In *The Temple*, there is no absolute depiction of grief or joy. Even in his most desperate poem, 'Grief', the spectre of joy is there in the musical images and musical language. Likewise, even in his most musical and joyful of poems, such as 'The Starre', which enacts the winding joyful dance of adoration of God, there is an echo of the sinfulness that often leads to suffering and grief.

Likewise, Herbert's poem 'Christmas (II)',[44] although it is a joyful poem, presumes a previous engagement with grief. Its position in *The Temple*, following as it does the penitential lyric 'Deniall', is significant.[45] Joy, in this instance, comes after a moment of disorderly disintegration. In 'Deniall', the speaker struggles to remain devotional and produce poetry when he imagines God does not hear his pleas or tears:

> When my devotions could not pierce
> Thy silent ears,
> Then was my heart broken, as was my verse;
> My breast was full of fears
> And disorder: (lines 1–5)

In 'Deniall', as in so many other poems in *The Temple*, Herbert figures his soul as a musical instrument that God might tune and order: 'Therefore my soul lay out of sight, / Untun'd, unstrung' (lines 21–22). At the close of the lyric, the speaker prays to God to 'cheer and tune [his] heartless breast' (line 30)[46] so it will 'chime' (line 33) with God's favour, 'And mend [his] rhyme' (line 34). Thus, 'Christmas (II)', as joyful as it is, follows a darker moment in the progression of *The Temple*. Indeed, in the poem itself, the darkness of sin is figured by the sun-eclipsing night against which the Lord of light, the son of God (here the commonplace pun of sun/son is in play) holds a candle (line 13).

The subject matter of 'Christmas (II)', the incarnation, provides Herbert with the opportunity to address the seemingly incommensurable problem that salvation comes through Christ alone, and yet music and musical language seem capable of working on the human body and soul to facilitate spiritual conversion. Instead of tracing the descent and return of a shooting star, in this

joyful pastoral poem Herbert engages with the mystery of the incarnation: of God's descent into human form.

The speaker, responding to hearing the shepherds singing at the birth of the infant Christ (Luke 2:20), sets up a conceit in which his soul is a shepherd that feeds a flock of thoughts, words, and deeds (line 4). As in 'The Familie', Herbert describes the orderly interaction of the parts of the self, shepherd, and flock in this conceit, in terms of polyphonic musical expression:

> The shepherds sing; and shall I silent be?
> My God, no hymne for thee?
> My soul's a shepherd too; a flock it feeds
> Of thoughts, and words, and deeds.
> The pasture is thy word: the streams, thy grace
> Enriching all the place.
> Shepherd and flock shall sing, and all my powers
> Out-sing the day-light houres. (lines 1–8)

Those parts of the self that are singing in harmony in 'Christmas (II)', however, are not simply the kind and soft parts of the psyche that St Paul wanted to cultivate in Ephesians 4:30, as we saw already; rather, the 'thoughts, words, and deeds' that are singing in the poem are the same sinful 'thoughts, words, and deeds' repented of in the General Confession in the *Book of Common Prayer*.[47] Said at every service of Holy Communion, the General Confession would have been deeply resonant with Herbert's auditors:

> ALMIGHTY God, Father of oure Lorde Jesus Christe, Maker of all thyngs, Judge of all menne, we acknowledge and bewayl our manifolde synnes and wickednesse, which we from tyme to tyme most *grevously* have committed, By *thoughte*, *worde*, and *deede*, Against thy divine Majestie, provokynge most justlye thy wrathe and indignation againste us: we do earnestly repente, and bee heartely sorye for these our mis-doings, the remembraunce of them is *grevous* unto us: the burthen of theim is intollerable: have mercy upon us, have mercy upon us, mooste mercyfull father, for thy sonne oure Lorde Jesus Christes sake, forgeve us all that is paste, and graunte that we may ever hereafter serve and please thee, in newnes of lyfe, to the honour and glorye of thy name throughe Jesus Christ our Lorde. Amen.[48]

In the poem, Herbert re-works the 'thoughts', 'words', and 'deeds', which are the powers by which man sins, into the metaphorical flock that sings in polyphony with the shepherd, thus transforming sinning into singing. Even through poetic allusion, Herbert manages to bring grief and joy together.

As the conceit continues in the poem, the speaker finds the earthly sun insufficiently constant in its rays. He chides it for giving way to night and longs for

a constant 'willing shiner' (line 16) that will accompany him through all the days and nights of his music making:

> Then will we chide the sun for letting night
> > Take up his place and right:
> We sing one common Lord; wherefore he should
> > Himself the candle hold.
> I will go searching, till I find a sunne
> > Shall stay, till we have done;
> A willing shiner, that shall shine as gladly,
> > As frost-nipt sunnes look sadly. (lines 10–17)

Herbert's speaker longs for a continual relationship with the divine and struggles with the variability of daily life. The rising and setting sun is a particularly apt image for the continual change of lived human experience. In the final lines of the poem, however, Herbert imagines a future apotheosis for his speaker as he joins in a reciprocal song and dance with God:

> Then will we sing, and shine all our own day,
> > And one another pay:
> His beams shall cheer my breast, and both so twine,
> Till ev'n his beams sing, and my musick shine. (lines 18–21)

In this pastoral apotheosis, Herbert accounts poetically for two seemingly incommensurable systems of ascent to God: Pythagorean-Platonic and Christian. From a Pythagorean-Platonic perspective, music has the power to move the soul toward the Divine and can work like grace to effect the conversion of a soul, but from a Protestant perspective the role of divine intermediation is allotted to Christ alone. In a poem about God's capacity to become human (which He does to become the intermediating propitiation for humanity's sins), Herbert offers a dynamic vision of the affective powers of music, combining God's capacity to penetrate and tune the human heart with humanity's capacity to affect God Himself by means of music, so that Christ's 'beams sing, and [humanity's] music shine[s]' (line 21).[49] The poem manages to evoke a feeling of closure that corresponds to the speaker's vision of completeness in unity with Christ by the simplest means: the final line is extended by two feet so that rather than sounding truncated as all the other even lines of the poem, the line balances fully to make an elegant final heroic couplet.

Herbert undertakes, through his innovative and musical manipulations of the sounds of language, to paint in aural images the conversions his poems describe. For Herbert and his contemporaries, it was understood that a congruity and correspondence between an outward sign and the thing symbolised helped to create the conditions for mystical and affective spiritual experience.

Thus, Richard Hooker, when considering the efficacy of music in liturgy, amongst other liturgical practices, observed that 'The sensible things which Religion hath hallowed, are resemblances framed according to things spiritually understood, whereunto they serve as a hand to lead and a way to direct'.[50] Similarly, Hooker comments in Book Five of his *Lawes*:

> That which inwardlie each man should be, the Church outwardlie ought to testifie. And therefore the Duties of our Religion which are seene must be such as that affection which is unseen ought to be. *Signes must resemble the thinges they signifie.* If religion bear the greatest sway in our hartes, our outwarde religious duties must show it as farre as the Church hath outward habilitie. *Duties of religion performed by whole societies of men, ought to have in them according to our power, a sensible excellencie, correspondent to the majestie of him whome we worship.* Yea, then are the publique duties of religion best ordered, when the militant Church doth resemble by sensible means, as it maie in such cases, that hidden dignitie and glorie wherewith the church triumphant in heaven is bewtified.[51]

Hooker's direction to worship the Lord in the beauty of holiness links aesthetic principles of similitude between sign and signified to an ethical or moral obligation for the actions of the Church to be consistent, honest, and non-hypocritical. Herbert struggled with how best to use language in the service of his God. On the one hand, he longed to 'plainly say, *My God, My King*' ('Jordan (I)', line 15), and if his poetry was only for himself, then perhaps that's all Herbert would have written, but lyric poetry, as personal an expression as it is, is in essence a social art form. Herbert believed in its potential as a mechanism of spiritual conversion, and he used a variety of musical and rhetorical tools to make his language sensually, emotionally, and intellectually stimulating.

The musicality of Herbert's finely wrought metres, his intricate rhymes, his diction, and his witty and transcendent images make his verse full of conversional potential, both for the decided convert who needs to massage his or her heart to keep it soft and capable of feeling the compassion that imitates Christ's love, and for a catechumen seeking to kindle his or her faith. Herbert's musical language helps auditors to engage fruitfully in the griefs that are always a part of the human experience. Moreover, Herbert believed in music's capacity to 'relieve [man's] drooping spirits, compose his distracted thoughts, and raise ... his weary soul so far above the earth, that it gave him an earnest of the joys of heaven before he possest them'.[52] As highly musical language, Herbert's poetry approaches this height of artistic affectiveness.

Of course, poetry, like any art, only has these effects sometimes, for some people, in some circumstances, but Herbert was hopeful that his musical words might turn the ear and thereby the heart of his auditors towards God, helping

them to feel their own griefs and joys and thereby softening their hearts as part of the spiritual process of conversion. In 'Praise (III)' he concludes with the wish, 'O that I might some other hearts Convert' (line 39). Likewise, as he writes in the very opening lines of *The Temple*, he wishes to 'rime' his hearers towards the good:

Thou whose sweet youth and early hopes inhance
Thy rate and price, and mark thee for a treasure;
Hearken unto a Verser, who may chance
Ryme thee to good, and make a bait of pleasure:
A verse may finde him who a sermon flies,
And turn delight into a sacrifice. ('The Church-porch', lines 1–6)

NOTES

The author gratefully acknowledges the helpful criticism of Prof. Kenneth Borris and Julie Cumming as well as audiences at 'The Early Modern Conversions Project Team Meeting' (Ann Arbor, May 2016) and 'The Fifth Triennial Conference of the George Herbert Society' (Paris, May 2017), and the editors of and fellow contributors to this volume.

Herbert's stanza forms are an important mechanism of his poems as 'conversion machines'. *The Digital Temple* allows the three most significant sources for Herbert's poetry to be compared, and to visualize the poems as they were originally conceived and received. https://digitaltemple.upress.virginia.edu/home.html

For the Williams MS. Jones B62, Bodleian MS. Tanner 307, see https://digital.bodleian.ox.ac.uk/; for *The Temple: Sacred Poems and Private Ejaculations*, first edition (STC 13183, Folger Shakespeare Library copy), see https://luna.folger.edu/luna/servlet

1. Barbara Lewalski, in *Protestant Poetics and the Seventeenth-Century Religious Lyric*, for example, discusses 'the long slow process of sanctification in *The Temple*,' p. 287, and Daniel Doerksen, in *Picturing religious experience: George Herbert, Calvin, and the Scriptures*, similarly traces a path of 'continual' repentance in Herbert's poetry, observing that afflictions, for Herbert, interrupt the relationship between God and man and yet, are also the means by which God 'tempers' and 'tunes' the individual soul, p. 142.
2. Walton, 'The Life of Mr. George Herbert', p. 127.
3. Ibid., p. 127. See also, Miller-Blaise, '"O write in brasse"', available at <http://journals.openedition.org/episteme/402> (last accessed 26 June 2019), who notes that 'Izaak Walton's version [of the letter] is corroborated by (and may have been based on) John Ferrar's own account of George Herbert's will at his death: "And when Mr Herbert dy'd, he recommended only of all his Papers, that of his Divine Poems, & willed it to be delivered into the hands of his brother N. F. appointing him to be the Midwife, to bring that piece into the World, If he so thought good of it, else to [burn it]"'. See also Ferrar, *A Life of Nicholas Ferrar*, p. 59 (also cited by Miller-Blaise).
4. In chapter XVI of his prose handbook, *A Priest to the Temple,* for example, Herbert calls man's time here on earth, 'the intermediate days of Conversion', advising his readers that at any given moment a sinful man might turn towards his maker and be saved.
5. According to Richard Strier's account of Herbert's Calvinistic theology, once a

convert receives God's grace he is ever after assured of his own salvation, and this 'Assurance is the defining quality of faith' (Strier, *Love Known*, p. 133). However, though a Christian might be intellectually assured by church doctrine of his salvation, Herbert's affective and emotionally dynamic poetry suggests that for him the human experience of conversion is much more complex than such a doctrine can account for. The doctrine of Assurance may well have held intellectually for Herbert the priest, but when Herbert the poet offers moments of sublime conversion in *The Temple*, such conversions are, significantly, never felt to be final or absolute. I am supported in my reading of Herbert's biblical poetics as more mystical than dogmatic by Gary Kuchar, who in his commentary on Herbert's poem, 'Assurance' remarks, 'the systematization of God's ways through human wit for the sake of total assurance rebounds back in the form of despair and doubt ... Herbert roots the experience of assurance not just in Pauline concepts of faith alone but also in the Johannine idea that divine love manifests in the human soul through fellowship and spiritual intercourse with God, hence the affirmation of a qualified form of reciprocity between man and God in the final two lines: "What for it self love once began, / Now love and truth will end in man" (pp. 37–42). This Johannine emphasis on the reciprocal dynamics of love between the soul and God modifies the strong Pauline emphasis on faith alone in the poem's penultimate stanza The result is a lyrical synthesis of covenantal and Johannine ideas that transcends, if it does not outright offend, categories such as Calvinist and Arminian' (Kuchar, *George Herbert*, pp. 119–20).

6. Wilcox, '"Return unto me!"' p. 93.
7. All citations of Herbert's English poems are from Wilcox, *The English Poems of George Herbert*.
8. Strier, *Love Known*, p. 55.
9. '*Jerusalem convertere ad dominum deum tuum*' (Hosea 14:1, *Vulgate*), the refrain from that concludes *The Lamentations of Jeremiah* sung during the triduum in the mediaeval and Renaissance church, for example, is typically translated, 'Jerusalem, return to the Lord thy God'. In the 1611 *King James Version*, for example, the verse reads, 'O Israel, returne vnto the Lord thy God'. All quotations of the Holy Bible in English in this essay are from the 1611 *King James Version*, available at <https://www.kingjamesbibleonline.org/1611-Bible/> (last accessed 28 June 2019).
10. In this way, the term 'conversion' is more encompassing than 'sanctification,' which is the term that Barbara Lewalski uses in *Protestant Poetics*, p. 25 and p. 287 to describe the process of becoming holy in *The Temple*.
11. Moreover, as Wilcox points out in '"Return unto me!"', 'The struggle to keep on the right track after conversion provided narrative tension and the excitement of repeated divine interventions', p. 103.
12. I am pulling apart the idea of being sad, or in a state of grief, and connecting to the physical sensations of that state of privation because it helps us to think about the two parts of the poetic experience as readers or auditors: we must already have the state of grief inside of us for a poem such as 'Grief' to affect us, but the sensuality of the poetry, its musicality, helps us to feel the sensations of grief or joy in our bodies that we might not otherwise be experiencing or connecting with.
13. See Oley, 'A Prefatory View'.
14. Puttenham, *The Art of English Poesy*, p. 154.
15. Plato, *Timaeus*, 47C–D.
16. Hooker, *Of the Laws of Ecclesiastical Polity*, Book V.38.1.
17. 'Sweet' is a musical term meaning 'well-tuned.'
18. Herbert, *A Priest to the Temple*, p. 289.
19. Ibid., p. 289.

20. Doerksen, *Conforming to the word*, p. 118.
21. The poem suggests that change is natural to the human condition. Nevertheless, even if change is the constant, the human longing for stability is still expressed by Herbert. In 'The Flower', for example, he writes, 'Oh that I once past changing were' (line 22). Yet, Herbert understands that there is no fixed human experience; he will be unchanging only in the afterlife, where he will be 'Fast in [God's] Paradise, where no flower can wither!' (line 23).
22. See Doerksen, *Conforming to the word*, p. 118 for a discussion of 'The Family' as a dramatisation of the speaker's 'inner household of thoughts and feelings.'
23. See also, Wilcox, *English Poems*, p. 478: 'the thoughts behave as though they have their own musical line to sing or play, while all they do is make a disharmonious "noise"'.
24. Campion, *The Works of Thomas Campion*, p. 55 (emphasis added).
25. Wilcox, *English Poems*, p. 478.
26. Donne, *The Sermons of John Donne*, p. 86.
27. Walton, 'The Life,' p. 119.
28. 'write' occurs 19 times, 'writeth' twice, and 'writes' only once, whereas 'sing' occurs 28 times, and 'sings' 3 times. This account of the incidences of 'write*' and 'sing*' in *The Temple* was generated using the digital humanities research tool, *Voyant Tools,* created by Stéfan Sinclair and Geoffrey Rockwell, available at <http://voyant-tools.org/> (last accessed 26 June 2019). 'Versing' appears only once.
29. Dowd, '"Oder Plays the Soul"', p. 70.
30. Here, 'bowres' most likely scanned as monosyllabic, as does 'houres' (line 11); for a synopsis of David Crystal's recent work on original pronunciation of Early Modern English see Meier, *The Original Pronunciation*. Also, see: Dobson, *English Pronunciation*, and Wray, 'English Pronunciation, c. 1500 – c. 1625'. Half the 'B' rhymes in the poem are diphthongs with r-coloration: 'fears' and 'ears' – 'houres' and 'bowres' – 'fears' and 'tears' alternate with the pure-vowels of the masculine rhymes: 'neat' – 'seat', 'go' – 'slow', and 'day' – 'stay'. Herbert uses what Ben Jonson referred to as the 'dog's' sound of the rhotic /r/ to create some of the subtle phonemic music of the poetry (Jonson, *The English Grammar,* p. 50).
31. This poem was set to music as two anthems by Herbert's contemporary, John Jenkins (1592–1678). Jenkins's musical settings turn the poem into an even more potentially conversional piece of art. They both literally and figuratively amplify Herbert's already musical language. Jenkins also composed three-voiced anthems to lyrics from 'The Starre' and 'Christmas', discussed below in this essay, and 'The Dawning', all extant in Christ Church MSS Mus. 736–8.
32. See also, Wilcox, *English Poems*, p. 125 and Sherwood, *Herbert's Prayerful Art*, pp. 118–19; both critics have remarked that the theological basis for a God experiencing grief is unorthodox, or 'controversial', citing Richard Sibbes (1577–1635) to that effect. Sibbes, however, was anything but orthodox in his theology. See Tyacke, *Aspects of English Protestantism*, pp. 121–23 to this effect. The idea that God grieves for man's sins has clear biblical precedence. For example, Isaiah 53:3–4, which is taken as a prophetic description of the Christ's passion: 'He is despised and rejected of men; a man of sorrows, and acquainted with grief: and we hid as it were our faces from him; he was despised, and we esteemed him not. / Surely he hath borne our griefs, and carried our sorrows: yet we did esteem him stricken, smitten of God, and afflicted'. The idea of a God that grieves was generally accepted in the seventeenth century. Consider, for example, the final stanza of Samuel Crossman's (ca. 1624–1683) famous hymn, 'My Song Is Love Unknown' (1664):

> Here might I stay and sing,
> No story so divine;
> Never was love, dear King!
> Never was grief like Thine.
> This is my Friend,
> in Whose sweet praise
> I all my days
> could gladly spend.

Crossman's use of 'grief' and 'sweet' echo Herbert's devotional poetic language, especially the refrain, 'Was ever grief like mine' and 'Never was grief like mine' from Herbert's dramatic lyric account of Christ's passion in 'The Sacrifice'. Likewise, the meta-poetic stance of singing about singing is often found in Crossman's as in Herbert's verse, and calling the Christ, 'my Friend' recalls Herbert's intimate tone in poems such as 'Love (III)'. Indeed, much of 'My Song is Love Unknown' is a paraphrase of Herbert's poem 'Love Unknown.' For a line-by-line comparison of the two poems, see Westermeyer, 'Lent', pp. 140–41.

33. The interrogative first stanza is not the beginning of the conversation, but clearly a reaction to Grace; it is God who makes the first move in the conversion process.
34. Ephs. 4:30–32.
35. Referring to man as a worm alludes to Job 25: 1–6: 'Then answered Bildad the Shuhite, and said: Dominion and feare are with him, hee maketh peace in his high places. Is there any number of his armies? and vpon whom doeth not his light arise? How then can man bee iustified with God? or how can he be cleane that is borne of a woman? Behold euen to the moone, and it shineth not, yea the starres are not pure in his sight. How much lesse man, that is a worme: and the sonne of man which is a worme?'
36. Strier, *Love Known*, p. 10.
37. There is a wonderful ambiguity in the grammar of lines 10–12. The verb, 'express' is in the plural form, and therefore grammatically goes with 'sinnes'. However, the sense, syntactically, and semantically, is that the darkness, the 'sable hue' expresses, or reflects the darkness of sin, and also, that the darkness of night, like a sable coat, can push out, or express the sins from the sinner, as if under pressure.
38. In John Jenkins's musical setting of the poem, the contrasting moods of the lines, 'melt into dew' and 'When saucie mirth …' is brought out in the music by an emotive and stretched out cadence at the end of the former line, and a shift to a fast dotted rhythm in the setting of the latter. For further discussion of Jenkins's settings of Herbert's poetry, see my doctoral dissertation, *Metaphysical Music: A Study of the Musical Qualities & Contexts of the Poetry of John Donne, George Herbert, & Richard Crashaw* https://escholarship.mcgill.ca/concern/theses/tx31qq02n.
39. The poem follows an English sonnet rhyme scheme, with an extra quatrain before the final couplet: ABABCDCDEFEFCGCGHH. It is thus in form like a fattened sonnet, swelling in the middle – an appropriate form for a poem that laments that a lover's music (the sonnet being the quintessential love song form) is insufficient to contain the speaker's excessive grief.
40. There is a reasonable argument for marking 'to' as stressed in relation to '-er' and 'sup-' which would make the line scan as regularly iambic with a simple first foot substitution. However, my point about the rolling triple feeling of the line is born out by the amount of times Herbert places a weakly stressed monosyllabic word in what should be a strong stressed syllable position in the poem: it occurs again in lines 10, 15, 16, and 17.

41. As I pointed out at the opening of this essay, there is no final perfect balance reached between grief and joy in *The Temple*. In 'The Thanksgiving', for example, Herbert's speaker wonders at the contrast between the inherent grief in the life of Christ and the notion that he ought to sing joyfully about the passion:

> *My God, my God, why dost thou part from me?*
> Was such a grief as cannot be.
> Shall I then sing, skipping, thy doleful storie,
> And side with thy triumphant glorie?
> Shall thy strokes be my stroking? thorns, my flower?
> Thy rod, my posie? cross, my bower? (lines 9–14)

Yet, the speaker goes on to imagine how he will praise god:

> My musick shall finde thee, and ev'ry string
> Shall have his attribute to sing;
> That altogether may accord in thee,
> And prove one God, one harmonie. (lines 39–42)

42. The stanza form of this poem emphasises the bird imagery, as the stanzas are shaped like birds with outstretched wings in flight.
43. Murphy's translation of *The Latin Poetry*, pp. 34–35.
44. 'Christmas II' is considered by many critics to be the second half of one longer poem, 'Christmas'. See e.g., Wilcox, *English Poems*, pp. 290–1. John T. Shawcross, however, makes the claim in, 'Herbert's Double Poems', that 'the two poems do not belong together', p. 217.
45. In *The Temple*, not only do a number of poems like 'The Familie' contain contrasting moods within themselves, but Herbert's ordering of the poems itself helps to dramatise and to evoke in its readers the dynamic oscillations between grief and joy encompassed by conversion. Consider this sequence of poems, for example (I have indicated negative and positive emotional affect with + and −):

> + Praise (I)
> − Affliction (II)
> + Mattens
> − Sinne (II)
> + Even-song

Or a little later on in *The Temple*:

> + Humilitie
> − Frailtie
> + Constancie
> − Affliction (III)
> + The Starre
> + Sunday
> − Avarice

Certainly, there are also various thematic groupings that help determine the order of poems in *The Temple*, but emotional contrast is clearly a desired effect.
46. His breast is 'heartless' not because it is unfeeling, but because, in the conceit of the poem, his heart is in his knee: 'all day long / My heart was in my knee, / But no hearing' (lines 18–20).
47. Although this particular allusion to the General Confession has not heretofore been noted by scholars, as far as I am aware, Herbert's indebtedness to the language of

the *Book of Common Prayer* is commented upon by Christina Malcomson. She notes that Herbert's 'devotional poetry ... bears strong resemblance to aspects of the Book of Common Prayer, and therefore may have been conceived as an opportunity for collective worship rather than private meditation' (*George Herbert: A Literary Life*, p. xii). Herbert clearly intended for many of his poems to be sung; as Walton notes in 'The Life', p. 119, he apparently set and sang a number of them himself.

48. Church of England, p. 134; emphasis added.
49. Those heavenly joys that the sweetened heart might partake in ultimately involve not just a conversion of the sinner's heart, but God himself might be touched by the music. In the final days of his life, Herbert is said to have 'call'd for one of his Instruments' and prayed –

> My God, my God,
> My music shall find thee,
> And every string
> Shall have his attribute to sing.

– before breaking into a hymn of thanksgiving (Walton, 'The Life', p. 129).
50. Hooker, *Lawes*, IV.1.3.
51. Hooker, *Lawes*, V.6.2; emphasis added. For this citation, I am indebted to Prof. Torrance Kirby's lecture, 'Richard Hooker's theory of law: an Elizabethan metaphysics of Conversion', presented on 17 November 2016 at McGill University, Montreal. See also, Kirby, 'The Hermeneutics', pp. 63–83.
52. Walton, 'The Life', p. 98.

WORKS CITED

Campion, Thomas, *The Works of Thomas Campion,* Walter. R. Davis (ed.) (New York: Norton, 1969).

Church of England, *The Book of Common Prayer: The Texts of 1549, 1559, and 1662,* Brin Cummings (ed.) (Oxford: Oxford University Press, 2011).

Crossman, Samuel, 'My Song Is Love Unknown,' in *The Young Man's Meditation. Or Some Few Sacred Poems Upon Select Subjects, and Scriptures* (London: Daniel Sedgwick, [1664] 1863).

Dobson, Eric John, *English Pronunciation: 1500–1700* (Oxford: Clarendon Press, 1985).

Doerksen, Daniel, *Conforming to the word: Herbert, Donne, and the English church before Laud* (Lewisburg: Bucknell University Press, 1997).

_____, *Picturing religious experience: George Herbert, Calvin, and the Scriptures* (Newark: University of Delaware Press, 2011).

Donne, John, *The Sermons of John Donne*, George Potter and Evelyn M. Simpson (eds) vol. 8 (Berkeley: University of California Press, 1962).

Dowd, Michelle. '"Oder Plays the Soul": Anne Clifford, *The Temple*, and the Spiritual Logic of Housework', in *George Herbert's Travels: International Print and Culture Legacies*, Christopher Hodgkins (ed.) (Newark: University of Delaware Press, 2011), pp. 59–79.

Duckles, Vincent, 'John Jenkins's Settings of Lyrics by George Herbert', *The Musical Quarterly*, vol. 48, no. 4, October 1962, pp. 461–75.

Ferrar, Nicholas, '*A Life of Nicholas Ferrar*', in *The Ferrar papers: containing a life of Nicholas Ferrar; the Winding-sheet, an ascetic dialogue; a collection of short moral histories; a selection of family letters*, Bernard Blackstone (ed.) (Cambridge: Cambridge University Press, 1938).

Gottleib, Sidney, 'Herbert's Case of "Conscience": Public or Private Poem?' *Studies in English Literature 1500–1900*, vol. 25, no. 1, Winter 1985, pp. 109–126.

Herbert, George, *A Priest to the Temple, George Herbert: The Complete English Poems,* John Tobin (ed.) (London: Penguin, 1991).

———, *The Digital Temple*, Robert Whalen and Christopher Hodgkins (ed.) (The University of Virginia Press, 2012).

———, *The English Poems of George Herbert*, Helen Wilcox (ed.) (Cambridge: Cambridge University Press, 2007).

———, *The Latin Poetry of George Herbert: A Bilingual Edition*, trans. Paul R. Murphy and Mark McCloskey (Athens: Ohio University Press, 1965).

———, *The Works of George Herbert*, F. E. Hutchinson (ed.) (Oxford: Clarendon Press, 1978).

Hooker, Richard, *Of the Lawes of Ecclesiastical Polity. Preface, Books I–IV*, George Edelen (ed.) vol. 1 (Cambridge: The Belknap Press of Harvard University Press, [1597] 1977).

———, *Of the Lawes of Ecclesiastical Polity. Book V*, W. Speed Hill (ed.) vol. 2 (Cambridge: The Belknap Press of Harvard University Press, [1597] 1977).

Jenkins, John, 'Christmas (II)', ('The Shephards sing, and shall I silent bee'). Christ Church, Oxford. MSS 736–8, ff. 24v–25/24v–25/25v–26.

———, 'The Dawning', ('Awake sad hart, whome sorrow ever drownes'). Christ Church, Oxford. MSS 736-8, ff. 25v–26/25v–26/26v–27.

———, 'Ephes. 4.30. Grieve not the Holy Spirit', stanzas 1–3, ('And art thou greived, sweet and sacred Dove'). Christ Church , Oxford. MSS 73–8, ff. 31v–32/32/32v–32v–33.

———, 'Ephes. 4.30. Grieve not the Holy Spirit', stanzas 4–6, ('O take they Lute and tune it'). Christ Church, Oxford. MSS 736–8, ff. 31/31/32.

———, 'The Starre', stanzas 1–4, ('Bright spark, shott from a brighter place'). Christ Church, Oxford. MSS 736–8, ff. 33/33/34.

———, 'The Starre', stanzas 5–8, ('Then with our Trinitie of light'). Christ Church, Oxford. MSS 736–8, ff. 32v/32v/33v.Jonson, Ben, *The English Grammar*, Alice Vinton Waite (ed.) (New York: Sturgis & Walton Company, [1640] 1909), *Internet Archive* 2014, <https://archive.org/details/englishgrammar00jons> (last accessed 28 June 2019).

Kirby, Torrance, 'The Hermeneutics of Richard Hooker's Defence of the "Sensible Excellencie" of Public Worship', in *Literature, Belief and Knowledge in Early Modern England: Knowing Faith, Crossroads of Knowledge in Early Modern Literature*, Subha Mukherji and Tim Stuart-Buttle (eds), vol. 1 (Cham: Palgrave Macmillan, 2018), pp. 63–83.

———, 'Richard Hooker's theory of law: an Elizabethan metaphysics of Conversion,' lecture presented on 17 November 2016 at McGill University, Montreal.

Kuchar, Gary, *George Herbert and the Mystery of the Word Poetry and Scripture in Seventeenth-century England* (Cham: Palgrave Macmillan, 2017).

Lewalski, Barbara, *Protestant Poetics and the Seventeenth-Century Religious Lyric* (Princeton: Princeton University Press, 1979).

Lewton-Brain, Anna, *Metaphysical Music: A Study of the Musical Qualities & Contexts of the Poetry of John Donne, George Herbert, & Richard Crashaw*, PhD diss., McGill University, 2019 <https://escholarship.mcgill.ca/concern/theses/tx31qq02n> (last accessed 11 February 2023).

Malcomson, Christina, *George Herbert: A Literary Life* (New York: Palgrave MacMillan, 2004).

Martz, Louis L., 'The Action of Grief in Herbert's "The Church"', in Margo Swiss and

David A. Kent (eds) *Speaking Grief in English Literary Culture: Shakespeare to Milton* (Pittsburgh: Duquesne University Press, 2002), pp. 119–35.

Meier, Paul, *The Original Pronunciation of Shakespeare's English*, Paul Meier Dialect Services, 2018, <http://www.paulmeier.com/OP.pdf> (last accessed 28 June 2019).

Miller-Blaise, Anne-Marie, '"O write in brasse": George Herbert's trajectory from pen to print', *Études Épistémè* 1 April 2012, <http://journals.openedition.org/episteme/402> (last accessed 26 June 2019).

Oley, Barnabas, 'A Prefatory View of the Life and Virtues of the Author, and Excellencies of This Book', in *Herbert's Remains. Or, Sundry Pieces of that Sweet Singer of the Temple, Mr. George Herbert* (London: Timothy Garthwait, 1652), sigs. a1–c6v.

Plato, *Timaeus and Critias*, trans. Robin Waterfield, Andrew Gregory (ed.) (Oxford: Oxford University Press, 2008).

Puttenham, George, *The Art of English Poesy: A Critical Edition*, Frank Whigham and Wayne A. Rebhorn (eds) (Ithaca, NY, and London: Cornell University Press, 2008).

Shawcross, John T., 'Herbert's Double Poems: A Problem in the Text of *The Temple*', in Claude J. Summers and Ted-Larry Pebworth (eds), *'Too Rich to Clothe the Sunne': Essays on George Herbert* (Pittsburgh: University of Pittsburgh Press, 1980), pp. 211–28.

Sherwood, Terry G., *Herbert's Prayerful Art* (Toronto: University of Toronto Press, 1989).

Sinclair, Stéfan and Geoffrey Rockwell, *Voyant Tools,* version 2.4 (M22), 2019, <http://voyant-tools.org/> (last accessed 26 June 2019).

Strier, Richard, *Love Known: Theology and Experience in George Herbert's Poetry* (Chicago: University of Chicago Press, 1983).

Tyacke, Nicholas, *Aspects of English Protestantism, c. 1530–1700* (Manchester: Manchester University Press, 2001).

Vulgate, The Latin Vulgate Bible, 2012, <http://vulgate.org/> (last accessed 28 June 2019).

Walton, Izaak, 'The Life of Mr. George Herbert,' in Constantinos A. Patrides, *George Herbert: The Critical Heritage* (London: Routledge & Kegan Paul, [1675] 1983), pp. 90–132.

Westermeyer, Paul, 'Lent', *Hymnal Companion to Evangelical Lutheran Worship*, 1st ed., vol. 1 (Minneapolis: Augsburg Fortress, 2010), pp. 140–42.

Wilcox, Helen, (ed.), *The English Poems of George Herbert* (Cambridge: Cambridge University Press, 2007).

———, '"Return unto me!": Literature and Conversion in Early Modern England', in Jan N. Bremmer, Wout J. Bekkum, and Arie L. Molendijk (eds), *Paradigms, Poetics, and Politics of Conversion.* (Leuven: Peeters, 2006), pp. 85–105.

Wray, Alison, 'English Pronunciation, c. 1500 – c. 1625', in *English Choral Practice 1400–1650*, John Morehen (ed.) (Cambridge: Cambridge University Press, 1995), pp. 90–108.

10

THEATRES OF MACHINES AND THEATRES OF CRUELTY: INSTRUMENTS OF CONVERSION ON THE EARLY MODERN STAGE

Yelda Nasifoglu

I

In 1583, Niccolò Circignani (1516–1596) was commissioned to paint a martyrdom cycle of thirty-four frescoes for the chapel of the Venerable English College in Rome.[1] The murals, along with the chapel, have since been destroyed; however, they were memorialised in a series of engravings by Giovanni Battista Cavalieri (1525–1601) and published the following year in folio as *Ecclesiae Anglicanae trophaea* (Rome, 1584).[2] Cavalieri's lavish illustrations recount the history of the Catholic church in England through the heroic deaths of its martyrs, beginning with St Alban (d. ca. 305?), *protomartyr Anglorum* of Roman Britain, and ending with the contemporary incidents of martyrdom from the English Mission. The images are awash in violence, vividly depicting mutilations, decapitations, and executions. Three of them are dedicated to the hanging, drawing, and quartering of the English Jesuits Edmund Campion (1540–1581) and Alexander Briant (1556–1581), and English College alumnus Ralph Sherwin (1549/50–1581) just a few years earlier. They had been caught trying to convert Elizabethan England back to Catholicism and paid for it with their lives. Yet they had not completely failed their mission: the engraving depicting their torture bears the inscription 'Horum constanti morte aliquot hominum millia ad Romanam Ecclesiam conversa sunt' (Fig. 10.1).[3] The message is clear: it was through witnessing the Catholic martyrs' defiance against death that thousands of Protestants had

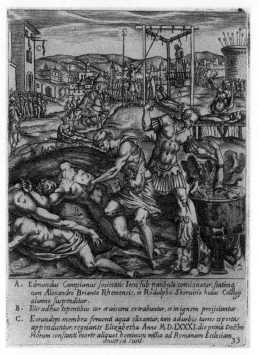

Fig. 10.1 'The execution of Edmund Campion, Alexander Briant and Ralph Sherwin' in Cavalieri, *Ecclesiae Anglicanae trophaea* (Rome, 1584), p. 33r. (Source: The New York Public Library, Spencer Coll. Ital. 1585 93–166 no. 4, https://digitalcollections.nypl.org/items/8a1d821d-0f48-d230-e040-e00a180642ed.)

been converted to the Catholic Church. Martyrdom through public torture, *theatrum crudelitatum*, was part of the machinery of conversion.

Decades later, another theatre of cruelty would play out within the College walls, this time in the form of an academic comedy featuring as its protagonist a square desperate to be converted into a circle, and willing to endure torture in the process. With geometric shapes and instruments as its characters, the play seems innocuous enough. However, it is surprisingly effective in throwing into relief changing attitudes not only towards martyrdom but also towards instruments during a pivotal period for natural philosophy in the early seventeenth century.

II

Blame Not Our Author has survived in a small quarto manuscript in the Archives of the English College.[4] As its title page is missing, its date and author remain unknown. Its modern editor has named it from the opening lines of the

prologue and dated it to sometime between 1613 and 1635 based on water-mark, inscriptions, and internal evidence. It is assumed to have been authored by a mathematics tutor since traditionally college plays were written by the masters rather than students.[5]

The play opens with Quadro awakening from a restless sleep. Disoriented with an intense feeling of unease, he wonders why his passions are growing 'vnbounded' (30).[6] Looking up, seeing 'the heauens all orbicular / The planets, stars & hierarchyes [a]bove / All circular' (31–33), he realises the source of his anxiety: it is the incongruity of being 'a quadro' in a 'circled vniuerse' (37). The only remedy to his predicament, he decides, is to change his form from a square into a circle. Yet who could implement such a radical conversion and 'change that what's essentiall' (41)? Looking up, he first appeals to the 'cristall optiques' of the celestial spheres 'to metamorphize thinges below' (44–45), but the gods remain deaf to his pleas (52). He then turns to nature for help, but really it is wit and artifice that he seeks. He decides to pursue Compass, a Daedalian 'architecte of humain wonder' (136) and summons his servant Rectangulum to make the arrangements.

Rectangulum has legitimate concerns about a fundamental flaw in his master's plan. Within the Euclidean world, a quadratus is literally defined by its four equal right-angled sides. 'Syr hee that's quadratus ... should receiue no alteration' (63), he pleads, for if Quadro is changed into a circle, the essential definition of a quadro itself would change and turn everything square into round. Such a change in definition would also spell sartorial disaster; their quadrangular caps, presumably the four-cornered Catholic *biretta*, would be turned into Londoners' flat caps.[7] There would be culinary issues, too; that their square plates would be turned into round dishes would be the least of their problems. Their food would change from hearty meat to dough and fruit. Instead of four-cornered meat pies, they would have to resort to eating pasta. Their 'foursquard shoesoles of beif' (72) would be turned into pomegranates, and their chief diet would be meatless Norfolk dumplings. Problems would multiply in other areas as well: their house would turn into a tennis court, walkways would become entangled, disorder would reign, and Compass would soon find 'all thinges out of square' (94).

Yet Quadro is determined. Cajoled into doing as he is told, Rectangulum decides to take advantage of the situation for his own devious plan. He wants to be made a perfect figure himself but not through any unnecessary physical labour involving Euclidean gesturing; he just needs a patent signed by the highest legal authority, Regulus, the rule. It would perhaps be a simple nuance in his definition but not without geometric consequences, so his first step is to stifle any dissent by turning all the other shapes against one another. He easily convinces Compass, who is unable to comprehend why a square would want to be turned into a circle anyway, that Quadro is plotting against him.

So, when the latter enthusiastically welcomes him as the 'True finder of the hidden misteries' and desperately implores him to 'Come wth thy powerfull skill encircle mee / And turne mee to a peripheria ... Ile vndergoe whatsoeuer youl' prscribe' (136–37, 143–44, 156), he is not fooled and already has a counter-attack planned. Playing along, he first gives Quadro potions to loosen his joints, to crush 'parts that / your waxen corpusculū may wthout incrustation bee / formed to a pfect rotundity' (153–56) and begins to measure him in detail, purportedly getting ready to pare off his four corners. Growing impatient with the process, Quadro, who has already downgraded his dimensional ambitions to just being turned into a periphery rather than a surface, implores him to hurry up and remove his corners, even if it meant he would be further pared down into a punctum, a point (164–65).

Feigning difficulties, Compass suggests to Quadro that in order to be directly 'brought to a peripheria', 'it were farr better yow indured my instrument / called the Squarenighers daughter' (166–68) as he lures Quadro into a torture device. Assuring him that he is being fitted with a 'metamorphosis', he binds him in two metal hoops and instructs him to hold the position for an hour. For 'perfecter transformation' he needs to fetch additional potions, and his 'Vitruuius instrumentiū partiū' (175, 179–80) for further measurements, he claims, and abandons him. Waiting and daydreaming of his forthcoming orbicular life, Quadro starts to feel the paralysing weight on his neck and shoulders, his joints growing feeble, and his 'vitall[e] parts benummed' (214–15). A cold chill runs through his body – perhaps through the compass puncture in the midst of his belly – as he realises he has been tricked. Devastated, he swears vengeance on the 'base and grosse mecanicke Cumpasse' who has 'allmost slaine [him] by false surquadrie' (311–12).

From there on, with expert manipulation on Rectangulum's part, the play disintegrates into geometric revenge plots with numerous shapes airing their grievances and threatening one another with Euclidean violence. Line has been 'tortered' by Compass with punctures and joints, and turned 'diuisible in infinitū' (315–16). He plans to take out his anger on Compass's friend Circulum: 'let me a lone with him Ile slise / him thurroe the midst and make as many triangulurs / of him as the Cooke doth when he sliseth an edge flapiack / in to portions' (323–26). But Circulum is not interested in a fight and is in fact embarrassed by his close association with such a promiscuous instrument: 'Why should I subiugate my selue to one / Ignoble slauish in the hands of all / Base compasse minion of each pedlers pack / Turned and tossed by each Carpenter' (401–5). Turning on his now unpopular friend, he declares 'Death to the name of cumpas' (418); 'I will trample on the miscreant / Contemne him as mecanicke instrument / scorne of the vulgar refuse of the world' (428–30). Rectangulum tramples on Line making a right angle while quoting from Jesuit mathematician Christoph Clavius's famed edition of Euclid's *Elements of*

Geometry: 'Cū vero recta linea supra rectā consistens lineā' (when a straight line stands on a straight line), and is threatened in return: 'Are you makeinge definitions vpon my backe, by yᵉ / helpe of my Cozen Cord Ile bee on your Iacke' (352–53).[8] Semicirculus warns Rhombus: Regulus will 'cracke your ledgs and make yee a Trapesia' (923). In this chaotic battleground, promising refuge from all the violence but really attempting to silence the competition, Rectangulum hides Quadro, Compass, and Circulus in a 'secret presse' (816), with further designs to imprison the remaining figures.

Eventually Regulus, the governor of the 'mathematicall spheare' (684), is called upon to restore order. He is the rule, both the instrument and the law, and is particularly incensed by Rectangulum's plans to circumvent the rules and manipulate definitions in order to be made into a perfect figure: 'Presumptuous slaue bringe present torture fourth / hee that by villany doth seeke to rise / Draus vengeance on his hatefull surquedrie' (1047–49). He releases the falsely-imprisoned, and the play ends with the grave warning 'Let him that squars from rule and compasse bee / Vasaile to feare and base seruility' (1076–77).

<div align="center">III</div>

Featuring seemingly harmless geometric shapes and instruments, *Blame Not Our Author* contains a startling amount of violence, with constant threats of bodily harm or reports of the characters being punctured or sliced or broken. The perpetrators are usually the instruments, compass and rule. Circulum has been 'quartered' and 'martyred' by Compass with incisions (467–69) and Rhombus is threatened with some leg-cracking by Regulus (923). The geometric forms are not entirely helpless victims, however, and plan to retaliate by torturing Compass on the rack (290, 701) or to 'buchar' (804) him – that is, if he hasn't already been disembowelled, with his belly sliced and his 'puddings crept out' (699–700). Indeed, even Line is capable of committing violence beyond the boundaries of its two-dimensional existence. Most unusually given its Catholic setting, the play contains a reference to drawing 'Papists' with a cord and hanging them with God's 'sacred line' (654–57).

No doubt such direct references to violence constitute a reflection, albeit a comedic one, of the world surrounding the stage. The Venerable English College in Rome (henceforth the College) had been established as one node of a continental network of English Catholic institutions after the Elizabethan Religious Settlement of 1559, and its mission almost guaranteed torture and martyrdom to any alumnus caught on English soil. During the reign of Mary I (1553–58), England had gone through an intense period of Roman Catholic restoration. With Elizabeth's accession in 1558, this was fiercely reversed. With the independence of the Church of England from Rome having been restored, life became increasingly difficult for English Catholics. They were

excluded from holding office, and later from attending university.[9] Even if a minority was able to survive, there was a serious shortage of priests. The primary purpose of the College was to remedy this shortage, yet its mission was far more complex than just the education of clergymen.

William Allen (1532–94), the spiritual leader of the English Catholic diaspora, was an enthusiastic adherent of Marian Catholicism. With the Elizabethan purge of the universities, he was driven out of his fellowship at Oxford, and he fled to the Continent. He first founded the English College at Douai in 1568, and four years later he received the necessary authority from Pope Gregory XIII to send missionaries to England for its reconversion. Yet by 1576, the College in Douai was no longer able to accommodate the increasing number of students. Allen found a solution by way of converting the English Hospice in Rome, originally founded in 1362, into a seminary. Three years later, it received its Bull of Foundation as a College from the Pope and was run by the Jesuits (though not officially as a Jesuit college) until the suppression of the order in 1773.[10]

Elizabethan England was a particularly dangerous place to be an English Catholic. The demarcations of treason and heresy had already blurred during the Tudor reign, but it became particularly acute with the establishment of the Church of England with Elizabeth as its 'Supreme Governor'. The 1570 papal bull *Regnans in excelsis* declared Elizabeth a heretic, absolved her subjects of their allegiance, and instructed them to disobey her laws, causing a unique situation where, as Peter Marshall explains, 'Catholics, simply by virtue of being Catholics, were traitors to the crown'.[11] Religious disputes were no longer matters of conscience but came perilously close to questioning the legitimacy of the heir to the throne, which was defined by the state as an act of sedition. Indeed, in Allen's case it was sedition par excellence: not only was he an ardent supporter of *Regnans in excelsis*, but he also participated in the Spanish and French plans for invading England and even took part in the 1588 Spanish Armada. Under such circumstances, anyone caught on the English Mission would be tortured to extract confession or evidence and executed for treason by 'drawing and quartering'.[12] This was by far the cruellest of punishments. The prisoner would be laid on a hurdle and 'drawn' or dragged to the place of execution where he would be hanged on the gallows until half strangled. He would then be cut down to have his heart and entrails removed and burnt. Finally, he would be decapitated, and the body divided into quarters to be displayed publicly.[13] As noted earlier, this was the manner in which Campion, Briant, and Sherwin (the latter was the first College alumnus to be martyred) were executed in 1581 (Fig. 10.1). The annual reports of the College extant from the period are full of detailed accounts of the 'barbarous torture' suffered by the priests before being 'butchered' for the constancy of their faith.

This world of violence is mirrored in the play. In *Blame Not Our Author*, the most direct reference to torture and martyrdom is the contrivance into which Quadro is lured. Compass's torture device, 'Squarenighers daughter', is a play on words referring to an actual instrument called the 'Scavenger's daughter', itself a corruption of the name of its alleged inventor Leonard Skevington, a lieutenant of the Tower of London during the reign of Henry VIII.[14] Students of the College would have been well acquainted with the instrument. One of its alumni, Luke Kirby (d. 1582), had been subjected to the device alongside the English Jesuit Thomas Cottam (1549–82), who had taught philosophy at the English College in Douai, before they were eventually executed at Tyburn.[15] A demonstration of the instrument was published in *Theatrum crudelitatum haereticorum nostri temporis* (Antwerp, 1587), a chronicle of English Catholic martyrs authored by the exiled Anglo-Dutch antiquary Richard Verstegan (or Rowlands) (1548/50–1640) a few years after his visit to the College (Fig. 10.2).[16]

Catholic recusants were not the only victims of the 'Scavenger's daughter'. In fact, the first mention of the device in print is in John Foxe's *Actes and Monuments* (London, 1563), conventionally known as 'Foxe's *Book of Martyrs*', in the lengthy section on the Protestants executed during the reign of Mary I. It was used to inflict torture on Cuthbert Simpson (d. 1558), the deacon of a London congregation, in an attempt to extract the names of the attendees to 'the english seruice'.[17] In a letter recounting the torments he had suffered in the Tower, Simpson described the torture simply as being 'set in an engine of Yron for the space of .iij. houres', which left much room for interpretation.[18] Indeed, the woodcut published in Foxe's *Book of Martyrs* inaccurately depicted 'Sceuyngtons gyues' as an iron collar attached to the feet with long bars. The error was corrected the following year in a marginal note to Simpson's letter, printed in Myles Coverdale's compilation of letters from the Protestant martyrs of Mary's regime, that explained 'Thys Engine is called Skenyngtons Giues, wherin the body standeth double, the head being drawē towardes the feete'.[19]

As described in Coverdale's marginal note and later illustrated in Verstegan's *Theatrum crudelitatum haereticorum nostri temporis*, rather than stretching the body in the rack, the instrument effectively contracted and compressed it into a circle. It consisted of a broad iron hoop, composed of two semi-circular pieces connected with a hinge. The prisoner would be forced to kneel on the floor with the hoop clasped and tightened around him, pressing the abdomen, thighs, and lower legs into one another. Prescribed to be used for over an hour, such extreme compression would cause bleeding from the nose, and sometimes from the hands and feet of the victim.[20] Indeed, Quadro, trapped in the 'Squarenighers daughter' with an 'atlanticke' burden on his neck, would feel his joints growing feeble and his vital parts numb – to the point of fearing he would perish in his 'metamorphosis' (213–18).

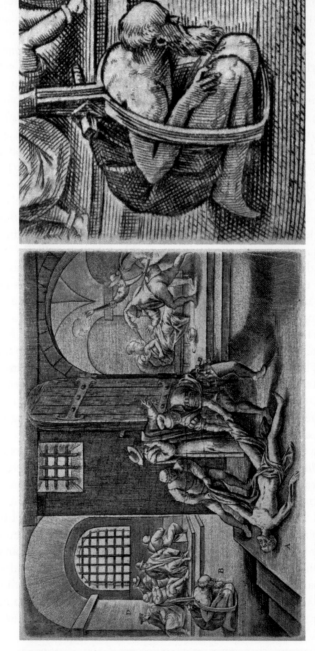

Fig. 10.2 (a) 'Persecutions of Catholics by Calvinist Protestants in England' in Rowlands (Verstegan), *Theatrum crudelitatum haereticorum nostri temporis* (Antwerp, 1592), p. 75. (b) Detail showing the 'scavenger's daughter' device (Source: The Bodleian Libraries, University of Oxford, Antiq.d.B.1592.1.)

With mathematical shapes and instruments as its characters, *Blame Not Our Author* may seem exceptional, but it fits within the landscape of early seventeenth-century English academic drama which did at times feature unusual elements. For instance, Thomas Tomkis's comedy *Lingva, or, the combat of the tongue, and the fiue senses for superiority* (London, 1607) was the story of a tongue's struggle to be recognised as one of the human sensory organs, and the anonymous play *Heteroclitanomalonomia* (ca. 1613) was about a war between Nomen (noun) and Verbum (verb) which would eventually be resolved with the establishment of grammar rules.[21] What makes *Blame Not Our Author* particularly unique, however, is its casual depiction of instruments of torture.[22] Of such devices, the 'Scavenger's daughter' is considered to have been a relatively mild one, which may have justified its use in a comedy, especially since its ability to fold the body into a sphere is exceptionally fitting for the play.[23] The 'secret presse' used by Rectangulum to imprison some of the characters would have had less comedic value, however.[24] Large presses, such as those for olives or grapes, had been used for inflicting torture by crushing their victim – a slow and painful death. As illustrated in Antonio Gallonio's *Trattato de gli instrumenti di martirio* (Rome, 1591 in Italian, 1594 in Latin), St Jonas was martyred in this manner in a winepress (Fig. 10.3).[25] In the English legal system, crushing to death, known as *peine forte et dure*, had been in use at least since the 15th century as the method of execution of those refusing to enter a plea in a capital case.[26] Its most infamous victim was the Catholic recusant Margaret Clitherow (1552/53–1586), whose crimes included sending her son Henry abroad to France to study at an English College, which had been declared an offense in 1585.[27] As memorialised by Verstegan in *Theatrum crudelitatum haereticorum nostri temporis*, Clitherow was tortured and executed in a makeshift press (Fig. 10.4).[28]

Such humorous depiction of real-life, ghastly instruments of torture may be partly attributed to the Carnival season when College plays were usually presented. There is even a direct reference to Carnival in the play when Line worries about indulging in too much 'macarone' during the festivities, and no longer satisfying its Euclidean definition as 'longitudino latitudinis expers' (length without breadth) by adding 'some latitude' to its 'longitude' (297–301). It may also signal a reaction to being surrounded by images of torture and martyrdom which had become part of the landscape of Post-Reformation Europe.

Prior to this period, paintings depicting Christ's passion had already been in use for devotional purposes in churches, but with the spread of printing, religious violence, Catholic or Protestant, could now be amplified, memorialised, and propagandised in publications reproduced in multiple editions all over Europe. These martyrologies were influenced by early hagiographies, such as Eusebius's *Historia ecclesiastica* (4th century) which had included extended sections on early Christian martyrs, but their new incarnations were

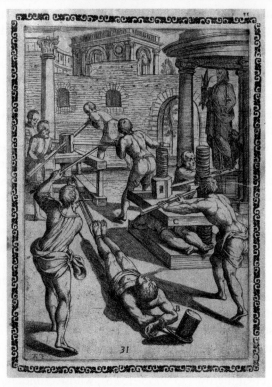

Fig. 10.3 'Martyrdom of St. Jonas in a wine press' in Gallonio, *Trattato de gli instrumenti di martirio* (Rome, 1591), [p.] 31. (Source: Bibliothèque nationale de France, département Réserve des livres rares, RES 4-NFG-9, https://gallica.bnf.fr/ark:/12148/bpt6k8571638/f39.item.)

much more explicit in their descriptions of the martyrs' suffering (especially of contemporary ones) and increasingly included illustrations matching in detail.[29]

The first Lutheran martyrs were burned at the stake in 1523, and as their numbers multiplied in the ensuing years, Protestant martyrologies began to appear in print.[30] Among the most notable were Jean Crespin's *Le livre des martyrs* (Geneva, 1554), Adriaen Cornelis Van Haemstede's *Des geschiedenis ende den doodt der vromer Martelaren* (Emden, 1559), Ludwig Rabus's 8-volume *Historien der Heyligen* (Strasbourg, 1552–58), and Foxe's *Book of Martyrs* (London, 1563). Arguably the most famous of these, Foxe's 1800-page tome was a history of Christianity in England and Scotland and included a lengthy section dedicated to the Protestant martyrs executed during the reign of Mary I, which was still fresh in public memory in Elizabethan England.[31] The book was immensely popular and appeared in four unabridged editions

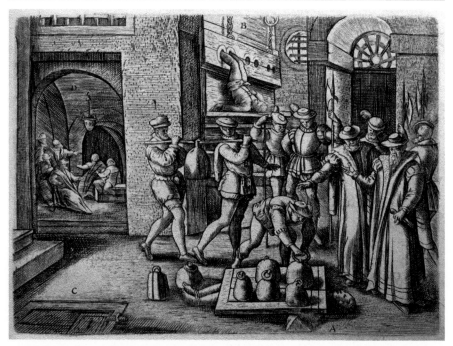

Fig. 10.4 'Martyrdom of Margaret Clitherow' in Rowlands (Verstegan), *Theatrum crudelitatum haereticorum nostri temporis* (Antwerp, 1592), p. 77. (Source: The Bodleian Libraries, University of Oxford, Antiq.d.B.1592.1.)

(1563, 1570, 1576, 1583) during Foxe's lifetime alone. Undoubtedly contributing to its appeal was the copious number of intricately detailed woodcuts offering dramatic illustrations of torture and suffering.[32] Such use of illustrations was certainly unusual. The devotional use of images was already rejected in Protestantism, and there was also a trend to avoid illustrating religious books.[33] In their martyrologies, Crespin and Van Haemstede had not included any illustrations, and the limited number of woodcuts used by Rabus were far less sensational, depicting figures as detached and expressionless.[34] Foxe, and his publisher and collaborator John Day (1521/52–1584), were not as apprehensive about representational illustrations and evidently appreciated their rhetorical utility.[35] They expanded the number of woodcuts from fifty-seven in the first edition to 153 in the second, in each dedicating about half of them to Marian martyrs.[36] English recusant Robert Parsons (or Persons; 1546–1610), who led the first Jesuit mission to England in 1580, acknowledged their powerful impact and lamented how 'the spectacle and representation of martyrdomes (as they are called) delighteth many to gaze on, who cannot read'.[37]

The Catholic Church had traditionally embraced the use of images, but during the Reformation this led to accusations of idolatry. As part of its Counter-Reformation measures, the Church sought to codify 'the legitimate use of images' in Christian pedagogy, distinguishing it from superstition and idol-worshipping. The Council of Trent decree 'on the invocation, veneration, and relics, of saints, and on sacred images' adopted in 1563 emphasised that divinity itself could not be rendered visible 'by colours or figures'. Rather, paintings and other representations were meant to be instructional: they allowed not only 'remembering, and continually revolving in mind the articles of faith', but by setting 'before the eyes of the faithful', 'the miracles which God has performed by means of the saints, and their salutary examples', they encouraged people to 'order their own lives and manners in imitation of the saints' and 'to adore and love God, and to cultivate piety'.[38] Within decades, elaborately illustrated martyrologies, such as those by Cavalieri, Verstegan, and Gallonio, mentioned above, began to proliferate.[39]

For the English Mission, as the number of Catholic martyrs increased under Elizabeth I's reign, 'imitation of the saints' took on specific meaning. The martyrology cycle painted by Circignani in the College chapel had been financed by George Gilbert (d. 1583), a wealthy English gentleman from Suffolk, who had been converted to Catholicism by Robert Parsons in 1579. He was an enthusiastic supporter of the English Mission, expressing a strong desire to 'die combating the heretics, or on the scaffold for the faith in England'. His purpose for commissioning the cycle, College rector Alphonsus Agazzari (d. 1602; rector in 1579–86 and 1596–97) explained, 'was not only to honour those glorious martyrs, and to manifest before the world the glory and splendour of the Church in England, but also that the students at the College, beholding the example of their predecessors, might stimulate themselves to follow it'.[40] Indeed, William Allen, father of the English Mission, had seen martyrdom as crucial to the cause. In his defence of the English Colleges in Rome and Rheims, published in 1581, he argued that 'blood so yielded' would ultimately 'make a stronger intercession for our Countrie and afflicted Church, then any prayers lightly in the world'. It was not by force or war but by displays of 'long confession', 'slow martyrdom', and 'suffering of the yonger Priests' that he hoped 'to win our nation to God againe'.[41] Circignani's theatre of cruelty was therefore not only meant to inspire an internalised performance of contemplation, of suffering along with the martyrs, but it was also to motivate the students towards martyrdom, which in turn would help convert England back to Catholicism.

This machinery of conversion was primarily fuelled by visualisation. Praising Circignani's work, College alumnus and later president of Douai College, Richard Barret (ca. 1544–99) noted how the 'sense of sight which is very keen, by seeing everything most clearly at one view, excites the ardour of devotion, more than if we came to know the same things by ear'.[42] Notably, Barret

was invoking Horace's 'Ars poetica', where the Roman poet had stressed the primacy of vision in theatre. Comparing action and narration, Horace had highlighted how an event witnessed on stage made a stronger impression on the mind than words alone.[43] Indeed, while dinnertime readings, especially during the early 1580s, of passages from Bede on the conversion of England and Eusebius on the martyrdom of early Christians were meant to strengthen the students' resolve, it was the contemplation of images that compelled them to martyr themselves, to mentally rehearse the disintegration of their bodies into instruments of conversion. It is revealing that while the students were educated at the Collegio Romano, they were in fact discouraged from taking degrees or even the full course of studies: their mission was martyrdom or priesthood, not higher study. In his private correspondence, Allen explained 'Our students, being intended for the English harvest, are not required to excel or be great proficients in theological science'.[44] It was an effective strategy; between 1581 and 1679, the College saw forty-one of its alumni martyred for their Counter-Reformation missionary work, twenty-eight of these during Elizabeth I's reign.[45]

For *Blame Not Our Author*, Circignani's frescoes in the College chapel, as well as the numerous printed martyrologies in circulation, provided a backdrop of striking depictions of mutilation and brutality, and it is not surprising that some of the violent imagery permeated the comedy. Yet the references to martyrdom and instruments of torture go beyond providing the political and cultural background to the play, they also bridge the seemingly incongruous worlds of martyrology and geometry by highlighting some unexpected affinities.

If visualisation was vital to the machinery of conversion, it was especially integral to classical geometry. Indeed, Euclid's *Elements of Geometry* (ca. 300 BCE; hereafter the *Elements*) is one of the few texts to have survived from antiquity with diagrams. It is not a coincidence that John Day, the printer of Foxe's *Book of Martyrs*, would also produce the first English translation of the *Elements* (London, 1570), a thick folio of almost 500 leaves renowned for its intricate woodcuts of nearly 1,300 geometric diagrams, some of which are assembled as three-dimensional pop-ups.[46] Day, who was arguably the most accomplished printer in Elizabethan England, particularly excelled in printing illustrated books (including the first Protestant emblem book in England), fully cognisant of the persuasive power of visualisation.

It is important to point out that in classical (pre-algebraic) geometry, diagrams fulfil a purpose beyond visualisation. They are not illustrations of the textually expressed propositions; rather, drawing the diagram is how one read the geometrical text.[47] Book 1, proposition 1 of the *Elements*, for example, is a set of instructions on how to construct an equilateral triangle on a given straight line; without drawing it, it is impossible to prove that the sides of the

resulting triangle are equal. Indeed, one can see the geometric proof take shape in real time by either drawing the diagram or following it with a stylus. It is a performance with a climactic end. Philosopher Thomas Hobbes (1588–1679) reportedly described his accidental encounter with geometry for the first time at the age of forty as a conversion experience. Chancing upon the Pythagorean theorem in a copy of the *Elements* at a gentleman's library, he was not persuaded by the proposition at first, declaring 'By God ... this is impossible!' However, once he read its demonstration (almost certainly by drawing or following the diagram), and then all the other demonstrations it was built on, 'he was demonstratively convinced of that trueth. This made him in love with geometry'.[48] A Euclidean convert, Hobbes would subsequently build his system of philosophy as the *Elements of Philosophy* and vehemently oppose any novel approach to geometry that did away with diagrams.[49]

Geometric visualisations are produced with the help of instruments which are in fact built into the Euclidean propositions, so that the diagrams are constructed by the turning of a compass or the extending of a rule, making reading geometry a manual or gestural performance. The martyrology references in *Blame Not Our Author* underline the violence, however abstract, involved in the generation and transformation of geometric forms by puncturing or cutting or slicing with compass and rule in hand. In Apollonius's *Conics*, written in the 3rd or 2nd century BCE, the imagery is even more stark, with curves being defined as sections of a cone. One must mentally cut through a virtual cone to visualise the shapes in their mind's eye: a straight horizontal cut would produce a circle, a vertical cut anywhere outside the apex would produce a parabola, a cut angled to the side of the cone would produce a hyperbola, and so on.[50] It would take the development of analytical geometry, in which shapes are defined in algebraic terms (for instance, the parabola as $y = x^2$) rather than via combat with instruments, for this figurative violence to subside.

IV

The most recognisable symbol of Christianity is an instrument of violence: the cross. According to Oratorian priest Antonio Gallonio (1556–1605), it was on the 'blessed and holy cross' that Christ, through his sufferings, earned for his flock the 'great fortitude' they needed 'to endure the most arduous hardships of every sort, even, if need were, to the shedding of their blood and the most cruel lopping off of all their limbs'.[51] In his 1591 treatise on the instruments of martyrdom, Gallonio systematically catalogues all the implements that were used to inflict such hardships – to persecute and then to martyr faithful Christians. Ostensibly it is a work of ecclesiastical scholarship based on previous martyrologies and church histories, but it also includes technical information (for instance on pulleys) extracted from classical sources such as the Roman writer Vitruvius. Over twelve chapters, beginning, appropriately enough, with the

cross, Gallonio surveys in astonishing detail a wide range of tools including the wheel, the pulley, the press, the wooden horse, and other tools for scourging, tearing, burning, branding, and cutting the flesh. He updated the work in the subsequent Latin edition, adding the instruments that had been used on those martyred by Protestants. The accompanying forty-six illustrations strikingly show the instruments in action, depicting the martyrs in stoic postures calmly enduring the methodical decimation of their bodies. The final illustration is an engraving of diverse torture instruments arranged into a trophy (Fig. 10.5).

Gallonio's treatise coincided with the Renaissance tradition of theatres of machines, books almost entirely composed of illustrations of mechanical inventions with little accompanying text.[52] This was an extension of an earlier manuscript tradition of books of machines, such as Mariano Taccola's *De ingeneis* (1433) and *De machinis* (1449) or Konrad Kyeser's widely-circulated *Bellifortis* (ca. 1405), but like other illustrated manuscripts, these were

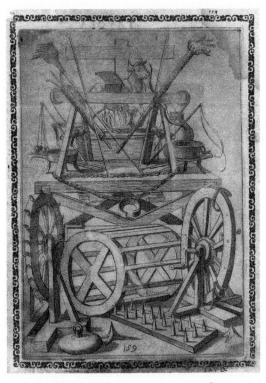

Fig. 10.5 'Trophy composed of all the instruments of martyrdom' in Gallonio, *Trattato de gli instrumenti di martirio* (Rome, 1591), [p.] 159. (Source: Bibliothèque nationale de France, département Réserve des livres rares, RES 4-NFG-9, https://gallica.bnf.fr/ark:/12148/bpt6k8571638/167.item.)

difficult and expensive to reproduce. With the advent of relief and intaglio printmaking, which facilitated the reproduction of illustrations, these books became widespread. Jacques Besson's *Théâtre des instrumens mathématiques et méchaniques* (ca. 1571) is considered to be the first printed example of the genre and was soon followed by other similar works such as Jean Errard's *Le premier livre des instruments mathematiques mechaniques* (Nancy, 1584) and Agostino Ramelli's *Le diverse et artificiose machine* (Paris, 1588).[53] Using copious illustrations of instruments and detailed technical descriptions, Gallonio mimicked the format of such works, but conveyed a markedly different message. Theatres of machines were celebrations of human ingenuity and mechanical elegance, often framed in a theological context whether as emulating the mathematical principles of divine creation or compensating for human deficiencies after the Fall.[54] Gallonio's treatise, instead, emphasised the ultimate futility of human ingenuity: regardless of the creativity and efficiency of their cruelty, and despite the immense suffering they inflicted on the bodies of martyrs, instruments of martyrdom were ineffective against the fortitude of their victims' faith.

What transforms instruments of torture into instruments of martyrdom is partly the complex relationship martyrs have with physical pain. In both Catholic and Protestant martyrologies, martyrs are presented as being uniquely resilient to pain (a reflection of their spiritual purity) and are often portrayed in an 'analgesic state' with serene expressions, calmly facing their brutal torturers.[55] Martyrs embraced and sometimes even sought out pain: Foxe described how some English Protestant martyrs 'leaped for joy' on their way to the stake, and Catholic recusant Clitherow's cheerful reception of her torture led to the accusation that her martyrdom was effectively a suicide.[56] The pain induced by these instruments enabled the martyr to witness Christ's passion as it was performed on their own bodies – they converted the Christian into the martyr, disassembling the mortal body to free the immortal soul.

The connection to Christ's passion is crucial in order to understand the agency of instruments, for if the brutal implements of torture had any power at all over the bodies of martyrs, it was not derived from the cruelty of their heretical operators but from divine will. When he defended the necessity of martyrdom for the English Mission, William Allen explained that the Church was built on persecution and that the students would be following a long tradition of martyrdom that had begun with Christ's own: 'The church grewe and increased by persecution' and Christ had planted his 'law and religion ... by giving up his blood and life, for which his Father promised him, that he should see semen longæuum'.[57] Allen was referring to the Book of Isaiah 53:10, which ascribes Christ's suffering directly to God. Indeed, according to the prophecy, not only would it be God's will to have Christ suffer, but the Lord himself would break or crush him (the Latin verb *conterere*) to ensure the longevity

(*semen longevum*) of the church.[58] God's direct participation in this theatre of cruelty is thrown into particularly stark relief in the medieval pictorial tradition of 'Christ in the Winepress', a visual expression of Christ's blood being transubstantiated into wine.[59] Its most celebrated example is Hieronymus Wierix's ca. 1619 engraving which illustrates this literal interpretation of Christ's passion in vivid detail (Fig. 10.6). It depicts Christ standing in a large winepress, struggling to keep upright under the weight of the cross on his back. Rather than carrying the cross, however, he is being crushed by it, the holy ghost fluttering down on its one end, and God operating the ratchet to tighten the screw on the other. Christ is effectively pressed by the cross, with blood gushing out of his wounds and flowing into a chalice as wine.[60] In this performance of divine will, God stands out as the real operator of the instruments of martyrdom.

Instruments of martyrdom, as depicted in Gallonio's treatise, Wierix's engraving, and martyrologies in general, are particularly helpful in understanding the status of instruments on the eve of the development of experimental

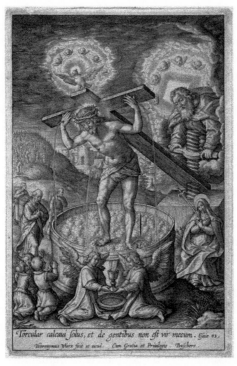

Fig. 10.6 'Christ in the Wine Press' by Hieronymus Wierix, before 1619. (Source: New York, The Metropolitan Museum of Art, 53.601.19(132), https://www.metmuseum.org/art/collection/search/383698.)

science. Here, far from neutral objects of human ingenuity, instruments derive their power from their operators. In divine hands, they mediate between the heavenly and the profane. Indeed, in Christian visual culture, there are numerous examples of divinity wielding instruments to interact with the created world; for instance, a fourteenth-century illuminated manuscript of Bartholomeus Anglicus's encyclopedic *De proprietatibus rerum* depicts angels as heavenly machinists turning the axis of the earth.[61] Instruments also appear in representations of the act of creation itself. Illustrations of Genesis in *Bibles moralisées*, illuminated medieval Bibles dating back to the thirteenth century, show 'God the architect' drawing an encircled universe with a pair of compasses. The act of creation is symbolised by the drawing of the circle, giving order to unformed matter: 'Ici crie Dex ciel et terre, soleil et lune et toz elemenz'.[62] Thus, if they are operated by the divine, instruments can give form to matter, and create and help run the universe. In mortal hands, on the other hand, they may be of great utility, but they are ultimately powerless to effect real change – just as without God's participation, instruments of martyrdom are simply instruments of human cruelty.

This close relation between the agency of instruments and their operators is helpful in interpreting the portrayal of the mathematical instruments in *Blame Not Our Author*. In his quest to change his 'forme' (40), Quadro first appeals to the heavens – to the gods, stars, and planets. He is aware that such a spontaneous conversion from square to circle would have indeed required higher intervention. The opening lines of the play declared its main subject to be 'the formes summed in forth Species / Of Quality' (3–4), referring to Aristotle who classified form or shape as one of the species of quality (*Categories*, 10a11). And according to Aristotle, mathematical forms were fully tied to their definitions: 'the square is no more of a circle than is – let us say – the rectangle. To neither of these the definition we give of a circle applies.' (*Categories*, 11a10–13).[63] Quadro, named after its very four sides, would not have fitted the definition of a circle either, and if the definition could not be altered to accommodate him, an intervention was needed to 'change that what's essentiall' (41).

Quadro's pleas are met with divine silence, however. Not willing to take no for an answer, he takes the matter into his own hands, turning from the heavens to artifice. Interestingly, his servant Rectangulum, who is on his own quest to be a perfect figure, simply seeks a legal patent to that effect signed by Regulus, the rule, avoiding the messiness of any physical shapeshifting. Quadro, on the other hand, is determined to be made circular. Seeking a powerful instrument suited for the task, he solicits the help of Compass, the 'sacred paterne of earths machina' (99),'the architecte of humain wonder / True finder of the hidden misteries / Of natures secret closet that vnrippes / The closest knotts of darke aenigmata's' (137–40), hinting at the instrument's role in the creation of the universe, its witnessing of nature's secrets at their veiling. But

he soon finds that while divine power may be mediated in the world by way of instruments, the instruments themselves hold no power independent of their users. When he is tricked by Compass into the 'Squarenighers daughter' device, his angles are left a bit bruised but thoroughly intact. Without a divine operator at the helm, Quadro is left untransformed, having suffered most profane tortures from a 'base and grosse' Compass (311), the ignoble instrument of lowly 'mechanickes' (460).

The ultimate failure of Quadro and Rectangulum in perfecting their forms via compass and rule is partly due to their insolence: they are lowly shapes unabashedly seeking higher status through pretension and trickery. And it is partly due to the limitations of the instruments themselves. Even with nobler intentions, Compass would have been powerless to help Quadro. Compass and rule, the two main instruments featured in the play, have been integral to mathematics since antiquity. For instance, as mentioned above, in the *Elements* they help construct and transform the mathematical forms formulated in the postulates and propositions: a straight line is drawn with a rule from any point to any point (book 1, postulate 1), and an equilateral triangle is drawn with a compass and rule (book 1, proposition 1). But the instruments are woefully limited in solving several classical problems, one of which was the quadrature or squaring of the circle, that is, defining a square with the equal area of a circle. In the eighteenth century, this was discovered to be an impossibility due to the irrationality of π which cannot be expressed as a fraction. (To give an example, the area of a circle with a radius of 2 would equal 4π; the side of a corresponding square with the same area would be $\sqrt{4\pi}$ or $2\sqrt{\pi}$, which cannot be precisely drawn.) Until then, however, many were afflicted with 'morbus cyclometricus' (the circle-measuring disease) to borrow the 19th-century mathematician Augustus De Morgan's term, their attempts sometimes attracting controversy if not bringing disgrace to their authors.[64]

Mathematically-speaking, a comedy about the futile attempts of a desperate square seeking a circular conversion would ostensibly be about the hazards of quadrature of the circle – indeed, the play closes with a stern warning against squaring from compass and rule. It may also be referencing or even poking fun at the square-circling efforts of the Jesuit mathematician Grégoire de Saint Vincent (1584–1667).[65] The anonymous author of the play would have been familiar with Saint Vincent and they may have even met in person in Rome when the latter was a student at the Collegio Romano until 1612 or when he returned in 1625–27 to work on the manuscript of his quadrature solution.[66] Due to considerable opposition to his claims, it would take a few decades for Saint Vincent to secure an imprimatur to publish his *Problema Austriacum plus ultra quadratura circuli* (Antwerp, 1647), a massive tome of almost 1250 pages in folio, but it is conceivable that the author of the play was familiar with the work in manuscript.[67]

While Saint Vincent's book post-dates the 1613–35 period in which *Blame Not Our Author* is thought to have been written, its title page is of particular interest in terms of the changes in the perceived agency of instruments around this time (Fig. 10.7a).[68] The engraving is visually divided into two areas by the title text which is superimposed on a lion skin hung between the pillars of Hercules. Allegorically, the pillars mark the boundary of the known world as they flank the entrance to the Strait of Gibraltar. At the front, before the pillars, we find ancient knowledge in the form of Archimedes drawing in the sand to illustrate his famous calculation of the area of a circle. Beyond the pillars, 'plus ultra', is new knowledge (Fig. 10.7b).[69] There, beaming from above, we see divine light shining through a square aperture and hitting the ground in perfectly circular form, which in turn is surveyed by three attentive putti. Announcing this heavenly quadrature is a quote from Horace, 'mutat quadrata rotundis' (*Epistles*, I.I.100) or 'changing square to round', which adorns the beam of light.[70]

The optical phenomenon of sunlight beaming through a square aperture to produce a circular projection has been known since antiquity. It appears as one of the problems posed in *Problemata physica*, the pseudo-Aristotelian collection of queries regarding natural phenomena: 'Why, when sunlight passes through quadrilaterals, for instance through wickerwork, does it not produce shapes that are rectangular, but circular ones?'[71] Yet Saint Vincent places its illustration in the 'plus ultra', new knowledge, section of the title page. This has been interpreted as an announcement of his claim to have found a traditional rule-and-compass solution to the quadrature of the circle, and the presence of the compass, not to mention the 'quadratura circuli' in the title, may support this interpretation. It has been suggested, however, that despite its title the squaring of the circle only occupies a small part in Saint Vincent's book, most of which concentrates on creating a method of exhaustion using the concept of limit and infinite series, venturing well beyond classical geometry. Indeed, Saint Vincent's work would later become influential on Gottfried Wilhelm Leibniz (1646–1716) as the latter formulated his version of the calculus.[72] What is novel in the world beyond the pillars here is not, perhaps, the demonstration of a geometric solution, but how new knowledge is obtained through the use of instruments. Indeed, the only compass we see in the illustration is in fact a divider in the hand of a putti, and he is not using it to draw but to analyse the circular projection on the ground.

Ostensibly, Saint Vincent's illustration is an allegorisation of a classical problem. Yet it is possible to also interpret it as that of a camera obscura. Rather than the projection of a beam of light defying quadrangular boundaries, the circular image cast on the ground is in fact a representation of the solar disk which the putti are dutifully measuring with a compass. In this theatre of quadrature, the compass promises knowledge, insight into the workings of the divine.

Fig. 10.7 (a) Title page for Saint-Vincent, *Problema Austriacum plvs vltra qvadratvra circvli* (Antwerp, 1647); engraving printed by Cornelis Galle the Younger based on a drawing by Abraham van Diepenbeeck. (b) Detail showing the circling the square by divine light. (Source: Amsterdam, The Rijksmuseum, RP-P-OB-7067, http://hdl.handle.net/10934/RM0001.COLLECT.114161.)

Of the optical phenomenon illustrated in Saint Vincent's title page (Fig. 10.7b), and described in the *Problemata*, a satisfactory explanation was given by Johannes Kepler (1571–1630) in his 1604 work on optics. Kepler noted that a small aperture of any shape caused an image of the observed object to be projected onto the ground or any surface. He confirmed this observation by replacing the light source with a book, which resulted in a quadrangular projection.[73] Kepler was basically describing the workings of the camera obscura, which he had instrumentalised for his astronomical observations. When studying eclipses, for instance, instead of naked-eye observations of the celestial objects, he examined their images projected in the camera obscura to take his measurements, which he then analysed mathematically.[74] For Kepler, in the 'theatre of the world', natural phenomena like eclipses were 'signs by which human minds, likenesses of God (Dei simulachra), are not only invited to study the divine works ... but are also assisted in inquiring more deeply'.[75] Instruments, such as the camera obscura which made up for the defects of the human eye (to which celestial objects appeared too small or too bright), facilitated these deeper inquiries into God's works.

Putting instruments at the forefront of discovery ascribed unprecedented power to artificial devices operated by mortals without any heavenly interference. Instruments could correct the human deficiencies affected by the Fall and provide new insights into the work of the divine; upending ancient philosophy, sometimes even Scripture, in the process. Unsurprisingly, the instrumental approach was initially met with considerable scepticism. The telescopic observations by Galileo Galilei (1564–1642), for instance, were the subject of numerous heated discussions at the Collegio Romano. But the significance of his findings was nonetheless recognised, and a large celebration was set up at the Collegio in Galileo's honour in 1611, with a young Saint Vincent as one of its more enthusiastic attendees. The tutors and students at the English College, if not witnesses to all the excitement, would have been at least familiar with the debates regarding the place of instruments in generating new knowledge.[76]

The first decades of the seventeenth century, which coincide with the period in which *Blame Not Our Author* is thought to have been written, saw the publication of several important works by, among others, Francis Bacon (1561–1626), Galileo and Kepler, that set off a series of intense debates on novel methods for obtaining natural knowledge. This was a period when nature was increasingly becoming mathematised – Galileo famously wrote 'this grand book, the universe ... is written in the language of mathematics, and its characters are triangles, circles, and other geometric figures without which it is humanly impossible to understand a single word of it'.[77] And instruments, whether they were traditional tools (such as the compass and rule) or newly adopted devices (such as telescopes), were needed to inspect, interrogate, and interpret the mathematical workings of nature. Bacon, advocating the use of instruments and experiments,

even suggested inducing nature to give up her secrets by using 'vexations of art', which has been interpreted as a metaphor for torture.[78]

In *Blame Not Our Author*, as we have seen, Quadro is promised a theatre of quadrature but finds himself in a theatre of cruelty instead. To understand what is at stake in this remarkable play, as I hope I have begun to show, we must grasp the complex of relationships between the divine and the human in early modernity, and see also how that complex is most intensive and influential in the yoking together, on one side, of the instrument-enabled torture of the physical world that gave birth to new scientific knowledge and, on the other, the power of instruments of pain to press the souls of people into conversion to what was construed by the opposing Churches as the one true faith.

NOTES

I am most grateful to Paul Yachnin and Bronwen Wilson for their insightful comments and suggestions on this paper, and to Simon Ditchfield and Ruth Noyes for theirs on its earlier versions. I also benefited greatly from constructive input on various parts of this research from workshop participants in Michigan, Montreal, Oxford, and York. My research has been supported by the Early Modern Conversions project based at McGill University.

1. Scholarship on the early years of the English College include Dillon, 'Martyrs and Murals', pp. 170–242; Foley, *Records of the English Province*; Gasquet, *A History of the Venerable English College*; Headon (ed.), *The Church of the English College*; Whitehead, '"Established and Putt in Good Order"', pp. 315–36; and Williams, *The Venerable English College*. On Circignani's frescoes, see Richardson, 'The English College Church', pp. 34–51.
2. Cavalieri, *Ecclesiae Anglicanae*. This book is dedicated to Pope Gregory XIII, founder of the College.
3. Ibid. p. 33r.
4. Anon., 'Blame Not Our Author', pp. 94–132. Secondary scholarship on this play includes Gossett, 'Drama in the English College', pp. 60–93, Introduction to 'Blame Not Our Author', pp. 83–93, and 'English Plays', pp. 23–33; Mazzio, 'The Three-Dimensional Self', pp. 39–65; and Nasifoglu, 'Embodied Geometry', pp. 311–16.
5. Gossett, Introduction to 'Blame Not Our Author', pp. 87 and 90.
6. Anon., 'Blame Not Our Author', p. 96, line 30; hereafter only line numbers will be indicated. Note that when quoting from the text, the editor's bracketed insertions have been retained. While it may be assumed that geometric shapes and instruments are genderless, the play uses the pronoun 'he' for each of its characters, a practice that is continued here.
7. Perhaps like those popularised by Henry VIII in the latter part of his reign; Hayward, *Rich Apparel*, p. 122.
8. Book 1, definition X in Clavius, *Evclidis elementorvm libri xv*, 1, fol. 5v.
9. For an overview of this period, see Marshall, *Reformation England*, and *Heretics and Believers*.
10. 'Allen, William (1532–1594)', *ODNB*; Gasquet, *A History*, pp. 59–61. On the circumstances in which the Jesuits were put in charge of the College, see Nice, 'Being "British" in Rome', pp. 1–24; and Whitehead, '"Established and Putt in Good Order"', pp. 315–36. For a reproduction of the 1579 statutes, see Meyer, *England and the Catholic Church*, pp. 481–5.

11. Marshall, *Reformation England*, p. 193.
12. Reportedly, the highest number of recorded cases of torture were during Elizabeth's reign; Langbein, *Torture and the Law*, p. 82. On the use of torture from a legal perspective, see also Hanson, 'Torture and Truth', pp. 53–84, and *Discovering the Subject*; Jardine, *A Reading*; and Parry, *The History of Torture*.
13. Ibid., p. 106.
14. Listing it under 'Scavenger's daughter, *n.*', *OED* notes numerous spellings for this device, namely 'Skevington's' or 'Skeffington's daughter', 'Skevington's gyves', and 'Skevington's irons'. On this device, see Jardine, *A Reading*, pp. 14–15, 84–85. There is scant information on Leonard Skevington but he is noted to be the son of William Skeffington, lord deputy of Ireland; see 'Skeffington, Sir William [called the Gunner] (d. 1535)', *ODNB*. Note that Jardine erroneously attributes the device to William, his father.
15. 'Cottam, Thomas (1549–1582)', *ODNB*. The Scavenger's daughter is described in the section on Cottam in Tanner, *Societas Jesu*, pp. 18–19.
16. Verstegan, *Theatrum crudelitatum*, pp. 74–75; Scavenger's daughter is illustrated as 'B' on p. 75. In the first edition, the instrument is described as 'Presbyter quidam cippis ligneis, pedibus in altum erectis, constrictus, tamdiu detinetur, quousque excrementorum suorum foetore suffocatur'. In the second edition, the explanatory note is changed to 'Instrumentum ferreum, quod instar globi hominem comprimit & rotundat, cui Catholicos includunt, & in eo horas aliquor detinent'; Verstegan, *Theatrum crudelitatum*, p. 74. On Verstegan, see 'Verstegan [formerly Rowlands], Richard (1548 × 50–1640), writer and intelligence informant', *ODNB*.
17. Foxe, *Actes and Monuments*, pp. 1650–51.
18. The letter was published in Coverdale, *Certain Most Godly*, pp. 686–87.
19. Ibid., p. 686.
20. Foley, *Records of the English Province*, vol. 2, p. 159.
21. Tomkis, *Lingua. A Pleasant Comoedie* (London, 1607). While Tomkis's play was printed multiple times before the Restoration, the *Heteroclitanomalonomia* only survived in manuscript which was published in two editions in the 1980s: Russell, *Stuart Academic Drama*, pp. 43–108; and Gossett and Berger (eds), *Collections*, vol. 14, pp. 57–97. See also Gossett, Introduction to 'Blame Not Our Author', p. 91; Ellerbeck, 'The Female Tongue', pp. 27–45; and Mazzio, 'Sins of the Tongue', pp. 93–124.
22. There would be performances of torture in Restoration drama later in the seventeenth century; see Thompson, *Performing Race and Torture*, pp. 31–41.
23. Noting a case where a warrant was issued for the use of the rack when a Scavenger's daughter failed to extract information out of a prisoner, a nineteenth-century writer on the subject has concluded that it may have been 'too mild a torture'; Jardine, *A Reading*, p. 30. The rack was the most frequently used instrument of torture in England during this period; Parry, *The History of Torture*, p. 76.
24. For an alternative interpretation of the device as a printing press instead, see Mazzio, 'Three-Dimensional Self', p. 56.
25. Gallonio, *Trattato de gli instrumenti*, plate 31.
26. On this form of punishment, see McKenzie, '"This Death Some Strong"', pp. 279–313.
27. A contemporary account of Clitherow's life and martyrdom was written by her chaplain John Mush as 'A True Report', pp. 360–440. Mush does not specify whether Henry was sent to Douai or Rheims; ibid., pp. 409–10. For details on the manner of Clitherow's execution, see Dillon, '"A Trewe Reporte"', pp. 277–322; and Lake and Questier, *The Trials*, pp. 106–8. See also 'Clitherow [née Middleton], Margaret [St Margaret Clitherow] (1552/53–1586)', *ODNB*.

28. Verstegan, *Theatrum crudelitatum* (Antwerp, 1587 and 1592), pp. 76–77.
29. For a general overview of early modern martyrologies, see Gregory, *Salvation at Stake*.
30. Protestant martyrologies are discussed in Gregory, 'Witnesses for the Gospel', pp. 139–96. Anabaptist martyrologies are outside of the scope of this chapter but for a discussion, see Gregory, *Salvation at Stake*.
31. Foxe, *Actes and Monuments*. For a critical online edition, see *The Unabridged Acts*, www.johnfoxe.org. Secondary literature on Foxe's work is vast. Some starting points include Editorial commentary and additional information in ibid.; Evenden and Freeman, *Religion and the Book*; Highley and King (eds), *John Foxe and His World*; King, *Foxe's 'Book of Martyrs'*; and Loades (ed.), *John Foxe and the English Reformation*.
32. Secondary sources on the illustrations include Aston and Ingram, 'The Iconography', pp. 90–98; Evenden and Freeman, '"Fayre Pictures"', pp. 186–231; King, 'Viewing the Pictures', pp. 162–242; and Muckart, *Absence and Artlessness*.
33. Pettegree, 'Illustrating the Book', pp. 133–44.
34. For a comparison between the illustrations used by Foxe and Rabus, see Aston and Ingram, 'The Iconography', pp. 86, 87n37.
35. It has been suggested that in general English Protestants were less antipathic towards pictorial art; see King, 'Viewing the Pictures', pp. 162–66. See also Aston, *Broken Idols*, and 'Iconoclasm in England', pp. 261–90.
36. Aston notes the proportion of illustrations dedicated to the Protestant martyrs as 30 out of 57 in the first edition, 77 out of 153 in the 1570 and 1576 editions, and 72 out of 153 in the 1583 edition; see 'The Illustrations: Books 10–12'.
37. Parsons, *The Third Part*, p. 400; Aston and Ingram, 'The Iconography', p. 70. On Parsons, see also Carrafiello, *Robert Parsons*; and 'Persons [Parsons], Robert (1546–1610), Jesuit', *ODNB*.
38. *The Canons and Decrees*, pp. 233–36; I quote from pp. 234 and 235.
39. Cavalieri, *Ecclesiae militantis* and *Ecclesiae Anglicanae*; Gallonio, *Trattato de gli instrumenti*; and Verstegan, *Theatrum crudelitatum* (Antwerp, 1587; 2nd edition in 1592). Secondary literature on these titles includes Dillon, '*Theatrum crudelitatum*', pp. 243–76; Mansour, 'Not Torments'; Noreen, '*Ecclesiae militantis triumphi*', pp. 167–83; Noyes, '"One of those Lutherans"', pp. 116–65; Touber, *Law, Medicine, and Engineering*, and 'Martyrological Torture', pp. 14–28; and Zacchi, 'Words and Images', pp. 53–75.
40. On Gilbert, see 'Gilbert, George (d. 1583)', *ODNB*; Dillon, 'Martyrs and Murals', pp. 175–76; and Foley, *Records of the English Province*, vol. 3, pp. 658–704. Both quotes are from Agazzari's 1583 letter announcing Gilbert's death, reproduced in ibid. pp. 687–701, at pp. 697 and 698.
41. Allen, *An Apologie*, fols 109v–110v.
42. Letter from Barret to Agazzari, 8 Nov. 1584, reproduced and translated in Renold (ed.), *Letters*, p. 114. Barret would later succeed Allen as president of Douai College; see 'Barret, Richard (ca. 1544–1599), Roman Catholic ecclesiastic', *ODNB*.
43. Horace, 'Ars poetica', pp. 442–89, at pp. 464 and 465.
44. Williams, *The Venerable English College*, p. 39. In contrast, Allen later defended the superior learning of the English missionaries in his preface to *A Briefe Historie*, and suggested it to be one of the reasons for their executions; see sig. aiij. On the role of scholarship in the English Mission, see Feingold, 'The Reluctant Martyr', pp. 627–50.
45. For a list of the College martyrs, see Williams, *The Venerable English College*, pp. 290–1.

46. Euclid, *The Elements*. I have discussed this edition in 'The Third Dimension', pp. 106–9. Sources on Day include Engel, *The Printer as Author*; Evenden, *Patents, Pictures and Patronage*; Oastler, *John Day*; and 'Day [Daye], John (1521/52–1584)', *ODNB*.

47. On the complex relationship between text and diagram in ancient mathematics, see Netz, *Shaping of Deduction*, pp. 12–67.

48. Clark (ed.), '*Brief Lives*', vol. 1, p. 332.

49. For the first instalment of this work, see Hobbes, *Elementorum philosophiae*. On Hobbes's opposition to analytical geometry, see Jesseph, *Squaring the Circle*. For a lengthier discussion of the changing nature of drawing in geometry during the early modern period, see Nasifoglu, 'Reading by Drawing', pp. 62–101.

50. Barrow (ed.), *Apollonii Conica*, book I, propositions 3–5, 11–13.

51. Gallonio, *Trattato de gli instrumenti* and *De sanctorum martyrum*. I quote from the English translation, *Tortures and Torments*, pp. 1–2. Sources on Gallonio and his treatise include Mansour, 'Not Torments', pp. 167–83; and Touber, 'Articulating Pain', pp. 59–89.

52. Sources on Renaissance theatres of machines include Lefèvre (ed.), *Picturing Machines*; and Rovida, *Machines and Signs*.

53. Besson, *Theatrvm instrvmentorvm*; Errard, *Le premier livre*; and Ramelli, *Le diverse*. The first edition of Besson's book appeared without a date or place of publication but is thought to date to 1571 or early 1572. Its second edition, printed in Lyon in 1578, is more widely available. On Besson, see Dolza, '"Industrious Observations"', pp. 3–19; and Keller, 'The Missing Years', pp. 28–39.

54. Dolza, '"Industrious Observations"', pp. 3–19, at p. 18.

55. Schoenfeldt, 'Aesthetics and Anesthetics', pp. 19–38, at p. 20. See also Touber, 'Martyrological Torture', pp. 14–28.

56. Knott, 'John Foxe', pp. 721–34, at p. 721; Mush, 'A True Report', pp. 360–440, at p. 418.

57. Allen, *An Apologie*, fol. 110v. Allen was not always successful in his message, however, as one of his protégés would infamously choose life over martyrdom; see Feingold, 'The Reluctant Martyr', pp. 627–50.

58. The passage in the Latin vulgate reads 'et Dominus voluit conterere eum in infirmitate si posuerit pro peccato animam suam videbit semen longevum et voluntas Domini in manu eius dirigetur', translated in the Douay-Rheims Bible as 'And our Lord would break him in infirmitie: if he shal put away his soule for sinne, he shal see seede of long age, and the wil of our Lord shal be directed in his hand'; tome 2, p. 527.

59. On the 'Christ in the Winepress' tradition, see Gertsman, 'Multiple Impressions', pp. 310–37.

60. I am grateful to Paul Yachnin for bringing Wierix's engraving to my attention. (An alternative version featuring other instruments of torture but without God's participation is The British Museum, 1859,0709.3038.) The inscription, 'Torcular calcaui solus, et de gentibus non est vir mecum' refers to the Book of Isaiah 63:3 which reads in the Latin vulgate as 'Torcular calcavi solus, et de Gentibus non est vir mecum; calcavi eos in furore meo et conculcavi eos in ira mea, et aspersus est sanguis eorum super vestimenta me, et omnia indumenta mea inquinavi', translated in the Douay-Rheims Bible as 'I haue troden the presse alone, and of the Gentiles there is not a man with me: I haue troden them in my furie, and haue troden them downe in my wrath: and their bloud is sprinkled vpon my garments, and I haue stayned al my rayment'; tome 2, p. 540.

61. Paris, Bibliothèque Sainte-Geneviève, MS 1029, fols 107v–108r.

62. Two of the earliest *Bibles moralisées* are Vienna, Österreichische Nationalbibliothek,

MSS 1179 and 2554; the quote is from MS 2554, fol. 1v. Scholarship on *Bibles moralisées* include Friedman, 'The Architect's Compass', pp. 419–29; Lowden, *The Making*; and Ruipérez, 'The Moral Compass', pp. 1–33. An index of extant manuscripts is provided in ibid., p. 33.

63. Aristotle, 'The Categories', pp. 13–109.

64. Despeaux and Rice, 'Augustus De Morgan's Anonymous Reviews', pp. 148–71, at p. 163.

65. For a brief biography of Saint Vincent (Latinised name Gregorius a Sancto Vincentio), see Hofmann, 'Saint Vincent', pp. 74–76. For more thorough treatments of his mathematical work, see Looy, 'A Chronology', pp. 57–75; and Meskens and Looy, *Between Tradition and Innovation*.

66. The pupils of the English College attended two hours of lectures at the Collegio Romano in the morning before returning to their college for tutorials with *repetitores* between lunch and supper; Whitehead, '"Established and Putt in Good Order"', pp. 315–36, at pp. 326–27. For a contemporary description of the College's programme of study, see Meyer, *England and the Catholic Church*, pp. 492–519.

67. Saint Vincent, *Opvs geometricvm*; the alternative title, *Problema Austriacum plus ultra quadratura circuli*, is provided on the title page. On Saint Vincent's manuscripts written or circulated in Rome, see Looy, 'A Chronology', pp. 57–75.

68. Secondary scholarship on this title page includes Ashworth, 'The Habsburg Circle', pp. 137–67; Remmert, 'Antiquity, Nobility, and Utility', pp. 537–63, and 'Die Quadratur des Kreises', pp. 131–34.

69. 'Plus ultra' was also the motto of the dedicatees of Saint Vincent's book, the House of Habsburg; Remmert, 'Antiquity, Nobility, and Utility', pp. 552–54.

70. Horace, 'Ars Poetica', pp. 442–89, at p. 465. In his preface addressing the House of Habsburg, Saint Vincent explains the title page in more political terms; see Saint Vincent, *Opvs geometricvm*, sig. a3r–4v.

71. Book xv, ch. 6 in Aristotle, *Problems*, 1, pp. 462–65. On the complex question of the authorship and dating of this work, see the editor's general introduction in ibid. pp. xiii–xxvi. On the awareness of the optical phenomenon since antiquity, see Lindberg, 'The Theory', pp. 154–76.

72. Meskens, 'Gregory of Saint Vincent', pp. 315–19; Meskens and Looy, *Between Tradition and Innovation*, pp. 89, 246–7.

73. Kepler, *Ad vitellionem paralipomena*, pp. 38–40. See also Gal and Chen-Morris, 'Baroque Optics', pp. 191–217, at pp. 192–4.

74. Chen-Morris, *Measuring Shadows*, esp. pp. 31–7. See also Dupré, 'Inside the Camera Obscura', pp. 219–44.

75. Kepler, *Ad vitellionem paralipomena*, p. 3. The English translation is quoted from Chen-Morris, *Measuring Shadows*, p. 33.

76. Lattis, *Between Copernicus and Galileo*, pp. 187–95; Wallace, *Galileo and His Sources*, pp. 283–84. We know of at least one College resident, London-born recusant essayist and poet George Fortescue (ca. 1588–1659; at the College in 1609–14), who may have met Galileo during this period. Fortescue corresponded with Galileo upon his return to England in 1617; see 'Fortescue, George (ca. 1588–1659)', *ODNB*.

77. Galileo, *Il saggiatore*, p. 25, and 'The Assayer', pp. 231–80, at pp. 237–38. For a general view of the increasing use of mathematics in the study of nature, see Dear, *Discipline and Experience*.

78. Merchant, 'Francis Bacon', pp. 551–99; Pesic, 'Wrestling with Proteus', pp. 81–94.

WORKS CITED

Allen, William, *An Apologie and True Declaration of the Institution and Endeuours of the Tvvo English Colleges* ([Rheims]: [Jean de Foigny?], 1581).

_____, *A Briefe Historie of the Glorious Martyrdom of XII. Reuerend Priests, Executed VVithin These Tvveluemonethes for Confession and Defence of the Catholike Faith but Vnder the False Pretence of Treason* ([Rheims]: [Jean de Foigny?], 1582).

Anon., 'Blame Not Our Author', in Suzanne Gossett (ed.), *Collections*, vol. 12 (Oxford: The Malone Society, 1983), pp. 94–132.

Aristotle 'The Categories', in Harold P. Cooke and Hugh Tredennick (eds), *The Categories, on Interpretation, Prior Analytics*, Loeb Classical Library 325 (London: Harvard University Press, 2002), pp. 13–109.

Aristotle, *Problems*, Robert Mayhew trans. and ed., 2 vols., Loeb Classical Library 316 and 317 (London: Harvard University Press, 2011).

Ashworth, W. B., 'The Habsburg Circle', in Bruce T. Moran (ed.), *Patronage and Institutions. Science, Technology, and Medicine at the European Court 1500–1700* (Woodbridge: Boydell Press, 1991), pp. 137–67.

Aston, Margaret, *Broken Idols of the English Reformation* (Cambridge: Cambridge University Press, 2016).

_____, 'Iconoclasm in England: Official and Clandestine', in *Faith and Fire: Popular and Unpopular Religion 1350–1600* (London: Hambledon Press, 1993), pp. 261–90.

_____, 'The Illustrations: Books 10–12', in *The Unabridged Acts and Monuments Online* (1576 edition), editorial commentary and additional information (Sheffield: HRI Online Publications, 2011), https://www.johnfoxe.org/ (last accessed 6 December 2022).

Aston, Margaret, and Elizabeth Ingram, 'The Iconography of the *Acts and Monuments*', in David Loades (ed.), *John Foxe and the English Reformation* (Aldershot: Ashgate, 1997), pp. 90–98.

Barrow, Isaac, (ed.), *Apollonii conica: methodo nova illustrata, & succinctè demonstrata* (London: William Godbid, 1675).

Besson, Jacques, *Theatrvm instrvmentorvm et machinarum* (Lyon: Barthelemy Vincent, 1578).

The Canons and Decrees of the Sacred and Oecumenical Council of Trent, trans. J. Waterworth (London: C. Dolman, 1848).

Carrafiello, Michael L., *Robert Parsons and English Catholicism, 1580–1610* (London: Associated University Presses, 1998).

Cavalieri, Giovanni Battista, *Ecclesiae Anglicanae trophaea* (Rome: Bartolomeo Grassi, 1584).

Cavalieri, Giovanni Battista, *Ecclesiae militantis triumphi* (Rome: Bartolomeo Grassi, 1583).

Chen-Morris, Raz, *Measuring Shadows: Kepler's Optics of Invisibility* (University Park: Pennsylvania State University Press).

Clark, Andrew, (ed.), *'Brief Lives', Chiefly of Contemporaries, Set Down by John Aubrey, between the Years 1669 & 1696*, 2 vols (Oxford: Clarendon Press, 1898).

Clavius, Christoph, *Evclidis elementorvm libri xv*, 2 vols (Rome: Vincentius Accoltus, 1574).

Coverdale, Myles, *Certain Most Godly, Fruitful, and Comfortable Letters of Such True Saintes and Holy Martyrs of God* (London: John Day, 1564).

Dear, Peter, *Discipline and Experience: The Mathematical Way in the Scientific Revolution* (London: University of Chicago Press, 1995).

Despeaux, Sloan Evans and Adrian C. Rice, 'Augustus De Morgan's Anonymous

Reviews for *The Athenæum*: A Mirror of a Victorian Mathematician', *Historia Mathematica* 43:2 (2016), pp. 148–71.

Dillon, Anne, 'Martyrs and Murals', in *The Construction of Martyrdom in the English Catholic Community, 1535–1603* (Burlington, VT: Ashgate, 2002), pp. 170–242.

———, '*Theatrum crudelitatum*: The Theatre of Cruelties', in *The Construction of Martyrdom in the English Catholic Community, 1535–1603* (Burlington, VT: Ashgate, 2002), pp. 243–76.

———, '"A Trewe Reporte of the Li[Fe] and Marterdome of Mrs. Margarete Clitherowe"', in *The Construction of Martyrdom in the English Catholic Community, 1535–1603* (Burlington, VT: Ashgate, 2002), pp. 277–322.

Dolza, Luisa, '"Industrious Observations, Grounded Conclusions, and Profitable Inventions and Discoveries; the Best State of That Province": Technology and Culture During Francis Bacon's Stay in France', in Claus Zittel, Gisela Engel, Romano Nanni and Nicole C. Karafyllis (eds), *Philosophies of Technology: Francis Bacon and His Contemporaries* (Leiden: Brill, 2008), pp. 3–19.

Dupré, Sven, 'Inside the *Camera Obscura*: Kepler's Experiment and Theory of Optical Imagery', *Early Science and Medicine* 13:3 (2008), pp. 219–44.

Ellerbeck, Erin, 'The Female Tongue as Translator in Thomas Tomkis's *Lingua, or The Combat of the Tongue and the Five Senses for Superiority*', *Renaissance and Reformation / Renaissance et Réforme* 32:1 (2009), pp. 27–45.

Engel, William E., *The Printer as Author in Early Modern English Book History. John Day and the Fabrication of a Protestant Memory Art* (Abingdon: Routledge, 2022).

The English College of Doway, *The Holie Bible Faithfvlly Translated into English, ovt of the Avthentical Latin*, 2 tomes (Douai: Laurence Kellam, 1609–10). [Cited as *Douay–Rheims Bible*.]

Errard, Jean, *Le premier livre des instruments mathematiques mechaniques* (Nancy: Jan-Janson, 1584).

Euclid, *The Elements of Geometrie of the Most Auncient Philosopher Euclide of Megara ... with a Very Fruitfull Preface by M. I. Dee*, trans. Henry Billingsley (London: John Day, 1570).

Evenden, Elizabeth, *Patents, Pictures and Patronage: John Day and the Tudor Book Trade* (Aldershot: Ashgate, 2008).

Evenden, Elizabeth and Thomas S. Freeman, '"Fayre Pictures and Painted Pageants:" The Illustrations of the "Book of Martyrs"', in *Religion and the Book in Early Modern England: The Making of Foxe's 'Book of Martyrs'* (Cambridge: Cambridge University Press, 2011), pp. 186–231.

Evenden, Elizabeth and Thomas S. Freeman, *Religion and the Book in Early Modern England: The Making of Foxe's 'Book of Martyrs'* (Cambridge: Cambridge University Press, 2011).

Feingold, Mordechai, 'The Reluctant Martyr: John Hart's English Mission', *Journal of Jesuit Studies* 6 (2019), pp. 627–50.

Foley, Henry, *Records of the English Province of the Society of Jesus*, 7 vols (London: Burns and Oates, 1875–83).

Foxe, John, *Actes and Monuments of These Latter and Perillous Days, Touching Matters of the Church* (London: John Day, 1563).

Friedman, John Block, 'The Architect's Compass in Creation Miniatures of the Later Middle Ages', *Traditio* 30 (1974), pp. 419–29.

Gal, Ofer and Raz Chen-Morris, 'Baroque Optics and the Disappearance of the Observer: From Kepler's *Optics* to Descartes' Doubt', *Journal of the History of Ideas* 71:2 (2010), pp. 191–217.

Galilei, Galileo, 'The Assayer', in Stillman Drake ed. and trans., *Discoveries and Opinions of Galileo* (New York: Doubleday & Co., 1957), pp. 231–80.

_____, *Il saggiatore nel quale con bilancia esquisita e giusta si ponderano le cose contenute nella Libra astronomica e filosofica di Lotario Sarsi Sigensano* (Rome: Giacomo Mascardi, 1623).

Gallonio, Antonio, *De sanctorum martyrum cruciatibus liber quo potissimum instrumenta, & modi, quibus iidem Christi martyres olim torquebantur, accuratissime tabellis expressa describuntur* (Rome: Tipografia della Congregazione dell'Oratorio, 1594).

_____, *Tortures and Torments of the Christian Martyrs*, trans. A. R. Allinson (Paris: The Fortune Press, 1903).

_____, *Trattato de gli instrumenti di martirio, e delle varie maniere di martoriare vsate da' gentili contro christiani, descritte et intagliate in rame* (Rome: Ascanio, e Girolamo Donangeli, 1591).

Gasquet, Cardinal, *A History of the Venerable English College, Rome* (New York: Longmans, Green and Co., 1920).

Gertsman, Elina, 'Multiple Impressions: Christ in the Winepress and the Semiotics of the Printed Image', *Art History* 36:2 (2013), pp. 310–37.

Gossett, Suzanne, 'Drama in the English College, Rome, 1591–1660', *English Literary Renaissance* 3:1 (1973), pp. 60–93.

_____, 'English Plays in the English College', *The Venerabile* XXVII (1983), pp. 23–33.

_____, Introduction to 'Blame Not Our Author', in Suzanne Gossett (ed.), *Collections*, vol. 12 (Oxford: The Malone Society, 1983), pp. 83–93.

Gossett, Suzanne, and Thomas L. Berger (eds), *Collections*, vol. 14 (Oxford: The Malone Society, 1988).

Gregory, Brad S., *Salvation at Stake: Christian Martyrdom in Early Modern Europe* (London: Harvard University Press, 1999).

_____, 'Witnesses for the Gospel: Protestants and Martyrdom', in *Salvation at Stake: Christian Martyrdom in Early Modern Europe* (London: Harvard University Press, 1999), pp. 139–96.

Hanson, Elizabeth, *Discovering the Subject in Renaissance England* (Cambridge: Cambridge University Press, 1998).

_____, 'Torture and Truth in Renaissance England', *Representations* 34 (1991), pp. 53–84.

Hayward, Maria, *Rich Apparel: Clothing and the Law in Henry VIII's England* (Surrey: Ashgate, 2009).

Headon, Andrew, (ed.), *The Church of the English College in Rome: Its History, Its Restoration* (Rome: Gangemi Editore, 2009).

Highley, Christopher, and John N. King (eds), *John Foxe and His World* (London: Routledge, 2002).

Hobbes, Thomas, *Elementorum philosophiae sectio prima de corpore* (London: Andrew Crooke, 1655).

Hofmann, J. E., 'Saint Vincent, Gregorius', in *Complete Dictionary of Scientific Biography*, 27 vols (Detroit: Charles Scribner's Sons, 2008), vol. 12, pp. 74–6.

Horace, 'Ars Poetica', in *Satires, Epistles, Ars Poetica*, trans. H. Rushton Fairclough, Loeb Classical Library 194 (London: Harvard University Press, 1929), pp. 442–89.

Jardine, David, *A Reading on the Use of Torture in the Criminal Law of England* (London: Baldwin and Cradock, 1837).

Jesseph, Douglas Michael, *Squaring the Circle: The War between Hobbes and Wallis* (London: University of Chicago Press, 1999).

Keller, Alex, 'The Missing Years of Jacques Besson, Inventor of Machines, Teacher of

Mathematics, Distiller of Oils, and Huguenot Pastor', *Technology and Culture* 14:1 (1973), pp. 28–39.

Kepler, Johannes, *Ad vitellionem paralipomena, quibus astronomiae pars optica traditvr* (Frankfurt: Claude Marne and the heirs of Jean Aubry, 1604).

King, John N., *Foxe's 'Book of Martyrs' and Early Modern Print Culture* (Cambridge: Cambridge University Press, 2006).

_____, 'Viewing the Pictures', in *Foxe's 'Book of Martyrs' and Early Modern Print Culture* (Cambridge: Cambridge University Press, 2006), pp. 162–242.

Knott, John R., 'John Foxe and the Joy of Suffering', *The Sixteenth Century Journal* 27:3 (1996), pp. 721–34.

Lake, Peter, and Michael Questier, *The Trials of Margaret Clitherow: Persecution, Martyrdom and the Politics of Sanctity in Elizabethan England*, 1st ed. (London: Continuum, 2011) and updated 2nd ed. (London: Bloomsbury Academic, 2019).

Langbein, John H., *Torture and the Law of Proof: Europe and England in the Ancien Régime* (London: University of Chicago Press, 2006).

Lattis, James M., *Between Copernicus and Galileo: Christoph Clavius and the Collapse of Ptolemaic Cosmology* (London: University of Chicago Press, 1994).

Lefèvre, Wolfgang, (ed.), *Picturing Machines 1400–1700* (London: The MIT Press, 2004).

Lindberg, David C., 'The Theory of Pinhole Images from Antiquity to the Thirteenth Century', *Archive for History of Exact Sciences* 5:2 (1968), pp.154–76.

Loades, David, (ed.), *John Foxe and the English Reformation* (Aldershot: Ashgate, 1997).

Looy, Herman van, 'A Chronology and Historical Analysis of the Mathematical Manuscripts of Gregorius a Sancto Vincentio (1584–1667)', *Historia Mathematica* 11:1 (1984), pp. 57–75.

Lowden, John, *The Making of the Bibles Moralisées* (University Park: Pennsylvania State University Press, 2000).

Mansour, Opher, 'Not Torments, but Delights: Antonio Gallonio's *Trattato de gli instrumenti di martirio* of 1591 and its Illustrations', in Andrew Hopkins and Maria Wyke (eds), *Roman Bodies: Antiquity to the Eighteenth Century* (London: The British School at Rome, 2005), pp. 167–83.

Marshall, Peter, *Heretics and Believers: A History of the English Reformation* (New Haven: Yale University Press, 2017).

Marshall, Peter, *Reformation England, 1480–1642*, 2nd ed. (London: Bloomsbury Academic, 2012).

Mazzio, Carla, 'Sins of the Tongue in Early Modern England', *Modern Language Studies* 28:3/4 (1998), pp. 93–124.

_____, 'The Three-Dimensional Self: Geometry, Melancholy, Drama', in David Glimp and Michelle R. Warren (eds), *Arts of Calculation: Quantifying Thought in Early Modern Europe* (Basingstoke, UK: Palgrave Macmillan, 2004), pp. 39–65.

McKenzie, Andrea, '"This Death Some Strong and Stout Hearted Man Doth Choose": The Practice of Peine Forte et Dure in Seventeenth- and Eighteenth-Century England', *Law and History Review* 23:2 (2005), pp. 279–313.

Merchant, Caroline, 'Francis Bacon and the 'Vexations of Art': Experimentation as Intervention', *BJHS* 46:4 (2013), pp. 551–99.

Meskens, Ad, 'Gregory of Saint Vincent: A Pioneer of the Calculus', *The Mathematical Gazette* 78:483 (1994), pp. 315–19.

Meskens, Ad, and Herman van Looy, *Between Tradition and Innovation: Gregorio a San Vicente and the Flemish Jesuit Mathematics School* (Leiden: Brill, 2021).

Meyer, Arnold Oskar, *England and the Catholic Church under Queen Elizabeth*, trans. J. R. McKee (London: Kegan Paul, Trench, Trübner & Co., Ltd., 1916).

Muckart, Heather, *Absence and Artlessness in Early Modern Church of England Martyr Portraits*, PhD diss., University of British Columbia, 2018.

Mush, John, 'A True Report of the Life and Martyrdom of Mrs. Margaret Clitherow', in John Morris (ed.), *The Troubles of Our Catholic Forefathers* (1877), pp. 360–440.

Nasifoglu, Yelda, 'Embodied Geometry in Early Modern Theatre', in Justin E. H. Smith (ed.), *Embodiment: A History* (Oxford: Oxford University Press, 2017), pp. 311–16.

———, 'Reading by Drawing. The Changing Nature of Mathematical Diagrams in Seventeenth-Century England' in Philip Beeley, Yelda Nasifoglu, and Benjamin Wardhaugh (eds), *Reading Mathematics in Early-Modern Europe. Studies in the Production, Collection, and Use of Mathematical Books* (London: Routledge, 2021), pp. 62–101.

———, 'The Third Dimension on the Page [on the 1570 English translation of Euclid's *Elements*]' in Daryl Green and Laura Moretti (eds), *Thinking 3D from Leonardo to Present* (Oxford: Oxford University Press, 2019), pp. 106–9.

Netz, Reviel, *Shaping of Deduction* (Cambridge: Cambridge University Press, 1999).

Nice, Jason A., 'Being "British" in Rome: The Welsh at the English College, 1578–1584', *The Catholic Historical Review* 92:1 (2006), pp. 1–24.

Noreen, Kirstin, '*Ecclesiae militantis triumphi*: Jesuit Iconography and the Counter-Reformation', *The Sixteenth Century Journal* 29:3 (1998), pp. 689–715.

Noyes, Ruth S., '"One of Those Lutherans We Used to Burn in Campo De' Fiori:" Engraving Sublimated Suffering in Counter-Reformation Rome', in Heather Graham and Lauren G. Kilroy-Ewbank (eds), *Visualizing Sensuous Suffering and Affective Pain in Early Modern Europe and the Spanish Americas* (Leiden: Brill, 2018), pp. 116–65.

Oastler, C. L., *John Day, the Elizabethan Printer* (Oxford: Oxford Bibliographical Society, 1975).

Parry, Leonard Arthur, *The History of Torture in England* (Montclair, NJ: Patterson Smith Publishing, 1975).

Parsons, Robert, *The Third Part a Treatise Intituled of Three Conversions of England* ([St Omer]: [n.p.], 1604).

Pesic, Peter, 'Wrestling with Proteus: Francis Bacon and the 'Torture' of Nature', *Isis* 90:1 (1999), pp. 81–94.

Pettegree, Andrew, 'Illustrating the Book: A Protestant Dilemma', in Christopher Highley and John N. King (eds), *John Foxe and His World* (London: Routledge, 2017), pp. 133–44.

Ramelli, Agostino, *Le diverse et artificiose machine* (Paris: by the author, 1588).

Remmert, Volker R., 'Antiquity, Nobility, and Utility: Picturing the Early Modern Mathematical Sciences', in Eleanor Robson and Jacqueline Stedall (eds), *The Oxford Handbook of the History of Mathematics* (Oxford: Oxford University Press, 2009), pp. 537–63.

———, 'Die Quadratur des Kreises ins Bild gesetzt: Das Frontispiz des *Opus geometricum* des Grégoire de St. Vincent', *Mathematische Semesterberichte* 54:2 (2007), pp. 131–34.

Renold, P., (ed.), *Letters of William Allen and Richard Barret 1572–1598* (London: Catholic Record Society, 1967).

Richardson, Carol M., 'The English College Church in the 1580s: Durante Alberti's Altarpiece and Niccolò Circignani's Frescoes', in Andrew Headon (ed.), *The*

Church of the English College in Rome: Its History, Its Restoration (Rome: Gangemi Editore, 2009), pp. 34–51.

Rovida, Edoardo, *Machines and Signs: A History of the Drawing of Machines* (London: Springer, 2013).

Ruipérez, Antonia Martínez, 'The Moral Compass and Mortal Slumber: Divine and Human Reason in the *Bibles Moralisées*', *Journal of the Warburg and Courtauld Institutes* 81 (2018), pp. 1–33.

Russell, David L., *Stuart Academic Drama: An Edition of Three University Plays* (New York: Garland, 1987).

Saint Vincent, Grégoire de, *Opvs geometricvm qvadratvrae circvli et sectionvm coni, decem libris comprehensum* (Antwerp: Johannes & Jacob van Meurs, 1647).

Schoenfeldt, Michael, 'Aesthetics and Anesthetics: The Art of Pain Management in Early Modern England', in Jan Frans van Dijkhuizen and Karl A.E. Enenkel (eds), *The Sense of Suffering: Constructions of Physical Pain in Early Modern Culture* (Leiden: Brill, 2009), pp. 19–38.

Tanner, Mathias, *Societas Jesu usque ad sanguinis et vitae profusionem militans* (Prague: Typis Universitatis Carolo-Ferdinandeae, 1675).

Thompson, Ayanna, *Performing Race and Torture on the Early Modern Stage* (London: Routledge, 2008).

Tomkis, Thomas, *Lingva, or, the Combat of the Tongue, and the Fiue Senses for Superiority. A Pleasant Comoedie* (London: Printed by G. Eld, for Simon Waterson, 1607).

Touber, Jetze, 'Articulating Pain: Martyrology, Torture and Execution in the Works of Antonio Gallonio (1556–1605)', in Jan Frans van Dijkhuizen and Karl A.E. Enenkel (eds), *Sense of Suffering: Constructions of Physical Pain in Early Modern Culture* (Leiden: Brill, 2009), pp. 59–89.

_____, *Law, Medicine, and Engineering in the Cult of the Saints in Counter-Reformation Rome. The Hagiographical Works of Antonio Gallonio, 1556–1605*, trans. Peter Longbottom (Boston: Brill, 2014).

_____, 'Martyrological Torture and the Invention of Empathy: Gallonio's Treatise on the Instruments of Martyrdom and Its Reception in the Seventeenth and Eighteenth Centuries', *Krypton* 3 (2014), pp. 14–28.

The Unabridged Acts and Monuments Online (1576 edition), (Sheffield: HRI Online Publications, 2011), https://www.johnfoxe.org/ (last accessed 6 December 2022).

Verstegan, Richard, *Theatrum crudelitatum haereticorum nostri temporis* (Antwerp: Adrianus Hubertus, 1587).

_____, *Theatrum crudelitatum haereticorum nostri temporis* (Antwerp: Adrianus Hubertus, 1592).

Wallace, William A., *Galileo and His Sources: Heritage of the Collegio Romano in Galileo's Science* (Guildford, Surrey: Princeton University Press, 1984).

Whitehead, Maurice, '"Established and Putt in Good Order:" the Venerable English College, Rome, under Jesuit Administration, 1579–1685', in James E. Kelly and Hannah Thomas (eds), *Jesuit Intellectual and Physical Exchange between England and Mainland Europe, c.1580–1789* (Leiden: Brill, 2019), pp. 315–36.

Williams, Michael E., *The Venerable English College, Rome: A History*, 2nd ed. (Herefordshire, UK: Gracewing, 2008).

Zacchi, Romana, 'Words and Images: Verstegan's "Theatre of Cruelties"', in Romana Zacchi and Massimiliano Morini (eds), *Richard Rowlands Verstegan: A Versatile Man in an Age of Turmoil* (Turnhout, Belgium: Brepols, 2012), pp. 53–75.

11

BODY OR SOUL: PROVING YOUR RELIGION IN THE EARLY MODERN MEDITERRANEAN

Eric R. Dursteler

Sometime in the spring of 1596, a man from the island of Santorini, Demetrio di Antonio, and three other Greeks set out in a small boat from the Ottoman island of Chios off the western coast of Anatolia, and headed for the Aegean Sea to trade for salt. Near the island of Mykonos in the eastern Cyclades, the boat was set upon by a larger felucca captained by Alessandro Beccaforte. Beccaforte was not a corsair, but rather one of the many opportunistic, occasional, small-time pirates who swarmed the eastern Mediterranean in the growing maritime anarchy that characterised the decades after the great naval battle of Lepanto in 1571.[1] Three of the men on the small boat were promptly released, but Demetrio was retained by his captors, who believed that he was a renegade Christian convert to Islam whose name was Mustafa and that he was married to a Muslim woman. He was transported to the thriving slave emporium of Malta, where he was quickly sold to Fra Ippolito Malaspina, a hero of Lepanto, friend and patron of Caravaggio, and a highly influential member of the Knights Hospitaller order.[2] With this Demetrio disappeared into the ranks of the nearly 3,000 enslaved men, women, and children who provided galley labour, domestic work, and other services on the island.[3]

Several months after being incorporated into Malaspina's household, however, Demetrio's story took an unexpected turn, when he claimed that he was a Christian and that he 'fasted on Wednesday in the Greek fashion' and so no longer wanted 'to eat the meat that [he] was given' on that day.[4] Other members of the household also began reporting that they had observed

Demetrio reciting his prayers in Greek and making the sign of the cross. These startling developments eventually led Malaspina to question whether his new slave was indeed Muslim, as Demetrio's captor had insisted during their negotiations, or whether the unfortunate man was in fact Christian, as he now claimed. To get to the bottom of this question, Malaspina determined to take the case to the Maltese Inquisition.

The issue of Demetrio's religious identity is what brought him before the inquisition: the challenge was to establish whether he was a renegade Christian convert to Islam, or a wronged Christian who had been fraudulently sold into slavery as a Muslim. At the core of this thorny local issue lies a broader question of how identities could be accurately decoded in a space such as the Mediterranean, in which mobility was the 'hallmark', religious frontiers were permeable, and conversion and religious nomadism endemic.[5] How could something as seemingly inscrutable and internal as belief be appraised, and then checked against external religious declarations and performances, particularly by institutions of the day that had a vested interest in the highly consequential issue of religious adherence? A close reading of the cases of Demetrio di Antonio and another captive in Malta, Agatha Zammit, evidences the central role that bodies played in efforts to assay identities in the early modern Mediterranean.[6] In an age captivated by anatomy and physiognomy, bodies mattered deeply in questions of religious identity and conversion.[7] They functioned as evidence, provided physical testimony, revealed details of life stories, and hinted at past choices and actions.[8] These confessions of the flesh were legible to inquisitors and could serve to either undergird or undercut the credibility of the accused.[9]

The inquisition had been established in Malta as an independent tribunal of the Roman Congregation of the Holy Office in 1574. In 1596 the lone inquisitor on the island was Innocenzo del Bufalo de Cancellieri, a Roman nobleman and future cardinal, who had been nominated by Clement VIII in 1595 and is considered Malta's 'most prominent Inquisitor of the sixteenth century'.[10] At the outset of his term, Bufalo had declared that it was his 'great desire ... to maintain the purity of the Catholic faith and extirpate heresy, which the enemy has never ceased to sow in the field of the Lord'. He cautioned, 'even the most magnificent edifice crumbles if its foundation is weak'.[11]

As with other branches of the Roman Inquisition, the Maltese tribunal was established to deal with 'crimes against the faith' represented primarily by Reformed ideas.[12] By the time of Bufalo's term, Protestantism was no longer seen as a viable threat on Malta; thus inquisitors focused increasingly on non-heretical practices, the sort of 'ignorance and superstition' that the post-Tridentine church attempted to eradicate through preaching, catechesis, confession, and repression.[13] In Malta these 'deviant practices' included folk beliefs, sorcery, non-normative sexuality, blasphemy, and heterodox foodways.[14]

Apostasy of the sort that Demetrio was accused of was common along the Mediterranean 'frontiers of heresy':[15] in Malta from 1634 to 1720 it fluctuated between 14 and 23 percent of all cases.[16]

In an age of upheaval, questions of identity were not just a Mediterranean affair: the great French thinker, Michel de Montaigne, wrote 'dissimulation is one of the most notable qualities of this age'.[17] Daniel Jütte has described the early modern era as an 'age of secrecy', and has argued that no other historical period had 'so profound a fascination' with furtiveness.[18] There is, of course, a rich historiography on this topic: Natalie Zemon Davis's *The Return of Martin Guerre* orbits around a tale of intentional misrepresentation, and perhaps self-deception.[19] Since its publication, scholars have revealed many more frauds, imposters, cross-dressers, aspiring saints, false tsars, mountebanks, and charlatans,[20] and more generally a culture in which 'telling lies and living a lie' was epidemic.[21]

Nicodemism, adopting what John Jeffries Martin has called the 'prudential self', was far and away the most common type of 'identity forgery' in this period.[22] In Reformation Europe both Roman Catholics and Protestants considered overlaying interior belief with exterior conformist profession and practice a defensible response to the dangerous politics of the age.[23] For Muslims, *taqiyya*, or outward conformity, was commonplace because, as one cleric wrote, 'god is not concerned with your exterior attitude, but with the intention of your hearts'.[24] Jewish scholars also debated the issue, and Orthodox clergy endorsed crypto-Christianity as an acceptable survival strategy in areas under Muslim rule.[25]

As a result of this instability and uncertainty, the early modern era was afflicted with a profound 'anxiety' and even 'panic', as Miriam Eliav-Feldon has described it, that not everything was as it appeared, and individuals may not have been whom they claimed.[26] This precipitated an intensive search for reliable ways to establish identity 'beyond doubt' in an age that lacked identity cards, birth certificates, fingerprinting, and visual records.[27] Indeed, many of the practices of identification and verification associated with modern states-began to be developed in the Mediterranean in response to 'the problem of captivity'.[28]

Because of its religious diversity and easy mobility, this anxiety may have been particularly acute in the Mediterranean, where fears of enemies from within and without were rampant.[29] The island of Malta, given its highly exposed location and tumultuous recent history, was especially susceptible to such fears.[30] Situated at 'the bottleneck between Sicily and North Africa', in a location where Islam and Christianity, and Muslim and Christian polities, 'overlapped', Malta was at the crossroads of the Mediterranean, and was a magnet for people from across the region.[31] It was, as one inquisitor described it, 'a little world inhabited by people from every nation'.[32] Despite the

imposing walls of the great fortress city of Valletta, however, Malta was less an impenetrable defensive bulwark than a permeable 'living membrane' across which people and goods moved with ease. The island was an important trading centre, the 'main warehouse' on the economically vibrant and interdependent central Mediterranean trading frontier, across which Malta trafficked extensively with North Africa, Sicily, and other areas.[33] A central component of this trade was human flesh: Malta was 'the capital of Christian piracy' and one of the Mediterranean's largest markets of enslaved Muslims.[34] Indeed, the number of slaves rose from 800 in 1582 to 1,800 in 1599 to 3,000 in 1630, which represented between 2 percent and 10 percent of the total population.[35] This concentration of slaves made Malta especially vulnerable to, and its inhabitants particularly concerned about, slave revolts: one of the most notable occurred in February 1596, just months before Demetrio's forced arrival on the island.[36]

A significant number of Malta's slaves were former Christians: a 1599 report indicates that of 1,600 public slaves, at least 600 were renegades. Many of these unfortunates presented themselves before the inquisition seeking its intervention and assistance on their behalf. Between 1577 and 1670, 922 apostates appeared before the Maltese Inquisition to return to the faith, and in the decade 1595–1605, a total of 96, including 17 women, appeared seeking its intervention on their behalf. Of these, Greeks represent the single largest group, almost 25 percent of the total.[37] To provide some perspective, in much larger and more populous Sicily from the sixteenth to the eighteenth century 846 renegades appeared before the inquisition to abjure their apostasy.[38]

It was not at all uncommon, therefore, for slaves, once they arrived at Malta, to appear before the tribunal and claim that they were either Christian, or a renegade who had been forcibly converted to Islam, which, they insisted, rendered their enslavement unlawful.[39] To be sure, there was often a good deal of suspicion about these renegades and their 'usual, painful lies', as one Sardinian inquisitor described them.[40] However, although corsairing is often portrayed as part of a broader unholy war between Islam and Christianity, the reality was that Muslims and Christians regularly preyed on their co-religionists. Molly Greene has shown how the Knights of Malta often targeted Greek merchants and shipping, which suggests the tension between the 'claims of religion' and the limits of 'state sovereignty'.[41] This occurred because it was difficult to identify who was who, but even more because slaving was so lucrative. While prices varied wildly, in the sixteenth century a 'good slave' could be worth as much as 'ten tons of wheat',[42] and the cost to redeem slaves was also elevated.[43] These sorts of profits made it tempting and not at all uncommon for Christian corsairs to sell Christian slaves: for example a French Hospitaller captured twenty Christian women from Russia and Hungary travelling on an Ottoman ship, and sold them in Messina's slave market to avoid inquisitional

interference. His justification was that they were not Christians, but rather 'prostitutes, infidels and Turks'.[44] Large profits similarly enticed Ottoman Muslims to illegally enslave and sell fellow Ottoman subjects who were Christian and Jewish.[45]

The issue of slaves trying to obtain their freedom by claiming to be Christian became so pronounced that in 1741 Inquisitor, and eventually Cardinal, Ludovico Gualterio Gualtieri sent an inquiry to Rome seeking guidance on how to proceed 'in the cases that occur not infrequently in Malta', in which individuals captured by corsairs in the Levant and brought to Malta claimed to be Christian, 'without providing any authentic document'. According to the letter, it was difficult, if not impossible, to ascertain their 'Patria', and this confusion was accentuated because 'among all [the Greek] populations, Christians and Muslims live promiscuously'. Beyond this, the inquisitor continues, it was difficult to tell who was Christian because the people were usually 'ignorant, and did not know how to do anything but the sign of the holy cross'.[46]

The Holy Office in Rome responded with an *Istruzione* designed to establish a clearer protocol for ascertaining 'who was Christian and who was not'.[47] First, the inquisitor was to explain to the person being interrogated that the deposition was only intended to assist them spiritually, and that the inquest could not be used as evidence to free them from their servitude. The inquisitor was then to interrogate the individual to ascertain if he or she was in fact Christian. The line of questioning to determine this ranged broadly:

> Where were [their parents] born, were there Christian churches there, what was the parish priest's name, and did [their parents] attend them.
> Were their parents baptized and did they have their children baptized.
> Did they have mixed betrothals or marriages with Mohammedan women.
> In these cases were the children baptized or not, and were they educated in the Christian religion or not.
> Did the abusive practice of apostatising from the Christian religion to the sect of the Turks exist in their homeland.
> Did they know any Christian persons in their land, who could attest that they were born of Christian parents.

The examination was to continue 'with other similar interrogations, … so as to come to discover the sincerity of their words or the truth of their motivation, or the reasons for which they have made the request to be allowed to participate in the sacraments'.[48] As these questions suggest, proving religious identity centred heavily on determining basic biographical information about captives and their families, trying to develop a snapshot of the religious life of their birth communities, and then seeking corroboration for their claims from confirmed Christian witnesses. This protocol did not really resolve the fundamental problem of

identification, however, and not surprisingly the problem persisted: Benedict XIV took up the matter in both a 1744 letter to ecclesiastical officials in Albania and a 1754 encyclical, *Ne Christifideles sub Turcarum ditione versante*.[49]

While these questions were generated over a century after Demetrio's case, they suggest the challenges that Bufalo faced in resolving the matter brought before him. In a series of encounters over the course of several months, the inquisitor attempted to penetrate the question of the enslaved Greek's identity, and this process provides a telling glimpse into the ways in which contemporaries attempted to navigate these gordian questions.

In an early session, Beccaforte, the man who had captured and sold Demetrio, was summoned before the tribunal and asked to recount his version of events. He stated that when the small boat was approached off Mykonos, three of the four men on board were dressed in the Greek fashion, while Demetrio was dressed like a 'Turk'. Beccaforte stated, 'I knew he was a Turk because he had a turban on his head, which he removed ... and threw inside the boat when he saw us'. Demetrio also 'wore a blue Turkish vest, [and] Turkish shoes'. Questioned why he did not think the other three men whom he had captured and then let go were Muslim, Beccaforte again referenced their dress. He knew they were Greeks 'because they were dressed in the Christian style' and wore clothing like 'Greek sailors from those parts of the Archipelago'.[50]

As this suggests, apparel was considered a 'distinguishing characteristic' in the early modern era,[51] and in the Mediterranean clothing, headgear, and shoes spoke volumes.[52] Numerous Ottoman sumptuary laws attempted to dictate styles, colours, and even scale based on religious and social status,[53] but there is ample evidence that these laws were regularly ignored and rarely enforced.[54] Costume books were a widely popular expression of this fascination with dress during the second half of the sixteenth century, particularly among travellers in the Mediterranean, and they served as a means to distinguish and classify individuals from across the region according to 'their habits',[55] as one traveller termed them, and to decode the structures of an unfamiliar society.[56] While it has been argued that dress was 'undoubtedly the primary visual marker of identity',[57] the ease of shedding this second skin, as Demetrio attempted to do when he removed his turban upon being sighted by Beccaforte, suggests some of its limitations in questions of identity.[58]

Another line of questioning that Bufalo pursued was linguistic. According to Beccaforte and other members of his crew, Demetrio was bilingual: 'he always spoke Greek' with his captors and fellow sailors, but 'with the other Turks' who were taken captive during the voyage to Malta, 'he spoke in Turkish'.[59] This line of questioning had only limited value in the multilingual Mediterranean of this day, however. The sea was a space of intense linguistic mixing; language did not function as a primary identity marker, rather linguistic frontiers were less sharply delineated and more malleable.[60] This reality

was particularly accentuated in a place like Malta where Maltese mixed with Italian, Spanish, French, Greek, Arabic, and other languages.[61] Thus, the fact that Demetrio spoke Turkish was not seen as a particularly compelling factor.

Demetrio's culinary practices served up somewhat more useful evidence. A fellow servant from Malaspina's household testified that 'at the beginning when [Demetrio] was purchased and brought to the house, he lived as a Turk and ate meat on Friday'. Indeed, when Demetrio had professed his Christian identity to Malaspina, he had emphasised that he 'fasted on Wednesday in the Greek fashion and did not want to eat meat'.[62] For inquisitional tribunals, foodways were an important marker of religious identity, and were often privileged over other religious practices or ritual knowledge. The most familiar example of this is from the Iberian context, where Morisco and Converso foodways were perceived as an essential marker of resistance or assimilation.[63] As in Demetrio's case, eating meat on Fridays, during Lent, or on other days of abstinence was considered a revealing marker of religious identity. Thus, foodways were widely invoked in cases involving renegades, Jews, Muslims, and Protestants.[64]

Beyond the triad of costume, language, and food, Demetrio's body attracted particular attention. In his testimony before Bufalo, Beccaforte stated that another indicator that his captive was a renegade was that 'he had a tuft of hair in the middle of his head like the Turks do'. The other three men in the boat, in contrast, were clearly not Muslim because they 'had black hair *alla grechesca* in the style of the Archipelago', and their beards were also those of men from that 'nation'.[65] Hair occupies a unique space astride the corporeal and the cultural, and in the early modern era it 'always serve[d] to communicate': it expressed gender and sexual identity, of course, but it also registered cultural alterity.[66] Thus, Demetrio's distinctive hairstyle of a shaved head with topknot was a familiar symbol of Muslim male identity, and was immediately apparent to Beccaforte and his men.[67] The roots of Muslim hair removal trace back to early Islamic and even pre-Islamic times,[68] and the practice was widespread in the early modern period.[69] Head shaving served a practical purpose for men wearing turbans, but it also acquired a symbolic valence:[70] it was sometimes part of Christian conversions to Islam,[71] and enslaved Muslims were forbidden to change their hairstyle, to prevent mixing with Christians.[72] A shaved head, however, did not always equate with Muslimness: slave traders shaved Christian men so they could sell them as Muslims,[73] and Christians sometimes shaved their heads in order to pass as Muslim.[74]

For Beccaforte, the facial hair of the men he captured also functioned as a cultural marker: though he makes no mention of Demetrio having one, the beards of the other men served to identify them as Greek. While beards were often specifically associated with Muslim and Jewish men, they were also common in Europe.[75] As Douglas Biow has observed, 'not all beards are the

same', however, and context and style definitely mattered.[76] For example, for some contemporaries length differentiated beards: Christians wore their beards shorter, and Muslims longer.[77] Even this distinction is problematic, as longer beards were also fashionable in parts of Europe, and shorter beards in parts of the Mediterranean.[78] It was also not uncommon for European travellers to the Mediterranean to grow beards and adopt Muslim clothing in order to blend in more seamlessly.[79]

Beyond beards and hair, whose plasticity made them easily alterable and therefore of limited utility in matters of identification, the bulk of the inquiry into Demetrio's religious identity centred on the state of what all the participants in the trial somewhat demurely referred to as his 'membro virile'. At their initial encounter near Mykonos, to verify the suspicions he had based on Demetrio's dress and language, Beccaforte brought him on board his felucca, and 'in the presence of my men' pulled down his trousers, a common and quick, if unsubtle, method to ascertain male religious identity.[80] One of his crew members who was present reported to the inquisitor that Demetrio's 'member' was 'Turkish because it was cut. I saw it'. For Beccaforte this was definitive evidence that his captive was 'truly a Turk'. Demetrio, too, recognised that his circumcision was central to establishing his religious identity: he attempted to neutralise this indisputable evidence by initially admitting, according to Beccaforte, that he was indeed a renegade, but claiming that 'the Turks had cut him forcibly because he had a Turkish wife, and that it was not long ago that they had cut him'. In contrast to this, Demetrio told Bufalo that it was in fact Beccaforte who had 'circumcised [me] by force with a razor because he intended to sell me as a Turk', and this explained both how he had come to be circumcised and why the scarring was still relatively fresh.[81] Neither story would have seemed improbable as almost all renegades seeking absolution claimed they had been forcibly circumcised, often when they had been either voluntarily or involuntarily inebriated.[82] The fact that the person allegedly responsible for Demetrio's forced circumcision was Christian did, however, add an unusual twist to this common story.

To get to the bottom of this issue, Bufalo sent Calorino Brigata, a Christian surgeon who had been a slave in the Levant for fifteen years, to inspect Demetrio. The primary role of inquisition physicians was to provide basic health care to inmates, ensure their ability to endure torture before and during its implementation, and to issue death certificates.[83] Corporal examinations as part of inquiries were also a common task,[84] and although forensic medicine in this period was still quite basic, inquisitorial manuals and records make clear that there was a good understanding of Jewish and Muslim circumcision practices and their physical manifestation at various stages of life.[85] Brigata, who had 'treated many Turks', reported that Demetrio's prepuce was only cut on the upper side in a 'half moon'. He found this quite unusual, as in his experience,

the 'Turks' 'usually cut all the skin that is around the tip of the virile member in a circular fashion and not in the way that [Demetrio's foreskin] was cut'. Because of this, Brigata concluded 'I am certain that this Demetrio was not cut in the way that the Turks usually do'. And while he could not judge whether 'the cut was fresh or old', it did not appear that Demetrio had been circumcised as a child. To further corroborate Brigata's conclusion, Bufalo followed up by sending two Arabs, one a slave in Malta and the other a free man named Musa, to inspect Demetrio. They confirmed that he was not circumcised in the way of 'we Moors and Arabs', and Musa testified 'I am certain that he was not cut by an expert and experienced person such as cuts [Arabs] ... and it seems to me that the incision is not too old, rather it must be about a year old'.[86]

The relationship of circumcision to both Muslim and Jewish male religious identity was historically, and remains, complex. Circumcision has been described as 'more a practice of Muslims than a practice of Islam' because, as Abdelwahab Bouhdiba explains, 'canonically and theologically, circumcision has no privileged status ... it is merely *sunna* [tradition]'.[87] The Qur'an does not mention circumcision, however the hadith sayings of Muhammad do: one describes him emerging circumcised from the womb, in another he declares 'let him who becomes a Muslim be circumcised, even if he is old'.[88] According to early commentators, circumcision functioned as a 'test of belief and a symbol of surrender to God's will'; it distinguished Muslims from unbelievers, prevented 'the devil from taking up his abode under the foreskin', and helped the faithful to 'keep their passions in balance'.[89] While circumcision is seen by contemporary Muslims as an essential, distinguishing characteristic of Muslim identity, along with the pork taboo,[90] within the Hanafi juridical tradition, which predominated in the Ottoman Empire, it was more a 'recommended practice'.[91]

In the early modern era, it was broadly known that Muslim and Jewish boys were circumcised at a young age, generally at birth for Jews, though the age varied greatly for Muslims.[92] The distinctive ways in which various cultures performed the procedure was also known.[93] In the Ottoman Empire, circumcision came to serve a highly public function through the elaborate celebrations associated with the sons of the sultans. Already in the fourteenth century Ottoman sultans elevated circumcision from a private event to a public spectacle, and by the sixteenth century circumcision festivities had become 'the most elaborate feasts ever recorded in Ottoman history'.[94] It was not until the middle of the seventeenth century, however, that circumcision became a more essential component of conversion rituals performed in the imperial divan, 'with a surgeon in attendance to carry out the circumcision on the premises'.[95]

Among contemporaries, circumcision was seen as the 'defining practice of Muslims', and for inquisitors it was one of the very few, elemental acts and evidences of apostasy.[96] Indeed, it was coterminous with conversion: as one

renegade put it, 'I was circumcised, which means made a Turk'.[97] Renegades often equated circumcision with Christian baptism:[98] as Paul Rycaut wrote, it served as 'an admission and introduction ... into the number of the faithful'.[99] For some, circumcision was also sufficient for salvation: as one renegade contended, 'if a Turk lived according to the law of nature without baptism ... simply by being circumcised he would be saved'.[100] Another renegade was told that circumcision 'was good for health' and would make him 'stronger'.[101] Whatever the motivation or justification, being marked in the flesh was considered by contemporaries as a condensed symbol, a powerful and generally irreversible insignia of cultural and religious identity.[102] Circumcision was an 'indelible' physical 'mark of exclusion' and testament to 'the irreversibility' of the act of conversion.[103]

In Demetrio's case, more than any other factor during his lengthy 'rigorous examination' by the tribunal, it was the incarnation of his religious identity in the form of a circumcised penis that ultimately seems to have been decisive in his trial's outcome. Despite its seeming incontrovertibility as evidence of conversion, circumcision 'often puzzled Christian authorities'. There was a certain ambiguity to circumcision: the absence of a foreskin might be the result of birth defect or medical intervention.[104] The fact that some Christians, specifically Copts and Ethiopian Orthodox, practiced circumcision also complicated the matter.[105] And, while it was widely assumed throughout Christian Europe that adult men who 'turned Turk' were required to be circumcised,[106] this was not always or necessarily the case.[107] In a case similar to that of Demetrio, a renegade was able to escape his Maltese captors, who did not tie him up because he spoke Greek and was not circumcised, even though the Maltese admitted that they knew that 'many of these Greeks are renegades but are not circumcised'.[108] Writing about North Africa, Lancelot Addison noted that 'in the admittance of a Renegado, or the denyer of his first Religion, circumcision is not exacted of the Moors, for fear that the undergoing of such a painful Sacrament should deter the Proselytes'.[109] Contemporary depictions of circumcisions likely reinforced male fears: a costume book in the Hermitage shows a boy being held by two men and a group of men singing and playing to calm him, 'so that', as the caption explains, 'he does not move because of the violence of the pain'.[110] Some, too, resisted, such as a Spanish boy soldier who dressed and lived 'as a Moor' after his capture, but avoided being 'cut' until he could escape,[111] the boy who jumped out a window to flee a master who wanted to cut him,[112] or the Greek who testified, 'I would sooner have my head cut off than be circumcised'.[113] In stark contrast, a Cypriot friar claimed to have been voluntarily circumcised so that he could travel more safely in Muslim lands.[114]

Despite these complicating factors, following the lengthy inquiry, Bufalo ultimately accepted Demetrio's version of events over that of Beccaforte, and

recognised him as a legitimate Christian. As a result, he was declared to be 'free like all other Christians'. Despite his exoneration, however, the inquisitor clearly harboured some concerns about Demetrio's conversion story, including lingering questions surrounding the four-month lag following his sale to Malaspina before he came forward with his claim. To ensure his 'healthy repentance', Bufalo decreed that Demetrio could not leave Malta for a year, had to confess and take the Eucharist four times annually, and was obligated to fast every Friday, notwithstanding his claim to prefer the Greek mid-week fast.[115] This penance was designed to permit ongoing oversight by ecclesiastical officials to ensure Demetrio's integration into the local Christian community and his performance of its key ritual acts.

If establishing male religious identity in Malta presented numerous challenges, female identity posed its own unique hurdles. While there were certain similarities in how inquisitors parsed women's dress, foodways, and language, they interpreted women's bodies as evidence differently. Women's bodies often conveyed a wider variety of heretical meanings than men's, in part because of the belief that women were less rational than men, and thus more vulnerable to illicit spiritual and sexual activity.[116] In contrast to some such as Demetrio, women's bodies were not 'visibly marked' by conversion, which could make religious nomadism more seamless for them.[117]

In the early modern Mediterranean, there were significant numbers of women on the move, and while outnumbered by men and boys, women and girls still made up a considerable percentage of the sea's enslaved. Women certainly converted in significant numbers too, though many fewer of them returned to Christianity: one estimate places the number at only about 7 percent.[118] The imprecision of women renegade numbers is a product of the fact that more women married and established families in their adopted homes, which made flight less attractive and less viable, resulting in many fewer women apostates and slaves appearing in the inquisitorial documentary record seeking reconciliation. This makes another case from the Maltese Inquisition all the more intriguing.

On 20 January 1599, Bufalo's successor as inquisitor, the Milanese Antonio Ortensio, began hearing testimony on an unusual case. Over the previous weeks there had been much gossip in the streets of Valletta about a woman being held in the Hospitallers' massive three-level *Gran Prigione* in the *ville nouvelle* of Valletta, which contained 900 of the Order's slaves and also functioned as the government's 'principal jail'.[119] The woman had been sailing from Tripoli to Alexandria on a caramoussal loaded with sulphur that had been trapped by contrary winds for forty days, before eventually being captured by two Maltese galleys. While the comings and goings of slaves were commonplace in Malta, as the inquisitional record states, 'many Maltese and other Christians' had come to the prison, which was easily accessible to the

public, to see this particular 'Turkish woman'.[120] The reason for the unusual level of interest was that there was a growing belief that she might in fact be a Maltese woman by the name of Agatha Zammit. The story of this woman, and whether she was in fact Agatha Zammit, illustrates the challenges faced by both institutions and individuals in establishing the identity of women, and the ways in which this could prove even more difficult than identifying men.[121]

Agatha was about forty years old and had been born in 1560 or 1561 in the village of Mosta, which, at the turn of the seventeenth century, numbered 636 inhabitants.[122] She married a man named Augustino, and they, or at least she, appears to have lived for a time on the small island of Gozo, directly west of Malta. In 1551 almost all of the perhaps 7,000 inhabitants of Gozo were enslaved during a raid by Barbary corsairs led by the infamous renegade corsair Dragut.[123] Agatha was likely part of the wave of Maltese who re-populated Gozo in the aftermath of the attack. During her years living there, she had the reputation of leading a 'dissolute life', indeed she reputedly maintained a 'carnal friendship' with a nobleman named Vicentino Cumbo.[124] It is possible that she was one of the many prostitutes who settled on the island after 1551 to work among the island's majority male population.[125]

Agatha's life was transformed in October 1583 when four corsair boats from Bizerta landed at Gozo. Encountering no resistance from the island's guard, they opportunistically attacked the town of Rabat at the foot of the citadel, while cannon fired down ineffectually on them. Seventy Gozitans, out of a population of 2,000, were 'taken by the infidels', and Agatha was among those unfortunate few.[126] Her husband Augustino waited for 'some years' after her abduction, then, assuming she was either dead or would never return, married a woman who worked for his sister, and subsequently had several children with her.[127]

Some fifteen years passed between Agatha's abduction and the appearance of the woman in Valletta's slave bagnio. As word spread about her presence, people in the community began to visit out of curiosity. A Dominican tertiary, Suor Perpetua, heard the rumours and was further informed that the woman 'did not want to return to the Christian faith'. The nun resolved to try and change the captive woman's mind, and went to the prison where she found her with her husband and two children. They conversed at length in Maltese, which the woman spoke 'excellently'. In Perpetua's telling, the woman acknowledged 'that she was Christian, the daughter of Christians, but that now she is a Turk, has a Turkish husband, and does not want to return to being a Christian'. As they spoke, Perpetua reported, the woman's husband intervened 'and did not want me to speak to her any more, nor did she want to tell me where she was from'. Indeed, the woman threatened that 'if they decide to make her become a Christian' she would poison herself. When the

nun told her she would be burned if she did not renounce her apostasy, the woman responded that in retaliation her husband 'would punish a thousand Christians' when he returned to the Levant.[128]

Another early visitor to the bagnio was Gio Paulo Xerri of Mosta, who reported that the woman had confessed to him that she had formerly been Christian and had been captured during the raid on Gozo. She further revealed that she had siblings on the island and complained that 'they did not come to visit her or bring her anything to eat'. When Xerri asked if she was Maltese, 'she responded no', and when he asked 'if she wanted to return to the Christian faith, she also said no'.[129] Despite her inconsistency, Xerri concluded that the woman was in fact Agatha Zammit of Mosta.

It was this uncertainty about the woman's identity that led the inquisition to intervene. While linguistic evidence, namely her ability to speak 'Moorish' and Maltese, was presented by several witnesses as compelling evidence, the multi-week inquiry focused instead almost entirely on the testimony borne on the woman's body. As in Demetrio's case, her flesh served both as the 'boundary between' and the 'site of interaction' with the inquisition and Maltese society. It was repeatedly examined and studied by friends, family, and lovers, as a mnemonic prompt to revive distant recollections of the younger woman they had known.[130]

Unlike in Demetrio's case, however, there was nothing as visible and tangible as the marks on his penis to facilitate the inquiry into the ostensible Agatha's case. While female circumcision, or more provocatively genital mutilation, is highly controversial today,[131] surprisingly little is known of the practice historically.[132] This is partly a product of limited sources: there is no mention in the Qur'an, and it appears only very minimally in the hadith literature.[133] Since female circumcision was not universally practiced in Islam, the question of whether it was recommended or required was a matter of debate. Another issue was the extent of the procedure – a symbolic clip of the clitoral prepuce was considered acceptable, where the more severe clitoridectomy and infibulation, which denied women their access to sexual pleasure, were not.[134] The great Ottoman traveller Evliya Çelebi considered female circumcision 'a custom peculiar to the Arabs'. He described festive processions paralleling those for young men at their circumcision, and the female surgeons (likely midwives) who removed the young girl's 'little red tongue' (kırmızı dilcik). The motivations for the practice, at least according to Evliya, were to increase women's sexual pleasure and to ease childbirth.[135] For others, it was the exact opposite: the medieval jurist Ibn al-Qayyim suggested that female circumcision moderated women's passion to protect their chastity but did not prevent them from fully enjoying sex. In his early nineteenth-century description of the practice, the renegade French physician, Clot Bey, reported that the procedure was performed in public baths at the age of seven or eight and was intended 'to

moderate the intensity' of Egyptian women's sexual desire.[136] In Agatha's case, however, there was never any examination or even mention of her genitalia; instead the inquisitor focused on her body shape, eye colour, and other distinguishing physical marks in his efforts to verify her identity.

After hearing the initial opinions of the casually curious, the inquisitor Ortensio initiated a more in-depth inquiry. In a sort of 'theatre of memory',[137] he sent a series of individuals who had known the woman when she was younger to observe her in prison and to contrast their recollections to the reality of the woman that they encountered. The early modern era was, broadly speaking, an ocular-centric age that increasingly, though not exclusively, privileged sight among the senses.[138] Thus, for tribunals such as the inquisition, truth rested heavily, though not exclusively, on 'the quality and believability' of the testimony of eyewitnesses.[139] Closely linked to this were views on physiognomy as a window into veiled interiority, which during the sixteenth century shifted from a focus on interior humoral constitution to external colouring and marks of the body.[140] The skin was seen as an 'impressionable surface' whose markings could make the interior self visible and 'speak truth' about its possessor.[141] Thus bodies served as evidence: eyes, weight, colouring, scars, moles, birthmarks, all were registered by institutions and provided a 'lexicon' to identify individuals.[142]

One man, who knew Agatha when she served in his house, stated that based on her physical appearance, 'I cannot really recognise this woman as Agatha'. She possessed 'several marks from smallpox on her nose, which Agatha did not have here in Malta, even though four years ago I had heard in the village how news had arrived that Agatha had had smallpox in Turkey'. He also commented on the woman's tone of voice: 'when Agatha was here in Malta, when speaking she had a somewhat hoarse voice, and this woman has a clear, healthy voice, and as for her speech, it appears very Maltese'.[143]

Agatha's erstwhile lover, Vicentino Cumbo, testified after his interaction that the incarcerated woman was not his mistress, 'because I would have easily recognised her, having enjoyed her friendship for a year'. Remembering his young mistress, he noted that Agatha was 'a gentlewoman', while the woman in the prison 'is very fleshy, and it seems impossible that [Agatha] can have become like this'. In addition, the woman in the prison had different colouring: she was 'white', whereas Agatha was 'brunette', or darker complected, and again fixating on body size, Cumbo emphasised that his young lover had been 'small', whereas the woman in the prison was 'large'.[144] In the early modern period skin colour could function as 'an indication of religious difference':[145] Muslims were historically often depicted as black or dark in contrast to white or fair Christians, and in some inquisitional contexts whiteness and Christianity were coterminous.[146] Whiteness was also an indication

of social status and female beauty,[147] and so it is also possible, and perhaps more likely, that Cumbo's wistful observation was more about his memory of a young lover's beauty in comparison to the large, dark, older woman he encountered.

Several of Agatha's family members also visited her in the slave prison and testified at some length about her corporeal markings. Her brothers Giovanni and Leonardo both expressed serious doubts that the imprisoned woman was their sister, based on a close examination of her body. Giovanni had two concerns: first, the real Agatha 'had a mark on her foot from a horse's hoof, and she had black eyes, and this woman does not have these marks, since her eyes are quite blue, and she does not have the aforementioned mark. In fact, I am convinced that if she were Agatha I would have recognised her because when she was captured she was a woman of 24, and thus she could not have transformed herself in such a way that I could not recognise her in any way'. Leonardo insisted he could not see 'any way that this woman is my sister, indeed I am certain that she is not because I find no mark by which I could believe that she is my sister.' Pressed on whether they were more intent on protecting the family's honour (and perhaps its patrimony) than preserving their sister's endangered soul, both brothers reaffirmed their statements and insisted they would do anything to see their real sister, 'save her soul and return to the Christian faith'.[148]

Agatha's sister Catterina concurred that the woman in the prison was not her sibling because the mark on her foot was different, as were her eyes. She explained, 'my sister had little black eyes, and this woman has big grey ones', and she had a mark 'on the edge of her eyelid beneath one eye', similar to one their sister Agnes bore. Catterina's husband, Augustino, stated that it seemed unlikely that Agatha 'could have totally changed her blood, her eyes, and every other sign in such a way that I could not recognise her'.[149] The recurring focus on the eyes in these testimonies is revealing. In contemporary notions of physiognomy, identity could be masked 'beneath the artifice and culture of make-up, haircuts, wigs, dress, and elocution', but face, body, voice, and especially eyes were considered to be nature's 'windows of the soul', and thus more revealing of the truth.[150]

The testimony of a fellow prisoner, Victoria, who was likely spying on behalf of the Maltese inquisitors, cast some uncertainty on this chorus of doubt. She reported encouraging her cellmate to 'return to the Christian faith because she would be married and set free', to which the woman replied that if her brother or sister would come and identify her as their sister, 'she would be willing to return to being Christian'. Victoria also attempted to examine the distinguishing markings on the woman's eye and foot, but 'when she discovered that I wanted to see, she pulled her foot toward herself', which Victoria interpreted as an attempt to not 'be revealed'.[151]

Eager to buttress conjecture with more expert evidence, on 24 February Inquisitor Ortensio ordered Camillo Lamanda, the surgeon of the inquisition, to examine the woman's body for evidence of the unique marks that had come up repeatedly in testimony. This was perhaps a somewhat unusual request for an inquisitional surgeon, whose investigations of female bodies outside the torture chamber centred largely on examining women accused of witchcraft for physical marks of diabolical possession,[152] or aspiring saints for evidence of holy imprints.[153] This was because women's bodies were simultaneously considered vulnerable and dangerous loci, prone to spiritual occupation by both holy and malign forces.[154] Lamanda's charge, however, was altogether different: to inspect a body as a means of identifying an individual and a perhaps unveiling an apostate. Following his physical examination of the woman, he reported in great detail:

> having looked at both feet, I found that on the left foot, above the toenail of the big toe there is a cut that has developed in the flesh noticeably and over a long time. One can see that it must have been either a stone's blow, or the stomp of some large animal, or some other powerful blow, because you can see that the split in the middle of this toe is not made with a cutting tool, but with a blow or bruise, because the mark of a contusion is very different from the mark of a cut, and this is an easy thing to recognise.

He also saw a mole under her left eye 'like a lentil'.[155] Here, at last it seemed, was solid evidence that went beyond conjecture and faulty memory, and which supported the view that the imprisoned woman was indeed Agatha, but feigning to be someone other than herself.

The final stage of the inquiry saw the alleged Agatha, at long last, called to testify on her own behalf on 27 February, over a month after the inquiry into her identity began. One might expect that this would have been the first step in the inquest, but women were rarely able to testify about their lives before inquisitions in an unmediated fashion.[156] At the outset of her testimony, she stated categorically, 'I swear to you by god, that I am not Maltese'. Her real name, she claimed, was Haiam, and she had been born in Istanbul. Her mother was 'the daughter of Greek Christians from Bosnia', and her father was unknown to her since her mother was not married. Her mother had been captured, brought as a slave to Istanbul, and converted to Islam. She died following Haiam's birth and left the child in the care of her mistress and owner, who raised the girl 'as her daughter'. When Haiam was fifteen, her stepmother/mistress betrothed her to an Ottoman official called Mehmed Agha. The couple moved to Tripoli where her husband held a governmental position, and lived there for fifteen years, during which time she gave birth to five children, all of whom died. She and her husband divorced because she had 'beat

one of his daughters and his black female slave', though she does not say who initiated the separation. Just three months later Haiam remarried, this time to a ship captain, Mehmed Rais, and soon after they set out for Alexandria, which is how she was captured. When queried specifically about the marks on her foot, she explained that twenty years earlier she had caught smallpox and as a result developed an abscess. When it was removed her nail came off, and then grew back split in two.[157] This was the extent of the mysterious woman's appearance before the tribunal.

Based on this testimony, the surgeon Lamanda was ordered to perform another examination. He reported, 'having better considered' the woman's foot, he now agreed with her explanation that the mark was caused by smallpox. Unfortunately for us, the transcript of the inquiry ends abruptly here, and there is no further statement on the case; thus we cannot be certain how it ended.[158] Given the absence of further examination, or assignment of penance as in Demetrio's case, or for that matter any mention of punishment for apostasy from Christianity, it seems reasonable to assume that Haiam's testimony carried the day, notwithstanding the notable body of contradictory evidence that undercut her account and her own prevarications and inconsistences. The reward for her success, however, would have been to remain in the Gran Prigione until she was either sold or, more hopefully, redeemed, which given the status and wealth of her husband is possible, even likely. Who she really was, whether in collusion with her relatives she was somehow carrying on a charade to avoid having to return to her former life, or whether she was in fact who she claimed to be, we will never know.

These two stories from the Maltese Inquisition illustrate some of the challenges faced in corroborating identities in an early modern Mediterranean in which religious self-fashioning and refashioning, often articulated through conversion or reversion, were widespread. Drawing religious lines of demarcation was critical in the age of confessionalisation; the unique cultural permeability of the Mediterranean made this both more difficult and at the same time more pressing. These cases also suggest how such issues were decoded by both individuals and institutions, and how the interpretation of 'external signs' in an attempt to unveil 'internal dispositions' became an 'obsession' for the inquisitions of the day.[159]

When Beccaforte first came upon Demetrio's boat, he had to assess the identity of the men quickly in order to determine how to interact with them. These sorts of encounters at sea were incredibly common, and yet were always fraught with uncertainty and peril. Beccaforte went through a type of identity checklist in order to rapidly classify the men on the ship. He gauged their clothing and physical appearance, he listened to their speech and the names they called each other, and ultimately he examined their bodies to verify his suspicions.

Faced with a similar dilemma, the inquisitional tribunal approached questions of identity from certain similar points of reference in an attempt to parse opposing narratives. In Demetrio's case, as in the original encounter at sea, the inquisitor pursued a detailed line of questioning that paralleled that of Beccaforte. External signs such as clothing, language, foodways, but especially Demetrio's body became the centrepieces of the inquiry. In the case of Agatha Zammit, faced with multiple divergent accounts, the inquisitor homed in quite narrowly and almost exclusively on her corporeality – her body shape, weight, colouring, eyes, and unusual physical marks and blemishes – as well as considering several competing narratives to explain these physical characteristics. In both inquiries, the questioning centred not on issues of belief, knowledge, or orthodoxy, but rather entirely on external, observable orthopraxis, in other words the 'performative aspects of identity'.[160]

Notwithstanding attempts to extract and rationalise identity through judicial inquiry, official documentation, medical analysis, surveillance, incarceration, and other forms of discipline, in the early modern Mediterranean it remained imprecise and protean. It was most often expressed and appraised through clothing, headgear, language, palate, and flesh.[161] If clothing could be easily changed, foodways altered, languages learned or forgotten, memories misplaced or feigned, the body served as silent witness of heterodoxy and apostasy, orthodoxy and fidelity, which could be examined, queried, and punished if necessary. The body was essential to both individuals attempting to navigate the complex intersectional culture of the age, and to institutional authorities intent on ensuring right belief and right action, and articulating and preserving clear religious boundaries in the precarious confessional climate of the day.[162]

NOTES

1. On the distinction see Greene, *Catholic Pirates and Greek Merchants*, pp. 53–54; Braudel, *The Mediterranean*, pp. 865–69.
2. Sciberras and Stone, *Caravaggio*, p. 25; Bologna, 'Caravaggio, the final years', p. 114.
3. Buttigieg, *Nobility, Faith and Masculinity*, p. 6.
4. The text of the inquiry is contained in the Cathedral Archives of Mdina, Archives of the Inquisition of Malta [hereafter AIM], *Processi e denunzie*, b. 15B, case 117, 7 Dec 1596, cc. 869r–938v. Because of the dialectical nature of inquisitional inquiries, which often played out over months and included multiple sessions with numerous witnesses and many repeat appearances, it is not practical to refer to specific page numbers and dates. Thus, I have cited the full case file and the initital date of the case.
5. Fiume, 'Rinnegati: le imbricazioni delle relazioni mediterranee', p. 59.
6. García-Arenal, 'Les conversions d'Européens à l'islam dans l'histoire', p. 275; Elam, '"In what chapter of his bosom?"', p. 143.
7. Sawday, *The Body Emblazoned*; Porter, *Windows of the Soul*; Benveniste and Plakotos, 'Converting Bodies, Embodying Conversion'.
8. Barbierato, 'Les corps comme preuve'.

9. Peterson, *Involuntary Confessions*.
10. Bonnici, 'The Tribunal of the Inquisition in Birgu', p. 779; Barbiche, *Correspondance du nonce en France Innocenzo del Bufalo*, pp. 7–10.
11. Ciappara, '"The Date Palm and the Olive Tree"', p. 262.
12. Schutte, 'Recent Research on the Roman Inquisition', p.110; Tedeschi and Monter, 'Toward a Statistical Profile of the Italian Inquisitions', pp. 89–126.
13. Cassar, *Witchcraft, Sorcery and the Inquisition*, pp. 6–7, p. 49; Schutte, 'Recent Research on the Roman Inquisition', pp. 107–8.
14. Gambin, *Two Death Sentences*, p. 4.
15. Monter, *Frontiers of Heresy*.
16. Gambin, *Two Death Sentences*, p. 18.
17. De Montaigne, *The Essayes or, Morall, Politicke and Militarie Discourses*, p. 376; Eliav-Feldon, *Renaissance Impostors and Proofs of Identity*, p. 219.
18. Jütte, *The Age of Secrecy*, pp. vii–viii.
19. Davis, *The Return of Martin Guerre*. The most noteworthy critique of Davis is Finlay, 'The Refashioning of Martin Guerre'.
20. See for example, Ginzburg, *Il Nicodemismo*; Sommerville, 'The "new art of lying"'; Zagorin, *Ways of Lying*; Snyder, *Dissimulation and the Culture of Secrecy*; Perrie, *Pretenders and Popular Monarchism*. Zagorin's panoramic survey in 'The Historical Significance of Lying and Dissimulation' is still essential.
21. Eliav-Feldon, 'Introduction', p. 1.
22. Martin, *Myths of Renaissance Individualism*, pp. 41–61; Eliav-Feldon, 'Introduction', p. 2.
23. Martin, *Venice's Hidden Enemies*, pp. 123–46; Zagorin, *Ways of Lying*.
24. Perry, 'Behind the Veil', p. 42. Also, 'Takiyya', *Encyclopedia of Islam*, pp. 134–36.
25. Zagorin, *Ways of Lying*, pp. 38–62; Krstić, *Contested Conversions to Islam*, pp. 123–24; Eliav-Feldon, *Renaissance Impostors*, pp. 26–27.
26. Ibid., p. 3; Eliav-Feldon, 'Introduction', p. 2.
27. Davis, *The Return of Martin Guerre*, p. 63. On this generally, see Caplan and Torpey, *Documenting Individual Identity*. On the medieval and early modern roots of modern methods of identification, see Groebner, *Who Are You?*
28. Hershenzon, 'Towards a connected history of bondage in the Mediterranean', pp. 5–6.
29. Taylor, 'The Enemy Within and Without', pp. 78–99. Hess, 'The Moriscos', pp. 1–25.
30. Cassar, 'The Reformation and Sixteenth-Century Malta', p. 52.
31. Vitkus, 'Turks and Jews in *The Jew of Malta*', p. 63; Ciappara, *Society and the Inquisition*, p. 209.
32. Ciappara, 'The Date Palm and the Olive Tree', p. 255.
33. Ciappara, 'Conversion Narratives and the Roman Inquisition in Malta', p. 513; Ciappara, 'The Date Palm and the Olive Tree', pp. 257–58.
34. Fiume, *Schiavitù mediterranee*, p. 7.
35. Brogini, 'Des échanges contraints aux échanges assumés', p. 37; Ciappara, 'Christians and Muslims on Malta', pp. 208–9.
36. Brogini, 'L'esclavage au quotidien à Malte', pp. 137–38; Brogini, *Malte, frontière de chrétienté*, pp. 664–65.
37. Ciappara, 'Conversion Narratives and the Roman Inquisition in Malta', pp. 511–12; Ciappara, 'The Date Palm and the Olive Tree', p. 270.
38. Messana, 'La resistenza musulmana e i martiri dell'Islam,' pp. 746–47; Fiume, *Schiavitù mediterranee*, pp. 97–98.
39. See for example, Caffiero, 'Zone di contatto', pp. 49–68.
40. Solinas, *Inquisizione sarda nel '600 e '700*, p. 75.

41. Greene, *Catholic Pirates and Greek Merchants*, p. 19.
42. Astarita, *Between Salt Water and Holy Water,* pp. 98–99. Also, Phillips, *Slavery in Medieval and Early Modern Iberia*, pp. 71–72.
43. Hershenzon, *The Captive Sea*, pp. 70–72.
44. Buttigieg, *Nobility, Faith and Masculinity*, pp. 119–20; Buttigieg, 'The Maltese Islands and the Religious Culture of the Hospitallers', p. 44.
45. White, 'Piracy of the Ottoman Mediterranean'.
46. Hill Museum & Manuscript Library [hereafter HMML], *Archives of the Inquisition-Cathedral Archives Mdina* [hereafter AIM], *Corrispondenza*, vol. 27, 10 June 1741, cc. 86r–87v.
47. Greene, 'Beyond the Northern Invasion', p. 61.
48. HMML, AIM, *Corrispondenza*, b. 27, 10 June 1741, cc. 86r–87v.
49. Caffiero, 'Zone di contatto', pp. 58–59.
50. AIM, *Processi e denunzie*, b. 15B, case 117, 7 Dec 1596, cc. 869r–938v.
51. Groebner, 'Describing the Person, Reading the Signs', p. 24.
52. Sharkey, *A History of Muslims, Christians, and Jews in the Middle East*, pp. 310–11.
53. Jirousek, *Ottoman Dress and Design in the West*, pp. 83–88; Mantran, *Istanbul au siècle de Soliman le Magnifique*, p. 72.
54. Murphey, 'Forms of Differentiation and Expressions of Individuality in Ottoman Society', pp. 136–38.
55. Mundy, *The Travels of Peter Mundy*, pp. 26–27.
56. Schick, 'Ottoman Costume Albums in a Cross-Cultural Context', p. 625; Wilson, 'Reproducing the Contours of Venetian Identity', p. 221. See also Faroqhi and Neumann, *Ottoman Costumes: From Textile to Identity*.
57. Paresys, 'The Dressed Body', p. 227; Aksan, 'Who was an Ottoman?' p. 307.
58. Wilson, 'Reflecting on the Turk in Late Sixteenth-Century Venetian Portrait Books', p. 52.
59. AIM, *Processi e denunzie*, b. 15B, case 117, 7 Dec 1596, cc. 869r–938v.
60. Dursteler, 'Language and Identity in the Early Modern Mediterranean', p. 36, p. 47.
61. Gambin, *Two Death Sentences*, p. 9; Cassar, 'Malta: Language, Literacy, and Identity', pp. 262–66.
62. AIM, *Processi e denunzie*, b. 15B, case 117, 7 Dec 1596, cc. 869r–938v. On Orthodox fasting, see pp. 271–82; Dalby, *Siren Feasts*, p. 191; Louvaris, 'Fast and Abstinence in Byzantium'; Barbu, 'The "Emperor's Pantry"', pp. 240–43.
63. Kissane, *Food, Religion and Communities in Early Modern Europe*, pp. 13–34; Dursteler, 'The "Abominable Pig" and the "Mother of All Vices"'.
64. Caffiero, 'Zone di contatto', p. 56.
65. AIM, *Processi e denunzie*, b. 15B, case 117, 7 Dec 1596, cc. 869r–938v.
66. Rosenthal, 'Raising Hair', pp. 1–2; Eliav-Feldon, *Renaissance Impostors and Proofs of Identity*, p. 191. On gender and sexuality, Parker, 'Barbers and Barbary'; Hanß, 'Hair, Emotions and Slavery in the Early Modern Habsburg Mediterranean'; Hanß, 'Face-Work'.
67. Brummett, *Mapping the Ottomans*, p. 211; Rothman, *Brokering Empire*, p. 31 n8; Plakotos, 'Interrogating Conversion', pp. 287–88. For another example, see Archivio di stato di Venezia (hereafter ASVe), *Sant'ufficio*, b. 79, 8 Oct 1624.
68. Wheeler, 'Gift of the Body in Islam'.
69. Findley, *Enlightening Europe on Islam and the Ottomans*, p. 138.
70. Tavernier, *Les six voyages*, p. 112.
71. Landweber, 'Leaving France, "Turning Turk," Becoming Ottoman', p. 219; Ciappara, 'Christendom and Islam', pp. 183–84; Ciappara, *Society and the Inquisition*, pp. 254–56.

72. Scaraffia, *Rinnegati*, 18.
73. Perinčić, 'The Slave Trade on the Adriatic', p. 117.
74. Rothman, 'Between Venice and Istanbul', pp. 40–41.
75. Horowitz, 'The New World and the Changing Face of Europe' p. 1185; Biow, 'The Beard in Sixteenth-Century Italy', pp. 176–77; Rosenthal, 'Raising Hair', p. 3.
76. Biow, *On the Importance of Being an Individual in Renaissance Italy*, pp. 193–94.
77. ASVe, *Collegio Relazioni*, b. 5, c. 21v, 'Relatione di Maffio Venier'; Tavernier, *Les six voyages*, p. 112. Also, Rycroft, 'Hair, Beards and the Fashioning of English Manhood', p. 78.
78. Matar, *Turks, Moors, and Englishmen in the Age of Discovery*, p. 58; Biow, *On the Importance of Being an Individual in Renaissance Italy*, pp. 194–97.
79. Rosenthal, 'Raising Hair', pp. 5–6.
80. HMML, *Archives of the Inquisition-Cathedral Archives Mdina Processi, Criminali*, vol. 147B, Case 83 (Item 19), 7 Nov 1600, cc. 315r–318v.
81. AIM, *Processi e denunzie*, b. 15B, case 117, 7 Dec 1596, cc. 869r–938v.
82. Rostagno, 'Apostasia all'Islam e Santo Ufficio', p. 301; Audisio, 'Renégats marseillais', p. 33, p. 39.
83. Walker, 'Physicians and Surgeons', p. 194, p. 196; Baudry, 'Medicine and the Inquisition in Portugal', pp. 96–97; Seitz, *Witchcraft and the Inquisition*, pp. 149–62.
84. AIM, *Processi e denunzie*, b. 17, case 107, 12 Dec 1600, cc. 232r–234v; HMML, AIM, *Processi Criminali*, b. 147B, Case 73, May 1600, cc. 307r–314v. Also, Walker, 'Physicians and Surgeons', p. 196; Baudry, 'Medicine and the Inquisition in Portugal', p. 97.
85. Barbierato, 'Les corps comme preuve'; Plakotos, 'Interrogating Conversion', pp. 286–87.
86. AIM, *Processi e denunzie*, b. 15B, case 117, 7 Dec 1596, cc. 869r–938v.
87. Bouhdiba, *Sexuality in Islam*, pp. 181–82.
88. Blake, *Time in Early Modern Islam*, p. 97.
89. Giladi, 'Normative Islam versus Local Tradition', pp. 258–61.
90. Blake, *Time in Early Modern Islam*, p. 97; Lewis and Churchill, *Islam*, p. 186.
91. Graf, *The Sultan's Renegades*, p. 69.
92. Kia, *Daily Life in the Ottoman Empire*, p. 213.
93. Holmberg, *Jews in the Early Modern English Imagination*, p. 88.
94. Faroqhi, 'Crisis and Change', p. 613. The most famous of these was in 1582 for Murad III's son: Blake, *Time in Early Modern Islam*, pp. 97–99. Also, Şahin, 'Staging an Empire', pp. 463–92; Terzioğlu, 'The Imperial Circumcision Festival of 1582', pp. 84–100.
95. Krstić, *Contested Conversions to Islam*, p. 113; Graf, *The Sultan's Renegades*, p. 69.
96. Keady, '"Cleane cutte of[f]"', p. 210; Rostagno, *Mi faccio turco*, p. 54.
97. ASVe, *Sant'ufficio*, b. 98, 23 Jan 1642.
98. Fiume, 'La schiavitù mediterranea tra medioevo ed età moderna', p. 316; Messana 'La resistenza musulmana e i martiri dell'Islam', p. 762.
99. Rycaut, *The Present State of the Ottoman Empire*, p. 157.
100. Del Col, *L'Inquisizione in Italia*, p. 476.
101. Rostagno, 'Apostasia all'Islam e Santo Ufficio', p. 301; Canosa, *Storia dell'inquisizione in Italia*, pp. 76–77.
102. Glick, *Marked in Your Flesh*, p. 18; Canosa, *Storia dell'inquisizione in Italia*, pp. 108–9.
103. Degenhardt, *Islamic Conversion and Christian Resistance*, p. 131; Keady, '"Cleane cutte of[f]"', pp. 218–19. Also, Vitkus, *Three Turk Plays*, p. 5.

104. Plakotos, 'Interrogating Conversion', p. 283 n74.
105. Masters, *Christians and Jews in the Ottoman Arab World*, p. 50; Cohen, *The Missionary* Strategies, pp. 180–86.
106. Vitkus, *Turning Turk*, p. 104.
107. Dutton, 'Conversion to Islam', p. 156; Woodberry, 'Conversion in Islam', p. 22.
108. HMML, AIM, *Processi Criminali*, b. 147B, Case 83, 7 Nov 1600, cc. 315r–318v. Also Plakotos, 'Interrogating Conversion', p. 285.
109. Addison, *West Barbary*, pp. 197–98.
110. State Hermitage Museum, St Petersburg, BA 1782, 'Persiche und Arabische Miniaturen nr 114', 35r.
111. HMML, AIM, *Processi Criminali*, b. 147B, Case 73, May 1600, cc. 307r–314v.
112. HMML, AIM, *Processi Criminali*, b. 147A, Case 61 (Item 1), 14 Oct 1599, cc. 1r–v.
113. AIM, *Processi e denunzie*, b. 16A, case 25, 5 Oct 1598, cc. 223r–225v.
114. Canosa, *Storia dell'inquisizione in Italia*, pp. 76–77.
115. AIM, *Processi e denunzie*, b. 15B, case 117, 7 Dec 1596, cc. 869r–938v.
116. Starr-LeBeau, 'Gendered Investigations', p. 354, pp. 356–58.
117. Holmberg, *Jews in the Early Modern English Imagination*, p. 90; Kraemer, *Unreliable Witnesses*, p. 183, pp. 198–99.
118. Ciappara, 'Conversion Narratives', p. 512.
119. Borg-Muscat, 'Prison life in Malta', pp. 42–45.
120. AIM, *Processi e denunzie*, b. 16A, case 35, Jan–Feb 1599, cc. 251r–263r.
121. For another example, see ASVe, *Sant'ufficio*, b. 123, 24 Mar 1684. For a parallel example of another male renegade, see HMML, AIM, *Processi Criminali*, b. 146, Case 68, 20 Oct 1598, cc. 67r–76v.
122. Cassar, *Society, Culture and Identity*, p. 143.
123. Cassar, 'The Reformation and Sixteenth-Century Malta', p. 52; Fiorini, 'The Resettlement of Gozo', pp. 204–6; Vella, *The Earliest Church*, xviii–xx.
124. AIM, *Processi e denunzie*, b. 16A, case 35, Jan–Feb 1599, cc. 251r–263r. A Vincent Cumbo is listed in the Gozo baptismal registers as the father of Ambrose born in 1598. No mother is listed. Vella, *The Earliest Church*, p. 22.
125. Fiorini, 'The Resettlement of Gozo', pp. 228–30.
126. Pozzo, *Historia della sacra religione militare*, pp. 242–43; Samut-Tagliaferro, *The Coastal Fortifications*, p. 26; Fiorini, 'The Resettlement of Gozo', p. 224. I thank Emanuel Buttigieg and his student, Fleur Brincat, for this information.
127. AIM, *Processi e denunzie*, b. 16A, case 35, Jan–Feb 1599, cc. 251r–263r.
128. Ibid.
129. Ibid.
130. Wilson, 'Reproducing the Contours of Venetian Identity', p. 264.
131. See for example Rogers, *Law's Cut on the Body*, pp. 38–41.
132. Berkey, 'Circumcision Circumscribed', p. 19.
133. Abusharaf, 'Introduction', pp. 2–3.
134. Giladi, 'Normative Islam', pp. 261–64.
135. Dankoff, *An Ottoman Mentality*, p. 61; Dankoff and Kim, *An Ottoman Traveller*, pp. 29–30, pp. 409–10.
136. Hatem, 'The Professionalization of Health', pp. 76–77.
137. Sciascia, *Il teatro della memoria*.
138. Clark, *Vanities of the Eye*, pp. 9–10; Smith, *Sensing the Past*, pp. 19–40.
139. Maifreda, *The Business of the Roman Inquisition*, pp. 194–95. See also Frisch, *The Invention of the Eyewitness*.

140. Groebner, 'Complexio/complexion', p. 373; Wilson, '"The Confusion of Faces",' pp. 179–80; Ziegler, 'Physiognomy, science, and proto-racism 1200–1550', p. 199.
141. Dauge-Roth, *Signing the Body*, p. 5.
142. Eliav-Feldon, *Renaissance Impostors and Proofs of Identity*, pp. 160–61; Groebner, 'Complexio/complexion', pp. 374–76.
143. AIM, *Processi e denunzie*, b. 16A, case 35, Jan–Feb 1599, cc. 251r–263r.
144. Ibid.
145. Degenhardt, *Islamic Conversion and Christian Resistance*, p. 12, pp. 58–61.
146. Vitkus, 'Early Modern Orientalism', pp. 224–25; Matar, *Mediterranean Captivity through Arab Eyes*, p. 39; Groebner, 'The Carnal Knowing of A Coloured Body', p. 226.
147. Matthews Grieco, 'The Body, Appearance, and Sexuality', p. 58, p. 62.
148. AIM, *Processi e denunzie*, b. 16A, case 35, Jan–Feb 1599, cc. 251r–263r.
149. Ibid.
150. Porter, *Windows of the Soul*, p. viii.
151. AIM, *Processi e denunzie*, b. 16A, case 35, Jan–Feb 1599, cc. 251r–263r.
152. Seitz, *Witchcraft, Demonology, and Confession*, p. 53, pp. 73–74.
153. Schutte, *Aspiring Saints*.
154. Starr-LeBeau, 'Gendered Investigations', p. 357.
155. AIM, *Processi e denunzie*, b. 16A, case 35, Jan–Feb 1599, cc. 251r–263r.
156. Starr-LeBeau, 'Gendered Investigations', p. 364.
157. AIM, *Processi e denunzie*, b. 16A, case 35, Jan–Feb 1599, cc. 251r–263r.
158. AIM, *Processi e denunzie*, b. 16A, case 35, 20 Jan 1599, cc. 251r–263r.
159. García-Arenal, 'Facing Uncertainty in Early Modern Iberia', p. 9.
160. Wilson, 'Reproducing the Contours of Venetian Identity', p. 229.
161. Aksan, 'Who was an Ottoman?' p. 305.
162. Davis, *The Return of Martin Guerre*, p. 63.

WORKS CITED

Abusharaf, Rogaia Mustafa, 'Introduction: The Custom in Question', in Rogaia Mustafa Abusharaf (ed.), *Female Circumcision: Multicultural Perspectives*, (Philadelphia: University of Pennsylvania Press, 2006).

Addison, Lancelot, *West Barbary, or, A short narrative of the revolutions of the kingdoms of Fez and Morocco* (Oxford: John Wilmot, 1671).

Aksan, Virginia, 'Who was an Ottoman? Reflections on "Wearing Hats" and "Turning Turk",' in Barbara Schmidt-Haberkamp (ed.), *Europa und die Türkei im 18. Jahrhundert / Europe and Turkey in the 18th Century*, (Bonn: V&R unipress, 2011).

Archivio di stato di Venezia, *Sant'ufficio*, b. 98, 23 Jan 1642.

Astarita, Tommaso, *Between Salt Water and Holy Water: A History of Southern Italy* (New York: W.W. Norton & Company, 2005).

Audisio, Gabriel, 'Renégats marseillais (1591–1595)', *Renaissance and Reformation* 28.3 (1992).

Barbiche, Bernard (ed.), *Correspondance du nonce en France Innocenzo del Bufalo, évêque de Camerino, 1601–1604* (Rome: Presses de l'Université Grégorienne, 1964).

Barbierato, Federico, 'Les corps comme preuve. Médecins et inquisiteurs dans les pratiques judiciaires du Saint-Office', *L'Atelier du Centre de recherches historiques* [En ligne], 11 | 2013, mis en ligne le 08 juillet 2013, consulté le 05 juillet 2020. URL: http://journals.openedition.org/acrh/5223; DOI: https://doi.org/10.4000/acrh.5223.

Barbu, Violeta, 'The "Emperor's Pantry": Food, Fasting and Feasting in Wallachia

(17th–18th Centuries)', in *Earthly Delights: Economies and Cultures of Food in Ottoman and Danubian Europe, c. 1500–1900*, (Leiden: Brill, 2018).

Baudry, Hervé, 'Medicine and the Inquisition in Portugal (Sixteenth and Seventeenth Centuries): People and Books', in Maria Pia Donato (ed.), *Medicine and the Inquisition in the Early Modern World* (Leiden: Brill, 2019).

Benveniste, Henriette-Rika, and Giorgos Plakotos, 'Converting Bodies, Embodying Conversion: The Production of Religious Identities in Late Medieval and Early Modern Europe', in Yaniv Fox and Yosi Yisraeli (eds), *Contesting Inter-Religious Conversion in the Medieval World* (London: Routledge, 2017).

Berkey, Jonathan P., 'Circumcision Circumscribed: Female Excision and Cultural Accommodation in the Medieval Near East', *International Journal of Middle East Studies* 28 (1996).

Biow, Douglas, 'The Beard in Sixteenth-Century Italy', in Julia L. Hairston and Walter Stephens (eds) *The Body in Early Modern Italy* (Baltimore: Johns Hopkins University Press, 2010).

———, *On the Importance of Being an Individual in Renaissance Italy: Men, Their Professions, and Their Beards* (Philadelphia: University of Pennsylvania Press, 2015).

Blake, Stephen P., *Time in Early Modern Islam: Calendar, Ceremony, and Chronology in the Safavid, Mughal and Ottoman Empires* (Cambridge: Cambridge University Press, 2013).

Bonnici, Alexander, 'The Tribunal of the Inquisition in Birgu', in Lino Bugeja, Mario Buhagiar and Stanley Fiorini (eds), *Birgu: A Maltese Maritime City*, vol. 2 *Artistic, Architectural and Ecclesiastical Aspects* (Msida: Malta University Services, 1993).

Bologna, Ferdinando, 'Caravaggio, the final years (1606–1610)', in Silvia Cassani and Maria Sapio (eds), *Caravaggio: The Final Years* (Naples: Electra, 2005).

Borg-Muscat, David, 'Prison life in Malta in the 18th Century: Valletta's *Gran Prigione*', *Storja 2001* (Malta: University of Malta, 2001).

Bouhdiba, Abdelwahab, *Sexuality in Islam* (Abingdon: Routledge, 2008).

Braudel, Fernand, *The Mediterranean and the Mediterranean World in the Age of Philip II*, vol. 2 (Berkeley: University of California Press, 1995).

Brogini, Anne, 'Des échanges contraints aux échanges assumés. Malte et la Régence de Tunis dans la première modernité', *Cahiers de la Méditerranée* 84 (2012).

———, 'L'esclavage au quotidien à Malte au xvie siècle', *Cahiers de la Méditerranée* 65 (2002).

———, *Malte, frontière de chrétienté (1530–1670)* (Rome: École française de Rome, 2005).

Brummett, Palmira, *Mapping the Ottomans: Sovereignty, Territory, and Identity in the Early Modern Mediterranean* (Cambridge: Cambridge University Press, 2015).

Buttigieg, Emanuel, 'The Maltese Islands and the Religious Culture of the Hospitallers: Isolation and Connectivity c.1540s–c.1690s', in Emanuel Buttigieg and Simon Phillips (eds), *Islands and Military Orders, c.1291–c.1798* (London: Routledge, 2016).

———, *Nobility, Faith and Masculinity: The Hospitaller Knights of Malta, c.1580–c.1700* (London: Continuum, 2011).

Caffiero, Marina, 'Zone di contatto. Da Cipro a Malta: la doppia identità di Melena/ Maria, tra islam e cristianesimo', *Bollettino della Società di Studi Valdesi* 17 (December 2015), pp. 49–68.

Canosa, Romano. *Storia dell'inquisizione in Italia dalla metà del cinquecento alla fine del settecento*, Angelo Ruggieri (ed.), vol. 2, *Venezia* (Rome: Sapere, 1999).

Caplan, Jane, and John Torpey (eds), *Documenting Individual Identity: The Development of State Practices in the Modern World* (Princeton: Princeton University Press, 2001).

Cassar, Carmel, 'Malta: Language, Literacy, and Identity in a Mediterranean Island Society', *National Identities* 3 (2001).

_____, 'The Reformation and Sixteenth-Century Malta', *Melita Historica* 10 (1988).

_____, *Society, Culture and Identity in Early Modern Malta* (Msida: Mireva, 2000).

_____, *Witchcraft, Sorcery and the Inquisition: A Study of Cultural Values in Early Modern Malta* (Msida: Mireva, 1996).

Cathedral Archives of Mdina, Archives of the Inquisition of Malta [hereafter AIM], *Processi e denunzie*, b. 15B, 16A, 17.

Ciappara, Frans, 'Christendom and Islam: A Fluid Frontier', *Mediterranean Studies* 13 (2004).

_____, 'Christians and Muslims on Malta in the Sixteenth to Eighteenth Centuries', in Charlotte Methuen, Andrew Spicer and John Wolffe (eds), *Christianity and Religious Plurality* (Woodbridge: Boydell and Brewer, 2015).

_____, 'Conversion Narratives and the Roman Inquisition in Malta, 1650–1700', *Journal of Religious History* 40 (2016).

_____, '"The Date Palm and the Olive Tree:" Safeguarding the Catholic Frontier in Malta (c.1595–c.1605)', in Dionisius A. Agius (ed.), *Georgio Scala and the Moorish Slaves: The Inquisition Malta 1598* (Santa Venera: Midsea Books, 2013).

_____, *Society and the Inquisition in Early Modern Malta* (San Gwann: Publishers Enterprises Group, 2001).

Clark, Stuart, *Vanities of the Eye: Vision in Early Modern European Culture* (Oxford: Oxford University Press, 2007).

Cohen, Leonardo, *The Missionary Strategies of the Jesuits in Ethiopia (1555–1632)* (Wiesbaden: Harrassowitz, 2009).

Dalby, Andrew, *Siren Feasts: A History of Food and Gastronomy in Greece* (London: Routledge, 1996).

Dankoff, Robert, *An Ottoman Mentality: The World of Evliya Çelebi* (Leiden: Brill, 2006).

Dankoff, Robert, and Sooyong Kim trans. and eds, *An Ottoman Traveller: Selections from the Book of Travels of Evliya Çelebi* (London: Eland Publishing, 2010).

Davis, Natalie Zemon, *The Return of Martin Guerre* (Cambridge: Harvard University Press, 1984).

Dauge-Roth, Katherine, *Signing the Body: Marks on Skin in Early Modern France.* (London: Routledge, 2019).

Degenhardt, Jane Hwang, *Islamic Conversion and Christian Resistance on the Early Modern Stage* (Edinburgh: Edinburgh University Press, 2010).

Del Col, Andrea. *L'Inquisizione in Italia: dal XII al XXI secolo* (Milan: Mondadori, 2006).

Dursteler, Eric R., 'The "Abominable Pig" and the "Mother of All Vices": Pork, Wine and the Culinary Clash of Civilizations in the Early Modern Mediterranean', in Julia Hauser, Kirill Dmitriev, and Bilal Orfali (eds), *Insatiable Appetite: Food as a Cultural Signifier* (Leiden: Brill, 2019).

_____, 'Language and Identity in the Early Modern Mediterranean', in John Watkins and Kathryn Reyerson (eds), *Mediterranean Identities in the Premodern Era – Islands, Entrepôts, Empires* (Farnham: Ashgate, 2014).

Dutton, Yasin, 'Conversion to Islam: the Qur'anic paradigm', in Christopher Lamb and M. Darrol Bryant (eds), *Religious Conversion: Contemporary Practices and Controversies* (London: Cassell, 1999).

Elam, Keir, '"In what chapter of his bosom?": Reading Shakespeare's Bodies', in Terence Hawkes (ed.), *Alternative Shakespeares,* vol. 2 (London: Routledge, 1996).

Eliav-Feldon, Miriam, 'Introduction', in *Dissimulation and Deceit in Early Modern*

Europe, Miriam Eliav-Feldon and Tamar Herzig (eds) (Houndmills: Palgrave Macmillan, 2015).

_____, *Renaissance Impostors and Proofs of Identity* (Houndmills: Palgrave Macmillan, 2012).

Encyclopedia of Islam, H. A. R. Gibbs, et al, new edition (Leiden: Brill, 1979–), 10: pp. 134–36, s.v. 'Takiyya'.

Faroqhi, Suraiya, 'Crisis and Change, 1590–1699', in *An Economic and Social History of the Ottoman Empire*, Halil İnalcık and Donald Quataert (eds), vol. 2 (Cambridge: Cambridge University Press, 1994).

Faroqhi, Suraiya, and Christoph K. Neumann (eds), *Ottoman Costumes: From Textile to Identity* (Istanbul: Eren, 2004).

Findley, Carter Vaughn, *Enlightening Europe on Islam and the Ottomans: Mouradgea d'Ohsson and His Masterpiece* (Leiden: Brill, 2019).

Finlay, Robert, 'The Refashioning of Martin Guerre', *American Historical Review* 93 (1988).

Fiorini, Stanley, 'The Resettlement of Gozo after 1551', *Melita Historica* 9.3 (1986).

Frisch, Andrea. *The Invention of the Eyewitness: Witnessing and Testimony in Early Modern France* (Chapel Hill: University of North Carolina Press, 2004.

Fiume, Giovanna, 'Rinnegati: le imbricazioni delle relazioni mediterranee', in *Identidades cuestionadas: Coexistencia y conflictos interreligiosos en el Mediterráneo (ss. XIV–XVIII)*, Borja Franco Llopis, Bruno Pomara Saverino, Manuel Lomas Cortés, and Bárbara Ruiz Bejarano (eds) (València: Universitat de València, 2016).

_____, 'La schiavitù mediterranea tra medioevo ed età moderna. Una proposta bibliografica', *Estudis. Revista de Historia Moderna* 41 (2015).

_____, *Schiavitù mediterranee: Corsari, rinnegati e santi di età moderna* (Milan: Bruno Mondadori, 2009).

Gambin, Kenneth, *Two Death Sentences by the Inquisition Tribunal of Malta, 1639* (Santa Venera: Midsea Books, 2006).

García-Arenal, Mercedes, 'Les conversions d'Européens à l'islam dans l'histoire: esquisse générale', *Social Compass* 46 (1999).

_____, 'Facing Uncertainty in Early Modern Iberia', in *Quest for Certainty in Early Modern Europe: From Inquisition to Inquiry, 1550–1700*, Barbara Fuchs and Mercedes García-Arenal (eds) (Toronto: University of Toronto Press, 2020).

Giladi, Avner, 'Normative Islam versus Local Tradition: Some Observations on Female Circumcision with Special Reference to Egypt', *Arabica* 44.2 (1997).

Ginzburg, Carlo, *Il Nicodemismo: simulazione e dissimulazione religiosa nell'Europa del '500* (Turin: Einaudi, 1970).

Glick, Leonard B., *Marked in Your Flesh: Circumcision from Ancient Judea to Modern America* (Oxford: Oxford University Press, 2005).

Graf, Tobias P., *The Sultan's Renegades: Christian-European Converts to Islam and the Making of the Ottoman Elite, 1575–1610* (Oxford: Oxford University Press, 2017).

Greene, Molly, 'Beyond the Northern Invasion: The Mediterranean in the Seventeenth Century', *Past & Present* 174 (2002).

_____, *Catholic Pirates and Greek Merchants: A Maritime History of the Early Modern Mediterranean* (Princeton: Princeton University Press, 2010).

Groebner, Valentin, 'The Carnal Knowing of a Coloured Body: Sex and Skin Colour in the Middle Ages', in *The Origins of Racism in the West*, Miriam Eliav-Feldon, Benjamin Isaac and Joseph Ziegler (eds) (Cambridge: Cambridge University Press, 2009).

_____, 'Complexio/complexion: Categorizing Individual Natures 1250–1600', in *The*

Moral Authority of Nature, Lorraine Daston and Fernando Vidal (eds) (Chicago: University of Chicago Press, 2003).

———, 'Describing the Person, Reading the Signs in Late Medieval and Renaissance Europe: Identity Papers, Vested Figures, and the Limits of Identification 1400–1600', in *Documenting Individual Identity: The Development of State Practices in the Modern World*, Jane Caplan and John Torpey (eds) (Princeton: Princeton University Press, 2001).

———, *Who Are You? Identification, Deception, and Surveillance in Early Modern Europe*, trans. Mark Kyburz and John Peck (New York: Zone Books, 2007).

Hanß, Stefan, 'Face-Work: Making Hair Matter in Sixteenth-Century Central Europe', *Gender & History* 33 (2021).

——— 'Hair, Emotions and Slavery in the Early Modern Habsburg Mediterranean', *History Workshop Journal* 87 (2019).

Hatem, Mervat F., 'The Professionalization of Health and the Control of Women's Bodies as Modern Governmentalities in Nineteenth-century Egypt', in Madeline C. Zilfi (ed.), *Women in the Ottoman Empire: Middle Eastern Women in the Early Modern Era* (Leiden: Brill, 1997).

Hershenzon, Daniel, *The Captive Sea: Slavery, Communication, and Commerce in Early Modern Spain and the Mediterranean* (Philadelphia: University of Pennsylvania Press, 2018).

———, 'Towards a Connected History of Bondage in the Mediterranean: Recent Trends in the Field', *History Compass* 15.8 (2017).

Hess, Andrew C., 'The Moriscos: An Ottoman Fifth Column in Sixteenth-Century Spain', *American Historical Review* 75 (1968).

Hill Museum & Manuscript Library, *Archives of the Inquisition-Cathedral Archives Mdina, Corrispondenza*, vol. 27.

Hill Museum & Manuscript Library, *Archives of the Inquisition-Cathedral Archives Mdina Processi Criminali*, vol. 147A, 147B.

Holmberg, Eva Johanna, *Jews in the Early Modern English Imagination: A Scattered Nation* (London: Routledge, 2016).

Horowitz, Elliott, 'The New World and the Changing Face of Europe', *Sixteenth Century Journal* 28 (1997).

Jirousek, Charlotte A., *Ottoman Dress and Design in the West: A Visual History of Cultural Exchange* (Bloomington: Indiana University Press, 2019).

Jütte, Daniel, *The Age of Secrecy: Jews, Christians, and the Economy of Secrets, 1400–1800*, trans. Jeremiah Riemer (New Haven: Yale University Press, 2015).

Keady, Marion Ann, '"Cleane cutte of[f]:" Circumcision and Identity in Early Modern English Barbary Captivity Narratives', *Études anglaises* 70 (2017).

Kia, Mehrdad, *Daily Life in the Ottoman Empire* (Santa Barbara: Greenwood, 2011).

Kissane, Christopher, *Food, Religion and Communities in Early Modern Europe* (London: Bloomsbury, 2018).

Kraemer, Ross Shepard, *Unreliable Witnesses: Religion, Gender, and History in the Greco-Roman Mediterranean* (Oxford: Oxford University Press, 2011).

Krstić, Tijana, *Contested Conversions to Islam: Narratives of Religious Change in the Early Modern Ottoman Empire* (Stanford: Stanford University Press, 2011).

Landweber, Julia, 'Leaving France, "Turning Turk," Becoming Ottoman: The transformation of Comte Claude-Alexandre de Bonneval into Humbaraci Ahmed Pasha,' in *Living in the Ottoman Realm: Everyday Life and Identity from the 13th to 20th Centuries*, Christine Isom-Verhaaren and Kent F. Schull (eds) (Bloomington: Indiana University Press, 2016).

Lewis, Bernard, and Buntzie Ellis Churchill, *Islam: The Religion and the People* (Upper Saddle River: Pearson, 2009).

Louvaris, Athanasius, 'Fast and Abstinence in Byzantium', in *Feast, Fast or Famine: Food and Drink in Byzantium*, Wendy Mayer and Silke Trzcionka (eds) (Leiden: Brill, 2005).

Maifreda, Germano, *The Business of the Roman Inquisition in the Early Modern Era* (New York: Routledge, 2017).

Mantran, Robert, *Istanbul au siècle de Soliman le Magnifique* (Paris: Hachette, 1994).

Martin, John Jeffries, *Myths of Renaissance Individualism* (Houndmills: Palgrave Macmillan, 2006).

_____, *Venice's Hidden Enemies: Italian Heretics in a Renaissance City* (Berkeley: University of California Press, 1993).

Masini, Eliseo. *Sacro arsenale, ovvero Pratica dell'Uffizio della Santa Inquisizione.* (Rome: Stamperia di S. Michele in Ripa, 1730).

Masters, Bruce, *Christians and Jews in the Ottoman Arab World: The Roots of Sectarianism* (Cambridge: Cambridge University Press, 2004).

Matar, Nabil, *Mediterranean Captivity through Arab Eyes, 1517–1798* (Leiden: Brill, 2021).

_____, *Turks, Moors, and Englishmen in the Age of Discovery* (New York: Columbia University Press, 1999).

Matthaiou, Anna, 'Διαιτητικές ἀπαγορεύσεις στήν τουρκοκρατία [Diaititikés ápagoréfseis stín tourkokratía]', *Τα Ιστορικά [Ta Historika]* 21 (1994).

Matthews Grieco, Sara F., 'The Body, Appearance, and Sexuality', in *A History of Women in the West*, vol. 3 *Renaissance and Enlightenment Paradoxes*, Natalie Davis and Arlene Farge (eds) (Cambridge: Harvard University Press, 1993).

Messana, Maria Sofia, 'La resistenza musulmana e i martiri dell'Islam: moriscos, schiavi e cristiani rinnegati di fronte all'inquisizione spagnola di Sicilia', *Quaderni storici* 42 (2007).

Michel de Montaigne, *The Essayes or, Morall, Politicke and Militarie Discourses of Lord Michael de Montaigne*, 3rd ed. (London: M. Flesher, 1632).

Monter, William, *Frontiers of Heresy: The Spanish Inquisition from the Basque Lands to Sicily* (Cambridge: Cambridge University Press, 1990).

Mundy, Peter, *The Travels of Peter Mundy, in Europe and Asia, 1608–1667*, vol. 1., ed. Richard Carnac Temple. (Cambridge: Hakluyt Society, 1907.)

Murphey, Rhoads, 'Forms of Differentiation and Expressions of Individuality in Ottoman Society', *Turcica* 34 (2002).

Paresys, Isabelle, 'The Dressed Body: The Moulding of Identities in Sixteenth-Century France', in William Monter (ed.), *Cultural Exchange in Early Modern Europe*, vol. 4, Forging European Identities, 1400–1700 (Cambridge: Cambridge University Press, 2006).

Parker, Patricia, 'Barbers and Barbary: Early Modern Cultural Semantics', *Renaissance Drama* 33 (2004).

Perinčić, Tea, 'The Slave Trade on the Adriatic in the 17th Century', *Miscellanea Hadriatica et Mediterranea* 1 (2013).

Perrie, Maureen, *Pretenders and Popular Monarchism in Early Modern Russia: The False Tsars of the Time of Troubles* (Cambridge: Cambridge University Press, 1995).

Perry, Mary Elizabeth, 'Behind the Veil: Moriscas and the Politics of Resistance and Survival', in *Spanish Women in the Golden Age: Images and Realities*, Magdalena S. Sanchez and Alain Saint-Saens (eds) (Westport: Greenwood Press, 1996).

Peterson, Nora Martin, *Involuntary Confessions of the Flesh in Early Modern France* (Newark: University of Delaware Press, 2016).

Phillips, William D., *Slavery in Medieval and Early Modern Iberia* (Philadelphia: University of Pennsylvania Press, 2014).

Plakotos, Giorgos, 'Interrogating Conversion: Discourses and Practices in the Venetian Inquisition (Sixteenth–Seventeenth Centuries)', in *The Roman Inquisition: Centre versus Peripheries*, Katherine Aron-Beller and Christopher Black (eds) (Leiden: Brill, 2018).

Porter, Martin, *Windows of the Soul: Physiognomy in European Culture 1470–1780* (Oxford: Clarendon Press, 2005).

Pozzo, Bortolameo dal, *Historia della sacra religione militare di S. Giouanni Gerosolimitano detta di Malta*, vol. 1 (Verona: Giovanni Berno, 1703).

Rogers, Juliet, *Law's Cut on the Body of Human Rights: Female Circumcision, Torture and Sacred Flesh* (Abingdon: Routledge, 2013).

Rosenthal, Angela, 'Raising Hair', *Eighteenth-Century Studies* 38 (2004).

Rostagno, Lucia, 'Apostasia all'Islam e Santo Ufficio in un processo dell'Inquisizione veneziana', *Il Veltro* 23 (1979).

_____, *Mi faccio turco: esperienze ed immagini dell'islam nell'Italia moderna* (Rome: Istituto per l'oriente C.A. Nallino, 1983).

Rothman, Ella-Natalie, 'Between Venice and Istanbul: Trans-Imperial Subjects and Cultural Mediation in the Early Modern Mediterranean', diss. University of Michigan, 2006.

Rothman, E. Natalie, *Brokering Empire: Trans-Imperial Subjects Between Venice and Istanbul* (Ithaca: Cornell University Press, 2012).

Rycroft, Eleanor, 'Hair, Beards and the Fashioning of English Manhood in Early Modern Travel Texts', in Jennifer Evans and Alun Withey (eds) *New Perspectives on the History of Facial Hair: Framing the Face* (London: Palgrave Macmillan, 2018).

Rycaut, Paul, *The Present State of the Ottoman Empire* (London: John Starkey and Henry Brome, 1670).

Şahin, Kaya, 'Staging an Empire: An Ottoman Circumcision Ceremony as Cultural Performance', *American Historical Review* 123 (2018): 463–492.

Samut-Tagliaferro, A., *The Coastal Fortifications of Gozo and Comino* (Santa Venera: Midsea Books, 1993).

Sawday, Jonathan, *The Body Emblazoned: Dissection and the Human Body in Renaissance Culture* (London: Routledge, 1995).

Scaraffia, Lucetta, *Rinnegati: Per una storia dell'identità occidentale* (Rome-Bari: Laterza, 1993).

Schick, Leslie Meral, 'Ottoman Costume Albums in a Cross-Cultural Context', in *Turkish Art 10th International Congress of Turkish Art 17–23 September 1995 Proceedings* (Geneva: Fondation Max Van Berchem, 1999).

Schutte, Anne Jacobsen, *Aspiring Saints: Pretense of Holiness, Inquisition, and Gender in the Republic of Venice, 1618–1750* (Baltimore: Johns Hopkins University Press, 2001).

_____, 'Recent Research on the Roman Inquisition: The Emergence of a New Paradigm', in *Politics and Reformations; History and Reformations. Essays in Honour of Thomas A. Brady, Jr.*, Christopher Ocker, Michael Printy, Peter Starenko, and Peter Wallace (eds) (Leiden: Brill 2007).

Sciascia, Leonardo, *Il teatro della memoria* (Turin: Einaudi, 1981).

Sciberras, Keith and David M. Stone, *Caravaggio: Art, Knighthood, and Malta* (Valletta: Midsea Books, 2006).

Seitz, Jonathan, *Witchcraft and the Inquisition in Early Modern Venice* (Cambridge: Cambridge University Press, 2011).

Seitz, Virginia Krause, *Witchcraft, Demonology, and Confession in Early Modern France* (Cambridge: Cambridge University Press, 2015).

Sharkey, Heather J., *A History of Muslims, Christians, and Jews in the Middle East* (Cambridge: Cambridge University Press, 2017).

Smith, Mark M., *Sensing the Past: Seeing, Hearing, Smelling, Tasting, and Touching in History* (Berkeley: University of California Press, 2007).

Snyder, Jon R., *Dissimulation and the Culture of Secrecy in Early Modern Europe* (Berkeley: University of California Press, 2009).

Solinas, Luigi, *Inquisizione sarda nel '600 e '700: denunce al Santo Officio* (Dolianova: Grafica del Parteolla, 2005).

Sommerville, Johann P., 'The "new art of lying": equivocation, mental reservation, and casuistry', in Edmund Leites (ed.), *Conscience and Casuistry in Early Modern Europe*, (Cambridge: Cambridge University Press, 1988).

Starr-LeBeau, Gretchen, 'Gendered Investigations in Roman Inquisitional Tribunals', in *The Roman Inquisition: Centre versus Peripheries*, Katherine Aron-Beller and Christopher Black (eds) (Leiden: Brill, 2018).

State Hermitage Museum, St Petersburg, BA 1782, 'Persiche und Arabische Miniaturen nr 114'.

Strothmann, Rudolf, and Moktar Djebli, 'Takiyya', in *Encyclopaedia of Islam*, 2nd ed., eds. P. J. Bearman, et al. (Leiden: Brill, 2000), 10: pp. 134–36.

Tavernier, Jean-Baptiste, *Les six voyages de Jean Baptiste Tavernier, Ecuyer Baron d'Aubonne, qu'il a fait en Turquie, en Perse, et aux Indes ...*, vol. 1 (Paris: Gervais Clouzier and Claude Barbin, 1676).

Taylor, Bruce, 'The Enemy Within and Without: An Anatomy of Fear on the Spanish Mediterranean Littoral', in *Fear in Early Modern Society*, William G. Naphy and Penny Roberts (eds) (Manchester: Manchester University Press, 1997).

Tedeschi, John, and William Monter, 'Toward a Statistical Profile of the Italian Inquisitions, Sixteenth to Eighteenth Centuries', in *The Prosecution of Heresy: Collected Studies on the Inquisition in Early Modern Italy* (Binghamton: Medieval and Renaissance Texts and Studies, 1991), pp. 89–126.

Terzioğlu, Derin, 'The Imperial Circumcision Festival of 1582: An Interpretation', *Muqarnas* 12 (1995).

Vella, Horatio C. R., *The Earliest Church Register in Gozo: 1554–1628* (Qormi: Print Right, 2010).

Vitkus, Daniel J., 'Early Modern Orientalism: Representations of Islam in Sixteenth- and Seventeenth-Century Europe', in *Western Views of Islam in Medieval and Early Modern Europe: Perception of Other*, David R. Blanks and Michael Frassetto (eds) (New York: St. Martin's Press, 1999).

——, *Three Turk Plays from Early Modern Period: Selimus, A Christian Turned Turk, and The Renegado* (New York: Columbia University Press, 2000).

——, 'Turks and Jews in *The Jew of Malta*', in *Early Modern English Drama: A Critical Companion*, Garrett A. Sullivan, Jr., Patrick Cheney, and Andrew Hadfield (eds) (Oxford: Oxford University Press, 2006).

——, *Turning Turk: English Theater and the Multicultural Mediterranean, 1570–1630* (New York: Palgrave Macmillan, 2003).

Walker, Timothy D., 'Physicians and Surgeons in the Service of the Portuguese Inquisition: Twelve Years After', in Maria Pia Donato (ed.), *Medicine and the Inquisition in the Early Modern World* (Leiden: Brill, 2019).

Wheeler, Brannon, 'Gift of the Body in Islam: The Prophet Muhammad's Camel Sacrifice and Distribution of Hair and Nails at his Farewell Pilgrimage', *Numen* 57 (2010).

White, Joshua M., 'Piracy of the Ottoman Mediterranean: Slave Laundering and Subjecthood', in Judith E. Tucker (ed.), *The Making of the Modern Mediterranean: Views from the South* (Berkeley: University of California Press, 2019).

Wilson, Bronwen, '"The Confusion of Faces": The Politics of Physiognomy, Concealed Hearts, and Public Visibility', in Bronwen Wilson and Paul Yachnin (eds), *Making Publics in Early Modern Europe: People, Things, Forms of Knowledge* (London: Routledge, 2010).

———, 'Reflecting on the Turk in Late Sixteenth-Century Venetian Portrait Books', *Word and Image* 19 (2003).

———, 'Reproducing the Contours of Venetian Identity in Sixteenth-Century Costume Books', *Studies in Iconography* 25 (2004).

Woodberry, J. Dudley, 'Conversion in Islam', in *Handbook of Religious Conversion*, H. Newton Malony and Samuel Southard (eds) (Birmingham, AL: Religious Education Press, 1992).

Zagorin, Perez, *Ways of Lying: Dissimulation, Persecution, and Conformity in Early Modern Europe* (Cambridge: Harvard University Press, 1990).

———, 'The Historical Significance of Lying and Dissimulation', *Social Research* 63 (1996).

———, *Ways of Lying: Dissimulation, Persecution, and Conformity in Early Modern Europe* (Cambridge: Harvard University Press, 1990).

Ziegler, 'Physiognomy, science, and proto-racism 1200–1550', in Miriam Eliav-Feldon, Benjamin Isaac and Joseph Ziegler (eds), *The Origins of Racism in the West* (Cambridge: Cambridge University Press, 2009).

12

WHAT MACHINES CANNOT DO: A LEIBNIZIAN ANIMADVERSION

Justin Smith

Ich will eine Maschine sein – Arme zu greifen, Beine zu gehen, kein Schmerz, kein Gedanke.

– Heiner Müller, *Hamletmaschine* (1977)

1.

In the 'China brain' thought experiment, articulated by Lawrence Davis in 1974[1] and then again by Ned Block in 1978,[2] each citizen of China is imagined playing the role of a single neuron, using telecommunication devices to connect them to one another in the same way that axons and dendrites connect the neurons of the brain together. In such a scenario, would China itself become conscious? In 1980, in turn, John Searle imagined the 'Chinese room', which was meant to show the falsehood of 'strong AI', that is, of the view that machines can never be made to literally understand anything.[3] A machine that could be shown to convincingly display 'understanding' of Chinese would be indistinguishable from a room in which Searle himself, or some other human being, was holed up, receiving sentences in good Chinese written on paper and passed through a slit in the wall, to which he would then respond, in equally good Chinese, by simply consulting various reference works available in the room. But Searle assures us that he does not himself understand Chinese. Therefore, the machine does not either.

It is difficult not to wonder: What is it with China, exactly, in analytic philosophy's thought experiments, which is to say fantasies, about automated thinking? Why choose this nation in particular? It is not enough to say that only China has, or had forty years ago, a population large enough to simulate the human brain: the human brain has around 100 billion neurons, and so the world's most populous nation is only about one percent of the way to being able to furnish one person per neuron. Given this shortage, it would have made just as much sense to let each citizen of Estonia, say, stand in for ten thousand neurons, as have each citizen of China stand in for one hundred. Or the experiment could have been imagined in a cosmopolitan vein, with each human being alive contributing to the 'earth brain' – a scenario which would have brought us at least a small step closer to a one-one correspondence between people and neurons. In the case of the Chinese room, Searle seems to have chosen this language in particular because he could attest that he did not know a single word of it. But nor does he know a word of Yukaghir or Tupi, and yet a moment's reflexion is enough to see that using one of these languages in the thought experiment would run the risk of eliciting very different intuitions.

Since at least the seventeenth century, Chinese people have been imagined by European observers as being themselves Chinese rooms, as being able to process information while lacking internal qualitative states, delivering rational and correct responses without any real conscious understanding of what they were doing; and China as a whole has been understood for equally long as the China brain, functioning as a whole and as a true unity, rather than, in contrast with European nations, as a collection of individuals. In the *Novissima Sinica* of 1699, G. W. Leibniz argues that the Chinese rely on a 'mere empirical geometry'.[4] For him, this is something close to an oxymoron, since he shares with Descartes the view of geometry as a rational and *a priori* activity par excellence. Doing geometry without innate abstract ideas is part of the same general condition as that other often observed by early modern Europeans, that the Chinese have extremely refined statecraft and advanced technology, but lack all knowledge of the divine order, and thus of the ultimate rational ground of human invention and creativity. Thus, Robert Fage writes in 1658: '[S]hips go over the Sea: the art of Printing and making of guns is more ancient with them then with us: they have good laws according to which they do live; but they want the knowledge of God'.[5] The Chinese are, in effect, wise automata: doing everything rational agents do, but evidently without any true rationality grounding their action. They are like the man in a cloak and hat observed by Descartes, whom he suspected of being a mere automaton, but now multiplied to the size of a great nation. Automatism and China, I mean, have been two sides of the same coin in the history of modern European philosophy.

2.

Leibniz is also, curiously, credited with inventing a version of the Chinese room argument, though it describes not a room, but a mill, and makes no mention of China. In the *Monadology* of 1714, he writes:

> It must be confessed, moreover, that perception, and that which depends on it, are inexplicable by mechanical causes, that is, by figures and motions, and, supposing that there were a mechanism so constructed as to think, feel and have perception, we might enter it as into a mill. And this granted, we should only find on visiting it, pieces which push one against another, but never anything by which to explain a perception. This must be sought, therefore, in the simple substance, and not in the composite or in the machine.[6]

This very well-known passage seems to be in tension with another, much less well-known, passage in a letter to A. C. Gackenholtz of 1701, in which Leibniz describes the human body as a sort of 'contemplation machine':

> Plants and animals and, to put it in one word, organic bodies, which nature produces, are machines disposed to the perpetuation of certain special offices, which they do first of all by means of individual nourishment, second of all through the propagation of the species, and, finally, through their perfection itself, that which each of them fulfills by its special office. And of course the human body is, manifestly, a machine disposed to the perpetuation of contemplation.[7]

The 'perfection' of the animal machine is for Leibniz, at least in the 1680s, its teleology, which he believes is something that can be identified, for natural and artificial machines alike, by empirical investigation. Ideally, we would understand every machine in terms entirely of the mechanical causes at work within it, down to its most elementary microstructure, but in the absence of such exhaustive knowledge we may seek to advance our understanding of a given machine by a sort of heuristic consideration of its ends. Intriguingly, Leibniz illustrates this view, in a text of 1677 entitled 'The Animal Machine', using the example of a mill, an example to which he would return decades later, as we have seen, for his famous argument against materialism of 1714. Thus, he writes in the earlier work:

> And this indeed, in sum, is seen to be the machine of the body, which sustains motion. Other things should not be mixed into this description, as the description of motion in a mill-house is one thing, while another is the description of its various applications for pressing out oil, for crushing grain, for splitting timber, which may be brought about by the work of this mill.[8]

If we do not know how a mill works, exactly, we will do best to pay attention to what it does, to its special office. The same is true, Leibniz thinks, of squirrels and spiders and all other natural beings.

The model of the human being, or more precisely of the human body, as a contemplation machine connects up interestingly with what Leibniz had written some years earlier, in a text of the late 1670s or early 1680s, in which he identifies various animal species as being machines for the execution of some trademark activity or *officium*: thus spiders are 'web-weaving machines', bees are 'honey-making machines', and squirrels, curiously, are 'jumping machines' (*machinae saltatrices*).⁹ Now a question arises as to whether Leibniz is consciously referring back to these models when he calls the human body a 'machine suited for the perpetuation of contemplation'. One significant difference is that it is, presumably, the squirrel or the spider *itself* that is the jumping or web-weaving machine, whereas in the case of the human being it is only the human *body* that is a machine for the perpetuation of contemplation, while contemplation, unlike jumping and web-weaving, is not a mechanical operation, but rather, as he puts it in the *Monadology*, a non-bodily activity of the simple substance or monad. For Leibniz, contemplation is in the end a variety of perception, while perception is, in turn, a metaphysical and not an organic or bodily activity: it is the representation of the multiple within the simple, or of the many within the one.

And yet, for Leibniz there may well be true 'contemplation machines' in at least a limited sense, namely, structured systems or apparatuses that do not simply host the non-bodily contemplative activity of monads, but rather reproduce, mirror, or simulate what it is that these non-bodily rational entities do, but do so in an entirely bodily way, without the underlying activity of a non-bodily entity being the thing that brings the contemplation, or its semblance, about. What sort of apparatuses might these be? Chinese people, perhaps, or perhaps Leibniz's own stepped reckoner, a calculating machine he designed and slowly improved upon between the 1670s and the 1690s. To be fair, Leibniz does most certainly believe that the Chinese have rational souls no less than do Europeans, but this does not necessarily mean that the activated rationality of the soul is the power behind the production of impressive technology or civic laws.¹⁰ These may be produced in an automatic way, as if by machines, by human beings whose rationality has gone dormant. Or contemplation may be instantiated in actual machines, initially created by human beings with active faculties of reason, who manage to transfer the activity of this faculty to apparatuses that then can produce rational answers to questions automatically, without even so much as a dormant rational soul.

China and computing, as we have seen, have a long, interwoven history in European reflections on the nature of the brain and of thought. Nowhere does Leibniz say that the Chinese are themselves automata, though he does seem to share in the widespread view that in Chinese history conscious knowledge of the

truths of reason has been lost, even though the souls of Chinese people remain rational, simply to the extent that they are human. In the 1714 *Discourse on the Natural Theology of the Chinese*, Leibniz affirms at numerous points that the ancient Chinese philosophers were much more aware of the basic distinction, founded on reason, between God and nature, in particular that for the ancients *Li* or 'the first principle' had been conceived as a 'supermundane intelligence' that had produced *Ki*, or the material world. By contrast today 'atheist Mandarins' deny that there is anything at all not immanent within nature.[11] The modern Chinese have effectively, Leibniz insinuates, lapsed into Spinozism. The result is a culture that expresses rationality in what it does, without reasoning about the process or the causes of its manifestations of reason. To this extent its mechanical reason is comparable to that of an adding-machine or of the more complex logic-processing machines Leibniz hoped would be developed someday soon. It is difficult to determine, now, whether for Leibniz this sort of automated reasoning is superior or inferior to conscious, reflective reasoning on the basis of abstract concepts. On the one hand, Leibniz plainly thinks that Europeans are more philosophical than the Chinese. He also thinks, however, that in the future, if things go well and we advance as he hopes we will, much reasoning activity will be transferred to machines capable of automated processing. This is, in the end, the ideal Leibniz expresses in the slogan *Calculemus!* – Let us calculate! – which he hoped would someday serve as a hortation among diplomats of any two states about to enter into conflict (Leibniz's particular diplomatic concern was to see to it that the Peace of Westphalia, signed in 1648 when he was two years old, should continue to hold): let us enter into the calculating machine the respective arguments of the two sides, and allow it to determine which of the sides is in the right.

Interests in Chinese matters enter into Leibniz's thought in yet a further way: in his reception of materials on the *I Ching* hexagrams, and their importance for his thinking about the binary calculus. Thus, Leibniz describes his own method in the 'Explanation of Binary Arithmetic' (1703): 'I have for many years used the simplest progression of all, which proceeds by twos, having found that it is useful for the perfection of the science of numbers. Thus I use no other characters in it bar 0 and 1, and when reaching two, I start again'.[12] Leibniz goes on, identifying an ancient antecedent to the method he had previously taken to be of his own invention:

> What is amazing in this reckoning is that this arithmetic by 0 and 1 is found to contain the mystery of the lines of an ancient King and philosopher named Fuxi, who is believed to have lived more than 4000 years ago, and whom the Chinese regard as the founder of their empire and their sciences. There are several linear figures attributed to him, all of which come back to this arithmetic, but it is sufficient to give here the *Figure of the Eight Cova*, as it is called, which is said to be fundamental.[13]

000	001	010	011	100	101	110	111
1	10	11	100	101	110	111	
0	1	2	3	4	5	6	7

Fig. 12.1 Leibniz's binary arithmetic. Adapted from Leibniz, *Leibnizens mathematische Schriften*, Vol 7, 1863. Lloyd Strickland and Harry Lewis, *Leibniz on Binary: The Invention of Computer Arithmetic* (Cambridge, MA: MIT Press, 2022), 197.

In line with his view of the Chinese as wise automata, Leibniz next claims that they have 'lost the meaning of the *Cova* or Lineations of Fuxi, perhaps more than a thousand years ago, and they have written commentaries on the subject in which they have sought I know not what far-out meanings, so that their true explanation has to come from Europeans'.[14] Taken together, all of these observations provide a fascinating picture of Leibniz's anthropology, his philosophy of arithmetic, and his rationalist metaphysics. The far-out commentaries Leibniz speaks of, without much real knowledge, are precisely the Chinese traditional uses of the binary alternation of solid and broken lines, familiar to us from the *I Ching*, for divinatory purposes. Leibniz is dismissive of these purposes, and it is not even clear that he knows that they are used in divination, but if he is aware, then his dismissal here is right in line with what he has to say, elsewhere, about traditional European divinatory practices. In a letter to Louis Bourguet of 1714, Leibniz famously writes: 'I despise almost nothing – except judiciary astrology'.[15] For Leibniz, the advancement of any science or discipline is directly connected not just with discovery and theory but also with the creation of a proper institutional structure for the facilitation of discovery and the production of theories. In a letter 'on the method of perfecting medicine' of 1694, Leibniz shows the remarkable manner in which modern record keeping and statistics have, as their closest historical antecedent, the divinatory practices of the authors of almanacs and medical calendars. He writes:

> I do not know whether in Paris they still keep the estates or anniversary lists of Baptisms and of Funerals in this large city, which they composed during the time I was there. This project seemed very useful, as much so as the *Bills of Mortality*[16] of London, from which able men have drawn conclusions of consequence. However one could go further, in having an annual medical history written up of Paris and the Île de France.[17]

Here, as in a letter to Hertel of 1691, Leibniz mentions a book by Ramazzini, which he cites as *Vom Zustande voriges Jahres, die Menschliche Gesundheit*

betreffend, gerichtet auf die Lombardey (On the State of the Previous Year, as Concerns Human Health, Directed toward Lombardy). He writes that Ramazzini 'would like to make a sort of *Medical Calendar*, but not, as the astrologers do, before the year has started, but rather when it is over'.[18] Of course, this seems like an obvious point: retrodiction is more accurate than prediction. But Leibniz seems to be on the verge of an important discovery, one stimulated no doubt by Ramazzini, that the compilation of health data for entire populations would not be a mere cataloguing of what has already happened; it would also help to predict what is likely to happen in the future in individual cases.

We may think of mantic practices, or divination, in the most general sense as the use of aleatoric techniques in order to either predict the future or to decide on a particular course of action. Leibniz understood, in his medical writings of the 1690s, that processing data about past epidemics would be a far better tool for anticipating future ones than would be more traditional varieties of fortune-telling: thus, effectively, that retrodiction can be, when coupled with evaluation of statistical data, a powerful tool for prediction; and he saw, moreover, that this could be done with the help of machines. But the aim here was something closer to an improvement of the art of fortune-telling, by a change in its basic techniques, than an abandonment of it for more mature intellectual endeavours altogether. And soon enough there would be fortune-telling machines, and slot machines, and love testers, and other devices that, either truthfully or purportedly, tell you about or help to determine the course of your future, all of which are based on the same mechanical principles, and some of which are based on the same computational principles, as Blaise Pascal's Pascaline device or Leibniz's stepped reckoner. We have never been quite sure, I mean to say, of the boundary between computation and divination. We turn to machines to tell us what to do, and how things are going to be. We want the indications that they deliver to us to be well-founded, but we also want them to facilitate chance, to mediate between us and the open future.

Divination, in short, is the ancestor of computation. Both are projections of how the future might be. The latter is based on rigorous data crunching that takes into ample consideration how the world has been up until now. The former also looks at the world in its present state, how things have settled into the present moment: how tea leaves have arranged themselves, how the heavens have turned. But it does so, generally, in a piecemeal and impressionistic way, and reads past and present signs from one domain of nature into another, or from nature into human affairs, in a way that strikes us today as unjustified. But the shared ancestry is unmistakable, and indeed seems to have been clearly understood by Leibniz and his contemporaries. When Leibniz writes to Bourguet that he despises judiciary astrology, this is not because he despises the effort to know the future, but because he thinks that the moderns

have landed upon a more effective method for doing so, namely, the compilation of what would soon come to be called 'statistics' regarding the past: retrodiction as the key to veracious prediction. Leibniz sees his own interest in the forecasting power of medical statistics as a sort of radical improvement of the methods and aims of astrology; and he sees the divinatory uses of the *I Ching* hexagrams as a radical degeneration of the computational uses to which the ancient Chinese binary code of solid and broken lines was once put.

Historians of science are often at a loss to make a clean divide between past practices that may be considered mantic and others that may be categorised as predictive. A farmer watches the behaviour of animals and attempts to infer coming changes in the weather. He spits on his hand and holds it up to the air to determine whether it is time to start planting. A woman observes the quality and texture of the membrane that has formed over a pot of milk. These all strike us as rational things to do, even, perhaps, the work of masters within the domain of their expertise. But what if the farmer sees the animals as delivering a message directly to him? What if the woman sees the image of death in the membrane, and takes it as an omen of something bad to come? It seems here that the imagination has moved in on the space of reason, and has undertaken conversions, unauthorised by science, of the forms and motions of nature into expressions of agency within the human world. Science was supposed to abolish this sort of conversion, by cultivating the sort of contempt that Leibniz expresses for judiciary astrology, which for its part reads agency, interest, and malice, into the forms and motions of the celestial bodies. The only conversion that was now to be permitted was of data into code, and then back out again.

3.

Medical statistics and binary hexagrams were, in his era, written on paper, but Leibniz understood that, eventually and ideally, the computational potential of these would ideally be transferred to machines. Leibniz himself designed a stepped reckoner for arithmetical computation, but he also understood that, with the encoding of data in binary, potentially any information could be processed by a machine, by what we today call a 'computer'. Leibniz's conception of 'machine', one must recall here, is maximally capacious, as in the end the structure of the entire natural world is mechanical. Natural entities, such as the bodies of plants or animals, are what Leibniz calls 'organic bodies', characterised by 'organism' in the same way that artificial machines are characterised by 'mechanism' (the '-ism' in both cases is a suffix of abstraction).[19] The organic, Leibniz maintains, is a subtype of the mechanical, namely, that which is mechanical, but also 'more divine' or 'more exquisite'.[20] Thus as synonyms of 'organic body', Leibniz regularly deploys the terms 'natural machine' and 'divine machine'. This divinity or exquisiteness is marked by the infinite structure of the organic body: unlike a clock, which is a machine when taken as a

whole, but which will quickly cease to be a machine once just a few key parts of it are removed, for Leibniz there is no finite series of steps of decomposition that would bring it about that any organic body ever cease to be organic. Thus, the organic body is the machine that remains a machine 'in its least parts', or, to be more precise, the machine that remains a machine *ad infinitum*. Thus, Leibniz writes in the *Système nouveau* of 1695 that 'a natural machine remains a machine in its least parts, and what is more, it remains that same machine that it always was, being merely transformed by the different folds that it receives'.[21] The image of enfolding (*implicatio*) and of unfolding (*explicatio*) in Leibniz has a long pedigree, moving back through German mystical thought in figures such as Nicholas of Cusa. It is an idea that resonates simultaneously with mathematical and metaphysical significance. In this instance, as applied to the organic body, the core idea is that such bodies cannot be put together by an arrangement of external parts, but rather the body is itself an infinite explication of the simple immaterial substance, which contains in metaphysical rigour and by way of implication everything that the body manifests phenomenally and by way of explication.

Though many commentators have blurred the distinction, the organic body (or divine machine, or natural machine) is not for Leibniz the same thing as the corporeal substance (or animal, plant, etc.). The corporeal substance is the organic body *taken together with* its soul or dominant monad or unifying principle: that which brings it about that the infinitely complex body is not a mere entity by aggregation, but rather is truly and substantially one. Thus Leibniz continues the above-cited passage from the *Système nouveau* as follows: 'Moreover, by means of the soul or form, there is a true unity that corresponds to what we call "moi" in ourselves, which could not occur in machines of art'.[22] Now it might seem that a corporeal substance, because it is composite, could not be one, since, obviously, it can be chopped up in myriad ways. But this is precisely why its infinite structure is crucial: because there is no decisive chop that could bring it about that the being in question is destroyed, it follows that the being itself is not really divisible at all, even if, in contrast with the monad, it is also not simple and without parts. To articulate this notion in terms more familiar from contemporary philosophy of biology than from Leibnizian metaphysics: suppose my arm makes up 10 percent of my body mass. Now amputate my arm. Does it follow that I am only 90 percent the person I was before? Of course not. I am every bit the person I was before, just missing my arm. Therefore, whatever I *am* cannot be something that simply results from putting together the finite assemblage of parts that constitute my body. I am not the same thing as my body. My body is divisible, but I am not.

Even the organic body, taken by itself as distinct from the corporeal substance, is, though divisible, nonetheless indestructible, in view of its infinite structure. It follows from this, alarmingly, that for Leibniz all animals are

immortal. When a dog 'dies', what really happens is that its organic body 'retreats to the smaller theatre',[23] becomes a sort of microorganism and floats around in the air or in the scum on top of a pond until the end of days. Presumably it is only when they are in the 'larger theatre' that these machines have the special office or *officium*, that they fulfill the function of the sort of machines they are: that bees make honey, that spiders make webs, and so on. Again, there is an imperfect analogy between the characteristic activity of human beings, rational contemplation, and those of all other animal species. It is not the human bodily machine that contemplates, whereas it is the arachnid bodily machine that spins webs. The human body, rather, is the machine that 'perpetuates contemplation', that serves as a vehicle for contemplation without itself being able to contemplate. It is the host of the monad that is the rational soul, and every monad needs a bodily host: for a monad to be fully disembodied would be for it to become identical to God, to apprehend the world not through the confused perception of individual bodily things, but by direct communion with the concepts of reason. This is impossible for fundamental theological reasons, and therefore there are no disembodied souls, human or animal or any other sort. Contemplation is not itself mechanical, but it requires a machine to host it. Human beings are the one species whose special office cannot be accounted for by appeal to the organic body or divine machine considered separately, but must also take the corporeal substance, together with the simple and non-bodily monad that unites it, into consideration.

The states of the organic body, however, unfold in parallel to the states of the soul. As Leibniz puts it, to return to a Leibnizian trope already invoked above, the body manifests in an unfolded or explicated way what the soul manifests in an enfolded or implicated way. Both the body and the soul are automata, in the sense that the succession of their states unfolds only from their own respective internal determinations. Nothing outside of my soul can knock the unfolding of its states off course, nothing can bring about something new in my soul from outside, something that was not already contained in what Leibniz sometimes calls, particularly in the period of the 1686 *Discourse on Metaphysics*, the 'complete concept'. And the same goes for the body: every state of it unfolds entirely from prior determination. The soul is thus no less an 'automaton' than the body, not in that it is made out of parts – as indeed the soul is simple – but in that its succession of states is always determined by its own preceding states. There is a peculiar auto-antonymy that threatens to emerge in the notion of the 'automatic', a Greek term whose Latin descendent is 'spontaneous'. To be 'spontaneous', we sometimes think, is to have the power to arbitrarily, and for no reason at all, do one thing rather than another, to behave, as younger people today like to say, in a 'random' way. But for Leibniz nothing can happen for no reason at all, and to be spontaneous does not at all mean to lack prior determination, but only to lack 'extrinsic denomination'

or determination that comes from outside. Lacking such determination, every substance is also free, for Leibniz, even if freedom does not entail the freedom to simply 'do whatever'. Freedom is freedom to be what one is.

These two parallel automata,[24] the body and the soul, are in perfect harmony with one another, and in principle the states of either of them, past or future, could be read out of the other. This is a corollary of the doctrine of pre-established harmony: body and soul do not interact, but nor do they need to interact in order to perfectly mirror one another. The autonomy, indeed automatism, of the soul, entails that all its past and future states are contained within its complete concept. This is what is sometimes called the 'doctrine of marks and traces', which Leibniz articulates in the *Discourse on Metaphysics*, nearly ten years before his explicit introduction of the doctrine of pre-established harmony: 'There are from all time in the soul of Alexander traces of everything that has happened to him and marks of everything that will happen to him and even traces of all that happens in the universe, though only God can know them all'.[25] This doctrine, together with the commitment to parallelism between soul and body, in turn implies that, for Leibniz, every body contains, in its structure, information from which one could, in principle, derive knowledge of all of its past and future states. Natural machines, then, are machines that potentially permit both retrodiction and prediction: by looking into how such a machine is at present structured, we may see both the history of how it came to be where it is now, and how it will change and transform in the future.

These considerations give us ample material to reconsider the distinction we have already made between the special office of squirrels and spiders (jumping, web-weaving) and that of human beings (rational contemplation). It is true that the machine of the human body does not itself contemplate, but the machine nonetheless gives a perfect, faithful read-out, as it were, of all of the states of the rational soul. In this respect at least, the machine of the human body is indeed a 'contemplation machine', even if there must be, beyond the body, a rational soul that consciously and inwardly, enfoldedly, contemplates what the body expresses in an unfolded way. From a third-person perspective, however, the succession of states of other human bodies would be exactly as it is even if there were no underlying rational soul. Other human beings, in other words, could be mere bodily automata under hats and cloaks. And, indeed, the entire Chinese nation could be instantiating what looks from the outside like wisdom, in statecraft and technology, in an entirely automatic way. There could be no external, third-person test to determine whether other bodies are corporeal substances complete with non-bodily souls. From my point of view, everything would be just the same if I were alone in a world of natural machines (though it is certain that at least God exists as a real 'other mind' outside of me). The conclusion, here, looks a good deal like Searle's conclusion that there could be no decision procedure, in dealing with an artificial machine,

for determining whether it has 'strong AI', which is to say consciousness, or not. The principal difference is that because for Leibniz all natural beings are machines, the same considerations apply to squirrels and human beings as to what would later be called 'computers', except of course that the thinking that is the specific activity of human beings is not strictly speaking a bodily activity; it is only sustained from moment to moment by a body.

<p style="text-align:center">4.</p>

What sort of machine is a computer? Machines are, almost by definition, dispositives of conversion, making something into something else. This much is generally easy to see in the case of manufacturing or agricultural machines, which turn molten steel into solid rods, or grain into flour, but rather less clear in the case of scientific machines, which are not meant to transform the world so much as to reveal it, though in practice the line between these two is generally not so clear. As Ian Hacking has argued, scientific research generally consists both in representing and intervening, and thus there is generally no revelation of the world without some alteration of it.[26] There is a special class of scientific machines that in the past century, and particularly in the past decade, has come to do a good deal more than science in the narrow sense. These machines represent the world in the form of 'data', and transform these data in order, variously, to tell us more about how the world is, or how to further transform it according to our will. These transformations are sometimes described, in what is presumed to be a figure of speech, as 'number-crunching'. These machines, 'computers', are sometimes thought to work in the same way human minds do, to have a relationship of aboutness toward the world. Yet, as philosophers from Leibniz to Searle have insisted, there are good reasons to doubt that any external inspection of what a computer does could ever enable us to discover its power of aboutness.

But computers are not the only apparatuses that suggest a powerful analogy to the human mind. Photographic technology, as well, which began already with *camerae obscurae* in the Renaissance, is thought to take in the world and reproduce it within its own 'dark chamber'. Let us call the broader class of such apparatuses 'black boxes'.[27]

It remains to be seen, now, whether these apparatuses are machines, in the sense we have described, at all.[28] One influential argument in the recent history-of-science scholarship tells us that it was largely the advent of photography, in the mid- to late nineteenth century, that precipitated the definitive split between art and science, that shifted naturalists away from the sort of idealisations characteristic of eighteenth century natural history illustrations, and toward what we now think of as 'objectivity'.[29] According to Lorraine Daston and Peter Galison, photography enabled a transition from the role of scientist as sage, who discerns the essences of things by some inscrutable internal

process, to that of scientist as technician, who uses scientific instruments such as the camera in a process of 'automatic transfer'. We no longer need to access the world directly, to grasp its essences with our own minds, and we can now avoid the problem, which had become sharpened since the rise of empiricism in the seventeenth century, of the inability of our organs of sense to deliver to us the world as it really is.

Photographic instruments can free us from the problem of the veil of perception, by taking over for us the responsibility of accessing the external world. What they deliver to us, in turn, are not the essences of things – in any case it turns out that what earlier natural historians thought were essences were really just oversimplifications – but rather ever more fine-grained, high-resolution reports on the complexity of the world, a complexity that could not be detected by the naked eye. The most familiar instance of this sort of transfer in the late nineteenth century is perhaps the work of Eadward Muybridge, who in taking multiple photographs in rapid succession of a running horse captured the dynamics of this process in a way that human beings had never previously detected, and forever changed both our knowledge of physiology as well as our approach to the artistic representation of animals in motion. Daston and Galison's preferred example, in turn, is drawn from the 1895 edition of A. M. Worthington's work, *The Splash of a Drop*.[30] This English physicist lived through the transition from illustration to photography, and when he began photographing the fluid-dynamical phenomenon that interested him, and studying the images, his understanding of the nature of reality, and of the paths of our knowledge of it, was fundamentally altered.

Key to the understanding of the scientist as technician, and to the process of scientific discovery as one of automatic transfer, is that this transfer is not, and cannot be, a conversion. A photographic apparatus is not a conversion machine. It does not translate what it receives into or out of a code that requires interpretation by an observer; on one admittedly oversimplified account of things it simply reflects back the world itself, as an image. Images are not generally thought of as data, even if they can be digitally encoded. Images are, rather, direct reflections of qualitative dimensions of the external world. The black box captures what the world is like to a perceiver: the colourful sunset, the bright rose. This captation, prior to the era of digital photography, could easily have seemed irreducible to sequences of zeroes and ones. For Leibniz, representation of the external world within the mind, which is to say of multiplicity within the unity, is a non-mechanical activity. It is simply in the nature of the non-bodily monad to represent in this way. Representation occurs not because of any external causal influence on the monad, since the monad is, as Leibniz likes to say, 'windowless'.[31] Rather, the monad contains within it, as representations, all of the states of all external things, just as it contains within its complete concept all of its own past and future states. Its representation of the rest of the world

is irreducible and non-mechanical. It is part of the very nature of a simple substance that it contains within itself all of the states of all of the infinitely many things in the world. This is what Leibniz has in mind when he says that each substance is in its own way confusedly omniscient.

It is not, for Leibniz, that minds, or monads or souls, convert the world into images, since for him the world just is the sum-total of infinitely many such images or representations, the sum total of infinitely many monadic points of view. Now an ordinary black box is not confusedly omniscient. It only takes in, represents, or reproduces a small sliver of the world: a sunset or a rose. Moreover, we may be sure that when a *camera obscura* reproduces a sunset by generating an image of the sunset, it is the sunset that is causing the image, directly, from outside. It is not simply in the nature of the camera to represent sunsets. And yet what is special about black boxes nonetheless suggests a useful analogy with non-mechanical minds, or souls or monads, as conceived by Leibniz: in both cases, there is a representation of the world from a particular point of view; in both cases, at least prior to the era of digital photography, the representation seems to be a direct expression of the nature of reality, rather than a conversion or translation or reduction of reality into a code. In these respects, the analogy of the human mind to a camera seems rather more useful than the analogy to a computer. Black boxes represent and reproduce the world, whereas computers translate and encode the world.

5.

Why, to return to a question we somewhat left hanging at the end of the first section, did Searle choose the Chinese language for his thought experiment, and not, say, Tupi? The Chinese have been represented in the European imagination since the seventeenth century as automata, as computers whose internal qualitative states and capacity for abstract thought cannot be discerned from a third-person perspective. Indigenous Amazonians, in turn, have been represented in more recent European thought as, so to speak, black boxes: as nodes of perception of a natural world in which they are enmeshed, and from which they are distinct only as points of view. Philippe Descola has recently argued that indigenous South American ontology is Leibnizian through and through: a picture of the world he identifies as 'perspectivism'. In his monumental *Par-delà nature et culture*, Descola has done much to reconstruct the non-anthropocentrist ontologies of societies outside the modern West. Thus, for example, after an extended comparative analysis of Amazonian indigenous world-views, he concludes:

> The Makuna, for example, say that tapirs groom themselves with roucou before dancing, and that peccaries play the horn during their rituals, while the Wari' suppose that peccaries make maize beer and that the

jaguar takes its prey back home for his wife to cook. For a long time, this sort of belief was taken as testimony of a sort of thought that is resistant to logic, incapable of distinguish the real from dreams and myths, or as simple figures of speech, metaphors, or word play. But the Makuna, the Wari', and many other Amerindian peoples who believe this sort of thing are not more myopic or credulous than we are. They know very well that the jaguar devours its prey raw, and that the peccary ruins maize crops rather than cultivating them. It is the jaguar and the peccary themselves, they say, that see themselves as carrying out acts that are identical to those of humans, who imagine themselves in good faith to be sharing with humans the same technologies, the same social existence, the same beliefs and aspirations. In short, Amerindians do not see what we call 'culture' as an appurtenance of human beings, since there are many animals and plants that are held to believe themselves to be in possession of it, and to live according to its norms.[32]

Descola, following the precedent of Eduardo Viveiros de Castro,[33] sees Leibniz's metaphysics as providing a point of access to this sort of animist ontology. Leibniz, like the Makuna and the Wari', supposes that he 'is a subject that is activated or "agented" by a point of view [est sujet qui se trouve activé ou 'agenté' par un point de vue]',[34] and thus that the discontinuity of forms in nature is underlain by a deeper unity, and is explained by a difference of perspectives. 'Perspectivism', Descola explains, 'is thus the expression of the idea that every being occupies a point of view of reference, and thus finds itself situated as a subject'.[35] Descola concludes that a Leibnizian perspectivism is 'an ethno-epistemological corollary of animism'.[36] Leibniz is indeed an 'animist', if by this term we understand the view that, to modify George Berkeley's slogan for his own idealism, *esse est percipere*, to be is to perceive.

In recent years some thinkers, mostly coming from anthropology, have sought to account for a broad capacity of representation spreading far beyond the bounds of the human species to all of nature, or at least of living nature. Thus, for example Eduardo Kohn attempts to describe 'how forests think': not by means of a complex central nervous system, and not in a way that involves the representation of objects by means of concepts, but simply to the extent that the forest contains innumerable perceivers, all of which live their lives in constant response to perceptual triggers or signs. 'Semiosis (the creation and interpretation of signs) permeates and constitutes the living world', Kohn argues, 'and it is through our partially shared semiotic propensities that multispecies relations are possible, and also analytically comprehensible'.[37] The great error of the prevailing theory of semiotics has been, according to Kohn, 'the assumption that all representational phenomena have symbolic properties'.[38] There is an important distinction, on his view, between symbolic and non-symbolic

representation, and this is co-extensive with the division between human and non-human living beings. But there is also a more fundamental division to be made, the one that marks out the domains of the animate and the inanimate. For Kohn this difference is grounded precisely in representation: living beings represent the world, while inanimate physical entities do not.[39]

In different ways, Gregory Bateson[40] and, later, Tim Ingold, have also sought to collapse the distinction between mind and nature, as well as between culture and nature, so as to account for human engagement with the natural environment as not fundamentally different from that of non-human beings acting within their ecologies in a species-specific way. It is true that human beings carry a swarm of symbolic representations and associations to every encounter they have with their natural environment, and we have no conclusive evidence that other beings are similarly constituted. But we do not need to invoke these symbolic representations in order to understand human beings as part of a broader system of representations that we call 'nature'. Thus, for example Ingold rejects the standard scientific 'separation of humanity from organic nature', in favour of 'an alternative mode of understanding based on the premise of our engagement with the world, rather than our detachment from it'.[41]

Nature, on a certain widespread 'animist' conception found across traditional societies throughout the world, limned again by Leibniz in the seventeenth century, and revived more fully in the twentieth and twenty-first centuries by a number of anthropologists, is an infinite ensemble of black boxes: each representing the world within itself, and gaining its individuality and its identity through the content of these representations. These are not encodings of the information of the world, but rather direct mirrorings of the world. Wherever there is such representation, there is thought, mental activity, perception. Wherever there is processing of information from the world as translated into a code, as philosophers from Leibniz to Searle have detected there can be no external, third-person discovery of 'strong AI', of consciousness, of the presence of mind. Minds are something like black boxes; computers are not minds. Minds represent the world, rather than simply processing it. Though of course the comparison between minds, conceived as monads, on the one hand, and black boxes on the other, has its limit in the fact that monadic representation is made possible only by the total containment of the multiple within the singular, the fact that it is all already in there and would be represented in exactly the same way even if the external world did not exist, while by contrast, we may presume, if there were no external world, nothing at all would be represented on the wall of a camera obscura. And still, the comparison is helpful: representation, whether by minds or cameras, cannot be reduced to mere encoding or data-processing.

There are nonetheless certain complications that prevent us from tying things off so elegantly. We have already noted the problem of digital photography,

which gives us images of the world, but does so by encoding them. There is also the obvious, and much older, problem of the origins of writing, which is a code if anything is, but which seems to begin in the stylisation or streamlining of pictorial representations of the natural world. But it is this same translation, of the inverted Phoenician bull's head into the letter 'A', of pictures into scripts, that opens up both the possibility of transmitting information as well as obscuring it. Images by contrast cannot hide what they are, but, at least ideally, reproduce the world directly. For the same reason, it is encoded information that makes possible the predictions of both data-processing and divination.

There is a more basic activity that unites both of these sorts of prediction as two species of a common genus: both involve translation of sequences of signs into propositions, into contentful claims about how the world is. The manipulation of the signs can be carried out by machines, in either a deterministic or an aleatoric way, but the elevation of these signs into thoughts requires something that is not a machine, a mind, a perceiver, a point of view. An image of the sunset that sears itself into the inner wall of a *camera obscura*, by contrast, is there whether it is beheld by a mind or not. Codes need interpretation, images do not. Human codes may have begun in images, but once the coding begins, extra work of mind is required in order for the code to be able to convey a thought of any sort. Images are more primitive, and perhaps are the common coin, the lingua franca of representation throughout nature, far beyond the boundaries of the human world. Encoding makes possible both what we think of as divination and what we think of as scientific prediction, the latter being, perhaps, a more refined or developed outgrowth of the former. It is encoding that enables both what we think of as magic and what we think of as science, and the essential kinship of these two remains clear into the seventeenth century, when for example medical statistics are conceived as a sort of reform of judiciary astrology, or binary code is conceived as suitable for either aleatoric divinatory purposes or for the deterministic purposes of what would later be thought of as 'programming'.

Straddling both sides of this division, between the aleatoric and the deterministic, between divination and prediction, there is however an enduring understanding that both of these purposes are within the purview of machines. Slot machines and calculating machines are both species of the same genus. The one lets us play with indeterminacy, the other invites us, when we are done with our play, to get down to work and to plan out our futures. What machines cannot do is represent, have mental content, consciousness. The slot machine, moreover, though it is approached in the hope of an immediate pay-out in coin, descends from more plainly mantic ancestors, which tell the player, on the basis of aleatoric gestures, whether to expect good luck or bad.

In Leibniz, aleatoric use of machines is a less advanced antecedent of their use in scientifically well-grounded calculation, but both of these are still

for him very much within the purview of machines. What lies beyond this purview is representation. Here Leibniz articulates a more basic distinction, between organic bodies on the one hand and monads on the other, which is to say between the kingdom of nature and the kingdom of grace.[42] Each of these kingdoms is in harmony with the other, and nature expresses the same reason, through unfolding, that is enfolded in the monads as they move toward their ends. Machines express reason, but do not themselves reason. Machines facilitate comprehension, but do not comprehend. Only what we have proposed to call 'black boxes' do this. If Leibniz is right, and if the 'animists' of Amazonia are right, such black boxes, such nodes of perception, are nowhere instantiated among machines, but spread everywhere throughout nature.

<div align="center">6.</div>

This, the reader may have detected by now, has been a sort of historical and genealogical argument against 'strong AI', against machine consciousness, 'the singularity', or whatever they are calling it. Those who expect machines to start thinking are barking up the wrong tree, making a category mistake. Machines manipulate codes and do work. As Heiner Müller understood, they do not think or feel. Minds, in contrast with machines, represent. They contain the multiplicity of the world within them, as images beheld from sundry perspectives, from points of view.

Nor is there any way to know they are really out there. But we know of ourselves that this is what our minds are like, and that it is in virtue of being like this that we may be said to exist at all. We feel ourselves, moreover, to exist in a community of like beings. This community will have its lines drawn nearer or further, depending on our prejudices. It will include all and only human beings, if we are humanists. It will exclude Chinese people, say, if we are Europeans moved by geopolitical or commercial motives to dehumanise others we know little about. This particular prejudice has been so ingrained, in fact, as to encroach upon perfectly compelling arguments against artificial intelligence: they defeat machine consciousness, but bring down Chinese civilization with them. If we are living in traditional societies that are not preoccupied with policing the boundary between the human and the non-human, in turn, the community will include all of nature: everything that deserves to be called a being.

<div align="center">*POSTSCRIPTUM FABULOSUM*</div>

The dragon snorts, and puffs out smoke, and swirls around the palace as if enraged. Yet the emperor and his courtiers are not afraid, but take delight in the spectacle, for the dragon is made of paper and wood, and his motions and breathing are driven by innumerable little explosions (*explosiunculae*) of

the pyrotechnical substance they call gunpowder. He is a great machine, but does not even know it. Meanwhile, on the other side of the orb of the earth, a jaguar sniffs, and takes in the infinite essences of the forest around him. He feels them all inside him: the parrot, the millipede, the wet leaves, the men. He breathes in deeper, and imagines he detects essences more distant still, but finds he lacks names for them: the beings of the ocean, and of other continents, too; the strange rearrangements of the stuff of nature that men there assemble, as if to recreate nature itself; the faint trace of a distant assemblage of the stuff of leaf and tree, which, with added fire, writhes like a giant serpent as men look on and laugh. Strange men. The jaguar breathes out, forgets everything he knew, leaps from a thicket and sinks his jaws into the thick neck of a blank-minded tapir.

NOTES

1. Davis's version of the thought experiment was presented in a seminar at MIT in 1974, and reported only later by others in attendance. See in particular Dennett, 'Toward a Cognitive Theory of Consciousness'.
2. Block, 'Troubles with Functionalism', pp. 261–325.
3. See Searle, 'Minds, Brains, and Programs', pp. 417–57.
4. Leibniz, *Novissima Sinica Historiam*, p. 384. 'Videntur enim ignorasse magnum illud mentis lumen, artem demonstrandi, et Geometria quadam Empirica contenti fuisse, qualem inter nos passim operari habent.'
5. Fage, *A Description of the Whole World*, p. 49.
6. Leibniz, *Monadology*, A IV 1, p. 546.
7. Leibniz, 'G. W. L. Epistola responsoria de Methodo Botanica ad Dissertationem', pp. 68–70; see Smith, *Divine Machines*, Appendix 5, 'On Botanical Method', p. 307.
8. Leibniz, 'Machina animalis', Leibniz-Handschriften III 5, 12, 1; see Smith, *Divine Machines*, Appendix 2, 'The Animal Machine', p. 291.
9. Leibniz, 'Corpus hominis, et uniuscuiusque animalis, est machina quaedam', Leibniz-Handschriften III, 1, 2, 1–2; see Smith, *Divine Machines*, Appendix 3, 'The Human Body, Like That of Any Animal, Is a Sort of Machine' p. 293.
10. See in particular Perkins, *Leibniz and China*.
11. Leibniz, *Discours sur la théologie naturelle des Chinois* (1714), §§ 1–2; §24.
12. Leibniz, *Die mathematischen Schriften von G. W. Leibniz* (hereafter 'GM'), vol. VII, p, 224. These translations are from Lloyd Strickland (unpublished).
13. GM VII, p. 224.
14. GM VII, p. 227.
15. Leibniz, *Die philosophischen Schriften von G. W. Leibniz* (hereafter 'G'), vol. III, p. 562.
16. Written in English in the original.
17. Leibniz, 'Extrait d'une lettre sur la maniére [sic] de perfectionner la Médecine', vol. II, p. 162.
18. Leibniz, *Leibnitz's Deutsche Schriften*, B II, p. 458. '[E]r sagt, er wolle dergestalt *Medicinische Calender* machen, aber nicht, wie die Astrologen, vorher, sondern wenn das Jahr umb.'
19. See, for a fairly comprehensive catalogue and analysis of the occurences of the term 'organism' in Leibniz, see Smith, *Divine Machines*, chapter 3: 'Organic Bodies, Part I: Nature and Structure'.

20. See Leibniz, *The Leibniz-Stahl Controversy*, p. 30. '[O]mnis organismus revera sit mechanismus, sed exquisitior'.
21. G IV, p. 482.
22. Ibid.
23. See, e.g., G VI, p. 601.
24. For an excellent account of the parallelism of spiritual and mechanical automata in Leibniz's philosophy, see Noble, *The Soul as Spiritual Automaton*.
25. G IV, p. 433.
26. See Hacking, *Representing and Intervening*.
27. Here, I am drawing on recent work on the contributions to photography of Hercule Florence (1804–1879), a French explorer and inventor who participated in the ill-fated Langsdorff Expedition in Brazil of 1828–1829, helping to chart the course of the Amazon. Florence was also a pioneer of photography, which he referred to as 'light writing', carried out by means of a *boîte noire* of his own construction. Recent research has also turned up indications that in his encounters with Amazonian Indigenous peoples he may have anticipated certain aspects of the turn to comparative ontology characteristic of late 20th and early 21st century French and South American anthropology, to be discussed below. See in particular Brizuela, 'Light Writing in the Tropics'; Florence, *Hercule Florence e o Brasil*; Florence, *À la découverte de l'Amazonie*.
28. I am drawing here, for the notion of 'apparatus', on Flusser, *Towards a Philosophy of Photography*.
29. See Daston and Galison, *Objectivity*.
30. Worthington, *The Splash of a Drop*.
31. See for example *Monadology*, A IV 1, p. 7. 'Les Monades n'ont point de fenêtres, par lesquelles quelque choses y puisse entrer ou sortir'.
32. Descola, *Par-delà nature et culture*, pp. 187–88.
33. See de Castro, *From the Enemy's Point of View*.
34. Descola, *Par-delà nature et culture*, p. 197.
35. Ibid., p. 197.
36. Descola, *Par-delà nature et culture*, p. 202.
37. Kohn, *How Forests Think*, p. 9.
38. Ibid., p. 40.
39. Ibid., p. 9.
40. See in particular Bateson, *Steps to an Ecology of Mind*.
41. Ingold, *The Perception of the Environment*, p. 11.
42. See, e.g., G VI, p. 601.

Works Cited

Bateson, Gregory, *Steps to an Ecology of Mind* (Chicago: University of Chicago Press, [1972] 2000).
Block, Ned, 'Troubles with Functionalism', in *Minnesota Studies in the Philosophy of Science 9* (1978), pp. 261–325.
Brizuela, Natalia, 'Light Writing in the Tropics', *Aperture Magazine* 215 (Summer, 2014).
Daston, Lorraine, and Peter Galison, *Objectivity* (Cambridge: MIT Press, 2007).
De Castro, Eduardo Viveiros, *From the Enemy's Point of View: Humanity and Divinity in an Amazonian Society* (Chicago: University of Chicago Press, 1992).
Dennett, Daniel, 'Toward a Cognitive Theory of Consciousness', in *Brainstorms: Philosophical Essays on Mind and Psychology* (Cambridge: MIT Press, 1978).
Descola, Philippe, *Par-delà nature et culture* (Paris: Gallimard, 2005).

Fage, Robert, *A Description of the Whole World, with Some General Rules Touching the Use of the Globe* (London: J. Owsley, 1658).

Florence, Hercule, *À la découverte de l'Amazonie: Les carnets du naturaliste Hercule Florence*, Mario Carelli (ed.) (Paris: Gallimard, 1992).

Florence, Leila, ed., *Hercule Florence e o Brasil: o precurso de um artista inventor* (São Paolo: Pinacoteca do Estado de São Paolo, 2009).

Flusser, Vilém, *Towards a Philosophy of Photography* (London: Reaktion, 2000).

Hacking, Ian, *Representing and Intervening: Introductory Topics in the Philosophy of Science* (Cambridge: Cambridge University Press, 1986).

Ingold, Tim, *The Perception of the Environment: Essays on Livelihood, Dwelling and Skill* (Routledge: London and New York, 2000).

Kohn, Eduardo, *How Forests Think: Toward an Anthropology Beyond the Human* (Berkeley: University of California Press, 2013).

Leibniz, Gottfried Wilhelm, 'Extrait d'une lettre sur la maniére [sic] de perfectionner la Médecine', in *Gothofredi Guilelmi Leibnitii Opera Omnia*, Louis Dutens (ed.) (Geneva: De Tournes, 1768).

Leibniz, Gottfried Wilhelm, 'G. W. L. Epistola responsoria de Methodo Botanica ad Dissertationem A. C. G. Medici eximii', in *Monatlicher Auszug* VIII (April, 1701).

Leibniz, Gottfried Wilhelm, 'Machina animalis', Leibniz-Handschriften III 5, 12, 1, in *Corpo e funzioni cognitive in Leibniz*, Enrico Pasini (ed.) (Milan: Franco Angeli, 1996).

Leibniz, Gottfried Wilhelm, *Die mathematischen Schriften von G. W. Leibniz*, C. I. Gerhardt (ed.) (Berlin, 1863).

Leibniz, Gottfried Wilhelm, *Die philosophischen Schriften von G. W. Leibniz*, C. I. Gerhardt (Berlin, 1849–1860).

Leibniz, Gottfried Wilhelm, *Discours sur la théologie naturelle des Chinois* (1714), trans. and ed., Daniel J. Cook and Henry Rosemont [*Gottfried Wilhelm Leibniz: Writings on China*] (Open Court Publishing, 1994).

Leibniz, Gottfried Wilhelm, *Leibnitz's Deutsche Schriften*, G. E. Guhrauer (ed.) (Berlin, 1838).

Leibniz, Gottfried Wilhelm, *Monadology*, A IV 1, 546.

Leibniz, Gottfried Wilhelm, *Novissima Sinica Historiam nostri temporis illustratura*, in *Gottfried Wilhelm Leibniz: Sämtliche Schriften und Briefe*, ed. Berlin-Brandenburgische Akademie der Wissenschaften, Berlin/Potsdam, 1923– (hereafter 'A'), Series IV, vol. 5.

Leibniz, Gottfried Wilhelm, *The Leibniz-Stahl Controversy*, trans. and ed. François Duchesneau and Justin E. H. Smith (New Haven: Yale University Press, 2016).

Noble, Christopher P., *The Soul as Spiritual Automaton in Leibniz's Synthetic Natural Philosophy*, PhD diss., Villanova University, 2016.

Perkins, Franklin, *Leibniz and China: A Commerce of Light* (Cambridge: Cambridge University Press, 2005).

Searle, John, 'Minds, Brains, and Programs', in *Behavioral and Brain Sciences* 3, 3 (1980), pp. 417–57.

Smith, Justin E. H., *Divine Machines: Leibniz and the Sciences of Life* (Princeton: Princeton University Press, 2011).

Worthington, A. M., *The Splash of a Drop* (London: Society for Promoting Christian Knowledge, 1895).

13

HUMAN CONVERSION MACHINES: HAMLET AND OTHERS

Paul Yachnin

I begin with the observation that humans, like all our creaturely kin, are no more and no less than biological machines. How could we be anything else? We are made out of organic materials rather than metal screws and gears, and we run on oxygen, water, and calories from the food we eat rather than on gasoline or electricity (although our brains do run partly on electricity); but we are nevertheless – just like cars or computers – things that are functional systems of interactive parts that run on energy and produce energy and movement of various kinds and that are composed, through and through, of matter. The fact that humans are machines has been well established since Descartes' mechanistic philosophy in the seventeenth century, and the mechanistic character of the human body and brain continues to be the generally agreed-upon view up to the present day, especially in neuroscientific research and in the thinking about humans that has grown up in conversation with neuroscience.[1] 'The three-pound, tofulike human brain', says neuroscientist Christof Koch, 'is by far the most complex chunk of organized active matter in the known universe. But it has to obey the same physical laws as dogs, trees and stars'.[2]

In what follows, I will focus on the question of consciousness and will put forward an idea about how conversion might be the wellspring of human consciousness and selfhood. I will bring Shakespeare, Augustine, Montaigne, Descartes, Leibniz, contributor to this volume Justin Smith, and a good number of others into the discussion. I will conclude with some thinking

out loud about the politics of conversion and consciousness and about how human conversion machines have begot scores of other kinds of conversion machines – texts, pictures, sculptures, buildings, works of music, and artifacts of many kinds. As I will suggest toward the end of the chapter, while conversion machines have a largely emancipatory function, not all human-made conversion machines work to awake the mind from its slumber inside the human machine; indeed, many of them serve to rewire and lock down the basic mechanistic character of human beings. Before I get to the complex operations of conversion machines, however, there is a more basic question to consider.

While I begin with the mechanistic nature of the human animal – and I intend not to lose sight of that fundamental and unexceptional fact – I nevertheless want to take up the question that was of great importance for Descartes and that continues to occupy the thinking of scientists and thinkers such as Koch, Daniel Dennett, David J. Chalmers, and many others. The question is, how is it that the human body-brain machine is possessed of conscious selfhood? The question is not so much about how the brain works. It works very well at the tasks of storing and processing huge amounts of information about how to live in the world as well as being able to keep the body running efficiently. And, as neuroscience has learned, the vast majority of the operations performed by the brain are not conscious.[3] The question has rather to do with what the philosophers call the 'quale' (plural, 'qualia') – 'a quality or property as perceived or experienced by a person' (*OED*). How can a machine, even a machine as complex as the human brain, have consciousness, and not merely localised moments of awareness of corporeal and environmental events? Consciousness is larger than that. How can the brain-body machine generate the power of self-knowing and the phenomenal fact of selfhood? By the way, Dennett's 1991 book, *Consciousness Explained*, developed a courageous, brain- and body-based, 'heterophenomenological', account of consciousness, but an account that has not generally been well-received.[4] In an exchange with Dennett, the philosopher John Searle argued, with considerable justification, that Dennett had not explained consciousness, but rather had in effect denied that consciousness exists. In order to be able to call to mind the nature of consciousness, Searle went down to a very basic experience of conscious feeling by asking readers to pinch themselves –

> I think we all really have conscious states. To remind everyone of this fact I asked my readers to perform the small experiment of pinching the left forearm with the right hand to produce a small pain. The pain has a certain sort of qualitative feeling to it, and such qualitative feelings are typical of the various sorts of conscious events that form the content of our waking and dreaming lives. To make explicit the differences between

conscious events and, for example, mountains and molecules, I said consciousness has a first-person or subjective ontology. By that I mean that conscious states only exist when experienced by a subject and they exist only from the first-person point of view of that subject.

Such events are the data which a theory of consciousness is supposed to explain. In my account of consciousness I start with the data; Dennett denies the existence of the data. To put it as clearly as I can: in his book, *Consciousness Explained*, Dennett denies the existence of consciousness. He continues to use the word, but he means something different by it. For him, it refers only to third-person phenomena, not to the first-person conscious feelings and experiences we all have. For Dennett there is no difference between us humans and complex zombies who lack any inner feelings, because we are all just complex zombies.[5]

In what follows, I will not venture to make an argument about the evolutionary origins of consciousness and I will mostly steer clear of ongoing neuroscientific research on consciousness. These are matters beyond my ken.[6] My focus is on how thinking about conversion can bring forward a novel way of understanding human consciousness and selfhood. I take some comfort from the fact that Shakespeare (the artist and thinker that I know best) seems to have anticipated Descartes' mechanistic account of human beings by about sixty years. The *OED* tells us that the play *Hamlet* provides the first instance of the English word 'machine' being used to describe the living human body. Hamlet signs off his love letter to Ophelia by calling his own body a machine: 'Thine evermore, most dear lady, / whilst this machine is to him'.[7] Like Hamlet, of course, we recognise that our bodies are machines. We often admit that fact, and Hamlet might be doing the same thing, in order to set our being – our minds or souls – over against the joints, ligaments, wiring, pumps, valves, and plumbing of our bodies. And, as we will see, what philosopher Gilbert Ryle called 'the Ghost in the Machine' is everywhere a haunting presence in Descartes' account of human beings.[8]

I take more than comfort from Shakespeare, of course. As I will suggest, a character like Hamlet shows us, in Shakespeare's brilliant theatrical case study, how conversion creates mindfulness and selfhood in Hamlet's 'machine'. Importantly, and keeping Ryle's critical phrase in mind, the self-consciousness that issues from conversion in Shakespeare's play is not some ghostly mind-stuff shimmering within the mechanical workings of Hamlet's body and brain. Rather, it is entirely of a piece with the body and brain of the Prince and with his actual physical, cognitive, linguistic, perceptual, and social processes.[9]

I am also going to draw many pieces of my argument from Justin Smith's chapter in this volume, especially his making new of Leibniz' account

of humans as 'contemplation machines', his discussion of the Leibnizian 'monadic' human being and the radical freedom that is a feature of the monad, or 'simple substance'.[10] My argument is also greatly informed by Smith's own revelatory suggestion that if our brains are machines, which they certainly are, then they are far more like cameras than like computers. They do not process data so much as they take in and represent the world as it is. 'It [the camera]', Smith comments, 'does not translate what it receives into or out of a code that requires interpretation by an observer; it simply reflects back the world itself, as an image' (p. 329). The unfolding of my argument about cameras and human conversion machines, however, will have to wait. Let me take a moment first to say something about what it is I want to argue over the course of the chapter; then I will take several steps back in order to acknowledge and address the strangeness of my central claim, especially its apparent strangeness in light of the great distance that seems to separate the conversions of people from the operations of machines.

In what follows, then, I want to suggest that human beings themselves are conversion machines *par excellence*. Let us consider the possibility that the human machine becomes a conscious self by way of an act of conversion. Might it be the case that the conversional turn, by which the human machine suddenly sees the world and itself wholly and wholly differently, is an event able to give birth to consciousness and selfhood? Converts suddenly see the world and themselves as a single, unified, simple substance. They see themselves together with the world as an indivisible whole rather than as divisible pieces in a larger agglomeration. They enter (or they realise that they have always already occupied) the realm of being rather than that of becoming. Hamlet becomes (or he discovers) who he is, with the emphasis on 'is', because Hamlet converts.

In his first soliloquy, Hamlet has a conversion experience. He begins from his sense of his own shattered self, his self-disgust, and his wish to die (the word 'sallied' means 'sullied', that is, made dirty or defiled):

> O, that this too too sallied flesh would melt,
> Thaw, and resolve itself into a dew!
> Or that the Everlasting had not fix'd
> His canon 'gainst self-slaughter! O God! God,
> How weary, stale, flat and unprofitable,
> Seem to me all the uses of this world!
> 1.2.129–34

These feelings issue from his father's death and his mother's re-marriage. He plants his vision of the world in the mire of misogyny; in his mind, all natural growth (even perhaps the sexual intercourse that created him) is nauseating. What we hear opens out from Hamlet's despair, disgust, and self-disgust into

what amounts to a panoramic view of the whole world – a total and true image in the mind that purports to show the world as it really is:

> Fie on't, ah fie! 'tis an unweeded garden
> That grows to seed, things rank and gross in nature
> Possess it merely. That it should come to this!
> But two months dead, nay, not so much, not two.
> So excellent a king, that was to this
> Hyperion to a satyr; so loving to my mother
> That he might not beteem the winds of heaven
> Visit her face too roughly. Heaven and earth,
> Must I remember? Why, she should hang on him
> As if increase of appetite had grown
> By what it fed on, and yet, within a month –
> Let me not think on't! Frailty, thy name is woman! –
>
> 135–46

The picture of the world has a temporal dimension too. It organises day-by-day time into a revelatory narrative – 'that it should come to this!' – that binds the characters, including Hamlet, together into a unified story able to bring the truth to light. A month before the present moment, it seemed to be a loving, human world ('human' as opposed to 'a beast, that wants discourse of reason'), but now it has become (and wasn't it always really?) a loveless world of beastly lust dressed up in queenly finery (new shoes for the funeral) and mere displays of mourning:

> A little month, or ere those shoes were old
> With which she followed my poor father's body,
> Like Niobe, all tears – why she, even she –
> O God, a beast that wants discourse of reason
> Would have mourn'd longer – married with my uncle,
> My father's brother, but no more like my father
> Than I to Hercules. Within a month,
> Ere yet the salt of most unrighteous tears
> Had left the flushing in her galled eyes,
> She married – O, most wicked speed: to post
> With such dexterity to incestious sheets,
> It is not, nor it cannot come to good,
> But break my heart, for I must hold my tongue.
>
> 147–59

It is as if Hamlet, at one glance, has seen the human world, the natural world, his mother, and himself – and even the sheets ('incestious sheets') on his mother's bed – wholly and entirely as 'rank and gross in nature' – overrun

with loathsome, weedy growth and subhuman sexual coupling. The soliloquy invites us not merely to see Hamlet in close-up, which is what his previous speech of rebuke to his mother has done. 'I have', he says to her, 'that within which passes show' (85), whereas her mourning, he suggests, has been nothing but show. The soliloquy that follows that edgy exchange with his mother provides more than a close-up view of Hamlet. It invites us into a conversation between Hamlet and God (or between Hamlet and himself) so that we are able to open our eyes to the world with Hamlet and to see the world as he has now come to see it. By virtue of what amounts to Hamlet's world-creating or world-changing conversional turn, a transformation of himself from object to subject, Hamlet brings his thinking self into being before our eyes.

CONVERSION VS THE MACHINE – AUGUSTINE TO DESCARTES

There will be more to say about Hamlet's conversional soliloquy, especially since it is not a turning toward happiness or blessedness, which is the usual outcome of conversion in the Christian tradition. Of course, it is, like other conversions, a turn toward what seems like total and inclusive truth about the world and oneself. It is also not like traditional Christian conversions since it is not clear that Hamlet is taking God as his interlocutor. The whole speech could be performed as if God were the direct addressee, especially if 'O God' in 'O God, a beast that wants discourse of reason' is spoken as a vocative rather than an expletive, but it seems more likely that Hamlet turns away from God as his conversation partner and speaks most of the speech to himself.

One more observation here: Hamlet's apparent re-turning to his own mind raises a significant question, which is captured in Hamlet's Montaignian comment, 'there is nothing either good or bad, but thinking makes it so' (2.2.249–50).[11] This suggests that while Hamlet might see the world wholly, and wholly differently, he nevertheless seems not to see the world as mindful, as irradiated, that is, by the presence of God. On this account, the conversional turn that awakes the mind in Hamlet's body-brain machine is not a turning to the world seen anew but rather a turning to the mind itself, where the mind comprehends the world – 'comprehends' meaning here both 'to understand' and 'to comprise'. In as much as this is true about Hamlet, then Shakespeare's play also anticipates Descartes' conversional turn that brings him face to face with his own thinking – a self- and world-creating conversion commonly known as the 'cogito'.[12] I will come back to the particular character of Hamlet's inward-turning conversion at the end of the chapter.

I should also pause here to say that the play *Hamlet* can stand as an exemplary literary conversion machine, that is, a made thing that can transform playgoers and readers in substantial and durable ways. That is the case even though the play is without any sustained religious or political investments, which would usually be central in a text bent on converting its readers.

The Earl of Shaftesbury in 1710 commented that the play 'appears to have most affected English hearts, and has perhaps been oftenest acted of any which have come upon the stage'. A century later, Samuel Taylor Coleridge said that to understand the play, 'it is essential that we should reflect on the constitution of our own minds'.[13]

The question before us here, however, is less complicated and more foundational than the particular character of Hamlet's conversion or the conversional character of the play itself. It is this: how can humans undergo a conversion that wakes them from the deep doziness of their machine nature into vitally conscious selfhood? What do machines have to do with conversion? Not conversion as a process such as milling grain into flour or the conversion of Euros into US dollars – machines manage those kinds of conversion very well. I am thinking instead about conversion as the transformation of the whole person, like the change of mind and heart that Augustine describes taking place after years of searching for who he truly was. By the way, Augustine speaks to God throughout *The Confessions*. Augustine's conversion happens one day when he finds himself weeping in deep misery in his garden. He hears children shouting, 'pick it up, read it!' He thinks perhaps God is speaking to him through the children, he stops his tears, and he picks up the Bible that is lying there. He reads one verse, and in an instant everything changes: 'I neither wished', he says, 'nor needed to read further. At once, with the last words of this sentence, it was as if a light of relief from all anxiety flooded into my heart. All the shadows of doubt were dispelled.'[14]

What do machines have to do with a life-changing event such as Augustine's conversion? We might want to bring forward here an argument that the book that Augustine picks up and reads is itself a conversion machine. After all, the word 'machine' had a wide range of meanings for people of the past. It could designate made things, not necessarily mechanical, that were designed to perform certain kinds of work in a machine-like manner. The *OED* includes definitions such as 'material or immaterial structure', 'scheme', 'plot', and 'apparatus'. In Chapter 9, Anna Lewton-Brain makes a compelling case for seeing George Herbert's book of poems, *The Temple*, as a conversion machine. Augustine anticipates his own book-driven conversion with accounts of how other books at other times have been able to trigger wholesale transformations in their readers. He tells a story about how a visitor told him a story about how he (the visitor) once wandered into 'a certain house' where he found and started to read a book that was lying there: 'He was amazed and set on fire, and during his reading began to think of taking up this way of life and of leaving his secular post in the civil service to be your servant. ... in pain at the coming to birth of new life, he returned his eyes to the book's pages. He read on and experienced a conversion inwardly where you [i.e., God] alone could see.'[15]

All this is true about how texts such as the Bible, *The Confessions*, or *The Temple* are able to initiate momentous change in human readers, but it gets us no closer to understanding how human machines come into the mindfulness that enables them to make such transformative textual machines. If the title of this chapter, 'human conversion machines', sounds strange, it might be because it seems to bind deep transformations in the minds or souls of people to something merely mechanical. Consider, to take another example, what William James, in *The Varieties of Religious Experience*, has to say about conversion:

> To be converted, to be regenerated, to receive grace, to experience religion, to gain an assurance, are so many phrases which denote the process, gradual or sudden, by which a self hitherto divided, and consciously wrong inferior and unhappy, becomes unified and consciously right superior and happy, in consequence of its firmer hold upon religious realities.[16]

How could a machine undergo such a transformation from division to unity, from abysmal wrongness to grace-filled rightness, and from unhappiness to happiness? Conversion, in James's telling, sounds like an ineluctable and momentous event in the life history of beings rather than the click and whirr of a machine. After all, a machine, in the standard modern definition, is 'a complex device, consisting of a number of interrelated parts, each having a definite function, together applying, using, or generating mechanical or (later) electrical power to perform a certain kind of work'. So says the *Oxford English Dictionary*.

The question cannot be pushed to one side by way of a categorical distinction between human beings and mere machines, especially since, as I have already suggested, we human beings are machines. And are not our brains, the seat of what we call our minds, also no more and no less than machines? 'But of course', Dennett says, 'the brain *is* a machine of sorts, an organ like the heart or lungs or kidneys with an ultimately mechanical explanation of all its powers.'[17] On this account, even if we might balk at the word 'machine', we can nevertheless see that the human brain, the organ of general-purpose reasoning, the seat of consciousness, and the apparent centre of human personhood, is a material, neuronal operating system, entirely subject to how the rest of the physical universe operates.

Indeed, a moment's reflection – your brain at work! – tells us that the *OED* definition of a machine as a 'device, consisting of a number of interrelated parts' is an apt description of our brains, down to how they run on electricity. By the way, Hamlet seems also to anticipate much thinking in modern neuroscience by recognising how his brain can operate automatically – without his conscious knowledge, just as if it – or just as if he himself? – were a machine.

When he is recounting to Horatio his escape from a plot against his life, he describes how his brain started to formulate effective action before he was aware of what it was up to: 'Being thus benetted round with villainies – / Or [i.e., ere] I could make a prologue to my brains, / They had begun the play' (5.2.29–31). But how could a machine, even the most intricate and sophisticated of machines, like the human body-brain, undergo a conversion – a transformation from being 'divided, and consciously wrong inferior and unhappy', to becoming 'unified and consciously right superior and happy'?

The question became urgent in Western thinking on account of the rise of mechanical philosophy in the seventeenth century and especially on account of Descartes. His posthumously published *Traité de l'homme* (Treatise on Man, 1664) is the first great mechanical-philosophical account of the human body-brain machine. The body and brain are entirely physical, mechanically functioning things, where the processes of respiration, circulation of the blood, digestion, perception, proprioception, bodily movement, and so on are enabled by 'animal spirits', which are made up of particles of different sizes and levels of energy or agitation, and which, Descartes tells us, travel everywhere throughout the body and brain and drive the functioning of all corporeal and cognitive processes – cognition to the exclusion of rational consciousness (like Hamlet's brains beginning to strategise without Hamlet's awareness).[18] At one point, Descartes compares the animal spirits pulsing through the nerves of the body to the pressurised water flow in the 'fountains in the gardens of our kings'. 'And truly', he comments, 'one can well compare the nerves of the machine I am describing to the tubes of the mechanisms of these fountains, its muscles and tendons to divers other engines and springs which serve to move these mechanisms, its animal spirits to the water which drives them, of which the heart is the source and the brain's cavities the water main.'[19]

Descartes' body-brain machine also has a mind or soul. Just after his description of the body-brain as a system of royal fountains, he installs the soul as the thinking and intending control centre of the waterworks: 'And finally when there shall be a rational soul in this machine, it will have its chief seat in the brain and will there reside like the turncock who must be in the main to which all the tubes of these machines repair when he wishes to excite, prevent, or in some manner alter their movements' (loc 521).[20]

This charming picture of the rational soul taking up his command post inside the machine and making it do what he wishes it to do obscures a very considerable problem.[21] From the point of view of Descartes' substance dualism, mind is something altogether different from the complex yet mind-less mechanism of the body and brain.[22] Immaterial mind stands on one side of a great divide; on the other side and quite out of reach – because it is an altogether different substance – is the extended materiality of body and brain. The mind-body problem that Descartes bequeaths to modernity is not merely

a version of the dualism at the heart of Platonism and all its descendants, but a vital question that Descartes makes more urgent by virtue of his compelling account of the mechanical character of the human body-brain. How, after all, can the human machine he describes so cogently also be a human being that is rationally conscious of itself?[23]

To begin to answer this question, I have brought forward a claim that human beings themselves are conversion machines, with Hamlet as Shakespeare's exemplary version of a human conversion machine. The limitation with that kind of argument, however, is that Hamlet's conversional coming into consciousness and selfhood is, in the first instance, a brilliant innovation in the art of dramatic characterisation, a technique by which Shakespeare is able to create what seems like a real person before our eyes. It is only secondarily and by implication an argument about how conversion can awaken consciousness and selfhood within human machines. In order to give my argument more weight and clarity, I will turn now to Leibniz by way of Justin Smith and to Smith's own thinking about how seeing the world and oneself in the world, which is what Hamlet does, should be understood to be the originative act of mindfulness in biological machines such as humans.

CONTEMPLATION MACHINES

Leibniz's thinking about humans as 'contemplation machines', extended and made new by Justin Smith in Chapter 12, will help me advance my claim about humans as conversion machines. Leibniz, while remaining within the substance-dualism problematic, nevertheless begins to move out from under the Cartesian mind-body problem by asking, what is it that the human machine does? All animals, including human animals, are machines. We can begin to understand what they are, to quote Smith, by considering 'some trademark activity or *officium*: thus spiders are "web-weaving machines", bees are "honey-making machines", and squirrels, curiously, are "jumping machines"' (p. 308). For Leibniz, human animals are different in kind from the other animals since their trademark activity is not of a piece with the physical character of their bodies but rather an officium of the mind – the cognitive work of perception and contemplation. For Leibniz, importantly, perception and contemplation are simply two forms of mindful cognition. According to Leibniz (to quote Smith again), 'the human *body* ... is a machine for the perpetuation of contemplation, while contemplation, unlike jumping and web-weaving, is not a mechanical operation, but rather, as [Leibniz] puts it in the *Monadology*, a non-bodily activity of the simple substance or monad' (p. 308).[24]

When we perceive or think, our perceptions or thoughts, while able to recognise the variety and divisibility of the objects of perception or thought, are nevertheless simple substances in themselves. Leibniz explains this in the *Monadology* by way of a metaphor about a mindful mill:

We are moreover obliged to confess that *perception* and that which depends on it *cannot be explained mechanically*, that is to say by figures and motions. Suppose that there were a machine so constructed as to produce thought, feeling, and perception, we could imagine it increased in size while retaining the same proportions, so that one could enter as one might a mill. On going inside we should only see the parts impinging on one another; we should not see anything which would explain a perception. The explanation of perception must therefore be sought in a simple substance, and not in a compound or in a machine. Moreover, there is nothing else whatever to be found in the simple substance except just this, viz. perceptions and their changes. It is in this alone that all *internal actions* of simple substances must consist.[25]

On this account, the thought that Augustine has at the moment of his conversion should recognise 'a variety in its object' (Leibniz' phrase).[26] In the garden, after all, there is the sound of children shouting, there is a book of scripture, there is a bench, and there is the apprehended presence of God. Augustine's perception of all these things, however, is monadic. His wholesale perception at the moment of conversion, does not undertake to recognise the variety or divisibility of what he hears, sees, and reads. Augustine's conversional perception weaves the children, the book, God, and himself into whole cloth where everything Augustine perceives is transformed into a simple substance – a perfect whole that is itself irradiated by consciousness. The fact that conversion represents the multiplicitous world, including the person seeing the world, as a monad is why I referred to it as world-creating or world-changing. The human conversion machine that represents the world as a simple substance finds its self, we might say, in the mirror of the transformed, newly monadic world.

Although, in his chapter, Smith does not consider how conversion transforms the human body-brain machine into a rational self, his argument nevertheless can help us see how the human conversion machine works. His argument does this by brilliantly likening the human brain, not to a computer, which is now the most common working metaphor, but rather to a camera, or what he calls here a black box:

what is special about black boxes … suggests a useful analogy with non-mechanical minds, or souls or monads, as conceived by Leibniz: in both cases, there is a representation of the world from a particular point of view; in both cases, at least prior to the era of digital photography, the representation seems to be a direct expression of the nature of reality, rather than a conversion or translation or reduction of reality into a code. In these respects, the analogy of the human mind to a camera seems rather more useful than the analogy to a computer. Black boxes represent

and reproduce the world, whereas computers translate and encode the world. (p. 318)

Of course, cameras do not grow minds or selves by representing the world, nor even by creating a 'a direct expression of the nature of reality', which is what Augustine and Hamlet do by seeing the world and themselves wholly and inclusively as they really are, so to speak. But Smith builds on the 'black box' metaphor by considering how recent 'perspectivist' theory, itself informed by Leibnizian metaphysics, issues in a vision of a world populated by creatures whose selfhood is conferred by how each one sees the world. Smith quotes Philippe Descola on how the 'subject ... is activated or "agented" by a point of view' (p. 319). All the creaturely machines in this account are made mindful by how they represent the world.[27] 'Nature', Smith says, '... is an infinite ensemble of black boxes: each representing the world within itself, and gaining its individuality and its identity through the content of these representations' (p. 320).

If we take Smith's argument back to the question of how the human machine becomes a thinking self by way of conversion, we can see, first of all, that it is simply in the nature of all creatures to be '"activated" or "agented"' by how each one represents the external world from its own point of view. 'Perspectivism', Descola explains, 'is thus the expression of the idea that every being occupies a point of view of reference, and thus finds itself situated as a subject' (quoted by Smith, p. 319). As Smith says, modifying George Berkeley's slogan, '*esse est percipere*, to be is to perceive' (p. 319). Against the background of this perspectivist account of how all creatures come into substantial being, conversion appears as simply the particular mode of seeing the world by which human animals achieve their own consciousness and selfhood.

All creatures, if we follow this argument, including humans, achieve being because they have a point of view on the world. But the differences between conversion-driven human mindfulness and the 'individuality and ... identity' (to quote Smith) of other animals are at least as important as the similarities.[28] The first is that conversion is an act performed or in some way experienced by humans rather than simply an integral attribute, as is the case for the other animals. A second difference seems to lie in the totalising scopic drive of human animals in the act or experience of conversion. Hamlet and Augustine see the whole world, including themselves, and they see the multiplicitous world as perfectly of a piece. Of course, we do not know how the other animals see the world. For all we know, they too might have their Augustine-like moments of revelation. We know so little because we don't speak their languages.[29] That is true, but it is also the case (and this is the third principal difference) that many human converts – we can call them 'super-converts' – evidently overflowing with the knowledge borne of their turning to see the world whole and wholly

new, seem suddenly bent on speaking, writing, performing actions, recruiting others, and even making art about the truth that they have discovered.

Augustine's *Confessions* is a prayerful speaking to the God to whom he has finally come home, but it is also a prayer written to be overheard by readers who might be seeking their own way home to salvation, just as Augustine himself has done in his autobiographical narrative. 'To whom do I tell these things?' Augustine asks at one point. 'Not to you, my God. But before you, I declare this to my race, to the human race' (p. 26). Hamlet feels his heart breaking because his present situation prevents him from speaking publicly about his vision of the world. 'But break my heart', he says at the end of his first soliloquy, 'for I must hold my tongue'. Yet Hamlet goes on to produce and contribute lines to a play that brings the image of the world he has seen in his mind to all the members of the court, including the king and the queen. The play-within-the-play is about how seemingly devoted wives will be happy to take new husbands once their first husbands have died. The dumb show that introduces the play stages a veiled accusation of fratricide against the king set inside a framing mime show of desire, violence, and the easy sexual corruptibility of women. The player-king in the dumb show, left sleeping in his garden by the player-queen, is murdered by a poisoner. Then the player-queen returns and finds her husband dead:

> *The Queen returns, finds the King dead, makes passionate action. The pois'ner with some two or three mutes come in again, seem to condole with her. The dead body is carried away. The pois'ner wooes the Queen with gifts; she seems loath and unwilling awhile, but in the end accepts love*

> 3.2.135sd

Hamlet's misogynist vision of a world wracked by sexual desire, especially by the insatiable carnal appetites of women, is confirmed by his father's ghost's lament about Gertrude's marriage to Claudius: 'lust, though to a radiant angel link'd, / Will sate itself in a celestial bed / And prey on garbage' (1.5.55–57). Although Hamlet's evangelism is generally blocked by his situation as merely the prince at his uncle's royal court, he nevertheless finds outlets in addition to 'The Mousetrap', which is itself a work of art designed 'to catch the conscience of the King' (2.2.605). He sermonises madly to his former beloved, Ophelia ('Get thee to a nunn'ry, why would'st thou be a breeder of sinners?' – 3.1.120–21). To his mother, he 'speak[s] daggers' (3.2.396) of moral righteousness:

> Mother, for love of grace,
> Lay not that flattering unction to your soul,
> That not your trespass but my madness speaks;

It will but skin and film the ulcerous place,
Whiles rank corruption, mining all within,
Infects unseen.

<div align="center">3.4.144–49</div>

Whereas his father's ghost has enjoined him to take quick and decisive action against the regicide Claudius, all Hamlet seems able to think about is how it might be possible to share with the world the truth he has discovered. Hamlet's story, then, is not mainly about the crooked pathway to revenge; rather, it is about how difficult it can be for one to speak publicly about the visionary knowledge that should be able to convert others as it has converted oneself. It is a fine piece of metatheatrical irony when Hamlet considers the visiting actor who has just performed a speech about the sack of Troy, the slaughter of King Priam, and the grieving of Queen Hecuba. If (Hamlet thinks) the actor knew what Hamlet knows about the death of Hamlet's father and the re-marriage of Hamlet's mother, the actor could speak and act so compellingly that he would readily take firm hold of the 'general ear': 'He would drown the stage with tears, / And cleave the general ear with horrid speech' (2.2.562–63). Hamlet finds himself incapable of such forms of transformative speech – 'Yet I / A dull and muddy-mettled rascal, peak / Like John-a-dreams, unpregnant of my cause, / And can say nothing' (566–69).

Knowledge, Power, Freedom

Hamlet's difficulties notwithstanding (more about Hamlet in a moment), the act or experience of conversion – suddenly seeing the world and oneself as a mindful unity – can bestow on the convert a storehouse of universal knowledge and can awaken great transformative power. The history of religion, political history, and the history of sex and gender are indeed organised around conversion stories about people awaking, after long struggle, to a new world and a new self now seen as entirely authentic. Many of the converts, emboldened by the apparent truth of their new understanding of the world and themselves, have undertaken to transform others and the world, their project illuminated by the brilliance of their conversional vision. Augustine is only one such figure among a great host of super-converts in Christian history (including a figure such as Bartolomé de las Casas), and in the history of Islam (Muhammad Ali and Malcolm X in modern America, for example).[30]

That people who have come face to face with what seems like the whole truth about the world and themselves feel newly empowered just makes good intuitive sense, but Leibniz can again be enlightening since his theory of the monad includes the idea of its radical autonomy. Smith sums up the idea of the freedom of the monad this way: 'Nothing outside of my soul can knock the unfolding of its states off course, nothing can bring about something new

in my soul from outside, something that was not already contained in what Leibniz sometimes calls, particularly in the period of the 1686 *Discourse on Metaphysics*, the "complete concept"' (p. 314). That the states of the soul are thought to unfold from within the person and not be visited on the person by outside forces can help us understand why someone like Augustine finds his new self and new vision of the world entirely authentic and empowering, as if he has finally seen clearly and fully who he is and what the world is, and seen all this from the inside, so to speak. And note that for Augustine, God is not an external force or figure; on the contrary, God is the home ground of Augustine's being, the source of being from which he has cut himself off through his years of wandering away from his true home.

Human conversion machines, especially super-converts such as Augustine, turn their minds toward the creation of new conversion machines – made things designed to open to other people new ways of seeing and being and capable also of bringing people together into communities around shared ideas about themselves and the world. The darker side of these conversional operations has to do with how conversion machines are able to induct people into certain required ways of living and into prescribed belief systems. Conversion is a driver of human community-building, but also an instrument that serves the machinery of institutional and political domination.[31] The univocal force of conversion machines can be heightened, of course, by how they often summon God as the guarantor of their truth-claims. It should thus come as no surprise that a conversion machine such as *The Confessions* can perform the offices of both liberation and indoctrination with equal force. If people who are feeling bereft of meaning and purpose happen to pick up Augustine's book, they will find themselves being led solely and movingly toward Christian conversion.[32]

On this account, the multitudinous conversion machines – the books, plays, pictures, artifacts, musical works, buildings, and practices made by super-converts and their followers – have the power to usher many people toward valuable, liberating, and empowering knowledge about themselves and the world. But conversion machines are also able to dismantle conversion's capacity to midwife new births of consciousness and selfhood. If we credit Leibniz' idea about the radical freedom of the monad, that 'nothing can bring about something new in my soul from outside', then it follows that conversion machines can short out the inward circuits by which human machines turn to see the world and themselves wholly, and wholly differently, and, by that turning, make themselves mindful. Conversion machines, as beneficial as they can be, nevertheless have the capacity to programme how humans see, think, and feel. They have the power, ironically enough, to undo the monadic character of human perception and contemplation and thereby to re-mechanise human bodies and brains.

All that said, there is still one good reason not to turn away from the multifarious conversion machines fashioned by human vision and ingenuity. It is that conversion machines themselves can open out into something akin to observation platforms where people can activate their inward circuitry and begin to look around for themselves. That kind of conversional freedom can issue simply from the restlessness of human cognition, especially when we are brought face to face with some kind of made thing that seems to have designs on us. Or it can emerge from the made thing itself, perhaps by how it layers up, in orchestrated polyphony, different ways of seeing or speaking. This is of course not true about all conversion machines and not true about any of them without taking into account the particular social situation and historical moment in which they are operating. However, it is true, for example, and exemplarily so, for the 'bundled' colonial patio crosses described by Anthony Meyer and true also about the remarkable early seventeenth-century novel *L'Isle des Hermaphrodites* discussed by Kathleen Long (both in this volume).

The play *Hamlet*, to which I return now by way of conclusion, provides another excellent model of the generative conversion machine I have in mind. Written after nearly a century-long series of forced conversions of the population of England back and forth between Catholicism and forms of Protestantism, the play pushed back against religious doctrine and even put on stage the religious struggles that still beset Shakespeare and the playgoers.[33] The Ghost seems to have returned to haunt Elsinore from Purgatory, a place of purification that existed only in a Catholic cosmos. The Ghost comes face-to-face with Prince Hamlet, who has just returned from university in Wittenburg, the birthplace of the Protestant Reformation. Perhaps most of the audience, Protestant offspring of Catholic parents, found themselves witnessing something like their own family history in a spectacle strikingly without any confessional affiliation and thereby open to conflicting interpretations.[34]

The play disentangles the characters and the dramatic action from prescribed ways of seeing and believing, transforming the playhouse into what I have elsewhere called a faith workshop, a place where it is possible to think freely and playfully about religious controversy (among other matters of consequence).[35] On this account, the aptly named Globe playhouse (open-air, uniformly lit, and with standing room for a thousand people) is an open, unbridled space where spectators can turn freely: they can really turn and see everything and everyone – they can look around, take in the world of the play wholly, and see for themselves the nature of that world and the meaning of the characters and the dramatic action.[36] Is it a Catholic cosmos or a Protestant one? Is Hamlet a 'sweet prince' (5.2.359) or 'the ambassador of death'?[37] And what, after all, are we to make of the Ghost?

The Ghost (apparently the ghost of Hamlet's father) could have been fashioned so as to bring supernatural, unquestionable truth into the play-world

(and it eventually does emerge that the Ghost has spoken truly about how the man he used to be was murdered), but the play undermines his authority by raising questions about his confessional identity and by having Hamlet suggest more than once that he could be a devil in disguise (1.5.39–42; 2.2.598–603). The play even makes a metatheatrical joke at the expense of the Ghost. He is calling on Hamlet's companions to swear that they will never make known what they have seen. 'Swear' he cries from beneath the earth. Then the Ghost is suddenly just an actor crying out his lines from beneath the stage. 'Come on', Hamlet says, 'you hear this fellow in the cellarage, / Consent to swear' (1.5.151–52); and the next moment, the Ghost is back as a real ghost: again he cries out, 'Swear by his sword' (161).

The design of the play invites the playgoers to take on the task of seeing the world of the play wholly and by their own lights, and by so doing to reprise or even deepen their own coming into consciousness and selfhood. The play's emergent secularity means that conversion for Hamlet and among the playgoers unfolds a self and a world without the otherworldly character of Augustinian or Pauline conversion. As I suggested earlier, Hamlet's conversion is a turning toward his own mind – a mind that comprehends the world – rather than toward a godly world with which the convert forms a single and unified whole. For Hamlet, the mindful self and the world are born together at the moment that the mind turns to face itself and sees itself thinking. 'Thinking', Hamlet says, 'makes it so'.

The character Hamlet, the lead human conversion machine in the play, performs the conversional awakening from mechanism that the playgoers are encouraged to enact for themselves. Coleridge, whose view of Hamlet I cited earlier, here sums up beautifully my claim about how the character Hamlet can lead us – not by way of a God-filled universe but by way of ourselves – toward the transformation of the operations of our cognition into the self-aware state of mindfulness that makes us human:

> I believe the character of Hamlet may be traced to Shakespeare's deep and accurate science in mental philosophy. Indeed, that this character must have some connection with the common fundamental laws of our nature may be assumed from the fact, that Hamlet has been the darling of every country in which the literature of England has been fostered. In order to understand him, it is essential that we should reflect on the constitution of our own minds.[38]

NOTES

1. The neurosurgeon Michael Egnor argues against 'brain-as-machine' by pointing out that the work the brain does is intrinsic to it while the work machines do is extrinsic to them since that work is designed by the humans who make the machines. Egnor, 'Yes, Your Brain is a Machine.'

2. Koch, 'Will Machines Ever Become Conscious?'
3. For unconscious cognition, see Kihlstrom, 'Cognition'.
4. A term coined by Dennett, *Consciousness Explained* (p. 96 and passim), 'hetero-phenomenological' is meant to acknowledge the phenomenological character of consciousness (what it feels like to the person whose consciousness it is) and at the same time to crack open the subject-centredness of consciousness and somehow make it available to external, scientific study.
5. Dennett and Searle, 'Mystery of Consciousness'.
6. For a recent neuroevolutionary argument about the origins of consciousness, see Feinberg and Mallatt, *Ancient Origins of Consciousness*.
7. *Riverside Shakespeare*, *Hamlet*, 2.2.123–24.
8. Ryle, 'Descartes' Myth', pp. 1–14.
9. There has been a robust debate around the 'inward self' in Shakespeare, a debate which grew out of the Anglo-American engagement with Deconstruction and neo-Marxism. A strong critique of the idea of Hamlet's inwardness is de Grazia, *Hamlet without Hamlet*. On the other side, which argues that inwardness is indeed a feature of Shakespeare's art and his conception of the person, is the historically informed work by Maus, *Inwardness and Theater*. For an excellent, philosophically-minded argument, see Bristol, 'Confusing Shakespeare's Characters with Real People'.
10. For the monad or simple substance, see 'Gottfried Wilhelm Leibniz', section 5.1, in *Stanford Encyclopedia of Philosophy*: 'Leibniz held instead that only beings endowed with true unity and capable of action can count as substances. The ultimate expression of Leibniz's view comes in his celebrated theory of monads, in which the only beings that will count as genuine substances and hence be considered real are mind-like simple substances endowed with perception and appetite.'
11. See de Montaigne, 'That the taste of good and evil things depends in large part on the opinion we have of them', in *Complete Essays*, pp. 52–72.
12. Descartes, *Discourse on the Method*, p. 28 (italics in original): 'while I was trying to think of all things being false in this way, it was necessarily the case that I, who was thinking them, had to be something; and observing this truth: *I am thinking therefore I exist*, was so secure and certain that it could not be shaken by any of the most extravagant suppositions of the sceptics, I judged that I could accept it without scruple, as the first principle of the philosophy I was seeking.'
13. For a brief account of how the play has moved and changed its readers, see Bevington, 'Critical Approaches', *Hamlet*. The quotes from Shaftesbury and Coleridge are from Bevington. For a wonderful modern example of the play's transformative power, see Berkoff, *I am Hamlet*.
14. Augustine, *Confessions*, p. 153.
15. *Ibid.*, pp. 143–44. For more on Augustine and the transformative power of books, see Miles, 'On Augustine's Reading'.
16. James, *Varieties of Religious Experience*, p. 150.
17. Dennett, *Consciousness Explained*, p. 31 (italics in original).
18. For a brilliant discussion of Descartes' elaboration of the theory of animal spirits, see Sutton, *Philosophy and Memory Traces*, pp. 21–49.
19. Descartes, *Treatise of Man*, loc 514.
20. For an excellent discussion of the history of the waterworks metaphor and of Descartes' mechanistic but vitalist account of living creatures, see Riskin, 'Descartes among the Machines'.
21. One of the best early articulations of the mind-body problem comes from the philosopher Princess Elisabeth of Bohemia. In a letter to Descartes dated May 1643, she wrote, 'I beg you to tell me how the human soul can determine the

movement of the animal spirits in the body so as to perform voluntary acts – being as it is merely a conscious substance. For the determination of the movement seems always to come about from the moving body's being propelled – to depend on the kind of impulse it gets from what it sets in motion, or again, on the nature and shape of this latter thing's surface. Now the first two conditions involve contact, and the third involves that the impelling [thing] has extension; but you utterly exclude extension from your notion of soul, and contact seems to me incompatible with a thing's being immaterial.' Quoted in Westphal, 'Descartes and the Mind-Body Problem'.

22. In the *Sixth Meditation* (*Philosophical Writings*, vol. 2, p. 59), Descartes offers us this insider account, so to speak, of his ideas about substance dualism: '[T]here is a great difference between the mind and the body, inasmuch as the body is by its very nature always divisible, while the mind is utterly indivisible. For when I consider the mind, or myself in so far as I am merely a thinking thing, I am unable to distinguish any parts within myself; I understand myself to be something quite single and complete By contrast, there is no corporeal or extended thing that I can think of which in my thought I cannot easily divide into parts; and this very fact makes me understand that it is divisible. This one argument would be enough to show me that the mind is completely different from the body'.

23. In the *Traité*, Descartes doesn't undertake to explain how the substances of mind and body are able to interconnect. He simply drops 'the soul' into the description from time to time. For a discussion of how Descartes undertook in his other writings to address the mind-body problem, see Rozemond, *Descartes's Dualism*. And for a promisingly cogent neuroscientific theory of consciousness, the so-called Integrated Information Theory (IIT), see Tononi and Koch, 'Consciousness: here, there and everywhere?' And see also Tononi, *Phi: A Voyage from the Brain to the Soul*.

24. Leibniz' argument for the special character of humans might make it seem that he has found himself back firmly inside the Cartesian mind-body problem, but he undertakes to push away from the problem by insisting that mnds and bodies operate in perfect parallelism. 'The states of the organic body', Smith comments, 'unfold in parallel to the states of the soul. As Leibniz puts it, ... the body manifests in an unfolded or explicated way what the soul manifests in an enfolded or impli-cated way' (p. x).

25. Leibniz, *The Monadology*, in *Philosophical Writings*, entry 17, pp. 5–6.

26. Ibid., entry 16, p. 5.

27. It is worth noting that these ideas about 'perspectivism' have some notable ante-cedents. Famously, Montaigne, (in *Complete Essays*, p. 505) speaks about how his cat's agency and subjectivity seems to be conferred by how she sees him: 'When I am playing with my cat, how do I know that she is not passing time with me rather than I with her.'

28. For the consciousness of animals, see, among many other works, see *Cambridge Declaration on Consciousness*.

29. In 'An Apology for Raymond Sebond', Montaigne puts forward an early argument for animal speech: 'Why should it be a defect in the beasts not in us which stops all communication between us?' *Complete Essays*, p. 506. More recently, a host of scientists have sought to repair the defect in human understanding by studying the expressive abilities and forms of communication of non-human animals. One excellent study is de Waal, *Are We Smart*.

30. For Bartholomé de las Casas, see Sullivan, *Indian Freedom*. For other Christian super-converts, see the fine, sceptical accounts in Jacoby, *Strange Gods*. For Muhammad Ali and Malcolm X, see Davis, *Public Confessions*.

31. For a related argument about the institionalisation of conversional knowledge and freedom, see Cayley, *The Rivers North of the Future.*
32. Note that 'conversion' can also refer to a renewal of conviction and devotion within a person's professed religion as well as a turning from one to another religion.
33. For historical background and insightful discussion of the play, see Greenblatt, *Hamlet in Purgatory.*
34. For more about the staging of the scene between the Ghost and Hamlet, see Yachnin, 'Performing Publicity'.
35. See Yachnin, 'Performance'.
36. For the capacity of the Globe yard, see Gurr, *Playgoing in Shakespeare's London*, p. 19.
37. The phrase 'the ambassador of death' is from Wilson Knight, 'The Embassy of Death', p. 35. Knight's argument finds much traction in the play, for example, in Hamlet's psychological abuse and public shaming of Ophelia and in his strategy to have the hapless Rosencrantz and Guildenstern executed, 'not shriving time allow'd' (5.2.47).
38. *Coleridge: Lectures on Shakespeare*, p. 142.

Works Cited

Augustine, St., *Confessions*, trans. Henry Charwick (Oxford: Oxford University Press, 1992).

Berkoff, Steven, *I am Hamlet* (New York: Grove Press, 1990).

Bevington, David, 'Critical Approaches', *Hamlet*, Internet Shakespeare Editions, https://internetshakespeare.uvic.ca/doc/Ham_CriticalSurvey/index.html (last accessed 28 December 2020).

Bristol, Michael, 'Confusing Shakespeare's Characters with Real People: Reflections on Reading in Four Questions', in *Shakespeare and Character*, Paul Yachnin and Jessica Slights (ed.) (New York: Palgrave Macmillan, 2009), pp. 21–40.

Cambridge Declaration on Consciousness (2012), https://web.archive.org/web/20131109230457/http://fcmconference.org/img/CambridgeDeclarationOnConsciousness.pdf (last accessed 23 December 2020).

Cayley, David, *The Rivers North of the Future: The Testament of Ivan Illich as told to David Cayley* (Toronto: Anansi, 2005).

Chalmers, David J., *The Conscious Mind: In Search of a Fundamental Theory* (Oxford: Oxford University Press, 1996).

Coleridge, Samuel Taylor, *Coleridge: Lectures on Shakespeare (1811–1819)*, Adam Roberts (ed.) (Edinburgh: Edinburgh University Press, 2017).

Davis, Rebecca L., *Public Confessions: The Religious Conversions that Changed American Politics* (Chapel Hill: University of North Carolina Press, 2021).

de Grazia, Margreta, *Hamlet* without Hamlet (Cambridge: Cambridge University Press, 2007).

Dennett, Daniel C., *Consciousness Explained* (New York: Little, Brown, 1991).

Dennett, Daniel and John Searle, 'The Mystery of Consciousness': An Exchange', *The New York Review*, Dec 21 1995, https://www.nybooks.com/articles/1995/12/21/the-mystery-of-consciousness-an-exchange/ (last accessed 15 December 2020).

Descartes, René, *A Discourse on the Method*, trans. Ian Maclean (Oxford: Oxford University Press, 2006).

Descartes, René, *The Philosophical Writings of Descartes*, 2 vols., trans. John Cottingham, Robert Stoothoff, and Dugald Murdoch (Cambridge: Cambridge University Press, 1985.

Descartes, René, *Treatise of Man*, trans. Thomas Steele Hall (Prometheus Books, 2003).

De Waal, Frans, *Are We Smart Enough to Know How Smart Animals Are?* (New York: W.W. Norton, 2017).

Egnor, Michael, 'Yes, Your Brain is a Machine – If You Choose to See it that Way', *MindMatters News*, Oct 29 2018, https://mindmatters.ai/2018/10/yes-your-brain-is-a-machine-if-you-choose-to-see-it-that-way/#:~:text=Unlike%20a%20machine%2C%20the%20brain,the%20activity%20of%20a%20machine (last accessed 4 September 2020).

Feinberg, Todd E., and Jon M. Mallatt, *The Ancient Origins of Consciousness: How the Brain Created Experience* (Boston: MIT Press, 2016).

Greenblatt, Stephen, *Hamlet in Purgatory* (Princeton: Princetom University Press, 2001).

Gurr, Andrew, *Playgoing in Shakespeare's London* (Cambridge: Cambridge University Press, 1987).

James, William, *The Varieties of Religious Experience* (1902), Matthew Bradley (ed.) (Oxford: Oxford University Press, 2012).

Jacoby, Susan, *Strange Gods: A Secular History of Conversion* (New York: Pantheon Books, 2016).

Koch, Christof, 'Will Machines Ever Become Conscious?' *Scientific American*, 1 Dec. 2019, https://www.scientificamerican.com/article/will-machines-ever-become-conscious/ (last accessed 1 August 2020).

Kihlstrom, John F., 'Cognition, unconscious processes', http://www.baars-gage.com/furtherreadinginstructors/Chapter08/Chapter8_Cognitive_Unconscious.pdf (last accessed 18 October 2020).

Leibniz, Gottfried, *The Philosophical Writings of Leibniz*, trans. Mary Morris (London and Toronto: J. M. Dent and Sons, 1934).

Maus, Katharine Eisaman, *Inwardness and Theater in the English Renaissance* (Chicago: University of Chicago Press, 1995).

Miles, Margaret R., 'On Reading Augustine and on Augustine's Reading', rpt. Religion Online https://www.religion-online.org/article/on-reading-augustine-and-on-augustines-reading/ (last accessed 21 December 2020).

Montaigne, Michel de, *The Complete Essays*, trans. M. A. Screech (London: Penguin Books, 1987).

Riskin, Jessica, 'Descartes among the Machines', in *The Restless Clock: A History of the Centuries-long Argument over What Makes Living Things Tick* (Chicago: University of Chicago Press, 2016), pp. 44–76.

Rozemond, Marleen, *Descartes's Dualism* (Cambridge: Harvard University Press, 1998).

Ryle, Gilbert, 'Descartes' Myth', in *The Concept of Mind* (1949; 60th Anniversary Edition, Abington: Routledge, 2009).

Shakespeare, William, *Riverside Shakespeare*, textual ed. Blakemore Evans (2nd ed. Boston: Houghton Mifflin, 1997).

Stanford Encyclopedia of Philosophy, 'Gottfried Wilhelm Leibniz', section 5.1, https://plato.stanford.edu/entries/leibniz/#MonWorPhe (last accessed 19 December 2020).

Sullivan, Francis Patrick (ed.), *Indian Freedom: The Cause of Bartolomé de las Casas, 1484–1566 A Reader*, (Kansas City: Sheed & Ward, 1995).

Sutton, John, *Philosophy and Memory Traces: Descartes to Connectionism* (Cambridge: Cambridge University Press, 1998).

Tononi, Giulio, *Phi: A Voyage from the Brain to the Soul* (New York: Pantheon Books, 2012).

Tononi, Giulio, and Christof Koch, 'Consciousness: here, there and everywhere?' *Philosophical Transactions of the Royal Society B, Biological Sciences*, 19 May

2015, https://royalsocietypublishing.org/doi/10.1098/rstb.2014.0167 (last accessed 22 October 2020).

Westphal, Jonathan, 'Descartes and the Discovery of the Mind-Body Problem', *The MIT Press Reader,* August 8 2019, https://thereader.mitpress.mit.edu/discovery-mind-body-problem/ (last accessed 27 October 2020).

Wilson Knight, G., 'The Embassy of Death: An Essay on *Hamlet*,' in *The Wheel of Fire: Interpretations of Shakespearian Tragedy* (rpt. London: Routledge, 2001), pp. 17–49.

Yachnin, Paul, 'Performing Publicity,' *Shakespeare Bulletin*, 28 (2010), pp. 201–19.

_____, 'Performance,' *The Imminent Frame*, 20 Dec. 2019, https://tif.ssrc.org/2019/12/20/performance-yachnin/ (last accessed 28 December 2020).

INDEX

References in *italics* refer to a figure.